LOST AND FOUND TRADITIONS

Native American Art 1965–1985

Ralph T. Coe

Edited by
Irene Gordon

Photographs by
Bobby Hansson

THE AMERICAN FEDERATION OF ARTS

This book has been published in conjunction with the exhibition *Lost and Found Traditions: Native American Art 1965–1985*, which was organized by the American Federation of Arts. The exhibition and publication have been made possible by major grants from the American Can Company Foundation with additional support from the National Endowment for the Arts. The publication has been supported by the Sacred Circles Fund; and by The J. M. Kaplan Fund, the DeWitt Wallace Fund, and The Henry Luce Foundation through the AFA's Revolving Fund for Publications.

The American Federation of Arts is a national nonprofit educational organization, founded in 1909 to broaden the knowledge and appreciation of the arts of the past and present. Its primary activities are the organization of exhibitions which travel throughout the United States and abroad and the fostering of a better understanding among nations by the international exchange of art.

Edited by Irene Gordon
Maps by Judy Skorpil
Design and Typography by Dana Levy, Perpetua Press, Los Angeles
Composition by Continental Typographics Inc., Chatsworth, Calif.
Printed by Toppan Printing Company, Tokyo

cover Greg Colfax (Makah). DETAIL OF KERFED BOX, 1982–85 (cat. no. 352).

CONTENTS

The American Can Company Foundation is pleased to have provided the principal acquisition and exhibition funding for *Lost and Found Traditions: Native American Art 1965–1985*. This unique, major exhibition of contemporary, *traditional* Native American art celebrates the American creative spirit by highlighting the diversity and richness of these indigenous art forms.

We at American Can believe that American art, old and new, is the tapestry of our cultural heritage. The art that comprises *Lost and Found Traditions* enhances our lives by revealing the diverse, artistic expressions of Native American artists. We salute the many talented men and women whose works have been selected for this exhibition and hope that those who view this work will share our excitement.

WILLIAM S. WOODSIDE
Chairman
American Can Company

ACKNOWLEDGMENTS

OVER THE YEARS, MUSEUM AUDIENCES HAVE HAD THE opportunity to experience the tremendous diversity, originality, and power of American Indian art of the past through a number of exhibitions, both large and small. Such presentations have aroused a growing interest over the question of the extent to which these traditions have survived. The American Federation of Arts takes pride in having been able to support the exploration of this question and–by means of this exhibition and publication–demonstrating that the old traditions continue to manifest themselves in the art that American Indians are creating today. We express our profound respect for the skill and dedication of the artists, both named and unnamed, whose works are included in the collection presented here.

Primary credit for *Lost and Found Traditions: Native American Art 1965–1985* goes to Ralph T. Coe, for his initial conception of the project and for his years of committed and tireless research. This exhibition could never have become a reality without his knowledge and his inexhaustible perseverence, matched with wit, sensitivity, and special skills in human communication.

From the very beginning, the project proposed to us by Mr. Coe required an unconventional approach. It called for assembling a body of work that was not to be found at that time in either institutions or private collections. The only approach, therefore, was to go into the field and assemble such a collection. This dream was transformed into reality when the American Can Company Foundation stepped forward with the vital funds needed for the extensive travel involved in such an undertaking and for purchase of the objects. To William S. Woodside, Chairman and Chief Executive Officer, we are particularly indebted for his continuous encouragement and support of the project. Others at the American Can Company whose help must be acknowledged include Peter Goldberg, Vice President, American Can Company Foundation; Barbara Kriz, Coordinator, Foundation Grants; and Kenneth Koprowski, Director, Corporate Communications.

Special gratitude is also extended to the National Endowment for the Arts, for its support of the project through two generous grants. We are also indebted to the Sacred Circles Fund for their special grant to this publication, which has made possible the extent and quality of reproduction these works deserve. Support for the catalogue has also been provided by the J. M. Kaplan Fund, the DeWitt Wallace Fund, and The Henry Luce Foundation through the AFA's Revolving Fund for Publications.

For their willingness to lend works from their collections, the AFA gratefully acknowledges Jan and Frederick Mayer, Denver, Colorado; Donald D. Jones and Reverend Thomas W. Wiederholt, Kansas City, Missouri; Randy Lee White, Questa, New Mexico; and Ralph T. Coe, Santa Fe. We are especially indebted to artist Robert Davidson for lending his important carvings and to Larry and Jeanne Hoback for making available the Nishga totem pole.

The task of organizing such an ambitious project has required considerable effort on the part of many AFA staff members. First, I wish to thank James Stave, Exhibition Coordinator, for his skillful handling of the myriad complicated details involved in the monitoring of acquisitions and in

all the aspects of organizing the exhibition and producing this publication. Special consideration for their roles in guiding the overall development of the project also go to Jane Tai, Associate Director; and to Jeffery Pavelka, Acting Director, Exhibition Program. The assembling of works from all over North America and all aspects in the preparation and care of the delicate objects in the exhibition has been very ably carried out by Albina de Meio, Registrar, with expert assistance from Carolyn Lasar, Associate Registrar. Susanna D'Alton Alde and Carol O'Biso must be acknowledged for invaluable roles as Exhibition Coordinator and Registrar, respectively, in the early years of planning. Special thanks must also go to Amy McEwen, Coordinator, Scheduling, for her determination and patience in the long process of arranging the exhibition's itinerary. Finally, credit is due Teri Roiger, Exhibition Assistant, for her thorough attention to the processing of Mr. Coe's voluminous notes sent from the field, as well as all manuscript material.

Beyond the invaluable contribution of Mr. Coe, the catalogue's author, this publication has benefited immensely from the editorial expertise of Irene Gordon, who, with probing insight, worked closely with the author in putting his words into their finished form. The challenging task of photographing a collection of such diverse objects was accomplished with great care and skill by Bobby Hansson. The difficult task of composing maps that include far-flung places frequently located only on surveyors' charts has been masterfully accomplished by Judy Skorpil. Special thanks go to Letitia Burns O'Connor and Dana Levy of Perpetua Press not only for their care in the design and production of this very special book, but also for their patient understanding of the unique problems such a project engenders.

Finally, we thank the museums across the country in whose galleries the works in this collection will receive their first public exhibition.

WILDER GREEN
Director
The American Federation of Arts

FOREWORD

THIS EXHIBITION RECORDS JOURNEYS INTO THE AMERICAN Indian world made during most of a decade. I began my travels in Indian country in the summer of 1977; the latest trip took place on Labor Day weekend 1985, when I visited the Passamaquoddy of Pleasant Point, Maine. Late one night, in the whitewashed guest room in the cabin of my friend and Passamaquoddy mentor, Bill Altvater, I recalled his reproof in the course of a conversation: "I don't mean to insult you, Ted, but an Indian is someone who lives in India. We go by tribes." His admonition echoes down through the centuries, for as early as 1646 another New England tribesman had asked a Massachusetts missionary, "Why do you call us Indians?"* In many ways not that much has changed between the Indian world I visited and that of long ago. The scenario is drastically different, but not the fundamental underlying patterns. The kinship between past and present that is still alive today in Indian communities is one of the themes of this project.

As related in the chapter that follows, this project grew out of the exhibition *Sacred Circles*, a historical survey of American Indian art I had organized at the request of the Arts Council of Great Britain, which was shown in London in the fall of 1976 and at the Nelson Gallery of Art, Kansas City, Missouri, in 1977. A year later the U.S. Information Agency, acting at the behest of American embassies, initiated negotiations for an exhibition of contemporary American Indian art, which I would assemble, the American Federation of Arts would organize, and the Agency would circulate. Collecting had already begun, when the peculiarities of bureaucratic regulations called a halt to government participation. Sporadic collecting continued on a restricted scale, and the entire project might have languished were it not for the interest of the American Can Company, who came to the rescue with substantial funds. It took foresight and imagination to support so unorthodox a program, and I hope that William Woodside, Chairman and Chief Executive Officer, American Can Company, and its Foundation officials, will take pleasure in viewing the results now presented publicly. Particularly to Mr. Woodside we owe the life of this project. At the suggestion of Brian Martin, Vice President, Corporate Communications, of the American Can Company, a film based on the life and work of the artisans included here was undertaken by Alvin Siskind, Producer, Visual Communications, Corporate Public Affairs. I thank Mr. Siskind for making typescripts of their comments available to me. He and his production crew—Don Goff, cameraman, and Bill Barrett, soundman—traveled the length of this continent from Rhode Island to the Olympic Peninsula with me, welcome companions in a little-seen America that became for us the real America.

Significant support at later stages came from grants-in-aid from both the Museum and the Folk Arts programs of the National Endowment for the Arts. A special grant dedicated to this publication was made by the Sacred Circles Fund, whose trustees have my thanks, particularly Mrs. Robert Phinney whose association with me goes back to *Sacred Circles* days.

At a pivotal moment the National Museum of American Art, Smithsonian Institution, granted me a year's stay at the institution as a senior visiting scholar. I wish to thank its director, Charles C. Eldredge, for interpret-

9

ing the mission of his museum as including American Indian art as an integral part of American culture. To him and to the staff of his museum, especially William Truettner, I am greatly indebted for numerous encouragements. Margy Sharp was particularly helpful in the early stages of cataloguing. The Atlantic Van Lines of nearby Baltimore deserve my thanks for accepting me as biweekly visitor while the growing collection was stored on their premises.

In Santa Fe, where I moved in late 1983, I have had many mentors, among them Andrew Hunter Whiteford and Barbara Mauldin. Susan McGreevy made many knowledgeable suggestions and to her and her husband, Thomas, I express my thanks for the extended use of their guest house, which gradually filled up with Southwestern art. At a later stage, Gregg Stock, executive director of SWAIA (Southwestern Association on Indian Affairs), and his wife, Sarah, accommodated me (and more objects) in their Santa Fe home, with a graciousness I can never repay.

Wilder Green, the imaginative director of the American Federation of Arts, and associate director Jane Tai, an equal believer in expanding the creative scope and direction of art exhibitions, believed from the beginning that contemporary American Indian art merited a fresh venue; to both I acknowledge my deep indebtedness. Neither wavered, through thick and thin, in their support of this project.

Jane Tai promised a superb photographer and an excellent editor, and she provided both. I wish to thank Irene Gordon for painlessly and efficiently coping with a text and catalogue entries written in a circular fashion with the body of the text meeting in the middle. Her encouragement, enthusiasm, and undaunted sense for the right expression were an inspiration. It was a pleasure to work closely with someone who can climb sympathetically into your mind.

I shall always remember Bobby Hansson photographing the objects displayed here, handling them, examining them, probing the drama within them without overstepping the validity of their innate character. It is especially difficult to photograph Indian objects, and it takes special understanding of Indian forms and techniques in order to communicate both their grand statements and their softer voices.

Over the years the fulcrum of this project was James Stave, American Federation of Arts Exhibition Coordinator. As the years passed, complex problems multiplied. His patience and fortitude never wavered; it would be impossible to count the times he pulled us back from the precipice. While I strayed over the continent, he was in place, plotting the logical steps. "Thank you, Jim," as the Westcoast Indians would say at a potlatch, "for being there."

In the early months of organization, Susanna D'Alton Alde and Carol O'Biso, former AFA staff members, were instrumental. The present Registrar, Albina de Meio, has exerted signal efforts on this project's behalf, which have included supervision of the removal and transport of the full-size totem pole from its remote Nass River Valley locale in British Columbia. I wish to thank Teri Roiger, Exhibition Assistant, for heroic efforts in deciphering masses of manuscript pages, and both Sandra Gilbert, Public Information and Promotion Director, and Amy McEwen, Coordinator, Scheduling, for their activities on behalf of this project.

The collection of objects assembled here has been enriched by a number of loans from both artists and collectors. Among the former I thank Randy Lee White, the distinguished Sioux painter, for lending a war bonnet that has been danced, a mark of faith and confidence in this project that means much. Robert Davidson, the noted Haida artist, has been equally gracious in lending the beautiful cedar models for his Edenshaw Memorial houseposts. Donald D. Jones and Reverend Thomas W. Wiederholt, friends who traveled with me in Indian country, are also lenders. I wish also to remember with particular gratitude the anonymous lender, now deceased, of the Navajo silver necklace, who stepped forward at a point when funds were short. Collectors Jan and Frederick Mayer, of Denver, Colorado, provided generous private funds for the purchase of Navajo textiles, thereby immeasurably enlarging the collecting possibilities in that quarter. To the greateartedness of Larry and Jeanne Hoback of New Aiyansh, British Columbia, this project owes the presence of the Nishga clan pole.

Traders are part of the story, and citation of places of acquisition in the catalogue entries is also meant as acknowledgment of their special help and encouragement. Leona Lattimer, Gift Shop Manager at the Vancouver Museums and Planetarium, must be singled out for her innumerable

kindnesses. While Frank Pushetonequa of Tama, Iowa, is cited as a trader, special mention must be made of his kindness, and that of his wife, Georgia, which made possible the cordially remembered visit two Korean scholars and I made to the Mesquakie Settlement at Tama.

I wish to thank Doreen Jensen (Gitksan) for inviting me to the National Native Indian Artists' Symposium held in 1982 in Hazelton, British Columbia. Jamake Highwater and Colin Williams were responsible for my attending the Aspen Institute seminar *Indian America: Past, Present and Future,* held in 1982 at Crestone, Colorado. Sara Wolsch, a Canadian Broadcasting Corporation producer, was particularly helpful with matters in Eastern Canada. Laura Holt, Librarian at the Laboratory of Anthropology, Santa Fe, New Mexico, was helpful with bibliographic advice, including introducing me to Edward T. Hall's writings on time, which provided reassuring evidence when "Indian time" seemed to lead me beyond where I had a footing. My Osage friend Carl Ponca, a teacher at the Institute of American Indian Arts at Santa Fe, has for countless reasons my thanks from the heart.

Robert Davidson (Haida) and George David (Westcoast) both invited me to potlatches in 1978 and 1985, affording me a privilege for which I am in their debt. In August 1978, Reverend Wiederholt and I were invited to see a totem pole that had recently been erected in New Aiyansh, British Columbia. Our hosts in this expedition were E. Bertram Berkley, a Kansas City business executive and a board member of what was then the Canadian Cellulose Corporation, and Roy Murphy, president of the company at the time. To them, and to Rod Robinson, a Nishga foreman for the company who was our guide on a tour of the Nass River settlements, to the entire staff of the lumber camp were we were housed with great courtesy, and to the Nishga people, who received us with true cordiality, I offer my heartfelt thanks for providing a rare experience. The deepest indebtedness of all I express to George and Molly Kicking Woman, Blackfeet dignitaries of Browning, Montana, for letting me attend their pipe ceremony, held in a faraway grove within a great circle of trees, which I shall never forget.

Above everyone else, to all those artists and artisans who patiently heard out my requests, and to all their relatives and friends who accommodated me, fed me, and interceded on my behalf, I offer thanks beyond anything mere words allow. Much that I heard or witnessed is excluded here to preserve anonymity. To those who may feel that I have betrayed a trust, my apologies, and my hope that they understand that if I have overstepped any line, I was motivated by the importance of putting the case for contemporary/traditional Native American arts into the open. I confirm a prejudice in favor of the contemporary work, which I was gratified to learn was shared by the Northwest Coast collector John G. Swan as long ago as 1875. It is reported that he "thought more of his [new] Haida pole than either of the [older] Tsimshian or Kwakiutl poles."** By my own experience I have come not only to share, but also to applaud his attitude.

RALPH T. COE
Santa Fe, New Mexico

*Robert E. Berkhofer, Jr., *The White Man's Indian* (New York: Vintage Books, 1978), p. 4.
**Douglas Cole, *Captured Heritage: The Scramble for Northwest Coast Artifacts* (Vancouver/Toronto: Douglas & McIntyre, 1984), pp. 29–30.

CULTURAL AREAS OF NATIVE NORTH AMERICA

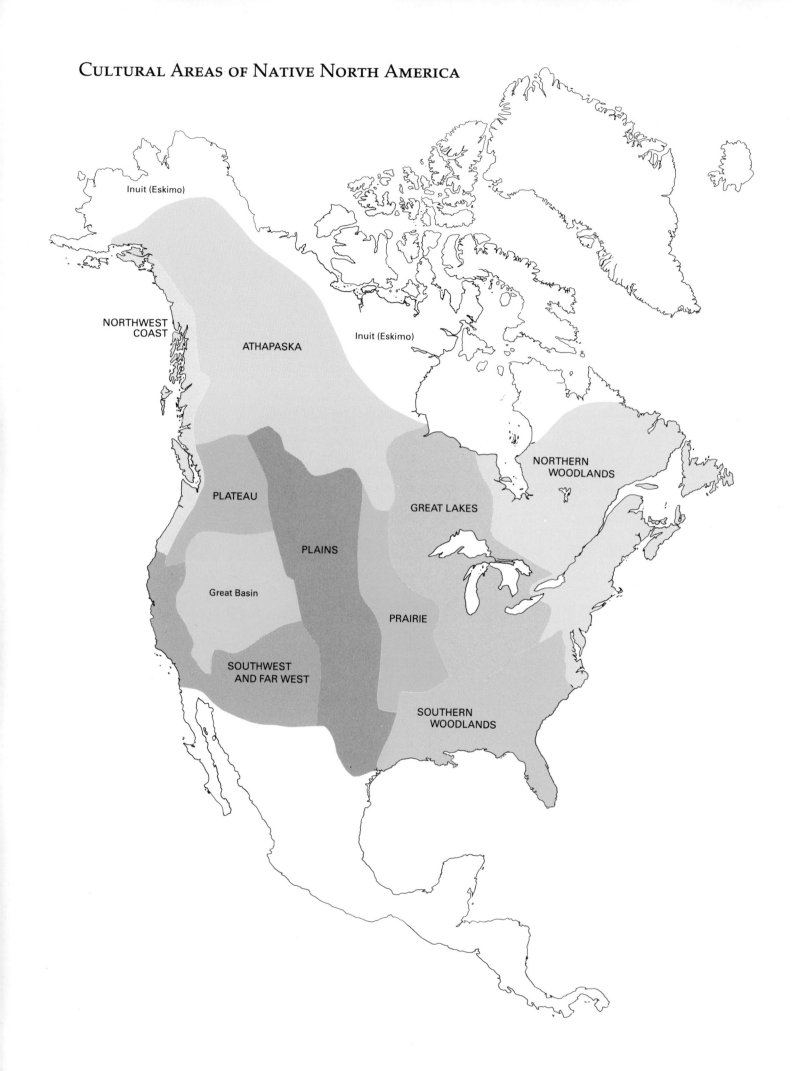

Inuit (Eskimo)

NORTHWEST COAST

ATHAPASKA

Inuit (Eskimo)

PLATEAU

NORTHERN WOODLANDS

GREAT LAKES

PLAINS

Great Basin

PRAIRIE

SOUTHWEST AND FAR WEST

SOUTHERN WOODLANDS

LOST AND FOUND TRADITIONS

Native American Art 1965–1985

I

"Off the Map"

WHILE CONSIDERABLE INTEREST HAS BEEN FOCUSED IN recent years on traditional American Indian art, little attention has been paid to contemporary/traditional American Indian Art. It is this recent art that is the subject of this wide-ranging project. The objects presented here address a number of questions. Does a viable traditional American Indian art exist today? Or, as has often been maintained, has such an art been lost in the wake of white displacement of old ways?

Since the old tribal cultures have been transformed through almost four centuries of white influence, it has often been assumed that there is no longer a basis from which an indigenous native art can emerge, except for the type of art that Indians aim exclusively at white patrons. All too often contemporary Indian arts and crafts have been dismissed as pale reflections of once-great art forms now gone forever, like a drum gone silent. An extreme view proposes that today's reservation arts are barely worthwhile at all, that they are not worth exhibiting, that they lost their quality before World War I and have been deteriorating ever since.

The Indians who live on reservations are often looked down upon as hopelessly behind the times. "I dislike those Indians who have gotten master's degrees and then go back to the pueblo and weave," a Santa Fe resident declared in 1984. "The only way to success in America is to get the best education possible and use it to make lots of money," an opinion shared by many who cannot understand why everyone may not wish to join the dominant culture. Those Indians residing off the reservations are often regarded by whites as non-Indians who have joined the mainstream in order to toss their Indianness aside. That urban Indians may retain traditional values and an interest in their reservations simply does not occur to shortsighted outsiders. Neither group is seen as having much to do with the other. In the *New York Times*, Grace Glueck recently stated, "Though still an identifiable ethnic minority, Native Americans, as they are now often referred to, are, by and large, as diverse in their cultural outlook as Americans in general and no longer feel dutiful about making art that reflects their Indian heritage."[1] This is a conclusion with frightening implications, for it strikes at the very core of Indian cohesiveness.

It is as if the Indians of old had departed from these shores, leaving nothing behind except an artistic heritage frozen in the past. Yet, the contrary is true. This project shows that their past is more than an occasional reference point for today's Indians, and that there is a legacy alive and active to this day. The works included here reveal that the whole question of what constitutes a living tradition in American Indian art is an open one, not a closed affair at all, and that old and new ideas of native art coexist side by side now as they have so often done in the past. To be a modern Indian does not mean that traditions must be cast aside (fig. 1). Rather, the past is frequently incorporated into the present with great breadth of vision, and with greater freedom than is granted by narrow definitions of tradition.

In their studies of Indian cultures, some writers tend to emphasize the values of the past, which reinforces the tendency to dismiss contemporary

traditionalism. An impression is thus conveyed of a culture not really knowingly in command of its art, but which exists, if at all, only as an art historical abstract. This confusion of past and present has not been lost upon Indians, who have dealt with it on countless occasions, aware that for many outsiders they hardly exist as people. "I know, we aren't supposed to be Indians any more," a North Dakota Sioux noted at a powwow. "As you see"—gesturing at a circle of dancers in full regalia—"we have vanished." The major emphasis has been on the art the Indians have lost; rarely is equal consideration given to the how, when, where, or what with regard to the objects the survivors are making or using today. However understandable this position may be, it is time for the balance to be redressed.

The fact that Indians have not laid aside their past as much as outsiders have presumed raises many questions about cultural survival and the forms it may take. Artistic solutions involving aspects of continuity and change are present in the many objects exhibited here. This is a complex matter for which there are no cut-and-dried answers. Nor do answers apply equally everywhere in the Indian world. It is a relative matter, varying greatly according to pressure and circumstance and how much the native mores have been interfered with. Outside encouragement also plays a large part.

Here we are concerned only with art, but art is an index to the Indian will to survive culturally, even if it does not tell the whole story or apply to all tribes at any one time. That depends on the state of individual tribal culture. In the classic Indian view, however, art is not separate from any other phase of life. Prayers, legends, language, social and religious expression in dance, visual art, and what is generally referred to as the "Indian way" all go together to create an integrated whole. Fragmentation of this unity has of course taken place wherever the holistic process has been interfered with, let alone where tribes have been exterminated or altered drastically away from tradition. But is this the whole story?

It has been assumed that as the Indians assimilated white ways early in this century the process of fragmentation was irreversible, with complete negation of the old cultures as the only foreseeable and inevitable result. Only inferior Indian art is supposed to have been produced after the onslaught, and that made for tourists. This was the "curio" trade, with no real roots in the past, since the old values were fast losing ground. It was deemed "poor" in its lack of native content, though this was not necessarily the case at all. Good Indian art, one was forced to assume, was to be found only in museums. The mirror went only one way, reflecting only the past.

In comparison with the art of the past, the contribution of contemporary reservation cultures could be bypassed, or not taken seriously. This state of affairs was clarified by an Ojibwa dealer: "Since tourists long ago bought our birchbark boxes and canoe models, they think of us not as artists, but as curio makers. One of my great difficulties is getting my customers to accept us as artistic people and not makers of odds and ends."[2] Part of the problem resides in applying just such white-generated terms as "tourist art," "curio trade," and "trade object" in a pejorative way to what is actually Indian originated, no matter what its final destination might be. Another misconception derives from our failure to recognize that Indians have always traded both within and outside their culture; it is second nature to the way they operate in all things. Many objects are, and always have been, created in the Indian world without a specific destination in mind. The history of Indian trading predates any white influence, and trading continues today unabated. It is a fascinating instrument of social continuity, and in these modern times its scope has been greatly enlarged. The circle of Indian trade relationships has been noted by Letta Wofford, a private trader in Santa Fe. "I've got friends in Santa Clara Pueblo who love Jicarilla Apache baskets. They like to trade their pottery for them. The Santo Domingo Pueblo people love to trade for contemporary Navajo-Paiute wedding baskets. They like the new Pendleton blankets, while I sell the old ones to white people." Due to faster means of travel, objects move rapidly across and over the powwow circuits. A "trade object" made in one tribe becomes a dance accessory badly needed by a member of another tribe, which no longer makes the item. "The best Osage trailers are made by two Pawnee brothers and are in great demand over here in Pawhuska; there's none made as well here," trader Andrew Gray, a full-blood Osage, reminded me in 1983 of a Pawnee-made Osage trailer I had purchased from him some years before (cat. no. 115).

The collection of objects presented here is studded with such examples of cross-cultural influences, which casts the notion of modern Indian trading in a different light, as a creative, positive aspect of Indian life. At times Indians even wanted to trade with me, as, for example, at the Mountain Ute annual Bear Dance of 1984 when it was learned I had some Indian-tanned hides at home. Some so-called tourist pieces are in fact the subject of great indigenous pride. "Just try telling Matilda Hill that her 'fancies' (cat. no. 46) are tourist curios," said Mohawk Rick Hill, author of an unpublished paper on the subject. "The Tuscarora have been able to trade pieces like that bird or beaded frame (cat. no. 47) at Niagara since the end of the War of 1812, when they were granted exclusive rights, and she wouldn't take kindly to anyone slighting her culture!"[3] Surely, a trade privilege established at Niagara Falls in 1816 should be acceptable as tradition by now. The same verdict applies equally to Algonkian splint basketry (cat. nos. 16–23), which was probably introduced by settlers in the Delaware River Valley in the seventeenth century, and to ribbon appliqué, one of the glories of Great Lakes period dress still flourishing today (cat. nos. 103 and 104), which originated in the démodé silk ribbons that had been worn by French ladies of fashion and ended up in New France as trade items.

FIGURE 1
Painted tepee and pickup truck, Iron Ring Celebration, Poplar, Montana, 1984.

It has long been a cliché that young Indians are not interested in learning the arts of their ancestors. After generations of white clothing, missionary schooling, short haircuts, log cabins, and tar paper shacks—sad steps in catching up with the Anglo world—television, film, fast foods, and pop culture have taken over. All this, the dogma asserts, has precluded continuance of the old arts. The Southwest, of course, was different; there, traditions held. There, the Indian cultures had often stayed in one locale, retrenched, and developed in situ relatively undisturbed. That evolution continues today, but even here a trader declared, "The old Southwest stuff is better; there isn't as much decay."[4] Elsewhere Indians have long been seen as belonging to a lost world in which "the general tendency is for the native arts to disappear."[5] Particularly in the 1920s and 1930s this trend appeared to be irreversible, and the notion has proved hard to dispel, despite the presence of craft classes initiated on the reservations during WPA days.[6]

As the elders passed from this world, the techniques, it was said, died with them, bit by bit. As customs diminished, the old arts had no place. The traditions, it was maintained, were becoming extinct all over the Indian lands. Except for the Southwest, where positive action had been taken by perceptive Santa Feans to encourage and preserve traditional work,[7] this litany was generally followed wherever Indian arts were discussed. What was not taken into sufficient account was the innate ability of Indian traditions to withstand erosion and the extraordinary ability of Indian artistry to adjust to circumstance in remolding itself by assimilating technology and change.

The inner core of Indian resistance to cultural annihilation has been discounted in many quarters, despite its obvious existence and the enduring toughness of the people. The honoring and gifting ceremonialism of the modern powwow circuit, with its requisite regalia, fancy-dress code, and behavioral systems is a stunning example of disguised and active resistance. The powwows, potlatches, giveaways, and ceremonial feasts are massive preservation mechanisms. Anyone who has heard powwow speakers invoke the old ways at great length realizes the collective importance of Pan-Indian projection of custom. There are strong individual feelings involved also, as expressed in the admonition of a Quileute elder on handing me a basket she had just finished. "The culture will go on," she said, fixing me with her glance, "the Quileute culture will definitely go on."

Ironically, tribal elders themselves—great complainers that they are about the passing of the good old days—have done their bit to confirm the idea of a growing Indian artistic debacle. Over and over one hears from elders such expressions as, "It is almost all gone...." This particular comment was uttered by a woman whose seventeen-year-old niece makes beadwork. Another elder voiced a similar lament before a class to whom she was teaching beading. Such observations make good sense from prominent Indian figures who have not only witnessed the dire consequences of white intrusion, but who, in a conservatively oriented culture, are also bastions of old teachings and accustomed ways. It is their tribal role to decry what may be passing; their destiny is to hand down the past to insure the future. In their capacity of providing sorely needed underlying continuity they do not take to change or

champion innovation. That is the method of their guardianship of the Indian way, now as it was in the past. Unfortunately, certain scholars have listened almost exclusively to the elders' laments and their verdict has been predictable, "No one seems interested in carrying on." Evidence suggested by the contacts made during the course of this project indicates that some of the dire predictions should be greeted with polite skepticism, despite all the white efforts that have been made literally to stamp out Indian culture. Never discount the power of the elders. Their complaints notwithstanding, the "old-timers" remain the greatest of teachers, passing down continuity through the work and example of their hands—the hand and spirit of transference that involves the whole mind, and which never separates techniques from ends.

In 1968 I visited old Haida Chief William Matthews at his home in the village of Masset in the Queen Charlotte Islands. He pointed out the depression before his house in which his family totem pole had once stood. Since I had seen the pole, which is now in the collections of Oxford University, he was moved to offer me gracious hospitality, which included smoked salmon taken from the living room freezer: "My nephews should be bringing me halibut or salmon like this. It is our custom!" he exclaimed. "Do you think they do that anymore? They go to the movies!" One of the last old Haidas—he could remember being attended by slaves as a boy—Chief Matthews died in 1974.[8] He was a connection with times past, yet, before he died he had seen Robert Davidson's totem pole for Masset village rise beside the village church (see cat. no. 368), a portent of the large-scale revival of Northwest Coast Indian art in full swing today.

"It will never be the same," the elders may lament. There is always truth in such a statement. Things cannot "be the same" today, just as, in the past, crises were resolved by innovation, and things changed. Yet, not all Indian arts and institutions are slated for inevitable death. There is also rebirth and regeneration, a process of inevitable evolution in which aspects of revitalization can and do occur. The secret of survival lies in part in the younger generations' capitalizing on the elders' teachings, and in the white man's recognition that instruments of continuity often remain unspoken in the Indian world, in face of outward evidence of dissolution.

So widespread is the hypothesis of a completely destroyed native art, it is hard for objectivity to prevail with regard to the contemporary scene. Contemporary/traditional Indian art is often thought of as a near desert, best passed over with little or no comment. That superior work is still being done in many quarters, sometimes even better than in the past, is a concept that would shatter a comfortable illusion. Admittedly the whole situation remains difficult, but constant negative opinions do not encourage the best work still being made either to emerge or survive. Until recently very little contemporary material was systematically collected upon which one could base an evaluation of current work.[9] What must be overcome is the frame of nostalgia through which many experts prefer to view the American Indian, an attitude not easily set aside.

My involvement with just such an endeavor grew out of the exhibition *Sacred Circles*, which I organized at the request of the Arts Council of Great Britain and was presented at the Hayward Gallery in London in the fall of 1976.[10] In the spring of 1977 it was shown at the Nelson Gallery of Art, in Kansas City, Missouri. At that time I asked John White, an ethnographer of Cherokee descent, to formulate a program of art, craft, and dance demonstrations, which continued throughout the eight weeks of the Kansas City venue.[11] *Sacred Circles* was intended to be a historical documentation, a chronological parade of works from archaeological times to the period just before our own, with a sprinkling of contemporary objects added for good measure. But to those of us connected to the exhibition on a day to day basis, those many dancers and demonstrators were affirming, "We are still here." They seemed to carry the message of the exhibition forward into the present, thereby raising the question: had *Sacred Circles* stopped too soon?

When I voiced my intention of going out to discover the answer, I found a variety of prejudices against assembling a contemporary/traditional collection. "You'll only draw fire, leave things be," was one comment, made before collecting had even begun. Another was even more discouraging, "What you are seeking simply isn't out there, and trying to reconstruct it simply isn't worth it." This widely accepted notion of inevitable disintegration—which has been presented in countless guises across many decades now—was given renewed focus as recently as 1982 by one of the most eminent schol-

ars in American Indian studies. "What are you trying to do?" he remarked when told of this exhibition project. "Save the last embers of a dying culture?" Connoisseur/collector Gaylord Torrence, however, evaluated the problem realistically, "There are such difficulties of access and communication between the two worlds that it is a brave, if not foolhardy thing, to attempt it."

Be that as it may, I thought, what if one assumed as a postulate that contemporary Indian art should be judged on its own merits, encountered fresh in the way that the old explorers came upon diverse works of Indian art in the field. What if one were to collect widely and freely on or near Indian reservations, not allowing a working knowledge of the tribe-by-tribe ethnology to interfere with opportunities to acquire works as they came to light? Would such an approach avoid the dangers of artificially forcing a reconstruction of what no longer exists, in ascertaining realistically what has actually survived the traumas and uncertainties of modern Indian life? I was warned not to expect too much and to proceed slowly. "That's more along the way we'd do it," an Indian advised me, "just let it happen, without forcing everything like the white man always does."

Nevertheless, the assumption raised specific questions. How does the pace of modern Indian life bear upon and illuminate the capacity for artistic continuation and renewal? What is really being made? where? by whom? Is that art a part of general Indian awareness? Have not the Indians themselves, in the assertions of the modern American Indian movement, made distinct present-day cases for their rights? They have learned to lobby, to use the media to gain recognition, and have become actively militant in making their points. How does this relate to art? Along with water, fishing, and land rights, and spiritual reassertion, is the future of their arts also a vital issue? That there are many sides to the Indian awakening in our times seemed certain. Is there sufficient reason to plead the old saw of "inevitable destiny"[12] in refusing to hold contemporary grass-roots Indian work to the full light? Surely, at least some answers could be arrived at by presenting a selection, no matter how incomplete, of what survives, what is being revived, thus permitting us really to see how the new art measures up to the grand accomplishments of the past.

Today's Indians are being re-evaluated in the light of contemporary issues; notices about these issues appear with increasing frequency in the press. Ironically, as artists they have been quietly waiting all along, surviving with difficulty under diminished circumstances, losing ground here, gaining there, still working at their arts. Rebirth and innovation can go hand in hand, as has happened, for example, with·the recent revival of the type of silver trade brooches made in the eighteenth century by the French Canandians for the Iroquois. In the hands of current Indian silversmiths the original decorations — which were not authentically Indian to begin with, but devised to appeal to Indian taste and only later made by the Iroquois people themselves —are being continued. They are also being augmented by new designs stemming from clan emblems and legendary associations and are being made into rings, medallions, and necklaces. Should such work be considered simply as an addendum, or coda, to the old work? Does it not exist as an element in the ongoing process of creative renewal?

In order to pursue these threads of continuity and change it would be essential to cross a border, for there was little precedent to follow in 1977. That barrier seemed formidable. What lay on the other side? There were hints in the form of Indian artisans who were invited to demonstrate their traditional crafts in public, but who immediately afterward melted back over the border into their world of the reservations. There were other hints in United States Department of the Interior "source directories," and also Canadian, but these mundane brochures gave little idea of quality standards, let alone any answers to larger questions concerning modern Indian arts. To undertake to collect experimentally, it would be necessary to leave white North America for that other North America still inhabited by Indians, to deal with their attitudes and feelings as they were encountered in reservations and settlements, in urban Indian ghettos, or in remote family enclaves where one might least expect art to be found. There seemed to be no alternative to such an approach.

Collecting and documenting the kind of art I had in mind would, it turned out, involve almost a decade of encounters and travel across the continent, in both the United States and Canada, with the exception of the Eskimo lands.[13] It required interacting directly with Indian artists and their communities, and working closely with their traders. It meant searching out such special people as Polly Sargent, who lives with Indian creativity among the

Gitksan, and who, from her listening post in Indian country, already knew what I wished to find out. The Indians in the history books had to be replaced by living Indians. What would they be like? Would they cooperate? Would direct contact shed positive light on the many stereotypes about contemporary Indians? It would mean, as Polly Sargent warned when inviting me to visit her remote homeland in northern British Columbia, "going right off the map."

NOTES

1. Grace Glueck, "Art: Modern Works of American Indians," *New York Times*, November 30, 1984.

2. Margaret Cozry, owner of The Algonquians in Toronto, to the author, May 1978.

3. Rick Hill to author, Grand Island, New York, December 1982.

4. A Santa Fe shop owner to the author, 1984.

5. *The Problem of Indian Administration*, Report of a Survey Made at the Request of [the] Secretary of the Interior, and Submitted to Him February 21, 1928 (Baltimore: Johns Hopkins Press, 1928), p. 646.

6. Typical of the WPA arts and crafts programs is the one that was held in Michigan for Ottawa basket makers, whose art is flourishing today.

7. Dr. Edgar Lee Hewitt of the School of American Research in Santa Fe started the Indian Market in that city in 1922 out of concern for the preservation of Indian arts and crafts traditions, not only of the Southwest, but also of the Plains.

8. For an account of Chief Matthews, see Mary Lee Stearns, *Haida Culture in Custody: The Masset Band* (Seattle: University of Washington Press, 1981), pp. 52–53, 232–33.

9. Since this project began some ten years ago, the picture has changed for the better—even the Smithsonian Institution has collected examples of contemporary Zuni pottery. The museums of British Columbia have collected recent Northwest Coast work in extenso, particularly the Provincial Museum in Victoria, which lends Indians objects from its holdings for ceremonial purposes. The Indian Arts and Crafts Board of the Department of the Interior, Washington, D.C., has perhaps the largest collection of modern Indian work, acquired over several generations. However this collection is not on view, nor is it easily accessible. There is no hint of its importance in the display at the Department's Main Building. Perhaps some day it will form part of a National Museum of the American Indian, once planned for the Mall.

10. See *Sacred Circles: Two Thousand Years of North American Indian Art*, catalogue by Ralph T. Coe, shown at the Hayward Gallery, London, October 7, 1976 – January 16, 1977. An exhibition organized by the Arts Council of Great Britain with the support of the British-American Associates (London: Arts Council of Great Britain, 1976).

11. Three of the objects included here had their origins as demonstration pieces made or begun during the *Sacred Circles* North American showing: the bulrush mat by Refugia Suke (cat. no. 106), the "cornhusk" bag by Lena Barney (cat. no. 226), and the Pomo basket by Susye Billy (cat. no. 337).

12. As early as 1851 the father of American anthropology, Lewis Henry Morgan, presaged the whole problem of the treatment of Indian cultures held in custody: "It cannot be forgotten, that in the after years our Republic must render an account, to the civilised world, for the disposal which it makes of the Indian. It is not sufficient, before the tribunal, to plead inevitable destiny; but it must be shown affirmatively, that no principles of justice were violated, no efforts were left untried to rescue them from their perilous position" (Lewis H. Morgan, *League of the Ho-De-No-Sau-Nee, or Iroquois* [1851; reprint, New York: Dodd Mead, 1901], vol. 2, p. 123).

13. Although at first some works were collected among the Labrador Eskimo, it was soon determined for logistical reasons alone not to pursue Eskimo contemporary art further.

II

COLLECTING AMERICAN INDIAN ART

IN THE FIELD 1977–1985

WHILE AMERICAN INDIAN ART IS STILL PART OF THE Native American culture, unless one is fortunate enough to be in Santa Fe at Indian Market time to examine all the booths, or visit its eastern counterpart at Hunter's Point, New York, it is necessary to search. One can skim a handful of accessible traders and Indian shops, but that is not enough, especially if what is wanted is not only the unusual as well as the typical, but also a fuller dimension and scope than is indicated by the prizes given at Indian shows, especially since these are often confined to pottery and jewelry, with a basket here and there. One must, finally, seek out the craftsmen and artists themselves and collect from them representative objects.

In 1977 I began visiting Indian groups and individuals and working closely with traders across the United States and Canada, assembling contemporary/traditional arts and crafts for this project. As the years went by the scope grew. Both contacts and possibilities expanded. I learned that it was most productive to go beyond the scholarly community and tap such people as William Altvater, Passamaquoddy basket maker; Chief Andrew Delisle at Caughnawaga for the Iroquois; Frank Pushetonequa for the Mesquakie of Tama, Iowa; or such non-Indians as James Hanson and Harold Moore for the Plains; Duaine Counsell and Sherman Holbert for the Great Lakes; Rick Dillingham, potter, connoisseur, dealer, and Dallas Johnson, program director of Save the Children, for the Southwest; Leona Lattimer in Vancouver, British Columbia, for the Northwest Coast — all people directly involved with the economic and social aspects of Indian daily life and therefore aware of what is going on artistically and what is being made where and by whom. I was familiar with the types of objects likely to be encountered, but these possibilities were kept at the back of my mind, articulated only when a type of object long thought to be dead suddenly appeared in locations as diverse as a fur store in Prince George, British Columbia, or a gift shop owned by Indians in Cherokee, North Carolina. Nor did I set out to extract only what was best, as an art critic might; I sought the general cultural picture. Yet, quality could not be dismissed — the Indians themselves always know who is doing the best work — and objects by the finest artists were acquired when encountered in the course of events. Due to an understandable enthusiasm, there is a general tendency to create cult figures among certain Indian artists, to stay with those names and never venture very far afield. The great and spectacular work contains its own rewards; however, the very question this project addresses required that attention be paid to the young people coming along, the continuators. It is necessary to sense the whole culture from which the genius springs, for without a basis in creativity, survival itself can be questioned. Only a stab in this direction was undertaken here, but even that little indicates a neglected richness that still exists.

Many of the objects presented here are a consequence of my having been there, and such circumstances evoke feelings very different from those that result when selecting works in isolation from the museum shelf. In the summer of 1978, at Masset, Queen Charlotte Islands, British Columbia, I inadvertently saw the extraordinary pair of houseposts being carved under the

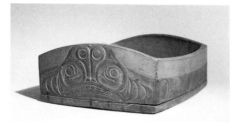

direction of Robert Davidson. Four months later I was a guest at the dedication of the gigantic posts at the memorial potlatch for Charles Edenshaw, the great-grandfather of Robert Davidson and one of the greatest Haida carvers of the late nineteenth-early twentieth century, who died in 1920 (fig. 2).[1] The models Davidson had carved for these posts persisted in my memory, and it was at this ceremony that I requested them for this project (cat. no. 368). The thirty-five-foot-high Nishga totem pole (cat. no. 382) came to light in 1978 when I was exploring the Nass Valley in British Columbia. There it lay on crosspieces in the woods (fig. 3) like a relic of the past though it had been carved some five years before. These two events are typical of the numerous encounters and accidents that engendered many purchases and loans.

As already noted, along with many examples of work by mature artists, there is the production of the continuators, the beginners. By the standards set for this project, work that is generally considered as marginal looms importantly here. A pot by a twelve-year-old Hopi girl (cat. no. 305) and numerous beaded buckles, beaded combs, and key chains made by novices demonstrate how a working tradition is passed on by concentrating first on smaller pieces. Totem pole models may be apprentice material; there is an example here (cat. no.381) by Tsimshian/Nishga Kenny McNeil, of Prince Rupert, British Columbia (fig. 4), who is being trained to carve by his uncle, the distinguished Tlingit/Tahltan artist Dempsey Bob (fig. 5), one of whose masterful masks of a hawk is included here (cat. no. 383). A Sioux catlinite pipe bowl (cat. no. 124) is also tentative work, since it is for the most part sawn rather than carved. There are better Plains pipes carved today, for example by Sioux Charles Ren Countre, but the beginner's pipe makes its own statement, promise, it is hoped, to be fully realized later.

Older people who may decide to try their skills are also part of the picture presented here. The wool blanket (cat. no. 353) by Salish Georgina Malloway (fig. 6) and the Yei textile by Navajo Mary Nez Jim (cat. no. 292) fall into this category. Both are unrefined works, but mark hardy beginnings. The aim was to collect as many aspects of the situation as possible, to convey arts in resurgence rather than in defeat, if that were indeed the case.

Absolutely essential in this endeavor was the cooperation of knowledgeable traders. In such well-defined fields as Navajo textiles, without help, the best quality remains elusive and unavailable. It was due to Jackson and J.C. Clark of Durango, Colorado, that I was able to obtain the largest Ganado Navajo rug woven in modern times, a true masterpiece (cat. no. 288). Another coup, accomplished with their help, was the acquisition of Isabel John's compositionally elaborate pictorial weaving (cat. no. 289), perhaps the finest Navajo textile of this type executed within the collecting period covered. On one occasion we covered over four hundred and fifty miles of Navajo weaving terrain in one day. There is always more to see, another artist to meet, and still others beyond those. At such times I found plenty left of the old-time trader spirit, though Rex Arrowsmith, one of the most distinguished traders of the 1950s and 1960s, when he owned a store on Old Santa Fe Trail, laments the commercialism of some modern trading: "We used to really enjoy trading with the Indians, and we were able to take the time to know them well. Now everything is reduced to money."[2] The fact that a piece is purchased from a trader does not imply that it is to be classified as rank commercialism. Many times, after I had tracked artisans down, I would be directed to the nearby shop where, they would assure me, they had a fine piece of work for sale.

The trading network — which includes Indian cooperatives and craft guilds, private traders both white and Indian, and individual artists who rent booths at powwows and Indian celebrations—sends work far and wide.[3] Subarctic moccasins turn up in Iowa (cat. no. 345) and Zuni jewelry appears in New York State. The Kwagiutl canoe model purchased at the shop of the University of British Columbia Museum of Anthropology at Vancouver (cat. no. 360) had already traveled east to Ottawa and back under the auspices of the co-op, and in the process the name of its carver was lost. An Iroquois German silver brooch made in Dutchess County, New York (cat. no. 34), was acquired from a dealer in northern Missouri who had gotten it from a trader in Schenectady, New York. A superb Ojibwa splint "porcupined" spherical basket (cat. no. 80) was acquired because a magnificent basket of this type had been spied in a home in Scottsdale, Arizona. An order for a duplicate was placed at the Scottsdale arts and crafts shop where it had been purchased, from where it was tracked back to Minnesota. It turned out, many months later, that "Minnesota" was actually Michigan, where the maker of the basket

FIGURE 3
Clan totem pole (cat. no. 382) carved by Eli Gosnell, George Gosnell, Joe Gosnell, and Sam McMillan (Nishga), 1977–78, as it lay in the woods near New Aiyansh, British Columbia, 1983.

lived (fig. 7).[4] Lack of information could be as disconcerting and frustrating as misinformation. At times, names of makers and places of origin were supplied by dealers; fortuitous accident contributed its share of facts; in some cases questions were never resolved. "This buckle [cat. no. 161] is by one of the Bears," the Indian proprietor of a gift shop at Mission, South Dakota, offered. "Well, we have...all sorts of Bears....It may be by a Cut Bear...I can't seem to remember which Bear made this." Later I saw more such buckles in Santa Fe, brought there by dealer Cathy Vogele of Rapid City, South Dakota, from whom I was finally able to learn the identity of the maker. Fate allowed me to run into Cree Johnny Shecapio and his wife, Emma, in Hazelton, British Columbia (fig. 8), and thus I finally found out who made the pair of Woodland snowshoes (cat. no. 27) I had purchased two years earlier at the shop at Curve Lake Reserve in Ontario.

The pawn counter, the classic Indian credit bureau and social center, can also be a source of acquisition. It is most active just before a big dance or celebration, the Crow Fair in Montana, for example, or the Oil Celebration at Poplar, Montana. Then the pawn area of the trader's store will be crowded with Indians taking their finery out of hock. Although as a rule I shied away from acquiring pieces that might be redeemed, in Montana and New Mexico I did purchase several objects in "dead pawn."

There is a casual and broken pace to the dissemination of Indian arts and crafts which follows an uncertainty principle. No one will wait for payment, sometimes not even for a few minutes. This was demonstrated vividly for me one Sunday in 1982 in Bismarck, North Dakota, at the Intertribal Powwow (held annually in late summer). I asked a woman to wait while I went off the powwow grounds to cash a traveler's check and then had to watch as another fellow shelled out the bills to buy what was surely the most beautiful beaded belt buckle I had ever seen. When I returned with a fistful of cash, I searched for the buckle beader, but she had vanished. "I don't know who she is," said the master of ceremonies. "She's got her gas money now and has gone off."[5]

At certain times there is no shopping at all: you deal with the culture at large. The Nass River Nishga totem pole mentioned above (cat. no. 382) is such a case. Had it already been raised and dedicated in the traditional way, any loan would have been impossible, since once put up, a totem pole is never tampered with, but is allowed to decay, eventually to fall. An example of this process may be seen today in the Gitksan villages of Gitsekukla and Kitwanga, where some of the poles have fallen (fig. 9) and have even been set on fire by youngsters where they lay. To my knowledge the Nishga pole is the only monument of this type from the traditional Northwest Coast Indian world that has been made available for outside exhibition. It comes from the upper reaches of the Nass River where only one other pole has been carved in the past seventy years. In its connotation it is totally unlike the poles that have been carved for export in the last fifteen years. A rare symbol of renewal and continuity, it forms a centerpiece of this project.

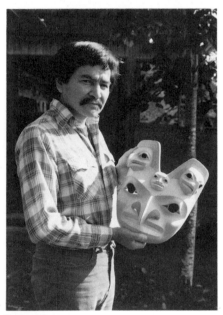

The pole represents continuance. I also looked for examples of in-novation. Leaning toward the past did not mean shutting out the present, as demonstrated, for example, by the growing tendency to embellish the water bucket (cat. no. 302) used in Native American Church meetings. What began as a simple bucket — used to slake the thirst brought on by the ceremonial chewing of peyote — has turned into a major vehicle of decoration with stylis-tic variants that reveal an origin in Oklahoma or Arizona. A beaded buckle with cosmological designs (cat. no. 188) can express vigorous adherence to traditional values, even though the making of beaded buckles, which evi-dently began in reserves near Calgary, Alberta, was probably inspired by the fancy dress of Texans who came to that city during the oil boom days after World War II. The fashion for beaded buckles quickly spread to the Montana reservations, then across the Plains and Plateau rapidly becoming the Pan-Indian manifestation we know today. For an Alberta powwow Indian trader to say, "This is a Montana-made buckle straight from Browning [or Havre, Heart Butte, etc.]," means he is offering you the best.[6]

In buying both old-time and innovative contemporary things, I trod increasingly in the gray area between what is considered traditional and what is not. What began as a comparatively simple program gradually underwent a change in dimension, for the more time I spent in the field, the more I learned that tradition does not subscribe to hard-and-fast rules. Something larger and more encompassing was involved than a simple repetition of old ways. It became increasingly clear to me that if I insisted on functioning in a white frame of reference I would fail. "Come in white man," an elderly Malecite woman called out when I knocked on her door in New Brunswick, at the edge of Kingsclear Reserve. On entering, I asked her how she knew I was white. Giving me a faraway look, she said, "Because you knocked." I did not know Eastern Algonkian customs. Along the northeastern coast, I learned, Indian homes are entered without knocking.[7] At another doorsill in New Brunswick a tiny Malecite woman looked me over. "And have you come to measure my head?" she deadpanned. "Since I only want to know where basket maker Ve-ronica Atwin lives," I assured her, "I've left my calipers at home." When I visited Carrier Indian Bernadette McCrory at Fort Fraser, British Columbia, there was less humor. I could sense a certain antagonism despite obligatory hospitality. "She's upset about people like you with degrees who write on Indians, when people like her, who make the real [birchbark] things, are forgotten."[8] I explained that I did not measure heads (greeted with a guffaw), and that I was trying to see that people like her were not forgotten. When she recognized that I was mindful of the inequality, things began to warm up, but they did not thaw enough to produce a piece.

Such responses were not isolated. They rest on the respect de-manded by Indians today. There is no doubt that unthinking and inconsider-ate acts have been perpetrated in the name of scholarship and collecting. At a conference in British Columbia a white scholar kept repeating "my people" do this and "my people" do that. Suddenly an Indian voice interrupted, "They aren't *your* people; they're *their* people!"[9] I quickly learned not to take notes, I rarely carried a camera and never used a tape recorder. I did not "study" In-dians. I remembered always that I was a guest in their nations. I made no claims to diplomatic immunity and learned to take whatever lumps came my way.

Indians in the American Southwest are all too familiar with insensi-tive tourists who pick over the jewelry, pottery, and weavings without caring to know, or respect, the non-material values these arts represent. But gen-erally welcome are those persons who take time to learn Indian feelings and preferences, who do not press indelicate questions about Indian spirituality, and who, most of all, carefully sustain respect as well as interest when they are vouchsafed a glimpse into that Indian spiritual world which is as mysteriously rewarding as it is difficult to enter. When Indians make up their minds to accept you, the shift can be sudden and unexpected. Then the program is entirely different. Nevertheless, it is a world that demands acknowledgment of Indian values and adherence to them, not lip service carelessly professed in order to gain easy access to an object. Indians quickly see through that with the wisdom of long experience. Of a Northern Plains mixed-blood trader it was said scathingly, "He realized one day that he was Indian—when he found out there was money in it."[10]

I had been told to proceed slowly and not to expect too much. You

may not see much, and you may not see the best pieces at all, I warned myself. It depends on building up lines of trust, and that takes time, more than you can ever allow, more than you will ever have at your disposal. It did not do to become overenthusiastic about new work, for that is not the Indian way.[11] One has to be ready for the manner in which Indians guard the traditions of their cultures through a wariness, often delivered with dry humor, and a reserved, unflinching politeness that may frequently convey an unstated message, "Go away closer." What is being protected from probing minds is nothing less than the *mysterium tremendum* that has regulated Indian religious beliefs and Indian relationships to nature for countless centuries. However, when trust is established, you are taken in without reservation, as my attendance at the Blackfeet Thunder Pipe ceremony attests (see ch. 3). You are fed and allowed to camp. But each time you are allowed access to only a tiny part of what is "there." At Inger, Minnesota, a stronghold of the Grand Medicine Lodge, I saw old and fairly recent miniature houselike tombs, the resting places of its members, but something told me to ask nothing and to act as if I weren't looking. Beyond the outer edge of the *mysterium tremendum* one does not trespass. "Ours is a hard religion, yes, a hard religion," commented Grace Daniels, a Stoney Indian I met at Morley, Alberta, at the foot of the Canadian Rockies, characterizing the spirituality of the Plains people. But she offered for the project what I did not expect, nor would have asked for, a Deer Dance headdress (cat. no. 202), which she finished while I waited overnight. "I'm known around here, and if I say it is all right for you to have it, it is all right."[12]

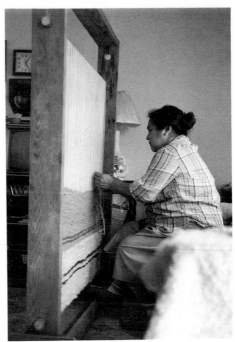

FIGURE 6
Georgina Malloway (Salish), Sardis, British Columbia, 1983. The textile included here (cat. no. 353) is at the lower end of the loom.

Acceptance and rejection might be expressed in unforeseen ways. One evening Frank Pushetonequa, my best friend at the Mesquakie Indian settlement in Tama, Iowa, took me to visit his brother. Suddenly, without any explanation, the brother beckoned me into his summer house. First I saw tools on a bench, then a bicycle. "I don't mind," I was told, "it is all right—look up." Gradually, along the wall I discerned a row of medicine bundles. "This is an earth bundle, this is a celestial one…." On another occasion, as I sat on the deck of the Labrador coastal steamer a young girl thumbed through my copy of Frank Speck's *Hunters in the Barrens* and declared, "I don't have to have a book on Naskapi, I *am* Naskapi, and I will tell you a legend." She did. Yet, she could not resist keeping the book, an ambivalence matched by her equivocal invitations to visit her grandfather's camp in the woods at North West River. In Maine I came across a graduate student who had been sent out of academe to interview the Princeton band of Passamaquoddy. At the boarding house dinner table that night she was extremely upset because her Indian informant, upon whom she was utterly dependent, had not shown up for their appointment. She could not understand this behavior, "They *promised* me she'd be there!" To me it seemed logical. "She didn't want to tell you that she didn't want to tell you." Many Indians feel this way.

One thing quickly taught by Indian country is never to plan a tight schedule that cannot be changed at a moment's notice. You travel fancy free or you lose out on a dance, or a ceremony, or an unknown artifact. Schedules for powwows, which are often announced by handbill or poster, and much of the religious calendar (particularly in the Southwest) are kept to devotedly, so that the people can know when to be there. For the rest, no Indian group likes to be pinned down on specifics. A potlatch "scheduled" at Vancouver Island for the end of August may end up being held in the middle of the month, throwing all your well-laid plans awry. In time you get used to this and go along with the inexorable flow of the Indian pattern. You learn not to count on anything, because something judged to be more important may intervene. A death or a family obligation takes precedence over everything else, contravening the accusation heard over and again from outsiders that Indians no longer feel dutiful toward their past. "When I go back home, I not only touch base with my family, but also with all those who came before me," says Osage painter Norman Akers.[13]

As a rule many Indians do not have a telephone, so communication is roundabout. And often Indians do not reply to letters, even when a self-addressed, stamped envelope is enclosed. But it all works out. If you want to see someone, go to the powwow. It all boils down to a simple situation. You have to be on the spot when something interesting occurs—in my case, the completion of an object—and this is not a predictable matter. Each experience is a challenge. When the moment arrives and you are delayed in Washington, D.C., you hope that trader friends like Sherman Holbert in Minnesota will go, cash in hand, to save Maude Kegg's bandolier bag (fig. 10 and cat. no. 71), or

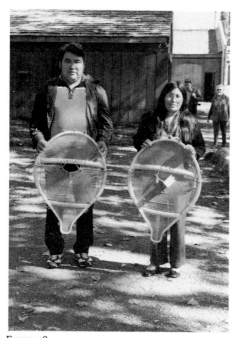

that Leona Lattimer in Vancouver will keep reminding Robert Davidson that a loan date is approaching. On returning from Montana to my home base in Kansas City I received a letter from Marie Pretty Paints Wallace (cat. no 179) asking for money to get her started on an elaborate beaded horse equipage, "like the best you'd see at Crow Fair parade." With cash and cashier checks on hand, I headed back to Crow Agency, driving straight through in about sixteen hours. When I finally bounced along the dirt road leading to her studio beside the Little Bighorn River and pulled to a stop, there wasn't one blink of surprise on Marie's part. It was as if I'd only been around the corner. "You're just in time to hear these tapes [of Doc Tate Nevaquaya, the famous Comanche flutist] I've set out for you," was her greeting. Experience develops a sixth sense that tells you when money is needed, or that something may or may not happen with or without it. Every good trader has this sensitivity to the Indian way.

Sometimes unknown problems intervene, objects are never seen again and valued friendships are severed, as in the case of John and Zona Loans Arrow. In the Indian Museum Store at Fort Yates I had found a child's vest, finely made of home-tanned buckskin in 1890s style. I had traced the maker to see if it could be beaded, and I found Zona Loans Arrow (cat. nos. 127 and 134). "Where did you get that from?" she exclaimed. "I made it ten years ago...I was living alone...and things were rough." Some months later I visited again. On a small oblong of linen was a partially beaded horse with an abnormally large, red eye circled by a rim of tiny silver beads. This was no ordinary horse, she hinted, but her grandfather's supernatural horse. "I'll have to tell you about it," she said. But she never did. Soon afterward the Loans Arrow telephone was disconnected. I learned from the priest at the Fort Yates mission that the Loans Arrows had simply left, leaving their trailer home locked behind them. "No one knows where they went, or when they're coming back." One must inure oneself to such precipitous action in the Indian world.

In the Southwest, where the cultures are more intact, and often flourishing, in fact, there is also challenge in the hunt, especially in locating the less obvious objects such as a Papago awl (cat. no. 322), or the fine Hopi dance tablitas (cat. nos. 308–310), until recently quite common, but now increasingly inaccessible. Where could I find such objects, or Hopi Kachina dolls, also recently used, without disturbing Hopi life? An Indian family I camp with told me about a rough-and-ready Texas trader who loves to trade at Hopi and who is accepted there. A rainstorm drenched me as I went over items in his open garage on an Arizona hilltop, but I departed with a group of things that had been traded the day before, fresh from the Hopi themselves (cat. nos. 308, 313–315, 318–320). An additional obstacle constantly accompanies the serious collector in the Southwest: creeping commercialism. Just as it is the richest area, it is also the easiest in which to make a fast dollar. Hence the unscrupulous selling of things that are not Indian, which are turned out by jobbers in Albuquerque, even in Hong Kong or Taiwan.

Contrary to the often-expressed declarations of disappearing traditions, and despite a tendency to count out the Indian cultures, especially those outside the Southwest, a major frustration of collecting directly in the field is plenitude, not scarcity. There is actually more than anyone can hope to choose from. The survival question is so much in the forefront of Indian affairs that when things do survive and continue, they are overlooked. I was interested in such questions as: Is there a Sioux who will make a ledger book in the old way? (Yes, William Running Hawk, cat. no. 159.) Do the Taos Pueblo people make elders' canes as they once did? (Yes, Manuel Romero, cat. no. 241.) Often the very person who informs you "there is nothing going on" is just the person who will offer to make you exactly what you dreamed of, on a second meeting. "Well, we look you over." The problem is always finding time to make those second or third visits. After eight years all I uncovered, I am convinced, is the tip of the iceberg.

Another requirement is learning new meanings for old words. An Indian artist will rarely say no, so you have to know all the possible variations of "yes": the ones that really mean no; the ones that may indicate future interest in making you something if you return; the ones that constitute an expression of real interest. Even when you return after what you guess to be a suitable lapse of time, you may learn that your favorite artisan's "hands are cold." This may mean any number of things, from unforeseen tribal obligations which had to be met to the arthritis that stalks the hands and fingers of many

living in cold or dampness. Most often an Indian yes means, "in time" (undetermined). The first time I stopped by Christine Hall's trailer at Wittenberg, Wisconsin, and told her I would like a splint bassinet, she was mildly committed; the little "yes." The second pass-by raised this to a real possibility. The third time elicited the real "yes," though I didn't read it correctly. Finally, the bassinet was finished (cat. no. 98). Time elapsed between initial request and delivery: three years. Once in a great while a "yes" means "I'll make it right now." This happened with Mary Adams and Gertrude Gray (fig. 12), a famous Mohawk mother-and-daughter basket-making team at Saint Regis Reserve who graciously agreed to set right to work on a splint hamper (cat. no. 38). A willingness to stay denotes real interest and can bring on an enviable spate of industry. Mary Adams worked so quickly that she made perhaps the only error of her life and had to unravel several rows of weaving. On the other side of the continent, at Hoh Reservation in Washington, I came across a half-completed Quileute basket; work had been delayed by the birth of a grandchild. "Why don't you walk down to the beach with my husband, maybe there are some seals there, and when you come back the lid will be almost finished," Leila Fisher offered (fig. 11 and cat. no. 347).

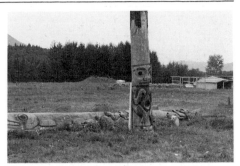

FIGURE 9
Totem poles (Gitksan), at Kitwanga, on the Skeena River, British Columbia, 1983.

The Indian working ethic is direct but never cast in stone, never hard and fast. Anyone associated with Indians has to intuit the inner complications of these work rhythms, make allowances for the unstated meanings, recognize the symptoms of other preoccupations, and heed them—drawing back when it is more politic to do so. Only endless patience fits into the pervasive Indian rhythm. White people haven't learned to pace themselves in the Indian way. They talk when they should be listening, and it is listening that is required to break beneath the surface, to go "underneath," as Ronald McCoy puts it.[14] If one waits, even a tepee with designs symbolizing Chief Joseph's 1877 retreat painted by one of his descendants, Maynard Lavadour (fig. 13), can appear (cat. no. 224). "He wants to do it, it's on his mind. He'll do it when he has the time," I was assured when I became concerned over the delays. It is fruitless to push deadlines white style. What is being acquired is not simply a piece of work but a portion of a culture that is precious and not parted with lightly. Often the best beadwork or basket or manta is tightly guarded in Indian families. A typical comment runs: "I might loan a birchbark box like that to you, but I won't sell it. My mother rarely makes them and we keep them."[15] One soon learns that one of the reasons it takes Indians so long to produce work is frequently due to an unstated reluctance to part with work, especially when special quality or effort is involved.

Reading the signals is an acquired art that no one outside the culture can be wholly versed in. This includes unkept appointments. The first time I was stood up I asked about it later. "Well, he didn't turn up with the things I wanted to show you, so I went on," I was informed, with obvious reluctance that the matter should be discussed at all.[16] Since this is normal Indian procedure, I also adopted it. If another matter intervened, I took advantage of it, as they would do in similar circumstances, and turned my car in the other direction. When I would show up later, no questions were ever asked, and I learned not to ask any either—not wishing to offend. In time, it all works out for the best. Considering the haphazard rhythm, from the white point of view, of trading, bartering, and selling sustained from the Indian past, it may seem amazing that things work out as well as they do. One must learn to throw away business formulas, appointment books, and just let things happen. There is an interior element of trust that operates here, but it is always in process of being earned once more. Neither side is quite sure of the other until the enterprise is finally settled, including the price. Anyone familiar with Indian country knows the Pan-Indian habit of selling "first come first served" in order to have money, no matter what the previous intention may have been. Here again, the Indian "yes" may mean nothing, unless you act. One has to be on guard for the ramifications of this custom. As in Mexico, where "everything is possible but nothing is sure," delivery of items is generally the buyer's responsibility, not the artisan's. You can lose even when you have supplied the raw materials as an advance. On the other hand, there is also unusual forthrightness and honesty. Only on four occasions was there deliberate sleight of hand shown me, and one of these was partly due to illness, an inability to cope.

When Indians mailed or shipped me things, they were always carefully packed in bubble wrap or plastic peanuts, with more care than white

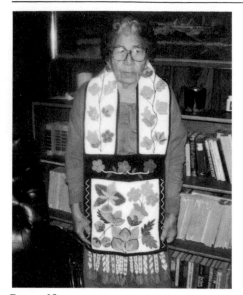

traders take. These objects were important to them. My first experience with this solicitousness came with the very first object I bought. Lena Barney, a Yakima craft artist (fig. 14), stayed up most of the night finishing the native hemp (cornhusk) bag she had started several days before (cat. no. 226). She wanted her money. She also wanted to say one thing. As I laid the cash out on the table where she was having a motel breakfast, up from under the table came the bag encased in a Ziploc pouch into which it fitted exactly. "Take care of it," she enunciated slowly, and then resumed her breakfast.[17] That was all.

Hearing about Indian artists is one thing, finding them is quite another. To search them out is a time-consuming task often conducted in un-familiar territory—sparsely populated areas where there are no street names, and where the post office box may be located miles from its owner. You are told to look for a house with a yellow door, or perhaps one with yellow win-dow trim. When at last you find it, the yellow door has long since been repainted, or the window trim has faded beyond recognition. The house may be almost invisible, set behind another, or in the shadow of a huge trailer parked alongside it. Complicating the situation even further is the fact that there are no house numbers on most reserves. The lack of numbers, of the sense of demarcation that is so much a part of white communal living, seems to belong to the indefiniteness of Indian country and the often spectacular expanse of space, which doesn't go by the numbers.

Despite the homogeneity brought about by Pan-Indianism — the powwows, the national and local Indian associations, such as the National Congress of American Indians in the United States and the National Indian Brotherhood in Canada — it is not easy to put your finger on just what an Indian is. There are all kinds of Indians, and they often resent being lumped together, as I have had to do in this project. If there is an Indian stereotype, I certainly never found it. Even the get-togetherness of the Indian social spirit fragments into countless parts: there is an Indian Museum Association, an Indian Nurses Association, an association that represents Navajo code talkers (heroes of World War II), and another for rodeos. Not all Indians are economi-cally distressed. There are tribes that are poorly off and others that receive income derived from natural resources. A successful fisherman in Alaska or British Columbia can earn as much as $60,000 to $100,000 before expenses (which are considerable), but in a poor season he can lose his shirt. There is the Indian who went to Harvard, and the one who wouldn't be caught dead there. There is the Indian who has traveled all over the world, and the one who won't leave the native ground for anything. More and more I thought of Indians as tribal individuals, strong individuals, who have something rarely encountered in the white world and to which they cling: a family, group (clan), and tribal identity that promotes that inner sense of solidarity and ease already mentioned. Suffice here to call it the Indian inner consciousness, with all its calls to duty and obligation, and its cultivation of identity.

But tribal histories are so different, and the friendships and en-mities of the past so well remembered, that tensions are there among tribes. Often it becomes a subject of teasing and joking when the Indian melting pot gets together, as at Haskell Indian Junior College in Lawrence, Kansas, or the Institute of American Indian Arts in Santa Fe, or at intertribal gatherings like those at Crow Agency, Montana, Gallup, New Mexico, and Anadarko, Okla-homa, or the Bismarck Intertribal in North Dakota. Sometimes Indian reti-cence would fade before tribal expressions of pride. "Their masks are painted with too many colors," say the Tsimshian of the Kwagiutl to the south. "We only use a little red and black [black on eyebrows and eyes, and red on the mouth]. That's enough."[18]

When I found evidence of cultural deterioration I saw no reason to gloss it over. Included here is the Micmac quilled box of poor quality (cat. no. 10), about all that is left of a once-widespread spectacular craft that was one of the glories of Woodlands art. In Allenspark, Colorado, I collected a quilled box (Ojibwa, made a thousand miles away from Micmac territory) with exact Micmac designs on the lid (cat. no. 11), far better executed than any Micmac seems able to do today. In fact, the designs are exactly like those the Micmac used last, at the time this art fell apart, about 1940. Wabigoon (Grassy Nar-rows), Ontario, was a bitter disappointment. I had been told to stop there by trader Sherman Holbert, from whom I had bought a birchbark container made there some years ago (before the time span set for this exhibition). A doleful sign at the lakeside warned that the water was highly contaminated and the fish mercury poisoned. No fishing for Indians; no work for Indian guides... nothing.[19] Labrador presented other obstacles. None of the Naskapi beau-

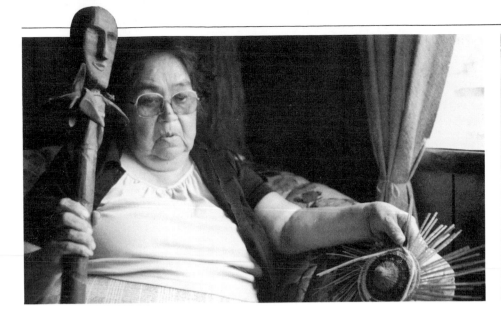

FIGURE 11
Leila Fisher (Quileute), with basket in work (cat. no. 347) and her family's old guardian spirit staff (which could be photographed since it had not been used for some time), Hoh Reservation, Washington, September 1983.

FIGURE 12
Gertrude Gray and Mary Adams (Mohawk), Snye, Quebec, 1983, consulting on the size of the lid of the splint basketry hamper included here (cat. no. 38).

tifully beaded peaked woolen caps (high-prestige items to this day), nor any Naskapi moccasins, sumptuously embellished with double-scroll patterns, are included here, even though they are still made. I had arranged to meet with one of the best Davis Inlet craft artists on the return down the Labrador coast, but that was not to occur. The same disparaging attitudes that characterized the settlement of the Western Plains states in the 1860s and seventies were at the moment arousing similar resentments, and I was advised not to leave the ship. Thus, I have relied on the Montagnais-Naskapi band at North West River, farther down the Labrador coast, whose work is not quite so archetypal. There are whole categories of objects that are not included in this very large presentation, even though I saw them. This is especially true of the Southwest. They are absent simply because the conditions of money, space, time, and schedules imposed by the white world had, ultimately, to prevail.

Almost every type of tribal art of the nineteenth century is either being made or is still capable of being made, except for such esoterica as finger-bone necklaces or burial paraphernalia no longer in use. A crooked knife (cat. no. 9) is sufficiently esoteric today as to pass the most difficult test of survival. The miracle is that such an object is being made at all. Had there not been a good deal of cultural retention, all would have been lost long ago. We have tended to rule out the extraordinary Indian tenacity of mind in these matters. It was not intended by outsiders that these lifeways should survive. White indifference left many of them intact in memory, and they have re-emerged today in a somewhat more tolerant world. Only a tenuous connecting link is needed to plant a seed of continuation, not armies of workers. "It was gone and I relearned it myself," was a comment heard repeatedly, though the shade of a grandmother with the requisite knowledge could be sensed hovering in the background.

At no time did I ask an artisan to work in a form or technique not natural to him or her. There was no attempt to induce people to make things with which they were unfamiliar. The arts were found, not reconstructed. When clothing or jewelry was made to order, it was done because a prototype could not be taken out of use. Never was the "last" or "the only one that may ever be made" searched out, although occasionally I felt close to such a verdict. The aim was to leave conditions untouched and to respect inviolate patterns of Indian culture.

The collecting odyssey among the Indians of North America came to an end. A last rush of objects collided with the harsh reality of "limits." Decisions on what to eliminate were painful. Nevertheless, enough varied material remained to give an equitable balance between objects and tribes. However imperfect the representation, it nevertheless proclaims the tremendous diversity of traditional Indian creativity today. Over seventy tribes had been visited. Many of the various ways by which tradition has managed to survive had been documented. I had embarked wondering whether all I would find were a few survivors working here and there, eking out a bare subsistence. Seven years later I discovered I had invoked a flood of material that was still gaining momentum. "The best news you could have given us is that it is getting too large," said Rick Hill, the Mohawk painter. "There is more out there than even we had thought."[20]

FIGURE 13
Maynard Lavadour (Cayuse/Nez Perce), before his booth at the Indian Market, Santa Fe, New Mexico, 1983, with his prizewinning cradle. See cat. nos. 222–224.

FIGURE 14
Lena Barney (Yakima), working on the corn-husk bag (cat. no. 226) as a demonstrator at the *Sacred Circles* exhibition, Nelson Gallery of Art, Kansas City, Missouri, 1977.

NOTES

1. The houseposts were temporarily raised on the stage of the Masset Community House, where the potlatch ceremonies and feast took place, then transferred the next day to the Edenshaw Memorial House. Late in the evening there was general conversation and impromptu native dancing on the stage, which I, as a guest, was permitted to witness. For an extensive discussion of the Edenshaw Memorial House, its potlatch dedication, and its misfortune, see Joan Lowndes, "Ceremony, Alphabets, Spaces: Robert Davidson," *Artscanada*, vol. 39, no. 1 (November 1982), pp. 1–9. The eagle housepost is illustrated on p. 7.

2. Conversation with the author while driving up to Taos to meet Tony Reyna, former governor of the Pueblo, whose shop we were going to visit.

3. It is virtually impossible to underrate the role this commerce plays in the dissemination of ideas and styles in the present-day art. The miracle is that, despite this flow back and forth, the knowledge of the traditional ways remains in individual tribal possession. There are really two levels at work here, Pan-Indianism and tribal styles, and the gray areas where they meet. Today, as in the past, it is not always possible to tell from what part of a large reservation a work originates, as for example at Fort Peck Reservation in Montana, which is some 110 miles long and the home of both Assiniboine and Sioux where, according to Jim Fogarty, husband of Joyce Growing Thunder Fogarty, an Assiniboine/Sioux (see cat. nos. 165–167), "designs for things like leggings are shared."

4. The information came from an old Smithsonian catalogue. Ellen Myette, of the Renwick Gallery, Washington, D.C., found the field photographs of Edith Bonde and forwarded them to me.

5. "Gas money" means funds to go home or travel with; it is usually money raised on the spot. On the last day of some major powwows, while things are being pulled together, the master of ceremonies offers work for sale at the speaker's platform, a sort of impromptu trade fair for everybody's benefit.

6. As, for example, a trader hawking from his booth at the Sarsi annual celebration, near Calgary, Alberta, August 1982. The connection between Texan dress and the appearance of the beaded belt buckle in Alberta after World War II was made by a longtime resident of that city. Some day an extensive study will inevitably be made of the Indian beaded belt buckle; until then, however, its origin and dissemination remain open to question.

7. This is the exact opposite of what constitutes proper behavior in Navajo country. There you stay in your car and wait; only after waiting do you get out of the car; and if no one comes out to greet you, you leave. If no one appears, it means that for some reason the family is not prepared to see you.

8. A neighbor who dropped in during my visit, September 1983.

9. This incident was reported to me by Polly Sargent, a wise woman who has been instrumental in the restoration of Gitksan culture.

10. This particular trader had formed a tribal museum, but then proceeded to sell things out of it, to the consternation of the woman who told me about it. Nevertheless, she herself insisted that I buy an old (nineteenth-century) beaded blanket from her. Since I have made it a policy not to buy their legacy from Indian families on the reservations, because such a practice would not only develop mistrust, but would also be one more example of "outside" collecting avarice, I refused. It soon became clear, however, that I might lose a friend; she needed the money then and there, and trading was the honorable way to obtain it. Thus, in this case, I broke my rule about acquiring old items.

11. At Poplar, Montana, when I expressed open interest in a pair of moccasins a woman was making, she turned my enthusiasm against me. But I did learn a technical detail, that she uses colored crepe paper to dye her quills, "because it gives soft clear colors." This is only one of countless examples I encountered of ingenious use of modern products.

12. There was a Native American Spiritual Conference going on at the time at the Morley campground. "Go there," I had been told, "and you'll see a Deer Dance." When I inquired discreetly about the dance, a bystander said, "We wouldn't do that—it's sort of sacred." In Indian country the rules vary, and one had constantly to be aware of this.

13. An off-hand comment made during a conversation in the parking lot at the Institute of American Indian Arts, Santa Fe, New Mexico, April 1985.

14. Ronald McCoy, Indian historian and art historian, in conversation with the author, Santa Fe, New Mexico, July 1985.

15. Margaret Cozry, the Ojibwa proprietor of The Algonquians, an arts and crafts shop in Toronto, Ontario, June 1978. Despite the strongly developed trading instincts, there is frequently conflict between the idea of making things for friends and relatives on a restricted basis and making things for sale. There seems to be a long-standing double standard here. The more cohesive the extended family, the greater the desire to keep the culture intact.

16. This was a trader with whom I worked closely in the years 1978–83, a gentleman to the core.

17. Coming directly to the point is allowable when the area to be covered is already established. Asking for the bag had taken time, and the transaction was not agreed to at once. The chief motivation was my willingness to pay the price, in excess of what I'd paid for fine old "corn-husk" bags.

18. Moses Morrison, Gitksan elder, to author, Kispaiox, British Columbia, August 1977.

19. A careful study has been published on the tragedy of Grassy Narrows; see Anastasia M. Shkilnyk, *A Poison Stronger than Love: The Destruction of an Ojibwa Community* (New Haven: Yale University Press, 1985). It bears out all that I could glimpse, and far more than I could guess, about the lifeless community.

20. Conversation with the author, Washington, D.C., March 1984.

III

TIMELESS WORKS OF ART

THE COMMINGLING OF ANCIENT AND MODERN WAYS, THE sudden clashes and contradictions encountered in Indian country become time-out-of-joint experiences that are at first difficult to deal with, even unnerving. It is only after lengthy personal contact that an inner consistency becomes discernible, then grows steadily larger. The problem, it eventually becomes clear, is that white preconceptions are out of adjustment with Indian realities, not the other way round. Anglos do not respond gracefully when pieces of a jigsaw puzzle are missing, and metaphysically speaking, this was happening to me during my earliest visits into Indian country. My needs and methods existed on another plane. Thus, as exciting as it was to find treasures in camps and trailers and shops and homes, it all seemed to be helter-skelter. No shopping list could be adhered to. There seemed to be no assured balance of content. Nothing was solid or firm. New possibilities were always developing, time limits kept extending. Yet slowly, eventually, order began to appear in the disorder. Tribes were accounted for. Patterns started to emerge. One summer an Oneida man I met in Colorado mitigated my concerns as we drove to a sweat lodge ceremony: "All those people making things for you want to help. If they didn't want to, they simply wouldn't. So your project has their interest. It's just that they're on Indian time."

Indian Time

THOUGH IT HAS BEEN THE SUBJECT of much Indian humor, nowhere in the voluminous literature on the modern Indian is there an adequate consideration of "Indian time," that peculiarly Native American reaction to all and any matters that is characteristic of the Indian world. Most white people treat it as a bad joke; it should be taken seriously. Everyone who works with Indians knows about "Indian time." It cannot be avoided. It teaches the great lesson of patience, and in this it commands respect. But to whites it remains a mystery, and thus they have sneered at it, using the term as a sobriquet for Indian "irresponsibility," as proof of the Indian lack of "progress" in the modern era. This contempt has obscured the role it plays—and the dimension it represents—in Indian cultures today. Indian time should be regarded carefully in relationship to the survival of traditional Indian arts today, for it alone allows sufficient fullness of time for those arts to function.

Exactly when the phrase "Indian time" was first coined is not presently known. However, it does seem to be Indian in origin. It has been suggested that it probably started sometime after World War II and was transmitted among students attending Haskell Indian Junior College at Lawrence, Kansas, a unique institution and a central station for disseminating recent Indian customs.[1] The role definition of Indian time—a paradigm of my own experience while collecting—is found in an article on Indian slang current at the school during the early 1960s: "The Indian considers that the white man is a slave to time. This view is confirmed for the student when he discovers that classes begin at predetermined hours. However, the Indian does not like to feel bound in this way; that is why he is not embarrassed when he is late for an appointment by white man's standards, for he kept the appointment by Indian time which could be defined as some *unspecified time* following a *specified time*."[2]

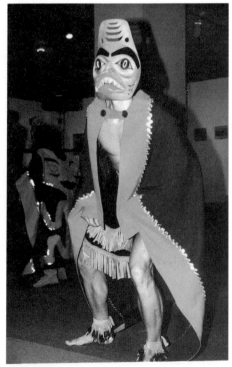

Indians are nearly always on "unspecified time," whether they live on the reservation or in the Indian ghettos of Minneapolis, Chicago, New York, or New England. This has nothing to do with intelligence, or with the ability to execute decisions once the mind is made up. It is a question of priority. It is simply a Declaration of Indian Independence, autonomy under the time system of the whites. It rejects anything that interferes with what is considered important. No embarrassment is involved, no matter how much it disconcerts and baffles Anglos, especially supervisors, who waste their time uselessly trying to prevent Indians from wasting theirs.[3] The flux of Indian time determined when Maynard Lavadour would paint the tepee (cat. no. 224). Pushing him before *he* was ready to do so would have achieved nothing and could have prevented the magnificent design that finally emerged. It explains equally why Refugia Suke's bulrush mat (cat. no. 106) only appeared after two years, and why Alice Little Mustache (fig. 15), one of the best Canadian Plains craft artists, never got around to making the shirt she promised me. She might have, had a second visit from me coincided with a more appropriate inner rhythm of her own. These complexities explain why it was frequently wiser for me — governed as I was by time and deadlines — to buy works from traders (see ch. 2) and circumvent some of the ebb and flow of artists living on Indian time.

In its turn, unspecific Indian time is governed by a larger, allover spectrum in which fragments become a whole, like a circle of life. No one has expressed this concept more eloquently than Black Elk (1863–1950), of the Oglala division of the Teton Dakota, one of the most powerful branches of the Sioux family.

You have noted that everything an Indian does is in a circle, and that is because the Power of the World always works in circles, and everything tries to be round. In the old days when we were a strong and happy people, all our power came to us from the sacred hoop of the nation and so long as the hoop was unbroken the people flourished. The flowering tree was the living center of the hoop, and the circle of the four quarters nourished it. The east gave peace and light, the south gave warmth, the west gave rain, and the north with its cold and mighty wind gave strength and endurance. This knowledge came to us from the outer world with our religion. Everything the Power of the World does is done in a circle. The Sky is round and I have heard that the earth is round like a ball and so are all the stars. The Wind, in its greatest power, whirls. Birds make their nests in circles, for theirs is the same religion as ours. The sun comes forth and goes down again in a circle. The moon does the same, and both are round.

Even the seasons form a great circle in their changing, and always come back again to where they were. The life of a man is a circle from childhood to childhood and so it is in everything where power moves. Our tepees were round like the nests of birds and these were always set in a circle, the nation's hoop, a nest of many nests where the Great Spirit meant for us to hatch our children.[4]

In the circular configuration at dance arbors far and wide, time and again I have seen Indians participating in this endlessness with concentrated expressions on their faces, absorbed in the abstraction of existence that goes round and round. The art works worn and carried by the dancers join this abstraction. Time stops within the sacred circle. "No matter how many detours are made along the way or how many distractions are pursued, they will get to where they want to go. It just takes a while. It may take *quite* a while, and everybody understands that. They have a total confidence about this, something not open to one-track minds."[5]

Preparation for a giveaway feast or a potlatch may go on for months, if not years. Such uneconomic preoccupation is a major symptom of a commitment that runs deep in the Indian psyche. Without that commitment the slow rhythm of ceremony would die. Contrary to the white world's concern about "wasting" time, the Indian is affirming that there is always enough time, that one never runs out of it. Only the Creator sets a schedule, through nature's realm. Therefore there is no overwhelming need to apply one to mundane affairs, including the on-time delivery of a piece of work.

Ceremonial Time

WHILE ON THE SURFACE, Indians seem to take little notice of temporal responsibility, with regard to ceremonial life — which includes a large segment of their lives — time commitments are assiduously kept. A Hopi will not neglect his planting, and will even travel a long distance "going back to do it," in order to fulfill his ancient role in reciprocity with the earth.[6] No Indian will fail to show up at his tribe's annual dance or celebration if he is expected to be there.

"I'm going back this time to learn the song my father left me and claim it, so that it will not go to someone else," Osage painter Norman Akers remarked,[7] referring to the annual dances held in sequence at Pawhuska, Hominy, and Fairfax, Oklahoma, which have a strong spiritual content that reaffirms "Osagehood" in all its dimensions. Even the powwow circuit reflects the old migratory time cycle, the old seasonal change of camps and the following of the animals that regulated Indian life in former days. It would seem that this recurring rhythm instilled patterns of movement and restlessness that are deeply ingrained in the Indian psyche, that there exists a primal belief that without proper reverence paid to it, nature's cycle might cease to benefit the people.

The Indian circular calendar is far more complicated than whites even casually acquainted with it perceive. It has nothing to do with the Julian calendar, but is determined by inner rhythms. At the Turkey Dance of the Caddo at Binger, Oklahoma, to which I was invited by Henry Shemayme (now chief of the tribe), ceremonial time took care of me in its own inexorable fashion. When I arrived at the arbor in late afternoon nothing much seemed to be happening yet at the Caddo dance grove. Had I followed my white instincts, I would have started glancing at my watch wondering, "When are they ever going to begin? Where are the dancers?" The secret is to accept the moment and flow with the certainty that the dance will—in time—come off. Since it was a post-funeral obligation, tradition required that it be finished by sundown. I picked out a convenient bench and had a snooze. "The food is out in the summerhouse," a woman awakened me sometime later, and I joined the feast. I was fortunate enough to sit next to the great lady giving the dance, and helped her open the trunk that contained the giveaway presents. Ceremonial time had treated me fairly because I had respected its nature.[8]

The lesson of the inexorability of ceremonial time was forcefully driven home when a prominent Blackfeet family invited me to their sacred pipe ceremony, which was to be held outside Browning, Montana. "We're going to have a pipe ceremony here this weekend, but you don't want to go to that..." was, after lengthy discussion, finally replaced, as the family rose as one to saunter out to the pickup truck, with "be here Friday." I barely managed to get out of them, "6:00." When I arrived in Browning at that time on the appointed day, there was no one at home except two raggle-tailed dogs. Finally, friends came by (sent, I think, to see if I was there). I followed them miles out of town, then off the paved roads on to a dirt road, then a rutted track, then nothing but fields—as if time itself had petered out. The ceremonial camp was in a circular grove within which time again stood still. It had once been a burial ground. "You sleep over there," I was eventually told, "in the larger tepee with the kids." Two days later when I was asked to leave it, I realized that I had been sleeping in what that morning would become the medicine tepee. A day-long ceremony was to be held on that day and the camp rose very early; even though extensive preparations heralded the ceremony, I was never told when it would occur. Only the rhythm of the camp informed me.

During the ceremony, time was totally suspended. As the treasures of the medicine bundle were slowly danced—particularly the "great pipe"—the communion observance (face-annointing with the earth pigments kept in pouches inside the bundle), the prayers, songs, and feasting were all within the circle formed by the medicine tepee.[9] There was a deliberate slowing down of time, one of the intentions of ceremonial seclusion. Finally, I had reached the vortex of Indian timelessness. I had fallen through white time (6:00 P.M.), to camp time (natural time), into ceremonial time (universal spatial time), and then began to withdraw back to what religious-minded Indians would consider irreality, for the ultimate reality existed within the ceremonial round. The slow, stately dancing of this ceremony had nothing to do with the energetic style powwow dancing. The measured dancing induces a feeling of stasis that provides entry into the realm of religious perception, a realm that is not perceived as time but as space — an all-at-once inclusiveness that has sometimes been called the creative state.

Although Indians say nothing about it, the artistic part of their culture is also created in the framework of ceremonial time — slow time — the delayed aspects of which were embodied by Earl Redeye, Jr., a young Seneca mask carver of Jimersonton, New York, on the Allegany Reservation. I asked him whether any of his work had been used in the Longhouse festivals. "Oh

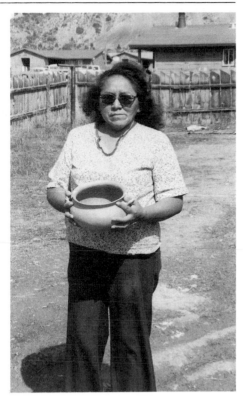

FIGURE 17
Lydia Pesata (Jicarilla Apache), Dulce, New Mexico, 1984, showing a micaceous pot, an art at which she is adept in addition to basketry. See cat. nos. 229, 230.

FIGURE 18
Regina Brave Bull (right) and her daughter
Elaine (Sioux) at their booth at the National
Congress of American Indians, Bismarck,
North Dakota, 1982. The quilt included here
(cat. no. 132) is just visible at far left.

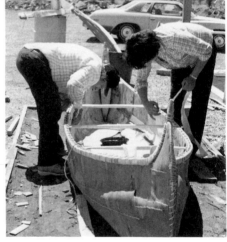

FIGURE 19
Cesar Newashish (Attikamek), constructing a
fur trader's canoe on the premises of O Kwa Ri,
Caughnawaga, Quebec, August 1980. Another
canoe of a group carved at this time is included
here (cat. no. 30).

no," he said quietly, "that will take a long time. The elders look over the masks in the Longhouse, and they know when the work is good. Only they know this. It may take years before my work is right for that. So I'll just keep on learning and carving. And if you want to buy my mask as a work of art that's all right, for it has no power."[10] The time frame of the beadworkers, tanners, potters, and carvers still interacts with age-old natural rhythms. When in Dulce, New Mexico, I found that basketweaver Lydia Pesata (fig. 17) was "upriver looking for sticks." I had arrived on the first nice day for collecting sumac. No one knew exactly when she would be back. A totem pole still cannot be carved until the tree can be floated down a river, and for this there has to be sufficient water (unless an accommodating lumber company trucks it to the carving site). Pueblo clay can only be gathered when conditions are right and after prayers are said. The best light-birchbark strips are gathered between May into July; the heavy birchbark—sometimes called sugar bark or winter bark—used for scraped decoration must be collected in late winter, just before the sap begins to rise. Bulrush must be "caught" at an extremely critical time, just before it flowers, around July 4 in the Northern Tier states.

Gathering cycles dovetail in turn with the ceremonial calendar, which is often set by augury or tribal tradition, in concert with the season. The Crow horse outfit commissioned from Marie Pretty Paints Wallace (cat. no. 179) had to wait, "because I've had to bead up things for people who need things for Crow Fair parade." Even though money talks, it does not talk loudly enough to pre-empt more pressing tribal obligations.

The time in which the artisans and artists work is abstract compared with ours, as broad as the white, beaded fields in which they set their designs. In fact, all the grounds in which Indians center their symbols, emblems, devices, and designs are curiously devoid of what might be called illusionism, i.e., they are without reference to a physical point. Even a totem pole has none; totem images exist in illimitable space.

So much effort has been spent by scholars in identifying the meaning or content of Indian designs, or pinpointing the exact animal portrayed in a Northwest Coast crest, or determining which symbol is painted on a particular Southwestern pot, that the matrix in which these devices occur has been significantly overlooked. Actually, that matrix is also illuminating, for it parallels that spaceless world for which Indians create, with ceremonial time as the prime animus. While creating, they are inside time and react to an internal rhythm that cannot be talked about, but which is nevertheless there. Ceremonial time is private time. Many craft workers do not like to be observed while working, and the firing of Pueblo pottery is mostly done in secret. Nathan Begay (cat. no. 304) kept talking about inviting me to a firing, and the more he talked the less likely it became that I would ever attend.

The mysticism of the space in which Indian designs reside demands overriding reticence. "You never buy the whole Indian, we always leave something out." What is left out is that individuality or particularization that has characterized Western art since the Renaissance. The so-called portrait mask of the Northwest Coast is usually generalized, not an individual, and depends ultimately for its effect on a delicacy of balance that is purely formal. While "realistic" masks of old women from the Nishga tribe of the same region have been said to represent actual people, they all represent the concept of a rich old woman who likes young boys, a Northwest Coast way of poking fun at the sexes.

The features and accoutrements of Hopi Kachina "dolls" (cat. nos. 311–317), no matter how detailed and lovingly fitted out they may be—down to such details as miniature hawk bells at the ankles—always belong to the symbolic world, never to reality. Their home is in the San Francisco peaks, which are themselves converted to mythic dimension. Distance lends not only religious enchantment, but also credibility to belief. The bear who gently rocked the trailer in which I was sleeping in the Nass River woods at the time I was negotiating for the loan of the Nishga totem pole (cat. no. 382) is not the bear carved on that pole. There he stares with unseeing eyes, looking beyond the physical world. His function is to extend pride of crest ownership into the space of mythic time.

The false-face masks of the Iroquois come from no particular place or time; they simply appear out of the forest, today no less than in the past. So wrapped up are outsiders in temporality that they do not make allowance for the "little people" of the Osage and Winnebago who inhabit the forests, fields, and prairies. Always, there is a deep-seated identification with land

and forest, the waters of river and sea, clouds and rain, sun and energy, life and growth, all symbolized in the art. Kachinas make children behave; masks cure; talking sticks enforce one's right to speak—all pertain to social control, or to the affirmation of the supernatural. All this differs greatly from the white notion of reality.[11] In the Indian view, mythic art belongs to the present as well as the past. In other words, it cannot become dated. For Indians, both past and contemporary art belong together. Mythology, even if it is now called "stories" by some Indians, still has symbolic value and permeates art.

However, the art does not belong to the future either—only to an unceasing present; it is part of those who have died, for they have never left. While everyone in a large family is preparing during the winter and spring for a summer ceremony—quilting or weaving for their giveaway; setting aside the money to buy the beef and all the feasting foods, to pay the drum, to make cash giveaways; putting ceremonial dress in shape so that "everything is right"—the ceremony is not thought of as taking place in the future time, for the honoree is already dwelling with the spirits of ancestors. He has joined his forebears as one more reaffirmation of the unending natural chain.

In much of today's Indian art, the past is reconstructed as justification of the present. This is one reason why innovation inevitably joins the tradition matrix—as long as the basic culture is strong enough to absorb the impact of new materials. While individual tepees rot and are replaced, *the* tepee remains constant. "I guess I'd better paint our elk again on a new tepee," bundle owner George Kicking Woman observed at dinner in the old family tepee the night before the pipe ceremony. Since the new exfoliates from the old, tepee designs can be used again and again without the conscious breaking away that characterizes "progress." Since old designs are never obsolete, they can be added to freely, without causing any interruption in meaning.[12] This is why contemporary/traditional Indian art is nowhere near as disruptive a factor in the total culture as a narrow historical interpretation would have it.

Indians are aware that an art form, like a developing personality, can extend beyond one generation; in fact, it can take an indefinite time to be fulfilled—at times claiming ancestral derivation for an object made during the person's own lifetime. Though the ceremonial dresses change according to fashion and style, allowing them to be dated by outsiders, their raison d'être never does, as long as the conception is not destroyed—and therein lies the danger. Conceptually one is looking at a continuous dress or outfit, no matter what has happened to the object itself over the years. Even when "obliterated" it can be revived, because the past is always present, therefore capable of regeneration. All one has to do to realize this is to look at Navajo sand painting designs, dynamically centered in unlimited space—like the Navajo legend of their own origin from the center of the earth—with neither beginning nor end.

How does one represent continuity? There are many ways. But what configuration best symbolizes, among the hundreds of works collected here, that enduring Indian consciousness? Adopting the example of the mandala of enlightenment surrounding Buddhist images, I sought a similar heightened image among the collected objects and found it in a beautiful quilt (cat. no. 132) by Sioux Regina Brave Bull (fig. 18), depicting an eagle surrounded by an eight-pointed star—a variant of the sacred circle. The moment she unfolded it in her home at Cannon Ball, North Dakota, the room was filled with radiating power and spiritual enlightenment. Light swirls from the yellow center of her quilt, carried outward on points of color (pieced from scraps). The tips of the giant star point toward the four edges of the earth. One recalls Black Elk's hoop of the nation's life. This is the unending circle, capable of any kind of prayerful or philosophical extension. While quilts have been made by Indians only since the 1890s, the meanings of their designs are as old as the offering of the pipe to the four directions, perhaps even older.

Indian motifs of sun circles and crosses on pre-contact Mississippi pottery, which derive from designs on petroglyphs that may date from prehistoric times, survive today in the most unexpected places, even on a New England bag. "That is the four-winds design," Ella Seketau explained at Kenyon, Rhode Island, pointing to a row of crosses traversing her fiber bag (cat. no. 24), a true descendant of a twine bag made by pre-contact New England Indians. Many objects in this collection show circular or directional "centering" designs. None of these designs can be understood by measuring them, for their contact is universal cosmos. They express infinity no matter how confined the field may be, whether restricted to a piece of buckskin (cat. no. 136)

FIGURE 20
Ancient Korean bronze mirror, pre-Lolang Period. National Museum of Korea, Seoul. See cat. no. 102.

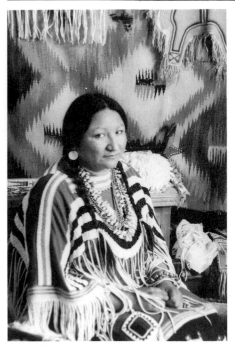

FIGURE 21
Joyce Growing Thunder Fogarty (Assiniboine/
Sioux), Taos, New Mexico, 1984, wearing a
beaded outfit she made several years earlier.
See cat. nos. 165–167.

or to the smaller field of a buckle in which a feathered circle is surrounded by
stars that break beyond the miniature format (cat. no. 188), making a composi-
tion in infinite space. Even the sun itself is here, in the guise of a Kwagiutl
mask (cat. no. 359), with beams projecting outward like radiating fingers—a
parallel to Regina Brave Bull's mandala-like design. Another sunlike feature
glitters around a hawk frontlet (cat. no. 361) by a different member of the same
Kwagiutl family of carvers. Since such frontlets are made to be worn on the
forehead, they move freely in space. The Indian imagination long ago
metamorphosed circle designs into squares, crosses, rectangles, oblongs, tri-
angles, and double triangles to give great artistic variety. Sometimes the
configurations defy easy analysis, but the underlying symbolism, which is
never fixed as either past or present, is never in doubt.

Beyond Chronology

IF CONTEMPORARY INDIAN ART is as decadent as opinion in some quarters
would have us believe, such symbols would long ago have become obsolete.
Admittedly, the strength of their presence can vary, but even in the Northeast
—the area earliest exposed to outside influence—it survives, in the rosettes
scraped onto the birchbark canoe by Cesar Newashish (cat. no. 30 and fig. 19),
on the birchbark container made by a member of his family (cat. no. 29), or in
the "starfish" design on the beaded pouch by Tony Atwin (cat. no. 14). These
manifestations are too basic to be erased by acculturation. It is shared belief—
shamanism, animal worship, nature divinity—that carries the symbols across
space. Once acquired, symbols survive, like the imprint of leaves that were
once pressed in a book. The leaf is lost, but the imprint keeps it intact in the
interior of the mind. "The power of the rhythmic message in the group is as
strong as anything I know. It is one of the basic components of the process of
identification, a hidden force that, like gravity, hold groups together."[13]

The communality of symbolism that stretches across continents
and cultures was forcibly demonstrated to me when I took two distinguished
Korean scholars to Tama, Iowa, to visit the Mesquakie. The Indians and the
Korean archaeologists conversed like kinsmen coming together after a long
estrangement, finding much in common in discovering each other again. Dur-
ing the course of the stay, we visited the trading shop of Frank Pushetonequa.
Suddenly Dr. Han Byong-sam, the senior Korean whispered, "That design
over there," pointing to a medallion necklace hanging behind the counter (cat.
no. 102). "We have exactly the same [design]…on a very ancient bronze mirror
[fig. 20]. In our mirror the center design represents the four directions, the
triangles on the edges are sunbeams, and the whole disk is the universe." I
asked our Indian host to explain the medallion necklace he had for sale. "The
pointed things are sunbeams," he replied, "and inside, our four sacred
directions."[14]

Such concordances cannot be measured logically. They have noth-
ing to do with Western thought processes. Like so many aspects of Indian
culture, they exist outside chronology. The same is true of the form and devel-
opment of Indian art, unless the artist has left his culture, which is not true of
the creators of the objects shown here. The time frame covered by their work,
from 1965 to 1985, is a conceptual unit. We have catalogued the works in the
Western way, but time really stops once you enter their precincts. There,
measurement is replaced by symbol and meaning. When I asked an Indian
elder the age of some works she had brought out from a back room, she
answered, "That is so old, it's so very old…that, it's just generations old," and
then lapsed into silence. In actual years some of the items were not old, they
belonged to her own youth. To her these works were *in* time, and my question
simply did not apply. I learned to be very careful when bringing up questions
of exact dating; the answer might be "a few years ago," or "in my grandma's
time, I think," or "I don't know." There was usually little concern with matters
of accuracy, unless there was an association with an event that gave the object
specific personal meaning, or an event that related to tribal matters as a whole.

"Indian time" is a recent phenomenon. Since there is no word for
time in any of the aboriginal Indian languages, the phrase depends wholly on
acculturated English. It is a product of the conflict between Indian and white
life-styles. In an earlier day, the contrast between the two was less immediate.
Until World War II, slow methods of journeying into and out of Indian country
provided a sort of decompression chamber, a space for time adjustment, so
that the two cultures did not clash so dramatically. Even today many Indians
deliberately revert to old ways. The horse of the past has given way to a pick-

up truck or van, with an interior decorated with Indian beaded miniatures of peyote drums, prayer feathers, and assorted beaded objects hung from the rear view mirror. Yet, according to Peter MacDonald, the former chairman of the Navajo Tribal Council, those attending Navajo "sings" today will often travel the last mile or two by horse and wagon, for old time's sake and to create a mood of receptivity.[15] In the Indian mind, the horse still travels the Plains, as does the buffalo. Both are still depicted. Unforgotten, each looms as a magnified presence, symbol of that which will not be lost.[16]

As Indians were increasingly subjected to white civilization they were fenced in, isolated like islands bypassed in the stream. Natural time was nurtured by segregation and remained. I could find little record of early Indian reactions to white time. There is, however, the case of Charles Eastman, a young Sioux, who wrote of his amazement in discovering that "[whites] have divided the day into hours, like the moons of the year. In fact, they measure everything."[17] Youths like Eastman had no experience with yardsticks, rulers, calendars, and clocks until the moment of their break with Indian culture. Only then were they forced to differentiate between Western concepts of time and their own "Indian" time—though no name for it existed then —or else lose their culture entirely. Not until Indians had seen service in two world wars did the phrase really take hold.

Indian resistance is expressed as an outrage against core change, not against simple matters of adaptation. The old ceremonial time is today under attack, often by those in charge of Indian policy. Nevertheless, because different time consciousnesses do not mix, but remain as separate as oil and water, Indian ceremonial time still has a chance of surviving. Its very unique-ness protects it. Indians on the way to a dance or powwow do not glance at their watches the way white people might. Despite the fact that the beading of watch straps is a modern Indian cottage industry, the time on the watch face is ignored. Perhaps we would do well to learn from cultures in which a system of values replaces time and heed the counsel of Joyce Growing Thunder Fogarty (fig. 21). A descendant of Joshua Wets-His-Arrow, the great Assiniboine lead-er, and One Bull, the nephew of Sioux warrior Sitting Bull, Joyce Fogarty has inherited the breadth of both her cultures. Among the finest craftworkers of her generation (cat. nos. 165–167),[18] she embodies the universe of the Plains Indians in her work. Soon after she learned I had moved to Santa Fe, her husband telephoned. "Since you are going to become a real westerner," he informed me, "Joyce is beading you a watch to keep with you [fig. 22]. It will be elegant, she says, but it will have no hands and no face."

FIGURE 22
Joyce Growing Thunder Fogarty (Assiniboine/ Sioux). Watch with no hands and no face. 1985. Watch frame, buckskin (replacing watch face and works), beads, 9⅝" 1. (watch and strap). Collection Ralph T. Coe, Sante Fe, New Mexico.

NOTES

1. Haskell Indian Junior College was founded as Haskell Institute in 1884 and named for Dudley C. Haskell, chairman of the House Committee on Indian Affairs. The purpose of the school was to provide facilities for the Indian youth, who were not able to attend schools because there were not a sufficient number of classes available to them. It continues as Haskell Indian Junior College, the only such federally funded Indian institution in the United States, accept-ing qualified candidates from all tribes.

2. Alan Dundes and C. Fayne Porter, "American Indian Slang," *American Speech, A Quarterly of Linguistic Usage* (December 1963), p. 276.

3. It should be mentioned that the discontinuity of Indian time can be troublesome to Indians as well. When a young Plains woman studying at the College of Santa Fe would lend her pickup truck to various Indian friends, it was never returned on time. Tiring of this attitude, she decided not to lend it anymore. Her friends—who appreciated the loan but to whom the time of return was simply not important—could not understand this reaction, which went strongly against the Indian concept of sharing.

4. T. C. McLuhan, comp., *Touch the Earth: A Self-Portrait of Indian Existence* (New York: Outerbridge & Dienstfrey, 1971), p. 42. The passage appears in the autobiography Black Elk dictated 1930–31.

5. Peter Stock, husband of Osage Kimberly Ponca Stock (see cat. nos. 112 and 113), commenting on the fact that Indian time is not incompatible with the setting of goals, a fact not understood by outsiders who have been subjected to Indian time. The goals are not scheduled, neverthe-less, they exist.

6. Hopi/Navajo Nathan Begay (cat. no. 304), who lives in Santa Fe, equated going home to his Hopi family at Moenkopi, Arizona, with "planting. It is important for me to go back and do this." Conversation with the author, May 1985.

7. In conversation with the author, Institute of American Indian Arts, Santa Fe, New Mexico, April 1985.

8. Out of this experience I would eventually acquire the traditional Caddo woman's hair tie (cat. no. 116). The three I saw that day led to an initial attempt to acquire one through my host, but nothing was forthcoming, and I eventually gave up. Months later, a fortuitous conversation

with a mutual friend led to a renewed attempt, which culminated in Hank Shemayme's discovery of a willing artisan, who made the elegantly crafted hair tie shown here.

9. This ceremony was being held out of season, after family consultation, to ask that one of its members, who was long overdue delivering her child, be given the protection of the Creator. Ordinarily such a ceremony would be held in the late winter "at the time you hear the first thunder...before there is any lightning in the sky, only the rumble." The ceremony is known as the Thunder Bundle ceremony. Its place in Blackfeet ceremonialism is indicated by Diamond Jenness: "These sun-dance bundles, however, formed but one group in a numerous series of medicine-bundles, the other most outstanding groups being the beaver and pipe bundles. The pipe bundles were associated with the worship of thunder, the beaver with tobacco cultivation" (Diamond Jenness, *Indians of Canada* [1932; reprint, Toronto: University of Toronto Press, 1984], p. 322). For more on the Thunder Bundle ceremony, see Harold McCracken and Paul Dyck, *A Blackfeet Sacred Ceremony Preserved: The Thunder Medicine Bundle of the Blackfeet People*, Educational Series, no. 1 (Cody, Wyo.: Buffalo Bill Historical Society, 1972).

10. Conversation with the author, November 1983. In contrast to the more conservative Iroquois (Mohawk, Tonawanda Seneca, Onondaga), the Allegany Seneca (including Jimersonton) carve unconsecrated masks for sale, and young carvers gain experience this way.

The subject of masks serves to underscore the fact that schisms still occur between factions of tribes with regard to what is appropriate in exposing these objects, whether they were made years ago or today. The Seneca Iroquois National Museum has issued a white paper that reads:

For the purposes of the Seneca-Iroquois National Museum the major items that are defined as of a sensitive nature is the universe of masks, both wooden and cornhusk, both large and miniature, which constitute one of the most distinctive markers of Iroquois culture recognized around the world. The decision of our Advisory Committee of the Museum in 1977 was that those masks which are unconsecrated would be allowed to be displayed since most of these in this category were made for commercial purposes. Masks that were used for ceremonial purposes, generally accompanied by "medicine," may be actively acquired by the Museum but cannot be publically displayed. This category of masks may be used by the local Longhouse community for ceremonial purposes, and may also be made available to appropriate scholars who have formally requested access to the collection. The Museum will also make every effort to have the masks in our collection "fed" [anointed with cornmeal] during an appropriate and annual ceremony to be conducted by members of the Longhouse community.

A different Iroquois philosophy, as expressed by Oren Lyons, an Onondaga Iroquois dignitary and himself a painter, emphatically holds that "no quarter can be given about the masks. It is not a question of quality. They cannot be shown. They are beings—our grandfathers—and whether they are carved for sale or not, they are the same. There is no distinction. They should return home." This forbids access even to scholars, because of the dangers to all mankind in handling such awesome portents of man's fate. In such cases it is clear that the modern world poses ongoing, living problems which can only be resolved by Indians themselves.

Coming down on the side of traditionalism—the message of this project—also means coming down on the side of deep-seated belief. The *form* that we may admire is expressing the *substance* for which the work of art was first and foremost made, and, as Oren Lyons says, that "is not a matter of quality." In deference to this view, no masks of the Iroquois have been included in this project.

11. During a session of *Indian America: Past, Present, and Future* an Aspen Institute seminar, held June 27–July 10, 1982, at Crestone, Colorado, Old Peter, a Cree medicine man, attempted to create a myth. "The white man came and took what was his," he began, "and profited by it, and the Indians kept what was theirs, and each went his own way...." "That's *not* what happened," angry Indian voices interrupted. "We all know it *never* happened that way." Old Peter is hardly what the Indians call a "sellout." He is an unceded Indian, i.e., he recognizes no treaty between his people and Canada, preferring to remain a stateless Indian. The myth he was beginning to unfold had nothing to do with historical reality, but was on the theme of reconciliation. His intent was misunderstood.

12. As an example of this, see the tunic made by Haida Jessie Natkong (cat. no. 362).

13. Edward T. Hall, *The Dance of Life: The Other Dimension of Time* (Garden City, N.Y.: Doubleday Anchor Press, 1984), p. 184.

14. "That contemporary/tradition you are interested in is one of the oldest things that we know," Dr. Han remarked after we had left the tribe's hospitality.

15. In an address at the Aspen Institute seminar *Indian America: Past, Present, and Future*, op. cit.

16. A related symbol at large is the image of an Indian on horseback adopted from James E. Fraser's equestrian sculpture, *The End of the Trail*. The subject is a favorite of beaded-buckle makers (see cat. no. 126) and is even depicted in a Navajo pictorial weaving made by Helen Begay in 1984, in which a Yei swoops from a cloud to succor the dejected gaunt Indian rider. (But Indian intepretations don't always follow the intended hard-times sentiment, as shown by the version offered by the master of ceremonies at the Bismarck Intertribal Powwow of 1982 as he held up a beaded belt buckle for sale: "It shows that Indian on a horse from that sculpture in Oklahoma or someplace. That poor Indian man has been out all night and is he going to get it when he finally gets home! No wonder he's unhappy and going slow."

17. Charles Eastman, *Indian Boyhood* (1902; reprint, New York: Dover Publications, 1971), p. 242.

18. At the Santa Fe Indian Market of 1985 she received the Best in Show award, which has focused a great deal of attention on her work, heretofore known only to a small circle of admirers.

IV

TRADITION

SPEAKING TO THE PRESENT, RESPECTING THE PAST

JOYCE GROWING THUNDER FOGARTY'S WATCH WITHOUT A FACE (fig. 22), is it traditional or non-traditional? The answer—true for so much about the form and content of Indian art today—is that it is both. As an object it is modern, but it guards the timelessness of the old ways—contemporary with a modern twist. An old-style shirt one time (cat. no. 167), a humorous watchband the next—so it is with many Indian artists—sober in the regard for the past, but mindful of the present. There are no absolutes, no set rules, but there is among most Indians a sense of the past actively alive in the present.

True, the further removed an Indian is from his own culture, the greater the possibility of a less traditional life-style. But sophistication—education, travel, urban living—does not of itself cancel regard for tradition. The dictionary meaning of *tradition* is specific: "the handing down of information, beliefs, and customs by word of mouth or by example from one generation to another without written instruction."[1] This excludes much of what Indians would include, namely, the whole of their culture. In her recollections written shortly before her death in 1978, Onondaga elder Adelphena Logan touched on this when she wrote, "The drum sets a tempo for memories…memories of sweet grass….My dream is a mingling of past, present, future."[2] Her dream is about tradition, and it translates as a telescoping of time into oneness, wholeness, all existing in unity. As the word is used today among Indians, tradition is generally associated with the old ways, the reliving of the heritage. Everyone knows what it means and when it is being activated, but little is said about it. When Joyce Fogarty was asked what she thought tradition was she said, after a pause, "Keeping up the old ways."[3] But neither from her, nor from anyone else did I receive the impression that this meant being old-fashioned.

In the 1920s and 1930s Indians unhappy with the life "outside," who returned home in desperation, were described as having gone "back to the blanket," thus cutting themselves off (in the white view) from all possibility of modern progress. The phrase hasn't been heard for years. Now a different view prevails. The returnee is welcome, for he brings a breadth of experience back with him. Well-educated Makah Greg Colfax (cat. nos. 350 and 352), who was just such a returnee not many years ago, teaches carving off the reservation and enjoys a position of respect as an exemplar of the culture. The Northwest Coast artists clustered around Vancouver, British Columbia, remain Haida or Tsimshian wherever they may carve, just as their ancestors who carved for the crowds at the World's Columbian Exposition of 1893 in Chicago were not any less Indian for the experience. Not long ago Nishga carver Norman Tait paddled and sailed the old-style, full-sized Tsimshian canoe, which he and his brothers, Robert and Alver (cat. no. 380), had just carved, from the building site at Vancouver all the way north to their ancestral Nass River, a distance of over five hundred miles. In this case, the direction was reversed, from modern life *up* to the old spiritual home, the opposite of the long treks the nineteenth-century Haida and Tsimshian made *down* the coast to Victoria in order to trade. The strong ties had prevailed, "We wanted to do this to have again the old experience."[4]

The more contact one has with the present-day keepers of Indian tradition, the more evident it becomes that the process must be viewed positively. Tradition has frequently been considered negatively, even as being harmful. One author, expressing a view not limited to himself alone, has maintained that "tradition always looks backwards, it tells how things were well enough done in the past, how old problems were solved. It gives little guidance as to how things may be done in the future, as to how new problems are to be solved."[5] What is ignored in such a proposition is the whole of Indian culture, which is steeped in lessons that do not date. The Indian ethic incorporates a code broad enough to admit aspects and fragments of Western culture, which may be referred to, tested, and even found wanting. This code is not past history, it is a living presence. "It is as if they [the ancestors] never left," said a young Indian student trying to define his concept of tradition.[6]

Just as Indians do not separate mythical events from historical facts (see ch. 3), they do not maintain a moral distinction between what happened in former Indian worlds and what is happening in this one. All is cut from identical cloth. "Being a good Indian is listening to all those lessons that tell us what to do," I heard Sioux Zona Loans Arrow (cat. no. 127) admonish her daughter (perhaps for my benefit as well). "They tell us to be honest and act straight." While Westerners distance themselves from "the dim past," Indians carry their past with them wherever they go. While this practice, inborn and inbred for countless generations, appears lacking in cohesion to outsiders, to Indians it is patently real. Motifs, techniques, forms, and events, all of which are art, can be combined in many different ways, including time shifts that blend distinctions. The Indian mind sees no apparent confusion. Indian readers easily fill in the time-space gaps in the rich pile-up of time and tradition that flows through this writing from the modern Nishga:

The elders of the tribe, without whom no major decision is ever taken, recall the early days, before the white man came and before the missionaries, when the Nishga lived in many villages and were rich because of the resources of their valley, especially the tiny oil-rich oolichan [eulachon], the smelt-like fish that has saved many a Nishga from starvation and provided a cultural link with the past that is as important in the life of the valley today as it was thousands of years ago."[7]

A white author attempting to combine all these "themes" — elders, government, pre-white culture, wealth, fishing, the importance of the eulachon, continuity with the past, life lived today — would be careful with his syntax in order to avoid confusion. This is not so with Indians, who write in the same manner as they speak.

Contrary to the dictionary definition of *tradition,* Indian tradition today is often written. Indians produce dozens of handbooks on craft subjects, in which they pass on methods and techniques.[8] A monograph on the work of William and Mary Commanda was produced in 1978 because Mr. Commanda asked the author if he would be interested in writing a book about them and their crafts.[9] This type of request, an irrefutable example of an Indian seeking by modern means to preserve his heritage, has occurred many times. In such cases Indians were asking that the act of preservation be done on their behalf. In the past, rather than let their traditions in art, song, story, or ritual be lost, Indian elders turned information on these matters over to white scholars, knowing they would be preserved. Did they know that the day would come when their depositions would be reclaimed? The recent generations are grateful: "Anthropologists who kept the information have helped us to regain our ways."[10]

More recently Indians have taken it upon themselves to see that their traditions are preserved. Ben Gray Hawk, a leader among the Badland Singers of Fort Peck Reservation in Montana, brings a tape recorder along to the rehearsal of a newly composed honoring song "to make sure we get it just right." A recent television program in Santa Fe featured an older Navajo woman giving a lecture-demonstration in the flat tones of her native tongue on the preparation and cooking of traditional dishes. Another program showed a film in which Hopi Emory Sekaquaptewa used unassailable tribal logic to link the power of the eagle—perhaps the most traditional power symbol for all Indians—to a major event in modern life. Describing how the Hopi were led into this, their fourth world, by an eagle he said of man's voyage into space, "We were awed by the technology of the event, as everyone was, but we were not as surprised as you might think when the first man landed on the moon and declared, 'The eagle has landed.' "[11] The Hopi have clung tenaciously to their old ways, even though they have lost some songs and dances

(at least they are no longer performed); other tribes have literally had to refind themselves. "Yes, I think we will have the Klukwalla again," Greg Colfax said, referring to the four-day ceremonial cycle that is the heart of Makah culture. "We're not quite ready yet, but we are slowly relearning the songs from the elders. But it takes a lot of preparation to get ourselves ready to do this. We have to change. Then we will be different. It's not easy. But it's coming."[12]

A renaissance is taking place in some parts of Indian America, and the Makah at Neah Bay, Washington, are a notable example. Here the impetus of the Ozette archaeological finds — a Makah site periodically engulfed by mudslides which has yielded, among other remains, extraordinary remnants of a mid-fifteenth-century village — and the influence of nearby Canadian Westcoast artists, such as George David and Art Thompson (cat. no. 355), who have married into Makah families, have spurred younger carvers, among them Greg Colfax, toward a recrudescence of their culture on several levels. Part of the results of this ferment is that the Makah have one of the most vital tribal museums in Indian North America. In a book on Klikitat basketry, artisan Nettie Kuneki writes: "We did not keep the ways of our forefathers, and we have lost much of our native art.... To me it is as if our art of basketry once died and now has come to life again. It is the rejuvenation of our identity, the reawakening of our great heritage of which our people were once most proud." And she sums up: "The arts were almost forgotten because of the cultural changes between the generations [from the turn of the century to World War II]. As time went on the cultural changes lost their effect and today our people are again practicing some traditions from their heritage."[13] At Parker, Arizona, Chemehuevi basket maker Mary·Lou Brown echoed the idea of death and rebirth. "The culture died and I am bringing it back to life again," she said as she worked on a basket.[14] Mary Lou Brown has a son and a very talented niece who have learned basketry from her. A corner has been turned, but the future of the art is not yet secure. Other Chemehuevi are trying to learn, "but their efforts so far are pretty poor. Maybe in time they will get it back."[15] In some places it is too late.

It is easy to forget just how profoundly the basis of Indian culture was attacked. When I met Pomo basket maker Elsie Allen at Ukiah, California, through her grandniece Susye Billy (fig. 29 and cat. no. 337), I asked her about the loss of the meanings of some basketry designs among her people. "When I was a young girl we were afraid," she said, referring to the overwhelming rejection of everything Indian, "and at that time we lost the explanations of a lot of the designs. We know them, and we can weave them, but we don't now know what they mean." It would take many lifetimes to recall what has been forgotten. But what has been remembered is very real. "They always think that it has all been forgotten," says Cayuse/Nez Perce Maynard Lavadour (cat. no. 224) of cultural historians, "but there's always someone around who knows just about how everything was made, or someone who can make it."[16]

The amount of work accomplished in comparison to olden times is indeed less. But that does not mean that extinction is at hand. In a number of important places the situation has improved greatly over what it was thirty or forty years ago. Speaking of his Ojibwa neighbors, Mille Lacs, Minnesota, trader Sherman Holbert pinpoints the reason. "Years ago many people around here were making tiny mukaks [birchbark containers] for the maple sugar and wild rice packing companies. But this was very routine and uninspired work, done for a few cents an item. Modern packaging has mostly put an end to that. What is being made today has to compete with a higher standard, that of quality merchandise anywhere. The best pieces get the most money. And the Indians who dance here and need things are exacting about what they will pay for."[17]

The Continuity of Tribal Tradition

As TRADITIONS EXPAND they overlap, extend, slowly absorb new influences. There is a chain of action and reaction which often escapes notice. This happened often in the past, due to intermarriage and to the active trade among Indians during which motifs and designs were exchanged as well as goods. Chuck Dailey, who has been director of the Institute of American Indian Arts Museum in Santa Fe since 1972, cites a tripartite influence upon recent Native American art forms: (1) the continuity of the tribal traditional forms, which he notes as being religious, functional, and necessary to the continuance of the culture; (2) the influence of modern Euro/American painting, which has encouraged Indians to express themselves in new modes; and (3) the estab-

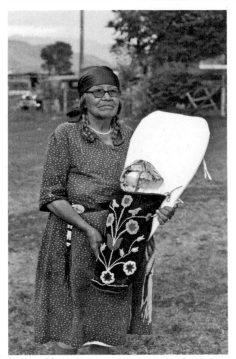

FIGURE 23
Agnes Vanderberg (Flathead), with the cradleboard included here (cat. no. 218), Arlee, Montana, 1982.

lishment of the Institute of American Indian Arts school at Santa Fe in 1962. He concludes that "the health and growth of Native American arts is based on the *balance* of all three influences."[18] The first of these influences—the role of tribal tradition—is essential to the remaining two, since it is not really so much an influence as it is a basis upon which all else rests.

Retention of the past is necessary to renewal and change. Loss of a sense of the past means that nothing moves forward. This is a fundamental element in the psychology of Indians, which transcends influences while absorbing them. "Things can be lost and found anywhere along the line; they continue, lag, and flow into completeness, so that each thing we make partakes of completeness, but is part of everything else, too."[19] This resolution is the process of tradition. As I was told with humor, "If it isn't traditional enough, just stick around and it will be."[20] A. L. Kroeber has stated that "the spread of culture is generally called diffusion, as is the internal handling through time called tradition."[21] The term "diffusion" describes the spread of forms, yet the integration of forms, technique, and function through time is actually a process of *fusion*, by means of which the cumulative collective tribal memory continues to be served. This is no less true today than it was in the past. However, the game plan has changed, which has led outsiders to declare that each new generation of Indians is no longer "traditional."

In the old days, tradition was perpetuated by example. By means of observation and imitation, technique and style were transferred from one hand to another. Help was given when needed. This system still prevails today. "I'd be struggling on one part [of a mask] and somebody would just come in and take it away from me and start carving all over one side of it," Greg Colfax reports of his early days. "In about twenty minutes, or half an hour later, they'd hand it back and say, 'Okay, now you do the other side.' The struggle of learning was the struggle to try to do something that someone who's been carving for eight or ten years was able to do, and then trying to duplicate that on the other side. It's a technique that I use on other people who want to learn how to carve."[22]

Almost every Indian artist encountered during the course of this project has had access to an elder or a relative who knew the techniques, and who in turn had learned them from a grandmother, grandfather, mother, father, aunt, uncle, older brother or sister. "From childhood we are watchers. It's not done by talk. We quietly watch. We help our mothers gather materials. We stay around and learn. We do this for each other, now as in the past," says Osage Carl Ponca of this Indian tutorial system. "At one time or another most of us are students, and then we are teachers."[23] In the extended Indian family structure the inculcating can take place within the immediate family or at a tribal culture camp of the type run during the summer near Arlee, Montana, by Flathead elder Agnes Vanderberg (fig. 23 and cat. nos. 218 and 220). "What we make up here," Mrs. Vanderberg observed, "they don't forget. It stays with them, and it stays with us."[24]

It is a circuit along which there is constant movement, from old to young, from relative to friend. It never ceased functioning, not even in the 1920s and thirties. As an elder passes on, she or he is replaced. Often the elders fear that due to the distractions and diversions of modern life, the system will die. Though their fears may be well founded, the system has persisted. "All those hands have done their work, and we do ours today."[25] During a discussion about his growing reputation as a master potter, Hopi/Navajo Nathan Begay told me (fig. 24 and cat. no. 304): "I hope to do the same for my sister [technically, his niece]. It gives pleasure and satisfaction to know that what you do is going to be passed on. She only watched me a few times. She has amazing feeling for clay. Next time I'm going to say, 'Nono, I'm just going to sit back and you do it all from scratch.' She did the pot in your show [cat. no. 305], but I helped her fire it. Now I won't need to do that anymore." He then showed me a paper his niece had written for school, "Making a Pottery." "It's very complete, except for those private [religious] parts she didn't want her teacher to read about."[26] The paper is further evidence that, contrary to the dictionary, tradition can be written down, as well as orally transmitted.

Modern technology has added to the age-old method of watching and imitation. The spectrum of sources open today to Indian sensibility is far more extensive than what existed formerly. Photography has made the history of Indian art available; what was formerly buried or hidden in museum depots is now open ground for exploration and discovery. Greg Colfax has spoken of this: "When I started carving, the main message to me was 'Carve every piece

that's been carved by your tribe.' That set me up to go back into museums, the Burke Museum [University of Washington, Seattle] and the Provincial Museum [Victoria, British Columbia] to look for pieces from Neah Bay. We're fortunate that the director of our museum has gone to every major museum in the United States and has seen or photographed and has a personal slide collection of hundreds of pieces from here…. He's got forty or fifty slides of just wolves, from Neah Bay and Vancouver Island. If I need to look at thunderbirds or eagles, or ravens, or various kinds of humans or monsters, they're here for me to look at and study [fig. 26]. It's good we have this. It's having an effect on many of the carvers."[27]

It is impossible to overestimate the effect such collections and photo archives have had on Northwest Coast artists not only in the recent past, but also what it bodes for the future, and this is only one case among many. "In rediscovering their art the first artists of the current revival travelled throughout Canada, and in some cases the United States and western Europe in order to see the works of past masters. Having regained this record of their past, they are determined not to re-create this situation for their grandchildren."[28] The same determination has affected the Sioux, who are even making with painstaking care bladder quill-containers, quilled buffalo-horn spoons with deer designs, and old-fashioned split-horn headdresses. "They're really going to work now more than when you were here," reports dealer Cathy Vogele from Rapid City, South Dakota, "and the quality is very high."[29] Even collection catalogues of European museums have been scoured by today's Indians. The sea-wolf mask by master Northwest Coast carver Art Thompson (cat. no. 355) follows a venerable example in the Museum für Völkerkunde in Hamburg. Thompson is a mature carver steeped in the culture of his people and a major talent in his own right. His mask is an act of homage, not mere copying. Such works are not mere "imitation and learning," as a major anthropologist categorized them,[30] but are agents of internal transfer. The methods of transmission may be somewhat different today, but the principle has operated for centuries: the artist envelops himself in his culture by assuming the mantle of the old work, just as a tribal dancer "becomes" the being whose mask he wears, as he perfects his animal spirit interpretation.

The creative integration of traditional forms and modern context is tellingly personified by the kerfed (steam-bent) and painted box with a frontal wolf image by Greg Colfax (fig. no. 27 and cat. no. 352). Intrigued, perhaps more than anyone else, with what this project was trying to accomplish, Colfax devised the subject, form, and treatment of this object especially for this undertaking. In his own words: "The box deals with the theme of traditions lost and found. Traditions lost are a sad thing, and when that happens anywhere, I believe, it's a sad situation. Life's major questions can't be answered; there's a great deal of struggling. This box is both the losing and the finding, and the results of finding, which becomes a joyful event."[31]

On the back panel of the box is painted the face of a man, whose eyes are unfocused. He cannot see the whale's tail above him, nor sense the beach life (the octopus tentacle), sea, air, and land about him. He wanders in dejection, for he has lost his traditions. On the front panel he is adopted by the supernatural wolf (the major tutelary spirit of the Makah). As he rides on the wolf's back his animal mentor tells him about his traditions. They are instilled in him by the force of the ride and by the words the wolf teaches him. The striding legs of the wolf stretch over onto one of the side panels. On the other side panel the man's face is painted as seeing, for his eyes now focus, and he has discovered his traditions. Now village friends all greet him, including the dog (there is a Makah old-time dance about the village dog).

This parable of loss, redemption, and renewal, of the death and rebirth of pride and values symbolizes the most positive aspects of tradition, its role as conveyor of the dignity of life. With it, man is propelled toward self-awareness and heightened perception. No longer is he a wanderer without identity. He belongs again to his people. Greg Colfax remembers a personal transition not many years ago, "My father knew I wasn't doing very well in the white man's world and told me to come back home, and from then on I began to find myself."[32] His carved and painted box, with the great wolf spirit projecting from its front, is powerful enough to suggest the many steps along the way to knowledge, the ones he himself took to the northern rain forests and fog-shrouded beaches of Cape Flattery, in returning to his home.

Many Indians in the mid-course of their lives do not feel that the past is eradicated because newer techniques or forms are employed. "While

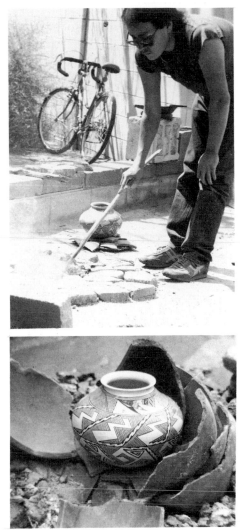

FIGURES 24 and 25
above
Nathan Begay (Hopi/Navajo), stirring the ashes before firing the pot included here (cat. no. 304).
below
Pot uncovered just after firing. Santa Fe, New Mexico, April 1984.

FIGURE 26
Greg Colfax (Makah). Sketch for a drum. 1982.
Pencil on paper, 11 x 10¼". See cat. no. 350.

many traditional techniques are still used, new techniques have been developed which are not as complicated. However, the work continues to be a fine and unique art," Canadian Great Lakes Ojibwa Mary Lou Fox Radulovich has astutely observed. "These objects make their own statement about the history, the traditions, and holistic world view of the Indian people."[33]

There is a general tendency to simplify designs and abbreviate the amount of decoration on moccasins, gun cases, and leggings, yet full-field beadwork is still made (cat. nos. 70 and 131); and despite the many small pieces produced today, modern competitive dance outfits can be of staggering complexity (fig. 28 and cat. no. 213). However, one would hardly wear such an extravagance when tending children or driving a pickup truck (where the fancy outfit or wearing blankets are packed out of sight until arrival at the dance ground area reveals the rich contents of such vehicles). For everyday use, a beaded belt buckle (cat. no. 185), or a reservation hat with feathered or beaded band (cat. no. 137) proclaims Indianness, as do a variety of other small scale objects. Miniature peyote drums, rattles, fans, and amulets hanging on rear view mirrors indicate membership in the Native American Church; beaded barrettes, key chains, jewelry accessories, beer can openers, cigarette cases and lighters (cat. no. 278) abound. There are beaded salt and pepper shakers, basketry-encased Coke and wine bottles, miniature Southwestern baskets (cat. no. 236), and tiny Algonkian splint baskets (cat. no. 18). Some of these are learning pieces; others are made for quick money or for trade; many are beautifully rendered with loving care. When I asked Flathead/Cree painter Jaune Quick-to-See Smith the reason for all this small-scale work, she replied, "We have this urge to decorate everything, to take something ordinary and make it ours, and this is one form it takes today."[34] "Making something ours" expresses particularly well the Indians' desire to put their stamp on everything they use, from the most elaborate ceremonial dress to the trivial items of everyday life.

"Those poor Indians," a patronizing Anglo once remarked, "all they can do is bead those cigarette cases and watch straps. It's not like the old days." He was wrong about everything, especially the "old days." The Sioux were beading holders for cigarette papers long before cigarette cases existed, that is, from about 1880; and many groups loom-beaded watch fobs at the turn of the century, which are now collectors items. It is in many ways more like the old days than one might at first expect.

Two authors who traveled through the Southwest some ten years ago searching for "innovative" basketry complained to a trader of their failure to find "any new exciting designs in baskets." His answer seems to suggest repression: " 'If any of my basket-makers started doing way-out baskets, I'd squash it! Look at those.' He pointed to some beautifully crafted [Navajo] traditional wedding plaques. 'Can you think of any improvement to be made on them?' "[35] Without the traditional wedding basket (see cat. no. 333), which holds the cornmeal that is prayed over and sprinkled during the ceremony, a proper Navajo wedding cannot take place. These baskets — which are also used by medicine men — are highly prized symbols of continuity, yet they have not stifled creativity. During the very time of the authors' journey, a resurgence was beginning to develop in Arizona among the Paiute basket makers of Navajo Mountain and Willow Springs, in the northwestern part of the Navajo Reservation. Old designs were being combined with new figural patterns and bright, varied colors, suggested in part by native basketry from adjacent parts of the state. Today, this innovation is an active feature of contemporary basket-making art in the Southwest. Even the wedding baskets have been freshly approached by some of the artisans, of whom there may be more than one hundred at work. Navajo Sally Black of Mexican Hat, Utah, one of the younger basket makers and one of the best now active in the United States, may be to her craft what Maria Martinez was to Pueblo pottery in the early years of this century (see cat. nos. 252–254) — at least there seems to be no end to Sally Black's creativity.

The authors who could not discover any "up-to-date" basketry did find what they considered to be a whole new breed of Indian fine artists, who "were still focusing on Indian subject matter and using Indian symbolism, but their approach was fresh, new elements from outside the Indian culture were incorporated into their work, and they were utilizing them with great sophistication and flair. In other words, they were 'doing their own thing,' and doing it very well."[36] Such an assessment goes counter to the Indian grain. "We don't go for trendy statements like 'God is dead,' " Carl Ponca observed, to

which might be added such jargon as "doing your own thing."

Significant developments often pass unnoticed by outsiders because of the elusive nature of Indians who do not bother to contradict preconceived ideas. Confusion also arises from the circumstance that many Indians, despite an innate eloquence, do not command a sufficient knowledge of English with which to inform outsiders of their concerns and intentions. "Many Indians may know a lot about tradition, but they may not know the English that expresses those perceptions and feelings," explained Grieg Arnold. "That doesn't mean that things aren't going on."[37] A tradition or a style may be undergoing revision, but it is not announced. It requires a philosopher of the stature of a John Dewey to elucidate what is actually going on: "Familiar things are absorbed and become a deposit in which the seeds or sparks of new conditions set up a turmoil. When the old has not been incorporated, the outcome is merely eccentricity. But great original artists take a tradition into themselves. They have not shunned but digested it."[38] Indians have known that reciprocating process for a long time. They also know that to survive, innovation has to be of proven tribal value. "Traditions die hard and innovation comes hard," writes Sioux activist Vine Deloria. "Indians have survived for thousands of years in all kinds of conditions. They do not fly from fad to fad seeking novelty. That is what makes them Indian."[39]

FIGURE 27
Greg Colfax (Makah), carving the kerfed box included here (cat. no. 352), Neah Bay, Washington, May 1985.

There is no built-in notion of cultural obsolescence among Indians. "Traditions fluctuate. They stop and start, go away and come back, and are even neglected. They can be resumed at any point in the circle."[40] As long as the embers still glow, culture can be rekindled. There is always potential for renewal, for flowing into continuity, something the white man often misunderstands when he makes such statements as "the last Sioux flute maker, Richard Foolbull," ignoring such present-day flute makers as Jim One Feather, or announces that "nothing has approached the sadness of the now dead craft of basket weaving,"[41] to cite only two random examples.

All that may be needed to rekindle the flame is a manual training shop in which to make flutes, or a place in which to hold a basketry class. "I've just finished teaching the coil basket-weaving class up at Lake Mendocino... and I had ten Indian students and I was really happy," said Pomo Susye Billy (fig. 29 and cat. no. 337). "In a lot of ways it seems like no one's doing it, but if you really ask around, you can find a person here and a person there that is interested. It's not in great numbers, like in the early days, but I think it is still definitely going on.... The people that are interested in it really feel that strongly."[42]

For want of appropriate tools or hand-tanned hides, an art may be lost. "I just can't get my needle through this commercial hide. I just *can't* get it through," Mescalero Apache elder Nona Blake exclaimed without preamble as I came into her house. "I *hate* this store-bought hide."[43] Mrs. Blake's fingers are no longer strong enough to push her awl quickly and easily through tough Tandy leather. This is indeed frustrating to an elder who remembers the rich, pliant, yielding buckskin she used to tan herself and for whom making things in exactly the right way is a paramount concern. Since it is a statement of what happens today, I bought her baby carrier (cat. no. 231).

Of paramount importance is keeping up the flow of quality materials, which no commercial substitutes can replace. The expanding world of Indian traditions has made startling use of many intrusive materials over the years, as, for example, the 1960s Taos Pueblo Buffalo Dance headdress fashioned from a buffalo's head in the time-honored way, in which the backing was made from a plastic Sears Roebuck infant seat — set into the mask upside-down, it made a perfect headrest.

Inexpensive and dependable sources for soft Indian-tanned hides and other native materials are needed. It takes heavy detective work and much travel through Indian North America to find exactly the right heirloom beads for contemplated work. "The trouble is to have the money on hand when you need it."[44] "I wish I knew where I could find some real tanning like the hide you gave me," said young Sioux doll maker Don Tenoso (fig. 41 and cat. no. 162), "the traders charge so much."[45] Difficulties along these lines may play a disproportionate and unfortunate role in separating the artists and artisans from the core of their culture. Part of the healing process lies in having the right materials at hand. "I had to find the exact right kind of red broadcloth to make the wearing blanket for you," said Osage Kimberly Ponca Stock (fig. 30 and cat. no. 112). "I can't find it here. My mother's bought it in Pawhuska,"[46] the Oklahoma town where suppliers know that the wearing

FIGURE 28
Rachel Bower (Flathead), wearing dance outfit
included here (cat. no. 213).

blanket of a firstborn Osage has to be red and thus keep red Spanish broadcloth on hand. When Cayuse/Nez Perce Maynard Lavadour agreed to paint his grandmother's tepee (fig. 31 and cat. no. 224), he wanted to find the right type of earthen paints to "finish it in the old way." The Santa Fe traders stocked the required pigments, but not the bright red color that is made from Oregon earth and favored by his people. So he had to use acrylics. "Something we have to live with, I guess," was his comment.[47]

Authenticity is important to tradition, as indicated by the pride of a Pueblo man who observed, "I make my drums right," i.e., hollowing out the log by hand, not with machine tools, and shaping without a lathe. However, according to Taos art teacher and craftsman Pat Trujillo (cat. no. 242), whose well-known father trained him carefully in this traditional art, lathes make good flutes.[48] Decisions in all these matters are personal, and substitution can lead to welcome innovation. There should always be room for flexibility, the harbinger of ingenuity that allows for growth.

So important is basic integrity that though no Indian languages have an equivalent word for the Euro/American term *tradition*, they usually have a single word meaning *doing things right*. "No…we don't have a word for tradition," said Pueblo dignitary Gabrielita Nave (fig. 32 and cat. no. 247), former director of Oke Oweenge, the San Juan Pueblo crafts cooperative, "but we do have words for 'old-timey' and 'done in the right way,' because these are important to us."[49]

Toward a Definition of Tradition

IN ORDER TO ARRIVE at a better understanding of what *tradition* means, I asked Carl Ponca if he would be willing to gather a group of his students at the Institute of American Indian Arts for an informal discussion of the subject. "They will all have ideas about that, and you'll get some insights, but you may also get some hostility," he warned me. "That's a very private thing to each of us. It isn't something we discuss much even among ourselves. We take it for granted. It just goes with the culture."[50] However, there was no hostility at the meeting, which took place some six months later, only interest from the twelve participants. When it was over, Carl Ponca said, "Well you have a start. Some of them want to talk to you alone because it is not their way to discuss these things in public. They're thinking about it."

The Anglo world insists on viewing tradition as an entity, as a body of information that is almost tactile, a sort of collection "handed down," as the dictionary says.[51] The Indian view is that tradition, like time, cannot be measured. It exists within everything, a sort of wholeness or allness that man touches, or establishes contact with, at every point, but particularly when he is in a ritualistic state. It is more than custom, belief, or myth. It is an essence that explains to Indians what they are psychologically. It manifests itself at different levels. Though it can be expressed, finally, by dance, ritual, or symbols, it is none of these things. It is something Indians step into in order to be themselves.

"How can we explain something that we live *within*? There is no need to explain it when you do that." Tradition was likened to dancing: "You lose perspective when you dance. You shut out even the people around you, lose the connection with the here and now, become someone else," one student offered. "When I was young," another recalled, "I thought everyone danced in the summer as we do. It never occurred to me that there are those who do not dance…. I didn't know what a white man was." Carl Ponca noted, "We always begin our summer dances with a song that repeats only four words over and over. They don't mean much of anything in English, 'young chiefs stand up.' To us those words demonstrate our pride in our lineage and our happiness in always remembering it. It is a happy song.[52] Tradition is not something you gab about…. It's in the doing, the putting on of dance clothing, for example, like the time you saw us putting on our outfits at Fairfax. You learned how we put it all on and in what order, and what you do [with the paraphernalia].[53] We know how to do this right because we have all watched as you did, only more often. You learn by watching, by being around. The minute you start studying rather than doing it, it becomes something else."[54] Another participant called tradition the process of remembering: "It is what is passed on by remembering. Memory can make things as alive today as they were yesterday."

In some ways tradition expresses a collective tribal will. It is what everyone has agreed upon to represent the tribal self-image. It is an under-

standing to which all subscribe, a distillation of the best practices derived from the past and acted out in the present. A disruptive factor is imbalance, something or someone who disturbs the understanding. Does being traditional, then, incur the possibility of being reactionary? Indian legends and myths are full of the hubris of a hero who, in the end, usually returns to balance. This is why the modern "crab syndrome"—relating the tribal member who must be pulled back into line to the crab who walks sideways—is considered a traditional mechanism for assuring communal well being.

At a symposium that had taken place a few years earlier,[55] participants more mature than the Santa Fe students addressed this question. La Donna Harris, a member of the Comanche tribe and president of Americans for Indian Opportunity, Washington, D.C., viewed the procedure as a positive one. "We discipline each other that way, keep everyone in line. If you understand the way the cultures work, you can make positive choices."[56] Clara Kidwell, a member of the Choctaw tribe and associate professor of Native American Studies at the University of California at Berkeley, expressed her conviction that "traditionalism is a sense of community of Indians." Roy Sampsel, also a Choctaw, at the time deputy assistant secretary for Indian Affairs, U.S. Department of the Interior, also felt that "ceremonialism is community experience. There is recognition of the individual by all the community participants. The group is the way individual behavior is recognized."

FIGURE 29
Susye Billy (Pomo), working on the last row of the basket included here (cat. no. 337), Hopland, California, May 1985.

More and more, whatever the age of the discussants, it became evident that the subject of tradition was uncharted ground. Just as there is no satisfactory answer to "what is an Indian?" there was no single definition of *tradition*. "If you make up a definition," Clara Kidwell noted, "it becomes a threat. Indians always know Indians; it's an energy thing."

Shortly after the Santa Fe meeting on tradition I discussed the subject at greater length with three artists: Nathan Begay, Hopi/Navajo; Greg Colfax, Makah; and Susye Billy, Pomo.

Nathan Begay (cat. no. 304 and fig. 24) had made two trips to New York City. On returning from the last, he felt ready to talk.[57] "I used to hate the whites when I was growing up because I was so negative about the Anglo school mind. Now maybe I should help them, too. It's fun here [in Santa Fe], there are no boundary lines. But that's the easy way out. Once alienation sets in, you're in trouble. But when you go back you become Indian. You get set straight. I want to farm. It's good to plant again. When I go back, I slow down. My thinking goes back to the past. I talk simply. I fit right in. Tradition is a state of mind.

"When you let tradition die, your culture dies. It can get real high, or can fade out when the pottery fades out, as it did at Sikyatki;[58] but that doesn't mean that the dances and the religion stop.

"Your tradition is 'there' always. You're flexible enough to make of it what you want. It's always with you. I pray to the old pots at the ruins and dream about making pottery. I tell them I want to learn it. We live for today, but never forget the past....

"There are some things in the past that are very important to know. To keep more you have to live by these things because they are basic. These things keep people in their own culture group. And we can also strain for new traditions so we won't all be 'Heinz 57 varieties' wandering around...."

In Neah Bay, Washington, Greg Colfax (cat. no. 350 and fig. 27) spoke while carving. "Whenever traditions are lost it's a sad thing. Traditions are important because they answer your major questions of life.... If those questions can't be answered there is a great deal of struggling. Finding traditions is a joyful event. When you have a tradition to fall back upon, you can answer those problems....

"Our job as artists is to go beyond, which implies a love of change, [always accomplished with] traditions in mind, by talking to the elders of the tribe and by being with your grandparents. The stories they tell are just amazing. When you become exposed to them, everything becomes a reflection of those events. There's a great deal of satisfaction being an artist of traditions."[59]

The "love of change" mentioned by Colfax refers to artistic development and does not involve breaking with tradition. It suggests awakening perceptual awareness and parallels John Dewey's view, cited above, that great artists do not shun tradition, but digest it. In digesting tradition, the Indian artist preserves it in order to pass it on, as Greg Colfax intends to do with his children: "When I started working with an adze it got to the point where they

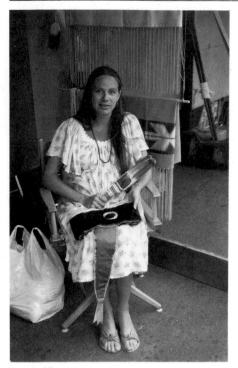

FIGURE 30
Kimberly Ponca Stock (Osage), at her booth at the Indian Market, Santa Fe, New Mexico, August 1983, with turban included here (cat. no. 113) on her lap.

started picking up the adze and working on things.... Pretty soon, when they're ready enough to handle an adze, strong enough, they can rough the stuff out and start to carve. This is something that a lot of children in Neah Bay experience with their grandparents and with some of their parents who are involved with the art work."

A sense of mission brought basket maker Susye Billy (cat. no. 337 and fig. 29) back to live among her people after a life away from them in North Dakota and Virginia. "I think it's really important for me to help maintain the culture as much as we can, so that it's not forgotten and lost; and so that we can pass this information on to our children.... My grandmother was a very fine weaver, and we had quite a few of her baskets when I was growing up, and I would always look at these baskets and ask my father, 'What are the materials? How were they started? How did she do this?' And he would always tell me, 'I'm not a weaver. Someday we can go back to our people and maybe there'll be someone that can teach you there.'...

"So I came and moved... into my grandmother's old house. It had been vacant for about five years ... no one had lived there since she passed on.... When I appeared at her [great-aunt's] doorstep and told her that I was interested in learning the weaving, she said, 'Well, that's very interesting. I started a class yesterday and no one came, and the next class is tomorrow, so you can come and it will really be the first class.'

"I sat at her feet for five years and studied with her every day. And as I began to learn about the basket weaving I realized that I couldn't separate it from learning the traditions and the customs, the religion, all their way of living, their whole life-style. And I realized that all these things went together, that you couldn't just learn one part, that they overlapped.... To me the traditional techniques have a power of their own, something that I can't understand, and it gives me a link to my ancestors.

"When I [first] arrived my great-aunt [Elsie Allen] held her hand out and handed me this awl and this knife, and said, 'They were your grandmother's and I wanted to give them to you.' At that moment I had, like, this magic that was given to me, and my grandmother's spirit was passed on to me.... This chair belonged to my grandmother. When I sit in it, I feel her energy, and I feel her spirit smiling on me and with me when I'm working.

"From the very beginning Elsie was amazed and would tell me, 'It really seems like you're just carrying on where your grandmother left off....' I did not start to do this for financial gain, and after I had been weaving for a while, I realized that this was actually a spiritual path for me, which was a complete surprise, because it had never occurred to me. Through the basketry I feel I have made connections with something very ancient within myself and from my people."[60]

The Core of Tradition

WHILE ALL THE things that Indians have said in this chapter about tradition are very important, not one of them tells us what tradition actually is. They know it exists, they believe they live within it, but they do not say what it is. Paul Wingert, historian of American Indian art, treated tradition as style: "The fundamental way in which an art tradition is manifested, through its forms and designs, is a singular development, and because this is true it is possible to isolate and to characterize the distinctive artistic features of a specific geographical area."[61] This is typical of the Western mind, which isolates into formal components what Indians consider to be an all-encompassing whole. Indians may talk about technique, methods, quality, they never mention style. If tradition is the "connections with something very ancient within myself and my people" that Susye Billy feels, then it is utterly divorced from the specific. What is being suggested here is an ethos larger than style, existing beyond intellect, what Greg Colfax referred to as "going beyond."

Only one entity is sufficiently vast and permanent to relate to the unstated Native American concept of tradition: nature. This is not nature limited to its physical forms and environmental cycles, but nature viewed as a force that cannot be transgressed if man is to survive. Actions contrary to the laws of nature engender disruption. So in song, dance, and the concomitant arts, Indians sought harmony with the seasons, the sun, the cycles of growth, decay, and renewal of which they are part. They proposed to establish an exquisite harmony between their own existence and nature's round. While the white man seeks to dominate nature, the Indian seeks to live with nature. The Indian mindful of tradition seeks to "center himself" in the balance of nature,

which extends outward in ever-widening circles from family, to clan, to surrounding tribes, and to the directional limits, where the sky takes over, and to the stars beyond. He seeks congruity with these circles of power and sacredness, which are boundless.

At the Santa Fe meeting on tradition one of the participants had hurriedly scrawled on a scrap of paper, "There is no time in space. It's only there to help us organize our minds." There is an order to the rhythms of nature, as Indian astronomeres knew long ago as they watched for the solstices from their medicine wheels, like the one on Medicine Mountain in Wyoming to which the sun returns every year. There is water, ever changing but changeless; the sky, forever fixed by an agent of change; the sun and the moon, each rising and setting every day—all the inexorable rhythms, always returning, always remaining. This is the reassurance, the comfort, that spiritually minded Indians derive from their traditions today. "Whites think of our existence as the past," one of the students at the meeting on tradition observed, "we know it is right here with us."

Indian tradition is the symbiosis between man and nature. That is the core of tradition, unstated though it may be. All kinds of empathic relationships have been developed by Indians between themselves and nature, and they still operate today. Ceremonies establish and renew the relationships. Culture is its summation, and propiation is its long established means. It ignores time in favor of continuity. It is not intellect, but heart. Indian tradition has much to teach a technological world about living in balance with natural forces.

FIGURE 31
Maynard Lavadour (Cayuse/Nez Perce). Sketch for tepee decoration. 1984. Felt marker on paper, 6⅛ x 3¾". See cat. no. 224.

NOTES

1. *Webster's Ninth New Collegiate Dictionary* (Springfield, Mass.: Merriam-Webster, 1983).
2. Adelphena Logan, *Memories of Sweet Grass*, American Indian Archaeological Institute (Washington, Conn.: Shiver Mountain Press, 1979), p. 3.
3. Conversation with the author, May 1985.
4. Norman Tait to the author, at the time of the National Native Indian Artists' Symposium, Hazelton, British Columbia, August 25–30, 1983.
5. George R. Stewart, *Man, An Autobiography* (New York: Random House, 1946), p. 179.
6. Comment made by a student at the Institute of American Indian Arts in Santa Fe during a special meeting held there, at the author's request, at which the students discussed their concept of tradition. Moderated by Osage Carl Ponca, a member of the faculty, it took place on an evening in April 1985. All footnotes noted as "I.A.I.A. Meeting on Tradition" refer to remarks made during the course of the meeting, which lasted about two hours, and the subsequent social hour, which lasted until early the next morning.
7. *Citizens Plus: The Nishga People of the Nass River in Northern British Columbia* (Brompton, Ont.: Charters Publishing, [ca. 1976–77]), p. 4.
8. To cite only two examples concerned with basket making: *Basic Iroquois Splint Basketry*, research by Louise Thompson, photography by Joel Johnson (Cornwall, Ont.: North American Indian Traveling College, n.d.); and *Baskets of the Dawnland People* (Pleasant Point, Me.: Bilingual Education Program [ca. 1980]).
9. David Gidmark, *The Indian Crafts of William and Mary Commanda* (Toronto-Montreal: McGraw-Hill Ryerson, 1980).
10. Student participant, I.A.I.A. Meeting on Tradition. For an example of the use of ethnological material by a Haida artist of the Northwest Coast, see catalogue number 368.
11. Pat Ferrero (producer/director), *Hopi: Songs of the Fourth World* (San Francisco: Ferrero Films, 1983).
12. Conversation with the author at Neah Bay, May 1985. The reinstitution of this ceremony was only a glimmer when I first visited Neah Bay in 1982.
13. Nettie Kuneki, Elsie Thomas, and Marie Slokish, *The Heritage of Klikitat Basketry* (Portland: Oregon Historical Society, 1982), pp. 11, 15.
14. Conversation with the author at the Colorado River Indian Tribes Museum, Parker, Arizona, February 1984, where she was demonstrating basketry.
15. John Kania, Santa Fe dealer in Indian art, to author, March 1985.
16. I.A.I.A. Meeting on Tradition.
17. Conversation with the author, December 1984.
18. Chuck Dailey, "The Younger Generation," *Official Indian Market Program* (Santa Fe: Southwestern Association on Indian Affairs, 1983), p. 42. To my knowledge, Dailey is the only person intimately connected with the advancement of contemporary Indian arts who has stressed balance as integral to the modern Indian aesthetic.
19. Carl Ponca, at I.A.I.A. Meeting on Tradition.
20. A participant at the I.A.I.A. Meeting on Traditon.
21. A. L. Kroeber, *Anthropology: Race, Language, Culture, Prehistory* (New York: Harcourt, Brace, 1948), p. 411.
22. Greg Colfax, Neah Bay, Washington, May 1985, from the sound track of the film made to accompany this project, directed by Alvin Siskind and produced under the auspices of Corporate Communications, American Can Company.
23. Carl Ponca at I.A.I.A. Meeting on Tradition.

FIGURE 32
Gabrielita Nave (Pueblo), maker of the embroidered manta included here (cat. no. 247), San Juan Pueblo, New Mexico, spring 1984.

24. Agnes Vanderberg to the author, Flathead culture camp, Arlee, Montana, August 1982.

25. Mary Lou Fox Radulovich, director of the Ojibwa Cultural Foundation, Manitoulin Island, Ontario, to the author, September 1982.

26. Conversation with the author, Santa Fe, New Mexico, May 1985.

27. Colfax, op. cit. He is referring to the Makah Museum at Neah Bay and its director, Grieg Arnold.

28. Dawn Hassett, Foreword in *Arts of the Salmon People*, exhibition catalogue (Prince Rupert, B.C.: Museum of Northern British Columbia, 1981), p. 4.

29. Telephone conversation with the author, May 1985, reporting the developments that had taken place over a three-year period.

30. Kroeber, op.cit., p. 557.

31. Colfax, op. cit.

32. Conversation with the author, August 1982.

33. Mary Lou Fox Radulovich, Foreword in *From Our Hands: An Exhibition of Native Hand Crafts*, exhibition catalogue (Toronto, Ont.: Art Gallery at Harbourfront), 1982.

34. Conversation with the author, Santa Fe, New Mexico, October 1984.

35. Guy and Doris Monthan, *Art and Indian Individualists: The Art of Seventeen Contemporary Southwestern Artists and Craftsmen* (Flagstaff, Ariz.: Northland Press, 1975), pp. xv–xvi.

36. Ibid., p. xiii.

37. Conversation with the author, Makah Museum, Neah Bay, Washington, May 1985, in response to my mentioning the eloquence with which Greg Colfax had expressed himself on tradition while he was being filmed (see note 22).

38. John Dewey, *Art as Experience* (New York: Minton, Balch, 1934), p. 159.

39. Vine Deloria, Jr., *Custer Died for Your Sins: An Indian Manifesto* (New York: Macmillan, 1969), p. 16.

40. Carl Ponca, I.A.I.A. Meeting on Tradition.

41. See Joseph H. Cash, *The Sioux People* (Phoenix, Ariz.: Indian Tribal Series, 1971), illustration opposite p. 82; and "The Dead Art of Basketry," *Art Talk* (Scottsdale, Ariz.), vol. 3, no. 6 (March 1985), p. 6. For a far more creative assessment of contemporary Southwestern basketry, see Barbara Mauldin, *Traditions in Transition*, Laboratory of Anthropology (Santa Fe: Museum of New Mexico, 1984).

42. Susye Billy speaking of her first basketry class, Hopland, California, May 1985; from the sound track of the film made to accompany this project (see note 22).

43. Nona Blake to author, Mescalero, New Mexico, April 1984.

44. Joyce Growing Thunder Fogarty (cat. nos. 165–167), to author, Taos, New Mexico, spring 1984, speaking about always finding desirable old heirloom beads for sale when you only have enough cash to buy a few of them, "not enough for what you want." Similar comments were echoed many times in Indian country.

45. Conversation with the author, Santa Fe, New Mexico, February 1985.

46. Conversation with the author, Kansas City, Missouri, fall 1979.

47. Conversation with the author, Santa Fe, New Mexico, December 1984.

48. Conversation with the author, Taos Pueblo, New Mexico, April 1984.

49. Conversation with the author, San Juan Pueblo, New Mexico, fall 1984.

50. Conversation with the author, Santa Fe, New Mexico, October 1984.

51. For the dictionary definition of *tradition*, see the opening page of this chapter.

52. Here Carl Ponca is talking about the annual dances of his tribe, the Osage, which are always held in June on three successive weekends at the three Osage settlements, Pawhuska, Fairfax, and Hominy, Oklahoma.

53. Here Carl Ponca is referring to my attending the Fairfax Osage dances in 1981 at his invitation. At that time, I watched him and a friend, Henry Lookout, don their ceremonial dress.

54. Another example of the reaffirmation of traditions by actions occurred when Elaine Brave Bull showed me her mother's eagle-star quilt (cat. no. 132) at Cannon Ball, North Dakota, in 1982, when she said, "It's all in the making," linking the idea of *watching* to *technique*.

55. *Indian America: Past, Present, and Future*, Aspen Institute seminar, held June 27–July 10, 1982, at Crestone, Colorado. The remarks that follow are from notes made by the author, who was one of the participants.

56. However, another pariticipant, David Harrison, a member of the Osage tribe and a lawyer in the Washington, D.C. area, who has had wide experience with Indian law, believes Indians have social conflicts to deal with, which "were always there, even before Columbus came here."

57. What follows are excerpts of a conversation between the author and Nathan Begay, which took place at the latter's home, Santa Fe, New Mexico, May 1985. Begay's comments on farming and planting are oblique references to Hopi dances and ceremonialism in general.

58. Here Nathan Begay is referring to a distinct and artistically important type of late prehistoric pottery which twentieth-century Hopi potters, beginning with Nampeyo at the turn of the century, have studied as sources of inspiration.

59. These remarks by Greg Colfax are adapted from the sound track of the film made to accompany this project (see note 22).

60. Susye Billy, Hopland, California, May 1985; from the sound track of the film made to accompany this project (see note 22).

61. Paul Wingert, *Primitive Art: Its Tradition and Styles* (New York: Oxford University Press, 1962), p. 77. This is an excellent comment on the constituents of a style, but tradition extends beyond these elements. Magnifying the formal elements of art into the sole carriers of tradition is a Western, not an Indian, conception.

V

THE NON-VANISHING INDIAN

THE ARTISTIC SURVIVAL SO PROMINENTLY INDICATED BY THE works shown on these pages underscores the tragedy of what has been lost since the early years of this century when large-scale collecting by major anthropological institutions largely ceased, except for the effort continued in some measure by the museums in the Southwest and by the Indian Arts and Crafts Board in Washington, D.C.[1] In the years since this project began, Canadian museums have brought their holdings of Northwest Coast art up to date, but the focus overall remains distinctly embedded in the past. This is due in no small part to collectors who prize only the old pieces infused with the patina of bygone years, overlooking the fact that age does not necessarily guarantee quality.

There are many old examples of types of objects shown here which are inferior to those produced during the last two decades. While one naturally admires the venerable work, these classics should not prevent us from treasuring recent contributions. There is beauty in new materials lovingly manipulated. There is a pliant freshness in newly worked birchbark, young sweet grass is redolent with the fragrance of early morning dew, recently hand-tanned buckskin is soft and velvety to the touch, smoked moosehide emits the aroma of woods—until, with age, it all disappears. These sensual pleasures, all absent from encased museum specimens, are an integral part of the Indian aesthetic. Young Choctaw Marcus Amerman admits it. "When I make a bone breastplate, the clean texture of the bone [hair pipes] and the shininess of the new beads fascinates me."[2] In sum, an impression of cultural depletion has been conveyed far in excess of what has actually occurred. "Why," asks Crow student Kitty Bell Deernose, "do they always look backward in judging us, when we have been working right along?"[3]

The answer lies partly with the myth of the vanishing Indian. We have never divested ourselves of this nineteenth-century view which cast the Indian in the role of the dying swan of the period. Along with the vanishing frontier, westward expansion, and the growth of cities came the vanishing Indian. Implied in the novels of James Fenimore Cooper, formalized by Nathaniel Hawthorne, Francis Parkman, Walt Whitman, and many others was a hopeless situation from which there was no escape. The idea of annihilation seemed confirmed by the near extermination of the buffalo and the unhorsing of the Plains Indian during the 1870s. It received definitive embodiment in Edward Curtis's photograph of a file of Navajo Indians riding into a dark defile of the Canyon de Chelly entitled *The Vanishing Race* (fig. 33).[4] The photograph was excellent theater, but it is not an apt image of the Indian of today. Ironically, today's Navajo have "returned" and have achieved the largest population of any tribe in North America. The present number of Indians on this continent is probably at least what it was in Columbus's time, despite the wholesale loss of tribes. It is time to dispense with the myth of the extinct Indian and deal with him realistically as a survivor—a miraculous survival considering what Western civilization inflicted. "We've been vanishing for centuries now," one Indian observed, "maybe you ought to get used to us being around for a lot longer."[5]

FIGURE 33
Edward S. Curtis. *The Vanishing Race—Navaho.*
© 1904. Platinum print, 5⅞ x 7¹³⁄₁₆″. Collection
Van Deren Coke, San Francisco.

The notion that Indian society today represents values of character
and family unity which our goal-oriented Western society is losing is usually
ignored, as being beyond comprehension. Given the depressed state of the
Indian peoples in comparison with their former, freer lives, it is remarkable
how much of their philosophy and ways remain. Poverty and unemployment
aside, today's Indians seem spiritually unconquered. The manifestations of
that endurance punctuate this project, offering a spiritual anagram to Western
materialistic illusionism. As someone justly pointed out at a conference in Brit-
ish Columbia, "We've only been sleeping, we're not dead."[6]

IT IS MUCH MORE DIFFICULT to reach hard and fast conclusions about the occur-
rence of art among Indian tribes than one would suppose. It is one thing to
contemplate quietly a carefully collated group of illustrations in a book and
draw conclusions, or to arrange systematically a group of museum objects
with a view to proving a point. It is quite another thing to come across living
art in the field. The process of discovery is not scientific. Occurrence and hap-
pening are paramount. Objects and capabilities may be there, but they are
hidden. What does not surface on one visit to a reservation may be there on a
future occasion. Conversely, what is seen one time may have vanished the
next, not to be encountered again. In these highly mobile times, Indians come
and go on and off their lands, and what they make moves with the same
speed. Though today's pace is faster, it makes one wonder about the thor-
oughness of the collecting conditions in buffalo days or earlier times. What
did all those explorers miss? There is no time to ponder. An instantaneous
sense of recognition is required to notice an elkhorn scraper (cat. no. 181) on a
trader's crowded tray, spot an elder's cane (cat. no. 241) on a Taos Pueblo wall,
or to realize that the tracing paper being worked up by two women bent over a
table in a Mille Lacs museum (cat. no. 71) in two or three years time will be a
complete bandolier bag, a "museum piece."

Today we pass conclusive judgment on what surely was often a
matter of chance. The gathering of objects and establishing dates can be frus-
trating and at times exasperating, but overall it is an experience that retains the
sense of discovery it must have afforded a George Catlin or Karl Bodmer. But
my case was a voyage of rediscovery after drastic upheaval. True, conditions
have changed, as Indians on numerous occasions point out. However, much
that has passed from Indian tradition probably would have disappeared with
the passage of time. Nothing remains forever except, hopefully, the ethos.
Prestige objects current in one period may be obsolete by the next. This pro-
cess of obsolescence and renewal must have taken place countless times in the
Indian past. Since no one recorded the disappearance, we are all too ready to
assume that subsequent productions are totally negative in their import. Actu-
ally they are part of the process of ensuring continuity. The decorated water

buckets of the peyote religion (cat. no. 302), all of them the product of the last few years, are a case in point. They could never have been envisioned in the nineteenth century, for there was no such thing as the Native American Church. There are items being made by Indians today—whole outfits, whistles and flutes, beaded belt buckles, car ornaments, beaded tennis shoes and buckskin caps, and miniatures of all sorts—that proclaim how the Indians are enlarging the scope of their traditions in the light of today. These innovations exist side by side with continuations and revivals of archetypal work of the past. Too recent to be treasured today, these new objects are, indeed, the artifacts that will be treasured tomorrow as traditional.

Works that have come to be associated with the total art history of a tribe may actually be the products of a short time in tribal existence, a fact conveniently overlooked in formulating historical assessments. Prejudging a given situation by outward appearances can be misleading at any time. One early historian of the Ojibwa believed that it was imperative that he record all that he could salvage of this tribe before its culture was totally extinguished.[7] He wrote not only before many of the Ojibwa birchbark scrolls of the Grand Medicine Lodge were even made, but also at a time when that archetype of Ojibwa culture, the large shoulder bag, had yet to appear. Despite all the melancholia surrounding the "vanishing Indian," even that subscribed to by Indians themselves, persistence has consistently generated renewed response to the traditional values of life.

Forms thought to have been abandoned long ago unexpectedly appear, disappointing our categorical acceptance of "dead" or "dying" Indian arts. Bone awls or scrapers, rattles and masks are being made today in a form closely similar to those made centuries ago, just as feather- and rabbit-skin cloaks, among the most ancient forms of Southwestern artistry, are still being made by one or two Pueblo women today.[8] Any form considered dormant may reappear at any moment. A current possible candidate for revival is the Eastern potato stamped or freehand-painted splint basket. As the many examples in this project attest, fine splint baskets are still being made in appreciable quantity, if not over the entire geographical spread of former times, and the old stamping technology is as simple as it is easily accessible. Any one Indian artistic production is too complex to fit into fixed categories of rise and decline. What seems gone will receive new life if there is a need.

A Dynamic Balance

THERE ARE OVER ONE HUNDRED BASKET MAKERS working on the Northwest Coast today.[9] Across the continent, over seventy-two Iroquois basket makers are presently at work in the United States and Canada.[10] A century ago there were perhaps three to five times as many in each area. Here numbers can be particularly misleading, since a wood carver may abandon his craft to take up fishing, or a basket maker may turn her interest to linguistics (cat. nos. 16, 17) and may or may not return to the practice of her art. Similarly, a wood worker may turn for a while to leather work, or a painter to making cradles. Certainly, the incidence of any one category of art is generally less than in the past, but there are exceptions, such as argillite carving (Haida), which has undergone a renaissance, or quilting (Plains, Plateau, and the Southeast), a relatively recent art that is much used today in the presenting of "giveaways." Where once quantities were produced, now only a small number of objects may be made. Use is obviously a decisive factor. Denim jeans have replaced trade cloth leggings, let alone buckskin ones; moccasins are for ceremonial, not daily, use; beaded cigarette lighters sell more readily than beaded vests or shirts and are easier to make. Long gone are the days when the tanning of hides was a daily commonplace. Home-tanned hides are so expensive that the better ones are often prohibitive in price, especially for a young artisan. Sometimes quality tanning is no longer done by Indians, but by whites who work for them, as, for example, the German woman at Golden Lake Reserve, Ontario (cat. nos. 31, 32).

Often commercial substitutions have to be made, for native materials are appreciably more difficult to obtain today. River brakes increasingly bow to pollution in the Southeast, requiring basket makers to travel in order to gather their materials. Narragansett twined-bag weaver Ella Seketau (fig. 35 and cat. no. 24) has to import her native hemp from Italy, for in America she would be harvesting marijuana. While another material, a special bulrush, still grows in her area, the small quantities are not worth the effort expended to gather it. This negative aspect of environmental loss is often balanced by an

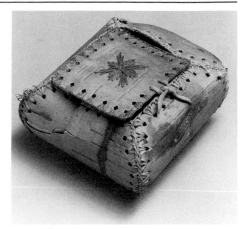

FIGURE 34
Birchbark box (Ojibwa), probably from Grand Portage Reservation, Minnesota, early 1900s. Prototype for the box made by Wabuse (Ojibwa). See cat. no. 77.

ingenuity that enlarges the repertory of design and color. All sorts of found objects are incorporated into the Indian technology in a way that defeats Western logic. A woman's multi-colored striped belt converts into a "rainbow" headband for a Cochiti Pueblo headdress (cat. no. 269 and fig. 37). Dental floss has been found to be stronger than sinew and is often used in combination with real sinew in sewing contemporary Plains moccasins. A plastic-handled feather duster from the supermarket is dismantled to provide brightly dyed feather attachments for a Plains object. Or a Sears Roebuck infant seat can serve as the headrest of a Buffalo Dance headdress.

Modern demands on time are an enemy of contemporary/traditional art. The intrusion of Europeanized life-styles encroaches on time formerly reserved for crafts, and it takes stout determination to go into the woods to gather materials in proper sequence. Even acquiring the requisite knowledge and geography takes time that many Indians now begrudge. Although her spirit lives on in her grandniece Susye Billy (see ch. 4), Elsie Allen's affinity with the natural world that provided her materials is rare today: "She watched the sky and also felt the sky, its changing moods and its signs of what was coming, so that she knew by the literal feel of the air, something reaching into her inner being, that now was a good time to make a trip to the eastern mountains to collect the reddish bark of the Redbud Tree, a bark that could be made into strips and used to weave beautiful red designs onto the sides of baskets."[11]

There are indications that in the last few years the Indian traditional artistic structure, taken as a whole, has stabilized. There are more craft classes, more carvers, more people learning to tan, more singers, more dancing, more sweat lodge ceremonies, all necessary to the art community. The proportion of interest enlarges or diminishes according to circumstance, from a paucity to a comfortable amount. Certain areas are burgeoning (Northwest Coast). Others are equitably holding their own (the Minnesota Ojibwa, many parts of the Plains). Some have retrenched into specialty arts (Seminole patchwork, the basket-making Micmac of Maria Reserve, see cat. no. 12). Some cultures are endangered and in need of support programs, which do not seem to be forthcoming (Northeast). The situation in Southern California is not a happy one. The Indians of Northern California (Hoopa and Karok) are discovering themselves (see cat. no. 336); still others are atttempting to do so (Southern New England). And, of course, there are those who never lost self-confidence (the Iroquois of New York State and Canada).

The Southwest is a case apart, a positive continuum, connected to an immemorial past by a stable present. Here, artistic continuity leads from strength to strength, and this is not limited to pottery, weaving, and jewelry. One creative group are the basket-making women of Dulce, New Mexico (Jicarilla Apache), who are not only making old-fashioned piñon pitch ollas, but are also recapturing natural dyes, under the aegis of Lydia Pesata (cat. no. 230). But even in this bastion there are intrusions. "The younger ones are content with the identity rather than the exact and proper making of the right ways," says Cochiti painter and feather dealer Joe Herrera (fig. 37 and cat. no. 269). Commercialization has become a quantitative problem. Kiln firing of ceramics now competes with dung firing—an unfortunate tendency. These are adjustments of degree rather than kind. So well established and publicized are the arts of the Southwest Indians, that they overshadow the achievements of other areas, a prejudice that should be adjusted, for Indian creativity is geographically widespread and knows no bounds.

There are as many examples of cross-cultural fertilization today as there were in the past. The most sought after fancy dress Osage trailers are made by the Pawnee (see ch. 1 and cat. no. 115). The large Pima basket from southern Arizona (cat. no. 321) woven with a beetle design—actually "warriors marching out" — that was borrowed from another desert tribe, the Chemehuevi, is truly stunning and authentic in every respect. The early work of Mitchell Zephier (cat. no. 143), the most notable Northern Plains silversmith, shows Southwestern influence. Southern Plains jewelry and modern Oklahoma Cherokee silver have also looked to the Southwest. Influence also travels in the opposite direction. The Alamo Navajo now make a type of bracelet with Oklahoma pink mussel shell that recalls the Cherokee bracelet by Craig Crider (cat. no. 62) collected at Tahlequah, Oklahoma. Cross-cultural fertilization is not necessarily a one-way street, though there can be no mistaking the seminal impact of Southwestern art in our times.[12]

Whites have integrated into the native cultures by marriage or trad-

ing. At the Sarsi powwow on the edge of Calgary, a white girl was tanning and beading while her Indian husband quilled and directed their endeavor. He was not a Plains Indian, but originally from near Manitoulin Island. "I didn't want to do those [Ojibwa] boxes," he explained, "so I came out here to quill the Plains way" (cat. nos. 199–201). The rain sash received as part of the San Juan Pueblo Deer Dance outfit (cat. no. 246) assembled by Gabrielita Nave turned out to be the work of Joyce Ortiz, a non-Indian who married into the San Juan Pueblo, who is also responsible for the authentic crocheted leggings included here (cat. no. 248). Laura Parkey, the Ottawa box maker (cat. no. 91), is white. That does not render her work less Indian, let alone that of her son Bernard, to whom she has passed on her skills. Makah sculptor Greg Colfax's wife, Linda, another non-Indian, is one of the most skilled young basket weavers at Neah Bay. A number of distinguished white artists have made a valid contribution to the continuance of Northwest Coast art: a Chilkat dancing blanket woven by Cheryl Samuel, a white student of these textiles, is sufficiently "authentic" to be proudly danced at a Kitwáncool feast by Tony Hunt, a member of the famous Kwagiutl carving family (cat. nos. 358, 359, 361).

Modern life has also altered the sex division of traditional work. "I know the beading and skin work I do used only to be done by the women, but that doesn't bother me a bit. I'm still an Indian man," smiles Cayuse/Nez Perce Maynard Lavadour (cat. nos. 222, 223). "It doesn't really matter as long as the culture is continued."[13] Ramona Sakiestewa, a Hopi weaver, does work that competes with the best old work, which was woven exclusively by men, and usually still is. Northwest Coast women artists have been influential; Frieda Dreising (Haida), Doreen Jensen (Gitksan), Dale Campbell (Tlingit/Tahltan), among others, would not have carved in the old days. Strict sex differentiation patterns began to break up in the 1940s when Popovi Da, son of the famous Maria Martinez, became acknowledged as a great potter. Today, the black-on-black pottery tradition of San Ildefonso Pueblo, created by Maria and her husband, Julian, and continued by Popovi (who died in 1971), is carried on by both male and female members of the family. The work of two young male members of this pueblo, Russell Sanchez (cat. nos. 252, 253) and Juan Tafoya (cat. no. 254), is included here. In their hands a great inheritance continues and is today a shared lingua franca—a symbol of Indianness at large.

Many of today's modern Indian painters and sculptors are also adept at traditional techniques and can switch from one mode to the other without losing sense of their own tradition. An example of this shifting is the Hunters Dance headdress by Cochiti Joe Herrera (cat. no. 269) which he danced before selling it to me. To the world at large, Joe Herrera is known as a painter. To Indians he is known as a feather dealer and dance leader, a serious Indian generalist: "I don't see any problem."[14] Kimberly Ponca Stock, who made the Osage wearing blanket (cat. no. 112), is a teacher of fiber at the Institute of American Indian Arts in Santa Fe and can weave in Bauhaus style. She has also helped design sets for the Santa Fe Opera. That doesn't make her "any less proud to be a member of the Osage tribe."[15] Mark Montour, who made a Mohawk cradle second to no other (cat. no. 39), except that it is new, is a painter. There need be no prohibition about such duality. The younger people work easily in both worlds. It is the outsider, not the Indian, who is adamantly purist. Stark purity is not the true nature of tradition's path. It is the white world, not the Indian, that expects an artist to practice *either* modern *or* traditional, never both. What outsiders frequently misunderstand is the fact that Indian artistic traditions have always been capacious enough to absorb much from the outside without losing their integrity.

If there is an overall characteristic that stamps contemporary/traditional work, it is a tendency to simplify. Designs are less continuous. There is less overall effect. Full-field beading is done only by those determined to do important work. Even then, the larger sizes of beads, which are easier to work, predominate. While many of the items included here are by older craft artists, there is also extremely careful work done by younger practitioners, particularly those who have been taught well. The magnificently beaded outfits by Regina Brave Bull (cat. nos. 128–131), Minnie Watson and Agnes Parker (cat. no. 189), Rachel Bower (cat. no. 213), Ruth Baldwin (cat. no. 107), and Joyce Growing Thunder Fogarty (cat. nos. 165–167) convey the Indian late-nineteenth-century aesthetic in all its magnificence. These works, and many others collected in the field, demand our respect because they are by Indians who have not ceded their cultures to the forces of gigantic pressures exerted from without.

FIGURE 36
Herman Charlie (Navajo), with some of his jewelry punches, Church Rock, New Mexico, September 1984. See cat. nos. 295–297.

FIGURE 37
Joe Herrera (Cochiti Pueblo), adjusting his dance headdress (cat. no. 269), Santa Fe, New Mexico, May 1985.

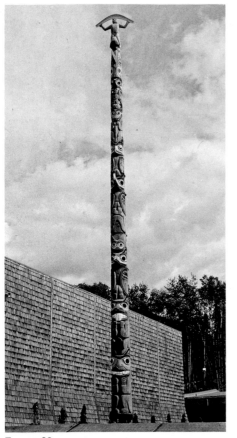

Survival

IN OUR CENTURY Indians have managed to survive forced assimilation, political reorganization, economic exploitation, and, most insidious of all, termination. Now, part way into the age of federally sponsored self-determination, they are struggling to cope with their own brands of politics. These range from the big-business aspects of the entrenched Navajo to the miniature government of the newly recognized Narragansett. In between are numerous middle-sized tribes, as the Caddo of Oklahoma, who settled down after a pre-election brou-haha involving missing voter registration records and elected as their chief Henry Shemayme, described by the tribal newspaper as a man who was bringing business sense and traditional ways to his position (and to whom this project owes the acquisition of the Caddo hair tie, cat. no. 116).

Over all Indian nations of the United States lies the shadow of the biggest bureaucracy of all, the federal government, exercising its power through the aegis of the Bureau of Indian Affairs of the Department of the Interior. Though the creation of the Alaskan Indian and Eskimo corporations appears to be an innovative part of self-determination federal policy, even here there is a possible spanner in the works. In 1992 the shareholders of these native-owned corporations—controlling untold wealth in natural resources—will vote on whether they wish to hold or divest themselves of their stock holdings. At that time, outside interests may have an opportunity to invest in these companies, opening a Pandora's box of eventual liquidation of Indian interests. "Use it or lose it," says Jerry Brown, Kenai Indian and head of one of the corporations, "there is no consideration of our indigenous rights as First People."[16]

Today the First People are determined to hold out against land grabs, or usurpation of water, land, and fishing rights. Industry is coming to terms with the natural resources on Indian lands, producing a measure of tribal wealth. In turn, some tribes have become capitalists, building resorts on their land, or owning industries outright. Ben Gray Hawk at Fort Peck Reservation, Montana, alternates between his superintendency of operations at A. & S. [Assiniboine-Sioux] Industries and his role as powwow master of ceremonies and Badland singer. Like Henry Shemayme, he is at once traditionalist and businessman.

Many tribes print newspapers with detailed stories on local and pan-tribal events. The *Lakota Times* (Martin, South Dakota) and also the *Navajo Times* (Window Rock, Arizona) publish daily, others are issued weekly. Many tribes maintain their own radio stations. There is a thriving Indian record industry; Indian House Records and Cassettes at Taos has more than eighty recordings of traditional Indian songs and music in its fall 1984 catalogue. Indians have these ways, along with the abundant ceremonials, celebrations, and spiritual meetings to keep in touch with each other.

Tribes are being helped to permanence by the composing of tribal histories and archives. The Navajo nation has its own press with serious monographs to its credit. The Iroquois now have a thick arts directory, the most complete of its kind.[17] In some cases tribal records are computerized. Research methods once the monopoly of anthropologists are now used by Indians themselves, following the lead of San Juan Pueblo anthropologist Alfonso Ortiz. Indians, in fact, have learned to use non-Indian anthropologists; Margaret Hardin, now at the Los Angeles County Museum of Natural History, was previously employed by the Zuni Pueblo school system as a programmer (see cat. nos. 280 and 281). Federal preservation funds have been tapped for reconstruction and stabilization work now being carried out at Acoma Pueblo, an ingenious solution to the specter of Indian unemployment. At San Ildefonso Pueblo, local funds are restoring the house of Maria Martinez, which began to fall into neglect after her death in 1980. The cause of preservation is not always well served. Old Osage tribal buildings at Pawhuska, Oklahoma, were recently lost, but such indifference has long been bestowed by the dominant culture even upon its own history.

When Hopi/Navajo potter Nathan Begay (cat. no. 304) returned home after a trip East he was distressed to find that "you could look through the windows and see the dancing going on, but the children were ignoring this, sprawled on the floor glued to the TV."[18] There are, of course, many distractions that, if carried too far, could drastically interfere with traditional values. However, all is not lost simply because the television set is turned on. The Winnebago cradle (cat. no. 98) was worked on while its weaver Christine Hall watched television. Sioux doll maker Don Tenoso (fig. 41 and cat. no. 162)

works in front of his set. When Kwagiutl carver Tony Hunt is not carving, he watches the World Series on television. Even that inveterate traditionalist Joyce Fogarty often beads while traveling in the family pickup with the radio at full blast. "It doesn't interfere at all," she says, looking up from her work, "I'm still Indian."[19]

Certain art museums and galleries have touted recent Indian painting as a new art form that was raised over the ashes of the old, about 1965. "Within the last two decades Native American art has changed fundamentally."[20] This view holds that traditional Native American art, except as a source, is dying. Nothing could be further from the truth. What such a premise ignores is that both "old" and "new" Indian art is often made by the same person, who experiences no dislocation as an artist. In the holistic view, one may be as old as the hills or as modern as tomorrow. Such a view takes into account the continuing vitality of traditional work.

AFTER TWO WEEKS OF DISCUSSION at the Aspen seminar *Indian America: Past, Present, and Future,*[21] the Indian participants were asked to name their one paramount concern. All emphatically agreed that their uppermost concern was survival, not only physical survival as people, but also spiritual survival as Indians. Far more than is generally supposed, many Indians wish to retain an identity that is theirs alone. In this desire the living arts serve as a catalyst. Since there was no Indian word for art in the old days, what we now call art was part of life as a whole. At bottom, it still is. "There will always be Indian art," Potawatomi Marty Kreipe declared. "There always has been, whatever you choose to call it. We move around, leave the res, we come back at pow-wow times or celebrations. Then we need our own things just as much as in the past. Maybe we need them more. Underneath it hasn't changed that much, not at all."[22]

Minorities can adopt middle-class ways to move upward along the scale of social mobility. Indians do not readily accept that method, at least the ones I talked with. They have suffered materially while waiting for the respect and recognition they feel is due their cultures. It all boils down to the issue of respecting their unique identity. The key point of reference is their quasi-independent status, handed down by Chief Justice John Marshall in 1831, as "domestic dependent nations."[23] This status they still argue. When they make art they are reminded. As they dance they are reminded; when the drum begins its beat, it is the heartbeat of the First People.

Even when old blood is diluted, as it so often is today by mixed marriages, Indianness tends to dominate. Indians do not on the whole subscribe to the melting pot. Under the most trying circumstances they maintain a remarkable sense of their origin. The Indians I talked to, whose food I ate, and whose camps I sometimes shared, do not really wish to assimilate. They want education and modern advantages, as long as these do not interfere with what they have chosen to be. Many still believe that the natural world is an analogue to the spiritual one and, in as much as they can, still abide by that concept. Even when they are Baptists or Catholics, inner Indianness remains. It keeps their art and religion alive. They prefer to remain Indian, like the objects shown here. With mind and spirit, they continue to keep their age-old covenant with their ways and the land.

FIGURE 40
Button blanket (Nishga), showing the white wolf, one of five blankets made by the women of the community for the use of the Episcopal priest at New Aiyansh, British Columbia, ca. 1972–74. See cat. no. 382.

NOTES

1. The massive collection of the Indian Arts and Crafts Board, in the custody of the Department of the Interior, has been kept in storage and unavailable to the general public; its proper installation would do much to shed light on the situation this project explores.

2. I.A.I.A. Meeting on Tradition; see chapter 4, note 6.

3. Conversation with the author, after a panel discussion on museum training, Institute of American Indian Arts, Santa Fe, New Mexico, spring 1984.

4. For the best scholarly synthesis of the concept of the vanishing Indian, see Lee Clark Mitchell, *Witness to a Vanishing America: The Nineteenth-Century Response* (Princeton: Princeton University Press, 1981).

 The Vanishing Race—Navaho appeared as the frontispiece to Edward Curtis's twenty-volume photographic vision of Indian life, *The North American Indian,* vol. 1, *The Apache, the Jicarillas, the Navaho,* ed. F. W. Hodge, foreword Theodore Roosevelt (Cambridge, Mass.: The University Press, 1907), with the caption: "The thought which this picture is meant to convey is that the Indians as a race, already shorn of their tribal strength and stripped of their primitive dress, are passing into the darkness of an unknown future." Written by Curtis himself, the caption had profound influence on subsequent literature.

FIGURE 41
Don Tenoso (Sioux), at work in his living room, Santa Fe, New Mexico, ca. 1984. See cat. no. 162.

5. Conversation with the author, Anadarko, Oklahoma, October 1981.

6. From notes taken by the author at the National Native Indian Artists' Symposium, Hazelton, British Columbia, August 25–30, 1983.

7. George Copway, or Kah-Ge-Ga-Gah-Bowh, *The Traditional History and Characteristic Sketches of the Ojibway Nation* (London: Charles Gilpin, 1850), p. viii. Copway is here expressing the threat to their culture felt by Native Americans by the mid-nineteenth century.

8. In this case the continuance depends on economics. "Well, she has some orders. One is from a museum in Germany or somewhere, so I guess she'll get busy so we can get the money," said a Jemez Pueblo man of his cloak-making wife. Conversation with the author, Jemez Springs, New Mexico, August 1984.

9. According to a survey made by J. C. H. King, assistant keeper of North American Ethnology, British Museum, London; letter to the author, October 1980.

10. See Christina B. Johansen and John P. Ferguson, eds., *Iroquois Arts: A Directory of a People and Their Work* (Warnerville, N.Y.: Association for the Advancement of Native North American Arts and Crafts, 1983), pp. 1–29. The author has met two Seneca artists not included in this valuable directory: splint basket maker Carrie Weir, Cold Spring, N.Y., and carver Earl Redeye, Jr., Jimersonton, N.Y. (see ch. 3).

11. Vinson Brown, *Elsie Allen, Pomo Basket Making: A Supreme Art for the Weaver* (Happy Camp, Calif.: Naturegraph Publishers, 1972), p. 4.

12. A number of contemporary Southwestern Plains silversmiths are using turquoise, a predominantly Southwestern material, in their work, the earrings by Preston Tonepahote being a case in point (cat. no. 206).

13. Conversation with the author, Santa Fe, New Mexico, April 1984. He had made a similar statement during an interview filmed for this project (see note 15).

14. Conversation with the author, Santa Fe, New Mexico, summer 1984.

15. Santa Fe, New Mexico, April 1984, from the sound track of the film made to accompany this project, directed by Alvin Siskind and produced under the auspices of Corporate Communications, American Can Company.

16. Conversation with the author, at the time of the Aspen Institute seminar *Indian America: Past, Present, and Future*, held June 27–July 10, 1982, at Crestone, Colorado.

17. See note 10.

18. Conversation with Gregg F. Stock, Santa Fe, New Mexico, September 1984.

19. Conversation with author while riding in the Fogarty pickup, February 1984.

20. *Magic Images: Contemporary Native American Art*, text by Edwin L. Wade and Rennard Strickland (Norman: University of Oklahoma Press in cooperation with Philbrook Art Center, 1982), p. 3.

21. See note 16.

22. Conversation with the author, on the way to Kickapoo Reservation, Horton, Kansas, October 1981.

23. Cherokee Nation v. Georgia, 30 U.S. (5 Pet.) 1, 8 L. Ed. 25 (1831). In this landmark decision Chief Justice Marshall ruled that while the Indian peoples were not foreign states, they were "domestic dependent nations," enjoying federal protection. See Monroe E. Price, *Law and the American Indian: Readings, Notes and Cases* (Indianapolis: Bobbs-Merrill, 1973), pp. 33–35. In Worcester v. Georgia, 31, U.S. (6 Pet.) 515, 8 L. Ed. 483 (1832) the court ruled: "The Cherokee Nation then, is a distinct community occupying its own territory... in which the laws of Georgia can have no force, and which, the citizens of Georgia have no right to enter but with the assent of the Cherokees themselves" (ibid., pp. 40–44). These cases are famous (or infamous) for the refusal of the state of Georgia to accede to this decision, and for the subsequent enforced removal of the Cherokee to what is now Oklahoma, the "Trail of Tears." It has been recorded that "it was of John Marshall's decision upholding the rights of self-government of the Cherokee Tribe that an old Indian fighter in the White House, President Jackson, said, 'John Marshall has made his decision. Now let him enforce it.'" See *The Legal Conscience: Selected Papers of Felix S. Cohen*, ed. Lucy Kramer Cohen, foreword Felix Frankfurter, introduction Eugene V. Rostow (New Haven: Yale University Press, 1960), p. 307.

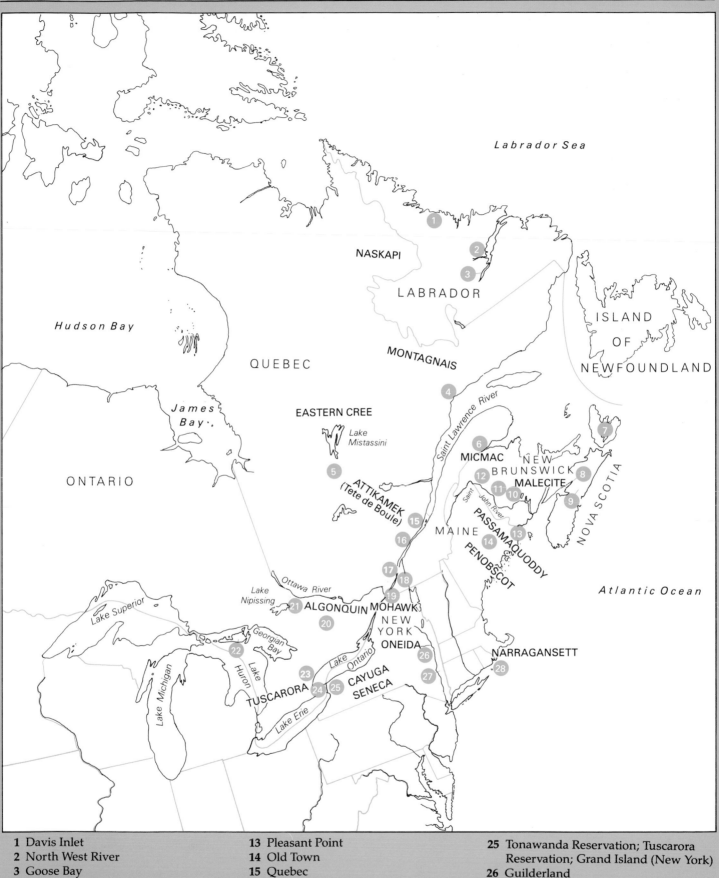

1 Davis Inlet
2 North West River
3 Goose Bay
4 Sept-Iles
5 Chibougamau
6 Maria Reserve (Quebec)
7 Eskasoni (Cape Breton Island)
8 Truro
9 Shubenacadie
10 Saint Mary's Reserve
11 Kingsclear Reserve
12 Tobique Reserve

13 Pleasant Point
14 Old Town
15 Quebec
16 Trois Rivières
17 Montreal
18 Caughnawaga Reserve
19 Saint Regis Reserve (Quebec)
20 Golden Lake Reserve
21 North Bay
22 Manitoulin Island (Ontario)
23 Toronto
24 Six Nations Reserve (Ontario)

25 Tonawanda Reservation; Tuscarora
 Reservation; Grand Island (New York)
26 Guilderland
27 Red Hook
28 Kenyon (Rhode Island)

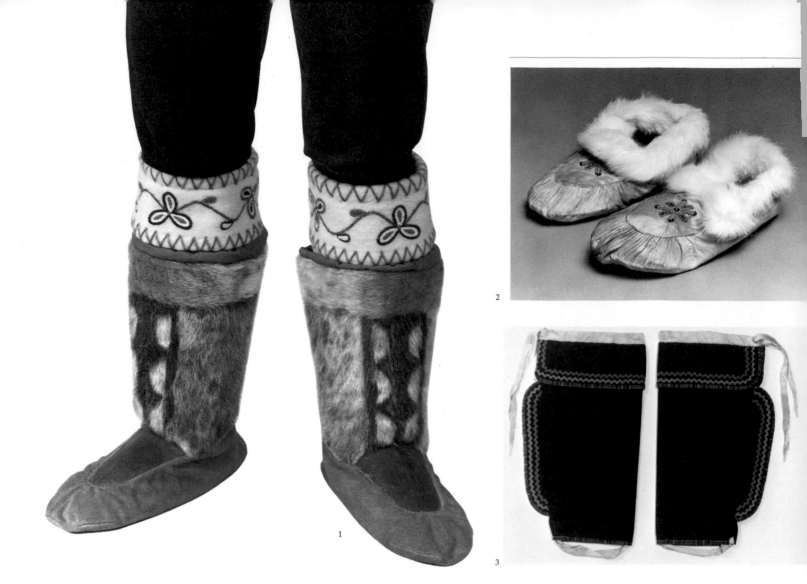

1

MUKLUKS, 1980
Sealskin and seal fur, commercially tanned leather, wool liners, embroidery materials
17¼" h. x 11⅜" l.; outer boot 13½" h.

Maker unknown
Subarctic
Eastern Canada

This was the most elaborate pair of mukluks seen in the Northeast. They are equipped with fully detachable wool liners that project above the sealskin-and-leather outer boot, adding a gay note of red, white, and blue embroidery to the somber seal fur, seal skin, and yellow-brown leather (resembling smoked hide). "It's just like snow above the tundra," was one comment. The outer boot can be tightened against the liners to keep out snow by pulling the drawstrings, much like pulling the strings to make a sleeping bag warm, from which the idea may come.

Purchased at Whetung Ojibwa Crafts, Curve Lake Reserve, Ontario, August 1981.

2

FUR-TRIMMED MOCCASINS, 1980
Caribou skin, beads, rabbit fur
3" h. x 9½" l.

Christine Rich
Montagnais/Naskapi
North West River, Labrador

Both the uppers and soft soles of these moccasins are made from two pieces of extremely thin smoked-caribou skin. The toes are puckered in finely stitched folds exactly as found in old-style moccasins from the same Band, but there is less beaded decoration than formerly. The sewing is done with what appears to be imitation sinew.

Purchased at Atikuian, North West River, Labrador, August 1980.

3

LEGGINGS, 1980
Broadcloth, rickrack, cotton, caribou hide
16½" h. x 8¼" w.

Phiomene Nuna
Montagnais/Naskapi
North West River, Labrador

While the great rocker-stamped Naskapi coats of the distant past were made chiefly in the eighteenth century, dress apparel such as these women's leggings is occasionally made, often using, as here, rickrack and cotton tartan trim, in a simple Northern manner. This example of modern finery was found at a craft shop I had been told was "down there" (in the center of Goose Bay, a town that straggles along for miles) which occasionally handled Indian items, as well as Labrador settler crafts.

Purchased at Labrador Crafts Shop, Goose Bay, Labrador, August 1980.

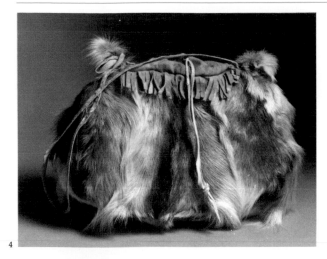

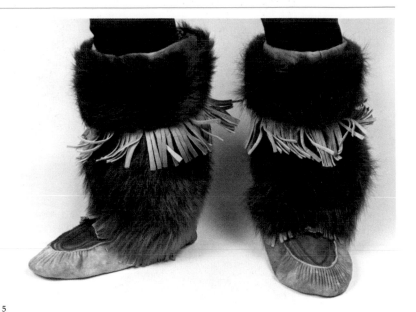

4

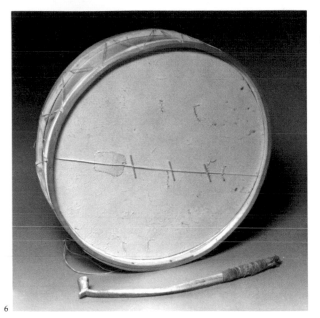

5

6

4

BAG, 1980
Caribou pelt, hide, cloth
8" h. x 12" w.

Mary Gregoire
Montagnais/Naskapi
North West River, Labrador

This pelt bag is one of the most elemental products of the untainted caribou-hunting Subarctic culture that one can still hope to encounter today. It is the product of a belief in the concept of the Master of the Caribou and of the social phenomenon of lone hunting parties in the Labrador barrens. Even the drawstrings and fringe are of smoked caribou hide, and the inner muslin liner manages to convey an archaic simplicity of means.

Purchased at Atikuian, North West River, Labrador, July 1980.

5

LEGGING BOOTS (MUKLUKS), 1980
Beaver pelt, smoked caribou hide, synthetic corduroy lining, fabric ties, piping
14½" h. x 11¼" l.

Mary Jane Nuna
Montagnais/Naskapi
North West River, Labrador

These luxuriant beaver-fur boots expand the need for conservation or warmth in the Far North to poetic metaphor. Not many years ago – up through the 1940s, in fact – death by freezing was not uncommon in trapping, whether Indians or whites ran the trap lines in the Labrador wilds. One needed only to misjudge the weather or the change of seasons by a few hours or minutes, or reach a trap-line hut lacking provisions or firewood, to meet a tragic end.

Purchased at Atikuian, North West River, Labrador, July 1980.

6

DRUM WITH BEATER, 1980
Caribou skin, wood, *babiche*, bone, nails, muslin, string, cloth
4⅛" h. x 16¼" diam.

Michel Pasteen
Montagnais/Naskapi
North West River, Labrador

"You'll not find much in Labrador, not since the Goose Bay Air Base shook things up," an expert informed me. "Those drums and toboggans are just about extinct." But both are still being made despite the changes coming to Labrador.

The drum heads are of caribou skin scraped to paperlike thinness, and the inevitable tears are stitched in the traditional way, forming patterns resembling bird tracks. Old-style red rim edges impart an accent that emphasizes the flat, round contours of the drum.

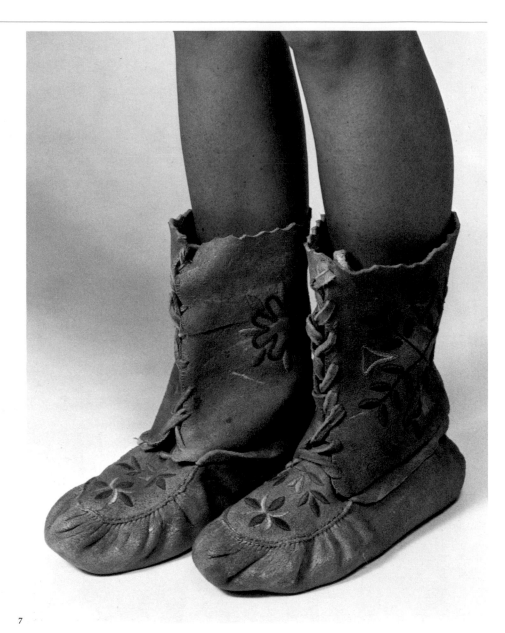

7

7

HIGH-TOPPED MOCCASINS, ca. 1970–75
Smoked moosehide, embroidery thread
11½" h. x 11" l.

Mrs. Vollant
Montagnais
Eastern Quebec

The colorful chain-and-pile stitched leaf-and-heart embroidery devices lend a note of Northern gaiety to this otherwise somber, brown-smoked high-topped footwear. The scars on the Indian-smoked hide used on this pair of moccasins are due to insect bites received by the moose when it was alive.

"I wondered if they'd be remembered by you," said the trader, Chief Andrew Delisle, in whose shop I had seen the moccasins hanging on a wall peg the year before I purchased them. The only information Chief Delisle was able to provide about them was that they had been made by a "Mrs. Vollant."

Purchased at O Kwa Ri, Caughnawaga, Quebec, August 1981.

8

KNIFE WITH SHEATH, ca. 1977–79
Caribou bone, string, smoked caribou hide, beads
11" l.

Maker unknown
Montagnais
Sept-Iles (Seven Islands), Quebec

Although collected on Six Nations Reserve, Ontario, this knife and sheath were made in extreme southeastern Quebec, according to the trader Guy Spital. The dot-and-notch motifs drilled and incised on the caribou handle are hunting-magic symbols. This is a rare shamanistic survival, though beaded hunting charms are still made by the Naskapi at Davis Inlet in Labrador to the northeast of Sept-Iles.

Purchased at Iroqrafts, Ohsweken, Six Nations Reserve, Ontario, August 1980.

Nails fastening the rim bands are modern, as is the muslin inside liner, which softens the sound. The old-style bird-quill snares are here replaced by dowel snares, visible across the drum head, which add timbre. "Just like old times," observed a young Montagnais girl on the boat to Labrador, "but these whites are ruining our hunting with their power projects, so the caribou doesn't listen to the singing the way he used to. That's what my grandfather says."

Nothing more than the name of the maker could be learned about this new double-faced drum, complete with suspension thong (the drums are suspended during use) and bone beater.

Purchased at Atikuian, North West River, Labrador, July 1980.

8

9

10

11

9

CROOKED KNIFE, ca. 1975–77
Wood, stainless steel, string, varnish
13" l.; linen sheath 7⅜" l.

T. Simeon
Montagnais
Sept-Iles (Seven Islands), Quebec

The once ubiquitous crooked knife is still made by a number of carvers in the Northeast, among them John Francis, the Passamaquoddy carver resident at Malden, Massachusetts. This sample closely follows the old-fashioned scroll-handled type – derived from a fiddlehead fern – except that it is outsized. It would take a giant's hand to rest the thumb against the scroll overhand, thus tightly securing the instrument in the palm. Perhaps it was meant as an art or exhibition item; or perhaps the carver simply got carried away, for one can carve effectively with it by holding it slipped down the palm a little.

Purchased at Whetung Ojibwa Crafts, Curve Lake Reserve, Ontario, August 1981.

10, 11

LIDDED MICMAC BOX, 1979
Porcupine quills, sweet grass, dye, thread
3⅜" h. x 4⅝" diam.

Joe and Libby Meuse
Micmac
Shubenacadie, Nova Scotia

LIDDED MICMAC-STYLE BOX, 1980–81
Porcupine quills, sweet grass, dye, thread
3⅛" h. x 2⅛" diam.

Evelyn Toulouse
Ojibwa
Manitoulin Island, Ontario

Today's Micmac are a long way from the makers of the magnificent corpus of quilled boxes, trays, letter holders, purse boxes, and miniature trunks that were made from the beginning of the nineteenth century until about 1940. Nowadays only empty echoes of these resound in the Micmac towns of New Brunswick and Nova Scotia. This is surely a culture in trouble. "They don't make those pieces any more," Margaret Cozry, an Ojibwa who runs The Algonquians, an arts and crafts shop in Toronto, flatly declared.

Evidently no one appears on Micmac territory today seeking quilled chair seats, old-style quill baskets, or quilled canoe models. When asked about these, an elderly quillworker in New Brunswick looked at me for a while and finally responded, "Oh, you mean *Indian* designs…." To her I was a puzzlement; it was nice that I inquired but a little daft for me to pursue. Yes, she could do it…but she never did.

Was there no Micmac quilling to be found anywhere? Finally, one round box and a comb box turned up at Truro, Nova Scotia. The round box (cat. no. 10) has the characteristic Micmac quilled chevron motif along the circumference and a modified cross design on the lid, but the quills have been turned down around the sides of the lid, following Ojibwa fashion. It is a diluted project, but it is Micmac, made by Joe (now deceased) and Libby Meuse of Shubenacadie, the most traditionalist holdout among the eleven Micmac settlements in New Brunswick and Nova Scotia. Their sweet grass is thinly braided around the basket's shoulder (a modern touch, also Ojibwa derived). The birchbark is sewn with flattened quills rather than thread, a welcome old feature. But this box is a far cry from the old quality. It is the lingering poesie of an expiring art.

A better-made box in Micmac style (cat. no. 11) came to light in Allenspark, Colorado. The geometric lid design in red, blue, and

12

13

12

white is like a restated excerpt from old Micmac designs. The chevrons around the circumference are really right in feeling, but the crisscross lattice feature doesn't strike quite the right note, and as a whole the box seemed to say "an Ojibwa working in Micmac style." I checked with Miss Cozry, for it seemed to be her telephone number on the label pasted inside the box. "Yes, she's a Manitoulin Island maker, somewhere around West Bay, exactly where I'm not sure. Her name is Evelyn Toulouse." Her basket was a copy of the type of work the Micmac were producing in 1940.*

Perhaps, like the Bella Coola Northwest Coast masks now made only by other Northwest Coast Indians, the only way Micmac quillwork will continue to live is through the hands of other Indians, unless the Micmac themselves revive it. At Millbrook Reserve near Truro, Nova Scotia, I came upon an Ojibwa oval, lidded box, gleaming with white quills (not for sale), which had come from the Thunder Bay region in Ontario. It had evidently been made as a presentation piece, for the graphic lid design is not Ojibwa, but like a Maritime style monogram. It turned out to be

the double *M* logo of the Micmac Indian Crafts cooperative.

The time is ripe, it would seem, for the beginning of a Micmac quilling revival in the Micmac homeland, perhaps grafted onto an Ojibwa strain. Such give and take is part of Indian cultural interaction from time immemorial, and it could happen here.

*For an example of this simplified style of Micmac quillwork in a set of six nesting boxes made in 1939, see Ruth Holmes Whitehead, *Micmac Quillwork: Micmac Indian Techniques of Porcupine Quilled Decoration 1600-1950* (Halifax: Nova Scotia Museum, 1982), plate 31.
Catalogue number 10 purchased at Glooscaps Trading Post, Truro, Nova Scotia, summer 1980.
Catalogue number 11 purchased from Charles Eagle Plume, Allenspark, Colorado, May 1982.

PORCUPINE AND RIBBONWORK LIDDED SPLINT BASKET, 1980
Black ash splints, sweet grass, nails
10" h. x 11¼" diam.

Maker unknown
Micmac
Maria Reserve, Quebec

"They went out and got the federal [Canadian grant] money and it has made some of the other Micmac reserves mad," the carver Sam Goose observed about the Maria Reserve Micmac, who have one of the most businesslike basket cooperatives among the Northeastern Indians. The band, whose baskets are marketed all across Canada, runs a semi-commercial handicraft industry. "In the winter everybody works at it, down to the kids." Since the gathering of splints and sorting of materials and the making of rims and handles is somewhat standardized, many of the baskets have a "typed" appearance.

While this porcupine and ribbonwork basket is green and rose, similar baskets are made in other gay colors, often acid orange or yellow, making them easily recognizable.

Purchased from Maria Basket Cooperative, Maria Reserve, Quebec, August 1980.

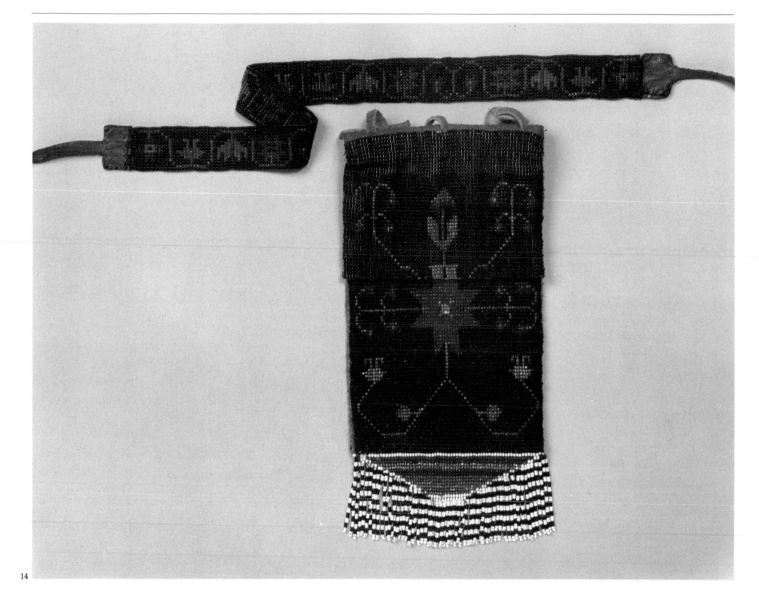

14

13

BASKET WITH SPLINT ROSES, 1981
Poplar splint, wire, green tape
15½" h. (including handle) x 14½" l. x 14" d.;
flowers 8–10" l.

Margaret Johnson (basket)
Micmac
Resident at Eskasoni, Cape Breton Island,
Nova Scotia

Annie Paul and others (flowers)
Micmac
Shubenacadie, Nova Scotia

During the summer of 1980, the day after Saint
Anne's Day (Saint Anne is the patron saint of
the Maritime Indians), I bought some damaged
splint flowers at the basket shop of Malecite
Mrs. Veronica Atwin at Kingsclear Reserve,
New Brunswick. "You should have seen the
good ones, all red roses, I put in a flower basket
for Saint Anne's Day Communion up at the
church. Father has them now; he could show
them to you," she said. The next summer I
tried to duplicate Mrs. Atwin's Communion
display. The basket was obtained at the Truro
Micmac Band's gift shop, and the splint roses
were bought at two highway trading posts.

Poplar splint roses were invented in 1937
by Madeline Knockwood, who is something of
a culture hero in having added this charming
aspect to splint basketry. In exceeding the limi-
tations of the craft she did more than she per-
haps intended; today the flowers crop up in
Maritime Indian homes displayed in vases on
shelves or mantles as symbols of Indianness.
They are often seen in churches as offerings to
the Virgin. Mrs. Knockwood died in 1947, but
her craft is carried on by others at Shubena-
cadie, notably Annie Paul.

The villages in which Margaret Johnson
and Annie Paul live both practice Micmac
crafts in fading circumstances due to a lack of
outside appreciation and encouragement.

Basket purchased from Micmac Arts and Crafts
Society, Truro, Nova Scotia, July 1981.
Flowers purchased at Glooscaps Trading Post and
Goo Goo's Basket Shop, Truro, Nova Scotia, July
1981.

14

BEADED POUCH AND HEADBAND, 1969–70
Beads, leather, smoked moosehide
Pouch 11⅛" l. (including beaded fringe) x
5¼" w.
Headband 47⅛" l. (including ties) x 1³⁄₁₆" w.

Tony Atwin
Malecite
Kingsclear Reserve, New Brunswick

This loom-beaded pouch and headband to
match were made by Tony Atwin, son of Ve-
ronica Atwin (see cat. nos. 16, 17), between
1969 and 1970 when he was a high school stu-
dent. Today he is a fishery patrolman on the
Saint John River and has not "gotten around to
making any more things." The pieces were
hanging on the wall of his mother's basket
shop. After a time the son proved willing to sell
them, though he was at first incredulous, then
reluctant.

The curved tendril-and-berry designs are
reminiscent of the Maritime curved motifs seen
on old-time coats, jackets, and collars of north-
ern Maine and extreme Eastern Canada. Mrs.
Atwin, contemplating the piece as she was sell-
ing it, observed, "You almost feel you're in a
berry patch with a starfish lying on the nearby
sand."

Purchased from Veronica Atwin, Kingsclear Reserve,
August 1980.

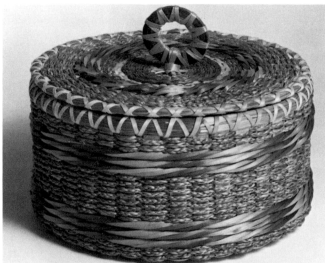

16

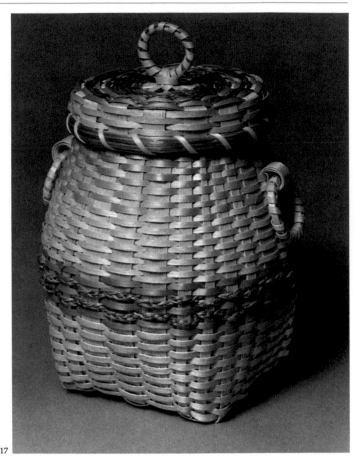

17

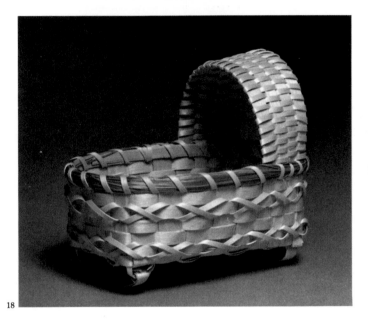

18

15

BABY COVERLET AND PILLOW, 1981
Felt, beads, pillow stuffing
Coverlet 17½" l. x 8½" w.
Pillow 9⅜" l. x 6¼" w.
(see colorplate, p. 113)

Kim Brook
Malecite
Saint Mary's Reserve, New Brunswick

Although twenty-two-year-old Kim Brook had shown some of her beadwork at the New Brunswick Museum at Saint John in 1980, she said this coverlet and pillow were "the first piece[s] I have sold." The running and zigzag devices and pinwheel flowerets are highly traditional in Malecite work, as is the artisan's use of opalescent and shiny beads, luminescent, "almost Christmas-like" against the red felt field. The festooned border beading and pendant drop motifs are highly ornamental, while the bird perched above a beaded heart (the central motif) is based directly on three-

dimensional stuffed-bird ornaments ("fancies") that Malecite women once made in abundance around the last decade of the nineteenth century.

Kim Brook's future as a beader is problematical. A busy wife and mother, she has other obligations, which interfere with this time-consuming handwork. "There is little time because if I don't go to the Indian Study Program at the University [across the Saint John River in Fredericton], my Indian girlfriends will think I'm a traitor to them and our progress."

Purchased from the maker, July 1981.

16, 17

"RAINBOW" FANCY BASKET, 1980
Black ash splints, sweet grass, dye
6¾" h. x 8⅜" diam.

MINIATURE HAMPER (FANCY BASKET), 1980
Black ash splints, sweet grass, dye
7⅛" h. x 5" w. (at shoulder)

Veronica Atwin
Malecite
Kingsclear Reserve, New Brunswick

"Rainbow baskets are my specialty," Mrs. Atwin explained, "and that little hamper is one of my novelty baskets." The banded optical effect of the "rainbow" workbasket is produced by twisting the outside weavers around every other standard; on the inside, the weavers run parallel and do not twist and thus effect a smooth interior wall. The hamper is a small-scale re-creation of the full-size hampers, several feet tall, once made by the Atlantic Maritime tribes to contain clothing and goose down for pillow and mattress stuffing. They are still made by the Mohawk farther inland (see cat. no. 38).

Mrs. Atwin unlocked her backyard basket shop to sell these baskets. The next year the little shop was closed and empty. Her son Tony (see cat. no. 14) explained that there were no baskets because his mother had not had the time to make them. "She's talking up the language, teaching Indian to the kids. Maybe next year...."

Purchased from the maker, August 1980.

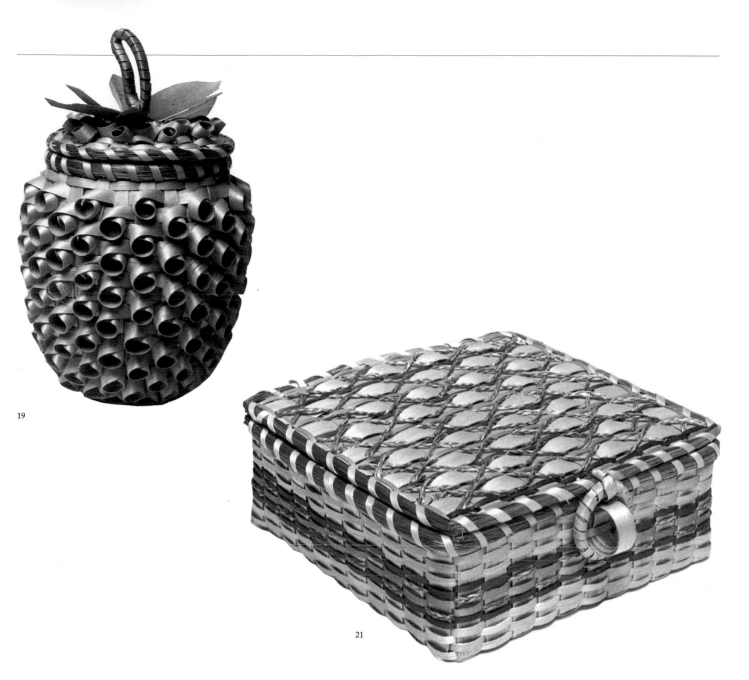

19

21

18

MINIATURE CRADLE, 1981
Brown ash splints, sweet grass
4½" h. x 5⅜" l. x 3½" d.

Lena Paul
Malecite
Tobique Reserve, New Brunswick

Miniature items like this cradle are very much part of Indian culture. Whole sets of miniature furniture are made for dollhouses, and such small items are also made as artifices, often serving as pincushions.

Mrs. Paul and her husband, the carver Sam Goose (Abner Paul), run a craft shop at Tobique Reserve.

Purchased from the maker, August 1981.

19, 20, 21

"STRAWBERRY" BASKET, 1980
Brown ash splints, sweet grass, dye
7" h.

CYLINDRICAL LIDDED BASKET, 1981–82
Brown ash splints, sweet grass, dye
7" h. x 10" diam.
(see colorplate, p. 115)

SQUARE LIDDED BOX, 1981–82
Brown ash splints, sweet grass, dye
2¼" h. x 7" w. x 7" d.

Clara Keezer
Passamaquoddy
Passamaquoddy Indian Reservation, Pleasant Point, Maine

These are all notable examples of the Algonkian Indian "fancy" basket, intended to be attractive embodiments of the maker's virtuosity. The "strawberry" basket was made by Clara Keezer on a very old wooden mold provided by traditionalist William Altvater, himself a specialist in heavy-duty and potato

baskets. Adorned with similar curlicue work, but with an utterly different effect, is the cylindrical basket, dyed red with a continuous spiral design that includes the lid (a personal touch). The square box with its sweet-grass strapwork braiding on the lid is an old-fashioned essay in a style popular a century ago but still occasionally made today.

Clara Keezer is the finest splint basket craftswoman I met in the Northeast. She learned at an early age from her mother, although, she observed, "You don't exactly learn; from the time I was a little girl it was around."

Catalogue number 19 special ordered August 1980 through William Altvater's Basket Shop (now closed), Pleasant Point, Maine; delivered November 1980. Catalogue numbers 20 and 21 ordered through the same shop July 1981; delivered March 1982.

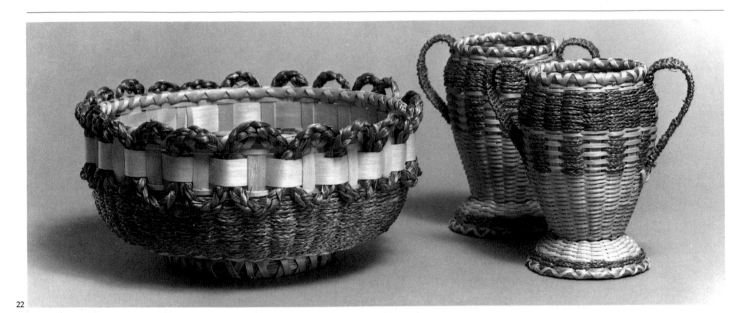

22

23

22

SPLINT BASKETRY GARNITURE, 1980
Brown ash splints, sweet grass
Bowl 6¼" h. x 10¼" diam.
Vases, each 6⅜" h. x 5¾" w. (at handles)

Josephine Bailey
Passamaquoddy
Passamaquoddy Indian Reservation, Pleasant
Point, Maine

"What can I do for you?" inquired Josephine Bailey from the porch of her home as I gazed at an abandoned sales kiosk that was overgrown with weeds and had a sign saying *Baskets*. "I used to run that, but I gave it up. Come in anyway and have some baskets." Mrs. Bailey's gentle features communicate an air of refinement and breeding. I was ushered into the back bed-workroom, where this garniture was assembled from what was available. The sweet grass loops encircling the vase and the loving-cup profiles of the vase convey an ineffable Victorian air long since discarded by the dominant culture, but still responded to here in a craggy, grassy Indian village on Passamaquoddy Bay in Maine.

Purchased from the maker, July 1980.

23

LIDDED SPLINT BASKET, 1979
Wood and splint, dyes, sweet grass
5⅛" h. x 7½" square (at bottom)

Edna Becker (?)
Penobscot
Old Town (Indian Island), Maine

Edna Becker, at Indian Island, Maine, is one of the Penobscot who still makes baskets, even though she is getting old. She also beads trinkets. The multi-colored parallel bands that encircle the basket and lid, creating a sort of candy-striped field, are Edna Becker's trademark, but whether she wove this basket herself or had it made especially for sale, I could not determine.

Purchased from the maker (?), June 1980.

24

BAG WITH CARRYING STRAP, 1974–75
Hemp, natural dyes
14" h. x 16½" w.

Ella Seketau
Narragansett
Kenyon, Rhode Island

This bag is reminiscent of a type that could have been seen by contemporaries of Roger Williams, founder of Rhode Island, as they dealt with the local Indians. In those times dogbane was primarily used for southern New England twine bags, the technique of which goes back to pre-contact times. Only a few seventeenth-century examples survive, and Ella Seketau has studied them. In the past, hemp was imported and naturalized in southern New England and could be used today, except that its harvesting is prohibited since it is the source of marijuana. Dogbane – the pre-contact source of twined cord, along with basswood, inner cedar bark, and swamp milkweed – still exists, but "those sea-going sailors had a big

24

25

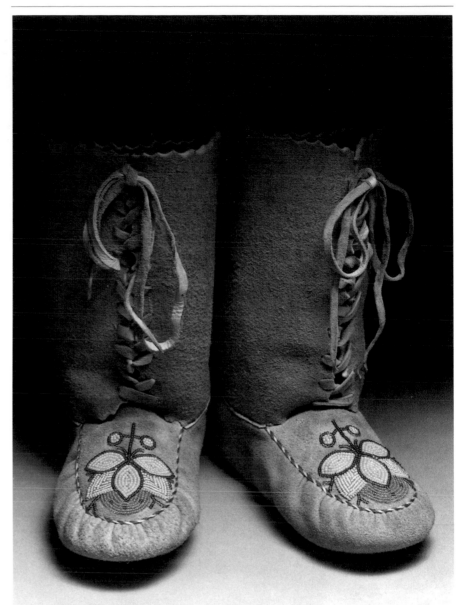

26

25

demand for rope from it. It was one of the first exports of the New England colonies, so today the supply is so exhausted that it would be hard to find enough to make a bag, so I re-import the hemp from Italy. But it's the same thing.'' Today there is such expansion of land use that dogbane cannot be replenished. Still, Ella Seketau keeps on. She makes bulrush mats also, ''but automobile pollution has stunted the growth of cattail and bulrush.''

The blue-colored hemp was dyed with rotted maple ''steeped for a couple of months in water; I added some commercial dye, too, but it's all faded now, and only the natural dye is there now, which I like better.'' The gray color comes from walnut-shell dye. It took about a month, working about six hours a day, to make this bag. It had been in constant use both as a personal piece and for school cultural programs, but Ella Seketau (fig. 35) surrendered it to this project so that more people would know about her tribe and its survival.

Purchased from the maker, October 1983.

MITTENS, 1980
Beaver, wool, smoked hide
13¼'' l. x 8½'' w. (at base)

Maker unknown
Eastern Cree
Quebec

These beaver mittens are so simple, yet so beautiful in their use of the beaver pelts that they make the point once and for all about the direct Indian relationship to nature. The bright red wool lining on blue threading along the bottom is a typical northern Algonkian color preference, going back to the painted and stamped blue and red designs on Naskapi caribou-skin coats and later woolen caps, some of which are still made today.

Purchased at Whetung Ojibwa Crafts, Curve Lake Reserve, Ontario, August 1981.

26

MUKLUKS, ca. 1975–77
Smoked moosehide, blanket lining, beads, commercial lacings
12¼'' h. x 10½'' l.

Maker unknown
Cree
James Bay Region, Canada

With its heavy lacings, thick hide, blue blanket lining (even the tall concealed tongue is lined), and outside ''arctic'' uppers, this pair of mukluks is redolent of the warmth required in northern climates. In older times the beading would have been more prolific. The intertwined yellow and violet threads across the vamp, the raspberry, light green, and yellow beading give an air of lightness and freshness in a harsh climate. Just when these mukluks were made is not clear.

''We've got a pair of Northern mukluks,'' Mary Lou Fox Radulovich of the Ojibwa Cultural Foundation had told me, ''but you'll have to wait until the girl who is using them brings them in! She's out with a program.''

Purchased at the Ojibwa Cultural Foundation, Manitoulin Island, Ontario, August 1980.

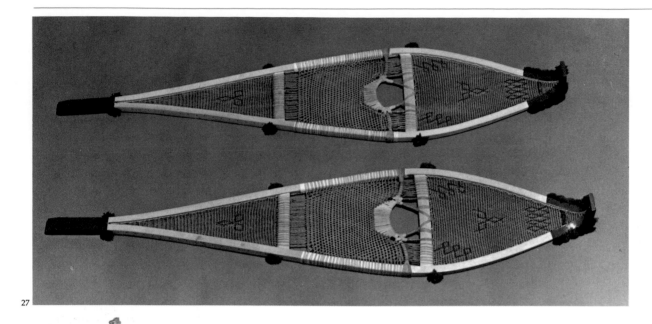

27

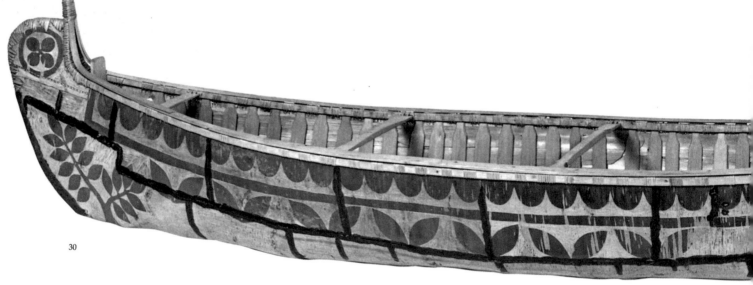

30

27

PAIR OF SNOWSHOES, ca. 1979–80
Wood, *babiche*, rawhide lacing, nails, nylon
thread, paint, wool balls
59″ l. x 12¾″ w.

Johnny and Emma Shecapio
Cree
Lake Mistassini, Chibougamau, Quebec

While the Maritime Montagnais, Naskapi, and
Micmac still produce sturdy working snow-
shoes in the rugged, time-honored way, I was
told in 1974 by a distinguished Canadian
ethnologist that old-style ''dressy'' snowshoes
from the far north of Eastern Canada would no
longer be found in the age of snowmobiles.
''You're too late,'' he said, ''the old protective
designs haven't been painted on toboggans
since the 1950s, and I can't imagine them put
on snowshoes anymore.'' Nothing was known
about the origin of this fancy, red-painted pair
of shoes of elongated, tapered design with
gracefully upturned front ends when they
were purchased, since no collecting data
accompanied them. ''Just accept the fact that
somebody made them up to get a living,'' said
the trader. ''It's probably as simple as that, or
somebody just had an impulse.''

The frames are steamed and bent, with
crossbraces set in to keep the form as the rims
dry. The *babiche* (native gut lacing or netting)
varies in weave, the heaviest area of netting
bearing the weight and pressure of the foot
(note the deerhide instep pad and *babiche* heel
reinforcements). The nylon cord used to join
the netting to the inside edges of the frame has
been melted in two places on each shoe to fuse
the *babiche* construction into a single, pliable
unit. The nails (painted red) and cloth
wrappings around the mid-section of the
frames are trade materials. Notable is the way
the *babiche* has been ''pulled'' to create the
protective designs (edged in red paint). Wool
balls and tufts attached to the painted frame
ends lend a festive air.

Two years after these were purchased, I
chanced upon the makers of these extraor-
dinary shoes, Johnny and Emma Shecapio, in
Hazelton, British Columbia (fig. 8). He spoke
no English, but she did. ''He makes the frames
and I do most of the weaving,'' Emma Shecapio
explained. ''The red color makes them easy to
see in the snow.'' They make snowshoes of sev-
eral types and take great pride in perpetuating
their culture. Emma Shecapio also makes excel-
lent hide objects.

Purchased at Whetung Ojibwa Crafts, Curve Lake
Reserve, Ontario, August 1981.

28

SNOWSHOVEL (date unknown)
Wood (fir?), stain
34″ l.

Maker unknown
Cree
Eastern Canada

The burned-in stamp ''Cree Craft'' and anchor
mark indicate a craft cooperative source for this
long-handled scoop. Further information is
lacking as to the origin of this traditional
implement.

Purchased at Whetung Ojibwa Crafts, Curve Lake
Reserve, Ontario, August 1981.

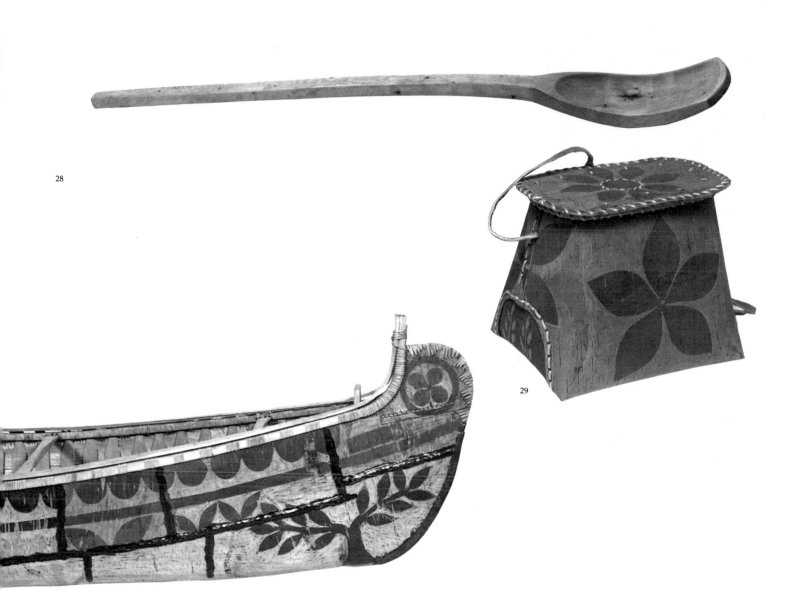

28

29

29

MUKAK, 1980
Birchbark, spruce root, smoked hide
9″ h. x 10¼″ w. x 8¼″ d.

Family of Cesar Newashish
Attikamek (Tete de Boule)
Manouane, Quebec

While Cesar Newashish was making birchbark canoes at Caughnawaga Mohawk Reserve (just south of Montreal on the Saint Lawrence River) at the invitation of Chief Andrew Delisle (see cat. no. 30), other members of his family were busy making a series of *mukaks* (containers) in the traditional way. The scraping of the flower-petal design on the lid and sides of this fine example is possible only when the bark sheets are gathered in early spring before the sap flows; only then is the inner bark a rich and dark russet color suitable for revealing such bark designs.

Purchased at O Kwa Ri, Caughnawaga, Quebec, August 1981.

30

FUR TRADER'S CANOE, 1980
Birchbark, jack pine, wood, spruce gum
17′ overall (measured the Indian way along bottom and including bow and stem curvature)

Cesar Newashish
Attikamek (Tete de Boule)
Manouane, Quebec

In August 1980 Mohawk Chief Andrew Delisle at Caughnawaga, Quebec, invited the well-known canoe maker Cesar Newashish and his family to come to O Kwa Ri (a large craft store in a shopping area bordering the Mohawk settlement) to manufacture several canoes. As a building site he provided a sand pit set into the concrete surface of the parking lot adjoining the store.

"They were built right here in the shopping center, but made the right way," Chief Delisle observed. "There were three of them made, a twenty-foot canoe [see fig. 19], a seventeen-foot-long one, and a fifteen-foot one [cat. no. 33]. The biggest one I sold, and it is being used on the Saint Lawrence by a family."

"Since this is a fur trader-type canoe and not a Manouane type, what would Cesar call it?" I asked.

"He'd call it a Mohawk canoe since it was made near the Saint Lawrence."

We are dealing here with an intercultural canoe type developed for the fur trade and manufactured by the Indians under French direction at Trois-Rivières as well as by Indians themselves. This type was popular far and wide among the Canadian population engaged in the fur trade. With high, curved bow and stern and heavy construction, these "liners of the fur trade" could stand rough open water and the strain of long portages on the vast trips up the Ottawa River through Lake Nipissing to Georgian Bay, the Sault, and then to the fur country far beyond Lake Superior. Large examples were over thirty feet long and had a commodious seven-foot beam, held twelve to fifteen people, and could transport up to five tons of furs back to the Montreal markets on the annual round trip. They were still being used in the trade in the 1890s.

This survival of the type is a reduced working version, but it is correct in every detail, except that the scraped decorative motifs are more closely spaced here than on the old-style fur traders' canoes.* The quatrefoil design at the open bow and stern is traditional, filling the space left by the extensive bow-stern sheer. The spruce-gum caulking has been colored to match the russet shade of the inner

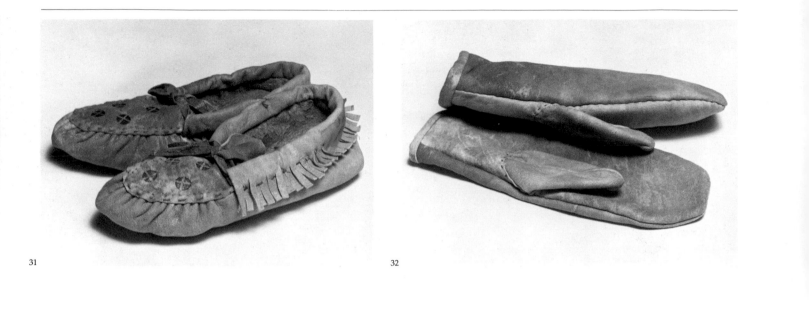

31

32

33

31, 32

MOCCASINS, 1981
Buckskin
2⅝″ h. x 9⅛″ l.

MITTENS, 1981
Buckskin
10½″ l.

Sarah Lavalley
Algonquin
Golden Lake Reserve, Ontario

The moccasins were commissioned directly from Mrs. Lavalley, a tall, refined woman in her late eighties. She included the mittens as a bonus. "The style is a pattern used in 1895, the stitching is the same." To make these objects Mrs. Lavalley used a home-tanned hide obtained from a neighboring German woman "who works to order for us."

The moccasins are pressure stamped with a motif recalling those found on Woodland Indian potato-stamped basketry, which is no longer made. The mittens are left undecorated. Old Algonquin garments and footwear were basically unornamented except for fringes and, in more recent times, bead accents. The pucker stitching of the moccasins is also characteristic of the simplicity of good taste of this small but famous tribe.

Ordered from the maker, August 1981; received November 1981.

33

FAMILY CANOE, 1981
Birchbark, jack pine, pine resin, cedar, varnish
15′ overall (measured the Indian way along bottom and including bow and stern curvature)

Stanley Sayazin
Algonquin
Golden Lake Reserve, Ontario

"Why there's a man who just built a canoe this summer, and it's down at the co-op right now," exclaimed Algonquin elder Mrs. Sarah Lavalley (cat. nos. 31, 32) when I asked where I might find a canoe. "He just took it into his head to make one, and it's for sale; I'll telephone Eleanor Commanda for you; she's probably at supper. Will you be around tomorrow? She'd open the shop."

At nine o'clock the next morning I was examining Stanley Sayazin's newly finished birchbark canoe, a "family" type, as this kind is called on Golden Lake. With its flat bottom, slight hull curvature, and regular and gentle curve to the stem, it is similar to the stable Wabanaki Chiman type canoe popular with Algonkian Indians ever since the Saint Francis Abenaki (composed of migrated New England tribes) came to Odana, Quebec, at the end of

bark revealed by scraping. The lacing roots were gathered by the men but processed by the women of the family, who also occupied themselves making birchbark containers (see cat. no. 29) during the building of the canoes.

Cesar Newashish is remembered for the full-size trader's canoe (also called a "maitre canot") he made in the 1950s for the Royal Ontario Museum in Toronto, where it is permanently on display. He proudly signs his canoes on the starboard panel at the bow, since he is fully conscious of his role not only as a traditionalist, but also as a preserver of this vital aspect of the Algonkian culture for the future.

*See Camil Guy, *The Weymontaching Birchbark Canoe,* Anthropological Papers, No. 20 (Ottawa: National Museums of Canada, 1974), plate 2.

Purchased at O Kwa Ri, Caughnawaga, Quebec, August 1981.

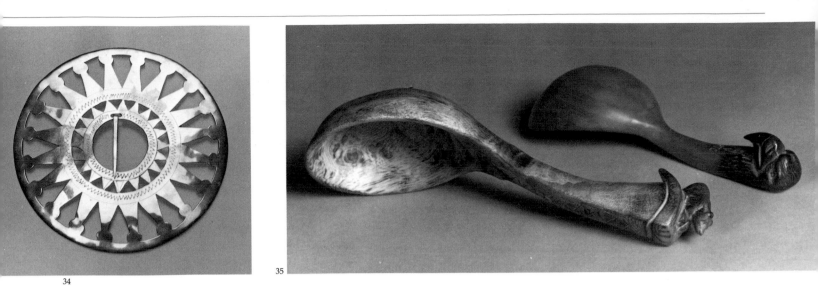

34

35

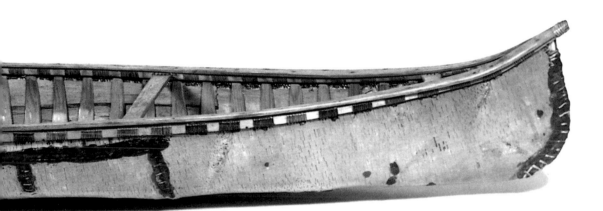

34 35

the eighteenth century. An almost straight sheer leads to the gunwales, plugged with wood dowels and attached to the hull with carefully spaced lacings. This elegantly simple, conservatively flared, maneuverable canoe, so typical of its class, is one of the glories of naval engineering anywhere: the perfect all-around Woodlands canoe. "It's made the right way," said Mrs. Lavalley in her quietly authoritative way, "no shortcuts."

Traditionally, this canoe would have been used to move families and their belongings from one camp to the next, for fishing, and for visiting. A smaller version would have been used for hunting, allowing for overlapping functions, but "contemporary ethnography adds nothing to our knowledge, since birch-bark canoes are no longer being built except for museums and private collections."* Be that as it may, the urge to make canoes persists, whether by invitation from another Indian group (cat. no. 30), commissions from outside the culture, or by obeying some inner creative urge, as in the case of this canoe.

*Camil Guy, The Weymontaching Birchbark Canoe, Anthropological Papers No. 20 (Ottawa: National Museums of Canada, 1974), p. 16.

Purchased at Craft Cooperative, Golden Lake Reserve, Ontario, August 1981.

BROOCH, ca. 1980
German silver
3½" diam.

Member of the Chrisjohn family
Oneida
Resident at Red Hook, New York

This is a modern verison of the cutout circular brooches made by the Iroquois after 1800.* Originally such brooches were made by silversmiths in Montreal, Quebec, and Philadelphia for the Indian trade. Most were of silver rather than German silver.

This object was obtained by a Schenectady, New York, trader and in turn acquired by Robert Dunham of Cowgill, Missouri. As in the past, trade objects still travel far and wide; this Iroquois brooch might have ended up with an Oklahoma Indian or a Potawatomi in Mayetta, Kansas, an example of how tribal material crosses over the country on the trader's circuit.

*This brooch is very close to an old example illustrated in Iroquois Silverwork: From the Collection of the Museum of the American Indian, Heye Foundation, catalogue of an exhibition circulated by the Gallery Association of New York State, 1982–83, p. 15.

Purchased from Robert Dunham, Cowgill, Missouri, 1982.

TWO WOODEN LADLES, 1982
Walnut 8½" l.
Burl 10½" l.

Richard Chrisjohn
Oneida
Resident at Red Hook, New York

The Woodlands wooden ladle has an ancient history and, miraculously, is still made by tribes as diverse as the Mesquakie, Potawatomi, and Iroquois. The Iroquois type, as here, often had a hooked handle, enabling the ladle to hang on the rim of feast dishes. In the walnut example the hook becomes an eagle head; the hook of the burl ladle has a bear standing on it. The bear is a clan symbol; the eagle guards the Iroquoian tree of peace.

Purchased at American Indian Treasures, Guilderland, New York, June 1983.

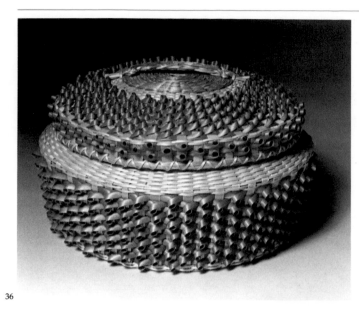

36

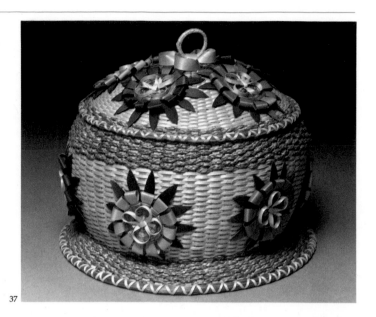

37

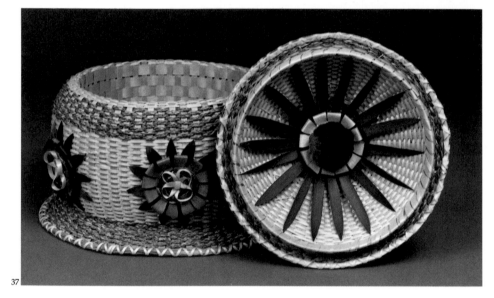

37

36

LIDDED SEWING BASKET, 1977
Black ash splints, sweet grass, red dye
7" h. x 12¼" diam.

Cecilia Thomas
Mohawk
Saint Regis Reserve, Quebec

"When I told Cecilia Thomas that she made beautiful baskets, tears came into her eyes and she started to cry," Margaret Cozry, the Ojibwa owner of The Algonquians, a shop on Queen Street, Toronto, related. "It seems that no one had ever told her that before. She's about eighty."

This basket is beautifully fashioned with dexterously handled curlicue work on the lid, below the shoulder of the basket proper; the bare shoulder, lid edges, and lid center give sculptural definition to the basket's form.

When I finally called on Cecilia Thomas at Saint Regis in 1983 she showed me a photograph of herself taken in 1974 as she presented a special basket to Queen Elizabeth II. "I always call that [type] my 'queen's' basket." Although Mrs. Thomas also made one for me, it did not turn out as well as the example shown here made some nine years earlier.

Purchased at The Algonquians, Toronto, August 1978.

37

FANCY SEWING BASKET, 1980–81
Brown ash splints, sweet grass, dye
9¼" h. (including loop handle) x 10" w.
(at shoulder)

Charlotte Delormier
Mohawk
Saint Regis Reserve, Cornwall Island, Quebec

This basketry construction, bulbous as an old spitoon, defies the imagination by its eccentricity. It is double woven, with a separate outside shell from which the basal flange extends. On the inside of the cover is a startling splint petal-mounted pincushion seen only when the basket is opened. Eleven flowers (three kinds of splint decorative work) animate the outer walls and the cover with radiant effusion, somehow conveying the impression made by a beehive hat.

The Victorian floridity of execution here underscores the archaism of taste that underlies modern Indian artistic manifestations. "Even when we are being modern, we can look back," said one Indian woman.

Purchased at Whetung Ojibwa Crafts, Curve Lake Reserve, Ontario, August 1981.

38

BASKETRY HAMPER WITH LID, 1983
Brown ash splints, dye
28¾" h. (including lid) x 15" diam.

Gertrude Gray (hamper) and Mary Adams (lid)
Mohawk
Saint Regis Reserve, Snye, Quebec

I commissioned this hamper from Gertrude Gray through her mother Mary Adams. "I'm going to see Gertrude this evening and I'll see. Come by tomorrow morning." When I arrived the next day Mrs. Adams assured me that her daughter would be arriving with a hamper. In due time the hamper projected through the door, with Gertrude Gray behind it. She had begun it early the previous evening and worked until one in the morning. Now she set to work again, cutting the indigo-dyed splints to size, inserting a row, and cutting some more. One by one she imbricated the blue splints in zigzag decorative accents, turning the hamper in her lap. Her mother made the

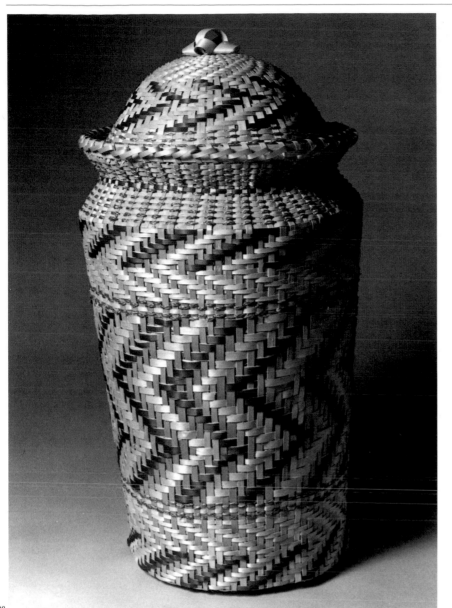

38

39

lid, using a spun-aluminum kitchen bowl as a mold, setting the crossed and recrossed starting splints over it from time to time as work progressed and a dome shape emerged (fig. 12).

They worked from 10:30 A.M. to 1:00 A.M., I made the coffee and answered the phone. When lid and body were joined and admired, Mrs. Gray explained that her blue zigzags were "Western designs" (derived from Navajo textiles). The cooperative venture was concluded by Mrs. Adams's decision, "Well, he makes coffee and answers the phone; we'll keep him."

Purchased from the makers, July 1983.

CRADLEBOARD, 1981–82
Wood, paint, varnish, rawhide, commercial thong
30⅜" h. x 10⅞" w.
(see colorplate, p. 116)

Mark Montour
Mohawk
Caughnawaga Reserve, Quebec

"You mean someone here can make the old-fashioned Mohawk cradle with the flowers and animal clan symbols painted on the back? It still survives, right here?"

"Yes," said Chief Andrew Delisle, pointing to a well-made old-style cradle with abstract Indian designs painted on the back in traditional style. "There's a young man who made this one. He does the other [older] design, too."

"Can he use old-fashioned rawhide ties instead of commercial?"

"He can make one that way."

This conversation took place in August 1981. Almost a year later this cradleboard arrived, beautifully fashioned, varnished, carved on the back, and painted with traditional symbols of increase, birth, and renewal. No nails are used, the basal plugs are filled in,

as in old-time examples; wooden plugs fasten the head protector to the carved and painted backbrace. The side lacings are rawhide. Blanket ties, however, are commercial hide. When I complained about the use of the latter, I was told by an Indian observer not to be such a purist, "They did that years ago, too."

The painted backboard depicts, from top to bottom: leaves (in the upper corners); a sunflower (bisected by the backbrace); a bird of wisdom and prayer – traditionally an eagle; a bird nest with nestlings atop a flowering tree with a winding trunk and nuts or berries. The flowers represent girls; the boys are represented by nuts. Two bears (clan symbols) face each other across the bottom edge. Such design patterns are due in part to the proximity of French Canadian embroidered coverlet designs.

Ordered from O Kwa Ri, Caughnawaga, Quebec, August 1981; received May 1982.

40

41, 42

40

RATTLE, 1981
Elm bark, commercial hide thong
8" l.

Maker unknown
Mohawk
Caughnawaga Reserve, Quebec

Elm bark folded rattles are used at various Iroquois festivals to keep time to the singing and recitations. This example is embellished with a turtle clan symbol gouged and painted black.

Purchased at O Kwa Ri, Caughnawaga, Quebec, August 1981.

41, 42

BEAR COMB, 1983
Moose antler
3⅛" h. x 2³⁄₁₆" w.

OTTERS COMB, 1983
Moose antler
3¹⁄₁₆" h. x 2⅛" w.

Stanley Hill
Mohawk
Resident at Grand Island, New York

"Dad's out on his motorcycle in the woods," Mrs. Stanley Hill informed me when I pulled up with her son Rick at the family home, a ranch house on Stony Point Road, Grand Island, New York. Stanley Hill used to be a high-steel construction worker, but at the age of 53 he found that he had a natural gift for carving bone. Today he is the exemplary of an industrious, hard-working artist in business for himself, but, according to his son, "When he isn't carving or off at a show, he's out on his motorcycle for a run."

Stanley Hill is celebrated for his bone carvings depicting Iroquois legends – the tree of peace, the corn spirit, the turtle, clan symbols, guardian eagles – carried out in a rich, highly personal narrative style. These figure carvings are made from moose antler. "Dad does a business with taxidermists and bone people all over to get his bone supply [which is stockpiled in his garage by his work bench]." His carvings have been widely exhibited and have won over sixty awards. This art uniquely extends into our day what had become a lost manifestation. "Iroquoian artistry in bone reached its height in the 1600s with the manufacture of antler hair combs and ladles (also awls and needles), often decorated with animal, bird, and human effigies."*

Did Stanley Hill also carve objects more closely linked to the art of the past of his people, I had wondered, for such carvings were not illustrated in the publication on his work.

43

44

43

In the Hill basement the answer was laid out: several old-style combs, a ladle or two, and a bone rattle.

The artist's response to certain observations was practical. The somewhat smaller comb shown here is more elaborately worked than old examples: "Look at the work on the otters; that's $250...the other has far less work on it...$100." This simpler work is included here because in its archaism it is closer to older examples, although there is no direct copying. The idea of surmounting combs with animal effigies stems from archaeological times. Sometimes Hill includes a human figure in the center. When queried about it he began to explain, "This is the great...er...figure of...," then exclaimed in frustration, "Who knows what it means!"

Legends of the Iroquois as Told by the Carvings of Stanley Hill, n.d.

Purchased from the maker, June 1983.

SALT CONTAINER, 1981
Cornhusk, corncob
6¼" h. (without stopper); stopper 2¾" l.

Maker unknown
Mohawk
Caughnawaga Reserve, Quebec

Several of the Iroquois cornhusk workers make old lime salt bottles along with cornhusk moccasins and, of course, "husk face masks." This container probably comes from Six Nations Reserve, Ontario, but it was sold at Caughnawaga, Quebec. The technique is coiled braiding, and the corncob stopper is traditional.

Purchased at O Kwa Ri, Caughnawaga, Quebec, August 1981.

44

DOLL, 1983
Cornhusk, cloth, beads, wool, buckskin, commercial hide
8½" h.

Edna Parker
Seneca
Tonawanda Reservation, New York

Several years ago I chanced on a beautifully made and decorated Iroquois cornhusk doll in the shop of the Museum of the American Indian in New York City. I hesitated; on returning to the shop later, I found that the doll had been sold. Who had made it remained a mystery.

I found this surprisingly similar doll at the Winona Trading Post in Santa Fe. It had a beaded "tree of life" design on the skirt and the same exquisite workmanship. How had it gotten there? Clayton Brascoupé, a Seneca

77

45

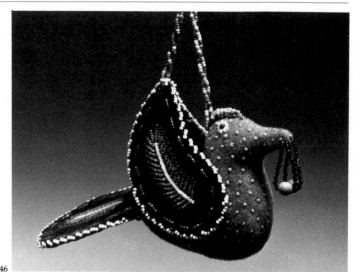

46

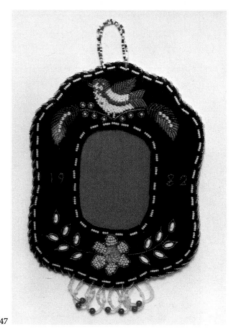

47

45

PADDLE, 1980
Maple
18½" l.

Hiyásta and Giwáyas
Seneca
Six Nations Reserve, Ontario

Carved of soft maple and smoothed to a satin finish, paddles like this are used to stir corn soup, stews, and mush. They take on a velvety patina with use. Paddles with narrower blades are used to stir maple syrup. The makers, whose Indian names are given, are a husband and wife carving team.

Purchased at Iroqrafts, Ohsweken, Six Nations Reserve, Ontario, August 1980.

46, 47

BIRD (BEADED FANCY), ca. 1980
Velvet, beads, felt, rayon, satin
5" h. x 7¼" l.

Matilda Hill
Tuscarora (Iroquois)
Tuscarora Reservation, New York

PICTURE FRAME (BEADED FANCY), ca. 1980
Velvet, beads, felt, rayon, satin, cardboard
8½" h. (excluding fringe) x 6¼" w.

Louise Henry
Tuscarora (Iroquois)
Tuscarora Reservation, New York

These bright bits of Indian fancy belong to a class of objects created to catch the eye of mid- and late-nineteenth-century visitors to Niagara Falls. In the late nineteenth century the making of "fancies" was a major Tuscarora cottage industry. One often finds them with beadwork inscriptions, "Niagara Falls 1970," or today, simply "Love." Other fancies include pincushions, purses, and heavily beaded model footwear. I despaired of finding this old quillwork

carver of flutes married to a Tesuque Pueblo woman and resident there, had brought the doll to Santa Fe. "I was in Tonawanda a few months ago and brought it back with me," he explained. "I can't remember her name, but she's well known and ran the museum shop."

Following this lead I thumbed through the Iroquois Arts Directory,* and I found Edna Parker. Mrs. Parker began making dressed cornhusk dolls for her husband's museum and crafts shop about 1950. She is also a beadworker and up to ten years ago made traditional clothing and baskets.

*Christina B. Johansen and John P. Ferguson, eds., *Iroquois Arts: A Dictionary of a People and Their Work* (Warnerville, N.Y.: Association for the Advancement of Native North American Arts and Crafts, 1983). Purchased at Winona Trading Post, Santa Fe, April 1984.

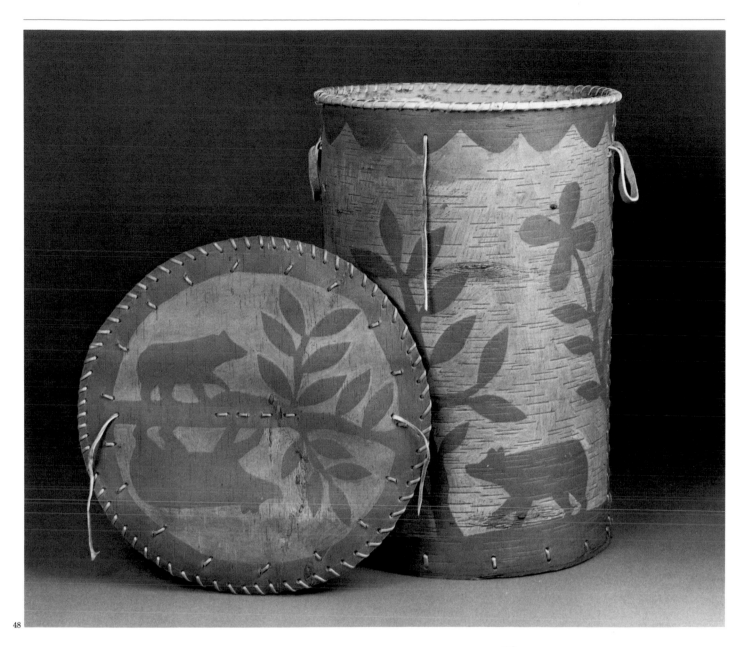

48

48

still at its best (inferior examples still come from Caughnawaga) until I gazed at the bulletin board outside the bedroom of Mrs. Alma Hill, wife of the Mohawk carver Stanley Hill (cat. nos. 41, 42). Quality examples dangled and swayed all over the board. She parted very reluctantly with this example of the work of Matilda Hill (no relation), who is now too old to do any more work of this kind. But, "I just can't part with the beaded picture frame," Alma Hill demurred as I held one questioningly. "I'll find you another one," her son promised. "There are several people at Tuscarora she [Matilda Hill] taught, and their work is excellent."

The beaded motifs on the wings and tail of the bird go back to the old-style Iroquois fancies and are rarely encountered today. The polka-dotted breast is more contemporary in feeling. "Beats any tea cozy I ever saw," was one white comment. But tea-cozy chickens were never made to dangle like a mobile, or made as an independent object in the Indian way. "We've always had charms; everything that's new is old with us."

The practice of making non-functional decorative accessories which grew out of the Niagara Falls fancies, the earliest work of this kind, has blossomed anew in our own time. The reservation tract house and the automobile interior have provided a terrain eminently suited to the display of such items as miniature war bonnets (in which safety pins substitute for feathers), tiny water drums (some even equipped with beaters), beaded animals, feather decorations, God's Eyes (see cat. no. 326), and the like. They are hung about as talismans of Indianness and also because they are pleasing.

Purchased from Mrs. Stanley Hill, Grand Island, New York, June 1983.

LARGE LIDDED BIRCHBARK CONTAINER, 1980-81
Birchbark, spruce lacing, smoked hide ties
24" h. x 17¼" diam. (lid)

Maker unknown
Algonkian (group unknown)
Quebec

This outsized container is based on the modern refuse can. (The older form of *mukak* from the same cultural area is represented by catalogue number 29.) It requires strong sheets of bark such as would be used in canoe-making, and plenty of room for imagery is implicit in the size.

The parade of animals – bear, rabbit, and bird in a forest – is enhanced by the scene on the lid in which a bear walks along the shore, with its reflection extending below.

Purchased at Iroqrafts, Ohsweken, Six Nations Reserve, Ontario, August 1981.

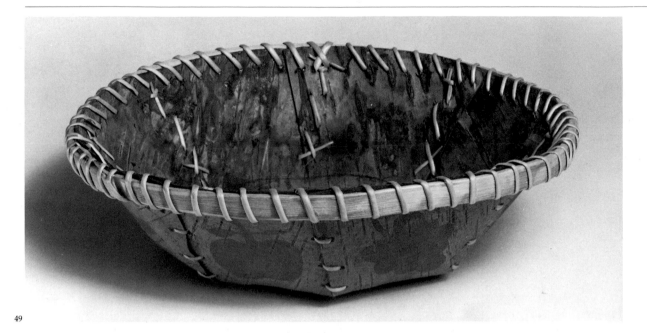

49

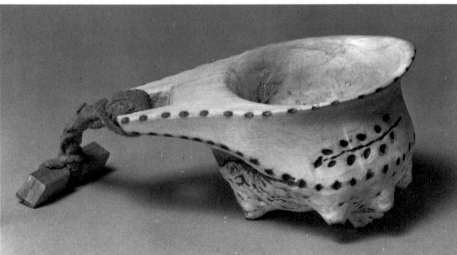

50

49

Fruit bowl, ca. 1980
Birchbark, wood, spruce lacing
4½" h. x 12¼" diam.

Maker unknown
Eastern Algonkian
Quebec

While a non-traditional type of birchbark work, this pie-shaped bowl – with its equally non-traditional grape, pear, banana, and apple motifs scraped on the outside – slips comfortably into an Indian measure of such things. It seems at home with the past, perhaps because of the natural materials out of which it is made.

Purchased at Whetung Ojibwa Crafts, Curve Lake Reserve, Ontario, August 1981.

50

Dipper, 1980–81
Ash
5⅜" l.

Maker unknown
Algonkian (group unknown)
Eastern Canada

Made from an ash burl, this drinking cup or dipper has burned-in dot-and-leaf stem designs typical of the decoration applied to Northeastern Woodlands carvings such as crooked knives or clubs. (Old Penobscot clubs were also decorated with engraved leaf patterns.) This sturdy receptacle is provided with a commercial thong and a small wooden block for attachment to a belt-loop.

Purchased at Whetung Ojibwa Crafts, Curve Lake Reserve, Ontario, August 1981.

SOUTHERN WOODLANDS

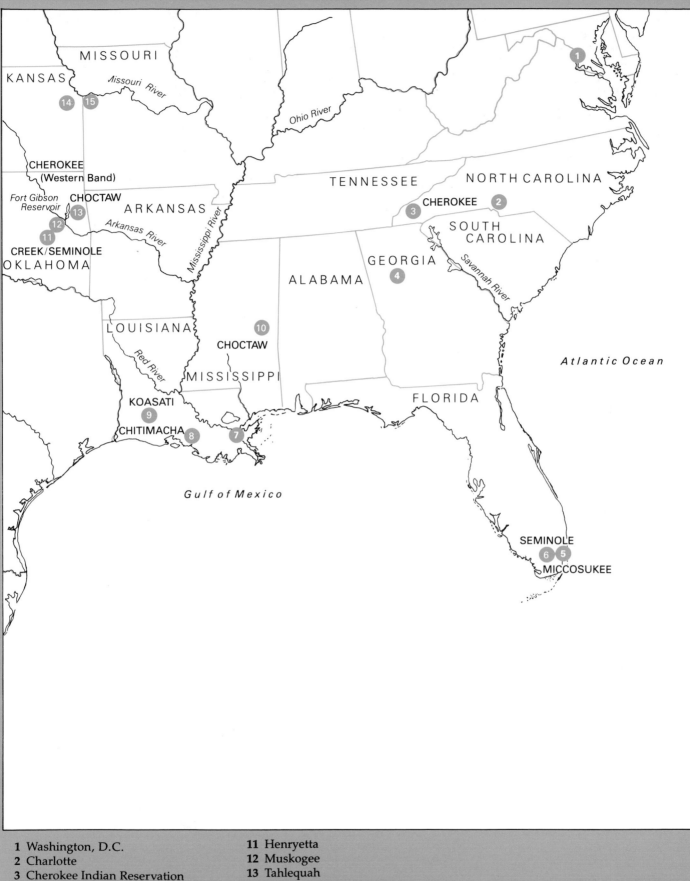

1 Washington, D.C.
2 Charlotte
3 Cherokee Indian Reservation
4 Atlanta
5 Miami
6 Miccosukee Indian Reservation
7 New Orleans
8 Chitimacha Indian Reservation
9 Elton
10 Philadelphia

11 Henryetta
12 Muskogee
13 Tahlequah
14 Lawrence
15 Kansas City

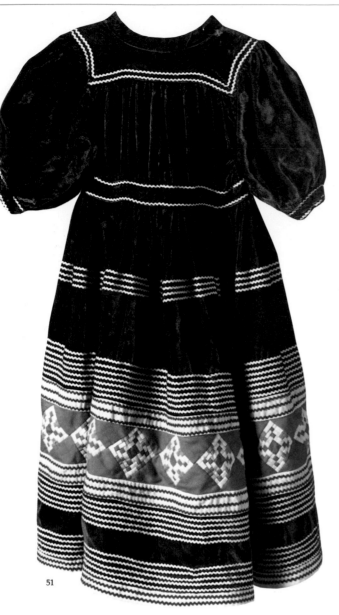

51

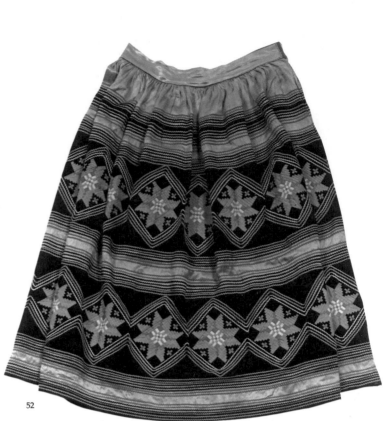

52

51, 52, 53

PATCHWORK DRESS FOR YOUNG GIRL, 1984
Velveteen, cotton, rickrack
27″ l. x 22½″ w. (across shoulders)

Margie Saunders

PATCHWORK SKIRT, 1984
Cotton, rayon satin, rickrack
35″ l. x 52½″ w. (at hemline)

Annie T. Jim

PATCHWORK JACKET, 1984
Cotton, rickrack
31″ l. x 65″ w. (across shoulders)
(see colorplate, p. 114)

Mary T. Osceola

Miccosukee
Miccosukee Indian Reservation, Florida

The Seminole and the Miccosukee people of Florida have not lost their unique art of patchwork clothing, which has developed in several stages since sewing machines were introduced among them by South Florida traders around the turn of the century. "The hum of the electric sewing machine can be heard from the open-sided chickee, where the Miccosukee woman sits patiently sewing long rows of patchwork."*

The patchwork dress worn by a young girl until she outgrew it – in the case of catalogue number 51, the granddaughter of the maker, Margie Saunders – is derived from the Seminole dresses of the 1890s or early 1900s, except that the rows of segmented designs are of contemporary complexity. The skirt by Annie T. Jim (cat. no. 52) has even more complex patterns, of a type reserved only for personal use and is not made for sale. It was bought from the maker, who appeared wearing it on her porch. "We call those designs the snowflake pattern," she volunteered. The man's jacket made by Mary Osceola (cat. no. 53) is of a contemporary type, though it is fastened with safety pins, rather than the buttons characteristic of "the older way."

Annie T. Jim and Mary T. Osceola are sisters; their brother is chairman of the Miccosukee tribe.

*Dorothy Downs, Miccosukee Arts and Crafts (Miami: The Miccosukee Tribe of Indians of Florida, 1982), p. 7.
Catalogue number 51 purchased at Shark Valley Arts and Crafts, Miccosukee Indian Reservation, Florida, March 1984.
Catalogue number 52 purchased from maker, March 1985.
Catalogue number 53 purchased from Pete Osceola, Santa Fe Indian Market, New Mexico, August 1984.

54, 55, 56

WASTEBASKET, 1981
River cane
16″ h. x 13½″ w. x 13½″ d.; diam. at shoulder 21½″ (irregular)

"COFFIN" BASKET, 1982
River cane
10″ h. x 13½″ w. x 8½″ d.
(see colorplate, p. 115)

LIDDED STORAGE BASKET, 1983
River cane
15″ h. (including lid) x 14″ w. x 14″ d.

Rowena Bradley
Cherokee
Swimmer Branch Community, Cherokee Indian Reservation, North Carolina

Rowena Bradley was taught to make baskets at the age of seven, before she went to school, by her distinguished mother. "I learned how to weave baskets because I wanted to. I enjoy doing it and always have, or I wouldn't have started at such an early age." She is acknowledged to be the foremost master of river cane basketry and "one of the most talented, creative basketweavers in the United States."* She is particularly expert at double weaving, in which one basket (the outside) is joined by a

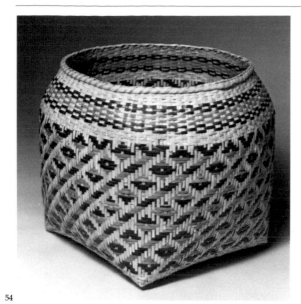

54

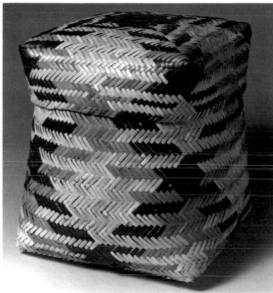

56

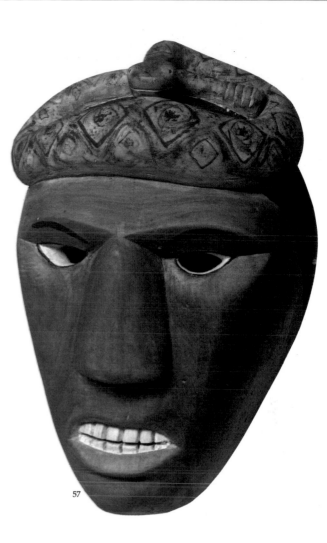

57

57

seamless edge to another separately woven inner basket, called a "return." The double weaving results in a striking difference in pattern between the exterior and interior (between the inner and outer baskets), and one is as interesting to contemplate as the other. Mrs. Bradley handles the river cane plaiting with an ease that assures largeness of form at the same time that it engenders an admirable firmness of weave; volume and detail live in harmonious accord in her work.

The lidded storage basket (cat. no. 56) is a double-woven basket with a broad diagonal zigzag design that is carried expansively over cover and body alike. In this type of work the directional colors pick up on the diagonals of the plaiting, creating a rich interlocking geometrical effect made all the more sumptuous by the pile and the give-and-take tactility of the double weave.

The coffin basket – the descriptive refers to its shape, not its purpose – is of historical interest. The British Museum in London has the oldest documented Cherokee basket, a "coffin" type of the early eighteenth century.** Rowena Bradley's mother made a version of this basket years ago; it is exhibited today at the Museum of the Cherokee Indian, Cherokee, North Carolina. The present double-woven

basket is Rowena Bradley's variant of this hallowed object. Hers is in no way a copy of either, but is rather among the designs that are "ones I have worked out." In her creative hands, such reverence becomes the springboard for free artistic association.

The wastebasket (cat. no. 54) is a single-woven basket in which the interior becomes a reverse projection of the exterior "Jacob's Ladder" pattern, increasing our perception of the volume captured within the basket's continuum and its simultaneous displacement of space without. The dyes are natural, derived from butternut root and bloodroot.

Rivercane Basketry by Rowena Bradley, exhibition catalogue (Cherokee, N.C.: Qualla Arts & Crafts Mutual, Members Gallery, 1974), n.p.
**The basket was formerly in the collection of Sir Hans Soane; see Christian F. Feest, *Native Arts, North America* (New York: Oxford University Press, 1980), p. 11, fig. 5.

Catalogue number 54 purchased at Qualla Arts & Crafts Mutual, Cherokee, North Carolina, May 1983. Catalogue numbers 55 and 56 purchased at El Camino Indian Gallery, Cherokee Indian Reservation, Cherokee, North Carolina, May 1983.

SNAKE MASK, 1982–83
Buckeye wood, shoe polish
14" h. x 9" w. x 5½" d.

Allen Long
Cherokee
Big Cove Community, Cherokee Indian Reservation, Cherokee, North Carolina

The rattlesnake was held sacred by the Cherokee, and when danced by medicine men or warriors, the Snake Mask denoted curing, or intention to do battle. Night celebrations, called booger dances, included masks of Indians, as well as whites and blacks, those people particularly who came to America whose encroachment threatened the Indians. In addition, there are animal (hunting) masks, including a Skin Mask (wild cat) used to stalk wild turkeys, and gourd masks with grotesque phallic noses and pubiclike hair patches, in effect, sexual buffoons annoying to women.

A strong element of social control and balance infused the use of these masks; however, they are no longer danced. "We lost that in the 1940s," said Allen Long, son of traditionalist Will West Long. Now in his sixties, he can remember "back a long time ago, they used to put·on masks and dance all night. I just

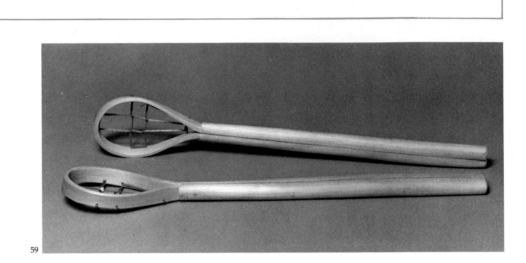

58

59

watched and learned to make some of the native masks. I first started carving masks when I was about twelve. I learned to carve from my father. He used red clay to color his masks, but today I use shoe polish because red clay sometimes comes off on your hands."

Strong archaeological evidence indicates that there once existed an ages-old tradition of wood carving in the eastern section of what is now the United States, of which only a portion survives, most notably among the Iroquois. No Iroquois masks are included in this project (see ch. 3, n. 10); this tradition is represented here by the Cherokee.

Purchased at Qualla Arts & Crafts Mutual, Cherokee, North Carolina, May 1983.

58

BLOWGUN AND TWO DARTS, 1983
River cane
Blowgun 47¼" l.; darts, each 12" l.

Hayes Lossiah
Cherokee
Cherokee Indian Reservation, Cherokee, North Carolina

After it has been cut to the desired length, the selected river cane stalk is straightened by heating. When used, a dart is inserted and the gun is placed in the mouth. A puff of breath releases the dart at the moment the aim establishes a trajectory that is satisfactory. The dart will travel sixty or seventy feet killing small game or birds. Today it is used in contests of skills at the Cherokee fall festival and "sometimes we kill a rabbit or two with it."

This blowgun is a wholly traditional example of an object of simple undecorated utilitarian beauty that has continued unchanged through the centuries. It is longer (therefore more efficient) and purer in concept than some highly decorated modern examples, which are first and foremost vehicles for beadwork display. The old-style gun is austere in its simplicity, but it has truer range and greater accuracy than those that have forsaken purity of concept for decorative effusion.

Purchased at Qualla Arts & Crafts Mutual, Cherokee, North Carolina, January 1984.

59

PAIR OF BALL-GAME STICKS, 1983
Hickory, fiber
21⅜" l.

Posey Long
Cherokee
Soco Community, Cherokee Indian Reservation, North Carolina

Posey Long is the veteran maker of ball-game sticks among the Eastern Cherokee, and he has won several first-place prizes at the Cherokee Indian fall festival. He also whittles wooden spoons. The hickory has to be straight, and it often takes half a day in the field to find the right wood. The shape is carved, the wood is bent after soaking and then pegged along the handle. The sticks are then hung for several days to season by drying.

The Cherokee ball game is a no-holds-barred game and includes chopping an opponent with the sticks, strangleholds, kicking. It is still played at the fall festival on the Qualla Boundary.

Purchased at Qualla Arts & Crafts Mutual, Cherokee, North Carolina, May 1983.

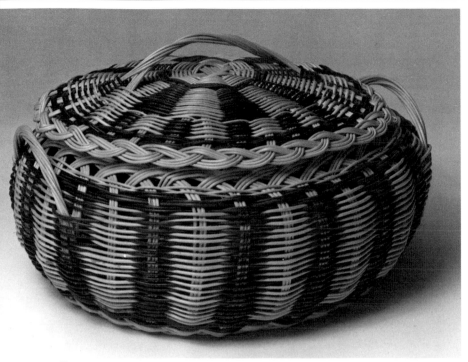

60

61

60

LIDDED BASKET, 1981
Buckrush, walnut dye
8½″ h. x 14″ diam.

Ella Mae Blackbear
Cherokee (Western Band)
Oklahoma

Buckrush basketry is the specialty of the Oklahoma Cherokee, who turned to this native flora after their nineteenth-century removal from the Southeast to Oklahoma. Many Western Cherokee baskets are small tourist items, but this double-woven example (except for the lid which is single-woven) by one of the finest contemporary weavers is a tour de force of buckrush weaving. The buckrush used here had probably remained from the summer of 1980, for the intervening harvest of this material had been poor.

Mrs. Blackbear has won many awards, including the Gallup Ceremonial first prize for baskets. Her work is included in the Museum of the Five Civilized Tribes in Muskogee, Oklahoma.

Purchased at Tahmels Indian Jewelry, Tahlequah, Oklahoma, April 1982.

61

SASH, 1983
Synthetic wool
68″ l. x 5⅝″ w. (including fringe)

Mary Shell
Cherokee (Western Band)
Tahlequah, Oklahoma

This single-weave sash is made of wools dyed in colors that recall the russet shades of the natural dyes used in Cherokee river cane basketry (cat. nos. 54–56). Such wide sashes could be folded around the head to form a man's turban. The plaid pattern here and in catalogue number 56 may echo the Scots-Irish bloodline shared by many Cherokee since the later eighteenth century, but chevron patterns are also used.

Mary Shell is the best-known Western Cherokee sash weaver. After a start at finger weaving learned from Myrtle Youngbird, Mrs. Shell on her own learned the different designs. She has often worked as a demonstrator at Ocanaluftee Indian Village since 1956, where I found her on the annual opening day of the village in May 1983, weaving steadily. "There are not many Cherokee women who do this type of weaving today. I have taught others, including two of my three daughters, with the hope that this craft will continue among my people.... Working out the different designs and blending the colors of the wool have always been the parts of this form of weaving which continue to hold my interest."*

*Statement in Juanita Hughes, *Wind Spirit: An Exhibition of Cherokee Arts and Crafts* (Cherokee, N.C.: Museum of the Cherokee Indian and the Qualla Arts & Crafts Mutual, n.d.), p. 26.
Purchased at Qualla Arts & Crafts Mutual, Cherokee, North Carolina, May 1983.

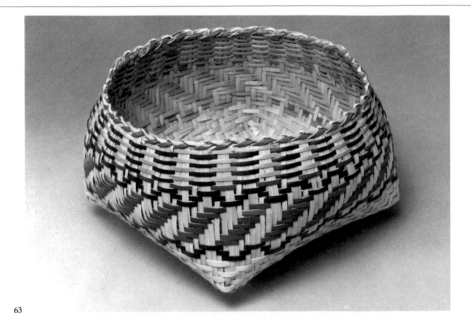

63

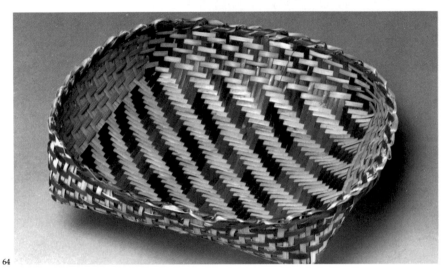

64

62

BRACELET, 1981
Silver, pink mussel shell, turquoise
1⅞" w. x 2⅝" l.

Craig Crider (silver work)
Larry Ridge (lapidary work on mussel shell)
Cherokee (Western Band)
Tahlequah, Oklahoma

This bracelet represents the very best in present-day Southern Woodlands area sterling silversmithing. Though derived from Southwestern jewelry – "We all went down to the Southwest at one time or another," says Bob Blue, a Kansas City Choctaw silversmith – it retains a flavor of its own. Pink mussel shell from Fort Gibson Reservoir has been popular with Oklahoma smiths from the Delaware to the Five Civilized Tribes for the last two decades.

Craig Crider is one-fourth Cherokee. He thinks over designs for a long time and says he put one hundred hours into the bracelet. Larry Ridge, whose specialty is lapidary work, is a full-blood Cherokee.

Purchased at Tahmels Indian Jewelry, Tahlequah, Oklahoma, April 1982.

63, 64

SMALL STORAGE BASKET, 1982
Cane reed, dye
6" h. x 6" w. x 3¼" d.

SMALL FANNER BASKET, 1982
Cane reed, dye
6½" h. x 6½" w. x 1½" d.

Ada Thomas
Chitimacha
Chitimacha Indian Reservation, Charenton, Louisiana

The Louisiana bayou Chitimacha practiced a particularly charming, delicately scaled variant of Southwestern cane basketry; even pre-1900 baskets (usually lidded) were intimate productions, exquisitely plaited. The tradition continues today in the hands of the sole remaining full-blood Chitimacha basket artist, Ada Thomas, most of whose baskets, like these, are single-woven. She made double-woven lidded baskets up to ten inches square for the exhibition held in 1981 at Louisiana State University,*

for which she had received a Craftsmen's Fellowship Grant from the National Endowment for the Arts, but light, airy single-weave baskets are her usual work.

Since farmers have used the adjoining river land and sprayed it with chemicals that killed off the vegetation that was the source of Chitimacha native dyes, today black, red, and yellow chemical dyes are tastefully used to accent the cane plaiting, with yellow used especially sparingly. The effect, if different, is authentic in a restrained, freshly creative contemporary way, an integral add-on to tradition.

Fanner baskets were used in winnowing. The design on the fanner basket is "alligator entrails"; the one on the shoulder of the small storage basket is "alligator necklace."

*Masterpieces of Chitimacha Basketry – Contemporary and Traditional, exhibition organized by the U.S. Department of the Interior and others, Anglo American Art Museum, Louisiana State University, Baton Rouge, January 11–March 14, 1981.

Purchased at the Holiday Inn Gift Shop, Cherokee, North Carolina, May 1983.

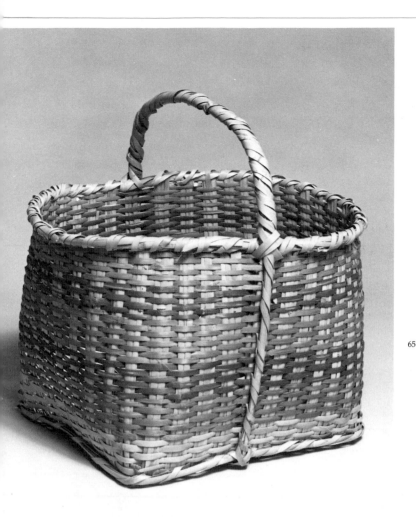

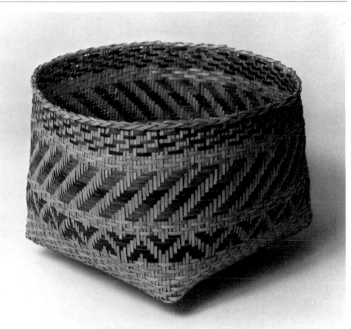

65

62

66

65

BASKET, ca. 1975
River cane, natural dyes
8½" h. x 11¼" diam.

Lorena Langley
Koasati
Elton, Louisiana

Southeastern river cane baskets have a notably different appearance and feel from Northeastern ash and oak splint work. The reed, which comes right from the ground and is not stripped from the tree, has a slender flexibility, which is part of the aesthetic of cane basketry. It creates a mesh, not dissimilar to chair caning. The shapes are often tublike, with substantial lids. Even when unlidded, as in this masterpiece by Lorena Langley, the side walls spring with a metallic tensile strength, almost the tautness one associates with tennis racket webbing. The weaving seems all of a piece. There are no add-ons, such as "porcupines" or ribbonwork; the changes in color or patterns occur in the plaiting itself. The result is a close surface interplay of texture and design, more like a textile than a construction.

If Cherokee work aspires to monumentality, and uses a wider cutting of cane, and Chitimacha work to diminutiveness, the Koasati work tends to fall between, striking a classic balance. Lorena Langley's control is as tight as Chitimacha work (see cat. nos. 63, 64), but it works up into larger scale. Actually, Ada Thomas's caning is cut only a fraction thinner than that incorporated by Lorena Langley into this basket. The design systems today are close in both tribes, except for the occasional employment of the Chitimacha running rattlesnake motif on the more traditional baskets. While Chitimacha cane is dyed on one edge only, Koasati cane is immersed in the dye, in order to convey interesting design reversals on the basket interior.

Purchased at a decorator's shop on Armitage Avenue, Chicago, winter 1976.

66

MARKET BASKET, ca. 1980
Swamp cane, commercial dyes
15⅜" h. (including handle) x 15¹⁄₁₆" w. x 13½" d. (at base)

Mollie Smith
Choctaw
Philadelphia, Mississippi

Choctaw basketry is rougher in workmanship than Cherokee or Koasati work. The cane is cut in wider bands and freely wrapped around the handle, as in old Alabama and Houma basketry. While the effect is not as subtle, there is a wickerlike strength of effect. This basket is woven by extending single weavers under and over gatherings of three vertical standards, a summary but sturdy technique.

Repeated attempts to acquire an example of the "elbow" form of basketry, a specialty of the Choctaw, were not successful.

Purchased at Native American Artists, Ltd., Lawrence, Kansas, spring 1981.

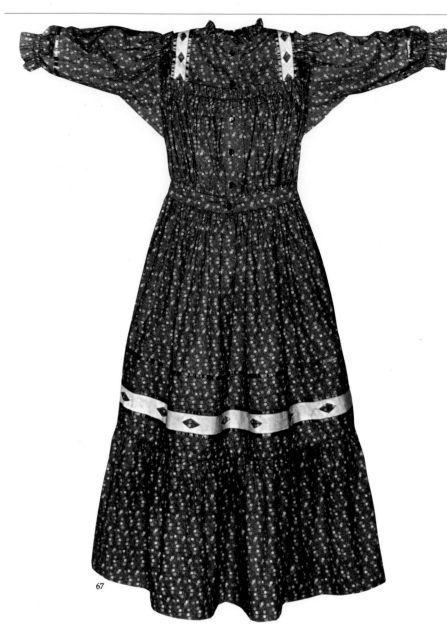

67

67

CHEROKEE "TORN-TAILORED" DRESS, 1982
Cotton, ribbon, buttons, elastic
58⅞" l. x 44¾" w.

Phyllis Fife Patrick and Sharon Fife Mouss
(The Fife Collection)
Creek/Seminole
Henryetta, Oklahoma

Cherokee women still dress in old-style puff-sleeved long dresses when the honor of the occasion demands. This dress could just as well have graced the Greek Revival colonnaded porch of the Cherokee Girls' Seminary at Tahlequah, the Western Cherokee capital, in the 1860s or 1870s. They are especially convenient because they do not require extensive alteration to make them fit; an adjustment at the elastic waistband will usually do.

Cool, gracefully gathered at waist and cuffs, these dresses are comfortable yet poignantly *retardataire*. Long ago the Cherokee amalgamated large parts of the southern white planter culture into their life-style and at times cling to this past.

Although acquired on the Qualla Boundary, North Carolina, this dress is Oklahoma work, part of the give and take between the Eastern and Western Cherokee Bands. It was designed and created in the late fall of 1982 at the Fife Collection by Phyllis Fife and her sister Sharon Mouss, young Creek/Seminole women, according to the ironed-on label at the collar.

Purchased at El Camino Indian Gallery, Cherokee Indian Reservation, Cherokee, North Carolina, May 1983.

1 Red Lake Indian Reservation
2 Bagley
3 White Earth Indian Reservation
4 Bemidji
5 Leech Lake Indian Reservation
6 Mille Lacs Indian Reservation;
 Onamia; Isle
7 Duluth
8 Grand Portage (Minnesota)
9 Thunder Bay
10 Agawa Bay
11 Escanaba

12 Neopit
13 Wittenberg
14 Minneapolis
15 Neillsville
16 Tomah
17 Wisconsin Dells
18 Baraboo
19 Madison
20 Tama Settlement; Toledo
21 Des Moines
22 Jones
23 Chicago

24 Petosky
25 Hubbard Lake
26 Wikwemikong Reserve; West Bay
 (Manitoulin Island)
27 Detroit
28 Toronto
29 Curve Lake Reserve

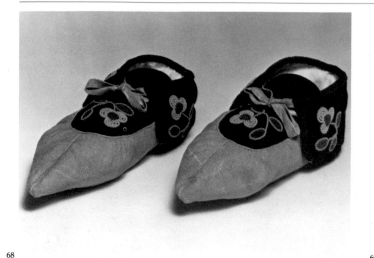

68

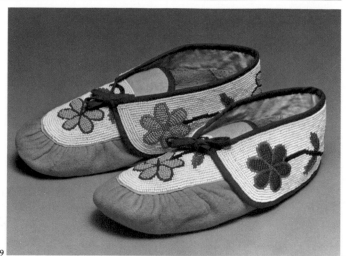

69

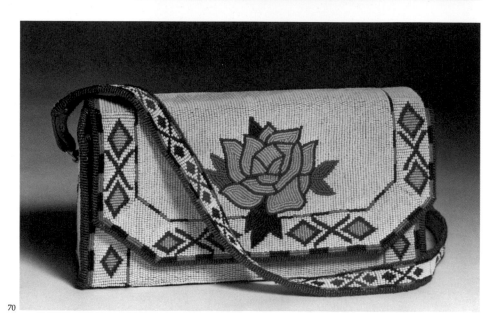

70

68, 69

OLD-STYLE MOCCASINS, 1980
Buckskin, beads, velvet, cloth, thread
4" h. x 9½" l.

Batiste Sams

NEW-STYLE MOCCASINS, 1980
Buckskin, beads, velvet, cloth, thread
3¼" h. x 8⅞" l.

Wabuse (Rabbit)

Ojibwa
Mille Lacs Indian Reservation, Minnesota

These two pairs of moccasins, made during the same year, demonstrate the coexistence of tradition and innovation in the best Ojibwa footwear produced today. The old-style moccasins are in the pointed-toe fashion prevalent among the Ojibwa in the period from 1880 to 1920. The ankle flaps and uppers are faced with black velvet, the preference of the time, but the beaded flower designs are less elaborate than would have formerly obtained. The new-style moccasins are a modified traditional pair, the toes rounded rather than pointed. Solid beading has replaced the old velvet, and the ties are no longer made of buckskin, but the result is full of integrity and authenticity.

Catalogue number 68 purchased at the Mille Lacs Indian Museum, Onamia, July 1980.
Catalogue number 69 purchased at Fort Mille Lacs Village, Onamia, Minnesota, July 1980.

70

PURSE, ca. 1970–75
Beads, commercial leather, velvet
6½" h. x 13" w.

Maker unknown
Ojibwa
Western Ontario

This purse is noteworthy for a number of reasons. First, it is a sumptuous example of full-field beading, a rarity in Algonkian art today. Next, it displays the Ojibwa rose, the source of a motif that has in our time traveled from Canadian Ojibwa lands in Western Ontario to the Canadian Cree, to the Rocky Boy Chippewa/Cree of Montana, and even to the Wind River Shoshone of Wyoming. Also, this bag is a modern-day variant of the beaded purses and doctors' bags that have been produced on the edge of the Woodlands, the Prairies, and particularly the Plains since after the Civil War.

Purchased at Agawa Bay Trading Post, Ontario, July 1980.

71

BANDOLIER BAG, 1980–82
Cotton velveteen, linen, beads, cotton backing
42½" l. (including shoulder straps) x 15" w.
(see colorplate, p. 119)

Maude Kegg
Ojibwa
Mille Lacs Indian Reservation, Minnesota

In June 1979 Mrs. Martin Kegg was discovered in the entryway to the Mille Lacs Indian Museum where she is an invaluable resource person in the summer. She was sitting before a worktable pinning a tracing-paper design onto a linen backing with the help of her colleague, Mrs. Jessie Clark (see cat. no. 72).

"That looks like it's going to be the facing for a bandolier bag."

"It is."

"I didn't know such things were still being made."

"We generally don't, but I thought I'd do one."

The bag was three years in the making. Maude Kegg worked on it in San Diego during the winter while visiting her daughter and at Mille Lacs during the summer. Progress was interrupted first by illness, then by a shortage of old-fashioned black cotton velveteen, for which a rayon substitute could not serve because "it is too stiff to make a flexible bag."

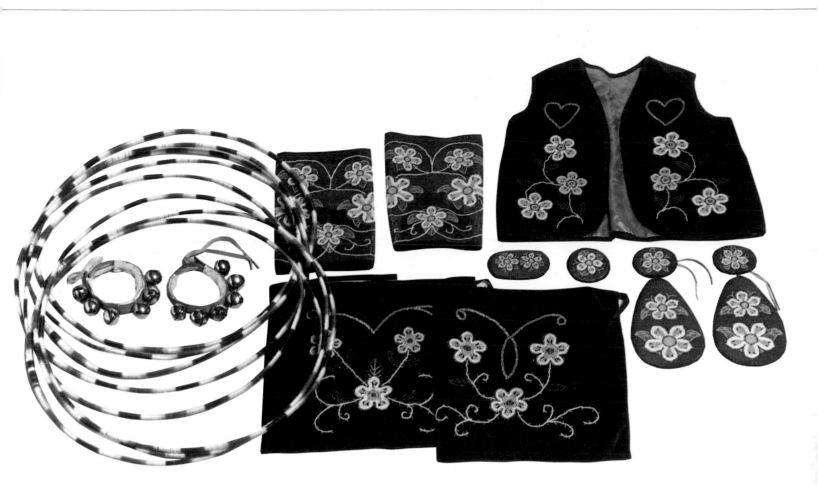

72

Finally, in the fall of 1982, with the proper fabric supplied, the bag was finished (fig. 10).

The end result of Maude Kegg's effort is an Ojibwa masterpiece, as fine as any bandolier bag worn for prestige by an Ojibwa dignitary in the past. In design it follows the white-field flowered type popular in the 1890s and early 1900s, but it is more colorful than bags of the past. No two floral elements are treated in exactly the same way, making the color a variegated tour de force. The strap and panel are spot stitched, the bottom tabs are loom beaded. The ribbed flower on the bag and strap is a personal choice of the maker.

In the past, during the fluorescence of Ojibwa beaded clothing after 1870, as many as six or more of these bags (developed from the military shot pouch) would be worn for special occasions. In our time only two fully beaded bags have been made at Mille Lacs, this one and one other made by Mrs. Jessie Clark. "It's a passing thing," said trader Sherman Holbert, "she just decided she'd make one. That's Maude for you. No one wears them today. You were lucky."

In December 1984, when a film crew visited a considerably frailer Maude Kegg, she was in the process of making two more.

Ordered from the maker, June 1979; received November 1982.

GIRL'S HOOP DANCE OUTFIT, 1978–85
Velveteen, beads, Velcro, cloth ties, wood, yarn
Vest 18" l. x 18½" w.
Leggings, each 11¼" l. x 14" w. (unfolded)
Eardrops 10¼" l.
Hoops 19" diam. (average)
Pair of aprons, each 13¾" l. x 14" w.
Hair ornament 3" diam.
Hair ornament 2¾" h. x 4¼" w.

Jessie Clark
Ojibwa (Mille Lacs Indian Reservation, Minnesota)
Resident at Minneapolis

When I found Mrs. Kegg tracing the patterns for her bandolier bag (cat. no. 71), her colleague Mrs. Clark was helping her. It was at that time that I heard of the velveteen dance outfit Mrs. Clark had partially completed for

her daughter, who was getting too big for it. Of special interest was the mention of beaded flowers on velveteen, a type of beading popular at the turn of the century among the Ojibwa of the Great Lakes.

Over the years we remained in touch. In 1980 Mrs. Clark had run out of velveteen; extensive search did not produce the same burgundy colored material, a failure that led to Mrs. Clark's decision "to solid bead the leggings. It's not traditional, but I'll have to do it that way." Actually, the leggings are all the more radiant for the non-traditionalism of the full-field beading. The outfit was finally finished Christmas 1985. Not until I opened the box did I realize that this traditional costume doubles as a modern Hoop Dance outfit for powwow dances. Nine hoops, gaily wrapped in colored yarn, were included, made by Jim Clark.

Ordered from the maker, June 1979; received December 1985.

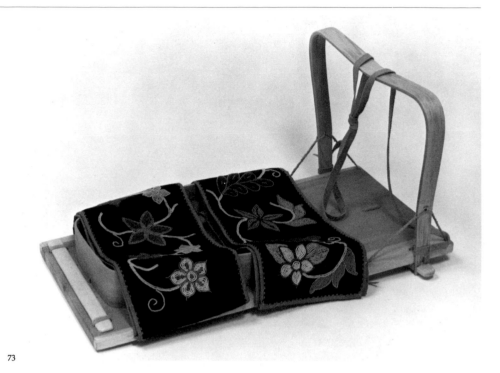

73

74

73

CRADLE AND TWO CRADLE WRAPS, 1982

CRADLE

Wood, bentwood, commercial-hide ties
24" l. x 10⅜" w. x 15" d. (projection of head protector)

Maker unknown
Ojibwa
Leech Lake Indian Reservation, Minnesota

TWO CRADLE WRAPS

Beads, velveteen, cotton
each 17¼" l. (panel) x 7" w.

Wabuse (Rabbit)
Ojibwa
Mille Lacs Indian Reservation, Minnesota

Among the Algonkian peoples, none made cradles more beautiful in their simplicity than the Ojibwa. This example was ordered to go with the pair of wraps already made by Wabuse earlier in the year. Such "married" components follow the old way. The Leech Lake cradle maker refused to be identified.

Purchased through Sherman Holbert, Fort Mille Lacs Village, Onamia, Minnesota: wraps, May 1982; cradle, October, 1982.

74

DANCE STICK, 1982
Bone, beads, otter and muskrat fur, fake sinew
19" l.

Ron Wilson
Ojibwa
Red Lake Reservation, Minnesota

"The eagle's claws at the ends were carved by my dad," said Ron Wilson when I met him by Mitchell Zephier's trading table (see cat. no. 143) at the National Congress of American Indians in Bismarck, North Dakota. "And I did the beading."

"That's the tightest and smallest beadwork I've seen on an Ojibwa piece," I observed.

"That stick has a lot of eagle and animal power," its maker admonished me. "You treat it right."

Purchased from the maker, Bismarck, North Dakota, August 1982.

75

ROACH, 1984–85
Yarn, porcupine fur, deer hair
20½" l.

Joe Hill
Ojibwa
Mille Lacs Indian Reservation, Minnesota

Joe Hill was taught the craft of making roaches by Fred Jones of the same reservation, who died in the mid-seventies. I had hoped this roach would be entirely finished in deer hair, but it turned out to have its base woven of yarn, which is the quicker, modern way of completing a roach. Later, Joe Hill began another roach, which was to be finished entirely in the old way with a deer-hair base.

Roaches are ceremonial imitations of the roach cut fashionable with eastern Indians until well into the nineteenth century and very occasionally are still seen today. This very long style of roach is typical of the Western Great Lakes and Northern Plains area today.

Purchased from Joe Hill through Sherman Holbert, Fort Mille Lacs Village, Onamia, Minnesota, 1985.

75

76

77

76

BIRCHBARK GARNITURE, 1979
Birchbark, quills, thread, sweet grass
Napkin holder 4½" h. x 4¼" w. x 4¼" d.
Square stamp box 2" h. x 3" w. x 3" d.
Oblong box 2" h. x 6½" w. x 4" d.

Terry Brightnose
Ojibwa (Mille Lacs Indian Reservation,
Minnesota)
Resident at Minneapolis

A handicapped Ojibwa woman, Terry
Brightnose makes her living by her skill in
fashioning small double-lined sweet grass-
edged bark containers with quilled "tulip"
decorations that make her work easily recog-
nized anywhere it is found. I have seen it for
sale as far west as Glacier National Park and as
far south as Anadarko, Oklahoma, where the
proprietor of McKee's Indian Store remem-
bered: "She used to come through here with
her station wagon, but I haven't seen her in
some time now."

These boxes belong to a long tradition of
sales items – for example, Micmac letter hold-
ers and card trays – made for the white market
by Woodlands Indians since the late eighteenth
century. The Ottawa on Manitoulin Island
make table mats and doilies, even bark teapots,
to this day. "It lets the woods into you without
your knowing it. It creeps up on you. All those
meadows and woods."

This set was selected from items by Terry
Brightnose available at the Mille Lacs Indian
Museum. "She brings in the pieces, but you
make up the set you want." This procedure is
quite prevalent in the world of Indian crafts.

Purchased at the Mille Lacs Indian Museum Sales
Shop, Onamia, Minnesota, June 1979.

77

TWO BIRCHBARK BOXES, 1981–82
Birchbark, basswood, ties
Oblong box 3½" h. x 9¾" w. x 6¼" d.
Square box 3⅛" h. x 4⅞" w. x 4⅞" d.

Wabuse (Rabbit)
Ojibwa
Mille Lacs Indian Reservation, Minnesota

In 1981 Fort Mille Lacs trader Sherman Holbert
gave a battered Ojibwa bark box (fig. 34) to
Wabuse "to see what she could save out of it by
using it as a model." Wabuse went right to
work. Her versions of the prototype box, of
which the square box shown here is one exam-
ple, are correct and beautifully understood,
copies in every detail down to the number of
lashings joining each convex side. Perhaps
even better is the oblong box, an invention of
the artisan made later. A variation on the proto-
type, this box demonstrates how change
occurs by the adaptation of a previous example
to a new end. How often this must have
occurred in Indian art of the past has gone
unrecorded.

Purchased at Fort Mille Lacs Village, Onamia, Min-
nesota: square box, spring 1981; oblong box, Septem-
ber 1982.

93

78

79

80

78

FEATHER-BONNET CONTAINER, ca. 1965
Birchbark, basswood ties, paint
24" h. x 13" diam.; handle on lid 2¾" h.

Maggie and Fred Sam (deceased)
Ojibwa
Mille Lacs Indian Reservation, Isle, Minnesota

Since this is a special feather-bonnet container, its bottom is removable so the bonnet can be removed from either end without damaging the feathers. It is decorated with painted pipes crossed with feathers, painted feather drops, red flowers with green leaves, and white stripes with more red flowers, rendered with a carefulness indicating that ritual or sacred contents may be stored within.

Purchased at Fort Mille Lacs Village, Onamia, Minnesota, October 1982.

79

FANCY BASKET, 1982
Black ash, sweet grass, brown dye
4½" h. x 6" w. (at shoulder); h. to top of comb 7"

William Robinson
Ojibwa (White Earth Indian Reservation, Minnesota)
Resident at Bagley, Minnesota

Splint basketry only came to the Great Lakes area during the nineteenth century. It was first brought to Wisconsin by the Oneida and Stockbridge resettlements there in 1829-30. Today it still flourishes among the Winnebago of Wisconsin, in such places as Escanaba, Michigan, and on White Earth Reservation in Minnesota, where William Robinson carries on the art of his late mother, Josephine Robinson, who in turn learned it from her mother.

Most Ojibwa work is inferior to Eastern work – the construction is looser – though there are notable exceptions (see cat. no. 80). But this fancy basket by William Robinson is of exemplary quality, sporting an oversized lid "comb" that creates a fantail effect, like that made many years ago on virtually identical baskets. "He really does the best work [around here]," said his stepaunt, Frances Keahna, also a basket maker.

Purchased at a trading shop in Bemidji, Minnesota, September 1982.

80

PORCUPINED SPHERICAL BASKET, 1981
Black ash splints
7⅜" h. x 8⅝" diam.

Edith Bonde
Ojibwa
Hubbard Lake, Michigan

Exquisite design, technical dexterity of a high order, and superbly controlled spacing of the raised "porcupines" that cover the globular surface combine perfectly to produce this masterpiece of black ash splint basketry. Rarely does Great Lakes splint basketry reach such perfection of understatement and delicacy of craftsmanship. Generally, Ojibwa baskets are less refined than comparable Maritime and Iroquois work, but not in this case. Color here would be superfluous. Form and scale are everything. The size of the porcupines, the width of the weavers (horizontal splints) and standards (vertical splints) expands slightly toward the equator and diminishes toward the poles of this basket.

Edith Bonde, a full-blood Ojibwa in her late sixties (fig. 7), was discovered by the outside world at the *Craft Multiples* exhibition held at the Renwick Gallery, Smithsonian Institu-

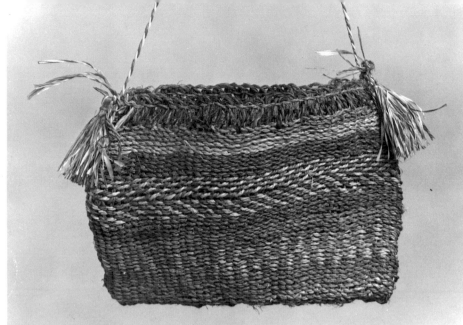

81

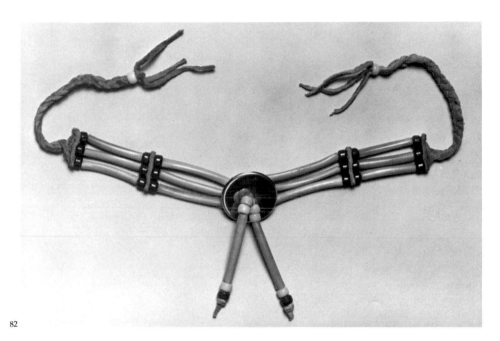

82

81

NETTLE BAG, ca. 1975
Nettle fiber, basswood strap, commercial dyes
7¾" h. x 11" l.

Mudwe (Mrs. Lucy Clark)
Ojibwa
Mille Lacs Indian Reservation, Minnesota

Though nettle-fiber bags were once common in Minnesota and Wisconsin in the Lake Superior region, I found only one woman making them today, Mudwe of Mille Lacs.* This is not her best weaving (the result is irregular), but it is more colorful than any of her other bags I saw. The chevron and vertical patterns and the open work at the top belong to the style of natural-fiber and woolen bags once made in large numbers by the Great Lakes and even Prairie tribes.

*Another has been located at Bad River Indian Reservation, Wisconsin.

Purchased from Sherman Holbert, Mille Lacs, Minnesota, October 1980.

Continued column 1

tion, Washington, D.C., in 1975–76. At that time she wrote:

I was born in the North Woods of northern Michigan, raised in lumber camps where my father worked and our family stayed all winter, so I got very little education other than nature.... When my mother put me off her lap so she could work at her baskets she gave me some scrap material to play with – that's how I learned to make baskets....I make only authentic Indian baskets same as my ancestors made. I work in my kitchen after the splints are off the log, using only a sharp knife and a pair of scissors. I use black ash only. This is more of a hobby for me, I do not make a lot of baskets, perhaps twelve or fifteen per year, and I only make them on order, which I never catch up with.

*Letter of March 12, 1975; made available to the author by Ellen Myette, Registrar, Renwick Gallery.

Purchased at The Hand and the Spirit Crafts Gallery, Scottsdale, Arizona, April 1981.

82

CHOKER NECKLACE, 1980
Rabbit bone, beads, thong, reflector back
21" l. (unfastened, including braided ties)

Maker unknown
Ojibwa
Mille Lacs Indian Reservation, Minnesota

While the Pan-Indian choker necklace has antecedents in bone necklaces and breastplates for both men and women, today's version is rarely made with such extensive use of natural materials and is rarely executed with such aesthetic restraint.

Purchased from the Mille Lacs Indian Museum Sales Shop, Onamia, Minnesota, July 1980.

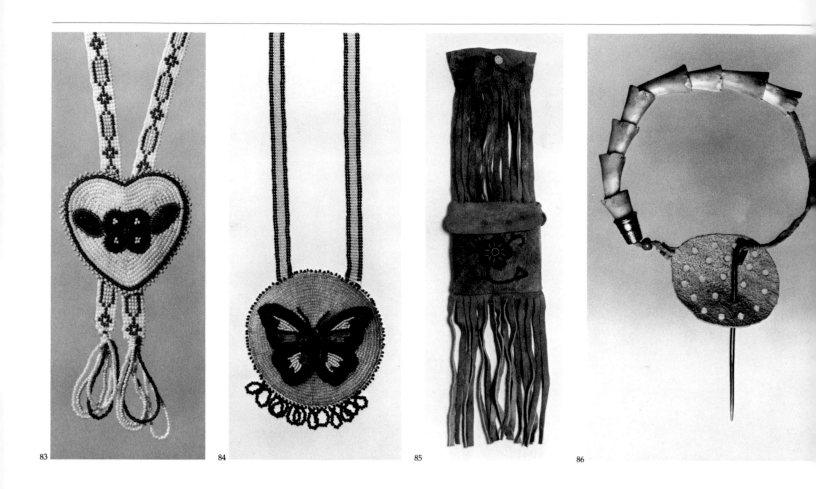

83 84 85 86

83, 84

HEART MEDALLION NECKLACE, 1980–81
Beads, Indian-tanned backing
19″ l.; heart 3¹¹⁄₁₆″ h.

BUTTERFLY MEDALLION NECKLACE, 1980–81
Beads, Indian-tanned backing
18″ l.; medallion 4″ diam.

Maude Kegg
Ojibwa
Mille Lacs Indian Reservation, Minnesota

"I don't know what we'd do without her," said a staff member at the Mille Lacs Indian Museum of Maude Kegg. "She watches to see that [the tours of the exhibitions] are done right, and lends her presence [prestige] to everything....She puts something extra into her beaded necklaces."

The "something extra" includes smoked-hide backings, loom-beaded neck bands, and in addition to the rose, which is her specialty, she shapes her medallions to conform to the profiles of hearts or butterflies. They are like exquisite cutouts taken right out of the woods,

reminders of the old birchbark pattern silhouettes the Great Lakes Indians used for beadwork and appliqué. Although the heart motif is of European origin, in the hands of the Woodland Indians it is a symbol of strength and friendship. The colorful beading is modern, and a riot of Woodland color is here – colored roses, green leaves, yellow light, multi-colored butterfly wings, opalescent hearts that float like clouds against blue sky, even brown earth – but the thought behind it is old.

For Mrs. Kegg's magnificent bandolier bag, see catalogue number 71.

Purchased at Mille Lacs Indian Museum Sales Shop, Onamia, Minnesota: heart medallion necklace, 1980/81; butterfly medallion necklace, July 1981.

85

PUZZLE POUCH, 1980
Indian-smoked buckskin, beads
17¼″ l.; pouch 4½″ h. x 4¼″ w.

Wabuse (Rabbit)
Ojibwa
Mille Lacs Indian Reservation, Minnesota

Puzzle pouches are an old favorite with Indians east of the Mississippi. How do you open it? The flaps are tightly closed inside; but pulling one side of the pouch toward you will loosen the upper fringes and allow them to be drawn forward until they can be pulled wide apart. The concealed opening of the pouch "keeps children from getting in, keeps things safe inside, and it's a game."

This pouch was the best of several examples seen among various Woodland tribes. Most were of commercially tanned hide and of souvenir quality, but this one is beautifully made.

Purchased from Sherman Holbert, Fort Mille Lacs Village, Onamia, Minnesota, summer 1981.

87

86

CUP AND PIN GAME, 1980
Deer-toe bones, thimble, skewer, buckskin
20¼″ l.

Pete Sam
Ojibwa
Mille Lacs Indian Reservation, Isle, Minnesota

The object of the cup-and-pin game, one of the most ubiquitous of all Indian games, is to catch all the deer bone "cups" on the pin. Accomplishing this requires no little skill. Often today, and for some time in the past, thimbles replace the bones, giving the game a thoroughly acculturated look that is absent here. The old-style flap and thong are made of home-tanned hide. According to descriptions cited in Culin's fundamental work,* in some versions of the game, thrusting the pin through the holes in the flap also gains points.

*Stewart Culin, *Games of the North American Indians*, in U.S. Bureau of American Ethnology, Twenty-fourth Annual Report..., 1902–3 (Washington, D.C.: GPO, 1907; reprint, New York: Dover Publications, 1975), pp. 534–35.

Purchased at Mille Lacs Indian Museum Sales Shop, Onamia, Minnesota, June 1980.

87

SLED, ca. 1975
Wood, nails, bolts, pegs
6″ h. x 34″ l. x 14″ w.

Maker unknown
Ojibwa
Curve Lake Reserve, Ontario

On inquiry, a number of unused sleds were located stored in the garage loft adjoining Whetung Indian Crafts at Curve Lake Reserve. Only an occasional handmade sled is seen during the wintertime at Curve Lake today. The combination of steam-bent runners, hand-fashioned wood pegs, and commercial screws and nails puts this sled in two worlds. This was the smallest of those available.

Purchased at Whetung Indian Crafts, Curve Lake, Ontario, August 1981.

88, 89

TUFTED, QUILLED LIDDED BOX, 1979–81
Birchbark, quills, sweet grass, dye, thread
3⅛″ h. x 6¼″ diam., signed on bottom
(see colorplate, p. 114)

TUFTED, QUILLED LIDDED BOX, 1979-81
2⅞″ h. x 6¼″ diam., signed and titled
"Rainbow Country"
(see colorplate, p. 114)

Rose Kimewon (Rose Williams)
Ottawa
Wikwemikong Reserve, Manitoulin Island, Ontario

Mrs. Kimewon is the best-known maker of quilled boxes on Manitoulin Island. In many ways she spearheaded what has become a renaissance of the art among her own people (who live on Canada's only unceded reserve) and the neighboring Ojibwa at West Bay and other reserves. It was she who developed the tufting technique for box lids, whereby the quill ends are gathered and trimmed like old-fashioned cut velvet, as in the tufted caribou

90

91

90

QUILLED LIDDED BOX, ca. 1978
Birchbark, quills, dye, sweet grass, thread
2¾" h. x 8½" diam.

Maker unknown
Ottawa
Ontario

This porcupine-quilled box is typical of work in this genre that finds its way into the trading stores of the Great Lakes area, except that the red trillium flowers are striking in their simplicity and wide spacing on the lid. The scalloped, white quillwork edging of the rim is more typical of Ottawa than Ojibwa quilling.

Purchased at Agawa Bay Trading Post, Ontario, August 1979.

91

QUILLED LIDDED BOX, 1983
Porcupine quills, sweet grass, thread
2" h. x 6½" w. x 5" d.

Laura Parkey
[Ottowa]
Petosky, Michigan

"I know an Ottawa lady who can put an underwater panther on a quilled box lid," said Richard Pohrt, an authority on American Indian art and culture at the Plains Indian Art Symposium held at Pierre, South Dakota, in April 1982. At his request, Laura Parkey made this box.

The underwater panther, depicted frequently on eighteenth-century quilled bags and nineteenth-century beaded medicine pouches, has just about disappeared from the Indian repertory of fabled beasts. A denizen of the Great Lakes rivers and streams, he shot lightning from his eyes by which many were killed. But if an Indian survived contact, he was invested with great power.

Mrs. Parkey is of white origin, one of those non-Indians who by marriage into an Indian family has absorbed the culture to the extent of becoming recognized both within the tribe and without. Her son, also an excellent box maker, learned the craft from his mother.

Purchased from the maker through Richard Pohrt, March 1983.

and moose hair work to the north (see cat. nos. 338, 339). This technique harks back, however, to the quilled tufting that the Micmac used to decorate bark letter trays with raised flowers.

Mrs. Kimewon is known for her boxes with lids on which are depicted eagles, bears, and geese, or abstract star sectional motifs (cat. no. 89). Individual inspirations, such as the rainbow design (cat. no. 90), occur rarely. She is one of the master artists among the Great Lakes tribes.

Purchased at Ten Mile Gift Shop, Manitoulin Island, Ontario, July 1981.

92

93

94

92

MOCCASINS, 1965–70
Smoked buckskin, beads, sinew, thread
4⅝" h. x 8¼" l.

Marcella Cloud
Winnebago
Baraboo , Wisconsin

This boat-shaped moccasin adheres carefully to the old nineteenth-century Winnebago patterns. The single flap is economically cut from the same piece of buckskin as the sole and uppers and is sewn with sinew, similar to old-time manufacture. The rows of small triangles, here in triple register, are a highly traditional old Winnebago motif, also found on woven bags of the tribe, and one of the most easily assigned Great Lakes Indian designs. Its significance has been lost, but it may have solar associations.

Purchased at Parson's Trading Post, Wisconsin Dells, Wisconsin, July 1980.

93

BEADED CUFFS, ca. 1977–79
Beads, cloth
11" l. x 7" w.

Myrtle Thompson
Winnebago
Neillsville, Wisconsin

These spot-stitched beaded cuffs are meant to be attached to a fancy shirt However, as independently conceived works of decorative art, they could be detached and saved for another use. This is an example of the changing, additive aspect of Indian apparel sometimes ignored by purists, who expect every outfit to be made out of whole cloth, as if the garments existed in a cultural vacuum without alteration or change. These cuffs have never been used.

The bilaterally split leaf-edge motifs are often a feature of Winnebago design and appear on beaded dresses and shirts as well.

Purchased at Parson's Trading Post, Wisconsin Dells, Wisconsin, July 1980.

94

SKIRT AND BLOUSE, ca. 1965–70
Satin, ribbon
Skirt 29½" l. x 29½" w.
Blouse 53⅞" l. x 25¼" w.

Ellen Lewis (deceased)
Winnebago
Wisconsin

The ribbonwork on the skirt is distinguished by the use of no fewer than six colors to establish the softly sensuous appliqué floral pattern, which has a ''running'' character that is characteristically Winnebago. The sewing is cross-stitched by hand, subsequently repaired in numerous areas by machine. The blouse is provided with old-fashioned gussets. There is a sufficient history of wear so that the satin is discolored. (These dresses are not dry cleaned but washed and allowed to dry in the open air, then carefully folded away.)

In addition to this ribbonwork type of blouse (or shift) and skirt, the Winnebago women also wear buckskin dresses, still occasionally made today, for special occasions.

Duaine Counsell, the trader from whom this outfit was purchased, explained that it was available because the maker had died in 1978, and her husband had sold her finery.

Purchased at Parson's Trading Post, Wisconsin Dells, Wisconsin, August 1980.

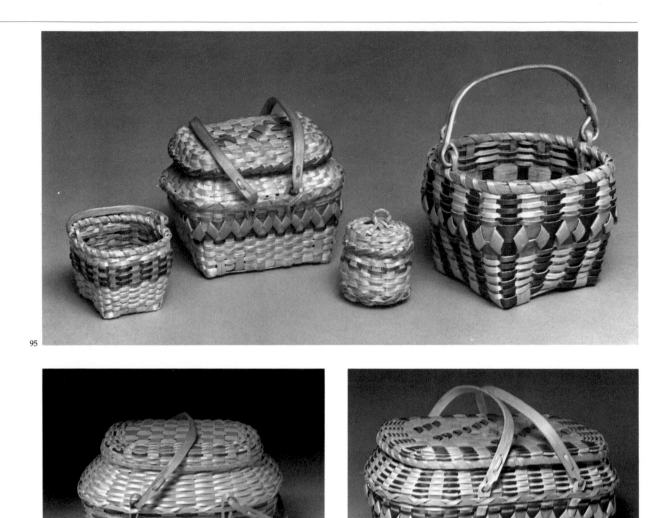

95

96, 97

95

SET OF MINIATURE BASKETS, 1978
Black ash splints, wood handles

BERRY BASKET
1" h. x 1½" w. x 1½" d.

LIDDED PICNIC BASKET
2¼" h. x 3" w. x 2½" d.

LIDDED SEWING BASKET
1¼" h. x 1" diam.

BERRY BASKET
2¼" h. x 2¾" square (at bottom)

Alvina Decorah (deceased)
Winnebago
Tomah, Wisconsin

Mrs. Decorah was a leading Winnebago basket
maker of the past generation. These are ex-
quisitely scaled and refined miniature exam-
ples of basket types at which she excelled (for a
full-scale picnic basket, see cat. no. 97).

Purchased at Parson's Trading Post, Wisconsin Dells,
Wisconsin, April 1980.

96, 97

SMALL PICNIC BASKET, 1979-80
Black ash splints, wood handles, dye
5¹⁄₁₆" h. x 8¼" l. x 7⅛" d.

Eva Whiterabbit
Winnebago
Wisconsin Dells, Wisconsin

LARGE PICNIC BASKET, 1979-80
Black ash splints, wood handles, dye
14⁹⁄₁₆" h. x 21¼" w. x 14¼" d.

Lucy Funmaker
Winnebago
Wittenberg, Wisconsin

"So you've got some baskets in there," said
George Whitewing, pointing to my car pulled
up in his farmyard near Wittenberg, Wiscon-
sin, "where are they from?" From the East, I
told him, Malecite, Micmac, Passamaquoddy,
Iroquois – from Maine and Eastern Canada.
"I've heard they make baskets too. My wife

does. Wait till I get her." After closer inspec-
tion: "Well, they're all right. They're nice bas-
kets, but they're weak in the shoulder. See, we
put in an extra support at the shoulder. Ours
are better."

Each of these baskets, variants on a stan-
dard Winnebago type, exhibits clearly the
strengthened shoulder and sturdiness that
George Whitewing emphasized as characteris-
tics of his people's technology.

Catalogue number 96 purchased at Parson's Trading
Post, Wisconsin Dells, Wisconsin, July 1980.
Catalogue number 97 purchased at Saint Anthony's
Menomonie Indian Shop, Neopit, Wisconsin,
November 1979.

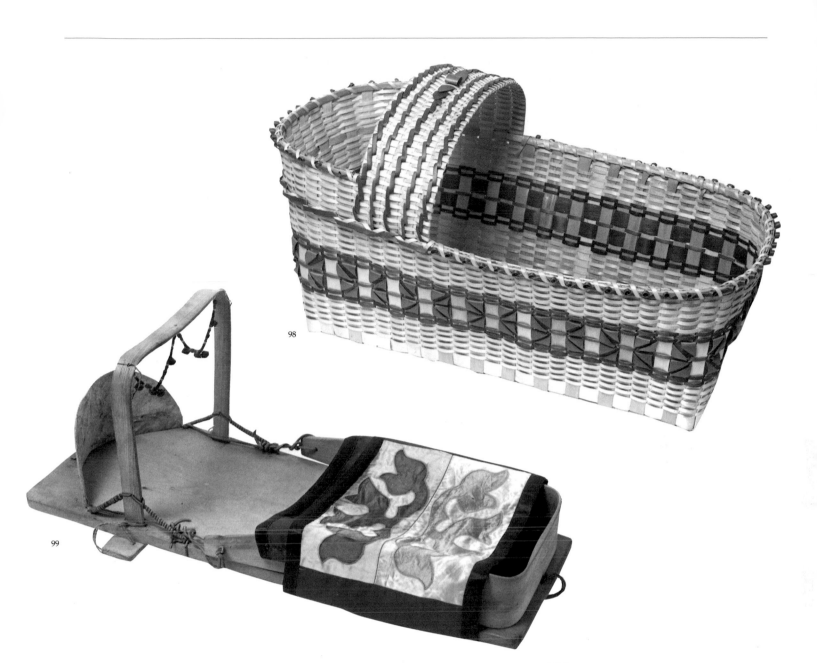

98

99

98, 99

BASSINET, 1980–81
Black ash splint
19″ h. (at hood) x 20¼″ w. x 7½″ d.

Christine Hall
Winnebago
Wittenberg, Wisconsin

CRADLE WITH CRADLEBOARD, ca. 1970
Wood, cowhide, commercial hide, beads, bells, ribbon appliqué, cloth wraps
11″ h. (at protector) x 28½″ w. x 11⅛″ d.

Maker unknown
Winnebago
Wisconsin

Even though they differ widely in style, this bassinet and cradle are catalogued together because both types are "traditional" with the Winnebago today.

The bassinet was commissioned from Mrs. Christine Hall, a master basket maker, at her trailer home near Wittenberg, Wisconsin. "Just make me the best," she was asked. The result of her efforts is this large, sturdy, "Cadillac" of bassinets, from the thicker splints of the

checker work walls and twilled bottom to the delicate and carefully built up bow-tie splint decorations serving as an ornamental band (typical of Great Lakes basketry) to the decoration of curlicue work all around the rim of this otherwise architectural conception. Work on this scale and of this complexity would strain the capacities of all but an extremely gifted artisan.

The cradleboard is a Winnebago variant of the standard Great Lakes wooden cradleboard, carved flat but embellished with a cowhide visor, as well as the usual bentwood head protector from which beaded and belled festoons are hung to attract the infant's attention. It comes equipped with ribbon appliqué cradle wraps of typical Winnebago pattern. The bentwood foot fender can be extended as the baby grows its first few inches.

The cradleboard belongs to a much older tradition than the bassinet, since split basketry was not introduced to Wisconsin until the time of the Oneida removal from New York State in 1830.

Catalogue number 98 purchased from the maker, October 1981.
Catalogue number 99 purchased at Parson's Trading Post, Wisconsin Dells, Wisconsin, July 1980.

100

SASH, 1975
Wool, beads
83″ l. (including fringes) x 8¾″ w.

Helen Russell (deceased)
Winnebago
Tomah, Wisconsin

The Great Lakes and Southeastern Indian women still make excellent hand-braided sashes for wear across the shoulder or as a waist tie, often with part of the sash fringe or ties hanging at the side. Two types of braiding are used, one of which, the chevron, is seen here. All sorts of variants can occur, including Choctaw/Cherokee plaids (see cat. no. 61).

Helen Russell, until she died in 1975, was the premier Winnebago sash maker, and this is the only piece in this exhibition that has been previously exhibited.* When I asked trader Duaine Counsell whether he might be able to get me a shawl like the one in the Grand Rapids exhibition, he replied, "I can get you *that* one," reaching down under the counter. "Here it is. But it's faded a little on one side

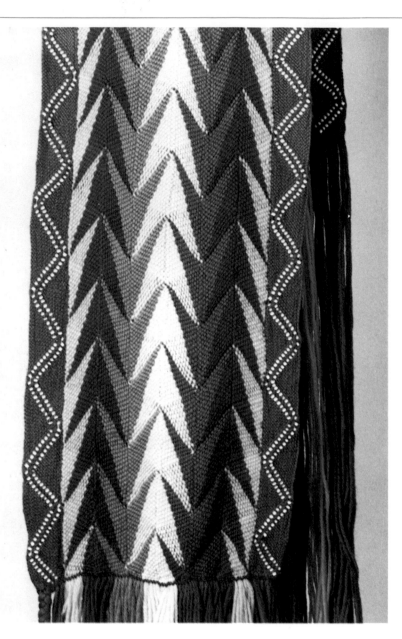

100

101

ARMLETS, ca. 1975–80
Beads, wool
27″ l. (including fringe) x 3⅞″ w.

Maker unknown
Potawatómi
Northern Wisconsin

A number of Potawatomi live in northern Wisconsin, where this pair of loom-beaded armlets originated. The floral designs are geometrically rendered and preserve to a pronounced degree the grid upon which loom beadwork is executed. Note that the weft threads are carried onto the braided wool fringes, where they add a unified grace note.

Purchased at Parson's Trading Post, Wisconsin Dells, Wisconsin, July 1981.

102

MEDALLION NECKLACE, 1980–81
Glass and plastic beads, commercial thong, plastic hair pipes, cowrie shells
21¼″ l. x 4⅝″ diam.

Member of the Keahna family
Mesquakie
Tama Settlement, Iowa

Few are the modern American Indian works that are examined in situ by an eminent Oriental archaeologist. This necklace was noticed by Dr. Han Byong-sam, director of the museum at Kwangju, South Korea, who asked to visit a living American Indian community when he was in Kansas City in 1981. Dr. Han was interested in possible cultural similarities between

because someone overexposed it to light during that tour.''

The Winnebago tend to make the loudest colored sashes. The technique, except in the use of heavy wool, has not changed much in the last century and a half, including the weaving of beads into the fabric of the sash.

*See *Beads; Their Use by Upper Great Lakes Indians*, exhibition catalogue (Grand Rapids, Mich.: Grand Rapids Public Museum, 1977), no. 114.

Purchased at Parson's Trading Post, Wisconsin Dells, Wisconsin, July 1980.

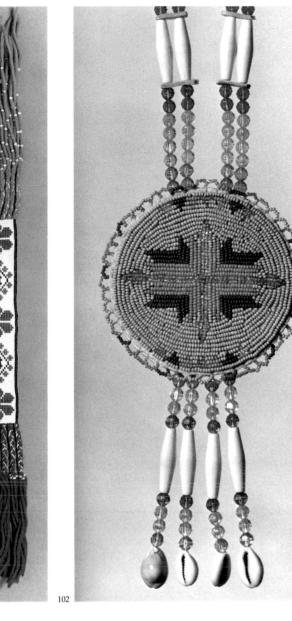

101 102

103

104

Asian and North American native groups. Pointing to this necklace hanging behind the counter at Moccasin Tracks Trading Post (owned by full-blood Mesquakie Frank Pushetonequa), Dr. Han said, ''We have exactly the same [medallion design] in Korea.''

''On what object?''

''On a very ancient bronze mirror in the Korean National Museum [see fig. 20].''

''What does the ancient design symbolize?'' I asked, out of Frank Pushetonequa's hearing.

''The triangles along the border are sunbeams and the center is the four directions.''

Turning to our host, I asked what the medallion design meant. ''The pointed things are sunbeams and inside our four sacred directions,'' Frank Pushetonequa explained.

Purchased at Moccasin Tracks Trading Post, Toledo, Iowa, May 1981.

SKIRT, 1965–70
Broadcloth, ribbon, sequins, cotton lining for ribbonwork
Skirt 36" l.; ribbonwork panel 29¼" h. x 13" w.
(see colorplate, p. 117)

Ada Old Bear
Mesquakie
Tama Settlement, Iowa

Often in the past Indian people altered their clothing, updating it by replacing worn-out parts. In this case, the ribbon appliqué panel is older than the skirt on which it is presently mounted, according to trader Frank Pushetonequa. Perhaps the old skirt had become worn. Perhaps the size of the owner's waist had increased.

Ada Old Bear is now in her eighties and is one of the most respected Mesquakie elders. According to Frank Pushetonequa she is very determined about the old ways and that things should be done in the right way. The outfit is handsewn throughout; the cross-stitching of the vine pattern on the ribbon panel is a more recent way of sewing, perhaps imitating machine stitching.

Purchased at Moccasin Tracks Trading Post, Toledo, Iowa, spring 1980.

GIRL'S SKIRT, ca. 1965–70
Wool, broadcloth, ribbon, thread
Skirt 32" l.; ribbonwork panel 31" l. x 13" w.
(see colorplate, p. 120)

Grace Papakee (deceased)
Mesquakie
Tama Settlement, Iowa

This is a ''lay-away'' skirt, given to a girl at birth or during early childhood and then put away for future use, until the youngster becomes interested in dancing, at which time it is taken out.

Judging from its fresh condition, this skirt was never worn. Its exact age is hard to determine. The colors – green, red, and white – are the Mesquakie national colors, often seen at the Tama Settlement annual Indian Days celebration held during the second weekend of August each year. The designs representing hearts and leaves in a tendril pattern are handsewn, but the panels are sewn onto the broadcloth by machine.

Purchased at Moccasin Tracks Trading Post, Toledo, Iowa, spring 1980.

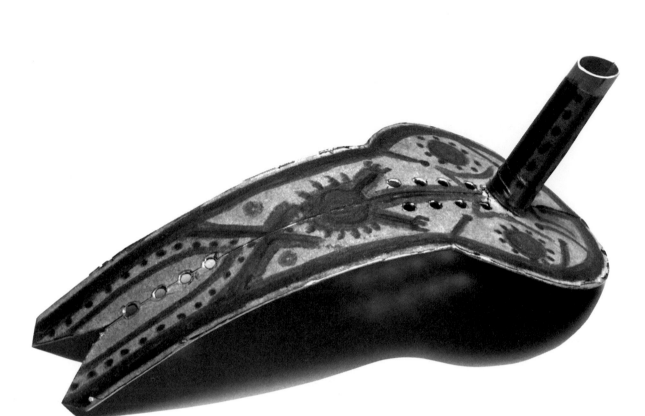

105

105

Roach spreader, ca. 1965
Aluminum, masking tape, felt-tip inks
8" l.

John Papakee (deceased)
Mesquakie
Tama Settlement, Iowa

John Papakee, whose wife was a skilled bead and ribbon worker (cat. no. 104), was famous as a maker of dance bustles and for his powwow dancing. It can be said that he put his life into sustaining his culture. In this roach spreader, which he wore during dances, in which he participated faithfully until shortly before his death in the late 1970s, the traditional elkhorn has been replaced with cut aluminum sheeting over which masking tape was applied and then decorated with Mesquakie tribal designs drawn with felt-tip pens. The use of metal rather than horn may derive from German silver roach spreaders made by contemporary Southern Plains silversmiths such as Julius Caesar (cat. no. 171), who lived and worked among the Mesquakie in the 1950s.

Purchased at Moccasin Tracks Trading Post, Toledo, Iowa, winter 1980.

106

Bulrush mat, 1977–79
Bulrushes, cord, dye
10'6" l. x 3'5⅜" w.
(see colorplate, p. 117)

Refugia Suke
Kickapoo (Mexican Band)
Resident at Jones, Oklahoma

Bulrush and cattail mats for sleeping, floor and bench coverings, and even medicine-bundle wrappers were once made in abundance by Great Lakes and eastern tribes. Rougher ones were used for wigwam siding. In the olden days such mats were relieved with dark and rust-colored lines, diagonal or straight, in a direct simple patterning, applied with natural dyes. The complex woven crisscross diagonal effects seen here were available only after the rushes could be steeped in commercial dyes, about 1890.

Today, as befits the cultural situation, a few mat workers are still active, perhaps about fifteen. A mat of this size is a monumental achievement and is one of the few of such size recorded in recent years. This very large, intricately patterned mat was started as a demonstration piece during the *Sacred Circles* exhibition held at the Nelson Gallery of Art in Kansas City in June 1977. The wooden frame leaned against a wall in the Gallery's open-air neo-Renaissance courtyard, nine completed rows

hanging from the upper ties of the frame. Spray from a garden hose kept the rushes pliable; other bunches of rushes stood in pails. Refugia Suke was seated on the stone floor nearby, tying off the end of a small size mat, accompanied by her translator, Katherine Wah Pe Pah:

"Would you be willing to sell that big mat when you finish it?" I asked.

"How much would you be willing to give for it?" was the response.

"I'd like to give a million dollars...but...."

"A million dollars would be acceptable."

"Would you go my bail bond if I went to jail on the check?"

"No, I wouldn't do that, so $300.00 would be all right."

In February 1979 a telephone call informed me that the mat was on its way.

Refugia Suke belongs to the Mexican Kickapoo Band who seceded from the United States after 1854, moving in increments to the Mexican desert. After the Civil War they raided Texas ranges and stole many cattle, unsettling the border country time and again. They maintain an old-style Great Lakes Indian culture, and travel between Refugia Suke's Band and the Oklahoma Kickapoo, who have settled around the town of Jones, is frequent.

Ordered from the maker, June 1977; received February 1979.

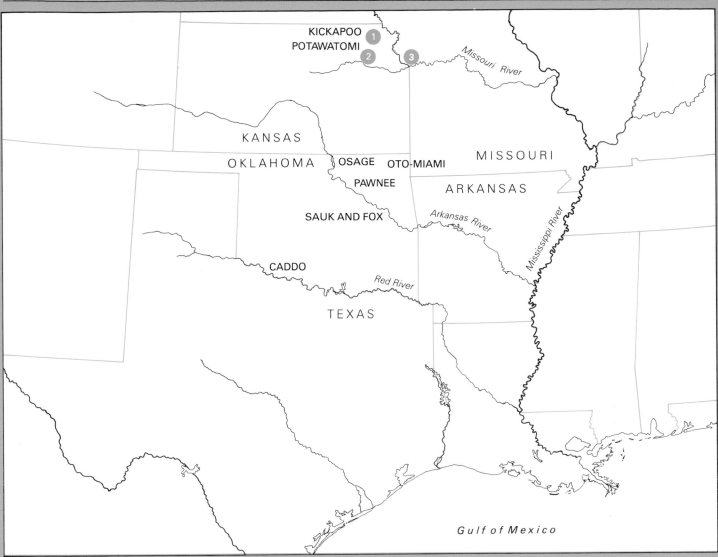

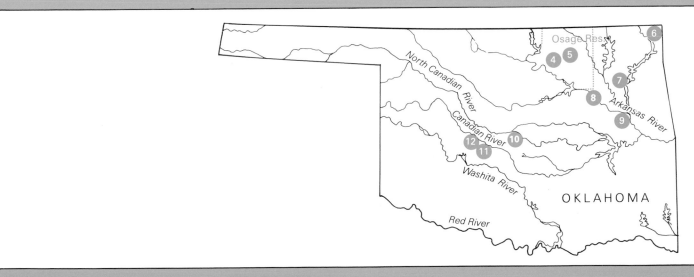

1 Kickapoo Indian Reservation; Horton
2 Potawatomi Indian Reservation
3 Kansas City
4 Fairfax
5 Pawhuska
6 Miami
7 Pryor
8 Tulsa
9 Muskogee
10 Oklahoma City

11 Lookeba; Binger
12 Hinton
 [for Meadow Lake Reserve
 see ATHAPASKA map]

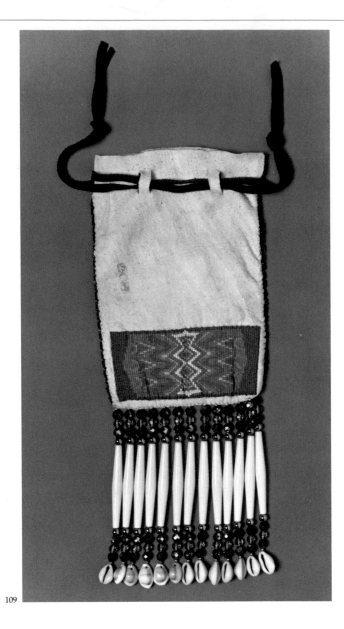

109

107

MAN'S OUTFIT, 1977
Broadcloth, beads, otter fur, sequins, commercial tanned hide, commercial soles, imitation bear claws, sewing materials
Leggings 29⅜" l. x 12" w. (at top)
Aprons, each 23⅛" l. x 18" w.
Turban 26½" l. (including trailer)
Feather 7⅜" l.
Necklace 18½" l.
Moccasins 4⅛" h. x 11⅜" l.
(see colorplate, p. 118)

Ruth Baldwin (deceased)
Oto/Miami
Miami area, Oklahoma

This splendid man's outfit all of a piece, shows the grandeur today's Oklahoma's Indians can reach when singlemindedness prevails. The beaded "hand" design on the tabs of the leggings relates to the outstanding hand design on Osage wearing blankets (see cat. no. 112). Since the Osage live nearby, and since the Oto also used hand design on blankets, the point of origin, during the 1920s, remains uncertain. Ultimately it derives from older Plains tradition. The opposition of color in the addorsed flower motifs is characteristic of nineteenth-century Kiowa beading, which may have been an influence here, since the Kiowa are in this same state, to the southwest. The turban has

eyelets in the trailer for the addition of medallions. The feather, with its quilled upper attachments embellished with ribbons for tufts, is reminiscent of Peyote church fans. The feather is false eagle and the "bear claws" are carved of bone (it would take a lifetime to assemble thirty matched actual bear claws of this size). The symbology and effect is genuine – respect for nature and harmony with it (floral motifs), power (bear-claw necklace), leadership and friendship (hand motif), and prayerful attitude (feather). Thus, the outfit expresses the continuity of the Indian virtues.

Mrs. Baldwin began the outfit for her husband, who died before it was finished; she herself died the following year, in 1978. Since the beading of the moccasins exists only in outline (the pattern would have been filled in, like those on the aprons and leggings), one can sense the point at which Mrs. Baldwin stopped her work. What kind of assistance she may have had in assembling the outfit is not known; she probably did not carve the necklace claws. The deaths of both Mrs. Baldwin and her husband undoubtedly account for the selling of this outfit; it was found far from the Indian community of which it is a part.

Purchased at Buffalo Chips Trading Post, Billings, Montana, December 1982.

108

BEADED PLAQUE, 1980?
Beads, commercial hide backing
diam. 4½" (irregular)
(see colorplate, p. 118)

Mary Martinez
Sauk and Fox
Pryor, Oklahoma

Osage trader Andrew Gray, proprietor of the Whitehair Trading Post in Pawhuska, Oklahoma, brought this piece to the author at the Nelson Gallery of Art in Kansas City. "She is one of the best beaders in Oklahoma," he said, gazing at this small beaded quasi-circular plaque, glinting with Japanese faceted beads. "She had to work on this like cutting out the slices of a pie." Only two years later did he finally tell me the name of the artist.

Each beaded "slice" is separated by a representation of a peyote bird ascending from a white circle; the blue field, as on the peyote kit also collected in Oklahoma (cat. no. 209), depicts the heavens (beyond the beaded rainbow) toward which the bird takes spiritual messages.

This is not a medallion for a necklace, but a unique creation, to be sewn to a shirt, shawl, or even to a peyote tepee. "The buyer would decide that," Mr. Gray explained.

Purchased from Andrew Gray, Kansas City, Missouri, spring 1980.

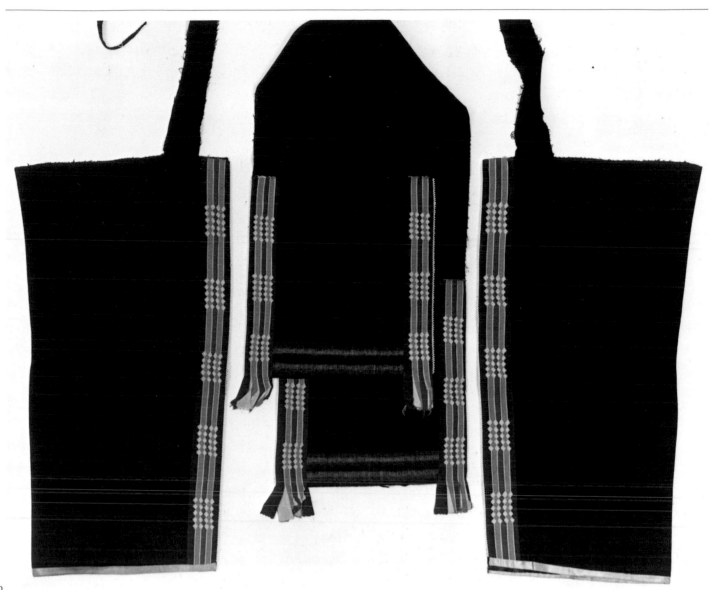

110

109

DANCE PURSE, 1981
Deerskin, beads, hair pipes, cowrie shells,
metal balls, commercial drawstring
15″ l. (including fringe)

Lawrence Stevens
Sauk and Fox
Oklahoma

Such purses are held in the hand by men dur-
ing both fancy (exhibition) and straight (tradi-
tional) powwow dancing. They are an integral
part of the modern Prairie Indian's finery and
have, to some degree, replaced dance sticks
and mirror cases. The hair-pipe fringe clacks as
the dancer steps along, and the finely beaded
panel glints in the light. The body of the purse
is soft, brain-tanned deerskin. The hair pipes
of the fringe are plastic rather than bone, and
the fringe beads are also plastic. The draw-
strings are commercial. The combination of
both traditional and non-traditional materials
in this purse underscores the younger Indian's
belief in his right to do as he pleases with his
past: "We revere it, but we are modern peo-
ple," a young man pointed out during the
Osage Tribal Ceremonial Dances.

Purchased at the Bacone College Museum Shop
(Ataloa Art Lodge), Muskogee, Oklahoma, April
1982.

110

BOY'S COSTUME SET, ca. 1968
Broadcloth, cloth appliqué, beads
Leggings 25¼″ l. x 13¼″ w.
Breechclout 59″ l. x 11¾″ w.

Georgeanne Robinson
Osage
Pawhuska, Oklahoma

Mrs. Robinson was well known in Prairie In-
dian art circles for her proprietorship of the
Red Man Shop, a craft dress shop in
Pawhuska, one of the three Osage towns in
northeastern Oklahoma, the settlement of
which follows the division of the tribe into the
three original gentes (patrilineal clans). A full-
blood tribal member, Mrs. Robinson gave
many demonstrations and fashion shows until
1980, when she closed her shop and retired.
Her brother, the Osage trader Andrew Gray,
proprietor of the Whitehair Trading Post,
where this outfit was found, explained that
"somewhere along the line the trailer for it was
lost."

After buying the outfit I visited Mrs.
Robinson in her shop nearby. "Yes," she said,
scrutinizing one of the leggings, "I could make
you a trailer again. But could the ribbonwork
be larger?" My request that the new trailer
match the rest of the work was the restoration's
undoing; I had not taken into account Mrs.
Robinson's failing eyesight, and the replace-
ment trailer was never made.

"She leads a quiet life now," I was told, but
her work is prized among the Osage and with
good reason.

Purchased at the Whitehair Trading Post, Pawhuska,
Oklahoma, late fall 1979.

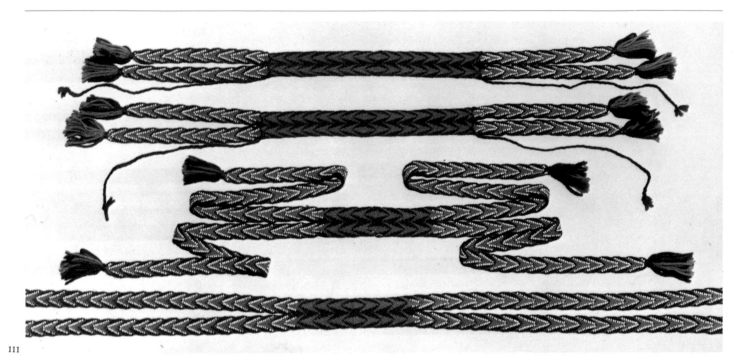

111

113

111

Four-piece dance set, ca. 1972
Wool, beads
Arm sashes, each 37" l. x 1¾" w.
Leg sashes, each 65" l. x 1¾" w.

Maude Cheshwalla
Osage
Pawhuska, Oklahoma

I was utterly defeated in my efforts to obtain wool finger weaving by Maude Cheshwalla, the doyenne of Osage sash making, directly from her. The first time I was about to select a set like this (different in color) from the counter at the Osage Tribal Museum, of which she is proprietor, an Osage dignitary appeared like lightning and outmaneuvered me. The next two times I tried, she looked at me and murmured, "You should have seen the ones I just sold."

When Andrew Gray spread this set out on his counter and asked, "Do you know who made these?" I recognized their origin immediately. It would be difficult to make a mistake in attribution. There is a depth of closely aligned color that makes Maude Cheshwalla's weaving recall fine old wine in a glass held up to the light. Finger weaving can differ vastly in quality. Hers is consistently excellent in its execution.

Purchased at the Whitehair Trading Post, Pawhuska, Oklahoma, winter 1981.

112

Wearing blanket, 1981
Broadcloth, ribbon, thread, beads, satin, Velcro
70½" l. x 61½" w.
(see colorplate, p. 120)

Kimberly Ponca Stock
Osage (Osage Indian Reservation, Fairfax, Oklahoma)
Resident at Santa Fe, New Mexico

"Wendy" Ponca Stock is a well-traveled graduate of the Kansas City Art Institute; her latest trip took her to the Greek islands to study crafts. She is now a fiber instructor at the Institute of American Indian Arts in Santa Fe, New Mexico. Mrs. Stock was runner-up at the Miss Indian America Contest in 1982, at which time she wore this blanket, which she had made at my request the year before. She is a tall woman, and the blanket was made to fit her large, slender proportions. She made the patterns for the ribbonwork appliqué by sketching them out, as an artist would do, "in my own way." The soft contours of her traditional ribbon edging patterns (here stitched by machine) create a running sense of undulation rather than the sharp-edged arrowlike effect usual with Osage ribbonwork. The "hand" designs (signifying friendship) appliquéd on Osage wearing blankets since the 1920s, are handsewn. "My mother bought me the red broadcloth; it's red because I'm firstborn [subsequent daughters wear blankets of darker colors]," she explained. Kimberly Stock's father is the Osage sculptor, Carl Ponca, and her family, like many Osage families, is deeply interested in preserving the culture and heritage of their people. Another hand-design blanket by Mrs. Stock (made before this one) is in the collection of the Institute of American Indian Arts, Santa Fe, New Mexico.

When she borrowed the blanket for the Miss Indian America Contest she announced, "I've got wearing rights to it."

Purchased from the maker, September 1981.

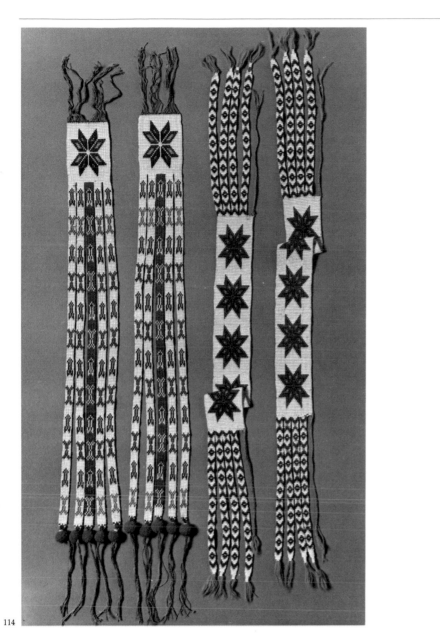

114

115

113

TURBAN, 1983
Rayon silk, otter fur, ribbon, trade mirror
4½" h.; diam. 13", excluding trailer

Kimberly Ponca Stock
Osage (Osage Indian Reservation, Fairfax,
Oklahoma)
Resident at Santa Fe, New Mexico

After she made the Osage wearing blanket (cat.
no. 112), Kimberly Stock began to teach at the
Institute of American Indian Arts in Santa Fe.
It was in that city in 1983 that I noticed that she
had just finished an Osage turban, made from
"a fine otter pelt" her father had gotten for her
(fig. 30).

This turban replaces one previously
acquired for this project at Pawhuska, which
was quite grand in effect, but not as carefully
made. Unlike the earlier purchase, which was
held together with staples, this turban is
handsewn throughout and has exquisite bead-
ing around the trade mirror. In fact, Mrs.
Stock's craftsmanship has improved in the
years since she made the wearing blanket.

Purchased from the maker, August 1983.

114

GARTERS AND EARDROPS, 1965
Beads, twisted wool and thread, cotton balls
Garters, each 34½" l.; eardrops, each 26¼" l.

Maker unknown
Osage
Osage Indian Reservation, Oklahoma

"This set is by my people, but I don't know
who, or from which Osage town," said full-
blood Osage trader Andrew Gray, during a
quiet time at the 1981 Osage Tribal Ceremonial
Dances. "I found them a long ways from here,
but still in Oklahoma. You won't get a better set
than this."

Loom beadwork of this quality is hard to
find among the Osage today, since it tends to
be used for dancing and is regularly resold to
tribe members. The eight-point-star device,
once an eastern motif, has become Pan-Indian
as a result of the powwow circuit. In Osage
country it appears also on metal armbands and
on beaded shawls intended for women.

Purchased from Andrew Gray, proprietor of the
Whitehair Trading Post, Pawhuska, Oklahoma, at the
Osage Tribal Ceremonial, June 1981.

115

OSAGE-STYLE TRAILER, ca. 1980
Broadcloth, ribbon, beads, otter fur, feathers
63" l. x 6" w.

Tom and Sam Thompson
Pawnee
Pawnee, Oklahoma

With its trim of dyed macaw feather (for peyote
fan use), loom-beaded decoration, feathered
rosettes, beautiful ribbonwork, and superb ot-
ter pelt, this trailer is as fine a piece of modern
Oklahoma Indian dance paraphernalia as ex-
ists. "Too bad I don't know who made it,"
mused Andrew Gray, when this was pur-
chased. Later the makers of this trailer, every
part of which evinces excellence of taste and
craftsmanship, were identified by him.

Purchased from Andrew Gray, proprietor of the
Whitehair Trading Post, Pawhuska, Oklahoma, in
Kansas City, Missouri, October 1981.

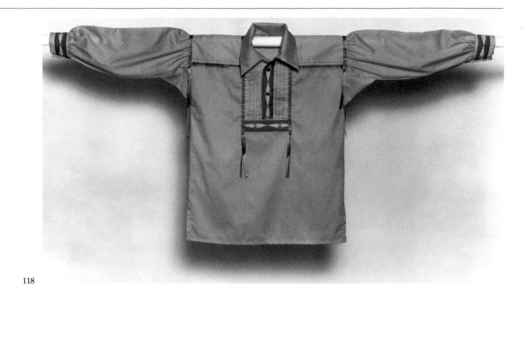

118

121

116

HAIR TIE, 1984
Velvet, ribbons, sequins, mirrors, buttons, bells, German silver clasp
61⅛″ l. (including fastener) x 4¹³⁄₁₆″ w.
(see colorplate, p. 120)

Etta Whitebead
Caddo
Lookeba, Oklahoma

Among the most impressive hair ornaments of any North American tribe are the hair ties worn by Caddo women at sacred events, such as the Turkey Dance. They are jealously guarded and rarely appear outside the tribal context. This one left the culture through the special efforts of Henry Shemayme (see ch. 3, n. 8). The butterfly-shaped tie is unique to these people, and its form recalls a type of banner stone made in late Archaic times (ca. 1500 B.C.).

Etta Whitebead is a full-blood Caddo, of which very few remain, born and raised eleven miles east of Hinton, Oklahoma, near the Miles and Scott communities.

Purchased from the maker through Henry Shemayme, Binger, Oklahoma, October 1984.

117

MOCCASINS, 1981
Indian-tanned buckskin, beads, nylon, thread
3⁹⁄₁₆″ h. x 10″ l.

Sarah Jessep
Potawatomi (Prairie Band)
Kickapoo Indian Reservation, Horton, Kansas

This pair of moccasins is as close to an old pair of Potawatomi moccasins as can be found. It is a somewhat domesticated version (the ties form a concealed ring of piping around the wearer's ankles) in which the old-style beaded ankle flaps have disappeared. Nonetheless, this is a purely Indian affair; no commercialism obtrudes.

Sarah Jessep is the sister of Julia Green (cat. nos. 118–120) and Louis Jessep (cat. no. 122).

Purchased from the maker, spring 1981.

118

MAN'S SHIRT, 1981
Cotton cloth, ribbon, "Indian head" metal buttons
34½″ l. x 67″ w., across sleeves

Julia Green
Potawatomi (Prairie Band)
Kickapoo Indian Reservation, Horton, Kansas

This shirt is torn-tailored in the old way, but sewing is by machine. Old-style gussets join sleeves to shoulders. The ribbon streamers affixed to such shirts show specific clan affiliation, according to Mad Bear, the Tuscarora medicine man, though less traditional Indians wear ribbon shirts simply to show Indianness. Its soft collar and loud orange color evoke modern informality; the slightly puffed sleeves reflect nineteenth-century elegance, while the cotton appliqué designs on the cuffs and shirt front (which has been pleated in the manner of evening dress shirts) are an Indian fashion commentary: "We [Indians] are free to choose," Mrs. Green declared.

Purchased from the maker, winter 1981.

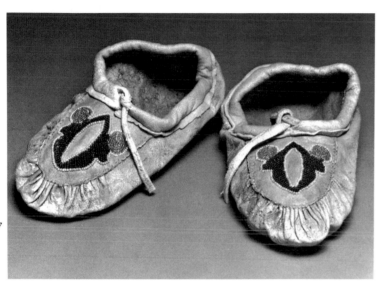

119

120

121

119

WEARING BLANKET, 1981
Broadcloth, ribbon
69¾" l. (including ribbon overhang) x 63¾" w.

Julia Green
Potawatomi (Prairie Band)
Kickapoo Indian Reservation, Horton, Kansas

"Well, what pattern do you want on it?" Mrs. Julia Green asked, taking out paper ribbon-appliqué patterns from a workbox. I chose one, and a month later this ribbonwork machine-sewn blanket was finished.

A Potawatomi by birth and a sister of Sarah Jessep (cat. no. 117) and Louis Jessep (cat. no. 122), Julia Green is one of the best ribbon workers on the Kickapoo Reservation. For years there have been cultural crossovers between the Kickapoo and nearby Potawatomi bands.

Purchased from the maker, February 1981.

120

MAN'S PEYOTE PRAYER SHAWL, 1981
Synthetic material, polyester, ribbon appliqué, ribbon binding
96" l. x 31" w.

Julia Green
Potawatomi (Prairie Band)
Kickapoo Indian Reservation, Horton, Kansas

While we visited with Julia Green, her husband was asleep after an all-night peyote meeting of the Native American Church, of which he is local treasurer. At that meeting he might have donned a prayer shawl such as this, with its refined elongated image of an ascendant messenger bird which forms a border separating the red and black halves of the field. Red is positive and day; black is night and negative. Prayer puts these contrasting forces in harmony, and the bird (propelled upward by the arrowlike triangles trailing beneath it) carries the prayers on high. This ecclesiastical robe is beautifully understated in design, yet compelling in its forceful combination of contrasting color and delicately embroidered center image that never breaks directionality.

Purchased from the maker, October 1981.
Collection Donald D. Jones, Kansas City, Missouri.

121

FAN, 1981
Deerhide, beads over wood core, twisted native thong, pheasant feathers
32" l. (including fringe)

Jennifer Wilson
Potawatomi (Prairie Band)
Kickapoo Indian Reservation, Horton, Kansas

Multi-feathered jointed and ribbed fans, which lend power and serve as an aid to prayer, are held by peyotists during rituals of the Native American Church. These are essentially a twentieth-century development.* Slanting rows of brightly colored beads (in peyote stitch) together with exotic and colored feathers is a fan invention of the last fifty years. The example shown here is in the Northern Prairie style, and the rather rough beading and plainness of this fan contrasts with the refined and elegant work of the Oklahoma tribes and the present-day Sioux (see cat. no. 140).

Jennifer Wilson is the daughter of Louis Jessep (cat. no. 122) from whom this fan was obtained at his combination house/store on the Kickapoo Reservation.

*For a chart on the spread of the Native American Church after 1870, see Weston La Barre, *The Peyote Cult* (New York: Schocken Books, 1978), p. 122.
Purchased from Louis Jessep, October 1981.

122

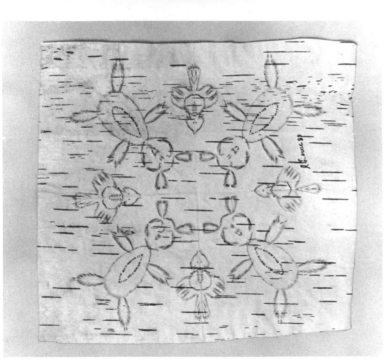

123

122

BOWL AND DICE GAME, 1981
Commercial salad bowl, cow bone, ink, nuts
diam. of bowl 11⅛″

Louis Jessep
Potawatomi (Prairie Band)
Kickapoo Indian Reservation, Horton, Kansas

This women's game is still played in a number of tribes. The bowl is placed against a pillow or blanket and rocked to shake the counters (seven circular counters, one horse and one turtle counter), accompanied by betting, vocal encouragement, and hilarity.

Louis Jessep, the brother of both Sara Jessep (cat. no. 117) and Mrs. Julia Green (cat. nos. 118–120), is a carver and drum maker who runs a craft shop at his antler-decorated house. "You never know what is there," I was told. "There's everything, including the Hong Kong varieties."

Purchased from maker, spring 1981.

123

BITE PRINT, 1983
Birchbark sheet
8¼″ h. x 7¾″ w. (irregular)

Angela Levac
Cree (Meadow Lake Reserve, Saskatchewan)
Resident at Prince George, British Columbia

Angela Levac was so impressed by the ancient art of birchbark dental printmaking that she tried to visit Angela Merasty of Beaver Lake Reserve, Saskatchewan, an elder who still knew how to do this type of work. But the older woman refused to let the young woman bother her, because others had asked to learn and they had never stayed with it. Persistence had its reward, however, and teaching finally

commenced. It takes a long time to transfer the technique for design to the teeth and also much effort to peel back to the thinnest sheets of bark, which show no defects. The sheet is folded in four parts, then opened after biting. First attempts are crude. "I'm still working at it and am getting better," young Angela Levac commented. "This one I'm proud of," she said, pointing to the print shown here.*

*"The North American Indians were not the only people to do bark bitings. There is one citation of an Ob-Ugarian bark biting from Siberia [hinting that] this modest art could be at the root of the evolution of Cree/Ojibwa design"; see *Wigwas*, catalogue of an exhibition of the bite prints of Angela Merasty, National Exhibition Center and Center for Indian Art, Thunder Bay, Ontario, June-July 1983, p. 3, fig. 7. Purchased from the maker, August 1983.

opposite BABY COVERLET AND PILLOW, 1981 (CAT. NO. 15)

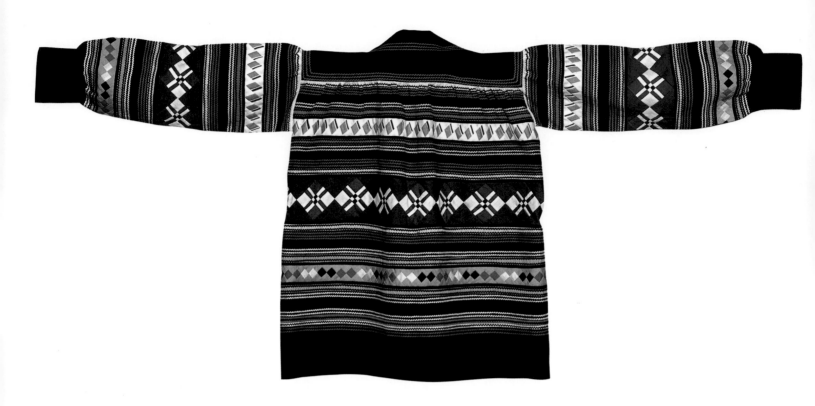

PATCHWORK JACKET, 1984 (Cat. no. 53)

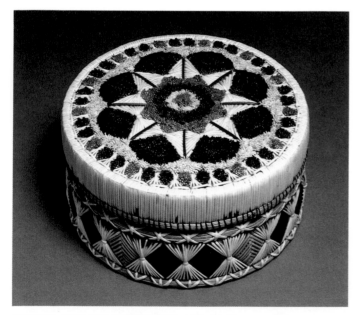

TUFTED, QUILLED LIDDED BOX, 1979–81 (Cat. no. 88)

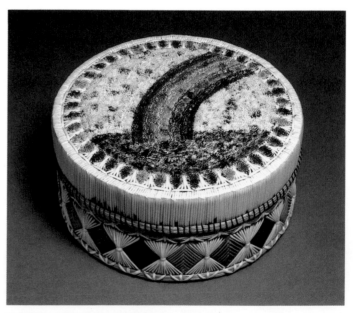

TUFTED, QUILLED LIDDED BOX, 1979–81 (Cat. no. 89)

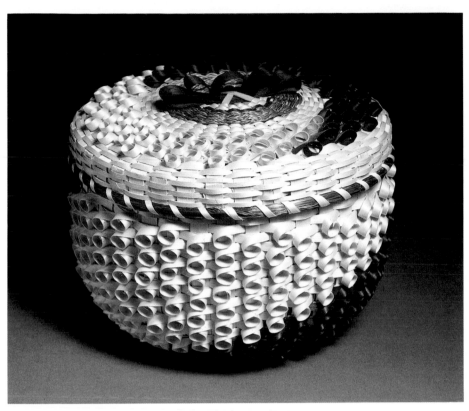

CYLINDRICAL LIDDED BASKET, 1981–82 (Cat. no. 20)

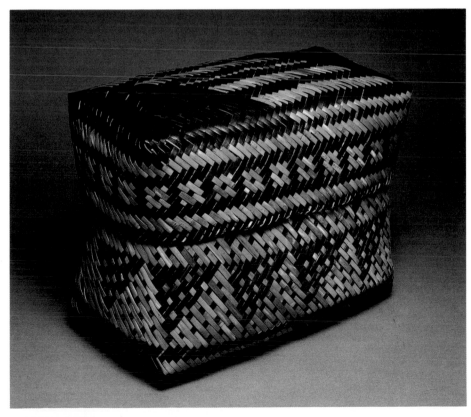

"COFFIN" BASKET, 1982 (Cat. no. 55)

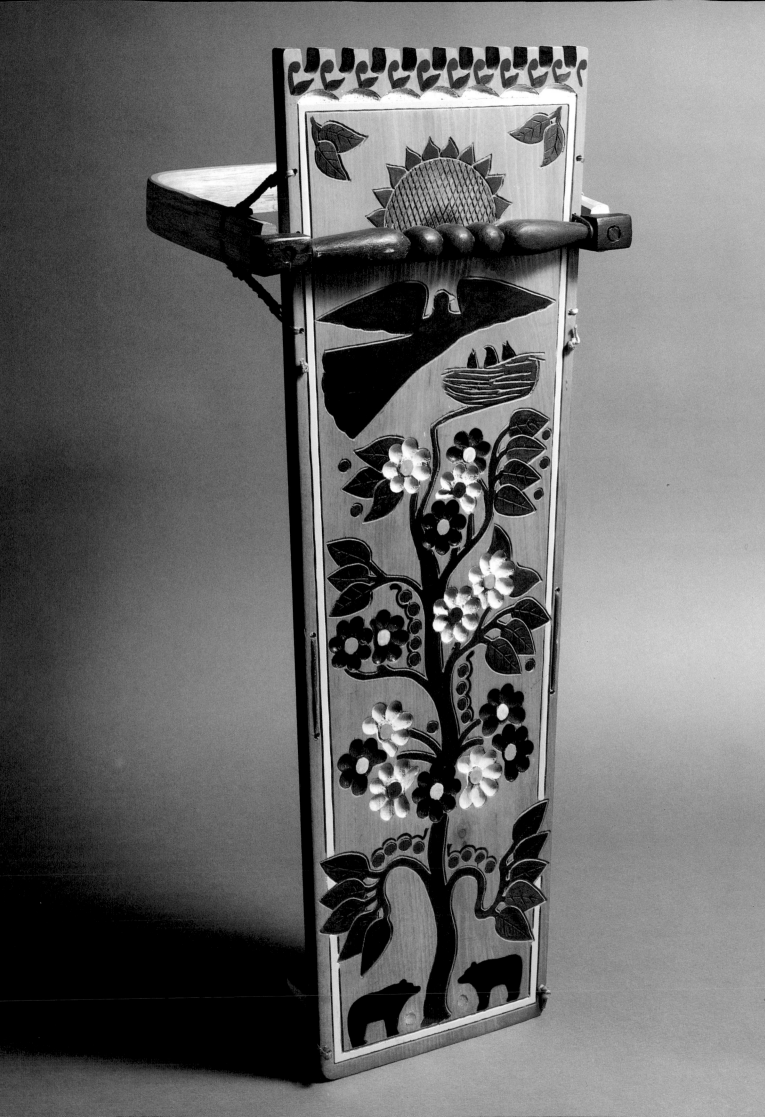

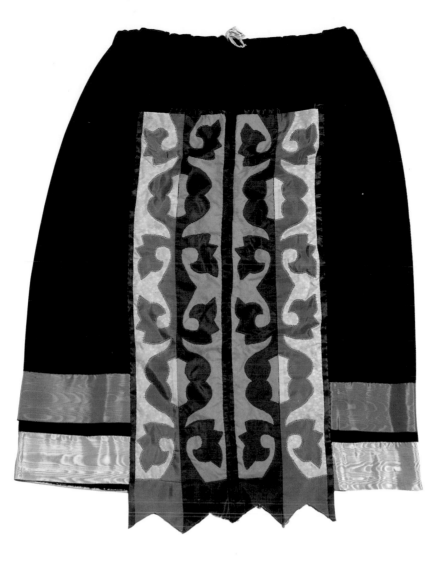

SKIRT, 1965–70 (Cat. no. 103)

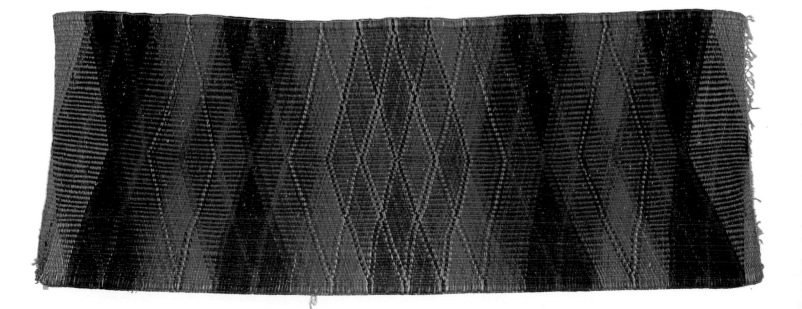

BULRUSH MAT, 1977–79 (Cat. no. 106)

opposite CRADLEBOARD, 1981–82 (Cat. no. 39)

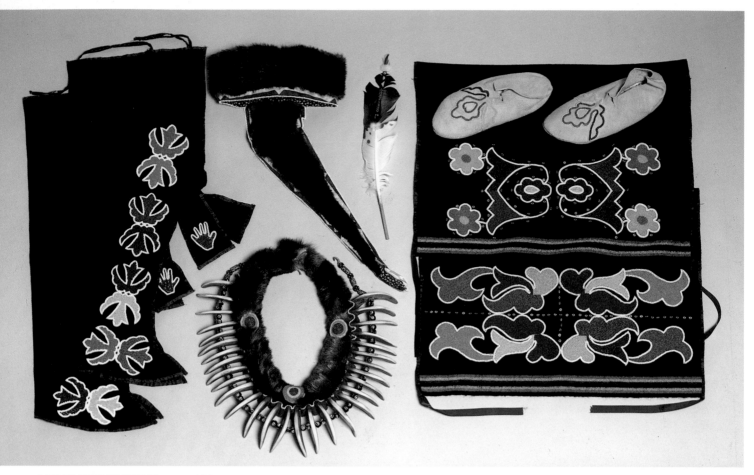

MAN'S OUTFIT, 1977 (Cat. no. 107)

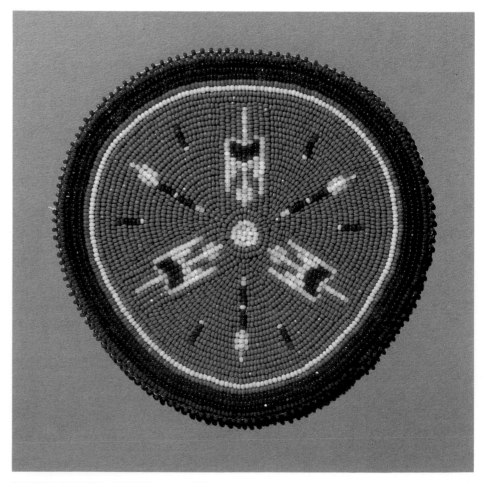

BEADED PLAQUE, 1980? (Cat. no. 108)

opposite BANDOLIER BAG, 1980–82 (Cat. no. 71)

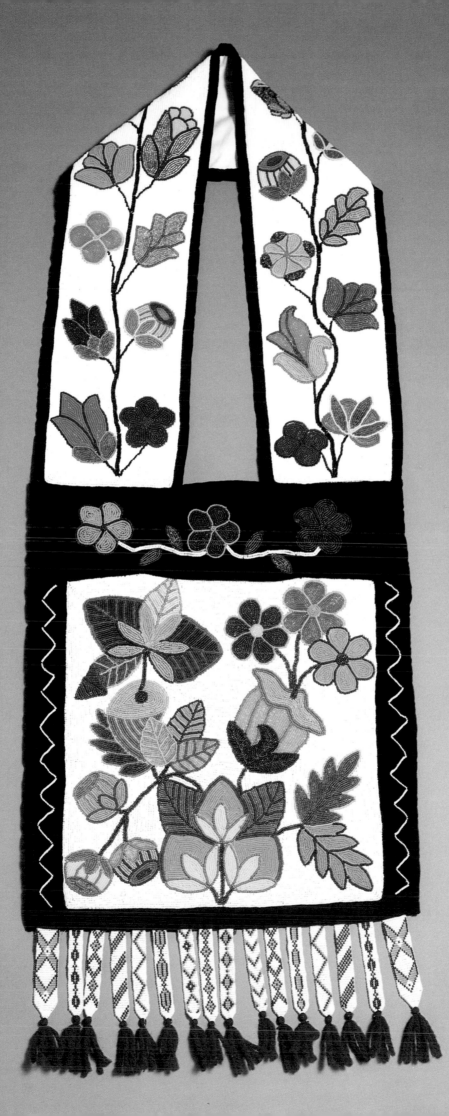

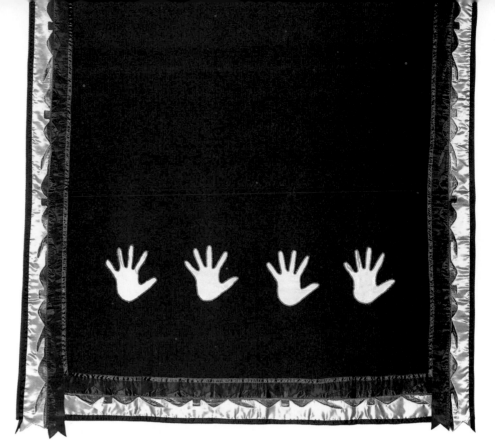

WEARING BLANKET, 1981 (Cat. no. 112)

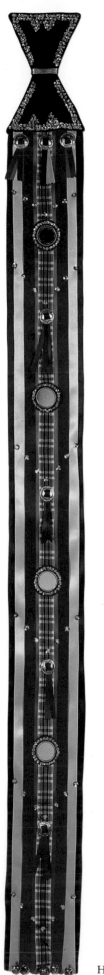

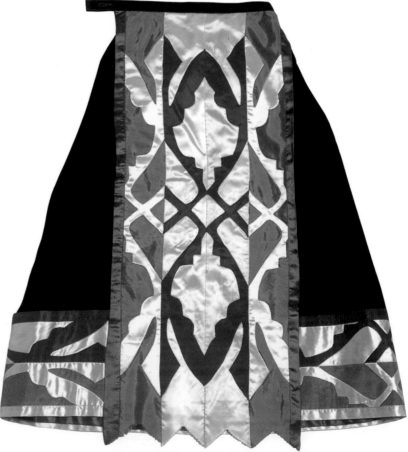

GIRL'S SKIRT, ca. 1965–70 (Cat. no. 104)

HAIR TIE, 1984 (Cat. no. 116)

Plains

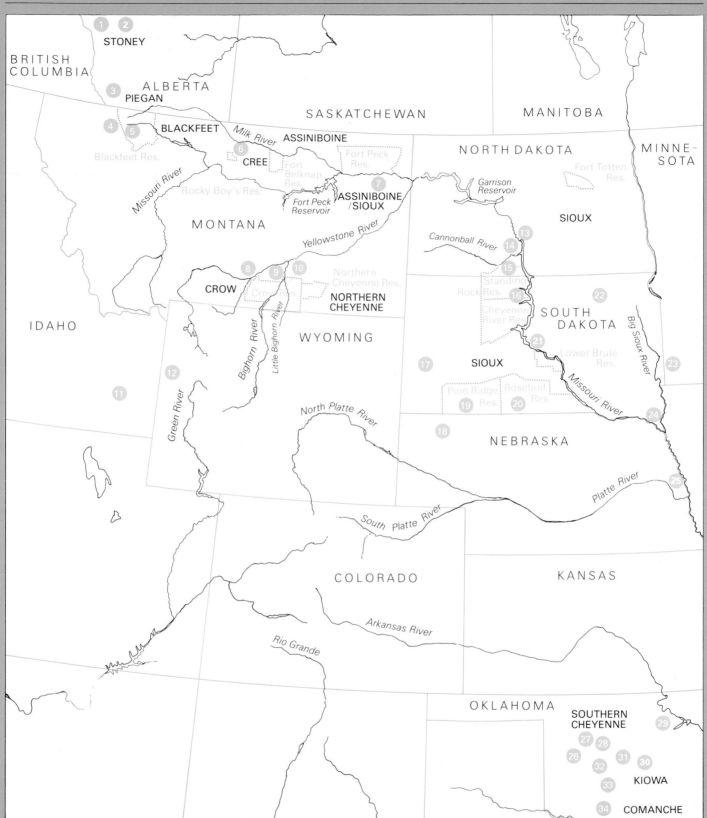

1 Morley
2 Calgary
3 Piegan Reserve
4 Glacier National Park
5 Saint Mary; Browning
6 Havre; Box Elder
7 Poplar
8 Billings
9 Hardin
10 Crow Agency
11 Fort Hall
12 Jackson

13 Bismarck
14 Cannon Ball
15 Fort Yates
16 Little Eagle
17 Rapid City; Keystone
18 Chadron
19 Pine Ridge; Oglala; Wounded Knee
20 Rosebud; Saint Francis; Mission
21 Pierre
22 Aberdeen
23 Pipestone
24 Vermillion

25 Omaha
26 Hammon
27 Seiling
28 Watonga; Canton
29 Pawnee
30 Oklahoma City
31 El Reno; Concho
32 Colony
33 Anadarko; Gracemont
34 Lawton
[for Red Pheasant Reserve
see ATHAPASKA map]

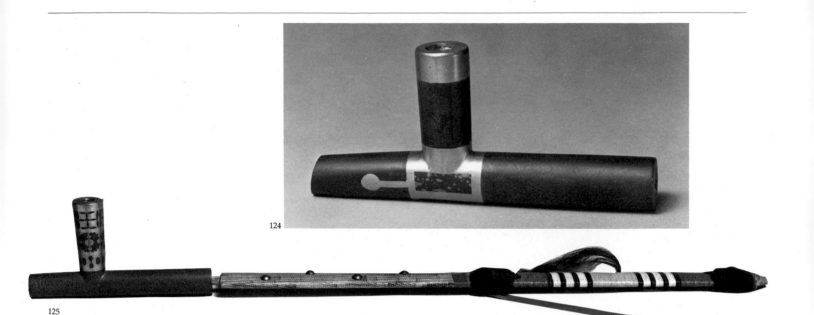

124

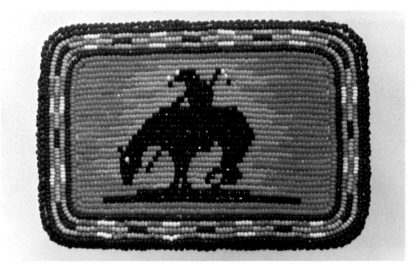

125

126

124

PIPE BOWL, 1978–79
Catlinite
3¹⁄₁₆″ h. x 5¾″ l.

Myron Taylor (Chaska)
Chippewa/Sioux
Pipestone, Minnesota

This black catlinite bowl is inlaid with lead and also with three small oblongs of mottled catlinite, which is found only in one pit at the Pipestone quarries, Quarry Stake No. 2 (see cat. no. 125). The mottled catlinite panels make the pipe bowl somewhat more valuable from the Indian point of view.

Purchased at Parson's Trading Post, Wisconsin Dells, Wisconsin, July 1980.

125

PIPE BOWL AND STEM, 1980-81
Catlinite, lead inlay, ashwood, tacks, quills, horsehair, mallard duck feathers, ribbons
bowl 4¼″ h. x 7⅞″ l.; stem 25½″ l.

Myron Taylor (Chaska)
Chippewa/Sioux
Pipestone, Minnesota

Chaska, one of the finest present-day Plains craftsmen, was one of the best pipe makers at work on the Northern Plains at the time he made this pipe and bowl. He was living quietly at Pipestone, Minnesota, site of the famed catlinite (Pipestone) quarries, named for the painter George Catlin, who visited and painted at the quarries in 1838. Only those of provable Indian descent may work the quarry pits today, which are a national monument. Chaska works slowly, with great skill and deliberation, and does not willingly suffer distraction from his pipe making. He is partial to elaborately inlaid pipe bowls such as this one, which is based on an older example. Working from a prototype releases his creativity and acts to stimulate his own exacting taste.

Liquid solder unwound from the spool probably was the source of the lead inlay, which is not as intricate here as in other of Chaska's bowls. The coil is melted down and cast into the intaglio outlines. The stem of this pipe is made of two pieces of carved ashwood so carefully assembled, the seams are barely visible. Before they were joined, a hot wire was laid longitudinally to burn the hole; a hot file has impressed its markings. Trade tacks are applied in a series of four. The quilling also shows the refined use of four, which denotes the cardinal points, shown here in the Sioux colors of these directions – black (west; home of rain and thunder beings); white (north; wind, cleansing of the spirit); red (east; light, wisdom); yellow (south; warmth, summer growth) – and of three, which refers to the trinity of earth, water, sky. Mallard feathers are a mystical touch, a good luck symbol from a magical bird that always returns. This pipe, which may be pointed to the four directions, up to the heavens, down to the earth, or revolved by the hands of the smoker in a sacred circle, is truly a vehicle for offering sacred tobacco to the cosmos.

The lathe and the drill have converted pipe making into manual shop work, except for those examples in which one encounters the Sioux conscience, as in the work of an especially gifted artist like Chaska.

Purchased at Parson's Trading Post, Wisconsin Dells, Wisconsin, August 1981.

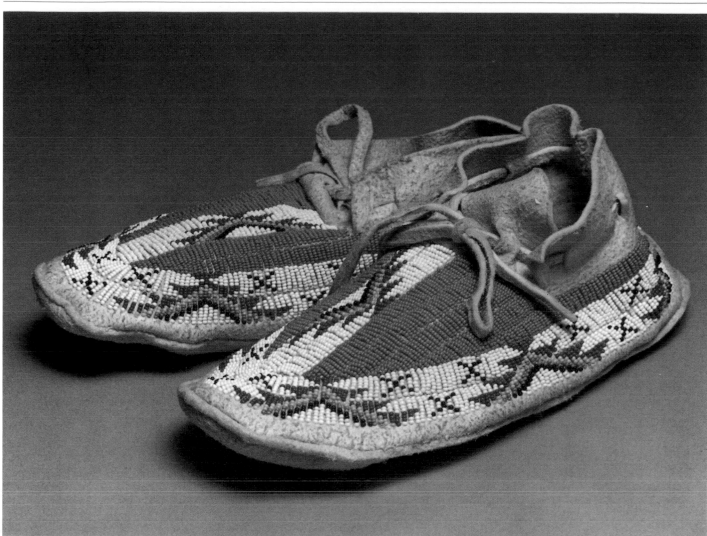

127

126

BEADED BUCKLE (*The End of the Trail*), 1983
Buckle frame, beads, hide backing
2¹⁵⁄₁₆" h. x 4¼" w.

Mae Whiteman
Sioux
Fort Totten Indian Reservation, Saint Michael,
North Dakota

In October 1982, at a shop in Saint Michael,
North Dakota, I encountered a fur dealer who
was wearing a beaded buckle depicting *The End
of the Trail* (see ch. 3, n. 16). Since the buckle
had been a gift to him, it was not for sale.
Muttsey, the proprietor of the shop, was not
sure that Mae Whiteman, who had made the
buckle, would do any more like it – "You know,
hands get old" – but he thought it would be
nice to have Fort Totten Sioux work repre-
sented in this project. In the end he served as
envoy, and during February 1983 Mrs.
Whiteman made the buckle shown here. The
checkered border is special to her buckle style,
as is the slightly raised edge. "I'm not wild
about parting with the piece," the trader
explained, "but I guess it is for a good end."

Purchased at The Country Store, Saint Michael,
North Dakota, March 1983.

127

MOCCASINS, 1981–82
Deerhide, beads, sinew
3¼" h. x 10½" l.

Zona Loans Arrow
Sioux
Standing Rock Indian Reservation, Fort Yates,
North Dakota

This fine pair of old-style moccasins was found
at a store in Fort Yates, where they were
offered for sale with commercial rubber soles
attached.

"These soles seem completely wrong with
such old-type beading."

"We resoled them to sell them. They
originally had soft soles."

"Can they be put back on?"

"Why don't you see the maker?"

I was given the names of two women. The
first one I called on immediately exclaimed,
"What has happened to my moccasins?" Mrs.
Zona Loans Arrow agreed to sew back soft
soles made from hide tanned in her basement.
The "new" soles were turned and edged with
piping when they were mailed back, with the
note, "Like old-new again, Ha!"

Purchased at the Indian Museum Store and from the
maker, Fort Yates, North Dakota, May 1982.

128

MOCCASINS, 1981
Deerskin, beads, cowhide soles, sinew
4⅜" h. x 12⅛" l.

Regina Brave Bull (deceased)
Sioux
Standing Rock Indian Reservation, Cannon
Ball, North Dakota

These moccasins were a special order, and they
are so large that the classic moccasin form
becomes distorted (see cat. no. 127 for an
example of the customary Sioux moccasin pro-
file). "These things happen when the foot size
is big," said their maker, Mrs. Brave Bull.
"They were too large even for him, so he didn't
take them."

While the beading at the bottom edge has
a typically old-type Sioux tepee design, the
roses on the uppers are an allusion to the
Ojibwa, "who also live in our state. We know
they are near us, but not often do we use their
stuff. They [the roses] took up a lot of space
easily."

Purchased at the Indian Museum Store, Fort Yates,
North Dakota, May 1982.

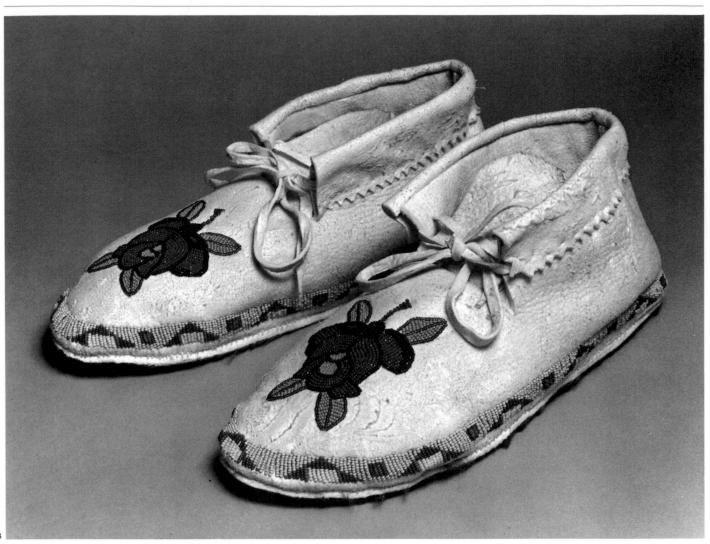

128

129, 130

MAN'S MOCCASINS, 1982
Buckskin, cowhide soles, beads
4¼" h. x 11⅛" l.
(see colorplate, p. 171)

WOMAN'S MOCCASINS, 1982
Buckskin, cowhide soles, beads
3¼" h. x 10" l.

Regina Brave Bull (deceased)
Sioux
Standing Rock Indian Reservation, Cannon
Ball, North Dakota

Both Regina Brave Bull and her daughter,
Elaine, who works closely with her, do their
own tanning and sew with sinew. They have a
command of the whole spectrum of Sioux
women's arts, including quilting (see cat. no.
132). They are among the best known and most
consistently productive beaders on the North-
ern Plains and have shown their work widely.
The bead colors in these moccasins, while
traditional, are sharper than in the past, and
the buckskin is soft and thick.

Catalogue number 129 purchased from the Brave
Bulls' booth at the National Congress of American
Indians, Bismarck, North Dakota, September 1982.
Catalogue number 130 purchased at the Indian
Museum Store, Fort Yates, North Dakota, May 1982.

131

WOMAN'S DRESS, 1983
Home-tanned buckskin, beads, canvas backing
47½" l. x 49½" w. (across sleeves)
(see colorplate, p. 172)

Regina Brave Bull (deceased)
Sioux
Standing Rock Indian Reservation, Cannon
Ball, North Dakota

No exhibition of Indian arts would be complete
without a full-size, Sioux woman's fancy dress
with heavily beaded yoke, the classic kind of
beaded-buckskin work for which Sioux women
have been famous since about 1885. The ideal
artisan must be someone experienced enough
to know exactly what is needed and willing to
put about a year's effort into the project. She
must be central to the Sioux culture – knowing,
authoritative – the perfect artisan, or she will
not stay the course. ''That it can be done,'' I
was told, ''does not mean that it will be done.''

The ideal artisan came in the person of Re-
gina Brave Bull, exactly such a great lady. ''Yes,
I'll make you an outfit like Elaine's [referring to
her daughter], but you mustn't be in a hurry.''

''You'll have to wait, just like an Indian
lady waits for a grand outfit,'' added Elaine.

I heard nothing for months, then a tele-
phone call informed me that Mrs. Brave Bull
had been in the hospital but was now feeling
better. I could expect the dress in May. In early
June, I was told by Elaine, ''Mother is quilting
for give-aways for our Indian Days. I'm head of
our Indian Days, and I have her working
hard.'' In late June, Mrs. Brave Bull was again
ill; by the time she was better it was too hot to
bead. Then a photo of the dress arrived. It was
almost finished, the skirt's hanging fringe had
yet to be added. A few days later the dress
arrived.

''We use canvas for the beads,'' Elaine
explained. ''It holds them better than skin and
will last much longer. We [the Sioux] have been
doing that for years.'' The use of canvas goes
back to 1900; today, the sewing is done with
nylon thread.

''There are twenty pounds of number 11
beads used in the dress.'' There was no equivo-
cating on the use of small beads, no short cut to
mastery. Dresses like this are not made; they
go through gestation, and the result is monu-
mental. Forty-seven lazy-stitched rows of
beads cross the yoke, with changes of patterns
and colors often shared by more than one row;
sometimes the changes occur within the row,
as in the smallest cross motifs. Turtle and tepee
motifs are used, together with two types of

124

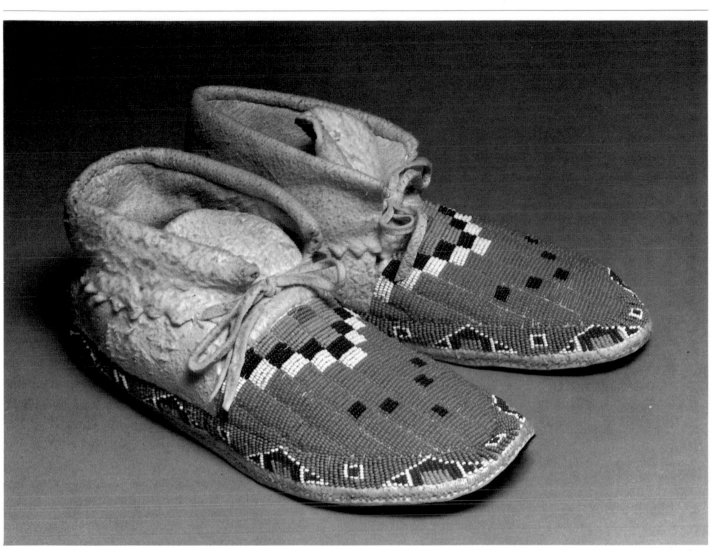

130

132

eight-pointed stars. The colors are livelier than in old days, but the effect adheres more to tradition than many a 1920s beaded dress.

Such a dress, which we consider as being typical of all Indian finery since time immemorial, only developed after buffalo days. Actually, it is the sine qua non reservation outfit, since its assertion of Indianness is aesthetic and mental. It is not a working outfit. It can only be worn on special occasions, a dance, an adoption ceremony, or a banquet evening with a cultural program. At the National Congress of American Indians held in Bismarck, North Dakota, in August 1982, Elaine wore her outfit on stage, at a fashion show with strong cultural overtones. On such heavy occasions, which are suffused with pride, such dresses are "working outfits," reminders of a proud heritage.

These dresses are still very much part of the Indian scene, and numerous tribal variations may still be found. They dress up the Indian scene from Fort Hall, Idaho, to Morley, Alberta, to Bismarck, North Dakota, to Pine Ridge, South Dakota, wherever the Northern Plains penchant for heavy cascades of beading still holds sway.

Commissioned from the maker August 1982; received July 1983.

EAGLE QUILT, 1982
Pieced cotton, quilting, thread
86" l. x 74" w.
(see colorplate, p. 169)

Regina Brave Bull (deceased)
Sioux
Standing Rock Indian Reservation, Cannon Ball, North Dakota

"If you want this quilt, you'd better come back in August to the Congress. I'm saving it for that. Got a lot of work yet to do," Regina Brave Bull told me when I visited her in May at her home on the northern edge of Cannon Ball, North Dakota. At the National Congress of American Indians at Bismarck, North Dakota, in August, I encountered Mrs. Brave Bull purposefully walking down an aisle, looking about. "Oh, there you are; so you've come." The quilt was there, too, hanging at the back of her booth (fig. 18).

Plains Indians have been making such quilts since the 1880s, as soon as reservation life became firmly established. In more recent times the art has spread to Oklahoma, the Southeast, and is now Pan-Indian. Since it involves the basic "from our hands" type of work that invests most Indian craft arts, it was easily assimilated from white settlers and their quilting bees, and it quickly became part of Indian home industry. Among the Sioux and many other Indian groups, the star pattern is prevalent (although trees, houses, tepees, and flower patterns are also occasionally found.) Sometimes imagination really takes hold, as with Mrs. Brave Bull's quilt, where the star is metamorphosed into a strident eagle with his eye at upper center – a powerful medicine symbol. "You'd better watch it, that quilt has power," said an onlooker as I negotiated its purchase.

Purchased from the maker at the National Congress of American Indians, Bismarck, North Dakota, August 1982.

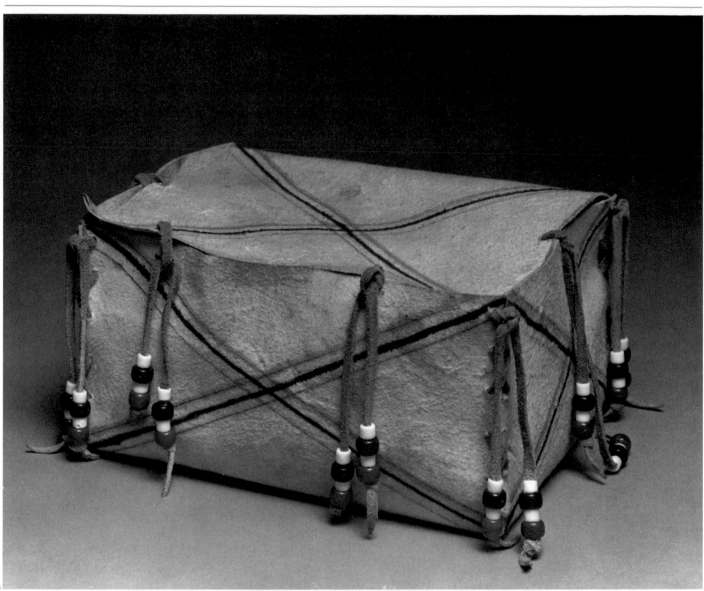

133

133

CONTAINER (parfleche style), 1981–82
Soft cowhide, beads, thongs
4¼″ h. x 6¼″ w. x 8½″ l.

Lillian Martinez
Sioux
Standing Rock Indian Reservation, Cannon Ball, North Dakota

This trunklike small trinket box is a direct descendant of the full-size (rawhide) trunk that was a mid-nineteenth century invention of the Prairie Sauk and Fox, a three-dimensional trunk expanded from the earlier flat meat cases devised for transport on horseback. The trunk idea soon spread from the Sauk and Fox to the Great Plains, where it was also common by the 1870s.

The saleslady who sold this box in Vermillion, South Dakota, was sure it was Mandan work. Her only supporting documentation was "the trader up the line from whom we got it." Later, several similar boxes, varying only in the color of the decorative line work, were found offered for sale at Fort Yates, North Dakota. "They are by Lillian Martinez," I was told, "she lives in a trailer over at Cannon Ball." There is much possibility for misinformation on the Plains, partially because of Indian secretiveness, partially because traders protect their sources.

While this trinket box may seem a pale survival in comparison with the large, vigorously painted rawhide trunks from which its shape is derived, Mrs. Martinez's boxes have a delicacy of their own and are poetic objects in their own right. The larger boxes are still made on the Northern Plains by a few makers.

Purchased at the W. H. Over Museum Shop, University of South Dakota, Vermillion, May 1982.

134

CANE (portion), 1982
Diamond willow, varnish
47″ l.

John Loans Arrow
Sioux
Standing Rock Indian Reservation, Fort Yates, North Dakota

When I called on John and Zona Loans Arrow at their mobile home in Fort Yates I was trying to locate the maker of a child's vest of home-tanned buckskin to see if I could persuade her to bead it. "Where did you get that from? I made it ten years ago when I was living alone at Cannon Ball. I was poorly and lonely...."

"I found it in the store's basement. Would you bead it, and could you put good soles on these moccasins?" (see cat. no. 127).

The result was a friendship. I forwarded money to buy the beads, and two months later,

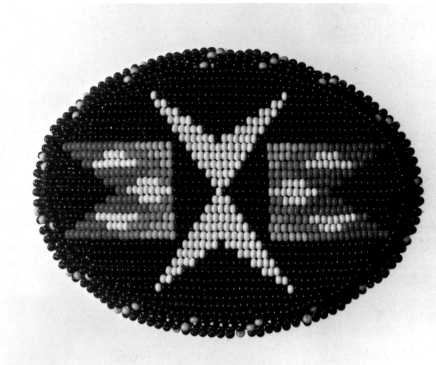

135

135

Beaded buckle, 1982
Buckle frame, beads, Indian-tanned backing
3" h. x 3¾" w. at center

Mike Stoup
Sioux
Rosebud Indian Reservation, Rosebud, South Dakota

"Well, I've got this one with me to show you," said Mike Stoup handing me this buckle in the financial office of the Rosebud branch of Sinte Gleska College.* It was bought on the spot. Mike, his friend Emil Her Many Horses, and Patricia Bird are among the young artists who work traditional Plains art with a fresh eye. Neither the concentrated oval format, black field, nacreous colors, nor "symbolic" design would have been framed together in this way in the past. "The small buckle frame makes us rethink our colors and the impact of our design. You have to say on a tiny surface what was said on a vest or shirt in the past. It's like a bull's eye or spotlight that says you're Indian," Mike Stoup observed.

*Sinte Gleska (Spotted Tail) was the Indian chief who induced his band (Brulé) to settle on the Rosebud Reservation.

Purchased from the maker, September 1982.

the beading was progressing on the vest (see ch. 2). At the time of my earlier visit Zona's husband, John, had already made this diamond willow cane, so I took it along, although he said he would make a fancier one. But in the interim tragedy struck. "Someone got in our trailer while we were gone and took John's pipe [his ceremonial pipe with a painted diamond willow stem] and the carved cane he made especially for you," Zona Loans Arrow reported.

Diamond willow is carefully searched out by men like John Loans Arrow, who prize its configurations. "I get it along Cannonball River west of the town."

Purchased from the maker, September 1982.

134

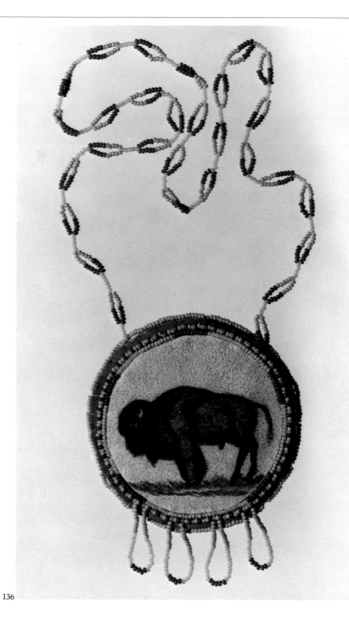

136

136

BUFFALO MEDALLION NECKLACE, 1980
Beads, painted Indian-tanned face and backing, cloth trim
10¼" l.; diam. of medallion 3¹¹⁄₁₆"

Harold Good Voice
Sioux
Rosebud Indian Reservation, Saint Francis,
South Dakota

"Would you be interested in this Buffalo medallion that Harold Good Voice brought in? He's been wearing it but needs money," said Harold Moore, director of the Buechel Memorial Museum at Saint Francis on Rosebud Reservation. The buffalo days seem to drift back encapsulated in this modest, tamed form. Or is it not really a medallion, but a ghost shield from the Guardian Vision days, reincarnated in some peculiar way?

The painted buffalo image is by Harold Good Voice himself, the beading is by his wife.

Purchased at the Gift Shop, Buechel Memorial Museum, Saint Francis, South Dakota, November 1981.

137

"STETSON" HAT, 1982
Straw hat, beads, commercially tanned band
6½" h. x 17" l.

Judy One Star
Sioux
Rosebud Indian Reservation, Saint Francis,
South Dakota

The elegantly beaded Stetson-style hat represented the very latest in Sioux haberdashery at the time of purchase. The beader is the sister-in-law of Denise One Star (cat. no. 163).

Purchased at the Gift Shop, Buechel Memorial Museum, Saint Francis, South Dakota, September 1982.

138

BEADED BILL CAP, 1982
Plastic net cap, beads
8" w. x 10½" l.

Rita Metcalf
Sioux
Rosebud Indian Reservation, Two Strike,
South Dakota

This is a heavily beaded example of a type of decorated cap popular with the North Central Plains Indians in the past few years. Size number 11 beads are lazy-stitched to form a rich flow of color from the button on the crown to the tip of the bill. The designs are an eclectic mix, intended to be decorative rather than symbolic.

Purchased at the Gift Shop, Buechel Memorial Museum, Saint Francis, South Dakota, September 1982.

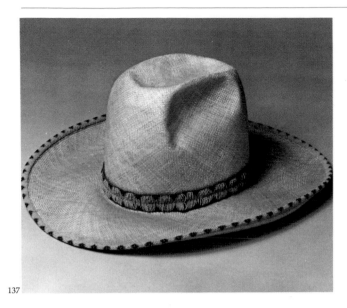

137

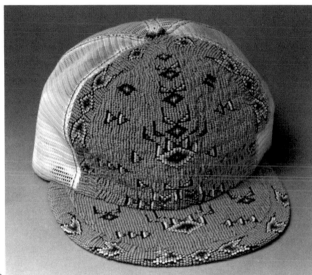

138

139

PAIR OF BEADED SNEAKERS, 1982
Beads, tennis shoes
10⅞" l.
(see colorplate, p. 171)

Effie Tybrec
Sioux (Rosebud Indian Reservation)
Resident at Rapid City, South Dakota

Since about the mid-seventies the Sioux have been beading sneakers. The vocabulary of design is mixed, but there is frequent reference to tepee flaps against a white field. These sneakers are an extreme component of modern-day Indian fashion, which includes beaded reservation hats (customarily of black felt with beaded band, and occasionally beaded edge of brim), baseball caps (cat. no. 138), and buckles.

Gift from Harold Moore, director of Buechel Memorial Museum, Saint Francis, South Dakota, to author, May/June 1983.
Collection Ralph T. Coe, Santa Fe, New Mexico

140

PEYOTE SET, 1983
Wood, beads, commercial tanning, featherwork, paper sticker, plastic, hair, metal studs
Wand 45" l.; fan 21" l. x 4" w.; rattle 22" l.
(see colorplate, p. 170)

Burnett Iron Shell
Sioux
Rosebud Indian Reservation, South Dakota

Perhaps the finest contemporary Native American Church paraphernalia is made by the Sioux. "The Sioux novices probably received their first Peyote ritual items from their mentors in eastern Nebraska and continued to do so until Sioux craftsmen became proficient in the new decorative techniques used and began producing 'instruments' of their own. Exactly when this happened is unclear, but certainly by the early 1960s (the time of my first encounter with Sioux Peyotists), Sioux craftsmen had attained a high degree of technical excellence and artistic innovation based upon a brief but intense history of total commitment to the Peyote way."[*]

One of these innovations was the development of a fixed prayer fan, rather than the loose type, with feathers extending like loose jointed fingers (see cat. no. 121). A superb example is found in this set by the Reverend Burnett Iron Shell. The set was obtained at my request and is a collector's rarity, for the Sioux "never developed an industry of making or selling Peyote items and it is rare to find a gourd (rattle) or fan for sale in shops near by Sioux country."[**] A particular Sioux preference (over against Southern Plains and Navajo peyote art) is the use of small beads.

The kit, not shown here, is modeled on an old-fashioned, hand-carried toolbox. Kits are usually not made by the author of its contents. For a Southern Plains example of a painted leather kit, see catalogue number 209. Other prominent Sioux peyote craftsmen include Clarence Rockboy, Duane Shields, and the Stoneman family.

[*]F. Dennis Lessard, "Instruments of Prayer: The Peyote Art of the Sioux," *American Indian Art Magazine*, vol. 9, no. 2 (Spring 1984), p. 24.
[**]Ibid.
Purchased through Harold Moore, director of the Buechel Memorial Museum, Saint Francis, South Dakota, 1983.
Collection Donald D. Jones, Kansas City, Missouri.

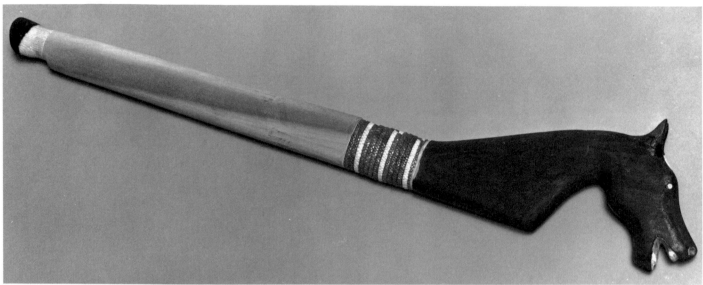

141

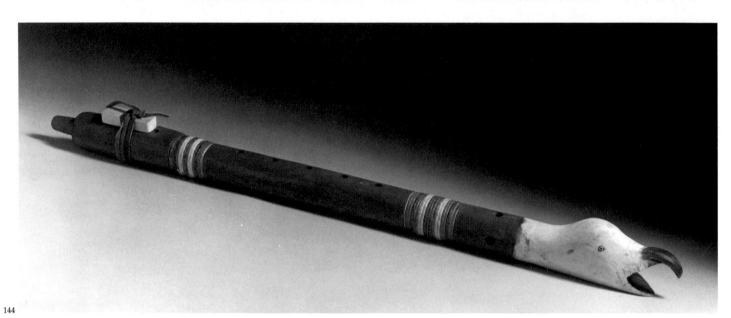

144

141

DANCE STICK, 1982
Wood, quills, beads
19⅞" l.

Lloyd One Star
Sioux
Rosebud Indian Reservation, Saint Francis, South Dakota

Today's Horse Dance sticks carry the old societal associations only indirectly; now they are used in general dancing, held in the hand along with fans, mirror cases, and shields. They are no longer of ceremonial use, since the Horse Dance Society, which originally dictated this type of stick, died out in the 1880s after this warrior society ceased to be important. "But we still remember," says Sioux artist Randy Lee White (see cat. no. 160), "it never gets out of us."

Purchased at the Gift Shop, Buechel Memorial Museum, Saint Francis, South Dakota, November 1981.

142

PENDANT NECKLACE, 1981
Trade silver, beads, bone hair pipes, plastic beads, Indian-head-and-buffalo nickel
16⅜" l.; diam. of medallion 4"

Dallas Bordeaux (Chief Eagle)
Sioux
Rosebud Indian Reservation, Marty, South Dakota

The metalwork of Dallas Bordeaux (Chief Eagle) represents a more conservative strain in modern Northern Plains jewelry than that of Mitchell Zephier (cat. no. 143). Bordeaux uses flat cutout sheeting in the raw and does not overlay, stipple, encrust with stones, or polish his images, which remain direct and simple in order to recall the old days. The medallion form itself is modern, but in his hands it is reminiscent of old-style metal gorgets and breast ornaments. The coin insert (which hangs free) is a play on "Indianness," in which white coinage becomes a double-edged image: a sacred buffalo incorporated into the materialism of the American economy.

Mr. Bordeaux is a graduate of the University of South Dakota at Vermillion; at the time this piece was purchased he had only recently assumed the title Chief Eagle from his late father.

Purchased at the W. H. Over Museum Shop, University of South Dakota, Vermillion, March 1982.

143

MEDALLION NECKLACE ("Sweat Lodge Vision, No. 1"), 1982
Trade silver, jewelers gold, copper, brass beads, bone, commercial tanning
20" l.; diam. of medallion 3¼"

Mitchell Zephier
Sioux (Rosebud Indian Reservation)
Resident at Rapid City, South Dakota

Mitchell Zephier (Pretty Voice Hawk) is the most gifted Northern Plains contemporary silversmith. A young man, with a great deal of time in which to realize his promise, he has already been the subject of a laudatory article by banker/trader James O. Aplan.* His work is readily sold in Europe, and he has visited Germany on invitation. Despite this growing reputation he participates in the Plains powwow circuit, where he can be found selling his work from tables and booths, and is a constant part of the Plains Indian scene.

The visionary quality of Zephier's metalwork is seen in this medallion necklace, which bears the inscription "Sweat Lodge Vision, No. 1" on the reverse. The sweat lodge ceremony is presently undergoing an intense revival throughout the Plains area. It is particularly popular among young people, so that this heavy pendant, with its polished surface and complicated raised imagery, is very contempo-

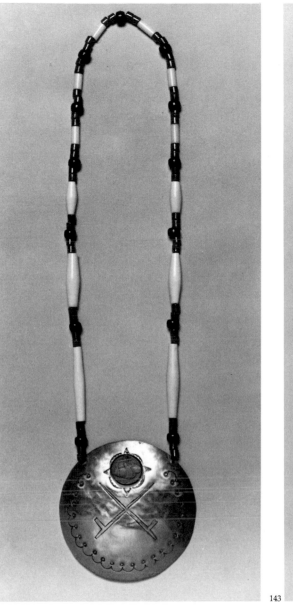

142

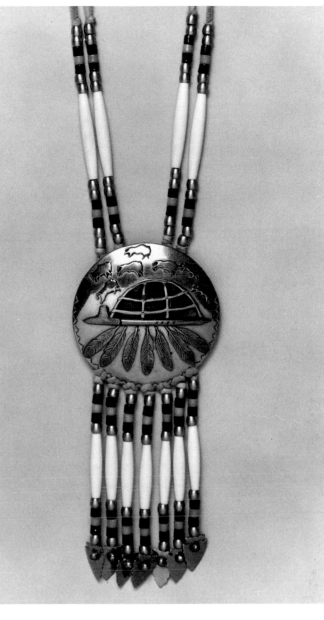

143

144

145

rary in personifying ceremonial preference. In the past, personal visions were painted on shields to protect the owner, but not depicted on shield-shaped jewelry; nor was the sweat lodge itself depicted, since in old times a vision quest was a highly personal ordeal, experienced alone, in solitude. Today there is interest in the process itself – in enacting the process of ceremony, which is looked upon more self-consciously than in the past.

In this medallion, tradition joins new and genuine frames of reference in order to further spirituality. The buffalo emerge from the sweat lodge, a whole psychic mind set erupts, and design exudes symbolic energy reminiscent of and related to the visionary function of shields. The sweat lodge vision depicted here was based on experience. "I've had those visions, and I've had some others…."

At the time this piece was purchased Zephier said he would do more work in sterling silver. "It's easier to handle than trade [nickel] silver. You can simply bend it to do more of what you want." However, in 1985 he was still favoring trade silver.

*James O. Aplan, "Mitchell Zephier," *Dakota West*, vol. 7, no. 3 (Summer 1981), pp. 14–17.
Purchased from the maker through Harold Moore, director of the Buechel Memorial Museum, Saint Francis, South Dakota, summer 1983.
Collection Donald D. Jones, Kansas City, Missouri.

FLUTE, 1978–80
Wood, quills, paint, beads, leather thong
26½" l.

Jim One Feather
Sioux
Rosebud Indian Reservation, Saint Francis, South Dakota

Cylindrical wood flutes, played much like a recorder, are traditionally used by young men of many tribes to play courting songs. Typically, the swain serenades the object of his affection with a call she will know is for her, even though she is in her parent's tepee. A variety of songs, however, may be played on the flute. At an Indian Dance event held at the museum in Saint Joseph, Missouri, in 1979, veteran Kickapoo flutemaker and player Lester Goslin demonstrated his art. "Ah, he is serenading his Sadie," said an elderly Indian woman. "It doesn't make any difference how old we are!"

Most of Jim One Feather's flutes depict an eagle, sometimes with a smaller bird serving as a stopper. In former times, a crane, considered an erotic symbol, was a favorite motif. The flutes are made by the One Feather family: Jim, his son, and his wife, who does the quill decorations.

Purchased at the Indian Museum Store, Fort Yates, North Dakota, April 1982.

CRADLEBOARD, 1982
Cowhide, wood, paint, felt, leather, brass tacks, down feathers, cotton lining
36" h. x 10" w.

Lloyd One Star
Sioux
Rosebud Indian Reservation, Saint Francis, South Dakota

A rawhide baby carrier is a Lloyd One Star invention. Old ones on the Plains were made of buckskin or trade cloth, or a combination of the two. The boldly painted designs are a simplification of the beadwork patterns used on late-nineteenth-century Sioux cradle covers.

Since this piece was purchased, a number of talented cradle makers have come to light, some innovative, some highly traditional. An overview of this work reveals the simultaneity of innovation and stasis, which composes tradition. The term "tradition and change" is a misnomer; rather, it is the duality of innovation and conservatism that are both integral to tradition.

Purchased through Harold Moore, director of the Buechel Memorial Museum, Saint Francis, South Dakota, March 1982.

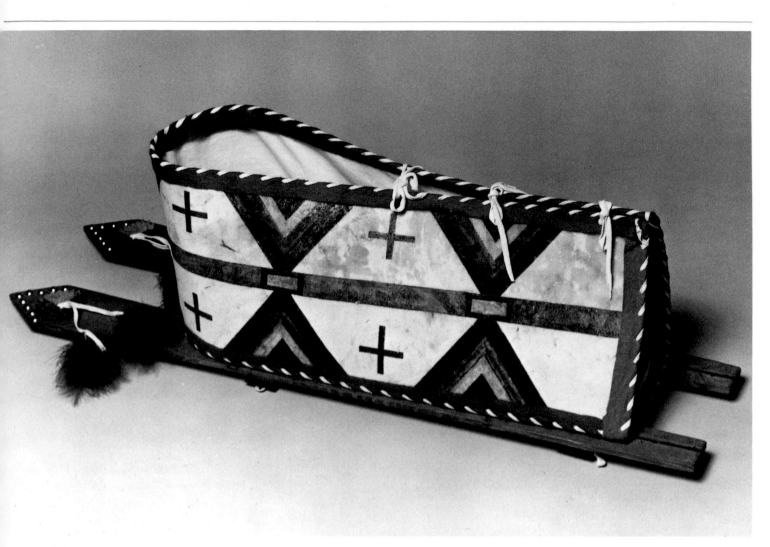

145

146

Buffalo-horn spoon, ca. 1982
Buffalo horn, porcupine quill
8¾" l.

Susan Shields-Them
Sioux
Rosebud Indian Reservation, South Dakota

Susan Shields-Them is an older craft worker who makes various things, including quilled barrettes, quilled princess crowns, and buffalo-horn spoons. This object is highly traditional in the use of buffalo horn; however, the scoop is not steam bent, but results from a slice through the horn, a sort of shortcut approach to the problem.

Purchased at the W. H. Over Museum Shop, University of South Dakota, Vermillion, May 1982.

147, 148

Awl, 1982
Cow tendon, needle
5⅞" l.

Edna Leighton
Sioux
Rosebud Indian Reservation, Grass Mountain, South Dakota

Awl, ca. 1980
Bone
6" l.

Maker unknown
Crow
Crow Indian Reservation, Montana

These awls demonstrate that archaic or semi-archaic types of Indian tools are still being made sporadically in the midst of the technological age (see also cat. no. 181).

Mrs. Edna Leighton, a soft-spoken and much respected elder among the Rosebud Sioux, took the awl out of her purse when I visited her home at Grass Mountain. Mrs. Leighton is an eminent beadworker and quilt maker; for her, fashioning these awls is a personal expression.

Catalogue number 147 purchased from the maker, September 1982.
Catalogue number 148 purchased at Lammer's Trading Post, Hardin, Montana, July 1982.

149

Pipe bag, 1982
Elk skin (?), beads, brass beads, nylon thread
21½" l. (including fringe) x 6⅝" w.

Douglas Fast Horse
Sioux
Pine Ridge Indian Reservation, Pine Ridge, South Dakota

This wide bag is more bulky in format than most old-style bags (cat. no. 150). With its turtle design, beaded band surmounted by two tepee motifs, heavily beaded border on three sides of the front, and its bright purple, yellow, and magenta colors, this image has a framed-in pictorial quality that is contemporary and Pan-Indian in feeling. On the back is a sun symbol with four radiating concentric circles (the four directions within the sacred circle). Since Douglas Fast Horse doesn't quill, the fringes are left as they are, or to be quilled if the owner so desires. The puffed-up character of the Indian tanning is due to the rich admixture of deer or cow brains in the tanning mordant, or to not having taken the skin down much in the scraping process. In any event, the thick cream effect is also a modern taste preference of the younger Plains artists.

Purchased from The Indians, Keystone, South Dakota, September 1982.

146

147

148

149

150

Pipe bag, 1980–82
Buckskin, beads, quills, dental floss, tinklers, horsehair
18¼" l. (including fringe) x 4" w.

Maker unknown
Sioux
Pine Ridge Indian Reservation, South Dakota

This woman's pipe bag is made of very finely scraped Indian-tanned buckskin. The beadwork is executed in lazy stitch. Both faces have designs that concern the number four: on the front, a turtle medallion (life symbol), the four winds (prongs), and the four directions are indicated several times; the obverse shows two deities with ever-open eyes and "meat rack" (three-pronged or trinitarian) symbols. "You couldn't be attacked, with those eyes always open to everything," observed Randy Lee White (see cat. no. 160) when he examined this piece. Readymade, Indian-produced quilling, available in Rapid City, was used evidently for the fringes.

While an estimable piece of work, in neither design nor concept is this bag daring. Nevertheless, it is authentic work, attuned to the spirit of the past.

Purchased from The Indians, Keystone, South Dakota, August 1982.

151

Tobacco tampers, 1981–82
Wood, quill, imitation dentalium shell, down feathers

Long tamper
14⅛" l. (excluding tassels)

Tim Lammers

Short tamper
9¾" l.

Maker unknown

Sioux
Pine Ridge Indian Reservation, South Dakota

These objects are used to tamp tobacco into pipe bowls during pipe rituals. Sometimes old tampers are still found with their pipes, as patinated as the pipe stem. The terminal pattern on the shorter tamper recalls the cut feathers found on peyote fans (see cat. no. 211). This stepped pattern is an ascent symbol.

Purchased from The Indians, Keystone, South Dakota, August 1982.

152

Pipe stem, 1982
Ash wood, porcupine quills
20½" l.

Aloysius New Holy
Sioux
Pine Ridge Indian Reservation, Oglala, South Dakota

We set out to visit William Running Hawk, the ledger-book maker (see cat. no. 159), but the mud on Pine Ridge Reservation stopped us; even four-wheel drive could not navigate a condition of earth known locally as gumbo. My mentor, Jim Hanson, suggested stopping by the New Holys instead. "The New Holys are a bohemian artistic family," he warned me, "and they live that way. Don't expect the Ritz." This prepared me for the "informal" studio – a government house in a subdivision – but not for the rollicking sense of ease found there.

Aloysius New Holy is one of the finest quill workers on the Plains; certainly the family he represents is the most influential in quilling, even as far away as Canada (see cat. no. 200). They have extended a system of quill wrapping, traditional but standardized, that is easily adopted by others. If the quilling is not as subtle and rich as that of Joyce Fogarty (cat. no. 166), wherein one feels an almost aristocratic,

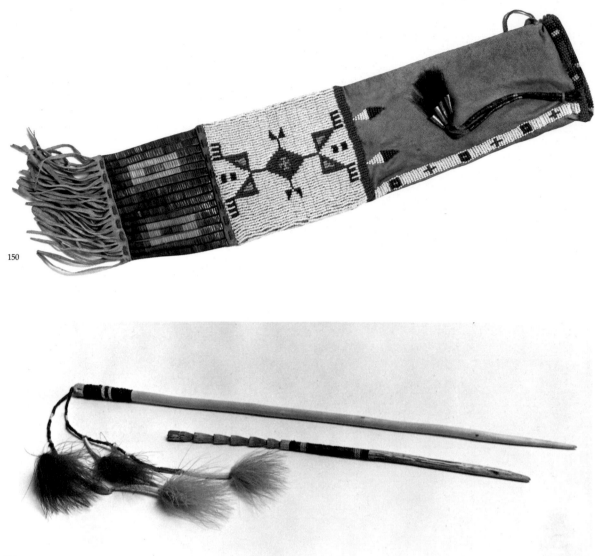

150

151

153

inner-directed sensibility at work, it has the virtue of easy emulation. For this reason, an example of Al New Holy's less well-known folded quill work is shown here, rather than the more easily emulated "flat" work. For intricacy of wrapping, this elegantly carved pipe stem cannot be faulted and is comparable only to Myron Taylor's work (cat. no. 125). The geometrical configurations of the stem – hexagonal, round, quadrilateral, and oval in turn – create a staccato counterpoint to the quilled patterns, which would be too consistent for maximum impact were it not for this element of carved relief. Myron Taylor achieves this sense of carved relief by adding feathers.

When we left Al New Holy, his nephew Walter was finishing a Sun Dance eagle-bone whistle. This object was not acquired because of the prohibition against purchasing objects made of endangered species, a ban from which Indians are protected by the Freedom of Religion Act.

Purchased from The Indians, Keystone, South Dakota, August 1982.

MEDALLION NECKLACE AND CHOKER, 1983
Quills, beads, rawhide, buckskin, miniature bone hair pipe
Medallion necklace 14" l.; diam. of medallion 2¾"
Choker 25" l. (including ties); diam. of medallion 1½"

Alice New Holy Blue Legs and M. Cathy Patton
Sioux
Pine Ridge Indian Reservation, Grass Creek, South Dakota

Brother Simon of the Holy Rosary Mission at Pine Ridge Reservation has long been a counselor to the Pine Ridge Community, particularly with regard to arts and crafts. "He's got the quillwork, he always knows what's going on," Jim Hanson of Chadron, Nebraska, my mentor in these matters, had told me. At the time of my visit, however, Brother Simon was on retreat and the safe was locked. Later I saw a group of quilled Pine Ridge medallion necklaces for sale in the gift shop at the museum in Aberdeen, South Dakota. Brother Simon had been through there.

The matter of quilled medallions dropped, until I received an unexpected visit in Washington from Mrs. Ken (Cathy) Vogele of Rapid City, South Dakota. "Mrs. Amiotte has sent

with me the quillwork you wanted by the Blue Legs," she said, setting five pieces down on my desk (see also cat. no. 154). I had met Mrs. Emma Amiotte (see cat. no. 158) the previous year at the Plains Indian Art Conference in Pierre, South Dakota, and the meeting had been followed by an exchange of letters and visits.

This choker and medallion necklace are in the Pine Ridge style, with concise circles of quilling lined up in concentric fashion to create the medallion, and dyed quills of contrasting colors radiating like spokes of a wheel against the solid field, which is white in the necklace, blue in the choker.

The Blue Legs family are close relatives of the New Holy family and share in the influence that Pine Ridge quilling has exercised on modern Plains quilling (see cat. no. 200).

In September 1985 Alice New Holy Blue Legs received a National Heritage Fellowship from the National Endowment for the Arts, the nation's highest award for accomplishment in a traditional arts field.

Purchased from Mrs. Emma Amiotte through Cathy Vogele, Washington, D.C., May 1983.

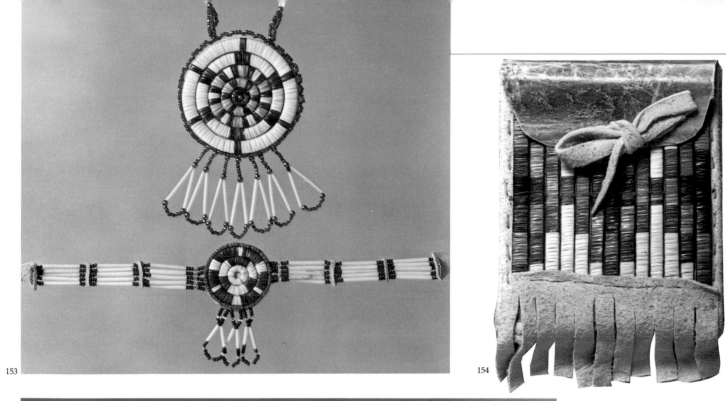

153

154

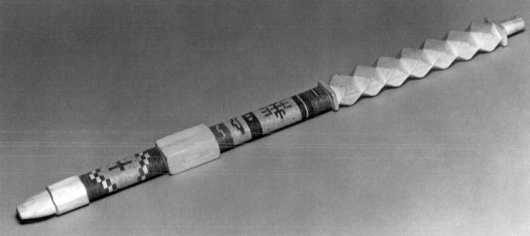

152

154

"Strike-a-Light" bag, 1983
Porcupine quills, buckskin, rawhide, thread
5⅜" h. (including fringe) x 3⅞" w.

Alice New Holy Blue Legs and M. Cathy
Patton
Sioux
Pine Ridge Indian Reservation, Grass Creek,
South Dakota

This handsome piece of quill work was given
by Emma Amiotte (see cat. no. 153) to Cathy
and Ken Vogele of Rapid City, South Dakota,
collectors and Indian enthusiasts, to bring to
my office in Washington, along with a quilled
medallion and two chokers I had asked for
more than a year before. "Strike-a-light" bags
are made to hang on a belt and contain a metal
"strike-a-light" with which to start a fire.

 Alice New Holy Blue Legs and M. Cathy
Patton are mother and daughter; they are re-
lated to the esteemed New Holy family of quill
workers (see cat. nos. 152 and 153).

Purchased from Mrs. Emma Amiotte through Cathy
Vogele, Washington, D.C., May 1983.

155

Rawhide parfleches, 1983
Cowhide, commercial ties, enamel paint
11" h. x 18½" w.
10¼" h. x 16" w.

Leo Fire Thunder
Sioux
Pine Ridge Indian Reservation, South Dakota

No matter whether they are called "Indian
suitcases," "meat containers," or "parfleches"
(that which stops an arrow), plain rawhide
dried-meat cases are functionally obsolete in
today's Indian cultures, having been replaced
by the carton, the box, and the bag. Still, excel-
lent rawhide work persists here and there, in
an occasional old-style parfleche, or, notably, in
the emblematic cutouts that are hung from the
pole of the Sun Dance lodge as symbols of
increase and renewal.

 On seeing the remarkably vigorous,
shaggy rawhide buffalo and human (male)
cutouts from the Pine Ridge Sun Dance of 1965
in the safekeeping of the Museum of the Fur
Trade at Chadron, Nebraska, I asked whether
the maker was still active.

 "Yes," my mentor Jim Hanson informed
me. "Leo Fire Thunder made this purse for my
wife."

"Would he be willing to make up a pair of
parfleches and a purse that we could show
publicly? That Sun Dance material is sacred
and has been used...."

 It took several months for the work to be
completed, for the damp and rainy spring of
1983 made it impossible for Leo Fire Thunder
to dry the raw cowhide sufficiently in order to
bend and scrape it. In former times the
parfleches would have been an exactly
matched pair, to be slung on each side of a
horse's flank.

 The painted tepee and directional symbols
are simplifications of old-time designs, and
emphasis is rather on the non-traditional buf-
falo silhouettes, with the cow hair left intact.
They directly recall the artist's Sun Dance
cutouts, which were also left furry.

Purchased from the maker through James Hanson,
September 1982; received July 1983.

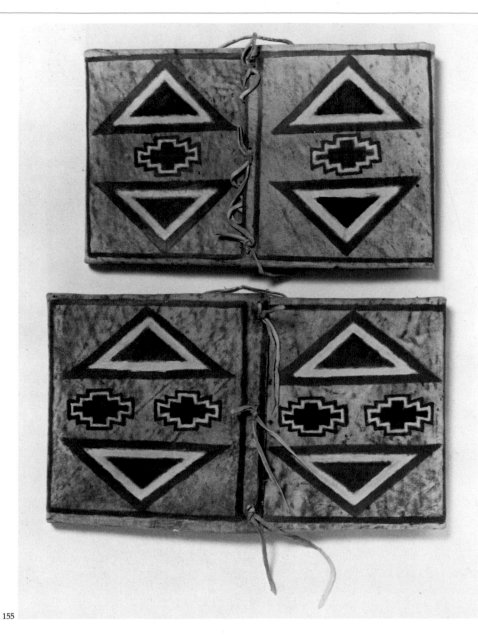

155

156

Pipe, 1982
Catlinite
20½" l. (bowl and stem); h. of bowl 5⅜"

Mark Zamiga
Sioux
Pine Ridge Indian Reservation, South Dakota

Pipes and stems of this type, made entirely of catlinite, are not usually functional. About 1905 such an object would perhaps have been made for an upper-class New York woman visiting the Plains. This is an impressive piece, "far better than the pipe and bowl he brought in before," the trader noted. But the young maker of it will be better when he carves without relying on the drill (which he used to make the holes that create the stippled effect on the pipe stem and body of the eagle) and on the hacksaw (the wings have been sawn through in tandem). But the forms are impressive, with a tension that awaits release. The relief carving on the upper stem is a conscious revival of the raised images (eagles, turtles, scrolls, etc.) carved on the wooden stems of old Sioux pipes. This is a classic case of a carver who deserves to be watched.

Purchased at The Indians, Keystone, South Dakota, August 1982.

157

Flute, ca. 1980–81
Wood, paint, commercial buckskin ties, shellac
21⅜" l.

Maker unknown
Sioux
Pine Ridge Indian Reservation, South Dakota

Many old courting flutes (see cat. no. 144) use a horse image on the stopper, because a good horse would get one out of a lot of scrapes and also aid in eloping, a not uncommon form of Plains marriage. Red and blue are sacred colors, red the most sacred of all. Therefore, a red horse would have been a great favorite as a horse who had been party to important exploits. Red and blue are male and female principles, symmetrical sides of prayer. Thus, this flute, if evaluated in its furthest application of memory, is still a potent instrument in its Indian world view. Red and blue are both reflected from the water (sky and evening sun).

Purchased from the booth of Buffalo Chips Trading Post at the National Congress of American Indians, Bismarck, North Dakota, August 1982.

158

"No-Face" doll, 1982
Cloth, commercial hide, beads, hair, miniature conchas, quills, dentalium shells, stuffing
9" h.

Emma Amiotte
Sioux (Pine Ridge Indian Reservation)
Resident at Rapid City, South Dakota

"My mother taught me to put no face on my dolls so that the owner can make up any faces she wants to, happy, sad, or in between," Mrs. Amiotte explained. Of mixed Spanish and Sioux descent, Mrs. Amiotte formerly managed the craft shop at the Sioux Indian Museum in Rapid City, South Dakota. The style of the doll's costume is a Sioux woman's broadcloth dress of about 1890–1900. The dentalium shells adorning the collar are of a type difficult to obtain today and were re-used here to confirm authenticity and quality. "I take pride in my dolls," Mrs. Amiotte declared.

Commissioned from the maker at the Plains Indian Art Conference in Pierre, South Dakota, April 1982; received December 1982.

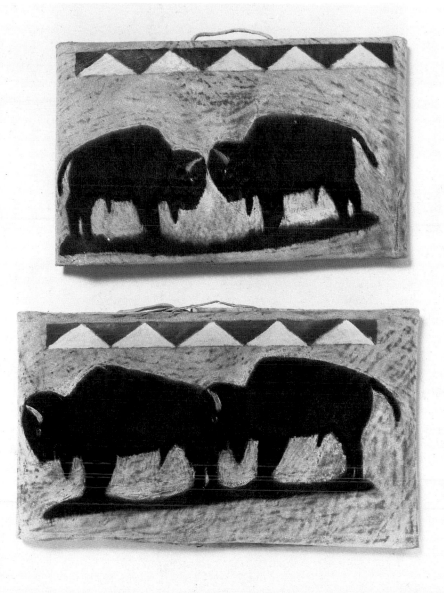

159

LEDGER BOOK, 1982
Trade ledger book, colored pencil
10⅜" h. x 8" w.
(see colorplate, p. 173)

William Running Hawk (deceased)
Sioux
Pine Ridge Indian Reservation, Lake
Wakpamini area, South Dakota

Toward the end of November 1981 I asked Jim Hanson of the Museum of the Fur Trade at Chadron, Nebraska, below the Pine Ridge Reservation, whether there was any probability that someone would still do an old-fashioned ledger book. Could that still be going on? Are the events, deeds, and exploits meaningful in this way? He knew of an older man and a younger one he could ask. On my next trip to Chadron I brought ledger books and colored pencils, just as traders did in the past. By way of "catechism," I also supplied a list of over fifty subjects, dealing with present life as well as the past. Some months later I was handed William Running Hawk's book.

These drawings grow on one as one turns the pages. They provide a rare opportunity to study a visual series of recollections from the past and the present of a prominent Sioux. What he selected to represent of his own life is

revealing, for there is continuity to the well-remembered past, but time shifts into the present, in the reflective Indian way. Yet, there is a progression to the isolation of old age. The drawings are not torn out of context and abstracted, but are heady and full of life as lived by an Indian individual of today with a rich store of memories. Bits of irony, work, wit, sobriety, recollections of military and domestic experience are magnified in these drawings. William Running Hawk, a drum maker and tanner of hides, was in his eighties when he created this book. His style here is in traditional "ledger book style," natural, worldly, contemporary, and timeless. The acquisition of this document was carried out in traditional fashion; no reactions were directly solicited. The drawings (with captions in Lakota by William's son) depict the following events:

1. White man named "Bear" by the Indians at Pine Ridge because he shot a bear at close quarters right outside his house. (This happened more than one hundred years ago; the story was related to William by his father-in-law, half Sioux John Bisonette, an Episcopalian priest. The bear power entered the man, hence his name.)

2. Grandfather Running Hawk in fancy regalia. (This gentleman died during World War II.)

3. Grandfather Running Hawk counting coup against a Crow Indian, traditional enemies of the Sioux (about 1870).

4. William's wife's grandfather, Gray Hat, a white trader. (This is John Bisonette, John's father, see drawing 1).

5. Grandfather Running Hawk as a warrior. (He was with Crazy Horse in June 1876 either at the Battle of the Rosebud River or the Battle of the Little Bighorn against Custer.)

6. Massacre of Wounded Knee, December 29, 1890. The moment when the cannon mounted on the hill fire on the Indian encampment below. The squaw and children on the far right seek the draw in an attempt to escape. (William heard tales of this event; to him this is living history.)

7. Pine Ridge Agency (about 1890–1900) with log buildings William saw as a child.

8. Chiefs being honored by a singer dressed in a Navajo blanket.

9. Scalp Dance or War Dance held (1917 or 1918) on William's leaving the reservation for military service in World War I.

10. William Running Hawk as a government cowboy (about 1920); horse has Oglala Sioux brand on forequarters and government brand on hindquarters.

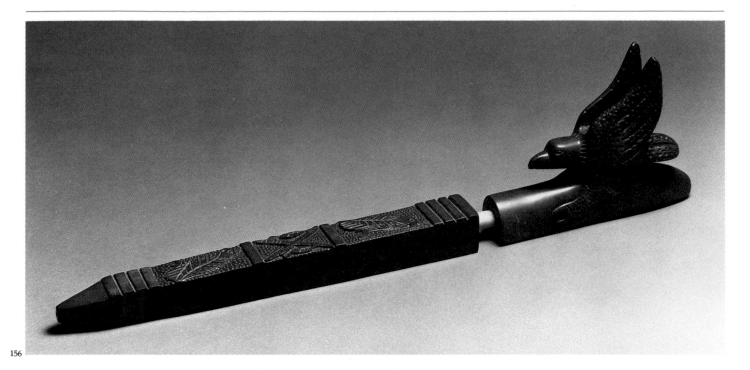

156

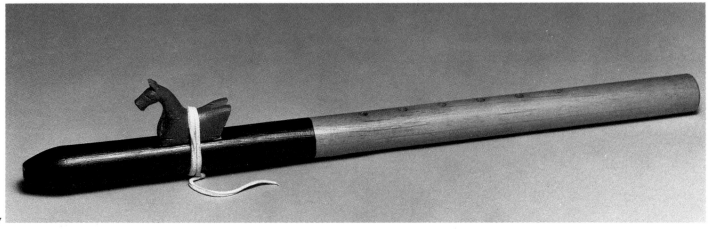

157

160

(see colorplate, p. 173)

11. William getting married to Lavinia Bisonette (about 1920). A "black robe" (minister) officiates.

12. A Fourth of July powwow (during the 1930s) with wagons and tents.

13. Lavinia selling her beadwork (during the 1940s).

14. William and Lavinia's new house in the town of Pine Ridge. (They moved from the country just before World War II.)

15. Sun Dance revival (about 1950). The pledger is undergoing piercing. "This happened."

16. A relative is killed in Vietnam. This is his funeral on the reservation at Lake Wakpamini. (More evidence of the store William sets by the flag and military honors, today as in the past.)

17. A peyote ceremony. (William is a peyotist and member of the Quarter Circle Moon Native American Church.) At prayer with a fan. Moon altar and fire. Peyote "kit" at right (see cat. no. 209).

18. Lavinia and William eating at home alone (1982). She has arthritis and uses crutches. Tragedy has visited them. They feel increasingly isolated. "We are old people now," reads the caption.

Purchased from the maker through James Hanson, September 1982.

LEDGER BOOK IN RAWHIDE CASE, 1981
Cowhide, four old ledger sheets, colored inks, watercolor
10¼" h. x 7¼" w.
(see colorplate, p. 173)

Randy Lee White
Sioux (Lower Brule Indian Reservation, South Dakota)
Resident at Questa, New Mexico

Randy Lee White [Horse], Lower Brule Sioux now in his thirties, was so thoroughly taught the language, symbols, and traditional customs and ceremonies of his people by his grandparents, that he is a walking encyclopedia of all these things. He is a participant in Indian life. His sensibility not only gifts him with insight beyond the ordinary into the vision and meaning of Plains culture, it also invests his understanding of the pictographic tradition of style and design, so central to that culture, with a lean, poetic, searching competence that assures its continuation and growth beyond the past and into the future. In addition to painting, he makes cast-paper painted objects (tepees, war shirts, lances) and watercolors, all of which issue from fundamental Indian themes rather than from art school subjects.

Randy Lee White first made this visionary ledger book as a moral tale for his little daughter. The spatterings on the pages are intended to re-

call the stains and vicissitudes visited by time on Indian objects in their environment. The cover displays a turtle design and horses' hoofs. The ties are both Indian tanned and commercial, to show "both sides of our lives today." The scenes depicted are:

1. This first episode fulfills the need the artist felt to refer to himself [bottom left] and his wife, to bring both of them into the book. His shield is by the lodge, decorated with a horse [White's Indian name, in Lakota, means "he who draws skinny horses"]. His wife Marina's Indian name means "walks alone." Both talk [speech waves]. The star at upper right refers to their daughter. ("I had a dream of what her name was to be. I looked up at the sky and saw a bright blue star that made an arc. This was her name, Falling Star. I didn't care if it was to be boy or girl, the name would be fitting either way. It gave a hint of what the child would be like.") [Here myth and reality mix.]

2. Marriage scene of the man and woman, depicted in the old way with three tepees symbolizing the three powers: water people, earth people, and sky people. ("The spotted horse refers to the man's name. He's really me in a way.")

3. Three of Spotted Horse's friends are killed and spurt blood. He rides forth to avenge their deaths. The three deaths are also those of the three powers, which are threatened by extinction.

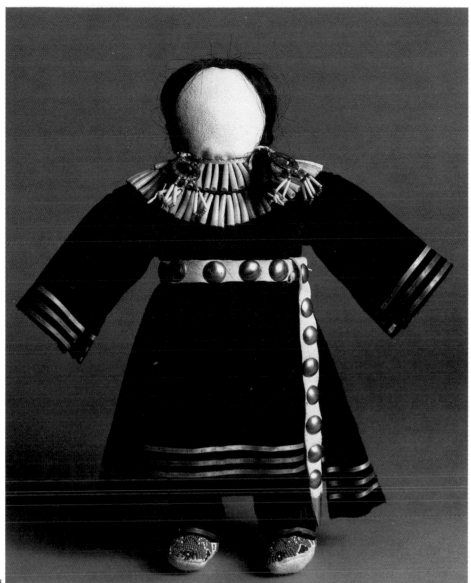

158

161

BEADED LEATHER BUCKLE, 1982
Buckle frame, beads, leather buckle, quills
3" diam.

Leonard Good Bear
Sioux (Cheyenne River Indian Reservation,
Eagle Butte, South Dakota)
Resident at Rapid City, South Dakota

"Well, we have Standing Bears, Little Bears...
all sorts of Bears, but I can't seem to remember
which Bear made this," said the Indian
proprietress of the Grass Mountain Shop at
Mission, South Dakota, the shopping town for
the Rosebud Sioux, as she studied this buckle.
The fine radial design is enhanced by quill
spokes, and the leather work conveys the In-
dian sense of play on Western wear, from
which the idea of making beaded buckles took
root a generation ago. Leonard Good Bear's fif-
teen-year-old daughter, Barbara Little Thunder
makes lizard- and turtle-effigy umbilical-cord
fetishes (protective amulets for the newborn),
an example of an art form often thought extinct
among Plains Indians. Both her mother and
father (a full-time garage mechanic in Rapid
City) are very much interested in "promoting
excellence in Plains art," according to their
friend, trader Cathy Vogele.

Purchased at Grass Mountain Shop, Mission, South
Dakota, September 1982.

162

PAIR OF MECHANICAL TOYS, 1985
Miniature mechanical horses made in Taiwan,
Indian-tanned hide, hair, metal, paint
3⅜" h. (including mounted rider) x 2⅞" l.

Don Tenoso
Sioux (Cheyenne River Indian Reservation,
South Dakota)
Resident at Santa Fe, New Mexico

These amusing and exquisitely crafted toys
represent a warrior and his wife dressed in
1890s Plains finery. Across his saddle the man
has a gun case containing a miniature gun; in
his right hand is a lance, on his left arm a
shield. He wears a Crow-style looped, beaded
necklace, and in his belt he carries a knife. The
zigzags on the horse represent lightning, and
the hand design indicates leadership. His con-
sort, astride a miniature painted hide (not
traditional), carries a Plains cradle on her back.
Her dress is decorated with miniature "elk
teeth," carved of bone. The hair is that of Don
Tenoso's wife, a Santa Clara Pueblo Indian.

Although the artist (fig. 41) started with
prefabricated toy horses, he has replaced
manes and tails and altered them with paint.
These extraordinary toys rest securely in the
tradition of Plains horse toys, first made from
sticks and then carved.

Commissioned January 1985.

4. On his way Spotted Horse is attacked and
killed by a party of Crows. [Note Crow style fore-
lock on man firing gun.]

5. Spotted Horse's scalp is lifted by his
Crow adversary.

6. His friend comes upon Spotted Horse
and laments the warrior's death.

7. His wife mourns at the burial scaffold,
with Spotted Horse's shield and lance hung
beside his shrouded body on the elevated plat-
form. [The star indicates the child to be born; life
is to be reborn in the child. The sacred buffalo
shield symbol appears three times in the book af-
firming "He is coming back." The wife before the
scaffold not only gives the traditional gesture of
mourning, but of renewal, redemption, and
return–the upraised hands of the Messiah or
Ghost Dance, a gesture heavy with mourning.]

Back Cover. The sacred buffalo shield and
signs of the four cosmological directions pin
down the final moral of the narrative: man's
worst enemy is himself; rebirth, hope, continu-
ation, the survival of water, earth, and sky is af-
firmed through the unborn child.

This is an old story Randy Lee White heard
as a child to which he has given his personal in-
terpretation. "I've heard stories like this from
old people of a woman who suffered this kind of
loss, a universal Indian story."

Purchased from Baumgartner Galleries, Washington,
D.C., February 1983.

Wic a Sa Itancan Wacipi

Scene 8

Okieize Wacipi

Scene 9

Pejuta yuta Lo wan pi

Scene 17

Wana Lila unkan pi

Scene 18

159

163

BEADED VISOR CAP, ca. 1981
Cloth and elastic cap, beads
diam. 7½" (irregular); brim 3¼" w.

Denise One Star
Sioux/Iroquois
Rosebud Indian Reservation, Saint Francis,
South Dakota

Denise One Star, an energetic young Iroquois married to a Rosebud Sioux, wore this cap when playing shortstop on the Rosebud Women's Baseball Team during the summer of 1981. Her mixed cultural background is reflected in the non-traditional brown beaded field and the loosely interpreted "tepee" motifs. This was among a group of "acculturated" items intended for display at the museum on Rosebud Indian Reservation.

Purchased at the Buechel Memorial Museum Gift Shop, Saint Francis, South Dakota, November 1981.

164

PEYOTE RATTLE, ca. 1982
Wood, gourd, reeds, dyed feather tip, cord fringe
22½" l. (including fringe)

Unidentified Sioux artisan
Sioux
North or South Dakota

Complete peyote rattles are to be had at numerous Indian trading stores, wherever the Native American Church flourishes, along with pre-shaped gourds (which make up the rattle) and separate handles, which are often kept in stock for the rattle maker. This rattle is an excellent example of typical diagonal peyote beading. Each bead is separately stitched with zigzag and ascending prayer motifs. Because of its extremely fine and delicate beadwork it was parted with reluctantly and then only for a high price.

"About the only place you see number 16 [very tiny] beads today is in small things like the handle on this [rattle]. I don't know where this one came from, but I sort of wish it could stay here," Muttsey, the proprietor of the shop, remarked.

Purchased at The Country Store, Saint Michael, North Dakota, September 1982.

165

BEADED SCABBARD, 1983
Rawhide, beads, ticks, leather, buckskin, old strouding
16" l. x 5" w.

Joyce Growing Thunder Fogarty
Assiniboine/Sioux (Fort Peck Indian Reservation, Poplar, Montana)
Resident at Rimrock, Arizona

Two scabbards arrived unexpectedly in the mail one day. "I thought you might want them," Joyce Fogarty, the sender, said over the phone. "It doesn't take me very long to make them up." The multiple stepped white "cubes" and bright blue field of the piece shown here create a positive and syncopated effect on the eye. At a distance the beaded design reorganizes itself into a Saint Andrew's cross. Rarely does one encounter such mastery of optical effects in beadwork, even in old Plains work. The rawhide is cow, the buckskin trailer fringes are home tanned. Typical of her thorough regard for correctness in every detail is the genuine Green River trade knife, found in Montana, Joyce Fogarty added to complete the ensemble.

Purchased from the maker, May 1983.

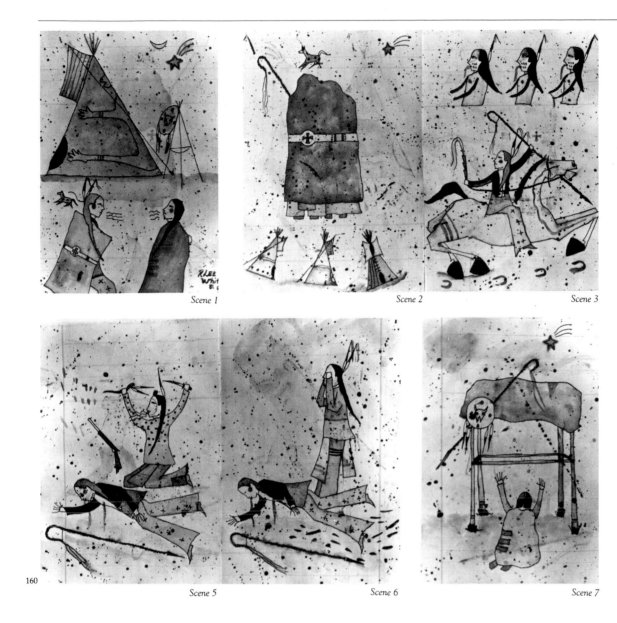

Scene 1 Scene 2 Scene 3

Scene 5 Scene 6 Scene 7

160

166

Quilled and beaded moccasins, 1982–83
Rawhide, quills, beads, tinklers, down feathers, sinew
4" h. x 10" l.
(see colorplate, p. 176)

Joyce Growing Thunder Fogarty
Assiniboine/Sioux (Fort Peck Indian Reservation, Poplar, Montana)
Resident at Rimrock, Arizona

On hearing that I was having trouble finding a pair of "the best" quilled moccasins, Joyce Fogarty admitted that she could make such a pair, though a great deal of labor was required. A subsequent letter described her efforts:

"Should have your mocs done soon. Putting horse tracks design around the ankle flaps. Still got to quill some fringes for the back. Tongue is all quills and sort of hides the design [eagles] some, but that's how many old ones seem to be. Trying to make you the best there is. If there are any fancier ones, I'd like to see them. These are all quills except for a bead border around the bottom. Used old colors (powder blue beads) on that. I hope your people there realize how much work a simple pair of moccasins can be." (March 9, 1983)

The finished moccasins were received about ten days later. They are equal to the very finest Sioux fancy dress moccasins of the 1890s. Joyce Fogarty is willing to go the extra mile in her craftsmanship; this concern shows up in the selection of the old pale blue beads for authenticity of style, in the beading that edges the tongue quilling so beautifully, in the elegant shades and color harmonies of the quillwork, and in the scraping of the raw cowhide to such thinness that light shines through it.

Purchased from the maker, March 1983.

167

War shirt, 1982–83
Cloth, hide, old glass beads, thread, weasel strips, otter fur, brass beads
32" l. x 67" w.
(see colorplates, pp. 174–75)

Joyce Growing Thunder Fogarty
Assiniboine/Sioux (Fort Peck Indian Reservation, Poplar, Montana)
Resident at Rimrock, Arizona

Joyce Growing Thunder Fogarty stood with her children on the boardwalk of downtown Jackson, Wyoming, in all her Indian-tanned finery one day in June 1982 (fig. 21). It could easily have been 1892. One half Assiniboine (father) and one half Sioux, Joyce Fogarty, now in her thirties, lives by and for her traditional crafts and believes in the old ways. She is happiest when doing old-style moccasins (see cat. no. 166), an eagle feather war bonnet, leggings, or a war shirt such as this. An incessant worker, her productivity is self-generated. No trader makes suggestions. She can also bead modern-day medallion necklaces. She has a contemporary concern that artisans of her stature be given recognition as befits their dignity

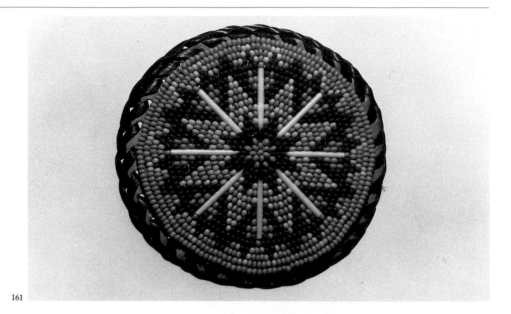

161

162

168

PAIR OF DOLLS, 1982
Cloth, home-tanned hide, beads, feathers,
porcupine hair, fake fur, wool, ribbon trim,
shell, fur, cut feathers, wood (bases)
male 15½" h. (to tip of roach feather)
female 14½" h.

Angela Shawl
Assiniboine/Sioux
Fort Belknap Indian Reservation, Montana

On my third visit to Juanita Tucker (cat. nos.
169 and 170) she showed me this pair of dolls,
"real old timers, very traditional." She wanted
to sell them because the maker, Angela Shawl,
to whom she had taught doll making, had
given them to her in lieu of cash for a debt.

Actually contemporary traditional, or
"straight," dancers of today (as opposed to
fancy powwow [competitive] dancers) are rep-
resented here in full regalia and great realism
of detail. They are not "old timers," as the calm
and static serenity of Juanita Tucker's old-time

and regrets the years of indifference or neglect.
She is too reserved to say much loudly, but
noted in a letter, "I wish many of my old grand-
mothers could have received some sort of rec-
ognition, they were great artists and lived in
poverty." Since Fort Peck is cold and seemed to
offer too little to sustaining her crafts, she and
her painter husband, Jim Fogarty, moved to
Rimrock, Arizona, and live by what they sell
and by land lease income. "Never sold things
before, because I had my own feelings about
making money off of Indian ways.... That [a
quilled knife case and quilled bag] and the
buckskin bow-and-arrow case are all I've ever
sold," she wrote soon after the move. In the
last year her work has come into great demand,
and she is fast gaining the recognition denied
her forebears.

After the war shirt was ordered, she wrote
as it evolved. "It's done in real bead designs
like the 1860s – 3½ inch wide strips with black
block designs on white background. Trying to
find some red cloth today to put the beadwork

on. Will put some long buckskin fringes along
the strips, probably twist and paint them earth
yellow. [They are straight and unpainted in the
finished shirt.] Should have this finished next
week" (September 27, 1982). "I'm still waiting
on brass beads and more otter fur to arrive"
(January 1, 1983). "I'm waiting on some brass
beads to show up, so I can finish off the trim,
also do a little quill work on it" (January 6,
1983). "Finally got the brass beads from N.Y.
Took ten days to get here. Mailed your shirt
January 13th" (January 18, 1983).

In response to a question about a specific
source for the shirt, she wrote: "Just tried to do
an old-style shirt from what I know or have
seen during my life. Got to see some pretty old
things, when I was small, was raised by my
grandparents who were real old timers. I was
around old folks mostly. Also of course I've
seen many things in books and been to a few
museums – never anything like Smithsonian,
Heye, or Chicago. It's hard to remember where
I've seen what. Or where I get my ideas
sometimes."

Purchased from the maker, January 1983.

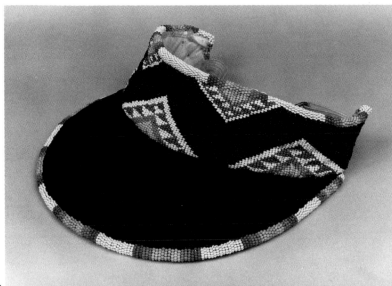

163

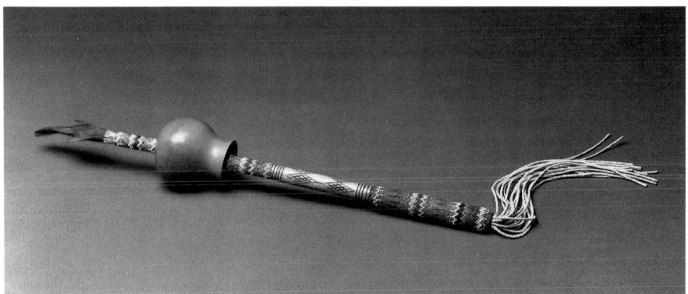

164

169

MOCCASINS, 1982
Buckskin, smoked-hide soles, old beaded panels
3½" h. x 10¼" l.

Juanita Tucker
Assiniboine
Fort Belknap Indian Reservation, Newtown, Montana

Rummaging in a workbox, elder Juanita Tucker brought forth this pair of recently finished moccasins, together with the remains of what proved to be an old shirt. "Those [pointing to the floral panels sewn on the moccasins] were on my father's old shirt; they were cut off when he died. I decided this spring to use them on a pair of mocs." From the style of these petal-shaped panels (white with blue border and floral pattern), they would appear to be of Western Great Lakes origin, perhaps affixed to another piece of clothing even before Juanita Tucker's father owned them. The re-use of portions of clothing, the constant repairs and emendations made to Indian dress, is ages old. Here one sees an instructive marriage of disparate elements. (The beadwork is not from Montana but originated in Minnesota, Eastern Sioux or perhaps Ojibwa.)

Purchased from the maker, September 1982.

170

DOLL, ca. 1970–75
Deerskin, stuffing, beads, wool, plastic, cloth, feathers
11" h.

Juanita Tucker
Assiniboine
Fort Belknap Indian Reservation, Newtown, Montana

Betsy Coe, the proprietress of The Artisan's Workshop in Havre, Montana, produced this doll from her back room with the statement, "That is a real treasure – home-tanned skin dress, exquisite miniature beading down to the belt purse." Although made some time during the 1970s, the style of the dress is pre-1900, as is the style of the coiffure.

The maker was hinted at, a woman named Juanita Tucker. "She is part black and pretty frail now, a very fine older lady.... If you show it to her...she may say it was taken away from her or stolen, or maybe she will tell you a lot. You can never be sure. She's wonderful at

doll (cat. no. 170) attests. This pair, by her pupil, are depicted in the act of dancing, with their feet off, or part way off, the ground. Attached to bases, they are not dolls as much as models of correct dress and explanations of dance practice, powwow style. "We like to keep Angela's dolls around to remind us of what we do," said a worker in a senior citizens' program. In their extreme verism and detailing (down to intent facial expressions and accoutrements that are in fashion today), they are the Plains parallel to contemporary developments in kachina carving in the Southwest. The contrast in approach to doll making between master and pupil (who is herself in middle age) is the difference between the generations.

Purchased from Juanita Tucker, Newtown, Montana, September 1982.

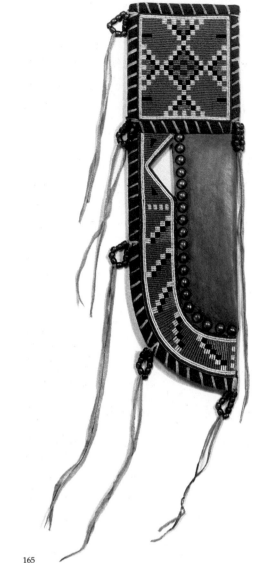

165

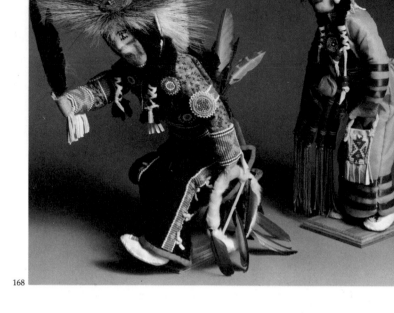

168

171

details like the tiny beaded dress fringes on front and back – that's her kind of work.''

When Mrs. Tucker was subsequently visited in her home, a pair of similar, but less well made, dolls she was working on left no doubt as to the correctness of Betsy Coe's attribution. A favorite elder, Mrs. Tucker is called on by friends and relatives and discusses old times. ''You want an Indian suitcase [parfleche]? I haven't made one in years because now the meat goes in there [pointing to the freezer]. We keep these dolls because they remind us of old times when we all wore braids [which Mrs. Tucker still wears]. They aren't just for play. When you folks get them, remember they are part of us.'' Her eyes, dimmed by cataracts, sparkled for a moment, then fastened on me again.

Brought into The Artisan's Workshop, Havre, Montana, by Gladys Schwartz, a Rocky Boy's Cree; purchased July 1982.

TRAILER EARRINGS, ca. 1979
German silver
7" l.

Julius Caesar (deceased)
Pawnee
Pawnee, Oklahoma

More than any other single artist, Julius Caesar kept alive Southern Plains silversmithing as a significant art form. His work includes rings, bracelets, pendants, gorgets, and earrings with a series of linked plates dangling from them in the manner of trailer headdresses, a unique contribution to Indian adornment that did not go unnoticed by other artists. While Caesar's work was not as a rule subtle in execution, it has a directness and power of design that renders it unmistakably his. His death in 1983 marked the end of an era in Pawnee silversmithing, though his son Bruce Caesar (cat. no. 172) is at least his equal.

Purchased through Nettie Standing at the Southern Plains Indian Museum Shop, Anadarko, Oklahoma, August 1980.
Private collection.

172

TIARA, 1975
German silver
3¼" h. (at center); 6¼" diam. (expandable)

Bruce Caesar
Pawnee/Sauk and Fox
Anadarko, Oklahoma

Bruce Caesar, the son of the late Julius Caesar (cat. no. 171) has carried Southern Plains silversmithing to new heights of elegance, surpassing in artistry any other younger artist who works in this medium. In this piece he applies his sense of invention, exquisite detailing, and command of openwork design to the tiara-type crowns worn by Indian princesses after their appointment to that office. These crowns are part of Pan-Indian ceremonialism and are widely made, but take on distinct local tribal characteristics: heavy sterling silver embellished only with turquoise among the Navajo; beaded designs among the Plains and

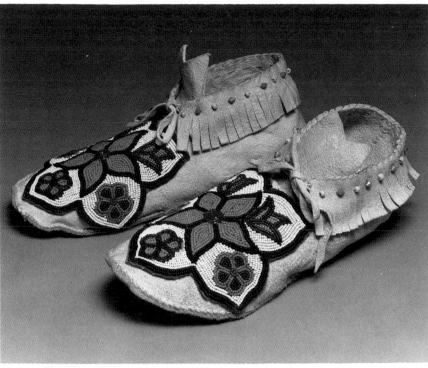

169

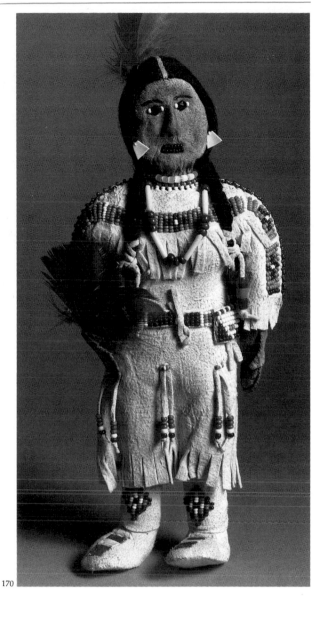

170

173

BEADED MEDALLION NECKLACE, ca. 1980–82
Beads, commercially prepared hide
21¼" l. (including beaded fringe); diam. of
medallion 3½"

Maker unknown
Northern Cheyenne
Lame Deer, Montana

This medallion necklace is a rather somber,
quiet piece, the motifs unaggressively stated,
the pale blue effect measured and clear, a little
like the stoic virtues of the Cheyenne people.
The attribution is that of the trader George
Lammer.

Purchased at Lammer's Trading Post, Hardin, Montana, July 1982.

174

KNIFE CASE, 1982
Rawhide, beads, soft commercial leather
12¼" l. (including buckle attachment and
fringe)

Jessie Copenhaver
Northern Cheyenne
Northern Cheyenne Indian Reservation,
Montana

This lazy-stitch beaded cowhide knife case was
found at the edge of the Northern Cheyenne
Reservation through Father Dan Crasky of the
Catholic Mission there. The use of cowhide
gives this case a highly traditional appearance,
and its design is identical to the work of a century ago, when both cowhide and saddle
leather were used for knife cases. The fringe is
Indian tanned.

Purchased at Saint Labra Mission, Northern Cheyenne Indian Reservation, Montana, July 1982.

Prairie tribes; and even a quilled version of the
debutante's tiara came to light at Rosebud,
South Dakota.

In this tiara the peyote bird (originally an
anhinga) is depicted in a feather circle. This
bird carries the prayers of the peyotists (members of the Native American Church) upward
into the spiritual realms. The tines along the
ends recall the Caddo woman's comb of the
nineteenth century, in which the tines went all
around the comb. These crowns can be seen as
an extension of the old combs, which were
worn on the back of the head, not the front,
and were much less noticeable than today's tiaras, which derive from old-fashioned ballroom dress. These tiaras are extensively used
today as crowns for Indian "princesses" and
award winners, such as Miss Indian America.
They are modern prestige items.

Purchased at the Southern Plains Indian Museum
Shop, Anadarko, Oklahoma, August 1980.
Private collection.

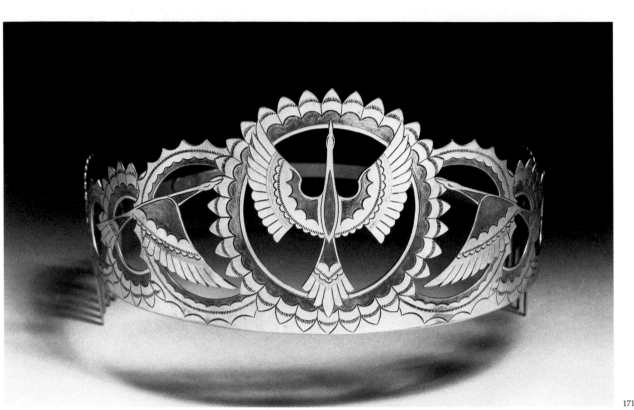

172

171

175

WAR BONNET, ca. 1980
Felt cap, eagle plumes, feathers, cut feathers, dyed horsehair, red felt, beads, smoked hide, down feathers, sinew
15" h. x 22" l.
(see colorplate, p. 177)

Maker unknown
Northern Cheyenne
Northern Cheyenne Indian Reservation, Lame Deer, Montana (?)

My criteria for a feather war bonnet – all eagle plumes, no turkey feathers, sinew sewn, straight old-fashioned wrappings, beading, and braided horsehair tassels – were impossible to meet, for it is a felony for a white person to purchase objects adorned with eagle feathers. Then Randy Lee White, the eminent

Sioux painter (see cat. no. 160), solved my problem. "Come to Questa, and I'll lend you one of *my* bonnets, all sinew sewn and right, and *contemporary*." Thanks to him, the soaring power of the eagle does invest this project.

This bonnet is recognizably Cheyenne in its traditional double-stepped beaded designs, here handled with old-time sobriety; it even has dust pigment (yellow earth) applied in the felt cap. In every respect it is equal to an old-time war bonnet. The lender says he was given the bonnet as a gift because the donor admired his work and because the *V*-shaped symbols on the beaded headband reminded him of the similar "horse tracks" Randy Lee White had put in his ledger book.

"I haven't danced it," Randy Lee White explained, "because I'm too young [in the Indian way of honors]," but it has been danced at Taos Pueblo at Feather Dances and War Dances, echoing into our own time long-standing Plains influences.

Particulars on the maker of this fine bonnet were never supplied.

Collection Randy Lee White, Questa, New Mexico.

176

HIGH-TOPPED MOCCASINS, ca. 1965–70
Buckskin, beads, commercial soles
13" h. x 9⅝" l.

Maker unknown
Crow
Crow Indian Reservation, Montana

These elegant, flower-decorated, cream-tanned woman's dress moccasins demonstrate the Crow flair for showy garments. The modern soles guarantee longer wear, and, in fact, this pair had "been around for quite a bit" when they were brought in for pawn at Hardin, Montana, a town just beyond the border of the Crow Reservation.

Brought into pawn by Rosebud Bull Tail, January 1982; purchased out of pawn at the Bargain Hut, Hardin, Montana, August 1982.

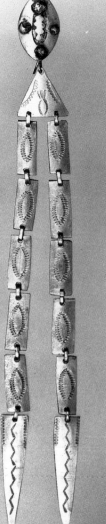

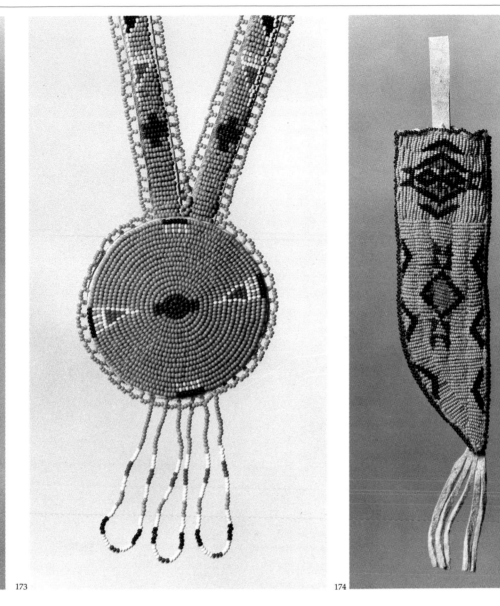

173

174

177

MEDALLION NECKLACE, ca. 1970–80
Beads, plastic beads, plastic hair pipes,
rhinestone, cowrie shells, commercial leather
ties and backing
21½" l.; diam. of medallion 4½"

Maker unknown
Crow
Crow Indian Reservation, Montana

This medallion, with its extravagant eight-
sided design, shows the elaboration the older
round medallion concept has reached in our
time on the Northern Plains. For a Southern
Plains variant on this idea, see catalogue num-
ber 204.

Purchased at Lammer's Trading Post, Hardin, Mon-
tana, July 1982.

178

BELT, ca. 1965–75
Beads, buckskin
2¼" w. x 64¾" l.

Maker unknown
Crow
Crow Indian Reservation, Crow Agency,
Montana

The white-on-white aesthetic of this piece is
part and parcel of the modern Crow taste pref-
erence. The loom beading and eight-pointed-
star motif is a powwow importation from the
Oklahoma tribes (see cat. no. 114), but the
Plains interpretation stresses the spatial in-
terruption by the white field. These are not
old-style Crow designs. The backing here is
Indian-tanned buckskin, the fringe ties are
commercial white buckskin.

Brought into pawn by Diana Fire Bear July 1982; pur-
chased out of pawn at the Bargain Hut, Hardin, Mon-
tana, August 1982.

179

HORSE OUTFIT, 1982–83
Buckskin, leather backing, beads, commercial
thong, bridle parts, tinklers, down feathers,
dye, goat-fur pelts
"Fur thing" 79" l. (including pelts) x 15¾" w.
(across beaded panels)
Martingale 34¼" l. x 12" h. (including hanging
fringe)
Stirrup covers 19½" h. x 12⅜" w.
Bridle 21" l.; reins 86" l.
(see colorplate, p. 179)

Marie Pretty Paints Wallace
Crow
Crow Indian Reservation, near Hardin,
Montana

The only Plains tribe that still makes outstand-
ing ceremonial use of the horse is the Crow.
Horses are proudly ridden at Crow Fair, the
largest Plains encampment and powwow,
where it is a great honor to receive a prize for
the best beaded horse outfit displayed during
the Fair parade. While rodeo influence per-
vades the modern day show-horse outfit, the
old warrior pride surfaces nonetheless.

It was toward the end of July 1982 that
Donald Stewart of the Crow Tribal Council
advised me to get in touch with Marie Pretty
Paints Wallace, "She'll do you a horse outfit if

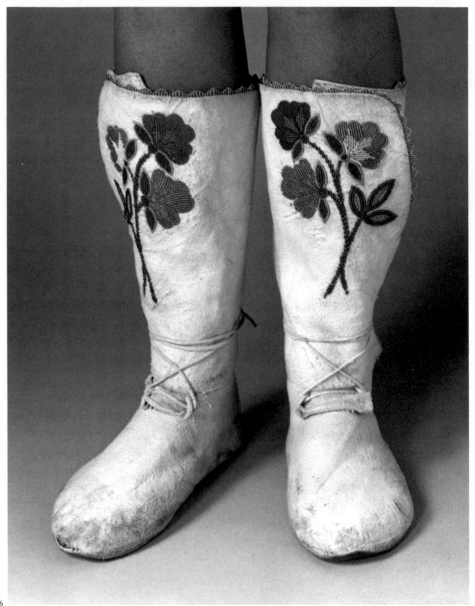

176

you want – you'd better get in touch with her." Mrs. Wallace, who played the role of midwife to Raquel Welch in the Hollywood film *Walks Far Woman*, is a prominent traditionalist who beads in a "studio" by the banks of the Little Bighorn River. I asked her to make a drawing of each piece, with the prices noted beside each item, and such a document was produced.

On returning to Kansas City, I received a letter requesting an immediate deposit of $500 for materials (see ch. 2). In November there was a further request for money, and news: "I am so lucky, I thought I was dreaming, but it is true. I was hired for the winter. Room and board here at Sun Lodge Motel.... So nice and warm. I get my meals at the café. On special at noon. I work Mon–Fri 9–5 each day [at the tribal gift shop]. I work on the deal [the horse outfit]. So don't worry about it. You'll be surprised when I'll write to you. When I finish it."

At the beginning of February 1983 there was another progress report: "Just a few lines to tell you, I have rec'd $300.00 for more material stuff. Thank you so much.... I have been sick with flu. My work delayed. But I am back on my feet. I am going to finish all your order. Okay the 4 [fur] thing. I bought a bridal [*sic*]. But without the bit. This I want you to know. Do you want me to put a bit on bridal. Or not. P.S. Try and wait for next week. It will be a surprise to get it. You know you will like it. Nothing like it, beautiful stuff. If I say it myself. I hope I satisfy all those in concern. Thank you."

Crow horse outfits are among the prize achievements of a people who love artistic elegance and who do not wish to appear ill-dressed on a formal occasion. Modern day outfits are a marriage between the old "horse nations" culture and recent participation by Indians in rodeos; in fact, the horse parade has become an aesthetic element in Crow life. Late-nineteenth- and early-twentieth-century horse adornments were in classic Crow beading style, white-edged hourglass-like motifs in blue, yellow, red, and green. Designs were overall patterns linked by beaded lines. Recent parade beading, beautifully represented by Marie Wallace's panels, feature smaller intertwined diamonds centered in bright blue fields. This produces an effect in which the field now dominates, almost the reverse of what went before.

"Where did your people get those modern telescoping diamonds and hook motifs?" I asked Red Star, the knowledgeable Crow artist and beader of buckles who lives in Lodge Grass on Crow Reservation.

"I hate to tell you, but probably from things like Oriental rugs," she replied.

Another source seems to be the zigzag diamonds and stars that have moved westward from the Oklahoma prairies in Pan-Indian powwow fashion. Whatever the sources, the Crow have not lost anything of their original dynamics for brilliant artistic display.

Ironically, most of the old-style Crow beadwork made today is done by white artisans for collectors, since they demand it.

Commissioned from the maker, July 1982; received March 1983.

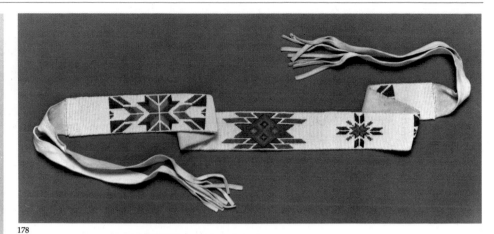

178

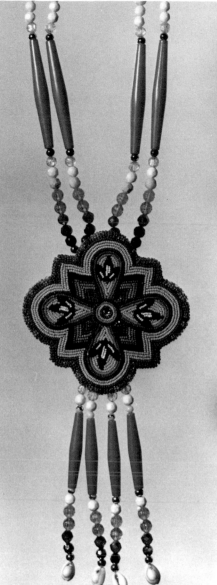

177

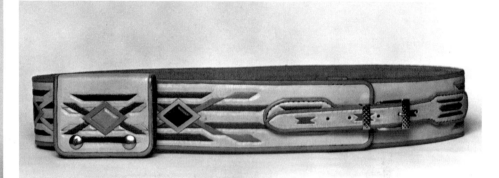

180

180

LEATHER BELT, 1980–81
Leather, paint
2¹⁵/₁₆" w. x 48½" l.

Maker unknown
Crow
Crow Indian Reservation, Montana

Tooled leather belts were made originally for those who could not afford a beaded belt. Today they are part of reservation dress and now often worn by dancers. This one is of special note, for both in color and design it attains a distinctive clarity. Its motif can be described fairly as "contemporary-traditional" and relates to the designs favored by the present-day Montana Crees.

Purchased at Lammer's Trading Post, Hardin, Montana, July 1982.

181

SCRAPER, ca. 1980–82
Elkhorn, sinew ties, metal blade, rawhide
10½" l.; blade 5" w.

Maker unknown
Crow
Crow Indian Reservation, Crow Agency, Montana

While acquired in Hardin, Montana (the town adjacent to Crow Reservation), details about this highly traditional old-fashioned Plains hide scraper remain uncertain. What is astonishing is that in this day of computer technology and modern knife blades, a scraper such as this is still being made. Blades have been crafted this way since time immemorial; metal blades (in this case an iron spring band) have been used in hide preparation since before the majority of Plains Indians moved out onto the Plains in the middle of the eighteenth century. This blade has not been used.

Purchased at Lammer's Trading Post, Hardin, Montana, July 1982.

182

BEADED BUCKLE, 1981–82
Buckle frame, beads, Indian-tanned backing
3¼" h. x 4½" l.

Erika Gros Ventre
Crow/Navajo
Crow Indian Reservation, Crow Agency, Montana

The large white-bordered triangles signify a Crow origin for this buckle, but the taupe field is unusual. In fact, the whole concept is a little off-key for traditional Crow work. Actually, it is intertribal, for Erika Gros Ventre is a Navajo married to a Crow painter named Cyrus Crow, according to Thom Myers the trader from whom this piece was purchased.

Purchased from the booth of Buffalo Chips Trading Post at the National Congress of American Indians, Bismarck, North Dakota, August 1982.

181

182

183, 184

PIPE BAG, 1979–80
Caribou hide (smoked side out), quills, badger teeth, sinew
23⅛″ l. (including fringe)
(see colorplate, p. 178)

PIPE BAG, 1979–80
Caribou hide (smoked side turned in), quills, horsehair, bells, tinklers, sinew
38″ l. (including fringe)
(see colorplate, p. 178)

Gordon Six Pipes
Cree (Red Pheasant Reserve, Saskatchewan)
Resident in Toronto area, Ontario

These are the best Plains pipe bags this collector found in all his travels. Even in a sweat lodge ritual conducted in full ceremonial style by a Cree medicine man, he did not see a pipe bag that was as beautiful as these two, or as ritualistically perfect in the correlation of design to thought. The smoked caribou hide for these

bags was supplied to Mr. Six Pipes by Guy Spital, proprietor of the shop on Six Nations Reserve, Ontario. Both bags are sinew sewn throughout and are magnificently patterned, edged, fringed, and cut. Better diagonal quilling, all three styles, is not to be found. Catalogue number 184 features quilling edged with horsehair embroidery, an extraordinary refinement at any time. The inclusion of badger teeth in catalogue number 183 is also most unusual.

The quilled designs are placed with a breathtaking simplicity, but this does not imply simplicity of meaning, for symbolic complexity abounds here. A system of four is invoked. On the face of catalogue number 183 four horse tracks (raiding symbols) center the four winds with the center of the universe in purple quilling (four plus one). The tall lance above is adorned with both sun (the hoop) and lunar motifs; these are rarely seen together, but both are allies helpful in raiding. The feathers attached to the lance and hoop can be seen as a four-plus-one combination or as two groups (divided by the lance) plus one (atop the lance), two plus one equaling the trinity of earth, water, sky. The badger teeth are in the same four-plus-one (or three-plus-one) combination.

Catalogue number 184 features a crooked lance, a warrior society lance indicating valor in raiding. The loose flaps of the rim symbolize the four directions, with the bag opening signifying the center of the universe, and they also conceal the ties when the bag is closed by drawing the thongs. The elongated diamonds below (the four directions) are in a pattern of four plus one, but can also be thought of as two plus one (center diamond), or as the Indian trinity of earth, sky, and water. The bells, tinklers, and fringe are also part of this system of holy numerical mysticism.

"You can almost sense the medicine working; those are killers – they are so right!" exclaimed Sioux artist Randy Lee White (cat. no. 160) on being handed these bags for scrutiny. "He isn't just repeating designs; he knows *why* he is doing it."

Purchased at Iroqrafts, Ohsweken, Six Nations Reserve, Ontario, August 1980.

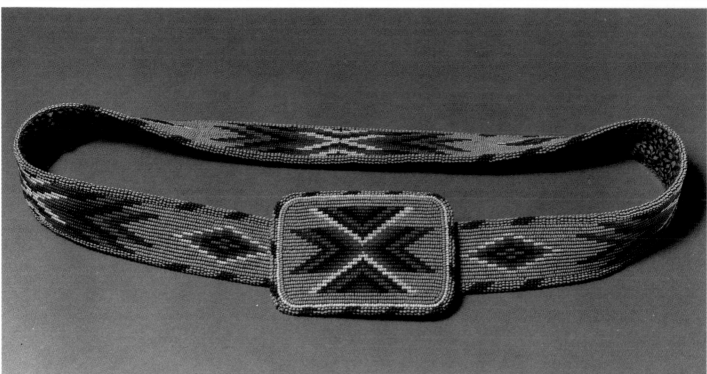

185

186

187

185

BEADED BELT AND BUCKLE, 1981
Beads, buckle frame, cloth, smoked-hide backing
1⅝" w. x 39¼" l. (including buckle); buckle 3" h. x 4¼" w.

Lee Eagleman
Chippewa/Cree
Rocky Boy's Indian Reservation, Montana

One never knows what there is amid the junk and discards of white and Indian cultures alike in the pawn shops found in towns near Indian reservations. One can come across objects of real style and value, pawned but not redeemed, hence for sale. When money is needed, a shop may receive a superior newly made piece such as this heavily beaded but unused belt and buckle set which came out from underneath the counter of Leon's Pawn Shop after I asked where the very best belts were to be found.

Purchased out of pawn at Leon's Pawn Shop, Havre, Montana, September 1982.

186, 187, 188

BEADED BUCKLE, 1982
Buckle frame, beads, smoked-hide backing
2⅞" h. x 3¾" w.

Maker unknown
Probably Chippewa/Cree
Rocky Boy's Indian Reservation, Montana

BEADED BUCKLE, 1982
Buckle frame, beads, smoked-hide backing
2⅝" h. x 4½" w.

Mary Jane Henderson
Chippewa/Cree
Rocky Boy's Indian Reservation, Montana

BEADED BUCKLE, 1982
Buckle frame, beads, suede backing
3" h. x 4½" w.
(see colorplate, p. 180)

Maker unknown
Chippewa/Cree
Rocky Boy's Indian Reservation, Montana

These three buckles have been grouped together to show the variations possible on the typical Rocky Boy feathered circle motif. Although catalogue number 186 was sold at the National Congress of American Indians convention as "Flathead," it was spotted as being by the maker of a belt worn by the Reverend Rains, of the Rocky Boy Lutheran Mission. There was no mistaking that bright orange, yellow, and blue iridescence. In catalogue number 187 the feather wheel seems to spin as it revolves against the borders. Catalogue number 188 is the most complex of the lot: it shows a cosmological night sky, with a feather moon and its encircling aureole surrounded by stars. Due to the circular beading pattern, the scene seems to burst from its frame and escape the confines of this world; all this on a surface some three inches high and four-and-a-half inches wide.

Catalogue number 186 purchased at the National Congress of American Indians, Bismarck, North Dakota, August 1982.
Catalogue number 187 purchased from the booth of Buffalo Chips Trading Post, at the same convention.
Catalogue number 188 purchased at Saint Mary's Lodge Gift Shop, Saint Mary, Montana, September 1982.

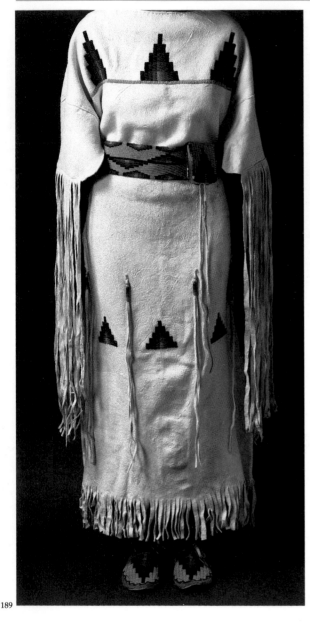

189

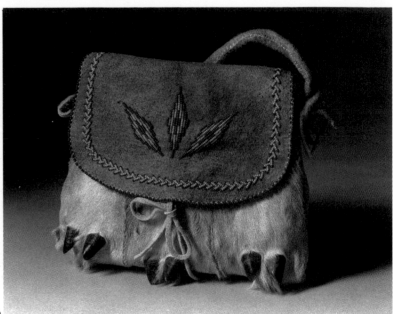

190

189

WOMAN'S COMPLETE OUTFIT, 1983
Cream-tanned hide, smoked hide, cowhide, beads
Dress 37½" w. (across sleeves, excluding fringe) x 52" l. (including fringe)
Belt with pouch 3" h. x 27½" l. (excluding ties)
Moccasins, 3¼" h. x 10¼" l.
Eardrops 2½" h. x 17½" l. (including fringe)
Leggings 9¾" h. x 6¾" w.

Minnie Watson and Agnes Parker
Chippewa/Cree
Rocky Boy's Indian Reservation, Montana

When I sought a complete woman's outfit, Mrs. Rains, wife of the Lutheran missionary, agreed to help and set up an appointment at the rectory with two "excellent ladies," Minnie Watson and Agnes Parker. "Minnie will head the project and Agnes will help her," she reported, "they've already worked it out between them."

When I walked in, Agnes Parker and I stared at each other in surprise. "I've seen you

before…," she pondered. "At the University of Kansas," I recalled, "you were demonstrating there…." We shook hands warmly and plans were agreed upon: a complete woman's outfit, home-tanned dress, with belt, purse, leggings, and even eardrops. "Just what we wear at 'our best.'"

During the next year I heard nothing; then, without warning, I was telephoned; the dress was finished. After a number of postal mishaps during which the wardrobe made a number of west-east round trips, the outfit arrived.

Here the American Plains (rather than the Canadian Cree) side of the Rocky Boy inheritance comes to the fore in the stepped tepee motifs used with great consistency on all the components. The dress is restrained in beading, giving the sumptuous cream tanning its sway. By contrast, the leggings, belt, and moccasins are fully beaded. The bright black and red-orange pyramid design is heightened in visual impact by being set against the cool blue field, making for a visually arresting ensemble.

Commissioned from the makers, summer 1982; received December 1983.

190

PURSE WITH LONG STRAP, ca. 1982
Deer fur and hooves, sinew, thread, beads, smoked hide, suede liner
8⅞" h. x 9⅞" w.

Maker unknown
Chippewa/Cree
Rocky Boy's Indian Reservation, Montana

The fur panels of this purse are made from six deer forelegs with the front toes still intact; the front flap is of smoked hide. It is decorated with beadwork diamonds and a closely spaced chevron pattern. A beaded border with a row of two shades of blue beads forms the flap edging. The long, stuffed, smoked-hide strap is for shoulder suspension rather than hand use.

"We haven't the faintest idea who made it, except that it comes from here [Rocky Boy]," said the salesgirl with a shake of her head. Though not as pristine in concept as the Montagnais/Naskapi caribou pelt bag (cat. no. 4), this piece is its Western equivalent.

Purchased at the Hobby Shop, Havre, Montana, August 1982.

193

192

191

191

PEPPER-SHAKER RATTLE, ca. 1970
Wood, pepper can, beads, horsehair, ribbon streamers, rubberband
28¼" l. including streamers

Maker unknown
Chippewa/Cree
Rocky Boy's Indian Reservation, Montana

This is a variant on the Native American Church peyote rattle. The ascendant prayer symbol of the beading is given an interesting quirk by bending the direction of the peyote stitching, like a gathering of smoke that suddenly swirls upward, echoing the prayers addressed by peyotists.

Rattles made of baking-powder cans (from government food allotments issued as reservation goods have been a standard feature on the Plains since the 1880s. Salt and pepper shakers, both metal and glass, are beaded today as sale items for home use. They are popular among the Jicarilla Apache and Nevada Paiute, as well as Northern Plains tribes.

Brought into The Artisan's Workshop, Havre, Montana, by A. Windy Boy, where it was purchased August 1982.

192

EARRINGS, ca. 1975–82
Bone, plastic
1" l.

Maker unknown
Chippewa/Cree
Rocky Boy's Indian Reservation, Montana

These earrings are full of associations for any Indian who plays the ubiquitous hand or bone gambling game circuit. They are miniatures of the marked and unmarked "bones" that are hidden in the palms in this widespread guessing game. The point is for the opposing team leaders to guess in which hand of a team member the "bone" is hidden (see cat. no. 193).

Brought into The Artisan's Workshop, Havre, Montana, by Katherine Windy Boy, where it was purchased September 1982.

193

HAND GAME SET, ca. 1975–82
Tubing, tape, cans, wood
Four "bones," each 2³⁄₁₆" l.; eleven counters, each 10³⁄₁₆" l.

Kenneth Gopher
Chippewa/Cree
Rocky Boy's Indian Reservation, Montana

So popular is the widespread Indian "bone," or hand gambling, game that sets are hard to acquire for anyone outside the culture in which they are being used. Numerous games operate at powwows and Indian Days, in an area set aside for the purpose. The drumming songs used on these occasions to confuse the guesses and add excitement stay forever in one's head. The object of the game is for the leader to guess which hand holds the concealed bone or cylinder. The counters are point keepers stuck in the ground by the team head. They pass back and forth as fortunes ebb and flow until finally all are taken up by the winning leader. Skillful players become adept at performing subtle offputting gestures.

The maker of this set was identified by the cook in a hotel kitchen. Amid smoke and steam, he took one look and said, "That's my brother-in-law, Kenneth Gopher. He made that."

Purchased at The Artisan's Workshop, Havre, Montana, September 1982.

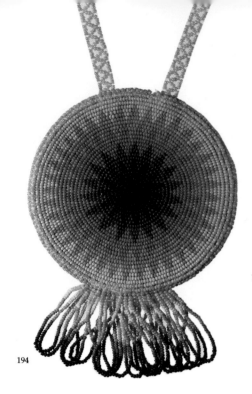

194

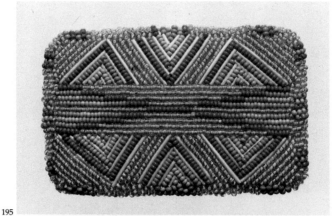

195

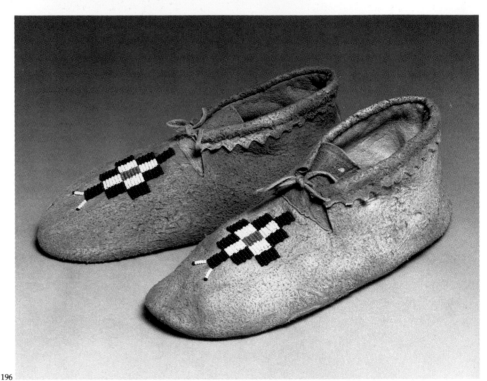

196

194

BEADED MEDALLION NECKLACE, 1982
Beads, prepared-hide backing, bone hair
pipes, cowrie shells
19″ l.; diam. of medallion 4⅛″

Gail Tatsy
Blackfeet
Blackfeet Indian Reservation, Montana

Classic expressions of modern medallion style
among the Sioux (cat. no. 153) and the
Blackfeet are reminiscent of the old
cosmological or "circles of the world" connota-
tions (when the medallions were applied to
buckskin shirts). Blackfeet work tends to em-
phasize concentric ring design, with even dis-
tribution of points, which adds optical projec-
tion to the design, with a sunburst effect
particularly noticeable in this medallion.

Purchased at Glacier Photo Studio, Browning, Mon-
tana, August 1982.

195

BEADED BUCKLE, 1980–81
Buckle frame, beads, quills, commercial
tanned backing
2⅜″ h. x 3¾″ w.

Patty Old Chief
Blackfeet
Blackfeet Indian Reservation, Browning,
Montana

This beautifully beaded quill-accented buckle
was found in a motel at the gateway to Glacier
National Park. The center band plays on the
Blackfeet mountain design, while the layered
effect of the triangles indicates that in buckles
the maker may work according to the dictates
of her own inspiration, in this case creating a
pleasing optical effect.

Purchased at Johnson's Motel and Cafe, Saint Mary,
Montana, September 1982.

196

MOCCASINS, 1982
Smoked hide, deer rawhide soles
3¾″ h. x 10¼″ l.

Mary Little Bull
Blackfeet
Blackfeet Indian Reservation, Browning,
Montana

"Mary Little Bull is one of our best crafters,"
said Mrs. Mary Hipps, proprietor of the
Blackfeet Tribal Arts and Crafts store in Saint
Mary, Montana. "She likes to use our tradi-
tional 'mountain' design [the beaded stepped
and checkered diamond pattern so simply but
effectively used here]."

This was the only pair of home-tanned
moccasins available in two visits, made a
month apart, to the Saint Mary shop, although
several magnificently beaded pairs were seen
at a pipe ceremony held a week later. "When
you're one of us, you wear those," said a dig-
nitary squatting next to me in the medicine
tepee as he glanced down at my non-Indian
footwear.

Purchased at Blackfeet Tribal Arts and Crafts, Saint
Mary, Montana, September 1982.

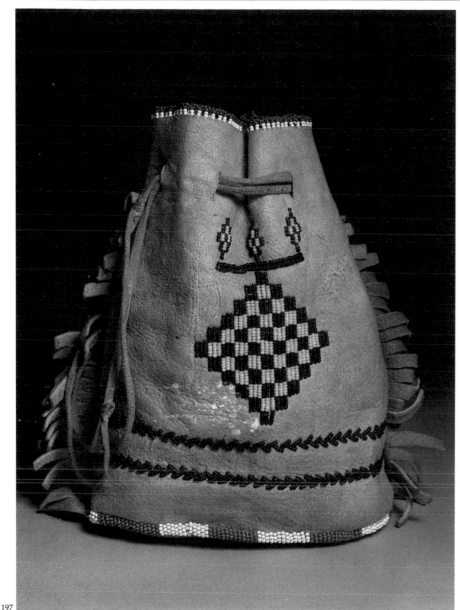

197

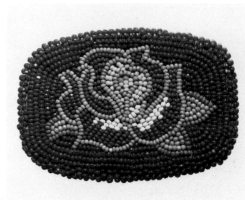

198

197

DANCE PURSE, 1982
Buckskin, beads, paisley cotton liner
8½" h. x 8" w.

Maker unknown
Canadian Blackfeet (Piegan)
Piegan Reserve, Alberta

"You'd better go back and collect that since it
was the only home-tanned item in the shop
[and the only Indian-tanned item openly for
sale on the Piegan Reserve]," said my traveling
companion, Father Tom Wiederholt.

"Do you know who made it?" I asked the
Piegan salesgirl. Silence, then a shake of the
head.

"Is there anyone I can ask about it?"

"No."

Used for dancing, this purse is the West-
ern Plains version of catalogue number 109.

Purchased at Eagle Gift Shop, Brocket, Alberta, July
1982.

198

BEADED BUCKLE, 1982
Buckle frame, beads, Indian-tanned backing
1⅞" h. x 2¾" w.

Debbie Myers
Ojibwa
Resident at Billings, Montana

"I *just* finished that last night in the garage,"
exclaimed Debbie Myers, an Ojibwa married to
Thom Myers, proprietor of Buffalo Chips Trad-
ing Post at Billings, Montana. "I hadn't beaded
in a long time and thought I'd try again and
drew a rose pattern first on a piece of paper."
The rose is a popular motif with the Minnesota
and Canadian Ojibwa (see cat. no. 70). It was
taken up by the Cree and came to Montana
through the Rocky Boy Cree (who came from
Canada in the 1880s). The Fort Hall (Idaho)
Nez Perce/Shoshone and the Wind River
(Wyoming) Shoshone/Arapahoe utilize the
rose. The Crow have also taken it up. Debbie
Myers represents a full turn of the circle; a Min-
nesota Ojibwa at work in Montana on a beaded
buckle with a rose design that would be at
home in any of these locations.

Purchased from the maker at Buffalo Chips Trading
Post, Billings, Montana, August 1982.

199, 200, 201

PIPE BAG, 1982–83
Buckskin, beads, rawhide, quills, bells
8⅛" w. x 31" l. (including fringe)

KNIFE CASE, 1982–83
Buckskin, beads, rawhide, quills
10¼" h. (including fringe)

HAIR ORNAMENT, 1982–83
Buckskin, beads, rawhide, quills, tinklers,
horsehair, down feathers
10" l. (including fringe)

Sandi and William Monague
Ojibwa
Resident in Alberta and Western Canada

Although all three items were displayed at the
stand William and Sandi Monague ran at the
Sarsi Annual Powwow held at Bragg, Alberta,
August 1982, they are not a set. The pieces
were bought during the course of the evening
festivities, but discussion of the purchases had
to be continued the next day.

A cross-cultural influence is manifest here.
William Monague is originally from the Beau
Soleil Band of the Great Lakes Ojibwa, Chris-
tian Island (Georgian Bay), Ontario. Sandi
Monague, an integral part of the craft team, is
white. She tanned the hide for the pipe bag
and beaded it; William then quilled the bottom
fringe. The knife case and hair ornament are

155

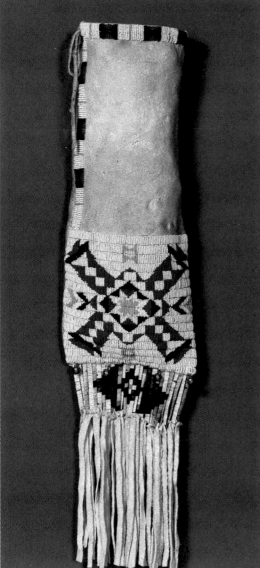

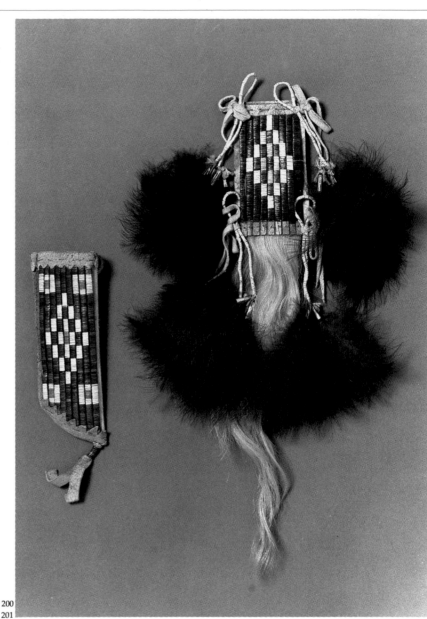

199

200
201

202

William's work. The quilling is Plains Indian style, and in this William Monague acknowledges the New Holys, Pine Ridge Sioux craftsmen (see cat. no. 152). The beaded *X* panel on the pipe bag is not a strict Plains interpretation; William described it as "sort of Plains-Ojibwa." Asked why he didn't want to work in the Great Lakes area, he remarked, "They've only got those quilled boxes on Manitoulin Island [see cat. no. 11] and that's not for me."

These are Indian works done by modern-day professional craft people. The original tribal context and cultural inheritance has been altered. But many old, "museum" Indian objects that elude exact attribution (or even those judged "pure" in style) were made in a mixed context by white wives or white "squaw men." Here is a specific illustration of what must have happened more often in the past than is generally allowed for. Indians have always moved around, adopted members of other tribes into the culture (the Iroquois, for example), and intermarried. Even when the artistic results remain unrecorded, they are still there to perplex those outside the Indian world who like to keep their classifications tidy.

Catalogue number 199 purchased from the makers, August 1982; received February 1983.
Catalogue numbers 200 and 201 purchased from the makers, August 1982.

DEER DANCE HEADDRESS, 1982
Rabbit fur, felt, felt trailer, mink pelt, ermine tails, deer antlers, ribbons, beaded medallions, deer toes, elkhorn buttons, smoked-hide ties
40" l. overall; cap 6½" h.
(see colorplate, p. 181)

Grace Daniels
Stoney
Morley, Alberta

After inquiring at the Stoney Indian Cultural Center and an afternoon's search of the Rocky Mountain foothills, I found Grace Daniels and her family at home on their hilltop ranch. A rodeo riding family, the Daniels raise their own horses. Mrs. Daniels is gifted at moosehair embroidery, beading, glove making, and excels as both a craftsman and designer.

Holding up a barely started Deer Dance headdress, a gray felt cap decorated with deer antlers, Mrs. Daniels promised, "I'll finish this for you if you'll come back tomorrow." In order to finish the piece on time Mrs. Daniels used four already made medallions and a loom-beaded band across the forehead with the perennial Indian trinity of the three powers (water, earth, and sky) centered on a diamond of the four directions with a red dot center. Perhaps the rush accounts for the Hong Kong beaded "star" medallion (orange and green on a white field) sewn to the trailer at the back edge of the cap; perhaps it would have been included in any case. The headdress is decorated with splendid embellishments: colored ribbons and white rabbit fur on the crown against which the beadwork headband vibrates like a multicolored mosaic. An extraordinary transformation from the previous day.

Purchased from the maker, August 1982.

156

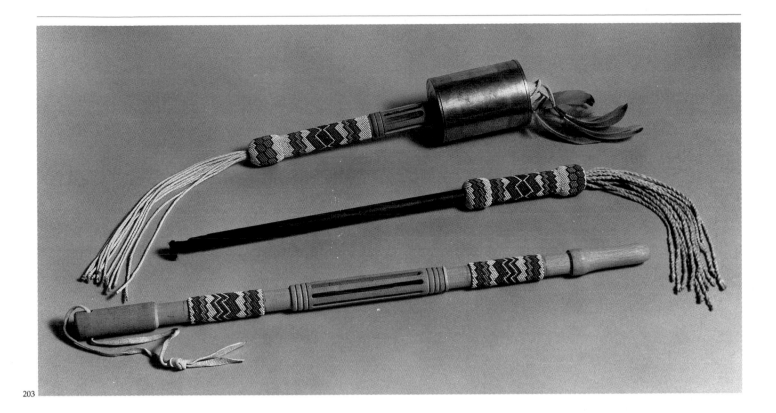

203

203

DANCE SET, ca. 1980
Wood, beads, tin can, feathers
Dance stick 31¼" l. (including strap); tin can
rattle 22⅝" l. (to top feathers); dance stick
27½" l.

John Ware
Kiowa
Anadarko, Oklahoma

This dance set contains some of the most exquisite items included here. The beading is tasteful and pure in its rendering of trinitarian (three-part) zigzags. The relationships of the white beading to the openwork sections of the rattle and handles of the dance sticks make these airy instruments of spirituality. One feels the release of the color diagonals into the ether as prayer, aided by the feathers atop the rattle and the rattling of the can. An evaporated-milk can is the source of the rattle proper. The staff (lower) bespeaks authority. The staff shown above it (center) is a strangely surrealistic object: evidently made as a fan handle, the feathers were replaced by a socket into the thread of which a used wire brush and its handle are screwed. In its present form it is a very ambiguous power symbol to say the least.

Purchased from the booth of Buffalo Chips Trading Post at the National Congress of American Indians, Bismarck, North Dakota, August 1982.

204

BEADED MEDALLION NECKLACE, 1980
Beads, commercial backing, bone hair pipes, cowrie shells
20" l; diam. of medallion 4"

Nettie Standing
Kiowa
Gracemont, Oklahoma

This snowflake medallion affirms that Nettie Standing is to the Southern Plains medallion what Maude Kegg is to the Great Lakes medallion: a consummate master. Manager of the crafts shop at the Southern Plains Indian Museum at Anadarko, Oklahoma, Mrs. Standing has greatly influenced the preservation of the indigenous arts of the area, in addition to providing a major outlet for such Southern Plains silversmiths as Julius and Bruce Caesar, among others. Another of her own specialties is making suede cloth (and occasionally buckskin) purses decorated with medallions. "I can make anything that's beaded," she quite correctly maintains.

Purchased from the maker at the Southern Plains Indian Museum Shop, Anadarko, Oklahoma, spring 1980.

205

PEYOTE BIRD PIN, 1980
Silver, turquoise
1⅞" l.

Preston Tonepahote
Kiowa (Anadarko, Oklahoma)
Resident at Kansas City, Missouri

During the 1930s an important repertory of peyote design jewelry developed in the Southern Plains. It continues today and is by now traditional. Perhaps the most typical design is that of the spirit messenger bird with its long neck, outstretched head, and body feathered like an arrow shaft. The bird graces earrings, cups, necklaces, bracelets, and pins, of which this is a typical example, except that it is executed in sterling silver rather than the nickel silver most often used by peyote style Plains jewelers. Hinged tails and wings often give a sense of movement to this aquatic bird symbol.

Purchased from the maker, fall 1980.

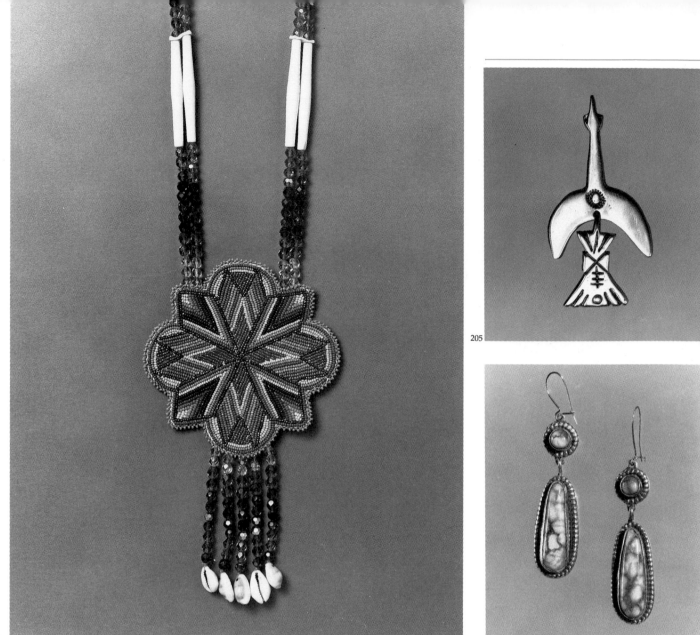

204

205

206

206

PAIR OF EARRINGS, 1980
Silver, turquoise
each 1¾" l.

Preston Tonepahote
Kiowa (Anadarko, Oklahoma)
Resident at Kansas City, Missouri

Preston Tonepahote, a full-blood Kiowa,
was trained by his father, the late Murray
Tonepahote, one of the most distinguished
Southern Plains silversmiths of a past genera-
tion. "I am very proud of the heritage my
father left me," Preston Tonepahote declares.
He works as a weather specialist at the Kansas
City International Airport and makes jewelry
at home. This pair of silver and turquoise drop
earrings was executed partly in exchange for
my giving a tour of the Nelson Gallery of Art to
Preston and his Chinese colleague, a Peking
airport weatherman visiting in Kansas City.

Purchased from the maker, fall 1980.

207

DRUM WITH STAND, ca. 1975
Commercial drum cylinder, elkhide drum
heads, rawhide lacings, wood stand
14⅛" h. x 29⅝" diam.; stand crosspieces 39½"
w. x 14⅛" l.

Stan Mattson
Kiowa (Anadarko, Oklahoma)
Resident at Vancouver, Washington (?)

"Yes, it's an Indian-made drum all right," I was
assured by the owner of McKee's Indian Store.
"It's by Stan Mattson. He's Kiowa. He and his
wife have moved away to some place in Wash-
ington state. I've had it several years now."
Several months later the maker's name was
confirmed again. I had the drum with me
when I went to call on Kiowa Nettie Standing
at her home at Gracemont, Oklahoma (see cat.
no. 204). "Why look at the fine drum you have
there," she said. "Who made it?" On hearing
his name, "Well, he's married to an Indian, but
he's white. He couldn't have made that," she
said tartly, "because that's a *real* Indian drum."

 Some three years later when I passed
through Anadarko to check up on the discrep-
ancy, both Mr. McKee and his wife were no
longer living. No one at the Kiowa tribal office
knew of a "Stan Mattson." Since, as an official
of the Southern Plains Indian Museum at Ana-
darko put it, the McKees "knew a lot of Indians

and things we don't know about them," their
attribution is used here. Perhaps the matter
will never be resolved. Nevertheless, the drum
is Indian. It is, in fact, a beautiful example of a
Southern Plains drum, large, with excellent
resonance, elkhide drum heads, rawhide
lacings, and traditional crosspiece drum stand.
It is more "traditional" than many of today's
powwow/Indian Days drums, which may be
commercial, or semi-traditional adaptations,
and are often simply set on the ground rather
than suspended on crosspieces, which pro-
vides additional resonance. The cylinder once
belonged to an old bass drum (one can still
make out the drilled holes for the original
thumbscrews), though the transformation is
complete almost beyond recognition. Regard-
less of its origin, it is an Indian drum on which
to beat the heart of a nation and a piece of sus-
pended sculptural form as taut and round as
the sacred circle of life that such drums
embody.

Purchased at McKee's Indian Store, Anadarko, Okla-
homa, May-July 1980.

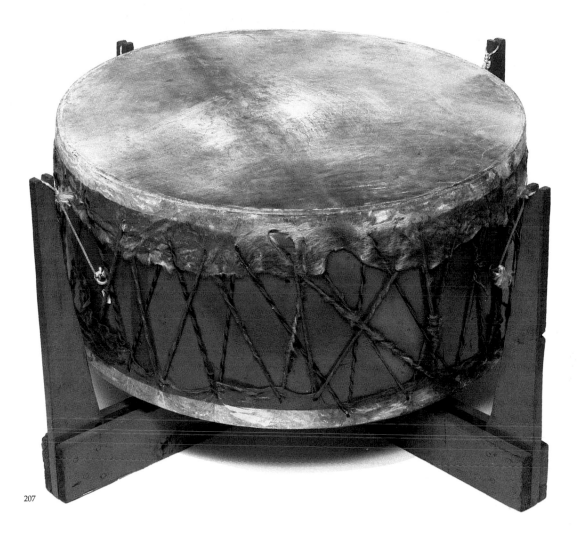

207

208

LEAF MEDALLION NECKLACE, 1982
Faceted beads, commercial-hide backing, bone hair pipes, metal beads, home-tanned ties
19¾" l.

Ed Wapp
Kiowa/Mesquakie
Resident at Seattle, Washington

Ed Wapp is a professor at Washington State University and a distinguished ethno-musicologist and Indian flutist. Invited to concertize and be a resource person at *Indian America: Past, Present and Future*, an Aspen Institute symposium held during the summer of 1982 at Crestone, Colorado, Professor Wapp brought some of his beadwork with him. "My work shows a little of my dual inheritance," he pointed out. "My mother [Kiowa] taught me." The cutout leaf is Woodland, but its colorful execution is pure Oklahoma.

In the gift shop of a lodge at Glacier National Park in Montana, the back lower shelf of the display held a similar piece by Ed Wapp, one more indication of the diffusion of Indian art today.

Purchased from the maker, Crestone, Colorado, August 1982.

209

NATIVE AMERICAN CHURCH TOOLED
LEATHER BOX, 1980
Leather, leather lacings, paint, screws, locks
7⅜" h. x 21⅛" w. x 7⅛" d.
(see colorplates, pp. 182–83)

Johnny Hoof (deceased)
Southern Arapahoe
Watonga, Oklahoma

Peyote "kits," modeled on the old-fashioned toolbox, are used by members of the Native American Church to store and carry religious paraphernalia, including fans, rattles, and the sacramental "father peyote" bud. They are taken to the meetings and are in themselves objects of respect. Sometimes they are plain varnished boxes, often made of cedar, sometimes they are painted with religious symbols. Rarely are they painted as elaborately as this example.

The strong colors decorating the box can be said to approximate the color visions experienced by peyotists and are thus a spiritual effusion. The scenes and symbols on the box are: peyote bud centered on two moon altars flanked by a pair of aquatic messenger birds (lid); peyote tepee used in Southern Plains meetings (left end); peyote fan and rattle (right end); Christian peyote cross (front of lid); peyote ceremony in progress with water drum, spiritual birds rising from the altar, and two participants in prayer (back). The box is thus an embodiment of Native American Church ritual and spiritual universe.

Mr. Hoof, described as being "about forty-five years old" at the time this kit was purchased, specialized in tooled leather work (not traditional in the past, but current since the Western craze, see cat. no. 161) and also made buckles and wallets.

Purchased at McKee's Indian Store, Anadarko, Oklahoma, February 1981.

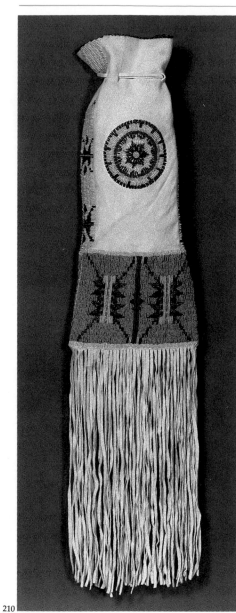

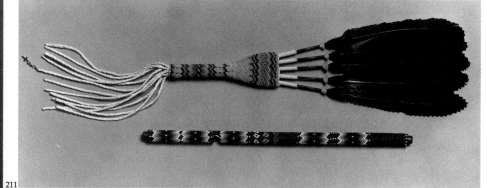

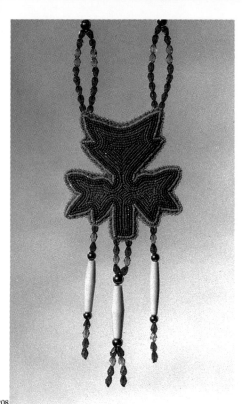

211

208

210

210

PIPE BAG, 1983–84
Beads, home-tanned buckskin, rayon lining
31" l. (including fringe) x 7½" w.

Patricia Russell
Southern Cheyenne
Canton, Oklahoma

Southern Cheyenne people do not live on reservations but are scattered in such towns as Concho, Hammon, Watonga, or Seiling, Oklahoma, and are not easy to track down. I learned of the fate of Johnny Hoof (cat. no. 209), the Arapahoe leather worker I had been seeking, from Patricia Russell's mother, who told me that he had lived at Watonga and had died two years before. It was at her house, too, that I first saw this bag, which was only partly done at the time.

After finishing the bag, the maker, whose full name is Patricia Mousetail Nibbs Russell and whose Indian names are Crooked Nose Woman and Spirit Woman, wrote me: "Beadwork is my life. Thanks to all the old Cheyenne people before me, and nowadays, I feel like I just picked up where the old people left off." However, this fine bag differs from old-time Southern Cheyenne work in its wild colors (pink in particular) and the inclusion of a beaded rosette. It lacks quilling of the fringe.

Purchased from the maker, April 1984.

211

WHISTLE AND PEYOTE-TYPE FAN, 1981
Metal tubing, dyed macaw feathers, hide, beads
Fan 21" l. (including fringe); 5" w. (across feathers); whistle 12¼" l.

John White Eagle
Southern Cheyenne
Colony, Oklahoma

These pieces demonstrate the vivid use of color in Southern Plains (Oklahoma) art today. Since World War II the colorism has spread farther north and become part of the Pan-Indian movement. It contains echoes of the show-card colors used in Prairie/Plains painting of the 1930s, and of response to peyotism. There is also an increasing reaction to Indianism; to be colorful is to be Indian. Nonetheless, as these items bear witness, the hottest blues still belong to Oklahoma. With its iridescent macaw feathers, this peyote-type fan hints at even more sumptuous colorism found in today's peyote ceremonialism. Whistles such as this one (like a small baton or dance stick) which are held in the hand, can be heard emanating in a trill from the dance circle on countless Indian Days.

Purchased at Cherokee Trading Post, on highway west of El Reno, Oklahoma, fall 1981.

212

WEARING BLANKET, ca. 1975–76
Green broadcloth, sequins, beads, imitation pearls, rhinestones
63" l. x 60" w.
(see colorplate, p. 184)

Maker unknown
Comanche
Lawton area, Oklahoma

This woman's wearing blanket, obtained by Osage Andrew Gray in trade, is ingeniously conceived. "A Yankee doodle of a blanket," Gray observed, "but nobody said who made it."

The design consists of three American eagles alighting, each surrounded by spiraling flowers and stems. Stars border the edges at the far left and right, and two more are placed between the eagle motifs, twelve spangled stars in all. Several thousand sequins are incorporated in the sewing, together with glittering rhinestones and artificial pearls. Green thread is used throughout to match the blanket color. The medicine powers of the eagle are combined here with the bird's patriotic associations possibly for bicentennial observance, since a man would not wear this blanket.

Purchased at Whitehair Trading Post, Pawhuska, Oklahoma, February 1981.

Plateau

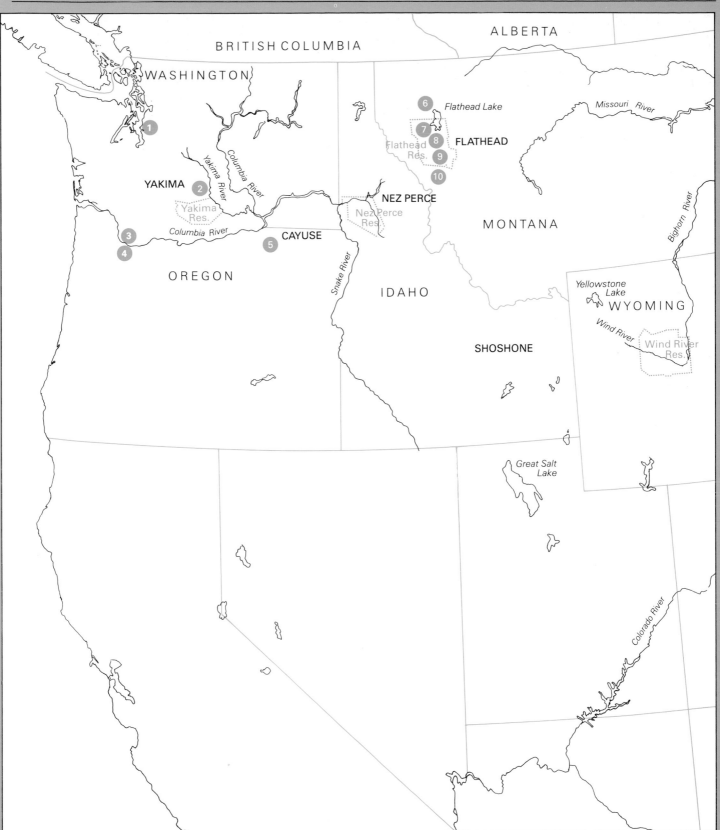

1 Seattle
2 Yakima
3 Vancouver
4 Portland
5 Pendleton
6 Kalispell
7 Elmo
8 Pablo
9 Arlee
10 Missoula

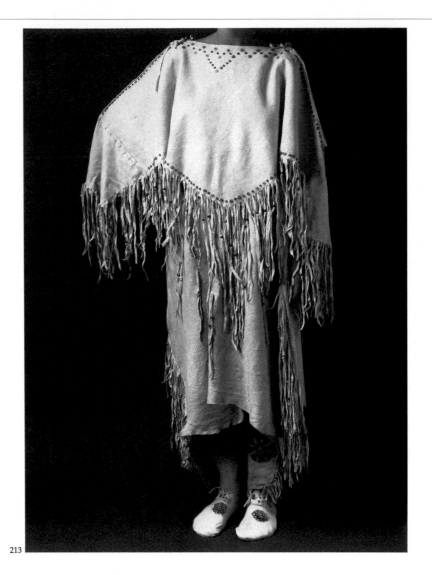

213

213

COMPLETE DANCE OUTFIT, ca. 1975
Buckskin, beads, hair pipes, ermine fur,
buttons
Yoke 32¼" l. (including fringe) x 54" w. (across
sleeves)
Skirt 32¼" l. x 17½" w.
Purse 12¼" h. x 8½" w.
Barrette 6⅜" l. x 3³⁄₁₆" w.
Eardrops 21" l.
Breastplate necklace 32" l. x 2⅞" w.
High-top moccasins 17¾" h. x 10" l.
Choker 13⅛" l. x 1¼" w.

Rachel Bower
Flathead
Flathead Reservation, Montana

When I asked at the Flathead camp where I
might get a complete dance outfit, the answer
came in an instant. "If you'll meet us in
Kalispell on August 27th after I'm through
dancing, I'll sell you mine," offered Rachel
Bower (fig. 28), co-teacher with Agnes
Vanderberg (cat. nos. 218 and 220) at the Flat-
head summer culture camp.

The beaded flowers on the purse, ear-
drops, moccasins, and barrette are of the softly
piled type of beading evolved by Agnes
Vanderberg and in Flathead country is a sine
qua non expression of being a Flathead. They
have a lovely three-dimensional blooming
quality and give to the touch, like crushed pet-
als. Rachel Bower did the tanning herself. A
great deal of the stitching is done by thong
interlacing, especially in the yoke and skirt.
Some time later she informed me, "I'm going
to work on another outfit and it will be more
traditional, that is, without a belt and less
beading."

Purchased from the maker, at the Western Flower
Growers Association convention, Kalispell, Montana,
August 1982.

214, 215

HIGH-TOP MOCCASINS, 1982
Smoked deerhide, beads
10¼" h. x 9¼" l.

BABY MOCCASINS, 1982
Smoked deerhide, beads
1⅞" h. x 6" l.

Agnes Kenmille
Flathead
Flathead Reservation, Elmo, Montana

While a Flathead Indian by birth, Agnes
Kenmille, the maker of these moccasins, heads
the Kootenai Indian cultural program at Elmo,
Montana. Mrs. Kenmille is one of the best In-
dian tanners among the western tribes and is
also an artisan of rare excellence. The evenness
of the (sinew sewn) stitching is evident in the
care with which the uppers and the soles of the
moccasins are joined. Mrs. Kenmille's control
of spacing in beadwork makes for perfectly
articulated designs; both the radial rosette of
the high-top moccasins and the flame design of
the baby moccasins are personal trademarks.

The tanning is of a softness that is also
easily recognized, even when the hides appear

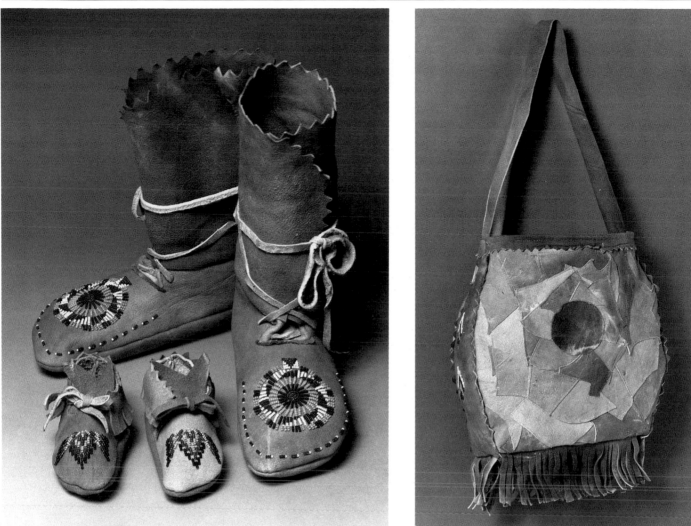

214
215

216

216

at midwestern trading posts. Mrs. Kenmille's tanning operation involves two sheds, one for scraping the skins and the other for the tanning process. Sitting in her house overlooking Flathead Lake, she said, "A lot of people come to me because they know I'll never do a hide the inferior way, no chemicals or lime. See that hide soaking in the water bucket?...It will soak and soak until it's soft. That takes time. It takes the patience few have today. If I mend a hole in the hide, you'll hardly see it at all. It's scrape, scrape, scrape, rub, rub, rub, brains and all. Who wants to do that today?"

Purchased from the maker, August 1982.

216

BAG WITH STRAP, 1982
Home tanned deerskin, smoked deerskin, beads, lining material, thread
15" h. (including fringe)

Agnes Kenmille
Flathead
Flathead Reservation, Elmo, Montana

This idiosyncratic bag – Mrs. Kenmille considers these bags to be her specialty – is made of smoked-hide scraps left over from other work. But there is no quality of "leftovers" about it. The scraps are carefully assembled, in this case into a picture of sun and clouds. These bags are intended for general use.

Purchased from the maker, August 1982.

217

BONE BREASTPLATE, ca. 1970
Bone hair pipes, leather, glass beads, brass beads, ties
14¼" h. x 13¾" w.

Louis Big Crane
Flathead
Flathead Reservation, Pablo, Montana

Louis Big Crane's breastplate – exactly like old-style work – has seen hard wear; a piece of clothes line is attached to it and a hair pipe or two are missing. "It makes it authentic," said his friend Rachel Bower (see cat. no. 213). Louis Big Crane is pressman at *Charkoosta*, the Flathead newspaper, published at Pablo, Montana.

Purchased from the maker, at the Western Flower Growers Association convention, Kalispell, Montana, August 1982.

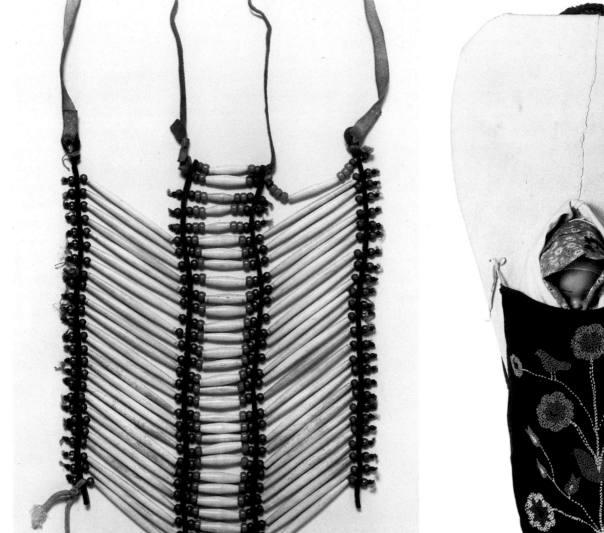

217

218

218

CRADLEBOARD, 1982
Deerskin, wood, beads, wool sash
30" h. x 15" w.

Agnes Vanderberg
Flathead
Flathead Reservation, Arlee, Montana

During a visit to the Flathead culture camp in high country near the Mission Mountain Range, I asked Agnes Vanderberg to make a home-tanned cradleboard. A month later this highly traditional carrier was finished. The flap was beaded by Mrs. Vanderberg's mother a long time ago – "so long ago I don't remember" – and is therefore an heirloom addition, a fact recognized in the extreme simplicity of the un-adorned headboard, against which the old beaded bird-and-flower design of the flap, with its black field, is set off spectacularly (fig. 23).

Mrs. Vanderberg, now in her eighties, heads the summer cultural camp for the Flat-head people. An untiring traditionalist, she spins the old stories for children, faces down the tribal council to get funds for the camp ("I get what I want," she says as she smiles with determination). She has been remarkably suc-cessful in preserving the culture in its multiple aspects. Among her protégés is Rachel Bower, whose beaded dance outfit is included here (cat. no. 213).

Purchased from the maker, August 1982.

219

DRUM, ca. 1976
Wood, heavy cord, paint, oiled elkhide
11¾" h. x 25¹¹⁄₁₆" diam.

Rick Vanderberg
Flathead
Flathead Reservation, Arlee, Montana

When I called on Agnes Vanderberg, her son sat at the other end of the front room with his back to me, never acknowledging my pres-ence. After a while he went out of the room without saying a word; Mrs. Vanderberg soon followed to confer with him. "Believe it or not," she said when she returned, "he will sell it." As I left she informed me: "I can tell you that drum has a secret. I told him to put a medicine inside when he made it, to make the drum sound better. It's in there."

Purchased from the maker, August 1982.

220

DIGGING STICK, 1982
Deer antler, wood (lawn mower handle)
18" l.; handle 9" w.

Agnes Vanderberg
Flathead
Flathead Reservation, Arlee, Montana

"You're not taking my digging stick?" Mrs. Vanderberg demanded with matriarchal pride when I had overlooked it. "Yes I am," was the quick reply. These sticks are used to dig bitterroot (the state flower of Montana), the fleshy roots of which are considered an Indian delicacy.

Purchased from the maker, August 1982.

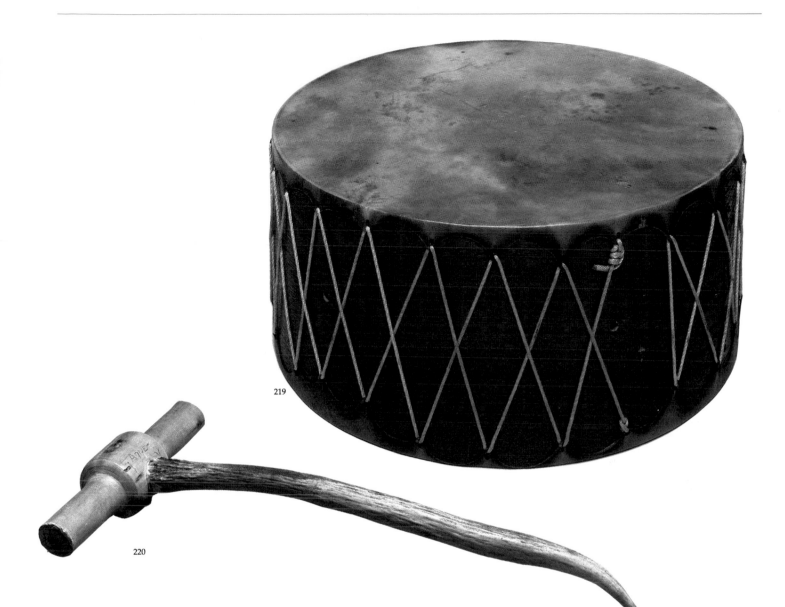

219

220

221

BEAR-CLAW NECKLACE, ca. 1980
Bear claws, beads, bone hair pipes, mink fur
16" l.

Mr. McAdams
Shoshone
Wind River Indian Reservation, Wyoming

This necklace, which came to light at a trading post in Montana, is a personal interpretation of a medicine necklace. The quality is excellent; the necklace is double register and shows twelve bear claws, with a cluster of three at the bottom. The lacy effect is increased by the soft mink fur and the white beading, which is a Wind River specialty. The openwork structure adds to this evanescent spirituality.

Purchased at the Blackfeet Trading Post, Browning, Montana, August 1982.

222

LEGGINGS (portion), 1983
Pendleton blanket, beads, home-tanned ties
28" l. x 13" w.

Maynard Lavadour
Cayuse/Nez Perce (Pendleton, Oregon)
Resident at Santa Fe, New Mexico

"Oh, so good!" softly exclaimed Maynard Lavadour, a collateral descendant of the renowned Chief Joseph (ca. 1840–1904) when I indicated I wished to purchase this pair of Plateau beaded leggings. Maynard Lavadour's smiling joviality and gently balanced outlook conceals an inner strength of purpose derived from training in various traditional crafts learned from his grandmother, whom he quietly reveres. He espouses the traditions of his people with constant enthusiasm. These leggings utilize a type of design outlined in white beads which evidently influenced Crow Plains beading in the late nineteenth century.

At the time this pair of leggings was purchased he was working away in a cabin in the mountains near Taos. For other examples of Maynard Lavadour's work, see catalogue number 223 and figure 13 .

Purchased from the maker at his booth at the Santa Fe Indian Market, New Mexico, August 1983.

223

CAPOTE, 1983
Greenlander cloth (wool)
58" l. (to top of hood exclusive of flap) x 60" w. (across sleeves)

Maynard Lavadour
Cayuse/Nez Perce (Pendleton, Oregon)
Resident at Santa Fe, New Mexico

Throughout the Northern Plains and Plateau area the hooded capote was worn for warmth. Its form was based upon the French fur traders' winter coats. While capotes are still made over a wide area (Randy Lee White [see cat. no. 160] showed me one that had been made for him at Questa, New Mexico), no one else has done for the capote what Maynard Lavadour, a student at the Institute of American Indian Arts, Santa Fe, at the time, has accomplished. He has produced color variants on these elegant, graceful coats in red/black, buff, or

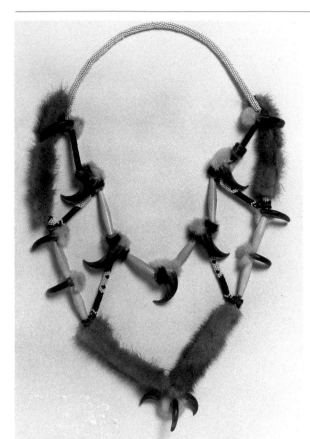

221

222

224

Pendleton blanket materials and has decorated them tastefully with beading, even beaded trailers that attach to the hood. Perhaps the fact that he comes from Pendleton (home of the famous woolen mill) has encouraged his interest in these directions. This particular "Greenlander" capote was made for Kimberly Ponca Stock (see cat. nos. 112 and 113), but was relinquished for this project. The white capote with green, red, and yellow stripes recalls the Hudson Bay trade blanket from which these coats were once almost exclusively made. It is Maynard Lavadour's basic model.

Purchased from the maker, Santa Fe Indian Market, New Mexico, August 1983.

TEPEE (detail), 1984
Canvas, acrylic paint, lodgepole pine
h. 15' (approximate); diam. of base 12'

Armenia Miles
Nez Perce (Pendleton, Oregon)
Resident at Seattle, Washington

Maynard Lavadour
Cayuse/Nez Perce (Pendleton, Oregon)
Resident at Santa Fe, New Mexico

Armenia Miles is Maynard Lavadour's great-aunt. In the Indian way, they regard each other as grandmother and grandson; thus their collaboration is along close family lines. Armenia Miles originally made this as an unpainted tepee for Mr. and Mrs. Gregg Stock of Santa Fe and shipped it there from Seattle. Knowing that her great-nephew was about to return to Santa Fe from his reservation in Oregon, she suggested that he paint this tepee for this project and she would make another for the Stocks.

When I eventually met him in Santa Fe, he had not yet painted the tepee, but on a piece of memo paper he quickly indicated the design he intended to paint (fig. 31). The sketch recalled the ledger-book style of outline drawings of which William Running Hawk's is a late survival (see cat. no. 159) and Randy Lee White's is a modern variant (see cat. no. 160). It began about 1870 and reached its apogee in the nineties. Maynard Lavadour's design symbolizes Chief Joseph's retreat across Montana in the year 1877. Lavadour is a collateral descendant of the famous chief and felt he had the right to memorialize this historic event. The frieze of red triangles encircling the entire bottom of the tepee (shown in the detail reproduced here)

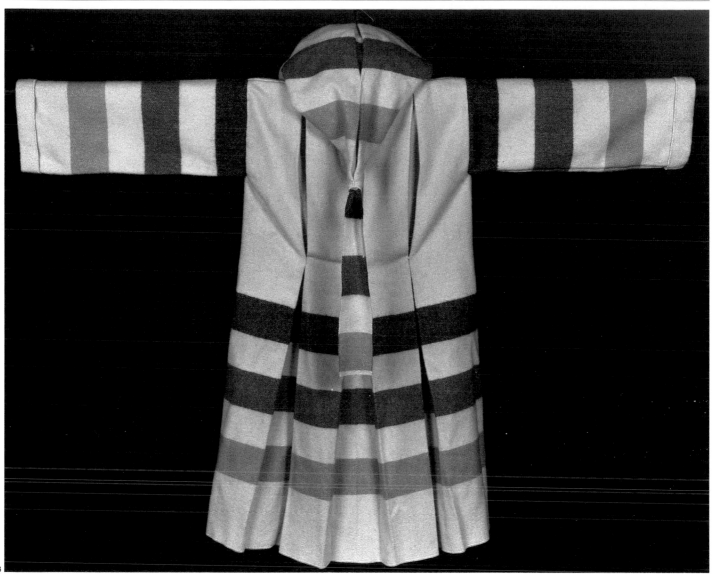

223

225, 226

represents the mountain chain in southern Montana, which Chief Joseph and his band crisscrossed while being pursued by the U.S. Army. The white line immediately beneath the mountains represents the path of escape, which stretched for some fifteen hundred miles, until the surrender that came only forty miles from safety in Canada. The pattern of red dots around the uppermost part of the tepee represents the bullets which, due to Indian magic, "never reached Chief Joseph's band," according to the artist.

Bright red is a favored Nez Perce color for tepee painting. In Santa Fe there was no earth paint in this color available, so the tepee was painted in acrylics. While earth paints would have been more traditionally correct, the color is nevertheless authentic. The tepee poles were supplied by Pat Hartless of Missoula, Montana.

Tepee purchased from maker through Gregg Stock, Santa Fe, New Mexico, November 1984.

"CORNHUSK" BAG, ca. 1977
Native cornhusk, wool, smoked-hide trim
12" h. x 11" w.
(see colorplates, pp. 182–83)

Maker unknown
Yakima

"CORNHUSK" BAG, 1977
Native cornhusk, wool, smoked-hide trim
8⅝" h. x 9⅜" w.
(see colorplates, pp. 182–83)

Lena Barney
Yakima
Yakima, Washington

These flatwoven Plateau bags, which today tend to be smaller than those made at the turn of the century, are woven by a complex three-ply twining technique, whereby one strand is held in the teeth and the other two are brought forward and around it. The manufacture requires intense concentration on the part of the artisan. Lena Barney, who demonstrated this art at the *Sacred Circles* exhibition (Nelson Gallery of Art, Kansas City, May 1977, see fig. 14), worked almost all night finishing the bag shown here.

These bags have engendered a richly varied repertory of geometric (older) and pictorial designs, dexterously imbricated in either dyed cornhusk (cat. no. 226) or wool (cat. no. 225). Old nineteenth-century examples were made of native hemp, used much less frequently today. One face is always geometric, even when the other is pictorial. Since about 1920 beaded bags have been made depicting landscapes with clouds, hills, buildings, valleys, and trees; often horses or flowers appear on the face. The strawberry motif seen here on

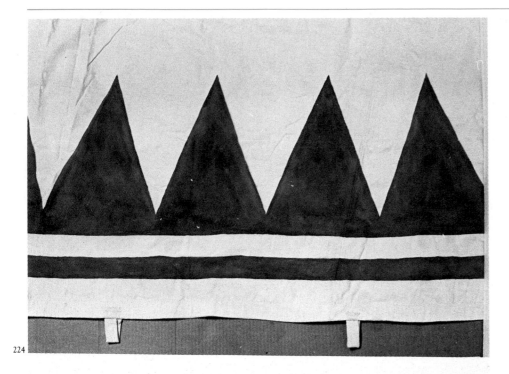

224

Mrs. Barney's bag is personal to her; the pine trees of the other bag, an undated work but surely as contemporary as Mrs. Barney's, exude an aroma of the Northwest forest areas, while the tawny field seems to echo the arid landscape of the inland areas of Washington state.

Catalogue number 225 purchased at West of the Moon Folk Art Gallery, San Francisco, California, November 1980.
Catalogue number 226 purchased from the maker, June 1977.
Private collection.

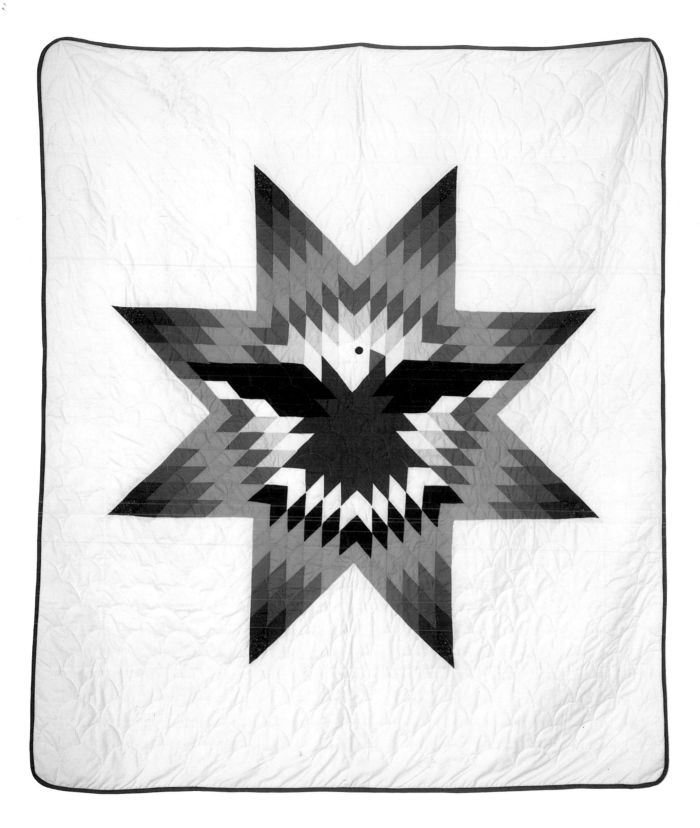

EAGLE QUILT, 1982 (Cat. no. 132)

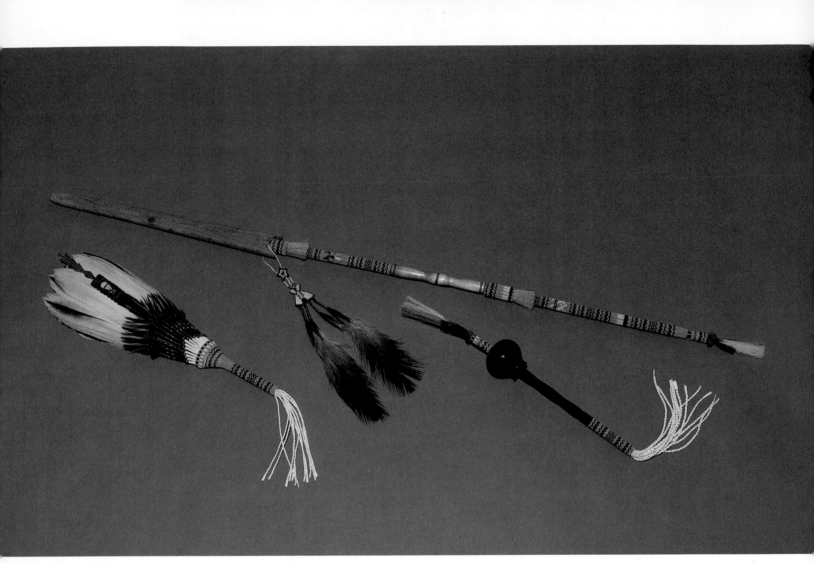

PEYOTE SET, 1983 (Cat. no. 140)

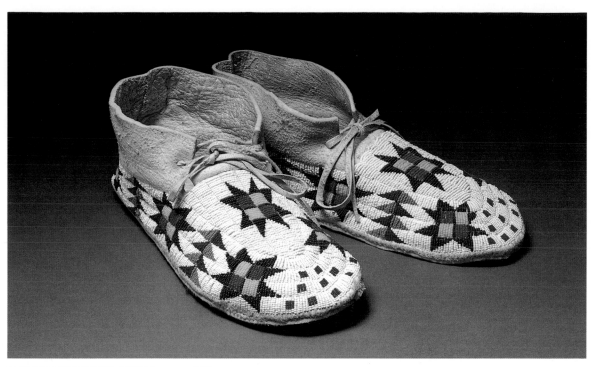

MAN'S MOCCASINS, 1982 (Cat. no. 129)

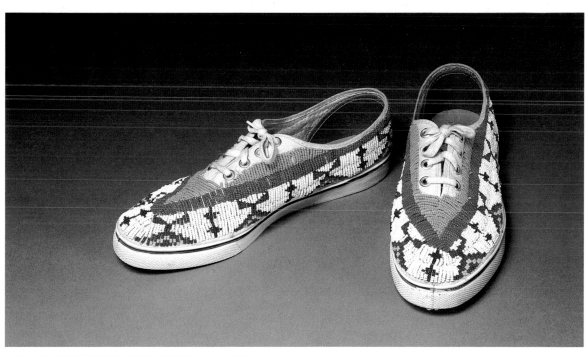

PAIR OF BEADED SNEAKERS, 1982 (Cat. no. 139)

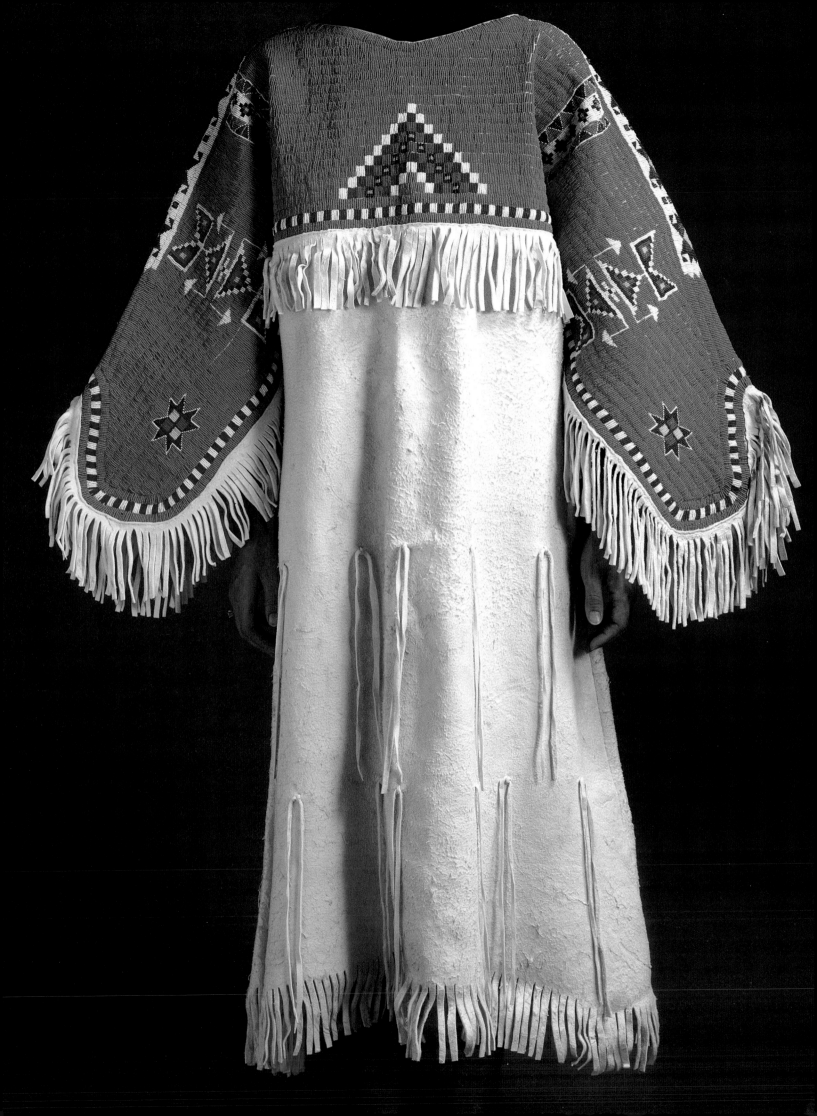

PAGE FROM LEDGER BOOK (scene 2), 1982 (Cat. no. 159)

PAGE FROM LEDGER BOOK (scene 4), 1981 (Cat. no. 160)

opposite WOMAN'S DRESS, 1983 (Cat. no. 131)

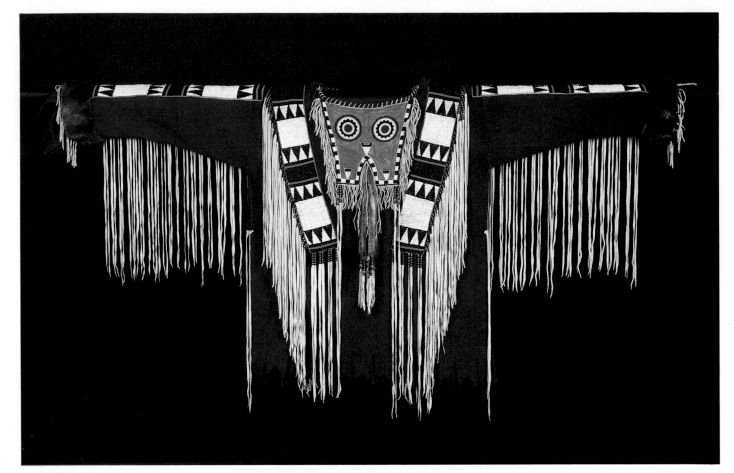

WAR SHIRT (and detail, *opposite*), 1982–83 (Cᴀᴛ. ɴᴏ. 167)

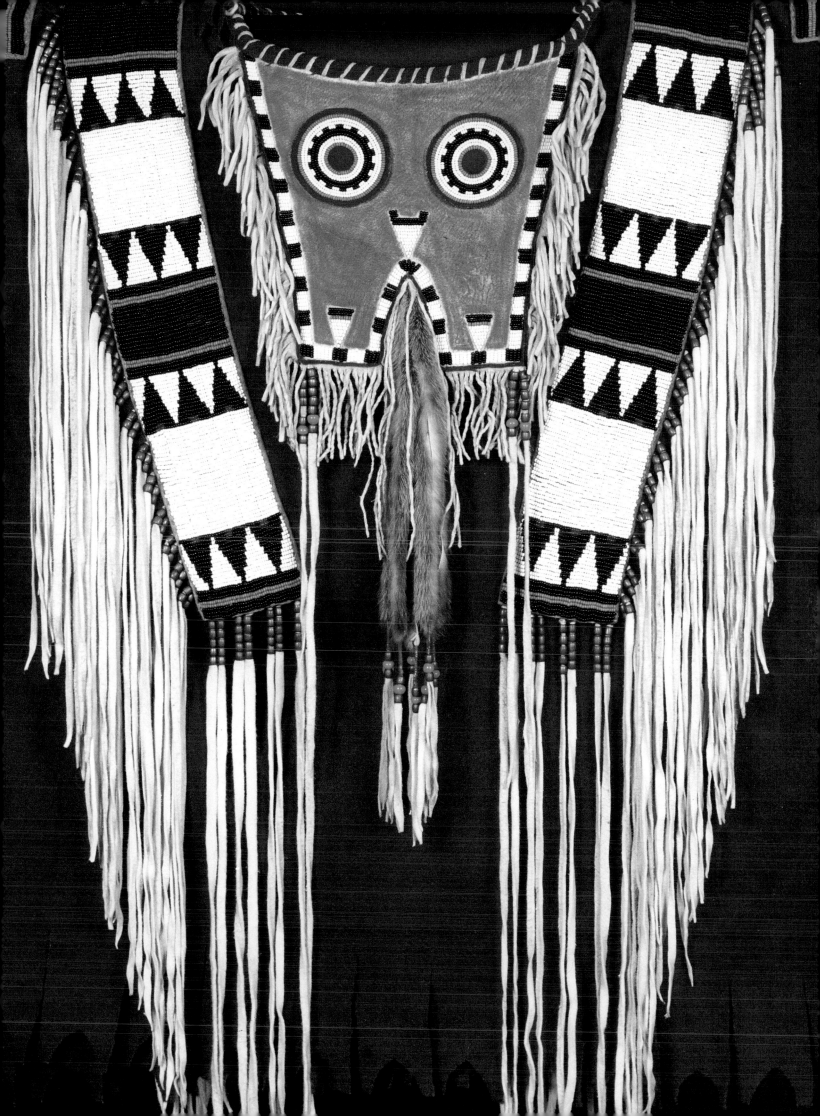

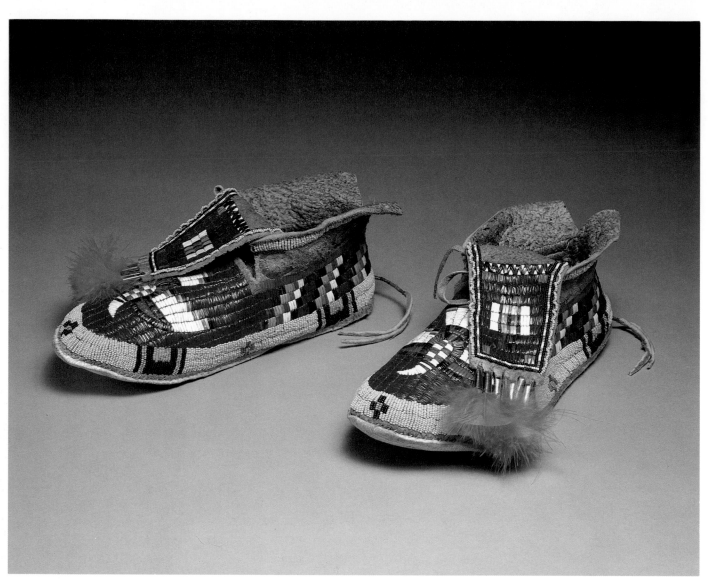

QUILLED AND BEADED MOCCASINS, 1982–83 (Cat. no. 166)

opposite WAR BONNET, ca. 1980 (Cat. no. 175)

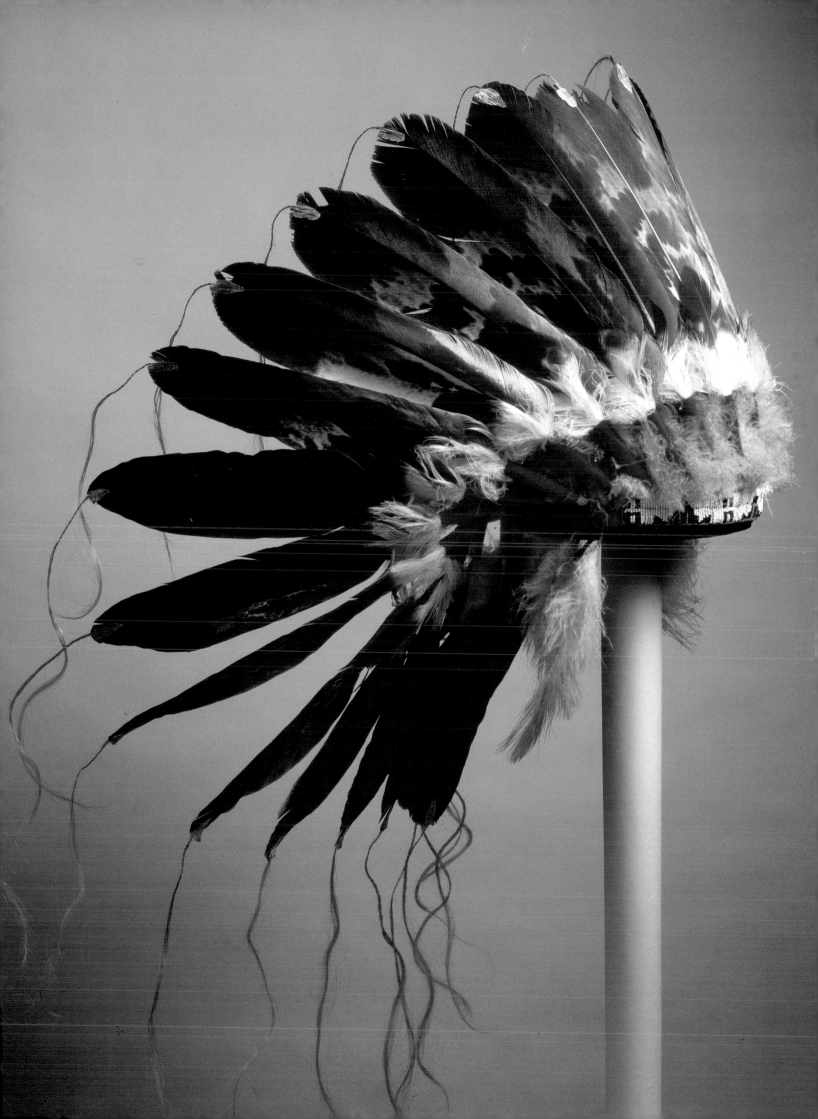

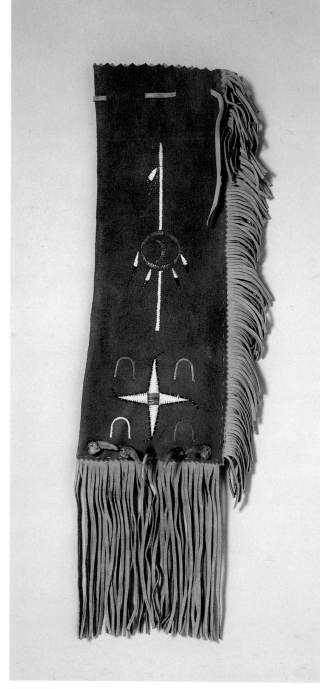

PIPE BAG, 1979–80 (Cat. no. 183)

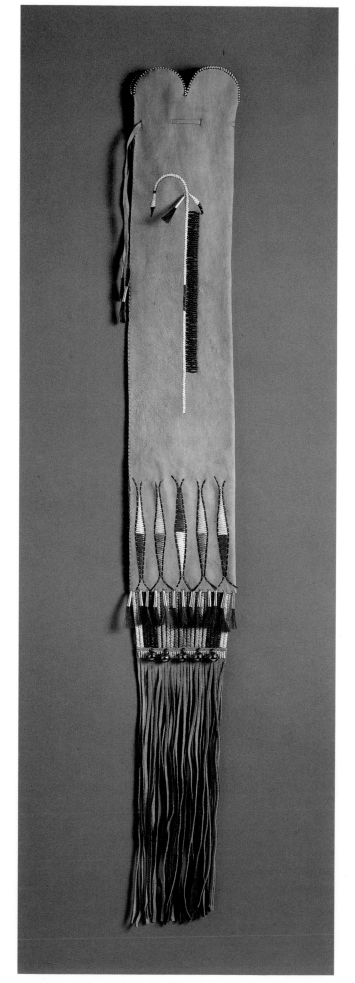

PIPE BAG, 1979–80 (Cat. no. 184)

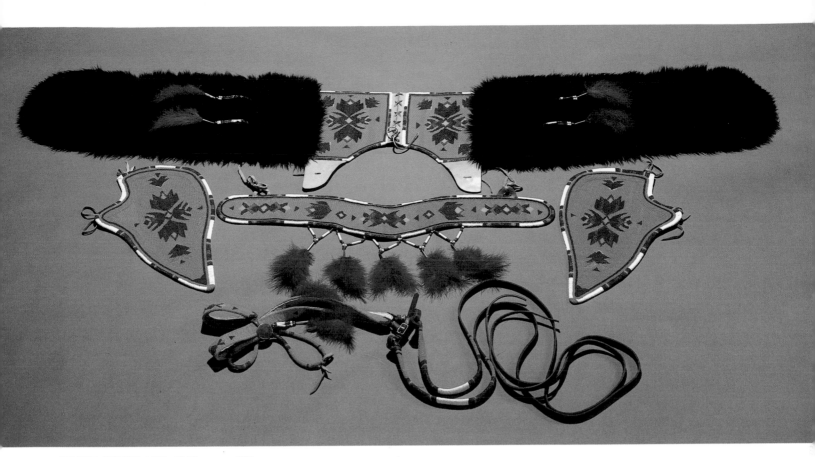

HORSE OUTFIT, 1982–83 (CAT. NO. 179)

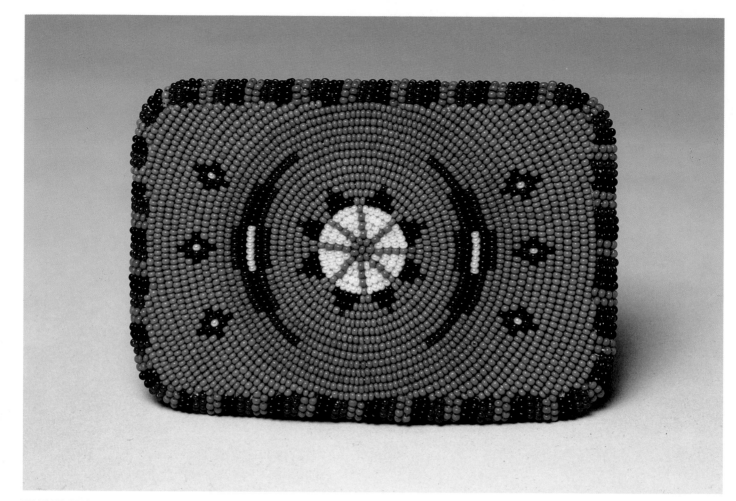

BEADED BUCKLE, 1982 (Cat. no. 188)

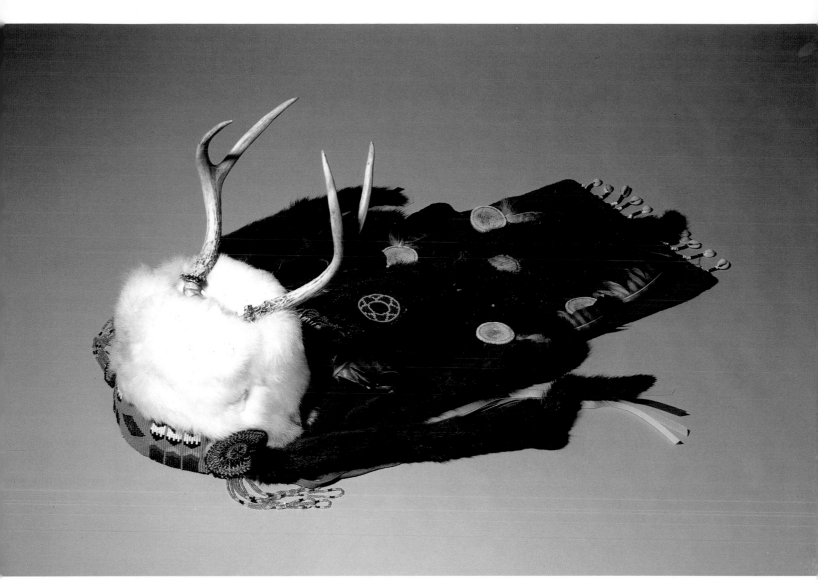

DEER DANCE HEADDRESS, 1982 (Cat. no. 202)

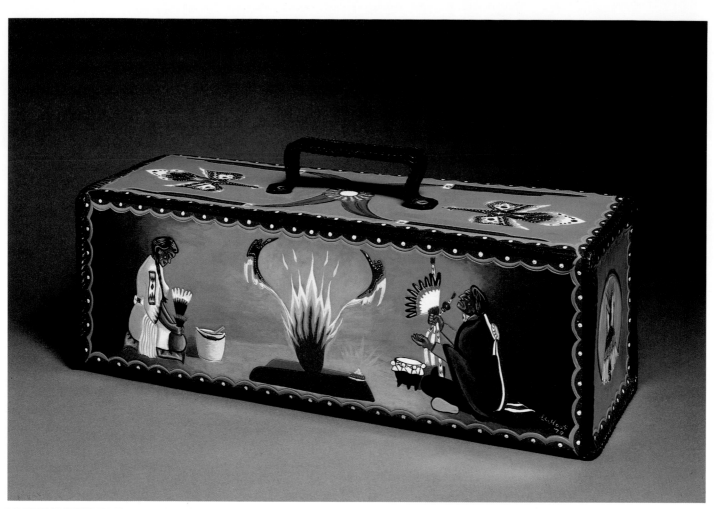

NATIVE AMERICAN CHURCH TOOLED LEATHER BOX, 1980 (Cat. no. 209)

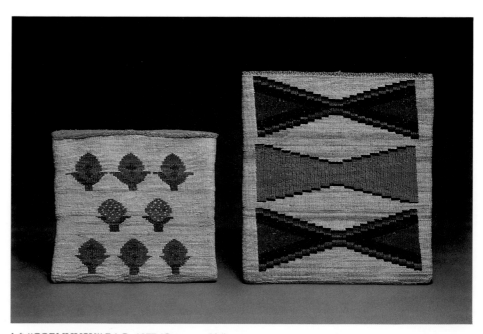

left ''CORNHUSK'' BAG, 1977 (Cat. no. 226)
right ''CORNHUSK'' BAG, ca. 1977 (Cat. no. 225)

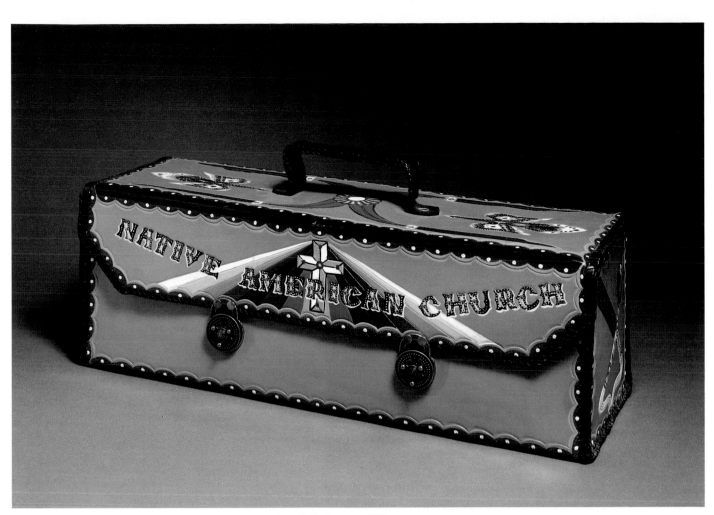

NATIVE AMERICAN CHURCH TOOLED LEATHER BOX, 1980 (Cat. no. 209)

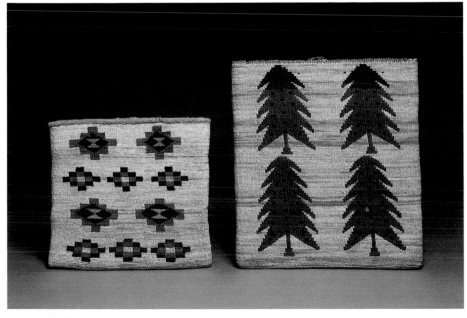

left "CORNHUSK" BAG, 1977 (Cat. no. 226)
right "CORNHUSK" BAG, ca. 1977 (Cat. no. 225)

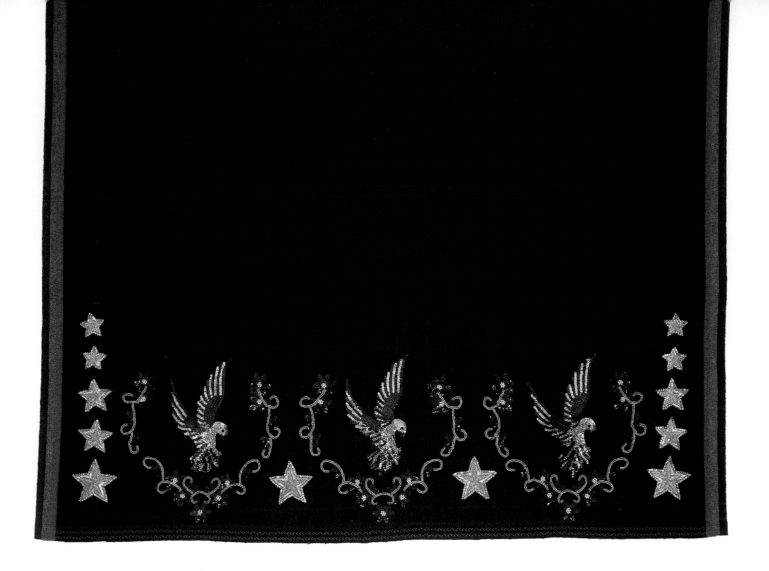

WEARING BLANKET, ca. 1975–76 (Cat. no. 212)

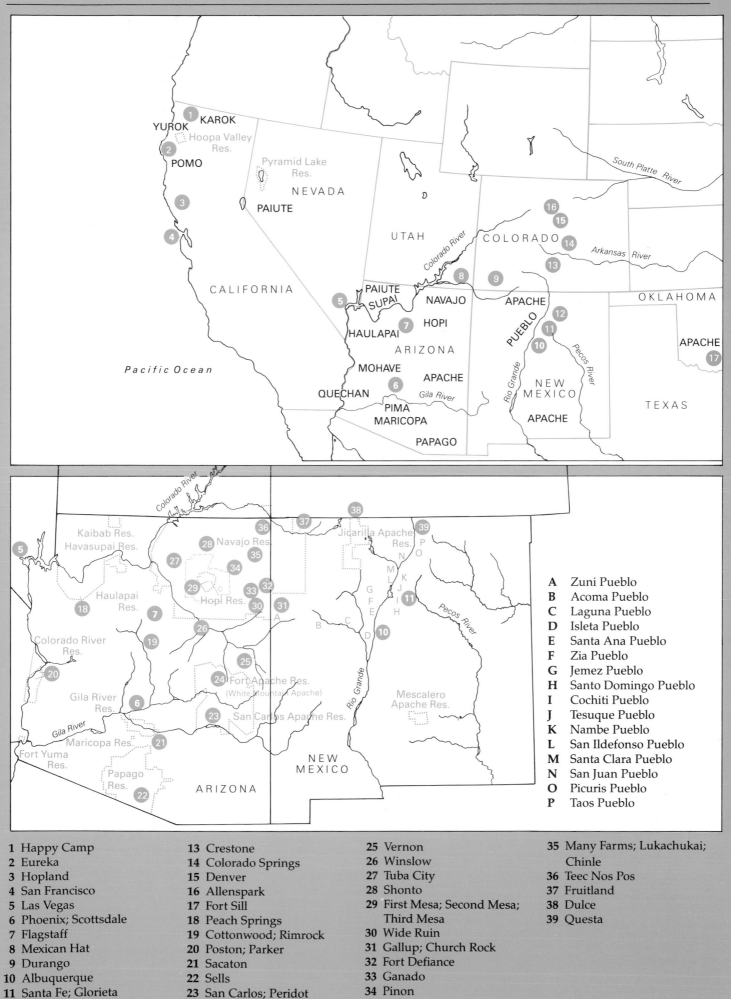

A Zuni Pueblo
B Acoma Pueblo
C Laguna Pueblo
D Isleta Pueblo
E Santa Ana Pueblo
F Zia Pueblo
G Jemez Pueblo
H Santo Domingo Pueblo
I Cochiti Pueblo
J Tesuque Pueblo
K Nambe Pueblo
L San Ildefonso Pueblo
M Santa Clara Pueblo
N San Juan Pueblo
O Picuris Pueblo
P Taos Pueblo

1 Happy Camp
2 Eureka
3 Hopland
4 San Francisco
5 Las Vegas
6 Phoenix; Scottsdale
7 Flagstaff
8 Mexican Hat
9 Durango
10 Albuquerque
11 Santa Fe; Glorieta
12 Taos

13 Crestone
14 Colorado Springs
15 Denver
16 Allenspark
17 Fort Sill
18 Peach Springs
19 Cottonwood; Rimrock
20 Poston; Parker
21 Sacaton
22 Sells
23 San Carlos; Peridot
24 Carrizo

25 Vernon
26 Winslow
27 Tuba City
28 Shonto
29 First Mesa; Second Mesa; Third Mesa
30 Wide Ruin
31 Gallup; Church Rock
32 Fort Defiance
33 Ganado
34 Pinon

35 Many Farms; Lukachukai; Chinle
36 Teec Nos Pos
37 Fruitland
38 Dulce
39 Questa

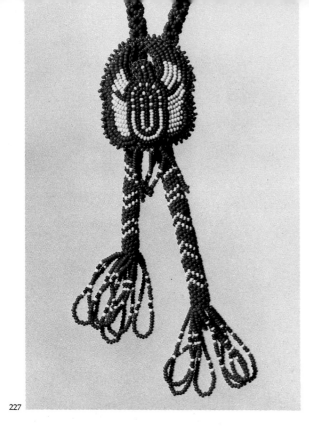

227

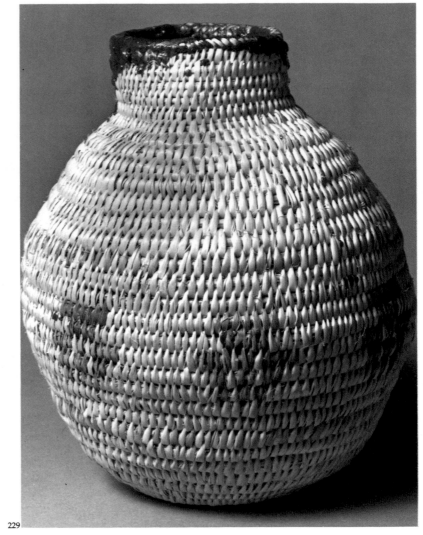

229

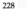

228

227

Bicentennial bolo tie, 1976
Beads, cloth
18½" l.; medallion 2" l.(irregular)

Mrs. Alice Spinks
San Carlos Apache (San Carlos Indian Reservation, Arizona)
Resident at Muskogee, Oklahoma

"It's very red, white, and blue," said Alice Spinks of this beaded bolo tie she made for her husband for the Bicentennial of the United States. The eagle shield was copied from "some design I saw." Mrs. Spinks has long taught beadwork at Bacone College, Muskogee, Oklahoma, and is a revered figure there. She is a master of traditional Apache beadwork styles, as well as modified styles brought in by modern usage (of which this bolo tie is an example). She does wood sculpture and carving as well. Her husband, a Karok Indian of Northern California, is the retired superintendent of the college grounds.

Acquired as a gift to the author, May 1982.
Collection Ralph T. Coe
Santa Fe, New Mexico

228

Miniature fiddle with bow, 1983
Wood, watercolor, thread
Fiddle 1⅞" l.; bow 1½" l.

Mike Darrow
Fort Sill Apache
Fort Sill Indian Reservation, Fort Sill, Oklahoma

This exquisite, tiny model of an Apache fiddle actually harks back to an earlier style of decorating such instruments than the full-scale fiddle by Craig Goseyun (cat. no. 235). The sound holes are painted on the surface. Mike Darrow graduated from the Institute of American Indian Arts in Santa Fe in 1982; about thirty years old, he is the grandson of the well-known sculptor Allen Houser and has a degree in Museum Training.

Purchased from the maker through the Institute of American Indian Arts, Santa Fe, New Mexico, January 1984.

229

Olla, 1984
Sumac, piñon pitch, natural dye
8⅜" h. x 7½" diam.

Lydia Pesata
Jicarilla Apache
Jicarilla Apache Indian Reservation, Dulce, New Mexico

"I'll try a water bottle, but I haven't made one in a while," offered master basket maker Lydia Pesata (fig. 17). Several months later she called, "Well, it's done now, but I don't know if it will hold water." When I picked it up, she explained further, "It's a little uneven in shape, I demonstrated the pitching to the ladies and got excited so it [the pitch] dripped on the rim."

In contrast to Southern Apache ollas, these Northern ones are pitched only on the inside (not inside and out, as in cat. no. 234). Lydia Pesata's example is actually perfectly watertight; it keeps water cool for hours, as a thermos does, and imparts a mild resin flavor to the water, which adds to the sensation of coolness.

Purchased from the maker, June 1984.

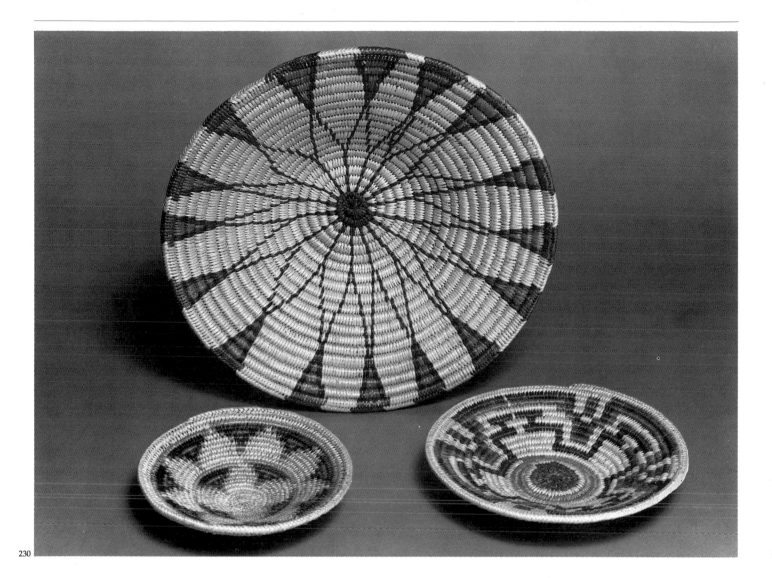

230

230

Tray basket, 1981 *(top)*
Sumac, willow, synthetic dye
4¹/₁₆″ h. x 16⅜″ diam.

Cecilia Harina

Tray basket, 1984 *(left)*
Sumac, willow, natural dye
2⅛″ h. x 8⅜″ diam.

Lydia Pesata

Tray basket, 1984 *(right)*
Sumac, willow, synthetic dye
2″ h. x 8⅜″ diam.

Louise Pesata

Jicarilla Apache
Jicarilla Apache Indian Reservation, Dulce,
New Mexico

Some of the finest Apache baskets made today
are woven by a dozen or so women at Dulce,
New Mexico.* Chief among them is Lydia
Pesata, whose mother-in-law, Louise Pesata, in
her seventies, also weaves fine tray baskets.
Lydia Pesata holds classes in basket weaving in
the tribe's workshop and also teaches older
women at the Jicarilla Crafts Museum nearby.

In the fall of 1982 she offered classes in Indian
tanning. She posted signs through the town of
Dulce and advertised in the paper for three
months, "and no one showed up.... Some-
times I get discouraged, but even if I can only
teach my own children I guess it's all right."
[Her daughter Molly, a student at the College
of Santa Fe, is also a first-class basket maker.]

"My mother-in-law can tan but doesn't do
it anymore, since she's employed by the tribe
to make baskets. Sometimes people come to
me and ask, 'Have you got any hides?' I used
them all last fall." She says the Southern Utes
come "because they can't find anyone to make
moccasins. 'You bring me old ones,' I tell them,
'and I'll copy them.' I made some for two of
them who wanted to dance; both daughters
won because of the home tanning." The future
of tanning may be precarious, but the basket
making has progressed way beyond a view ex-
pressed some years ago: "The Jicarilla may be
making some coiled baskets. There has been an
attempt to revive interest in their weaving."**
The tribe has taken a responsible lead in this
revival.

Lydia Pesata's small tray was incomplete
when first seen. She agreed to finish it the next
day, so it lacks an outer register of coils that
would have made it larger. She has used sumac

for both warp and weavers – "very small rods"
– and the colors are the result of her creative
experiments with dye sources. Dark colors
come from sumac that has been soaked for
three weeks, green from birch and sage (sage
in fall makes brown). "I get red from a lot of
things, paintbrush mahogany... it grows
higher up than here in a rocky area, Colorado
Springs, you know over the hill." This dili-
gence does not prevent others from using com-
mercial dyes to color their baskets, including
Louise Pesata and even Cecilia Harina, the
winner of an honorable mention in basketry at
the New Mexico State Fair in 1981 for the piece
shown here.

*On Southwestern basket makers of the present day,
see Barbara Mauldin, *Traditions in Transition: Contem-
porary Basket Weaving of the Southwest Indians,* exhibi-
tion catalogue (Santa Fe: Museum of New Mexico
Press, Library of Anthropology, 1984).

**Frank W. Lamb, *Indian Baskets of North America* (La
Pine, Oreg.: Rubidoux Publishing Company, 1972),
p. 110.

Baskets by Cecilia Harina and Louise Pesata pur-
chased at Jicarilla Arts and Crafts, Dulce, New
Mexico, January 1984.
Basket by Lydia Pesata purchased from the maker,
January 1984.

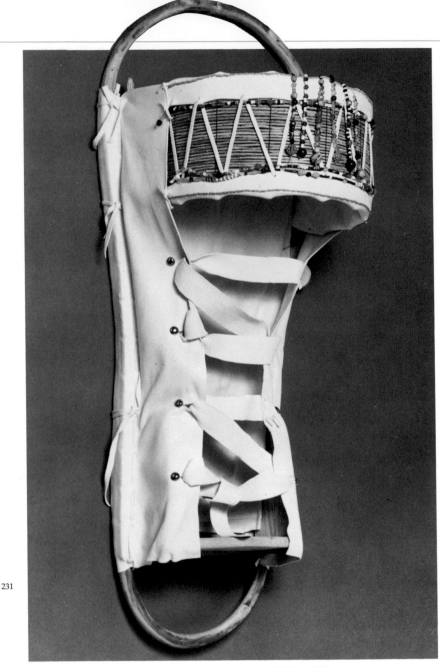

231

231

BABY CARRIER, 1984
Yucca branches, willow frame, wood slats, beads, commercial hide and ties, cottonwood
37⅛" h. x 14¾" w. x 11³⁄₁₆" d. (at hood)

Nona Blake
Mescalero Apache
Mescalero Apache Indian Reservation,
Mescalero, New Mexico

Finding someone who is still producing cradles was not easy, but I was finally directed to Nona Blake. At age eighty-four she is still at work. I found her at her home making a cradleboard, a large one, for a boy. The frame stood complete. "But I can't get good buckskin, I don't tan anymore. I'm too old – and my needles can't get through the tough stuff," she said, lifting the "tandy" cream hide she was cutting and shaking it disdainfully. Nevertheless, we struck a deal, and Nona Blake worked till two in the morning to finish the cradle on view here.

Nona Blake's cradle is in general form not changed one iota from olden days. But the back slats are cut from finished board and the greasy appearance of the slick factory-tanned buckskin is off-putting to a traditionalist. An Osage who saw the cradle in Santa Fe wondered why she had not turned the hide inside out, for it would have been more traditional that way. The beads suggest the protective amulets of old, but they are plastic. Nonetheless it is a well-made, thoroughly Apache cradle. "It's a statement the way it is," offered the anthropologist Susan McGreevy. For the last thirty to forty years Apache cradles have most often been made of canvas stained yellow, which has a sturdy old "trade material" effect. What we have here is an attempt to go back even further, but with hybrid results.

Purchased from the maker, February 1984.

232, 233

BEADED NECKLACE, ca. 1978–79
Beads, ribbon, backing
18" l. (including fringe) x 19" w. (excluding ribbon ties)

Maker unknown
White Mountain Apache
Fort Apache Indian Reservation, Arizona

BEADED NECKLACE, 1983
Beads, ribbon, backing
14" l. (including fringe) x 10⅛" w.
(see colorplate, p. 235)

Therman Kadayso
Kiowa (Oklahoma)
Resident at Mescalero Apache Indian Reservation, Mescalero, New Mexico

The *T*-shaped necklace is worn by girls during the puberty ceremony, a most important Apache rite of passage. By contrast, the boys' ceremony is neither as lengthy nor as impressive. These pieces are rarely seen on the market. The cloth backing of the upper bar of the *T*

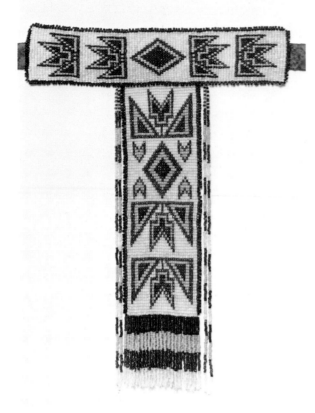

232

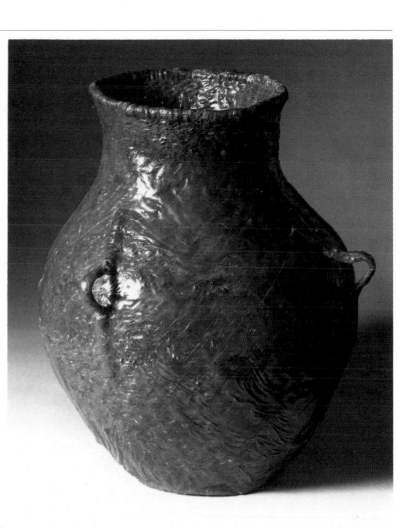

234

234

of catalogue number 232 shows some wear, but nothing is known about its origin.

The work by Therman Kadayso is a cogent example of cross-tribal influence. This necklace could not be more at the center of Apache philosophy in its designs, which link mind to spirit when worn by an Apache girl at her puberty ceremony, and in its *T* shape, which is dictated by custom. However, it was made by someone who is not Apache at all, but an Oklahoma Kiowa married into an Apache family. If one did not know the mixed circumstances, one would declare this to be an Apache conception of the purest blood.

Catalogue number 232 purchased at the Wampum Post, Allenspark, Colorado, April 1979.
Catalogue number 233 purchased at the Mescalero Tribal Store, Mescalero, New Mexico, January 1984.

WATER STORAGE BOTTLE, 1983
Sumac, piñon pitch
20″ h. x 15½″ diam. (irregular)

Lola Tuse
San Carlos Apache
San Carlos Indian Reservation, Peridot, Arizona

It is unusual for a modern Apache water storage bottle to be of this style. While referred to in the literature as crude, or "crudely made," in counterdistinction to the "beautiful burden baskets" (cat. no. 238) of this tribe,* which are also twined, this is a matter of white taste and not an Apache distinction. The twining does not include salient warps so the effect is amorphous in texture; but since the water bottle is covered with several coats of piñon pitch – even on the exterior – to render it watertight, the basketry walls are meant to be obscured, as if seen through a coating of molasses. The result is a ductile, overall form which can be

appreciated for distinctive functional purity on its own account. Many modern potters strive diligently for this rough and ready solid yet translucent embodiment.

It was customary to hang these bottles or jars from a housepost, so bent twig handles are provided. Northern (Jicarilla) Apache bottles (cat. no. 229) are pitched on the inside only.

*Helen H. Roberts, *Basketry of the San Carlos Apache Indians* (1929; reprint, Glorieta, N. Mex.: Rio Grande Press, 1972), p. 150.

Purchased at the shop of the Heard Museum, Phoenix, Arizona, March 1984.

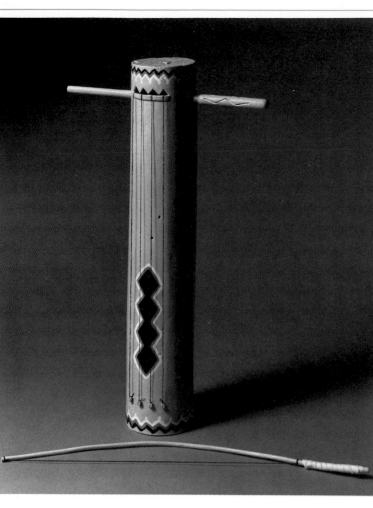

235

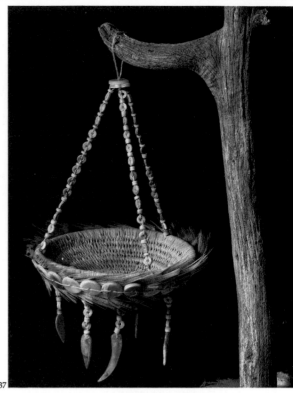

237

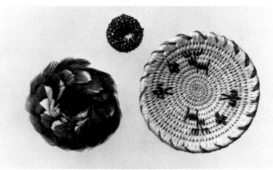

236

235

FIDDLE WITH BOW, 1984
Agave stalk, enamel paint, string, tape
Fiddle 14¾" l.; bow 13¹⁵⁄₁₆" l.

Craig Goseyun
San Carlos Apache
San Carlos Indian Reservation, San Carlos,
Arizona

Apache fiddles are of uncertain antiquity, but surely go back well into the 1800s and are almost certainly based on the idea of Spanish stringed instruments. In the past, most fiddles were made by the San Carlos Apache, as is this new example. Earlier Apache fiddles had one or two strings and less paint coverage. This one has four strings, and it is perfectly playable. The bright yellow and restrained blue that forms the zigzag designs at each end of the fiddle and outline the diamond-shaped sound holes are strictly of today. The sound box is completely and carefully hollowed out, in contrast to fiddles made sheerly for collectors and not intended to be played, where only a small area of pith behind the holes is gouged out.*

The maker – Craig Goseyun, a painter and graduate of the Institute of American Indian Arts at Santa Fe – has signed his work inside the sound box.

*See Alan Ferg, "Amos Gustina, Apache Fiddle Maker," *Indian Art Magazine*, vol. 6, no. 3 (Summer 1981), pp. 28–35. The method of hollowing the fiddle by opening a "window" and scooping out the pith without breaking through the two ends – used by Craig Goseyun – is not described in this article as one of the three methods generally used. A removable lid is provided as a cover for the window.

Purchased from the maker through the Institute of American Indian Arts, Santa Fe, New Mexico, January 1984.

236, 237

THREE MINIATURE BASKETS, 1983
Willow, feathers, beads, shell
Pomo-style beaded gift basket ⅝" diam.
Pomo-style feathered basket 1⁵⁄₁₆" diam.
Apache dish 2" diam.

HANGING POMO-STYLE BASKET, 1983
Willow, feathers, beads, shell
3¼" diam.

Tu Moonwalker
White Mountain Apache (Fort Apache Indian Reservation, Arizona)
Resident at Glorieta, New Mexico

Tu Moonwalker, of Apache descent, now in her mid-thirties, is a uniquely interesting cross-cultural Southwest/California basket maker. She knows the Pomo types, miniature baskets – both beaded and feathered – and hanging baskets. She also weaves excellently in Apache style, but prefers miniature work, so that a personal exquisiteness of scale dominates even her Apache ancestry. She prefers russet tones and autumnal combinations of willow, pheasant feathers, and pink shell dangles (hanging basket), metallic beads in soft hues (miniature beaded gift basket).

Purchased from the maker, Santa Fe Indian Market, New Mexico, August 1983.

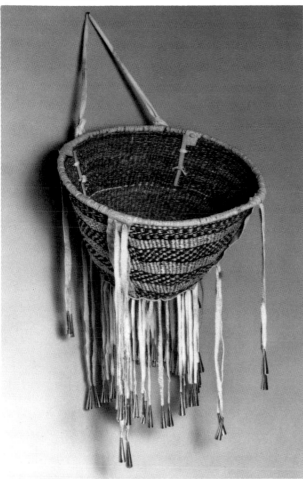

238

239

238

BURDEN BASKET, 1983
Willow, sumac, yucca, hand-tanned hide, devil's claw, tinklers
12″ h. (excluding fringe) x 17¾″ diam.

Ramona Beatty
White Mountain Apache
Fort Apache Indian Reservation, Carrizo, Arizona

Deep bowl-like burden baskets, a highly traditional basketry form of the Western Apache, are still used to hold gifts presented to young girls at the four-day puberty ceremony (along with metal drums and commercial boxes of various kinds) and are highly prized by the tribe. Many miniature and small burden baskets are made for the souvenir trade.

Rarely today do the full-size examples have the tinkler-decorated hanging fringe and burden strap cut from soft pliant Indian-tanned hide as here. Great care has also been taken with the outer cover of the bottom, of the same fine hide, with resultant great richness of decorative effect. The bottom hide preserves the basket from damage when it is on the ground. The interior of this basket also makes

it a gem. Its varicolored texture results from the use of both sumac and willow, including willow boiled in its bark, which gives some of the weavers a pink cast. The warps are sumac with the bark still on, giving a reddish undertone to the outside walls of bleached willow and devil's claw. Yucca, pale green at this stage in the life of the basket, has been used to weave the bottom of the basket (covered by buckskin on the outside). The variegated result almost resembles the colors of an Arizona desert seen in the sun.

The oldest method was to construct these baskets around four standing interior supporting sticks. The method employed here is also traditional: willow has been twined around sumac twigs gathered fan wise at the bottom and bound to a sumac willow ring at the outer circumference, which makes a less strong but flexible basket.

Purchased at the shop of the Heard Museum, Phoenix, Arizona, January 1984.

239

WEDDING MOCCASINS, ca. 1965
Indian-tanned buckskin, kaolin leather sole
14″ h. (as folded) x 9½″ l.

Maker unknown
Pueblo
Taos Pueblo, New Mexico

Traditional Taos Pueblo moccasins of home-tanned buckskin are increasingly difficult for outsiders to obtain. For proper ceremonial (kiva) use, the old ways are strictly maintained, but most moccasins for sale today have commercial uppers or tongues and commercial soles. It was expedient in the end to obtain this pair from Taos antiquarian Mrs. Rowena Myers Martinez, which met the project's date criterion.

Rio Grande Pueblo foot attire displays an excellent simplicity of taste, an almost Japanese-like sensibility exemplified by the rubbed kaolin surface of these wedding moccasins. These are kept by the bride all her life; constantly cleaned with kaolin, they become seasoned like an old adobe wall. As the moccasins wear out at the soles, they are unfolded and resoled, gradually becoming shorter, sometimes only "two folds" high.

Purchased at El Rincon, Taos, New Mexico, April 1984.

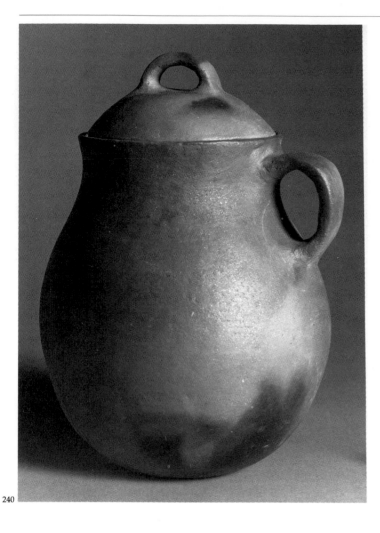

240

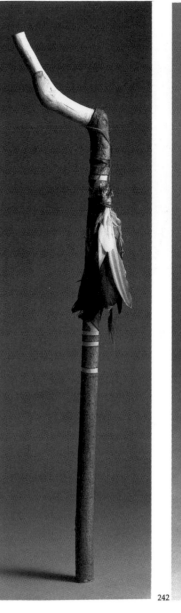

241

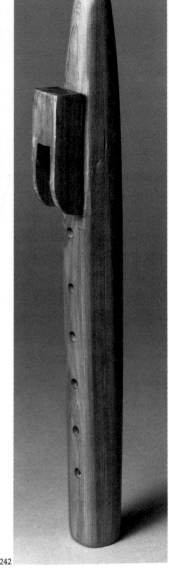

242

240

BEAN POT, 1983
Micaceous clay
9⅜" h. (including lid) x 6½" diam. (at fullest point)

Virginia Romero
Pueblo
Taos Pueblo, New Mexico

Virginia Romero, doyenne of Taos Pueblo potters, works in micaceous clay, as do the Picuris Pueblo potters not far to the south (cat. nos. 243 and 244). It is difficult to obtain her work today. Large "art" pieces (storage jars) of micaceous clay are being made today by non-Indians at Taos; it is the more modest examples, such as this bean pot, that are created in the genuine Indian spirit. The Spanish of northern New Mexico also make a similar functional micaceous ware for both use and sale. For a short time in the 1890s, large micaceous pots were also made at Tesuque Pueblo.

Purchased at Mudd-Carr Gallery, Santa Fe, New Mexico, March 1984.

241

ELDER'S CANE, ca. 1975–80
Flicker, grouse, macaw, and magpie feathers, cottonwood, sinew
20⅝" l.

Manuel Romero (deceased)
Pueblo
Taos Pueblo, New Mexico

Such canes are used by older men to lift themselves up from a sitting position. A bundle of flicker, grouse, magpie, and macaw feathers lends an exotic and colorful note to this otherwise modest object.

Purchased at the Whittaker Gallery, Taos Pueblo, New Mexico, April 1984.

242

FLUTE, 1984
Cedar wood
14" l.

Pat Trujillo
Pueblo
Taos Pueblo, New Mexico

"Yes, you can have this one, because it's sanded and finished, but you have to put the hide wrappings on here and here," said Pat Trujillo, flute and drum maker at Taos Pueblo. "I've glued the upper and lower parts together, but it needs a wrapping [thongs] to finish it right," he added. The piece – which has a particularly sweet tone – has been kept as its maker left it.

Pat Trujillo was taught by his father, Adam Trujillo, famous Taos Pueblo traditionalist, who also makes flutes. Pat teaches art at various pueblos, coming back and forth to Taos Pueblo, so that he can do his work at the workshop beside his house.

Purchased from the maker, April 1984.

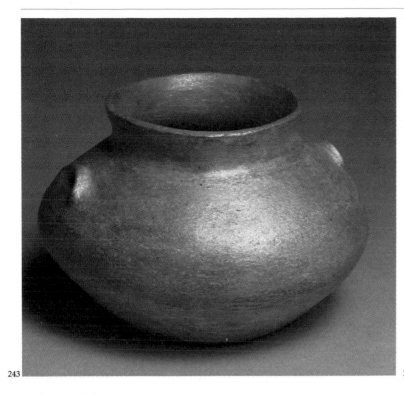

243

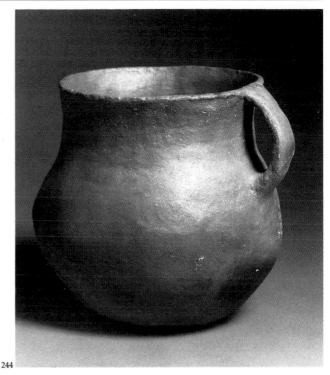

244

245

243

SMALL POT, 1982
Micaceous clay
3⅜" h. x 4⅝" diam. (at fullest point)

Anthony Durand
Pueblo
Picuris Pueblo, New Mexico

Anthony Durand is the grandson of master potter Cora Durand (see cat. no. 244) and has learned his art from her. Since this small pot was made, he has found the disused deposits of clay that used to give Picuris micaceous pots their "orange" hue – making an "advance" into the past by restoring what had been lost. Judging by this pot, it is safe to say that Anthony Durand is one of the most interesting Northern Pueblo potters coming along. His technique adds a thin-walled elegance that is his alone, particularly in his latest work.

Anthony Durand also supervises road work at his Pueblo, exemplifying a communal spirit of work and art that is one of the most striking features of Pueblo life.

Gift of Letta Wofford, Santa Fe, New Mexico, to the author, 1982.
Collection Ralph T. Coe, Santa Fe, New Mexico.

244

BEAN POT, 1984
Micaceous clay
6¾" h. x 6½" diam. (at fullest point)

Cora Durand
Pueblo
Picuris Pueblo, New Mexico

"We make the only Pueblo pottery that you're supposed to use," elder Cora Durand stated as she puddled clay in a large shallow pan outside her doorway at Picuris Pueblo. "You come back in a while when I'm through firing, oh, about two weeks, then you can cook beans." Mrs. Durand's work is distinguished by its straightforward strength, which invests its utilitarianism with the aesthetic of miniature earthenware sculpture.

Micaceous clay is used at Taos Pueblo and also by Hispanic potters. Cora Durand's grandson Anthony (see cat. no. 243) is following in her footsteps. "It's important," she maintains, "to continue our tradition."

Purchased from the maker, September 1984.

245

BUCKLE, 1983
Brass
2⅟₁₆" h. x 3" w.

Luis Mirabal
Pueblo
Nambe Pueblo, New Mexico

Indian art buckles are not confined to the Plains and Prairies, but appear in the Southeast, on the Northwest Coast (cat. no. 356), and in the Southwest, where the Navajo first used cinch belt buckles for their silver concha belts, and then, about 1900, turned to making matching silver buckles.

This modern brass buckle is by the talented painter Luis Mirabal, 1984 graduate of the Institute of American Indian Arts at Santa Fe, who already has a painting on exhibit at the New Mexico Museum of Fine Arts in the same city. For this example, the Southwestern design elements usually associated with pottery are sensitively modified to fit the buckle format.

Purchased at the Institute of American Indian Arts Museum, Santa Fe, New Mexico, January 1984.

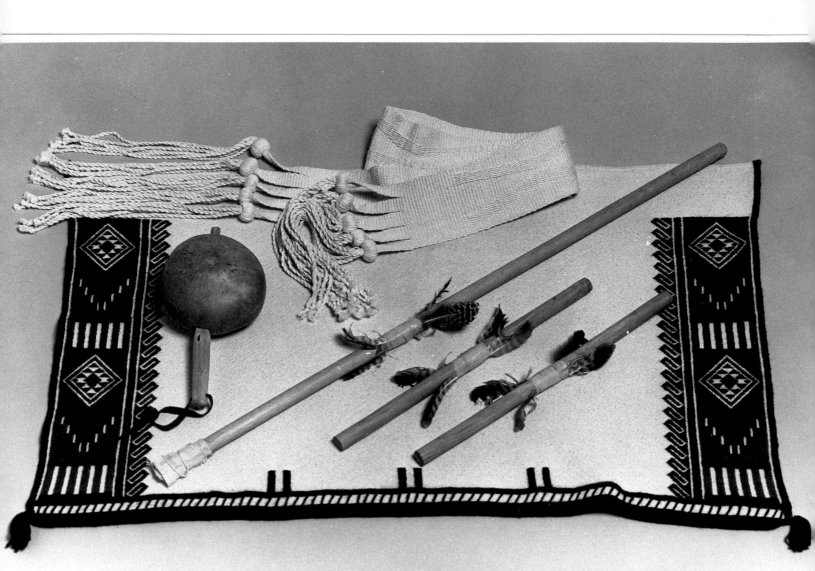

246

246

Deer Dance outfit, 1983–84
Broomsticks, feathers, tape, monk's cloth, wool embroidery, cornhusk, gourd, Indian-tanned ties, imitation-leather tie, cotton, cotton batting, felt, deer antlers, bamboo slats
Headdress 11" h. x 23" w.
Rattle 12" l. (including ties); diam. of rattle 6¼"
Short sticks, each 18¾" l.
Long stick 42⅜" l.

Stephen Trujillo

Kilt 27¼" l. x 42" w.

Romancita Sandoval

Rain sash 84" l. (including fringe) x 4⅞" w.

Joyce Ortiz

Pueblo

San Juan Pueblo, New Mexico

Pueblo animal dances are more than "dances," they are complex cosmic winter dramas, when agricultural concerns are at a low and animal ceremonialism (game propagation, weather control, and hunting success) is paramount. A typical Rio Grande Pueblo animal dance features two buffalo dancers, one or two buffalo maidens, and a hunter, who dance together, plus a supporting cast of deer dancers, antelope dancers, elk and bighorn sheep dancers.

San Juan Pueblo has an important Deer Dance of its own, which takes place in February and includes a long line of deer impersonators dressed in the kind of outfit shown here.

"During the pre-dawn portion of the San Juan Deer Dance, the deer are herded into the village by two San Juan hunters called "Apaches." Their identification as "Apaches" suggests that San Juan respects the Apache's hunting ability."* During the course of the day, into mid- to late afternoon, the animal dancers will appear several times with a slow entrance song (entry into the plaza at dawn), a slow dance, a period of meandering about the plaza in groups, which suddenly "freeze," followed by a climactic fast dance. This cycle is repeated several times. Sometimes there is an attempted "escape into the hills" by the animal impersonators. Sometimes pre-dawn action is accompanied by the firing of guns. To watch in the gray winter chill for the first animal silhouettes to appear atop a hill near San Ildefonso Pueblo, or suddenly to see along the road leading into San Felipe Pueblo the pre-dawn ritual stalking of the game is to experience firsthand the mystery of primordial hunting magic.

The kilt embroidery has terraced triangles (clouds), vertical bars (rain), and black braid with slanted stitches (falling rain) and small black rectangles (additional rain). The diamond patterns of the rain sash are made by

warp fronts; unquestionably the fringed sash is a very ancient textile form, the "cornhusk" rings or balls from which the heavily twisted fringe drops appear around 1200 A.D.

This outfit, the work of three artisans, was assembled with the cooperation of Oke Oweenge Arts and Crafts cooperative at San Juan Pueblo and coordinated by Gabrielita Nave (see cat. no. 247). "We put certain things in our designs that are closed to outsiders.... But it's all right for you have a Deer Dance outfit for a bonafide cultural effort, and I'll fit one up."

Stephen Trujillo, the senior among them and a distinguished traditionalist, had already made the basic headdress but added the antlers and "snow" to complete it in the correct way. (Since the Deer Dance is a winter dance, the symbology is apt.) Romancita Sandoval is one of the best embroiderers active among the eight Northern pueblos; a beautifully embroidered old-style shirt by her took a major prize at the Santa Fe Indian Market in 1984. Joyce Ortiz is a non-Indian member of the Pueblo through marriage.

*Don L. Roberts, "Calendar of Eastern Pueblo Ritual Drama," in Southwestern Indian Ritual Drama, ed. Charlotte J. Frusbie (Albuquerque: University of New Mexico Press, 1980), p. 106.

Purchased at Oke Oweenge Arts and Crafts, San Juan Pueblo, New Mexico, January 1984.

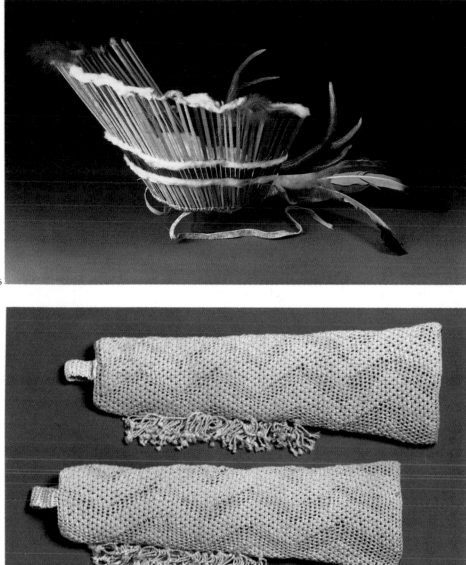

246

248

247

MANTA, 1984
Monk's cloth, wool
47¼" l. x 58¼" w.
(see colorplate, p. 234)

Gabrielita Nave
Pueblo
San Juan Pueblo, New Mexico

For a Pueblo manta (dance skirt) of the best quality I went to Gabrielita Nave. "Which kind of design do you want?" she asked, holding up a copy of Meras's volume on Pueblo embroidery as a source book.* Mrs. Nave spent two and a half months embroidering this manta, which does not reflect exactly anything in Mera (it is actually a Hopi-like design) but is totally traditional in its colors and in the inclusion of clouds with rain and butterflies, which are increase or life symbols. "The hard part," Mrs. Nave explained, "is what follows the bottom borders; you have to think out your stitches in relation to the proportion of the design steps."

Sixty or more years ago the cotton cloth was handwoven, but in recent times the embroidery has been done on manufactured monk's cloth, bolts of which are kept at the Oke Oweenge Arts and Crafts cooperative at the San Juan Pueblo of which Mrs. Nave (until her recent retirement) was director. Gracious and diplomatic to the core, Mrs. Nave is a traditionalist, who makes mantas often for other pueblos (Santo Domingo among them) for ceremonial dance use and is an ambassador who builds bridges to the world outside the Pueblo.

"It's as beautiful as any well-worked manta I've seen," said anthropologist Susan McGreevy, when I unwrapped it for her. "It'll stand with the best."

*Harry P. Mera, Pueblo Indian Embroidery, Memoirs of the Laboratory of Anthropology, vol. 4 (Santa Fe: University of New Mexico Press, 1943). Here is an example of the ethnological literature being helpful to a member of a group whose culture is secure.

Purchased from the maker, June 1984.

248

CROCHETED LEGGINGS, 1983
Cotton
28½" l. x 9⅛" w. (across tops)

Joyce Ortiz
[Pueblo]
San Juan Pueblo, New Mexico

This correctly made pair of crocheted leggings is almost identical to another pair I collected, which were made by a Hispanic woman who trades them to the Santo Domingo Indians, who sell jewelry at the Portal of the Palace of the Governor in Santa Fe. Mrs. Ortiz is herself a non-Indian member of San Juan Pueblo, but has learned the requisite techniques (see cat. no. 246).

Purchased at Oke Oweenge Arts and Crafts, San Juan Pueblo, New Mexico, December 1983.

249

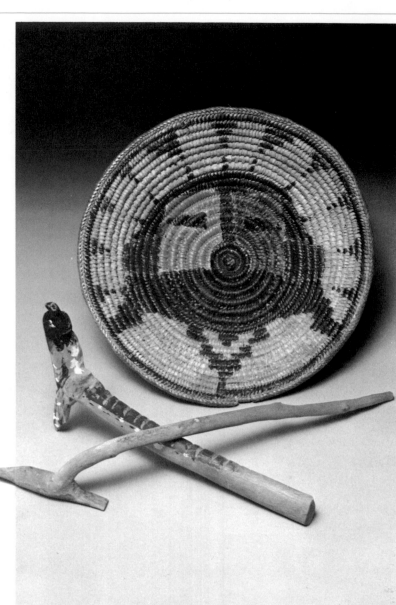

250

249

PAIR OF EARRINGS, 1984
Silver, silver wire
2¾" diam.

Manuel Galbadon
Pueblo
San Juan Pueblo, New Mexico

A stunning pair of round silver earrings in the "museum" section of the San Juan Pueblo arts and crafts cooperative led me to inquire whether anyone was presently making such earrings. The director, Gabrielita Nave (see cat. nos. 246 and 247), replied, "Oh, I think Mr. Galbadon would make another pair like that; I'll ask him." She followed through, and he made this handsome pair.

Purchased from the maker through Oke Oweenge Arts and Crafts, San Juan Pueblo, New Mexico, February 1984.

250

PAINTED BASKET AND RASPS, ca. 1970
Non-Indian basket, paint, cottonwood
Basket 12" diam.; rasps 15⅞" l., 12" l.

Lorenzo Aquino
Pueblo
San Juan Pueblo, New Mexico

Through Santa Fe trader Rex Arrowsmith I met Lorenzo and Reycita Aquino, respected San Juan tribal elders. Mrs. Aquino told us that her husband, now ninety-two, no longer made dance rasps, but after a while a box was produced with some of the last rasps he had made, all showing the splotchy painting that accompanies diminishing eyesight. I could not help noticing a basket painted with a kachina design hanging on the living room wall, above the door. Mrs. Aquino soon offered, "I'm eighty-four myself and I don't dance anymore...so if you want the basket he painted for me to go with the rasps, it is all right."

In the Pueblo Basket Dance the female dancers kneel before their male partners and strike the rasps over the inverted baskets. The basket acts as a resinator for the prayer songs.

The baskets themselves are obtained from various sources; this one is African. Such baskets are given to the female dancers for life.

Purchased from Mr. and Mrs. Lorenzo Aquino, San Juan Pueblo, New Mexico, March 1984.

251

PAIR OF RASPS, 1983
Cottonwood, paint, down feathers
Snake-with-bird rasp 15½" l.
Skunk rasp 15½" l.

Joe V. Trujillo
Pueblo
San Juan Pueblo, New Mexico

The head of each of these Basket Dance rasps has a carved and painted lively animal image which is concerned with hunting prowess. (For the use of rasps in the Pueblo Basket Dance, see cat. no. 250). Joe V. Trujillo, an adobe brick maker and wood carver, is much younger than Lorenzo Aquino (see cat. no. 250), but he carries on the elder's tradition with sprightly style.

Purchased at Native American Artifacts and Antiquities, Santa Fe, New Mexico, December 1983.

251

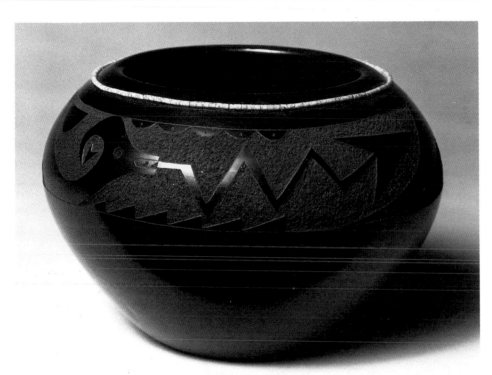

254

252, 253

CERAMIC BEAR FETISH, 1983
Clay, turquoise
2¼" h. x 3⅜" l.
(see colorplate, p. 234)

SMALL PLATE WITH TORQUOISE INSERT, 1984
Micaceous clay, turquoise
1¼" h. x 6⅜" diam.
(see colorplate, p. 234)

Russell Sanchez
Pueblo
San Ildefonso Pueblo, New Mexico

Traditional ceramic bear effigies were turned into an extraordinary art form of Pueblo pottery by Popovi Da (son of the renowned Indian potter Maria Martinez, d. 1980) and his son Tony Da at San Ildefonso Pueblo during the 1950s and sixties. Some of these pieces were elaborately embellished with line engraving and turquoise encrustations, particularly those of Tony Da, to a point where further elaboration would seem impossible.

Recent essays in the genre by Russell Sanchez and other young San Ildefonso potters are more modest. Though small in size, this is a very effective work. The micaceous surface is subtly confined to the upper arches of the

bear's legs, and the turquoise is simply set on the bear's back with little elaboration. While many bear fetishes of this type are marketed, others serve religious purposes in the kivas.

The small plate exhibits an *avanyu* (water serpent) design first used on pottery by Maria Martinez and her husband, Julian, over half a century ago when they developed their renowned black-on-black pottery, in the tradition of which the work of Russell Sanchez and Juan Tafoya (see cat. no. 254) is clearly placed. Other plates by Russell Sanchez combine this now-venerable symbol with a Volkswagen Beetle image – a combination of old and new that is part of the ageless evolution of Rio Grande pottery.

Catalogue number 252 purchased at Mudd-Carr Gallery, Santa Fe, New Mexico, June 1984.
Catalogue number 253 purchased at Mudd-Carr Gallery, Santa Fe, New Mexico, April 1984.

254

BLACK-ON-BLACK POT WITH TURQUOISE HEISHI RIM, 1984
Clay, turquoise
4½" h. x 6⅝" diam.

Juan Tafoya
Pueblo
San Ildefonso Pueblo, New Mexico

This elegant pot shows what has become of the tradition of black-on-black pottery with the *avanyu* (water serpent) design adumbrated in a group of pots made in 1917 by Maria Martinez, and decorated by her husband, Julian. Today the *avanyu* decorated pottery type is synonymous with San Ildefonso Pueblo, and among its practitioners are Maria's own descendants.

Equally distinguished is the work of Juan Tafoya, a nephew of the Santa Clara Pueblo master potter Margaret Tafoya. He points out that the serpent with a pointed "droplet" attached to the end of the horn belongs to his family's individual interpretation of the theme. "My mother [Donicia Tafoya] used that design. Maria gave us the example, and it has benefited all of us here at the Pueblo." The "droplet" is a storm pattern signifying rain or a storm, just as the zigzag issuing from the serpent's mouth indicates lightning. The serpent can have *V*-shaped feet (used more often on

255

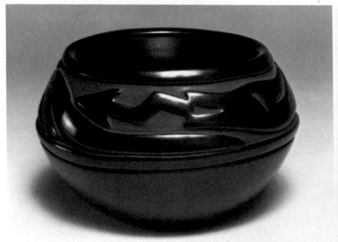

256

255

Bean pot, 1982–83
Micaceous clay
6½" h. x 6¼" diam.

Rose Naranjo
Pueblo (Taos Pueblo)
Resident at Santa Clara Pueblo, New Mexico

Since Rose Naranjo came originally from Taos Pueblo, she makes the micaceous clay pottery of her home Pueblo, though she lives with her husband in Santa Clara Pueblo. Her treatment of the genre, however, includes personalized features, notably handles that end in human hands or snake-lizard forms at the point of attachment.

Something of this adventurous spirit has been inherited by Mrs. Naranjo's daughter Jody Folwell, who has expanded the horizons of Pueblo pottery to include free-form modeling, new forms of decoration, and even Oriental formalism, all absorbed into Pueblo tradition in a most energetic and creative way.

Purchased from Letta Wofford, Santa Fe, New Mexico, April 1984.

256

Bowl, 1983
Blackware
4⁹⁄₁₆" h. x 7" diam. (at shoulder)

Elizabeth Naranjo
Pueblo
Santa Clara Pueblo, New Mexico

A major exhibition could be mounted devoted solely to the deeply carved blackware pots that originated with Margaret Tafoya at Santa Clara Pueblo and have influenced an active school of pottery there. This thick-walled bowl has a pleasing vernacular directness, consistent with the rather roughly carved serpent design.

Perhaps the finest Santa Clara work in this blackware is being carried on by Nathan Youngblood. Other distinguished Santa Clara potters include Toni Roller, Reyecita Naranjo, Christina Naranjo, Shirley Tafoya, Camillio Tafoya, Pablita Chavarria, and Helen Shupla, who specializes in ribbed melon-shaped uncarved ware. This development elaborates on turn-of-the-century plain polished blackware.*

*For a range of Santa Clara Pueblo contemporary blackware, see *One Space/Three Visions*, exhibition catalogue (New Mexico: The Albuquerque Museum, 1979). This major exhibition of Southwestern art includes work by many Pueblo artists not included in this project.

Purchased from Letta Wofford, Santa Fe, New Mexico, April 1984.

sale pottery) or "kiva steps" feet, seen here, which have a more ceremonial configuration.

This pot was first seen in its unfired gray state. "I'm planning to put turquoise heishi around the rim," Juan Tafoya said. "Call me tomorrow to see if the weather was right for firing." The next day it was finished. Despite the almost excessive use of torquoise decoration for some San Ildefonso contemporary pottery, this pot maintains a balance of restraint that is admirable, which is also discernible in the work of Russell Sanchez (see cat. nos. 252 and 253).

About individuality and tradition, Juan Tafoya says: "The way *you* see things is the way you build [a pot], but the style never changes. I am very much interested in continuing the art of pottery making which has been a part of my culture for hundreds of years and continues to be an expression of artistic creation, as well as a way of life for us today."

In contrast to the Western pueblos method (Laguna, Acoma, Zuni), where a great deal of present-day work is kiln-fired, the Santa Clara and San Ildefonso potters retain the traditional ground-dung firing technique.

Purchased from the maker, July 1984.

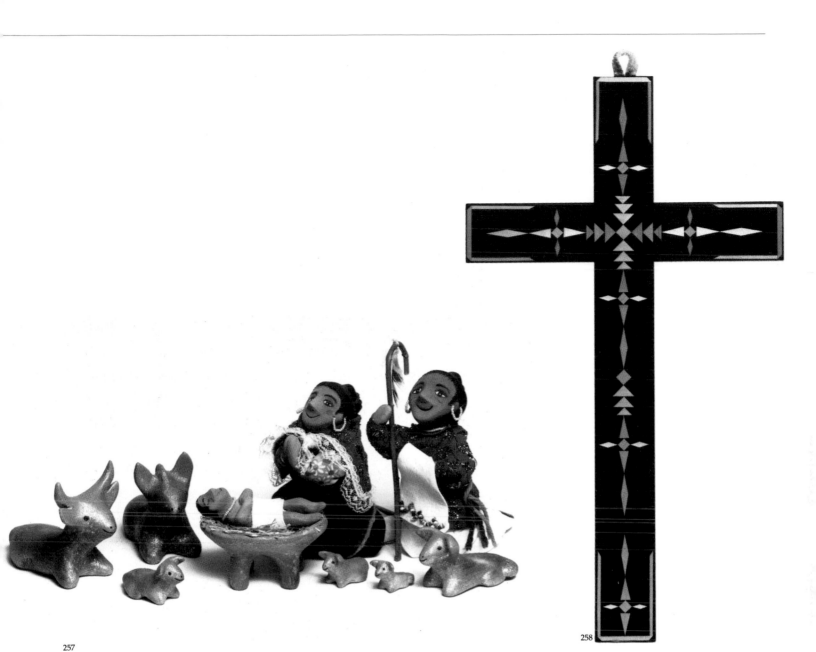

257

258

257

NACIMIENTO, 1984
Clay, cloth, beads, straw, paint, wood, commercial hide, child's swaddling cloth, wool
Animals, range 7/8"-4¾" l.
Manger 3¼" l. x 2½" w.
Child 3⁵⁄₁₆" l.
Mary 4¾" h.
Joseph 5" h.

Terry Tapia
Pueblo
Tesuque Pueblo, New Mexico

The Nacimiento group has been a popular pottery theme among the Pueblos since the late 1960s. It recalls to us that some of the most elaborate Pueblo dancing takes place at Christmastime, including performances in the Pueblo churches, the earthen floors of which connect the dancers to Mother Earth, as the stable floor did for the Holy Family. Terry Tapia has made four Nacimientos so far. This one has a colorfulness and exuberance that accords with its Tesuque origin, where pottery is often decorated with bright colors, including poster paints.

The making of figurines reached a new popularity after the mid-1960s, when Cochiti potter Helen Cordero created her *Storyteller*, a seated figure with outstretched legs over whom tiny figurines of children clamber and cling while the open-mouthed storyteller inculcates history and legend in the approved way of tribal education. Helen Cordero's work has been adopted in the cause of commerce by over sixty artisans from various pueblos.*

*See Barbara A. Babcock, "Clay Changes: Helen Cordero and the Pueblo Storyteller," *American Indian Art Magazine*, vol. 8, no. 2 (Spring 1983), pp. 30–39. Helen Cordero's early *Storyteller* figures remain touchstones, but the proliferation is not shown here, in favor of less known work.

Purchased from the maker, February 1984

258

CROSS, 1983
Cottonwood, stain, straw
13½" h. x 7½" w. (across arms)

Elmer Leon
Pueblo
Santa Ana Pueblo, New Mexico

It is easy to forget the long coexistence of Catholic and Indian ceremonialism among the Rio Grande Pueblo Indians. The Hopi stand alone among Pueblo peoples in having thrown Franciscan ritual permanently out of Hopi early in the eighteenth century. Only one maker of straw inlay crosses survives today among all the Pueblo; he is Elmer Leon, the maker of this cross. Dallas Johnson, Special Program Director of Save the Children, Albuquerque, alerted me to his existence and sent me to see his work on sale at the gift shop in the parish house of the Episcopal cathedral. Elmer Leon was trained at Santa Ana by the late Alfonso

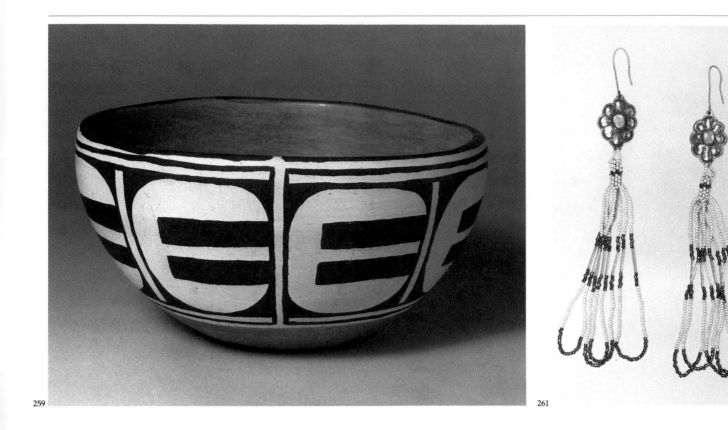

259

261

Garcia, whose crosses were very similar, but with simpler, less refined straw inlay.

Straw inlay, exceedingly exacting and time-consuming work, is another example of the intersection of the Hispanic and Indian cultures. Similar work is done today by a number of Hispanic New Mexican artists. Recently Elmer Leon completed two large and impressive crosses which utilize Indian motifs in the inlay, emphasizing the Indian side of his heritage.

Purchased at Packard's Trading Post, Santa Fe, New Mexico, February 1984.

259

DOUGH BOWL, 1981–83
Clay, slip, paint
6¾" h. x 12³⁄₁₆" diam.

Crucita Melchor
Pueblo
Santo Domingo Pueblo, New Mexico

Crucita Melchor's mother, Santa Melchor (d. 1978), made excellent Santo Domingo polychrome pottery into the 1960s and seventies. Her daughter continues to work in the same tradition, which in turn goes back to well before the turn of the century.* (Indeed, this bowl could have been made about 1900.)

There is a rightness about this thick-walled dough bowl that epitomizes Santo Domingo ware. The painted designs have been called bear paws, but the real "meaning" remains obscure. Their expansive pattern is in contrast to the fine line work now done at Acoma.

*Much interest has attached recently to the technical excellence of the Santo Domingo potter Robert Tenorio, who represented his Pueblo at a demonstration at the American Festival in London (Museum of Mankind, British Museum, spring 1985). The recognition is well deserved; as Rick Dillingham notes, "Robert Tenorio is superb...the Melchors go on their traditional way."

Purchased at Mudd-Carr Gallery, Santa Fe, New Mexico, February 1984.

260

POLYCHROMED OLLA, 1983
Clay, slip, paint
11⅝" h. x 10" diam.
(see colorplate, p. 233)

Crucita Melchor
Pueblo
Santo Domingo Pueblo, New Mexico

This gaily decorated pot by Crucita Melchor shows a certain antic sensibility, part of Indian humor, in the birds with musical notes painted beside them. The bird motif is an old one, but the notes are not. When asked why she painted the notes, Mrs. Melchor replied that she was tired of being asked by visiting Santo Domingo Pueblo tourists what her birds "did." What are they doing? "They sing," she told Rick Dillingham.

Purchased at Mudd-Carr Gallery, Santa Fe, New Mexico, February 1984.

262

264

261

PAIR OF EARRINGS, 1983
Brass, turquoise beads, faceted beads, old
brass beads
5" l.

Sylvia Chano
Pueblo
Santo Domingo Pueblo, New Mexico

Sylvia Chano sold these earrings at her booth
at the 1983 Santa Fe Indian Market. "Those are
old brass beads on those pendants," she
pointed out. Though not as well known as
Santo Domingo silversmithing, brass work is
also a specialty of this Pueblo. In contrast to
Navajo or Zuni silver, Santo Domingo jewelry
has an eclectic character, which sets it apart.
The pomegranate motif is used on Navajo
necklaces as a discrete neck clasp, not as the
spectacular pomegranate sunburst seen here.

Purchased from the maker, Santa Fe Indian Market,
New Mexico, August 1983.

262

NECKLACE, 1983
Turquoise beads, spondylus shell
13⅞" l.

Lila Coriz
Pueblo
Santo Domingo Pueblo, New Mexico

The elegantly fashioned tabs of spondylus
shell (from the Gulf of California) and the natu-
ral turquoise beads – both in subtly graded size
relationships – make this necklace, a general
type prevalent since time immemorial, a con-
noisseur's piece. It justifiably fetched a first
prize at the Santa Fe Indian Market.

Purchased at the booth of Lila and Eunice Coriz,
Santa Fe Indian Market, August 1983.

263

SIX-STRAND NECKLACE, 1984
Royston turquoise, spondylus shell
14¼" l.
(see colorplate, p. 235)

Joe F. Garcia Family
Pueblo
Santo Domingo Pueblo, New Mexico

When I called on the Garcia family at Santo Do-
mingo Pueblo I was shown a heavy, multi-
strand turquoise necklace, each strand gradu-
ated in size from top to bottom with the
greatest care. Two spondylus shells at the ends
joined the six strands into a single neck link. It
was a necklace of extraordinary quality, but it
wasn't for sale. "Our daughter dances that,"
explained Mr. Garcia. They agreed to make an
exact copy of this sumptuous necklace, to be
ready in about two months; it was ready even
before that time. All the family does the work,
Mrs. Garcia explained. The son Raymond (see
cat. no. 264) is a silversmith, but he makes their
heishi, too, when he isn't being a tribal
policeman.

Purchased from Joe F. Garcia, Santa Fe, New Mexico,
March 1984.

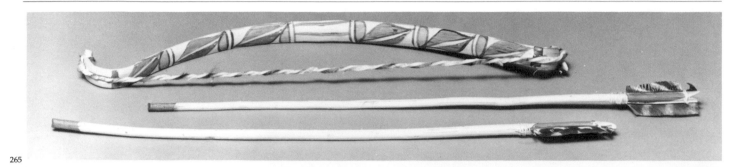

265

266

264

THREE HEISHI NECKLACES, 1983–84
Olive shell heishi, tinklers

FIVE-STRAND NECKLACE
13⅛" l.

Raymond Garcia

TEN-STRAND NECKLACE
15" l.

Orlinda Coriz

TEN-STRAND NECKLACE
14⅜" l.

Rose Montoya

Pueblo
Santo Domingo Pueblo, New Mexico

Olive shell is most commonly used for drilled-shell heishi necklaces, a specialty of the Southwest even before the present pueblos were settled. Turquoise, other types of shell, and even ''liquid silver'' are also strung today. Necklaces tend to be worn in multiples, and at dance time silver and turquoise necklaces are also worn in concert, making for a very grand effect.

Five-strand necklace purchased from Mrs. Joe F. Garcia at the Portal, Palace of the Governor, Santa Fe, New Mexico, September 1983.
Ten-strand necklace with braided loop purchased at Native American Artifacts and Antiquities, Santa Fe, New Mexico, September 1984.
Ten-strand necklace with tinkler clasps purchased from the booth of Juan Tafoya at Annual Feast Day, San Juan Pueblo, June 1984.

265

CHILD'S BOW WITH ARROW, 1984
Cottonwood, rawhide, wood, feather
Bow 16" l; arrow 17¾" l.

William Trujillo
Pueblo
Santo Domingo Pueblo, New Mexico

Diminutive bow and arrow sets such as the one shown here are still made in quantity by one or two Rio Grande Pueblo men, notably William Trujillo at Santo Domingo. They are still used by children and are also sold at Pueblo stores as far north as Taos. The designs painted on the bow are often similar to those on Santo Domingo pottery. This set was brought by Joe F. Garcia when he delivered his family's monumental turquoise necklace (cat. no. 263).

Purchased from Joe F. Garcia, Santa Fe, New Mexico, March 1984.

267

268

266

THREE FIGURINES, 1984
Clay, slip, pigment
One-piece suit 6″ h. x 5⅛″ d. (at legs)
Striped suit 5⅜″ h. x 4⅜″ d. (at legs)
Checkered suit 6″ h. x 5″ d. (at legs)

Seferina Ortiz
Pueblo
Cochiti Pueblo, New Mexico

As early as the 1880s Cochiti figures depicted "opera singers." Early in this century clay images of elephants and camels were made at Cochiti. While these "bathing beauties" seem utterly topical in subject, they may refer also to other things – water associations that go back a long way. "She just showed up with these and showed them to me," Santa Fe dealer Rick Dillingham recalled. "I doubt if she's been to the beach…." (Mermaid figurines are being made by another Cochiti potter, Ivan Lewis.)

The type of ceramic Cochiti figure most imitated by other New Mexican Pueblo potters is the *Storyteller,* which was invented by Helen Cordero in 1964 and has since become the most ubiquitous ceramic made by the Pueblo today (see cat. no. 257).

Purchased at Mudd-Carr Gallery, Santa Fe, New Mexico, February 1984.

267, 268

SMALL DRUM, 1983
Cottonwood, buckskin, paint, shoe polish, commercial leather wrappings
9¼″ h. x 14⅞″ diam.

TALL DRUM, 1984
Cottonwood, buckskin, paint, commercial leather wrappings
23¼″ h. x 13″ diam.

Marcello Quintana
Pueblo
Cochiti Pueblo, New Mexico

So closely is Cochiti Pueblo associated with drums, that its water tower is painted in the colors of a Cochiti blue and cream drum, even to the interlace. There are several other good drum makers (Arnold Herrera, for example), but the doyen is Marcello Quintana. "People come from all over [to see his drums]," one of his granddaughters proudly declared. "Yes,"

he corroborated, "from way over there [meaning France]."

Quintana carefully rounds out and hollows the logs by hand, in contrast to so many Taos Pueblo drums today which are machine grouted and of enormous diameter to serve as coffee tables or for powwow use. He generally obtains the buckskin from a white rancher up in the foothills of the Jemez Mountains. When I called upon him he had just finished two tall drums, both of which were drying in an outdoor shed. Although he had me sound them, he admitted that the stretched hide was still too wet to enable one to tell which was the best. He suggested that I return a few days later, when it was indeed easy to tell which had the rounder and nobler sound – the tall one shown here. The smaller drum with drum heads ringed with black shoe polish, was made of a convenient size to sell at the Santa Fe Indian Market. "But it didn't sell," he lamented. Both drums are signed by the maker.

Purchased from the maker, March 1984.

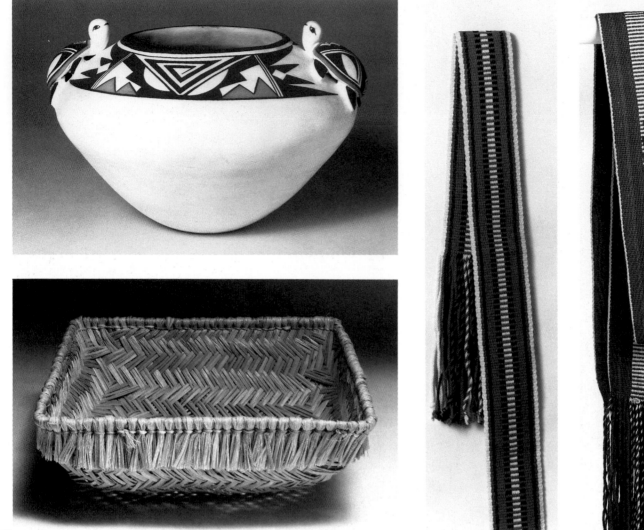

271

269

DANCE HEADDRESS, 1984
Macaw, parrot, and turkey down feathers,
elastic belt, yucca slats, ribbons
6" h. (at front) x 8" diam. (irregular); average
length of feathers at back 16"
(see colorplate, p. 242)

Joe H. Herrera
Pueblo
Cochiti Pueblo, New Mexico

Sidney Margolis, Santa Fe dealer in Indian arts
and antiquities, introduced me to the distin-
guished and well-educated Cochiti Pueblo
painter Joe Herrera.* Several weeks later, at a
meeting Herrera initiated, I purchased macaw
and parrot feathers – which, he assured me,
"would be perfectly all right to show people" –
for a headdress he proposed making for this
project. Months later he reappeared. The head-
dress was ready (fig. 37).

According to Herrera, this headdress was
danced by him in December 1984 in the revival
of a Hunters Dance, which had last been held
at Cochiti Pueblo in 1941. The dance requires
an equal number of male and female dancers,
about thirty to forty, plus the lead dancer and a
drummer, who wears a shoulder-strap hand
drum. The dance is similar to the Zuni Coman-
che dance, and "the songs are similar. It is
practically the same." Old-style feather ties
have been replaced by ribbon streamers, and
the headband has been fashioned from a belt
found in an Albuquerque women's shop.

*See Jean Snodgrass, comp., *American Indian Painters,
A Biographical Dictionary*, Contributions from the
Museum of the American Indian, Heye Foundation,
vol. 21, part 1 (New York: Museum of the American
Indian, 1969), p. 71.

Purchased from the maker, Santa Fe, New Mexico,
May 1985.

270

POT, 1984
Clay, paint
10" h. (overall) x 15" diam. (at shoulder)

Stella Teller
Pueblo
Isleta Pueblo, New Mexico

Stella Teller is the only potter working at Isleta
Pueblo, and her strong style is in a class by it-
self. The painted designs on the shoulder of
this pot recall both Mimbres and Acoma
designs, but the combination is Mrs. Teller's
own. The turtles in high relief, which recall
Cochiti turtle effigies, are her trademark. She
had just finished some large pots for an exhibi-
tion and allowed me to choose one. This piece
is kiln fired. Mrs. Teller heads the Museum
Shop at the All Pueblo Cultural Center in Al-
buquerque, New Mexico.

Purchased from the maker, September 1984.

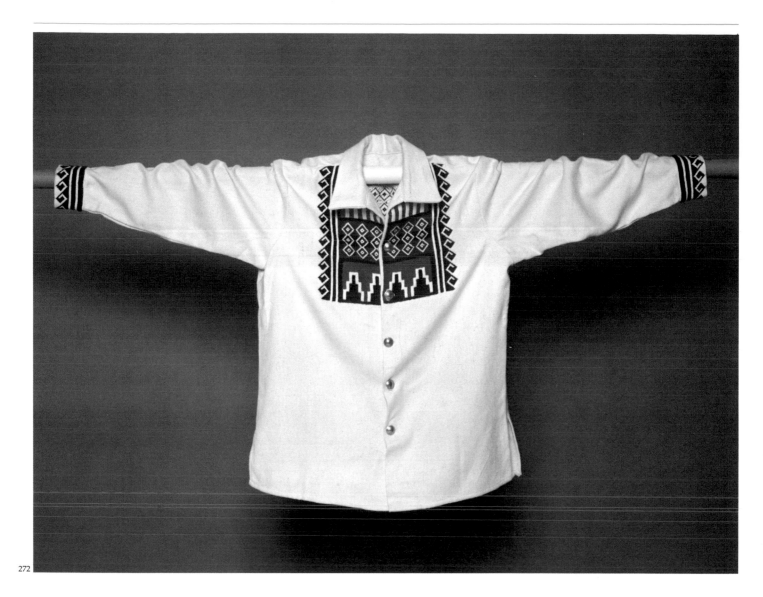

272

271

Basket, 1984
Yucca, metal ring
12½" square (at top) x 4½" d.

Corina N. Waquie
Pueblo
Jemez Pueblo, New Mexico

While the Hopi are commonly credited with making sifter baskets of yucca plaiting (see cat. no. 306), such baskets have also been made since prehistoric times by many Rio Grande Pueblo artisans. Today three women still make them at Jemez Pueblo. The square (rather than round) form is a fairly recent innovation, introduced about thirty to forty years ago, and are intended to hold bread and other foods. They are not made elsewhere in the Rio Grande region.

Purchased at the Civic Building, Jemez Pueblo, March 1984.

272

Shirt, 1984
Monk's cloth, wool embroidery, coin buttons
32" l. x 62¼" w. (across sleeves)

Lydia Chinana
Pueblo
Jemez Pueblo, New Mexico

The magnificent Jemez Pueblo embroidered shirts from the early part of the century in the collections of the Denver Art Museum and the School of American Research at Santa Fe, led me to the tribal Civic Building at Jemez Pueblo to see whether anyone could still embroider an old-style shirt. "I'm making one now," said Lydia Chinana, a young woman who turned out to be the tribal coordinator. She showed me the shirt pieced out and partially embroidered. About a month later it was finished.

Lydia Chinana is one of the five or six embroiders active at Jemez Pueblo. Today the old-style square-cut wedding shirts have largely disappeared in favor of the tailored style seen here with conventional collar, cuffs, and sleeves. The designs "have been taken from the kilts" and are standardized: terraced triangles (clouds); red lines, spread horizontally on the back shoulder panel rather than vertically as on the dance kilts (rain); and triangle/hook motifs, also adapted from kilts, on cuffs and edging the front panel.

The result is less emphatic than the old oblong tailored shirts, but attractive nonetheless – modern yet traditional. (The grand old-style shirts are still made occasionally, notably by Romancita Sandoval [see cat. no. 246 for her Deer Dance kilt], whose efforts have been prizewinners.) The nickel buttons, commercially available in Albuquerque and Santa Fe, are a favorite among contemporary Rio Grande peoples, recalling the coins (dimes, nickels) that were used on older jewelry.

Purchased from the maker, March 1984.

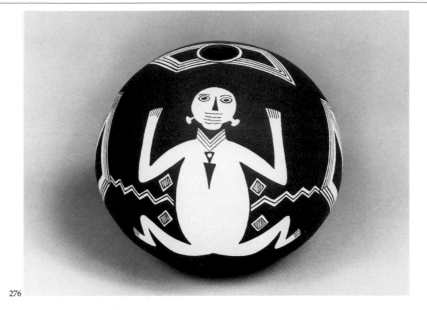

276

277

273, 274

HOPI-STYLE SASH, 1984
Cotton
7'4" l. (including fringe) x 3⁷⁄₁₆" w.
Joselita Galvan
Pueblo
Zia Pueblo, New Mexico

NAVAJO-STYLE SASH, ca. 1965–70
Cotton
9'2¾" l. (including fringe) x 4¼" w.
Maker unknown
Hopi Indian Reservation, Second Mesa,
Arizona

Woven sashes are a flourishing art form today
among the Pueblo; at times non-traditional col-
ors are introduced, but these two examples fol-
low precedent in their display of red, green,
black, and natural shades. The long Navajo-
style sash with a long red warp-floated center
panel with white bars on the inside was woven
at Hopi. Its very light meticulous weave is a
Hopi characteristic. The sash woven at
Zia Pueblo was still on the loom when first
seen. The flat woven warp with black warps in
addition to the white, red, and green is char-
acteristically Hopi. "But those bars all up and
down that way," the weaver pointed out, "is me."

Catalogue number 273 purchased from the maker,
February 1984.
Catalogue number 274 purchased at Four Winds Trad-
ing Post, Flagstaff, Arizona, February 1984.

275

OLLA, 1984
Clay, slip, paint
10¼" h. x 13" d. (at shoulder)
(see colorplate, p. 237)
Gladys Paquin
Pueblo
Laguna Pueblo, Paraje, New Mexico

Although not as spectacular in effect as work
by better-known potters from Santa Clara or
San Ildefonso, this is one of the most beautiful
and rhythmically satisfying pieces of painted
pottery encountered in the Southwest.

Gladys Paquin is of mixed Zuni (father)
and Laguna (mother) parentage, but was
raised by a grandmother at Santa Ana Pueblo.
According to Santa Fe dealer Rick Dillingham,
she "absorbed making pottery – nobody taught
her how. She's doing it on her own, but mixing
all her heritage in her work." She is a full-time
potter very much concerned with traditional
Laguna culture.

This pot of local Laguna clay is technically
excellent. The temper is volcanic tuff rather
than ground pot chards (the old way). The
neck "arch" design in two registers is Laguna
in origin, while the body decoration is a careful
reconsideration of the Zuni Rain Bird motif.

Purchased at Mudd-Carr Gallery, Santa Fe, New
Mexico, February 1984.

276

SEED JAR, 1983
Clay, slip, pigment
5" h. x 5" diam.
Emma Lewis
Pueblo
Acoma Pueblo, New Mexico

In the 1950s, Kenneth Chapman, ethnologist,
archaeologist, and authority on Southwestern
Indian pottery, showed Acoma potters photo-
graphs and/or drawings of Mimbres pottery –
the most celebrated prehistoric figurative
painted pottery of Southwestern New Mexico,
of prehistoric Mogollon tradition – and inter-
ested them in the designs. The finesse of
Mimbres draftsmanship and spacing accorded
well with the fine-line concept of pottery
decoration beautifully developed at Acoma

278

279

277

SMALL OLLA, 1983
Clay, slip, pigment
5¾" h. x 7" diam. (at shoulder)

Frances Torivio
Pueblo
Acoma Pueblo, New Mexico

Frances Torivio is in her mid-seventies; her sister is the well-known Acoma potter Lolita Concho. The designs painted on this pot are based on a prime old Acomita pot of about 1800 in the collections of the School of American Research at Santa Fe.* The shape, however, is not Acomita. The old-style short neck is more fully integrated into the shoulders here, creating a shape closer to the Acoma pottery of the 1890s. The painted design on the neck of the new pot also differs from the original, and the detailing is spontaneous, with more solid filling, making the designs stand out more starkly against the white slip field. This streak of originality proves that while underlying religious elements do not change, handling of them does, in this case refreshing an old concept with renewed understanding.

*See R. Dillingham, "The Pottery of Acoma Pueblo," *American Indian Art Magazine,* vol. 2, no. 4 (August 1977), p. 45, fig. 1.

Purchased at Mudd-Carr Gallery, Santa Fe, New Mexico, March 1984.

278

BIC LIGHTER CASES, 1983
Beads, plastic, cloth, commercial hide, disposable cigarette lighters
each 3¼" h. x 1⁹⁄₁₆" w.

Rawena Him
Pueblo
Zuni Pueblo, New Mexico

A stale, old refrain maintains that "all those poor Indians can do is bead cigarette lighters, key chains, and other trinkets." Actually, the Sioux were beading cigarette-paper cases by the 1800s; the Apache beaded distinguished looking cigarette cases during the 1930s, evolving a special "neo-traditional" beaded style for such pieces. Zuni has a long tradition of beading dolls, figurines holding ollas on their heads, and, since the 1890s, horses with or without riders. The smoking of cigarettes actually found its way into Indian America through Mexico and the Southwest, so tradition is very much behind the decision of Rawena Him, student at the Institute of American Indian Arts at Santa Fe, to bead these lighters in hot colors and Southwestern patterns.

Purchased at the Institute of American Indian Arts Museum, Santa Fe, New Mexico, January 1984.

Pueblo during the later part of this century, and the adoption of Mimbres-derived designs is now traditional at Acoma.

This small seed jar exists in at least one other version by Emma Lewis. They are perfect statements of their kind, bold yet self-contained, not mere repetitions of the past. According to Emma Lewis, this human design derived from a Mimbres pot illustrated "in that brown-covered book." The original presentation would have been on the convex surface of a bowl, spherically projected toward the viewer. Here the black-white fields have been reversed.

Purchased at Mudd-Carr Gallery, Santa Fe, New Mexico, March 1984.

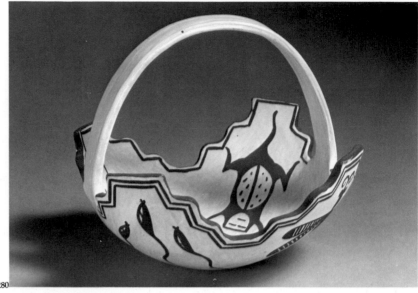
280

282

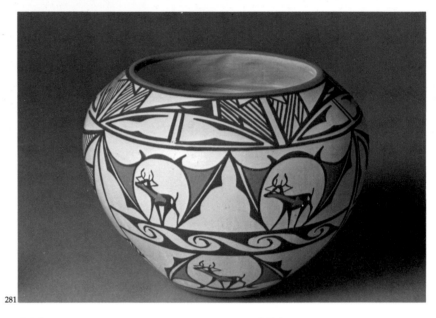
281

279

MANTA WITH NINE MANTA PINS, ca. 1972
Black wool, silver and turquoise pins, red and
green wool
38" l. x 25" w.

Maker unknown
Pueblo
Zuni Pueblo, New Mexico

This beautifully decorated black manta skirt
sports seven Zuni "silver dollar" pins depict-
ing President Eisenhower, each enframed by
twenty-six turquoise droplets. In addition
there are two 1972 Kennedy half-dollar pins
with twenty-two droplets composing their sur-
rounds. The "pins" are all sewn, not pinned,
to the skirt. According to Gabrielita Nave (cat.
no. 247), the material of this treadle-woven
manta was made either by Tewa Weavers at Al-
buquerque, or by one of the Isleta women who
wove there and has since worked on her own.

Such mantas are danced not only at Zuni
but also at other pueblos. The side fastenings
(pins) add a colorful and stately note to the
processional rhythm of the dancers. Though
each skirt is individually embellished, the pins
have a compelling similarity as their turquoise
surrounds glisten in the sun.

Brought into Richardson Trading Co. & Cash Pawn,
Gallup, New Mexico, by Roger Cellicion, February
1977; bought out of pawn, March 1984.

280

OFFERING BOWL, 1983
Clay, slip, paint
6" h. (including handle) x 7⅝" w.

Anderson Peynetsa
Pueblo
Zuni Pueblo, New Mexico

Anderson Peynetsa is a richly talented recent
graduate of Zuni high school, where a remark-
ably successful pottery instruction program
has been pursued with the help of anthropolo-
gist Margaret Hardin (see cat. no. 281). This
cornmeal offering bowl, painted with tadpoles
(water symbols), is a highly traditional form.

Practically all the pottery at the Zuni high
school program is kiln fired from clay that is
supplied, including this piece and its compan-
ion by the same potter (cat. no. 281). It would
seem that the kiln has spared young potters the
discouraging aspects of ground firing mishaps,
and a course of "taking the easy way out" can
be discerned here, in contrast to the younger
San Ildefonso potters, who make a point of
retaining the old firing methods. In 1984 the
School of American Research at Santa Fe
awarded a grant to Josephine Nahohai, an
older Zuni potter who still digs her own clay, to
teach the old firing method at the Pueblo so
that it would not be lost.

Purchased at the Museum Shop, Millicent Rogers
Museum, Taos, New Mexico, March 1984.

281

SMALL POT WITH DEER DESIGN, 1984
Clay, paint
3½" h. x 4¾" diam. (at shoulder)

Anderson Peynetsa
Pueblo
Zuni Pueblo, New Mexico

While the making of fine pottery at Zuni
Pueblo has never died, it reached a low ebb in
the 1960s and early seventies. Now the tradi-
tional pottery is in full-scale revival, abetted by
a school program. As resident anthropologist
Margaret Hardin (now at the Los Angeles
County Museum of Natural History) put it,
"The Zuni are clever enough to know how to
use anthropologists to reinforce their culture,
which is why I'm in their school program.
They know exactly what they want to
accomplish."

Anderson Peynetsa's painted decorations
often include the "Zuni deer" with heartline
set in a cartouche, a prominent Zuni motif
since the 1870s and understood by this young
potter perhaps most successfully on small
bowls such as this one.

Purchased at the Museum Shop, Millicent Rogers
Museum, Taos, New Mexico, August 1984.

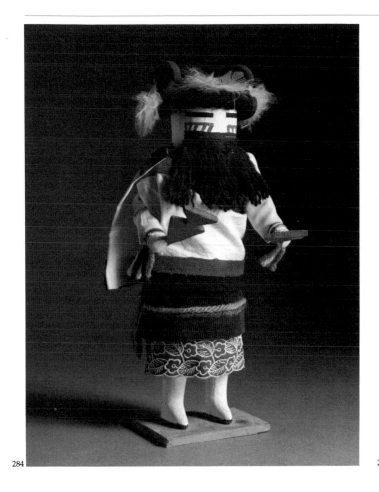

284

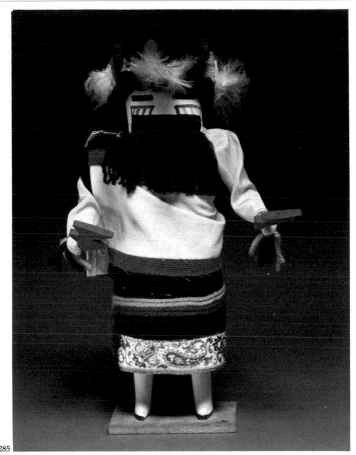

285

282

Two bracelets and ring, 1984
Silver, turquoise, green snail shell, jet, coral
Narrow bracelet 2⁷⁄₁₆" l. x ³⁄₁₆" w.
Ring ³⁄₈" w. x ¾" diam. (irregular)
Wide bracelet 2⅜" l. x 1¹⁄₁₆" w.

Roderick Kaskalla
Pueblo (Zuni Pueblo)
Resident at Nambe Pueblo, New Mexico

Twenty-nine year old Roderick Kaskalla was first taught silversmithing by his Zuni grandmother. Married to a Nambe Pueblo woman, he lives there, but returns to Zuni Pueblo for dances and to "feel at home." I was directed to him by Pearl Telachy, who runs the Nambe Trading Post along the Santa Fe–Taos highway. Rod Kaskalla was very interested in this project: "I'll make a bracelet and ring set, like the multi-panel channel piece you see on the shelf [beside the kitchen table at which he works], and I'll donate a narrow turquoise channel bracelet, since that's more traditional."

The thirty-six-panel bracelet is Roderick Kaskalla's fourth essay in this genre and shows his individual style; the narrow bracelet is very close to Zuni channel inlay work of 1920–40. "It takes a lot of filing.... The bigger pieces are the challenge. What I need is a larger, variable temperature compresser to take on bigger work."

Purchased from the maker, May 1984.

283, 284, 285, 286

Kachina (Taiawaipik Sio Angak'China),
ca. 1966–67
Cottonwood, wool, cotton, felt, paint, rayon, silk, feathers
14¾" h.
(see colorplate, p. 236)

Old woman kachina (Komokatsik),
ca. 1966–67
Cottonwood, wool, cotton, felt, paint, rayon, silk, feathers
12⅜" h.

Old woman kachina (Komokatsik),
ca. 1966–67
Cottonwood, wool, cotton, felt, paint, rayon, silk, feathers
12⅜" h.

Kachina maiden (Kokwele), ca. 1966–67
Cottonwood, wool, cotton, felt, paint, rayon, silk, feathers
11¾" h.
(see colorplate, p. 236)

Maker anonymous
Pueblo
Zuni Pueblo, New Mexico

While old and used Zuni kachina dolls do appear on the market, in the 1960s they were not usually made directly for sale to outsiders. These four dolls, which stand on bases and

were never used, languished for years in a Santa Fe shop.

The most difficult of this group to identify is the male kachina (cat. no. 283). He does not occur in Bunzel's classic study of Zuni kachinas published in 1932, but a variant appears in a recent German publication, where he is called Taiawaipik Sio Angak'China.* Catalogue numbers 284 and 285 are both the same "old woman" kachinas (Komokatsik);** catalogue number 286 represents the "kachina maiden," of which there are ten.*** It is doubtful that another such group of Zuni kachina dolls will appear on the market.

*Ruth L. Bunzel, *Zuñi Katcinas, An Analytical Study,* in U.S. Bureau of American Ethnology, Forty-seventh Annual Report..., 1929–30 (Washington, D.C.: GPO, 1932), pp. 837–1086; Horst Antes, *Kachina Figuren der Pueblo-Indianer Nordamerikas aus der Studien Sammlung Horst Antes* (Karlsruhe: Badisches Landesmuseum, 1980), p. 99, no. 190.

**Bunzel, pp. 1014–15, pl. 35 C.

***Ibid., pp. 1013-14, pls. 35 B and 37 C.

Purchased at Woodard's Indian Arts, Santa Fe, New Mexico, January 1984.

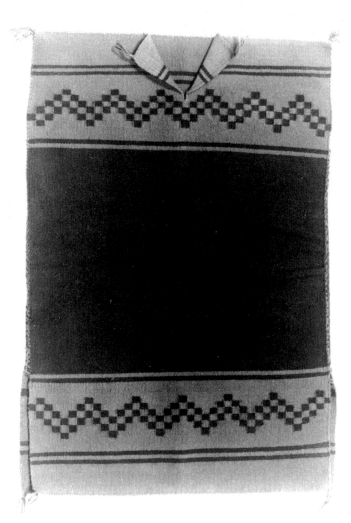

287

287

DRESS, 1979
Wool, cotton warp
39" l. x 26" w.

Mary Ruth James
Navajo
Navajo Indian Reservation, Chinle, Arizona

This is the type of dress that Navajo women fa-
vored in the period between 1860 and 1880. It
was succeeded in the 1890s by velveteen
blouses and skirts, which are still worn today.
Dresses in this style are now made as personal
gifts, or as a token of affectionate relationship.

Shirley Nez had graduated from Haskell
Indian Junior College and was pursuing grad-
uate studies at the University of Kansas in Law-
rence when the dress was brought to her in the
fall of 1981. (In 1982 she returned to teach at the
Navajo Reservation.) It had been created for her
in 1979 by her clan aunt, Mary Ruth James, who
lives at Chinle. It is made of two pieces of mate-
rial sewn together and required four large
spools of wool (dyed in red and black commer-
cial colors) to make up the necessary yarn. The
V-shaped collar is a modern touch.

"The pattern of the dress reminds me of a
checkerboard but she [Mrs. James] said she
had woven the rug dress without thinking of a
checkerboard," Miss Nez observed.

Purchased from Shirley Nez, Lawrence, Kansas, win-
ter 1981.

210

288

LARGE GANADO RUG, 1984
Handspun wool, commercial dye, bleach
9'4" l. x 15'2" w.
(see colorplate, pp. 238–39)

Mae Jim
Navajo
Navajo Indian Reservation, Ganado area,
Arizona

Two sets of individuals made possible the
inclusion of this rug, the largest and most
important Ganado-style Navajo rug woven in
the time span (1965–1985) covered by this
project. Frederick and Jan Mayer of Denver,
Colorado, offered to provide important funds
for a purchase program specifically directed to
Navajo textiles. This in turn allowed me to
work closely with Jackson and J. C. Clark of
Durango, Colorado, a father-and-son team
strategically positioned north of the Navajo
Reservation and its looms, with access to many
of the best weavers. "We have been watching
Mae Jim at work for months now on what may
well be the most important Navajo textile
we've ever handled. We're going to take some
cash down to Mae to secure our interest in it.
Do you want to come along?"

When we arrived, Mae Jim had just re-
versed her loom, constructed of heavy indus-
trial pipe, in order to wind back the half of the
rug that was completed.* Before us was an
emerging tapestry of superbly controlled
Ganado design, all the motifs of Ganado type,
continuing the Don Lorenzo Hubbell tradition:
bold red center; stars, probably derived from
Mexico; designs interspersed with gray and
white blocks; terrace and triangle devices that
indicate relationships to earlier (late-nine-
teenth-century Navajo basket) designs. As
railroads began to bring tourism to the South-
west and an appreciation of the Navajo
weavers, Hubbell, who ran the trading post at
Ganado (now a national monument) worked
out the general concept of a locally woven rug
that would compete with Oriental carpets. The
monumental power of Mae Jim's accomplish-
ment became even more apparent when the
rug was finally completed, taken down, and
exhibited at Toh-Atin Gallery, away from the
confines of the weaving shed.

Weaving and handling such a gargantuan
textile on the loom is so strenuous a task – the
rug was on the loom some eighteen months –
that only economic reward could encourage its
repetition. While very large Ganado rugs were

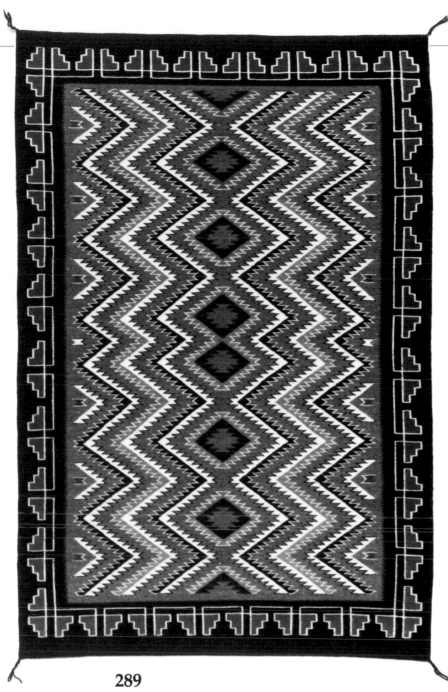

288

289

woven early in this century, actually to serve as floor coverings, today such a rug is an immediate exhibition piece. This does not mean that the work is any less Indian for being an art item.

The warps are nine per inch, and the weft weave is a tight thirty-six-thread per inch. The handspun wool is dyed red and black with commercial dyes, bleached for white, and left natural for gray. The rich red field is a typical Ganado feature. At the upper right (lower right in the illustration) there is a parting, or "spirit" line, which lets the spirit out of the rug and is also a thanks to the Spider Woman, who taught the Navajo weaving. The date is woven into the border.

When I last visited Mae Jim she was gathering wool for the next large effort, quite a task since she has only "six or seven" sheep of her own.

*For an illustration of Mae Jim at work on this rug, see *Ray Manley's The Fine Art of Navajo Weaving*, text by Steve Getzwiller (Tucson: Ray Manley Photography, 1984), p. 12.

Purchased at Toh-Atin Gallery, Durango, Colorado, April 1984.
Collection Jan and Frederick Mayer, Denver, Colorado.

PICTORIAL WEAVING, 1984
Handspun wool, natural and commercial dyes
5'1½" l. x 8'3" w.
(see colorplate, pp. 240–41)

Isabel John
Navajo
Navajo Indian Reservation, Many Farms, Arizona

The "pictorial" Navajo textile reaches its apogee in this elaborately composed and figured large-scale depiction of the last day of the nine-day Yeibichai healing ceremony (combined with a feast). It is early nightfall, for bonfires are lit. The hogan, at middle far right with smoke issuing, is the healing place. To the left of it are the dancers and leader. Cooking is going on in the background. Neighbors and friends are coming to the feast. In the center is a dance. The scene takes place not far from Canyon de Chelly, which can actually be seen from Isabel John's front door. She has added the Round Rock buttes (in the distance) for compositional balance and interest. The weaver's environment is depicted with the incisiveness of evident devotion.

Forty-four animals and some one hundred and nine human figures are rendered here. The subtle placement of the wagons and their effective compositional foreshortening and the punctuating effect of hogan domes show to advantage the discerning organizational clarity that operates in this weaver's mind, which makes her work superior to all others in the graduated control of color harmony. The work invites the scrutiny of almost microscopic inspection.

The warp is of wool, not the customary cotton, and runs ten to the inch. Weft count is thirty-six threads to the inch. The brown background color is vegetal; the salmon color (an Isabel John trademark) is lichen; the blues, other shades of brown, and orange are commercial dyes; and the white is natural bleached wool.

Isabel John, now in her fifties, has been weaving since she was eleven. She never went to school and learned to sign her name only for a silkscreen print of one of her compositions. In recent years she has won awards at the Gallup Ceremonial (the Intertribal Ceremonial held each August in Gallup, New Mexico.)

Purchased at Toh-Atin Gallery, Durango, Colorado, June 1984.
Collection Jan and Frederick Mayer, Denver, Colorado.

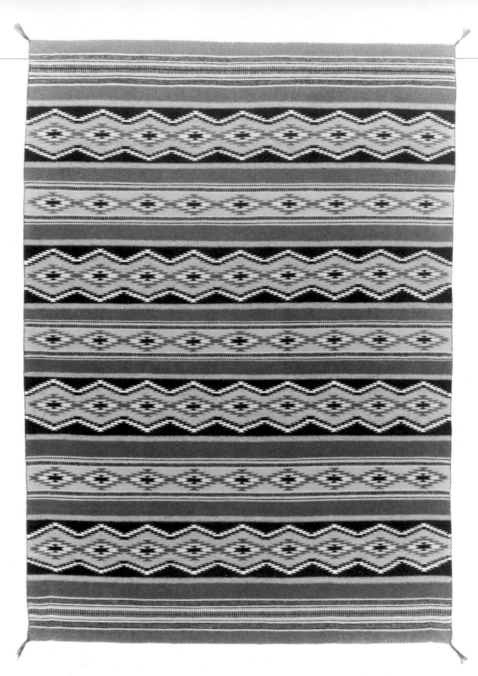

291

290

TEEC NOS POS RUG, 1983–84
Handspun wool, commercial dyes
6'2" l. x 3'11" w.

Bessie Lee
Navajo
Navajo Indian Reservation, Red Mesa Trading
Post, Arizona

This exceptional rug is distinguished by the red
accent along the borders that set off the center
field. The serrated designs are personal and
carried to an idiosyncratic extreme. Otherwise
this piece is a typical Teec Nos Pos "outline rug"
with traditional hook motifs. Though obtained
from traders, the wools are handspun; gray
wool is natural, white is bleached, and black,
tan, red, and brown wools are commercially
dyed. The warp count is ten per inch and the
weft count is thirty-eight threads per inch.

Purchased at Toh-Atin Gallery, Durango, Colorado,
June 1984.
Collection Jan and Frederick Mayer, Denver,
Colorado.

291

WIDE RUIN WEAVING, 1984
Handspun processed wool, vegetal dyes
5'1" l. x 3'7" w.

Darlene Yazzie
Navajo
Navajo Indian Reservation, Wide Ruin,
Arizona

Darlene Yazzie, who made this finely woven
textile (warp count eleven per inch, weft count
forty-four threads per inch), represents the
younger generation of weavers. In her twenties
and trained by her mother, she was weaving
full time at the Hubbell Trading Post at
Ganado, where her boredom was evident. This
may have been due to the routine weaving in
wools that are supposed to look like soft vege-
tal-dyed materials, but which are actually
chemically dyed, thus diluting the original
intent.

Purchased at Toh-Atin Gallery, Durango, Colorado,
June 1984.
Collection Jan and Frederick Mayer, Denver,
Colorado.

292

YEI TEXTILE, 1984
Wool, natural and commercial dyes
5'7¾" l. x 3'5" w.

Mary Nez Jim
Navajo
Navajo Indian Reservation, Shonto, Arizona

There are Navajo weavers who weave all the
time, such as Mae Jim (cat. no. 288) and Isabel
John (cat. no. 289), and homemaker weavers,
such as Darlene Yazzie (cat. no. 291). Then
there are the many occasional weavers,* the
majority by far, whose work is sporadic and
less consistently good, and who may or may
not be on the way to greatness, as is Mary Nez
Jim. This is one of Mrs. Jim's first weavings,
her fourth or fifth according to her son, who
brought it to Santa Fe for sale. The Shonto area
is not known for weaving at all, and this textile
in fact preserves a sort of archaic directness,
evident in the heavy use of local natural wools,

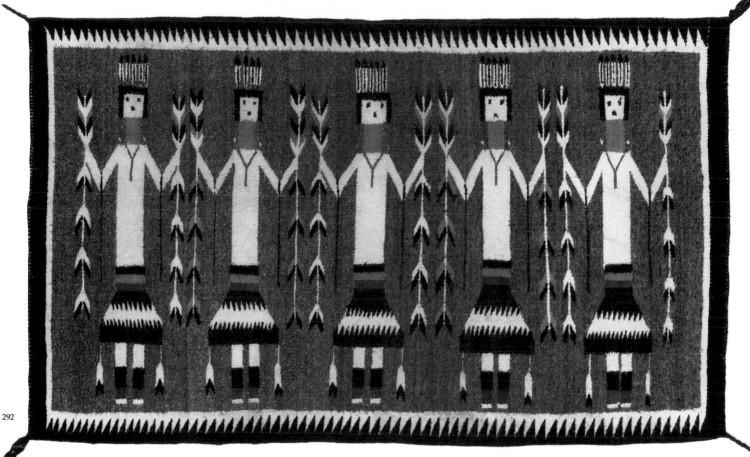

292

the shaggy almost uncarded textures, and the restrained use of dyes. It may well be the beginning of a local trend.

Yeis are secondary Navajo deities, and their inclusion in weaving, outside the context of sand painting, once (about 1915) caused a great deal of trouble. But by the 1930s they were woven in some quantity, and now they are ubiquitous. This particular Yei comes fresh from Navajo hands; there is a vertical "spirit" line (see cat. no. 288) at the inner border at the upper right.

*A classification outlined by Anne Hedland, curator of the Millicent Rogers Museum, Taos, New Mexico.

Purchased from the maker through her son Albert Jim, Santa Fe, New Mexico, May 1984.
Collection Jan and Frederick Mayer, Denver, Colorado.

293

RUG, ca. 1968–70
Wool
42¾" l. x 47½" w.

Maker unknown
Navajo
Navajo Indian Reservation, Fort Defiance area, Arizona

This rug serves as proof that such items are used by Navajo families at home. "There is no way of knowing who made the rug, or where it is originally from," Marge Richardson, a member of the trading family, answered my inquiry. "It's just an all-purpose rug. It's not really a saddle blanket because of its size and because of the quality of the weave, which is too good."

The striped effect at center recalls chiefs' blankets of the past, while the checkerboard pattern of blue, red, and natural color wool goes back to the 1880s, making the combination highly retrospective. Many textiles of this type are used outside the Navajo world as decorative objects, but until it was pawned, this one remained within the culture. Its simpler nature tells what the people can afford to keep with them.

Brought into Richardson Trading Co. & Cash Pawn, Gallup, New Mexico, by Marie Cleveland; bought out of pawn, April 1984.

294

BRACELET, 1983
Turquoise, silver
3½" l. x 2⅛" w.
(see colorplate, p. 243)

Howard Nelson
Navajo (Navajo Indian Reservation)
Resident at Winslow, Arizona

So productive are Navajo silversmiths today that the plethora of work challenges any process of selection. The criteria used for this project were restricted to those bracelets and other objects that harked back to precedence and to a style used earlier in the century, or even earlier. Were the old guidelines still respected? Perusal of the Gallup, New Mexico, jewelry emporiums revealed evidence of a recent revival of the elaborately stamped silver bracelets encouraged by the Fred Harvey & Co. for trade in the 1920s. Originally fitted with small square-cut stones, especially popular in the 1930s, they are now made of heavier silver,

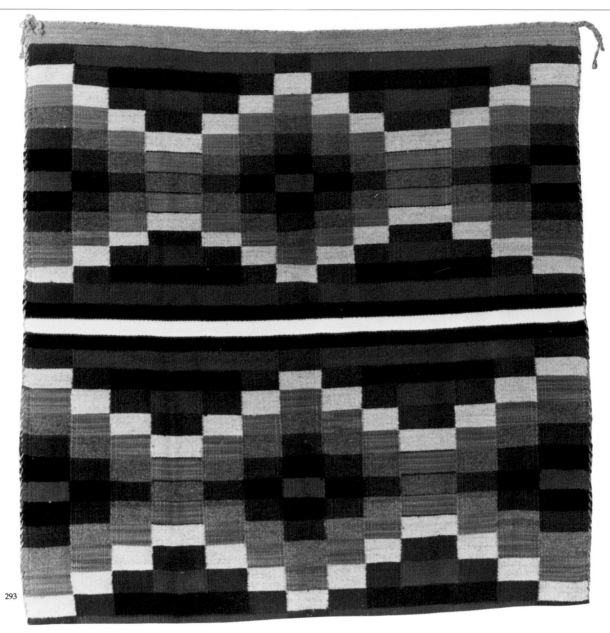

293

295, 296, 297

giving a massive effect that is unmistakably contemporary (see cat. no. 295).

Also found are continuations of the ubiquitous nugget bracelet of the 1930-50 period, a "textbook example" of which is this finely executed bracelet by Howard Nelson, which recalls the wire-set, strongly designed turquoise bracelets now old enough to be extensively pawned by today's Navajo people. In the contemporary bracelets, turquoise roundels are polished rather than left in the rough, and the thicker silver settings compete with the stones for attention. The silver balls in this bracelet (fourteen, a larger number than used formerly) are called "hogans" (smaller ones are called "tears"), and the striated edging elements indicate "rain." The rough-stoned, older pieces with their simple settings and direct effect are not to be surpassed, but in terms of craftsmanship and care of design and presentation, the best contemporary bracelets are of an elaboration that is powerful yet controlled.

Purchased at Tobe Turpen's Indian Trading Co., Gallup, New Mexico, February 1984.

TURQUOISE BRACELET, 1983
Silver, Manzano turquoise
2½" l. x 2" w.
(see colorplate, p. 243)

TURQUOISE BRACELET, 1983–84
Silver, treated turquoise
3" l. x 2¼" w.
(see colorplate, p. 243)

TURQUOISE BRACELET, 1983–84
Silver, spider web no. 8 turquoise
2⅝" l. x 2¼" w.
(see colorplate, p. 243)

Herman Charlie
Navajo (Navajo Indian Reservation)
Resident at Church Rock, New Mexico

According to his daughter, Herman Charlie is known among the Navajo as "an old-time silversmith." His work is bold in style, and it is

the massive bezels and heavy silver band that separate this new bracelet of Manzano turquoise (cat. no. 295) from the stamped ones fostered by Fred Harvey & Co. for the tourist trade in the 1920s and thirties. This is a deliberate continuation on the part of the artist, achieved with great succinctness of design. The bracelet of spider web number 8 turquoise (cat. no. 297) utilizes old-style high bezels. A mixture of metals was melted to make the bracelet of treated turquoise (cat. no. 296), which is cast with old-time punched designs.

While some younger silversmiths are making 1930s-style revival jewelry, Herman Charlie, now nearing seventy years of age (fig. 36), is simply continuing in the tradition in which he learned.

Catalogue number 295 purchased at Richardson Trading Co. & Cash Pawn, Gallup, New Mexico, February 1984.
Catalogue number 296 purchased from the maker, September 1984.
Private collection.
Catalogue number 297 purchased at Richardson Trading Co. & Cash Pawn, Gallup, New Mexico, September 1984.
Private collection.

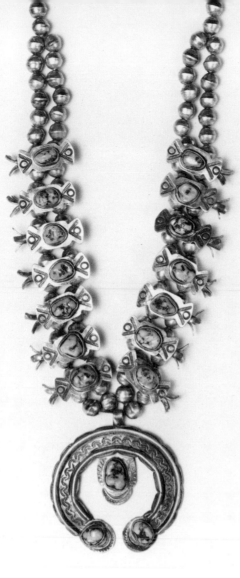

298

300

298

SQUASH BLOSSOM NECKLACE WITH NAJA,
1983–84
Silver, treated turquoise, nylon cord
12" l.; naja 2½" w.

Herman Charlie
Navajo (Navajo Indian Reservation)
Resident at Church Rock, New Mexico

Of all the silversmiths encountered in the
Navajo region, Herman Charlie best exempli-
fies an unreconstructed artisan of the 1930s
(see cat. nos. 295–297). This squash blossom
necklace is done in the rococo "box-and-bow"
style favored during those years. The squash
blossoms are almost obscured by the promi-
nence of the turquoise-set "boxes." The naja
(horseshoe-shaped pendant) is not cast but
elaborately constructed from sheet silver in the
old way.

Purchased from the maker, November 1984.
Private collection.

299

SQUASH BLOSSOM NECKLACE WITH NAJA,
1982
Silver, Bisbee turquoise
16½" l.; naja 2½" w.
(see colorplate, p. 243)

Russell Rockbridge
Navajo
Navajo Indian Reservation, Pinon, Arizona

This necklace is representative of the very
finest Navajo silver work done today. While this
simplicity harks back to earliest type of Navajo
silver necklaces (1880s), the conscious refine-
ment of craftsmanship is a praiseworthy
modern touch. The silver beads are smooth
rather than champfered at the half-joints,
another sign of care for the old ways. The
single Bisbee turquoise (derived from the
Arizona mine that closed in the 1940s) set into
the naja (horseshoe-shaped pendant) harks
back to the first tentative use of turquoise
embellishment for this type of necklace. The
exquisitely proportioned squash blossoms re-
late superbly to the whole composition. All
stages of tradition and innovation are met with
today in Navajo silverwork, but rarely does one
encounter such purity of aesthetic concept.

Purchased through Packard's Trading Post, Santa Fe,
New Mexico, Spring 1984.
Private collection.

300

PAIR OF EARRINGS, 1983
Silver, silver wire
1" l. (excluding wire suspension)

Maker unknown
Navajo
New Mexico or Arizona

These highly traditional Navajo earrings are
patterned after the individual "squash blos-
soms" of a squash blossom necklace. Such
earrings – they were the "original" Navajo
earrings – were common at the turn of the cen-
tury but were not as well crafted as this new
pair, in which the stamped designs vary on
each earring. Today the repertory of Navajo
earrings is much enlarged.

Purchased at the Case Trading Post, The Wheelwright
Museum of the American Indian, Santa Fe, New
Mexico, January 1984.

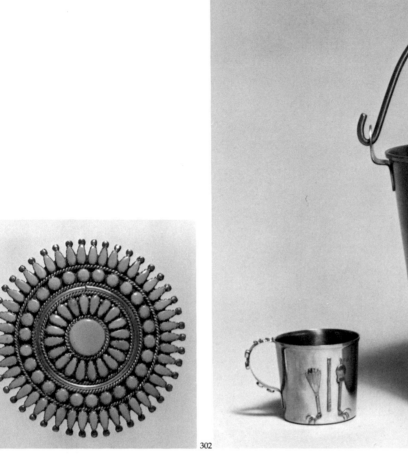

301

302

301

BROOCH OR PENDANT, 1983
Turquoise and silver
4″ diam.

Victor Begay
Navajo
Navajo Indian Reservation, Lukachukai,
Arizona

One of the factors that will confuse future
scholars who study contemporary Southwest-
ern jewelry is the migration of styles: Navajo
silversmiths now make bracelets in Hopi
overlay style, even in Pueblo styles, and use
various Zuni techniques. This well-executed
cluster-style brooch (or pendant) might well be
considered as Zuni work were it not made with
the heavier touch of the Navajo silversmith
(Zuni work tends to be more delicate in scale
and execution). It is an excellent piece of work,
but adaptational and evidence of the cross-cul-
tural exchanges that have come about through
quicker means of travel, Pan-Indian events,
and trading opportunities.

Purchased at J. B. Tanner Trading Co., Albuquerque,
New Mexico, January 1984.

302

WATER BUCKET AND CUP, 1984
Stainless steel bucket and cup, turquoise,
brass, paint, silver, silver solder
Bucket 9⅝″ h. (excluding handle) x 11½″ diam.
Cup 3″ h. x 4¼″ diam. (including handle)

Harold Thompson
Navajo
Navajo Indian Reservation, Lukachukai,
Arizona

In the 1960s in Oklahoma, the water buckets
used for peyote tea in the peyote religion of the
Native American Church began to be painted
with scenes and symbols like those in the
peyote kits (see cat. nos. 140 and 209). In
Navajo country about 1970, the jewelry-mak-
ing tradition was adapted to decorating the
water buckets and is in full flower today, an

excellent example of the expansion of tradition
in our times.

This prized stainless steel jeweled trade
bucket with cup was made to the order of Rita
Williams, who now has another bucket. The
fifty droplets of turquoise surrounding the
medallion represent the fifty states. On the
medallion itself are the four sacred mountains
of the Navajo. Raised fan, rattle, and tepee
designs are on the other side of the bucket and
on the cup. Buckets are often given as Father's
Day presents to the road man or water man,
celebrants of the peyote meetings.

Harold Thompson is a full-blood Návajo
"about 40 years old." This set comes from a
dealer who specializes in supplying peyote-
religion pieces to the Navajo coming into
Gallup.

Purchased at Ferrari Keepsake, Gallup, New Mexico,
August 1984.

304

303

303

Horse-drawn cart (mud toy), 1983
Mud, cloth, paste, wool, suede, paint, wool
string
4¾" h. x 8¾" l. x 4" d.

Mamie Deschilles
Navajo
Navajo Indian Reservation, Fruitland, New
Mexico

Sheepherding Navajo women used to take
time off to fashion playthings from the clay
banks and materials on the range. These toys
were very little known to the outside world.
Since they were made of ephemeral materials,
these Navajo "mud" toys – unlike Navajo dolls
– did not last. Now five or six Navajo women
are making toys again, but they are also a
genuine journey into nostalgia. Mrs. Deschillie
began making toys in 1981. "She started with
cardboard horses and riders and wagons, past-
ing sheep wool down, and fashioning details
with the materials at hand. In one early wagon
set, she used faces cut from catalogs embel-
lished with a pen for the human figures and a
plastic fruit container for the wagon body."*

In olden times (in fact, until about 1960)
wagons were common in the Navajo world.
Now the pickup truck and van have all but
replaced them.

Daily Times (Farmington, N. Mex.), February 20,
1983.

Purchased at the Case Trading Post, The Wheelright
Museum of the American Indian, Santa Fe, New
Mexico, December 1983.

304

Pot, 1983
Clay, slip
7" h. x 9½" diam. (at shoulder)

Nathan Begay
Hopi/Navajo (Navajo Indian Reservation, Tuba
City, Arizona)
Resident at Santa Fe, New Mexico

Nathan Begay, a student at the Institute of
American Indian Arts at Santa Fe, is already an
accomplished potter, with a deeply spiritual at-
titude toward all aspects of pottery making.
"It's the Hopi [Moenkopi] side of my ancestry
that does the pottery," he says. His work varies
in its sources. Prehistoric fine line work from
the Kayenta tradition is apparent in this slope-
shouldered pot with flaring lip, together with
two delicate areas of red fill. There is a tautness
to the design and a high polish that betokens
the exactitude of his style.

The shapes of his pots vary greatly. Some
of his pots are figural; some are elaborately

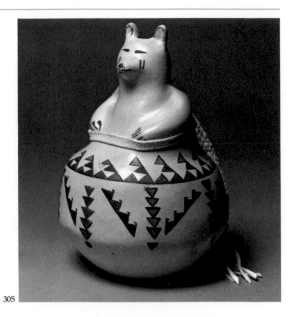

305

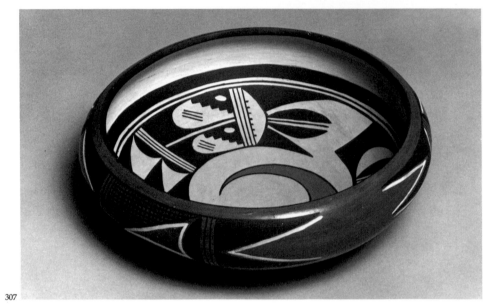

307

305

BEAR EFFIGY POT, 1983
Clay, paint
7⅛" h. x 4¾" diam.

Lolita Begay
Hopi/Navajo
Navajo Indian Reservation, Tuba City, Arizona

Lolita Begay, sister (in white reckoning, actually niece) of Hopi/Navajo potter Nathan Begay (cat. no. 304), was twelve years old when she fashioned this charming white-slipped ceramic bear under the watchful eye of her brother. He made the carrying strap. "This is the way we set the example for younger people, bringing them right along with us. I want her to know her pot is in this show."

Purchased from the maker through Nathan Begay, Santa Fe, New Mexico, January 1984.

306

SIFTER BASKET, 1979
Yucca fiber
3" h. x 19⅜" diam. (irregular)

Mrs. Victor Coochwytewa
Hopi
Hopi Indian Reservation, Shongopovi, Arizona

This characteristic Hopi yucca tray basket was found adorning one of the whitewashed walls of the house of Victor Coochwytewa, during the annual Bean Dance in April 1980 on the Second Mesa at the Hopi Reservation. Victor Coochwytewa, one of the best Hopi silversmiths, is famous for his overlay jewelry. When it was suggested that the basket become part of

painted, others sparsely embellished, all according to the solution desired. They are individually decorated with cool, breathtakingly precise drawing. All are thought out with great care over time. He uses the old dungground technique of firing (figs. 24 and 25) and does not fire his pots unless weather and spiritual feel are exactly right. They are prayed over so that they do not crack in the firing and so that a good pot will result.

Purchased from the maker, April 1984.

306

307

308, 309, 310

this project, Mrs. Coochwytewa was astonished. "I made that for my husband. It's his... but if you want it you can have it...."

The fineness of the pattern weave made this tray a desirable acquisition. It had been kept out of the bright mesa light, which preserved the greenness of the fiber (drab, faded old baskets are much more familiar). The double pattern is achieved by reversing the fibers, which are white on one side.

While we were waiting on the Coochwytewa's porch, located at the far end of the plaza, for the Bean Dance festivities to begin, a pair of masked Dawn kachinas holding pine bows appeared from nowhere; they stayed for several minutes, hymning in reedy voices, then suddenly turned the corner and were gone.

Purchased from the maker, April 1980.

BOWL, 1983
Clay, slip, paint
3" h. x 9½" diam.

Marcia Rickey (Flying Ant)
Hopi
Hopi Indian Reservation, First Mesa, Polacca, Arizona

Though it has her own vigorous feeling for design and direct feeling for clay, Marcia Rickey's shallow bowl is typical of the ware made by Hopi potters in the early part of the century. Like Crucita Melchor, her Rio Grande Valley counterpart in this exhibition (cat. nos. 259 and 260), Mrs. Rickey represents the solid and comfortable continuance of the Hopi style, not the virtuoso height reached by such Hopi potters as Dextra Quotskuyva Nampeyo or Rhondina Huma. Mrs. Rickey retains a conservative matte paint surface, and the painting on the sides of the bowl are influenced by familiarity with prehistoric Saint Johns polychrome pottery, a White Mountain, Arizona, red ware that was once (1175–1300) widely distributed through the Southwest.

Purchased from Letta Wofford, Santa Fe, New Mexico, April 1984.

SIO HEMIS TABLITA (ZUNI JEMEZ KACHINA), ca. 1970–75
Wood, acrylic paint, string, feather, cornhusk rings
18" h. x 14" w.
(see colorplate, p. 245)

Maker unknown
Hopi
Hopi Indian Reservation, Second Mesa, Arizona

SIO POLI HEMIS TABLITA (ZUNI BUTTERFLY JEMEZ KACHINA), 1980
Wood, acrylic paint, string, feathers, cornhusk rings
18⅛" h. x 14³⁄₁₆" w.
(see colorplate, p. 244)

Maker unknown
Hopi
Hopi Indian Reservation, First Mesa, Arizona

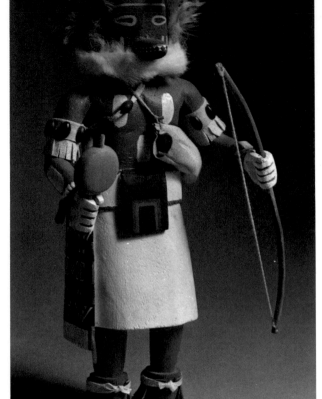

311

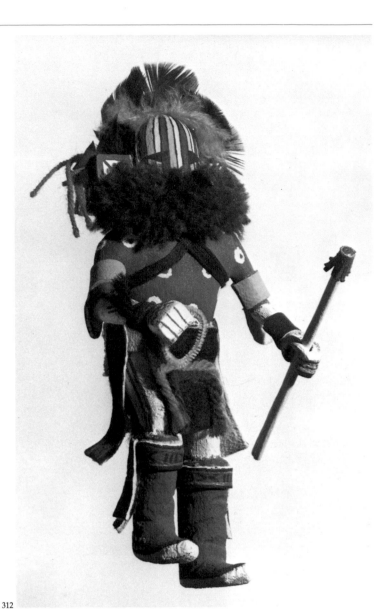

312

POLIK MANA TABLITA (BUTTERFLY KACHINA MAIDEN), 1981
Wood, acrylic paint, feathers, cornhusk rings
18½" h. x 16⅜" w.
(see colorplate, p. 244)

Maker unknown
Hopi
Hopi Indian Reservation, Third Mesa,
Hotevilla, Arizona

If any area of contemporary Hopi sculpture – one might even say Southwestern sculpture – has been underrated it is the world of Hopi dance tablitas. They are considered to be less personable than the kachina carvings (cat. nos. 311–317) and dull in comparison with the masks (which have not been included in this project in deference to Hopi religious values). Perhaps their status outside the culture has been indirectly affected by the fact that they are women's pieces and not three-dimensional kachina personifications, whose roles are generally assumed by men.

In actuality, tablitas (which are worn on the head) are magnificent structures, *retablo-*like, perambulating shrines, as it were, and capable of endless rearrangement and elaboration of kachina features. At this very moment the tablita is undergoing extraordinary development at Hopi. In the 1940s, they were painted on a flat surface in illusionary style. Since the 1950s they have become increasingly three-dimensional. Now there are raised elements, as seen here, to give the vitality of increased dimensionality. Two of the examples shown here have projecting mask features: the earliest (cat. no. 308) is in low relief; in the most recent (cat. no. 310), high relief is the culmination of dynamic aesthetic variety. Catalogue number 309 has a miniature Rugan (corn) kachina doll set under an open, rainbow-adorned arch, somewhat like a saint's figure in the niche of a Spanish altar. Painted on the fronts of catalogue numbers 309 and 310 are blossoms; catalogue 309 is decorated with corn and, in the lower portions, butterflies; bean sprouts are at the bottom corners of catalogue number 308 and reproduction symbols are on the "cheeks" of its mask. Cloud symbols and terraces surmount all three tablitas.

Unlike Hopi kachina dolls, tablitas are not carved for sale. They are usually carved for the girls by either their boyfriends or uncles. After the dances (particularly Powamu) are over, the girls continue to own their tablitas and can sell them. However, new tablitas that have been used, like these three, are increasingly hard to obtain. "It's hard to find tablitas now," said the Albuquerque trader from whom catalogue numbers 309 and 310 were obtained. "Those two are all I've had in a long time. You can get older ones more easily." This view was confirmed by another dealer, "I don't know why, but the Hopi are keeping them now."

Catalogue number 308 purchased from trader Mike Bradford, Cottonwood, Arizona, February 1984. Catalogue numbers 309 and 310 purchased at the Adobe Gallery, Albuquerque, New Mexico, February 1984.

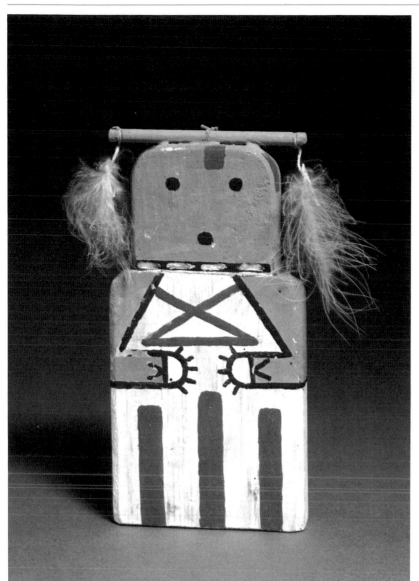

313

311

BADGER KACHINA, 1983
Cottonwood, acrylic paint, beads, string,
feathers, cotton, Indian-tanned buckskin
11½" h.

David Kootswytewa
Hopi
Hopi Indian Reservation, Second Mesa,
Shongopovi, Arizona

This badger kachina* is exceptionally well
carved, with refinement of detail down to the
thin Indian-tanned shoulder bag and upper
arm fringes. The bag even contains actual corn.
This is perhaps the most elegantly carved
kachina collected for this project. Though pro-
vided with hanging string for suspension in
Hopi homes, this badger was evidently never
used.

*Harold S. Colton, *Hopi Kachina Dolls with a Key to
Their Identification* (Albuquerque: University of New
Mexico Press, 1959), no. 89.

Purchased at J. B. Tanner Trading Co., Albuquerque,
New Mexico, December 1983.

312

FLOWER KACHINA, ca. 1975
Cottonwood, acrylic paint, cloth, wool, feath-
ers, pipe cleaner
7⅛" h.

Maker unknown
Hopi
Hopi Indian Reservation, Second Mesa,
Shongopovi, Arizona

According to the trader from whom it was ob-
tained, this small doll representing the flower
kachina* was collected at Shongopovi, Second
Mesa. It had been used before being sold.

*Harold S. Colton, *Hopi Kachina Dolls with a Key to
Their Identification* (Albuquerque: University of New
Mexico Press, 1959), no. 45.

Purchased at Four Winds Traders, Flagstaff, Arizona,
February 1984.

313

AHOTE KACHINA, ca. 1975
Cottonwood, paint, down
7" h.

Maker unknown
Hopi
Hopi Indian Reservation, Arizona

This child's Ahote kachina* remained in a Hopi
household long enough to have acquired
flyspecks on its back. Such figures are used as
playthings and cradle ornaments. Their
frontality, simply painted bar motifs, and
elemental dot eyes and mouth go back to some
of the oldest prehistoric forms of kachina
sculpture known so far. The bars alone remind
one forcibly of kachina sculpture of the proto-
kachinas of about A.D. 1190 found at Vernon,
Arizona (now in the Field Museum of Natural
History, Chicago).

*Harold S. Colton, *Hopi Kachina Dolls with a Key to
Their Identification* (Albuquerque: University of New
Mexico Press, 1959), no. 104.

Purchased from trader Mike Bradford, Cottonwood,
Arizona, February 1984.

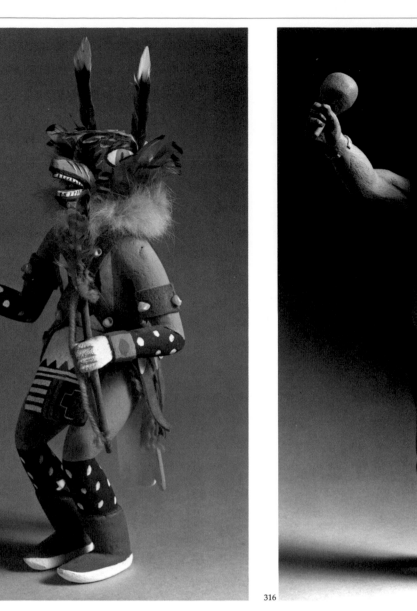

314

316

314

WOLF KACHINA, ca. 1979
Cottonwood, acrylic paint, shells, fur, wool
ties, leather
9¾" h.

Maker unknown
Hopi
Hopi Indian Reservation, First Mesa, Polacca,
Arizona

This doll represents the wolf kachina.* It is fur-
nished with a string for hanging from a rafter
or on a wall and has been used.

*Harold S. Colton, *Hopi Kachina Dolls with a Key to
Their Identification* (Albuquerque: University of New
Mexico Press, 1959), no. 86.

Purchased from trader Mike Bradford, Cottonwood,
Arizona, February 1984.

315

SHALAKO KACHINA, 1978–80
Cottonwood, acrylic paint, feathers
10⅛" h.
(see colorplate, p. 246)

Maker unknown
Hopi
Hopi Indian Reservation, Third Mesa, Oraibi,
Arizona (?)

A compact Hopi variant of the Zuni Shalako
kachina (a ten-foot-high being who opens the
Zuni ceremonial calendar in December) which
it does not resemble, this used kachina* still
has its hanging string. According to the trader
from whom it was acquired, it comes from old
Oraibi.

*Harold S. Colton, *Hopi Kachina Dolls with a Key to
Their Identification* (Albuquerque: University of New
Mexico Press, 1959), no. 117.

Purchased from trader Mike Bradford, Cottonwood,
Arizona, February 1984.

316

MUDHEAD KACHINA, 1968
Cottonwood, paint, feathers
14½" h.

Henry Shelton
Hopi (Hopi Indian Reservation, Third Mesa,
Oraibi, Arizona)
Resident at Flagstaff, Arizona

This Mudhead kachina* is the only doll
included here which was carved for competi-
tive judging at the Gallup Intertribal Indian
Ceremonial of 1968. The judge in this case was
Barton Wright, perhaps the foremost contem-
porary scholar on kachinas. It gained second
prize and still retains its ribbon. Except for the
head feathers, all features of this kachina are
hand carved, including kilt, boots, socks,

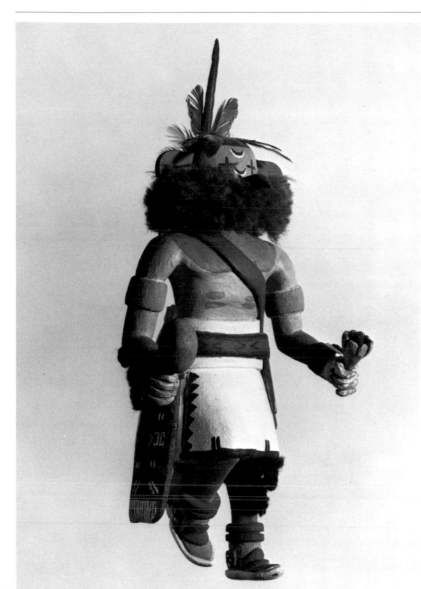

317

protruding neckerchief, and ketoh (wrist guard), amounting to a technical tour de force. The strident posture also seems to say "I am a carving, and then a kachina." From the connoisseurship point of view, this very fine object stands favorably in comparison with Late Renaissance and Baroque small sculptures in boxwood or pearwood.

Henry Shelton's carving talent was discovered while he was serving as a janitor/preparator at the Museum of Northern Arizona in Flagstaff. His carving goes beyond clownlike jocularity and reaches a stately sobriety, incorporating the duality of the Southwestern clown: the trickster who, as part of us, is present even at serious moments.

*Harold S. Colton, *Hopi Kachina Dolls with a Key to Their Identification* (Albuquerque: University of New Mexico Press, 1959), no. 59.
Purchased at the Adobe Gallery, Albuquerque, New Mexico, February 1984.

317

ROADRUNNER KACHINA, 1981
Cottonwood, acrylic paint, feathers, wool
10⅛" h. (including feather)

Maker unknown
Hopi
Hopi Indian Reservation, First Mesa, Arizona

One of the advantages of recently made kachinas is that in most cases the accoutrements – corn, rattles, flutes, moisture tablets – are often still intact; older dolls tend to lose these features. This recent Roadrunner kachina* lacks the flute and the moisture (rain making) tablet, cited as standard equipment for this kachina. Nonetheless, it appears to be complete, underscoring that, aside from basics that are always adhered to, the dolls are subject to more variation in detail than ethnological strictness sometimes allows.

*Harold S. Colton, *Hopi Kachina Dolls with a Key to Their Identification* (Albuquerque: University of New Mexico Press, 1959), no. 207. Fewkes reported that the moisture tablet was a painted skin stretched over a framework attached to the back; see Jesse Walter Fewkes, *Hopi Katcinas Drawn by Native Artists*, in U.S. Bureau of American Ethnology, Twenty-first Annual Report..., 1899–1900 (Washington, D.C.: GPO, 1903), p. 80, commentary to plate XVIII.

Purchased at Shop of the Rainbow Man, Santa Fe, New Mexico, April 1984.

318

Bow, ca. 1976
Cottonwood, leather, cloth, string, pine branches
22¹³⁄₁₆" l.

Maker unknown
Hopi
Hopi Indian Reservation, Second Mesa, Mishongnovi, Arizona (?)

This ceremonial bow was danced by a left-handed kachina. The pine branches are a symbol of life. It was obtained at Mishongnovi according to the trader from whom it was acquired.

Purchased from trader Mike Bradford, Cottonwood, Arizona, February 1984.

318

319

320

319

DANCE SPEAR, ca. 1978
Cottonwood, paint
24⅛" l.

Maker unknown
Hopi
Place of origin unknown

This dance spear serves as a lightning symbol in kachina dancing. It has been used. The trader who acquired it as part of an exchange with some Hopi explained: "I can't remember now where it came from; you know you deal up and down all over the place, visit any number of people in a day. Besides, where it comes from doesn't indicate where it was made."

Purchased from trader Mike Bradford, Cottonwood, Arizona, February 1984.

320

RATTLE, ca. 1976
Cottonwood, gourd, paint
9¾" h. x 4⅞" diam.

Maker unknown
Hopi
Hopi Indian Reservation, Third Mesa, Oraibi, Arizona

This is a particularly traditional and common Hopi rattle, usually given to children, with a sun symbol painted on both sides surrounding four directional crosses. It has seen quite a bit of use. This type of rattle is incorporated into the head of the rattle kachina.

Purchased from trader Mike Bradford, Cottonwood, Arizona, February 1984.

321

LARGE BASKET, 1980
Willow, devil's claw
6¾" h. x 24" diam.

Lucy Jones
Pima
Gila River Indian Reservation, Arizona

"This is by one of our best basket makers," said Harriet Manual of the Gila River Arts & Crafts cooperative as, somewhat reluctantly, she had this masterpiece of basketry taken down from the wall of her shop. Fifty-four coils span this centripetal design in which an army of beetles leave the center to advance out of their confines at a three-hundred-sixty-degree march. It is an implacable, complex statement. This design has its origins in Colorado desert basketry and is a heretofore borrowed element in Pima-Papago work. Like the contemporary and

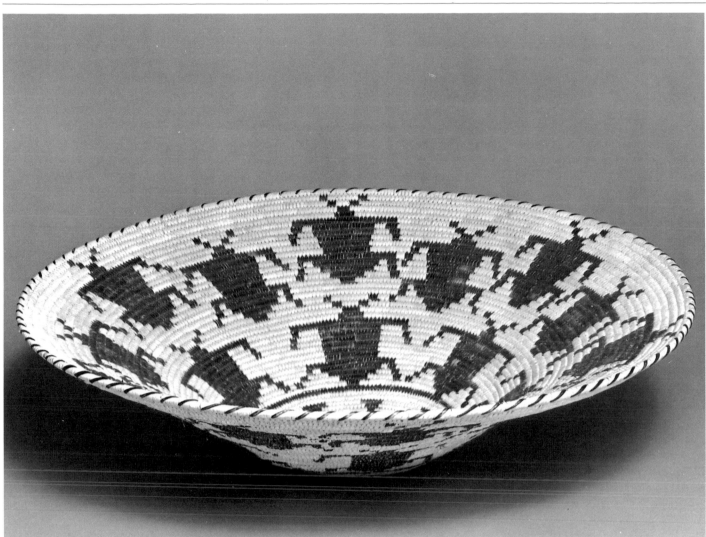

321

322

323

inventive southern Paiute basket weavers who combine other Arizona Indian basket design sources in perfect stride in their work (see cat. no. 333), Lucy Jones also shows here how designs from the work of a neighboring tribe are adapted to innovative use and become a refreshing element. This is a precise example of cultural interchange and growth, which must have functioned in the past.

At the Colorado River Tribes Reservation complaints were voiced about this very basket. "Do you know that big basket hanging up there at Casa Grande?" asked Chemehuevi master basket maker Mary Lou Brown at Parker, Arizona. "Those are our beetles, not theirs. They took them from us.... They are warriors going out into battle."

Purchased at Gila River Arts & Crafts, Sacaton, Arizona, February 1984.

AWL, 1970–75
Mesquite wood, metal pin
6¼" l.

Frank Mendez
Papago
Papago Indian Reservation, Sells, Arizona

The overhand twist of the Papago basket makers are perfectly expressed by the "swollen bottle cork" grip of the mesquite handle of this tool. Often such modest objects as this awl lend an insight into the conservation of Indian techniques in a way that the finished work they address cannot. This was found at a shop operated for Indians by John and Gladys Townsend, Quechan Indians from Fort Yuma, Arizona.

Purchased at Four Feathers Indian Arts, Poston, Arizona, February 1984.

TALL VASE, 1980
Clay, paint
16" h. x 8⅜" diam. (at shoulder)

Barbara Johnson
Maricopa
Gila River Indian Reservation, Arizona

Though originally a California desert tribe, the Maricopa were removed during the 1880s to Pima-Papago territory. Their reddish pottery has a parched desert feel about it, rather gourdlike. In fact, this tall water container reminds one of the shape on the Quechan rattle on view here (cat. no. 329). There is also a Mexican Indian flavor, elusive, yet hinted at by the animated designs and hot red color.

Purchased at Gila River Arts & Crafts, Sacaton, Arizona, February 1984.

324

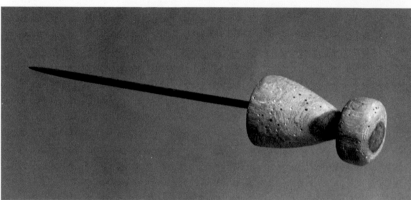

322

323

324

TWO BELTS, 1984
Beads, dental floss
left 22″ l. x 1¾″ w.
right 24″ l. x 1¾″ w.

Delano Carter
Mohave
Colorado River Indian Reservation, Parker,
Arizona

So much attention has been paid to Plains
beadwork that the very beautiful beadwork of
the desert tribes has been neglected, perhaps
because the repertory is more limited and
understated. Nonetheless, the "color liber-
ation" of recent years enable such loom
beaders as Delano Carter to compete with
strengthened design, as the two forceful
variants on the same motif in these belts attest.

Purchased at Colorado River Indian Tribes Library
and Museum, Parker, Arizona, March 1984.

325

PURSE, 1983–84
Beads
8½″ h. (including handle and fringe) x 3″ w.

Rebecca Knox
Mohave
Colorado River Indian Reservation, Parker,
Arizona

Such purses have been made, mostly for sale,
by the Mohave since the 1890s with very little
change. Coins were wrapped in a light-silk
handkerchief and inserted into the pouch.

Purchased at Colorado River Indian Tribes Library
and Museum, Parker, Arizona, March 1984.

326

PAIR OF HAIR ORNAMENTS, ca. 1980
Mesquite wood, wool yarn
each 10½″ h.

Maker unknown
Mohave
Colorado River Indian Reservation, Arizona

In Indian homes of the Southwest, one sees
over and again a yarn-wrapped concentric dia-
mond-shaped decoration called "God's Eyes."
Whatever its origin in Mexico (Huichol), God's
Eyes are now a ubiquitous part of modern
Southwestern Indian decor. The yarn device is
used similarly to enframe Pueblo decorative
panels showing kachina and eagle dancers.
There is a general connotation in the God's
Eyes of spirits watching, which seems to be a
part of the diamond motifs on Mohave-
Quechan capes (cat. no. 330) and on these or-
naments, about which the only information
forthcoming was that "they are used in the hair
at dances."

Purchased at Four Feathers Indian Arts, Poston,
Arizona, March 1984.

325

326

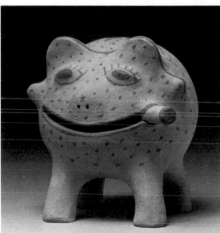

327

327

POTTERY FROG, 1975
Clay, paint
4¾" h. x 6" l.

Elmer Gates
Mohave
Colorado River Indian Reservation, Parker, Arizona

Mohave ceramic frogs represent a "fire brand" and are part of tribal legend: a frog, carrying with him a glowing piece of charcoal (here translated as a cigarette), swam across the Colorado River to give the tribe fire. Despite the element of playfulness, no joke is intended. It is more a modern-day projection of Mohave dreams and legends. Cigarette smoking was brought into the desert area from Mexico before it was common in the East and is part of long Mohave experience. The shape of the frog's body is in the best organic Mohave tradition and the drawing that embellishes it is well controlled.

Elmer Gates is one of the few Mohave potters working today; he is certainly the best. He works in a studio improvised in an old World War II building complex on the Colorado River Indian Reservation. His clay figures go back directly to the figurines the Mohave and Yuma (Quechan) Indians have made for sale since the 1880s. The pop-eyed style is peculiar to the artist, allowing his work to be easily recognizable.

Purchased at Four Feathers Indian Arts, Poston, Arizona, March 1984.

328

PAIR OF FIGURINES, ca. 1970–72
Clay, hair, beads, paint
Male 9⅝" h.
Female 9½" h.

Elmer Gates
Mohave
Colorado River Indian Reservation, Parker, Arizona

Both Mohave and Yuma (Quechan) desert potters began making charming ceramic standing figurines for sale in the late nineteenth century. The tradition is most notably carried on today by Elmer Gates. An attempt to order new figurines from him failed, but this pair, which he made about fifteen years ago, were found in Taos. The woman wears a miniature version of the type of beaded net cape seen full size here (cat. no. 330), though of course the old Rancheria style of dress retained here has long been discontinued.

Purchased at El Rincon, Taos, New Mexico, 1985. Private collection.

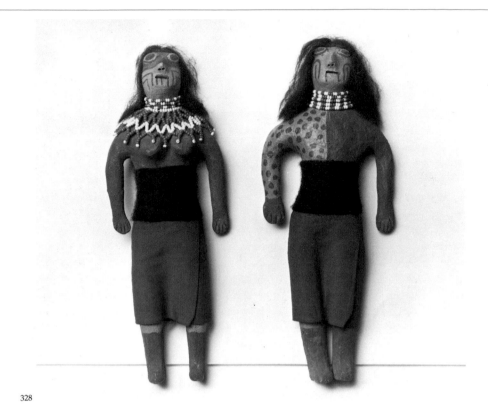

328

329

RATTLE, 1982
Gourd, cottonwood, clay, enamel paint,
pebbles
14½" l.

Robert Escalante
Quechan
Fort Yuma Indian Reservation, California

Mr. and Mrs. Robert Escalante were maintain-
ing a tamale and coffee stand by the dance
grounds at the 1984 Fort Yuma powwow when
they extended an invitation to visit them so
that they could show me a rattle. These rattles
are used in Quechan prayer and are shaken
while the medicine man sings "bird songs"
and "lightning songs." This rattle, made some
years earlier, was properly seasoned by use
and had a touch-resilient tone. "You've got to
shake it around and get the gourd dust out
through the holes to give it the right sound,"
Mr. Escalante explained. While the use of
enamel paint is modern, the concept is a direct
survival from ancient times.

Purchased from the maker, March 1984.

330

YOUNG GIRL'S CAPE, 1984
Beads
12¼" l. x 23½" w.
(see colorplate, p. 247)

Anita Thomas
Supai
Colorado River Indian Reservation, Parker,
Arizona

Net beading used for necklaces and capes is as
old a tradition among the desert tribes as the
introduction of beads. However, the color
scheme in the nineteenth century tended to be
blue and white. Since the 1950s, the old pat-
terns have become more spirited, a tendency
that is demonstrated in this fine example.

Purchased at Colorado River Indian Tribes Library
and Museum, Parker, Arizona, March 1984.

331

BASKET, 1984
Sumac
6" h. x 8⅝" diam.

Elnora Mapatis
Hualapai
Hualapai Indian Reservation, Peach Springs,
Arizona

This basket represents the northwestern Ari-
zona Colorado River drainage basketry com-
plex. Less complicated in its aesthetic than
other baskets from this area (plaques and tray
baskets, for example), it represents a
reaffirmation of basics. Elnora Mapatis is an
elder well known because of her many bas-
ketry demonstrations.

Purchased from the maker by Susan McGreevy,
August 1985.

329

331

332

Beaded bottle, 1977
Wine bottle, beads, buckskin bottom
14⅜" h. (including stopper)
(see colorplate, p. 247)

Lorena Thomas
Pyramid Lake Paiute (Great Basin)
Pyramid Lake Indian Reservation, Nevada

This tour de force in Paiute beading won second prize at the 1977 Intertribal Indian Ceremonial in Gallup, New Mexico. The designs extend in a slanting configuration, so that there is a sweep and vitality to their pattern.

In addition to beading bottles, the northern Paiute bead baskets, salt cellars, and a variety of objects – even the bases of hurricane lanterns. The colors on the baskets and bottles run to brilliant oranges, deep rusts, blues, and reds, and astringent hues favored by the Paiutes over the restrainted colored beads with

which the Pomo decorate their baskets. (In recent years the Pomo have taken to fully beading small baskets also, since it is harder to obtain the feathers for feathered gift baskets.) The Jicarilla Apache of Dulce, New Mexico, also bead bottles and salt cellars, chiefly in higher-keyed pastel colors.

The class of Indian decorative art dedicated to the adornment of functional items is prevalent across the continent. Church altar candlesticks, eyeglass cases (the Tuscarora make these), beaded utensils, such as bottle openers, letter holders, and card cases (initiated by the Micmac about the turn of the century) are only a few examples of the Indianizing of an untold variety of everyday objects.

Purchased at Main Trail Gallery, Jackson, Wyoming, July 1982.

333

Wedding basket, ca. 1970
Yucca, dyes
3¼" h. x 12⅞" diam.

Maker unknown
Southern Paiute
Arizona or Utah

Generic baskets for Navajo wedding ceremonies were traditionally made by the Navajo with designs shown in this example. After the early 1960s they were made almost exclusively by the southern Paiute for Navajo use. In the last few years they have again been made by some Navajo, such as Sally Black of Mexican Hat, Utah, using what is now basically a Paiute model. These "wedding" baskets are not rarities. Stacks of them can be seen at Navajo traders. They are sold and then bought by other Navajo according to ceremonial needs; this one still retains some of the ceremonial cornmeal clinging like surface dust to the interstices between the coils. A bit of rag is often added,

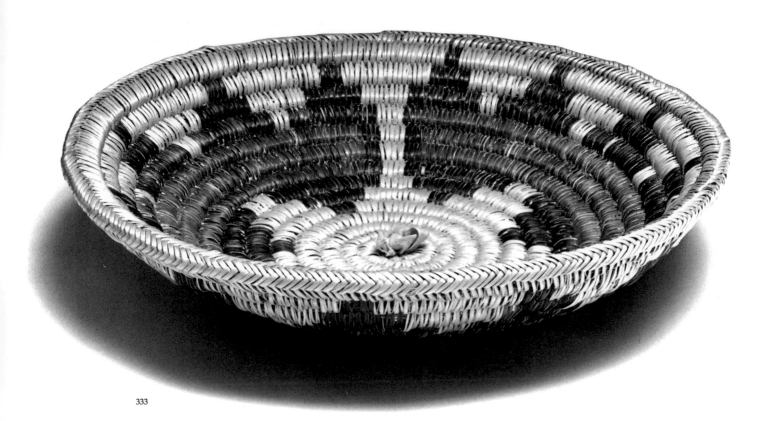

333

334

TRINKET BASKET, 1984
Bear grass, hazel bark, natural dyes, Indian-tanned buckskin
3⅞" h. x 3⅛" diam.

Vera Ryerson
Yurok
Eureka, California

Like the Karok hat (cat. no. 336), this charming small basket was ordered especially for this project. This type of basket comes in different sizes, for storage of, for example, dentalium shell or jewelry. Although elderly, Vera Ryerson holds basketry classes in her home, teaching the neighboring Karok, as well as her own people. Linda C. Vit, director of the Northern California Indian Development Council, says of her: "She has quite a few pupils and teaches two classes a week. She does more than just show you how to make a basket. She shows you how to gather your own materials and prepare them and why they are used. For instance, spruce swells when wet and becomes tight, holding water, which bear grass does not."

Purchased from the Northern California Indian Development Council, Eureka, California, July 1983.

335

ELKHORN PURSE, ca. 1980
Elkhorn
5⅛" l. x 1⅜" diam.

George Blake (?)
Hoopa
Hoopa Valley Indian Reservation, California

The Hoopa, Karok, and Yurok peoples of Northern California attached great cultural value to shell money, which was kept in elkhorn purses such as this one. These purses were treasured items and had great prestige meaning; they still do today, though the money system has lapsed. This purse is as fine as any old one made in the days before the craft revival stimulated this example of a nearly lost art. It is attributed to George Blake, now in his late thirties.

Purchased at Winona Trading Post, Santa Fe, New Mexico, April 1984.

as here, to plug the center hole in order to prevent the meal from spilling out.

While this basket was chosen for its typicality and traditionalism, a recent, highly creative development is taking place in basketry by the Paiute of Willow Springs (near Tuba City) and Navajo Mountain in southern Utah (both on the Navajo Reservation). This involves not only the use of motifs suggested by knowledge of other Arizona tribal designs, but also the invention of designs that seem to be entirely original, featuring butterfly patterns, animals, and idiosyncratic variants on the standard "wedding" design. The variations seem endlessly promising. Here is tradition in the making which bears watching.*

*For a discussion and illustrations of this development, see Andrew W. Whiteford and Susan B. McGreevy, *Translating Tradition, Basketry Arts of the San Juan Paiute*, exhibition catalogue (Santa Fe: Wheelright Museum of the American Indian, 1985).

Purchased at J. B. Tanner Trading Co., Albuquerque, New Mexico, January 1984.

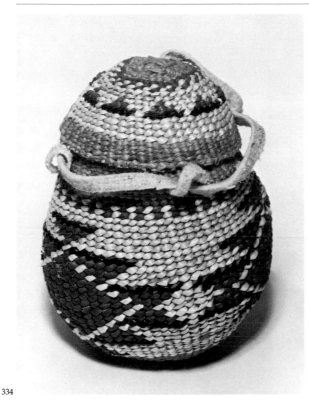

334

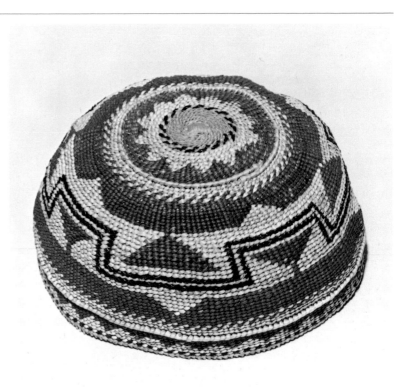

336

336

HAT, 1984
Bear grass, hazel bark, natural dyes
3½" h. x 8½" diam.

Madeline Davis
Karok
Happy Camp, California

At the spring 1983 convention of the American Indian Art Dealers Association at Denver, Colorado, Karok Indian Linda C. Vit, director of the Northern California Indian Development Council, showed samples of modern work by the Northern California tribes of the Trinity River Wilderness area – Hoopa, Karok, Yurok. A willow root baby carrier, traditional acorn-mush wooden spoons, a basket shown here (cat. no. 334), and this hat were among the types shown.

Admittedly, this woman's hat is not quite as well made as many older examples. It is awkwardly sized for ordinary wear, and its loose weave accounts for its inconsistent

shape. But this does not make it any less a treasure, for it is the work of a woman in her eighties, whose hands are arthritic due to long years of working the basket materials in water (which is cold, since the weaving is done in winter). Even natural dyes are used; maidenhair fern for black color, alder for red. The miracle is that this work is being made at all, considering the cultural disorientation visited upon Northern California by white settlement. We are at the cutting edge of cultural survival here.

Purchased from the Northern California Indian Development Council, Eureka, California, July 1983.

337

BASKET, 1973–85
Sedge, redwood, single willow rod foundation
1¾" h. x 4¾" diam. (at mid-section)

Susye Billy
Pomo
Hopland, California

Susye Billy began this basket when she demonstrated Pomo basket weaving at the *Sacred Circles* exhibition held at the Nelson Gallery of Art in 1977. At that time it was simply a disk, hardly begun. It is Susye Billy's habit to travel around with a number of these "starters," they are almost extensions of her person. In January 1985, the basket was almost finished; however, she agreed to put off completing the last, uppermost, rows until she could be filmed while doing it. On that occasion she tied in the last row, eight years since she had begun (fig. 29). The lighter accents inserted into the dark oblong designs (the meanings of which are

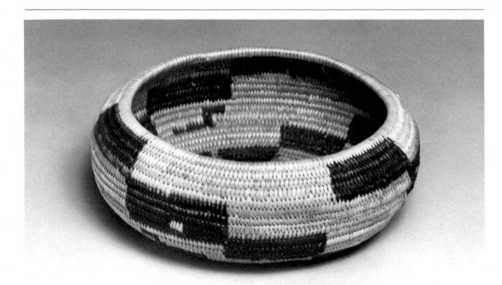

337

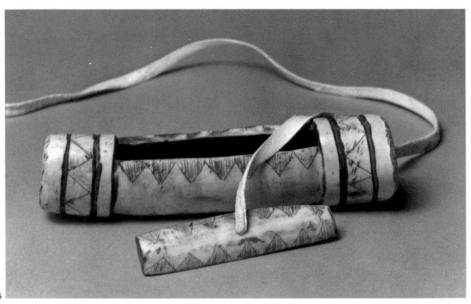

335

now lost) allow a weaver to continue work despite a menstrual taboo.

In the film, Susye Billy talked about her grandmother and her aunt, both expert basket weavers and of her desire to learn the craft (see ch. 4). She spoke, too, about her use of traditional materials and the problem of securing them in a changing world:

"I feel that the generations before me tried all the different materials and found these to be the best materials, and so I'm pretty strict on that....The materials that we use are the willow....We strip them for some kinds of baskets and some of them we leave the bark on, it's very thin. And then we use three main colored fibers: the white material is a sage grass root... and I use the bulrush root for the black fiber... and I use the new shoots of the Redbud, and that gives a reddish-brown color....Of course,

we have to dig all our materials...they can't be bought anywhere and it's very hard today to find the places where the materials grow and to be able to gather them....

"The way that rivers have been dammed up, the way that the waters run different now, wipe out the roots and things that used to grow along the sides of the rivers. And a lot of the willows have been cut down along the roads, where they've put in roads that used to just be dirt roads....And so we've lost a lot of our gathering sites, and I really feel that contributes to the fact that a lot of people aren't weaving today...it's so difficult. You have to be very determined to be a basket weaver today."

Purchased from the maker, May 1985.

opposite POLYCHROMED OLLA, 1983 (Cat. no. 260)

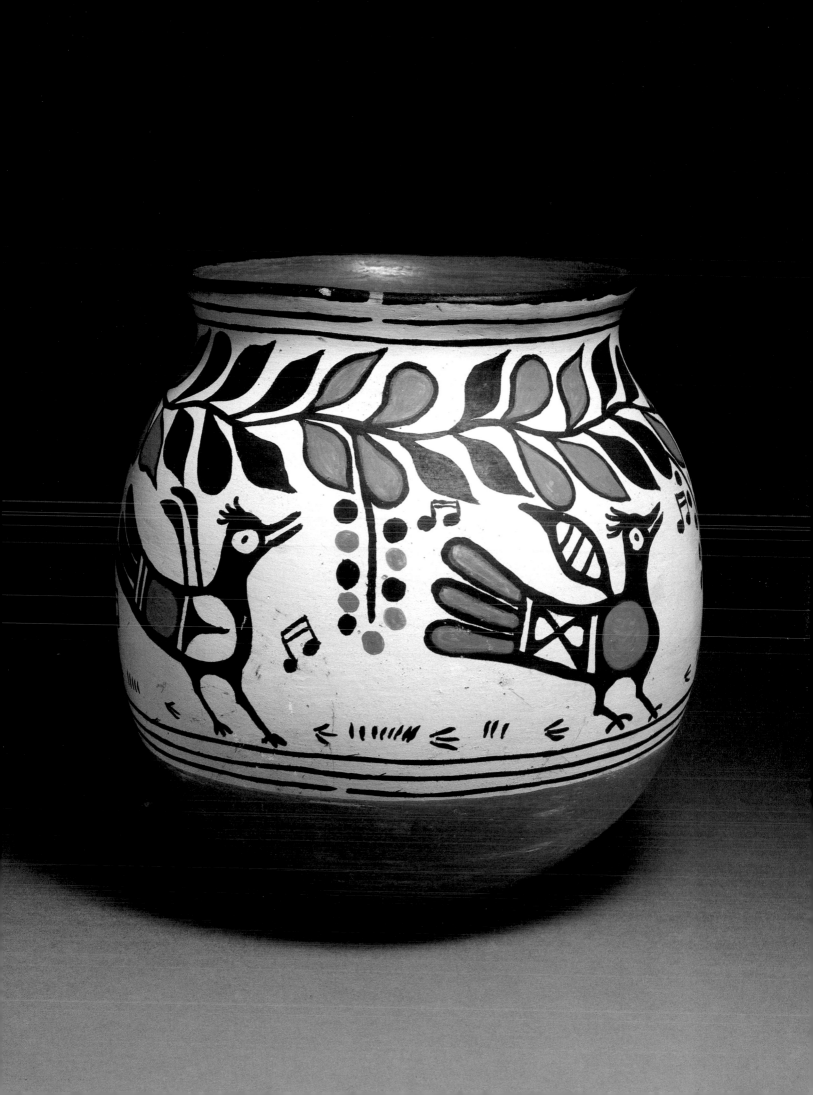

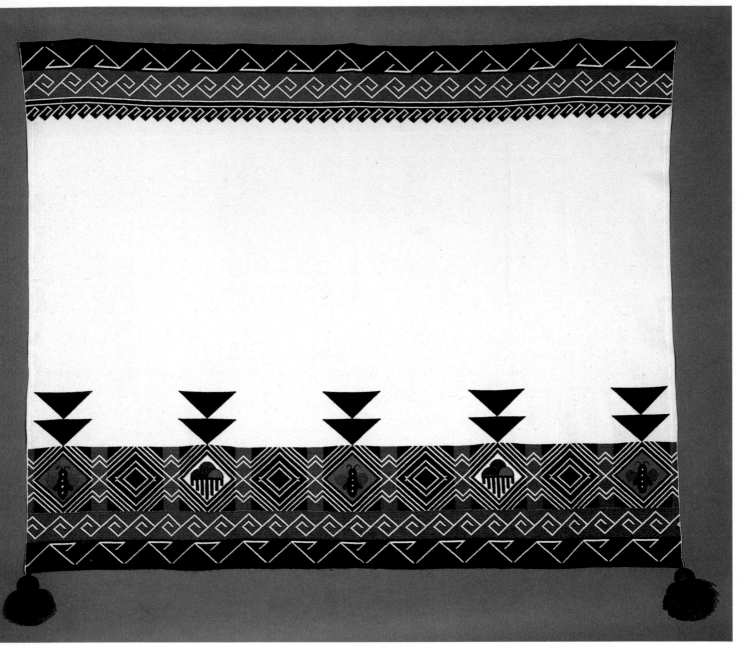

MANTA, 1984 (Cat. no. 247)

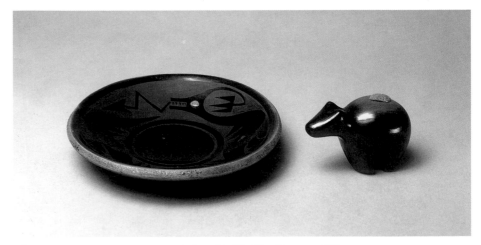

left SMALL PLATE WITH TURQUOISE INSERT, 1984 (Cat. no. 253)
right CERAMIC BEAR FETISH, 1983 (Cat. no. 252)

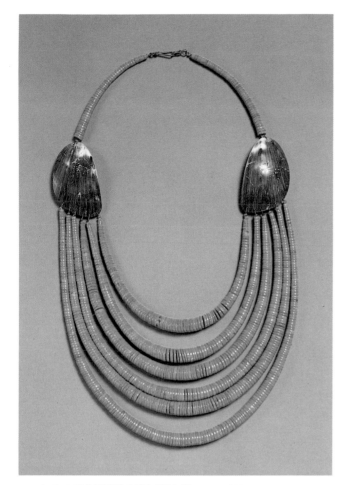

SIX-STRAND NECKLACE, 1984 (Cat. no. 263)

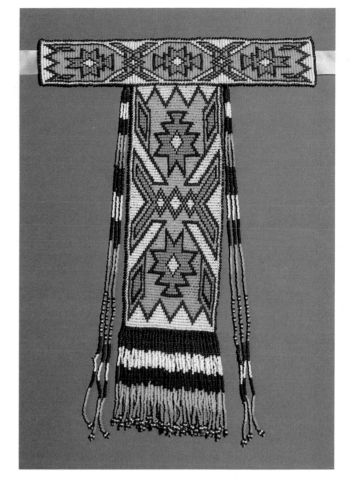

BEADED NECKLACE, 1983 (Cat. no. 233)

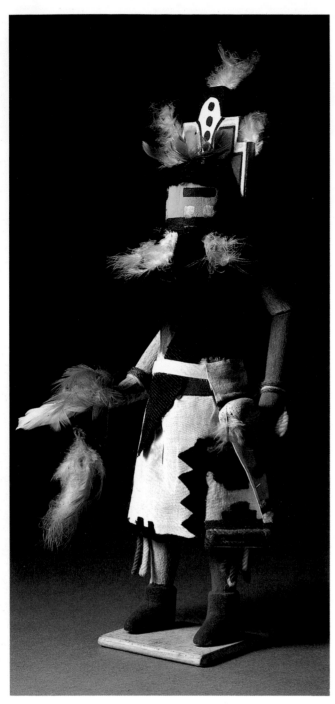

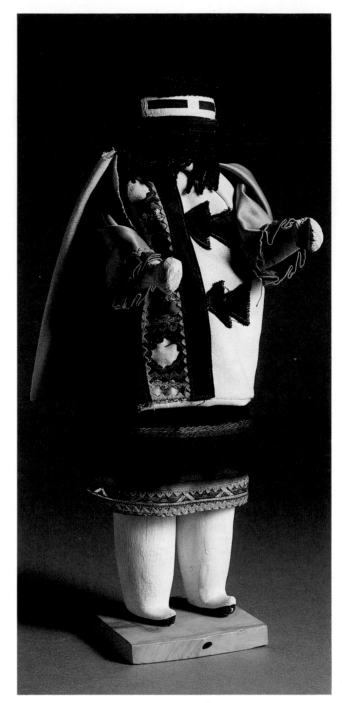

KACHINA (TAIAWAIPIK SIO ANGAK'CHINA), ca. 1966–67
(CAT. NO. 283)

KACHINA MAIDEN (KOKWELE), ca. 1966–67 (CAT. NO. 286)

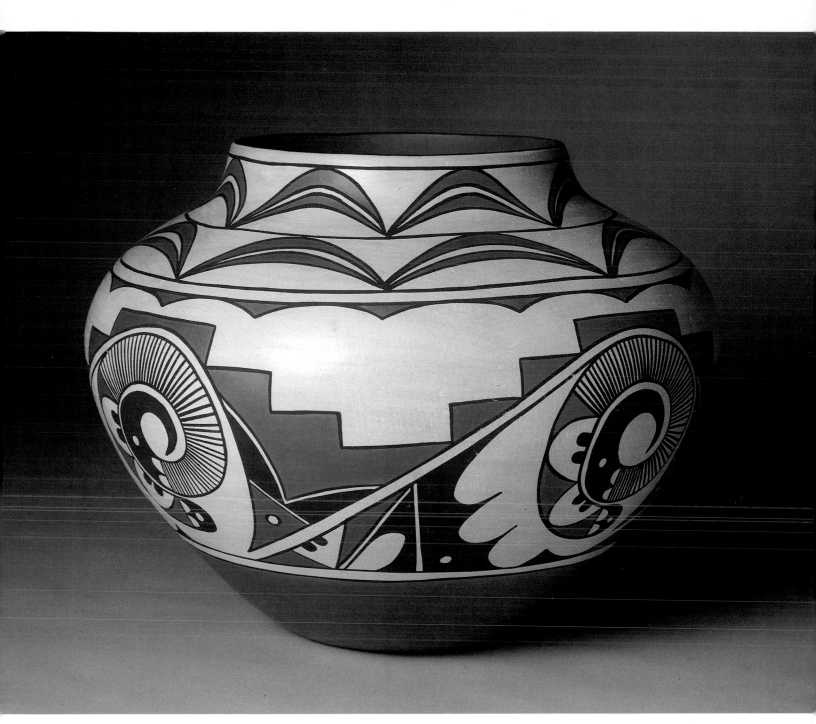

OLLA, 1984 (CAT. NO. 275)

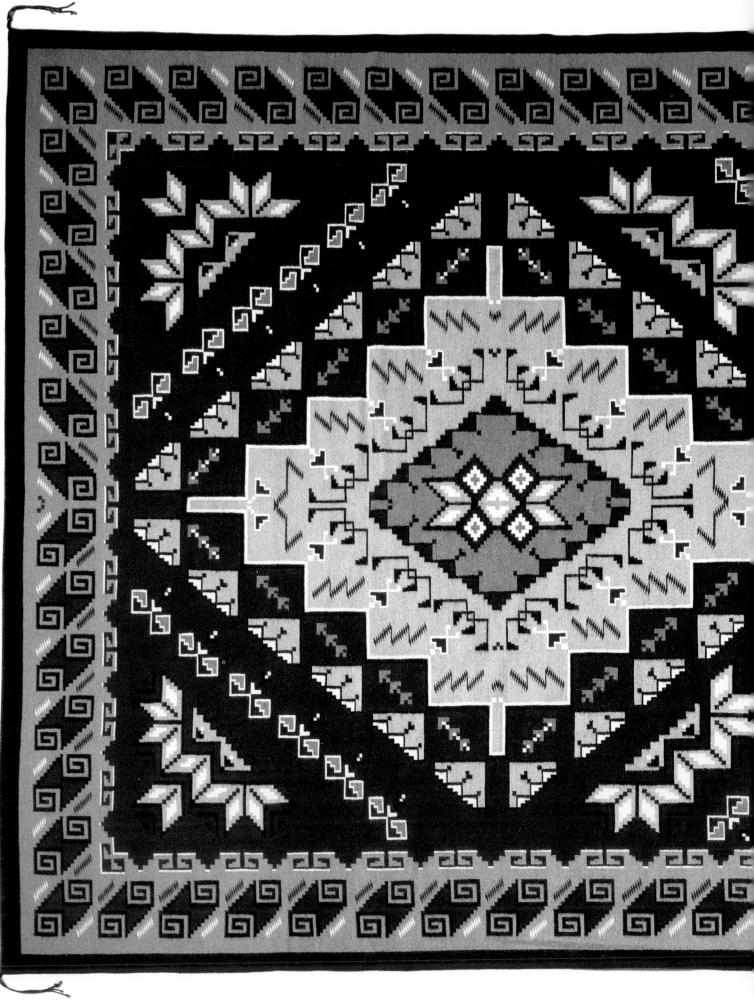

LARGE GANADO RUG, 1984 (Cat. no. 288)

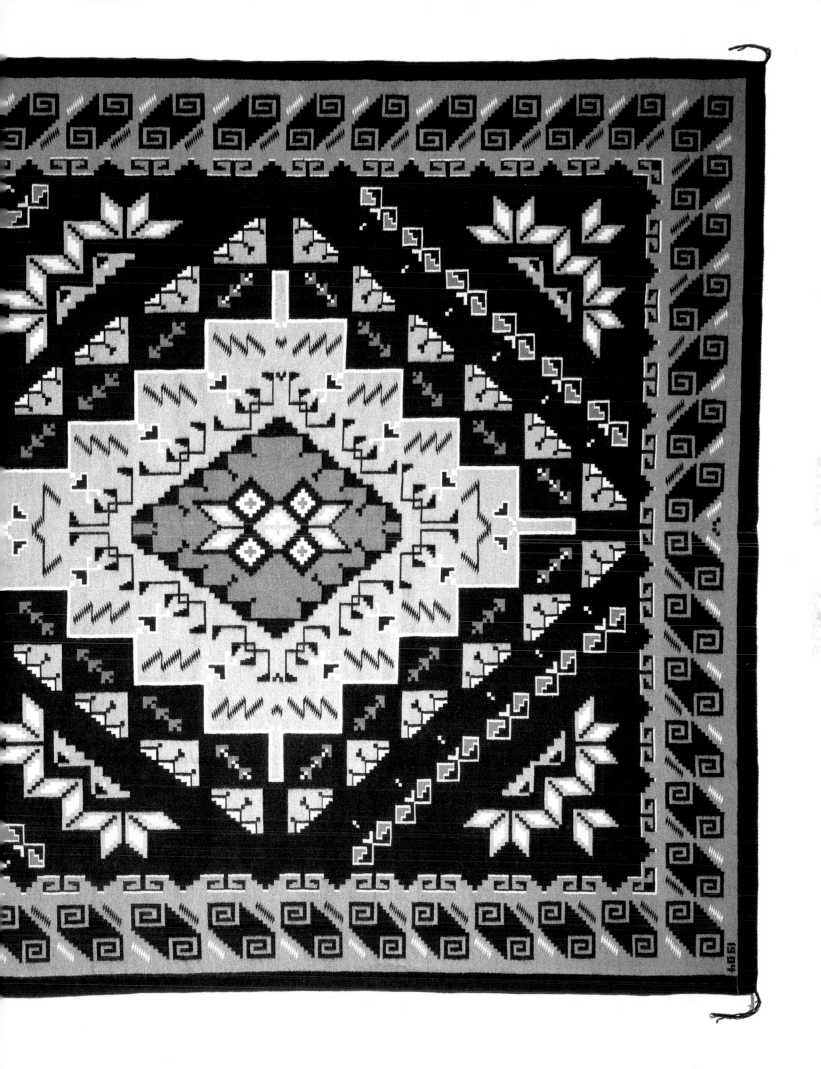

239

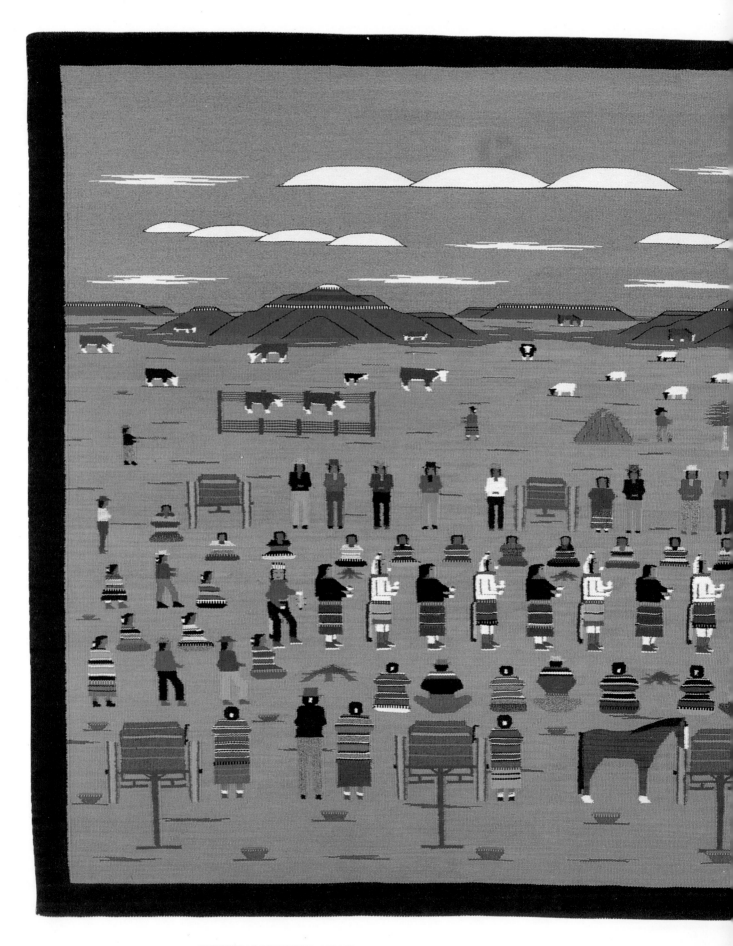

PICTORIAL WEAVING, 1984 (Cat. no. 289)

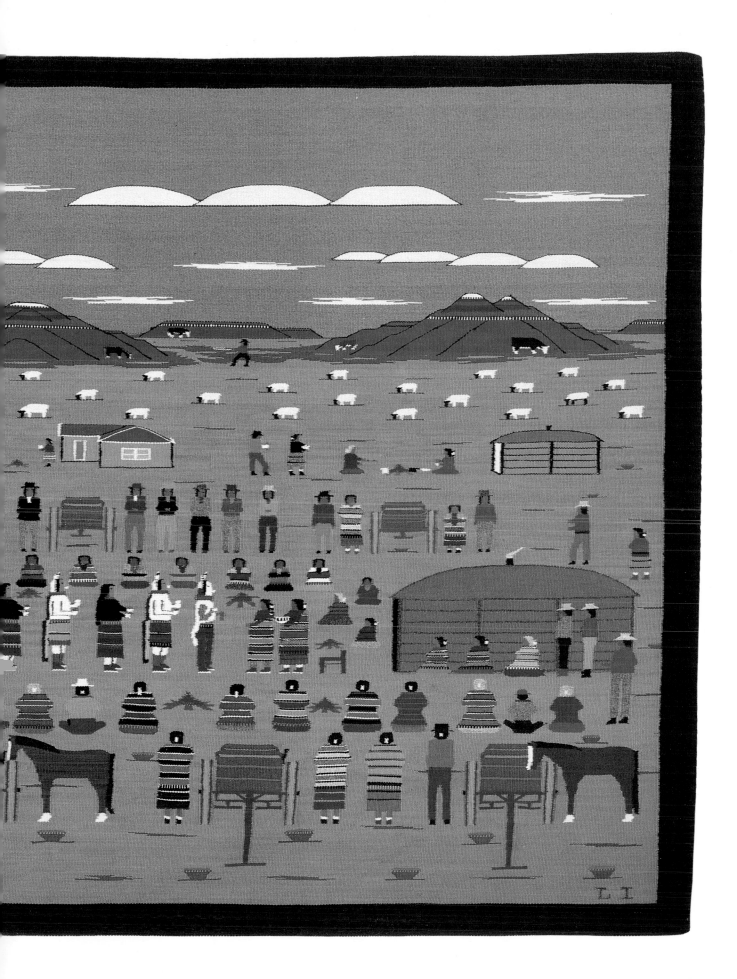

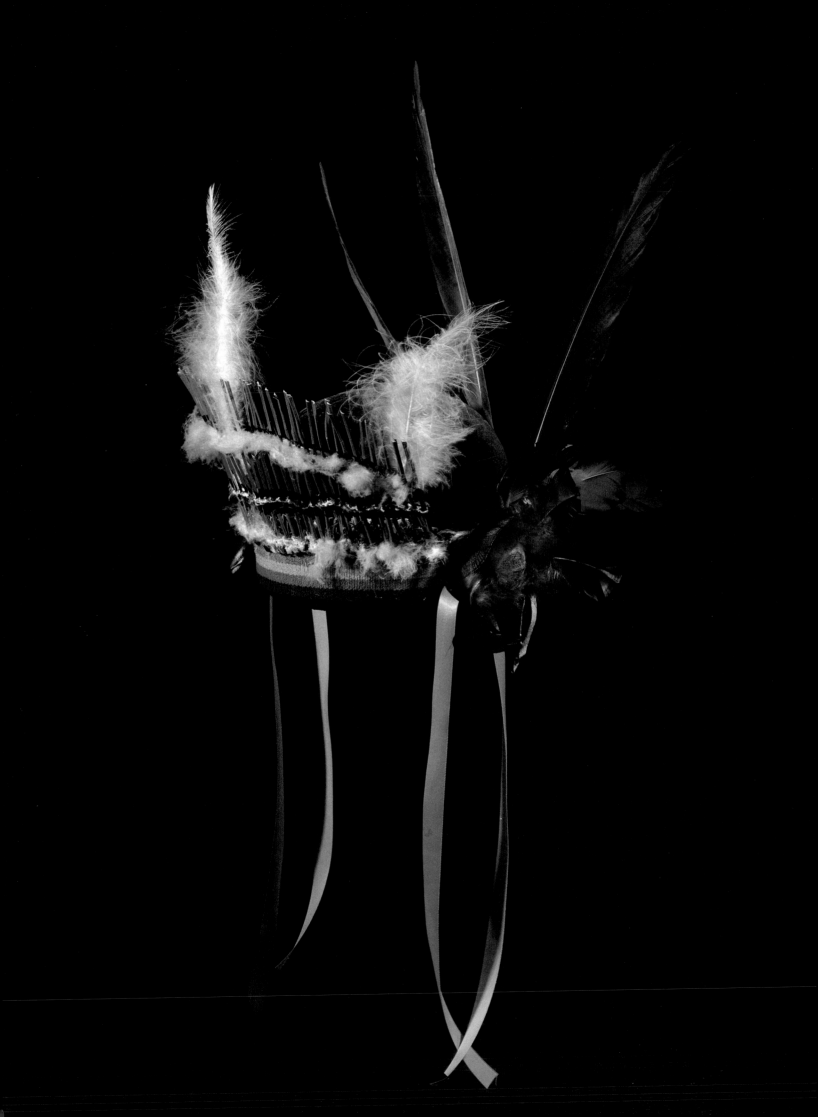

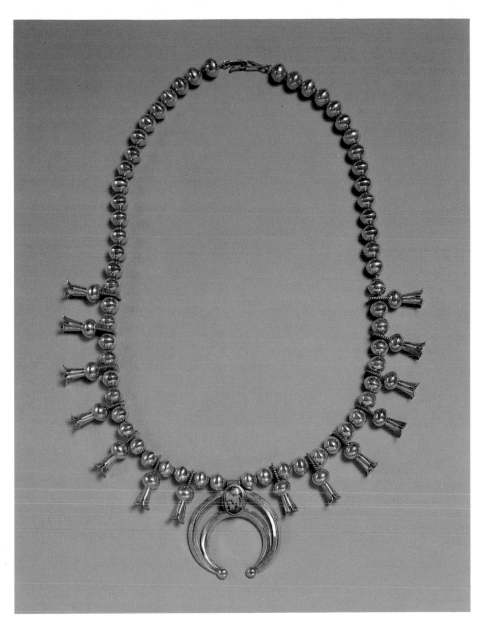

SQUASH BLOSSOM NECKLACE WITH NAJA, 1982 (Cat. no. 299)

BRACELET, 1983 (Cat. no. 294)

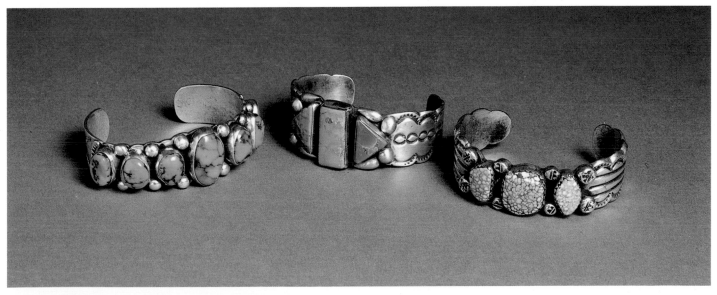

left TURQUOISE BRACELET, 1983–84 (Cat. no. 296)
center TURQUOISE BRACELET, 1983 (Cat. no. 295)
right TURQUOISE BRACELET, 1983–84 (Cat. no. 297)

opposite DANCE HEADDRESS, 1984 (Cat. no. 269)

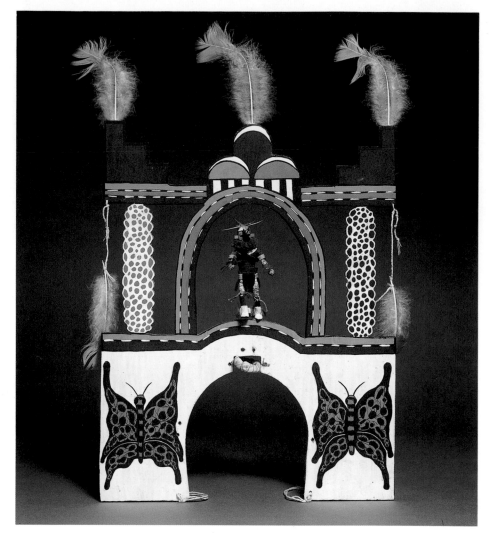

SIO POLI HEMIS TABLITA (ZUNI BUTTERFLY JEMEZ KACHINA), 1980 (Cat. no. 309)

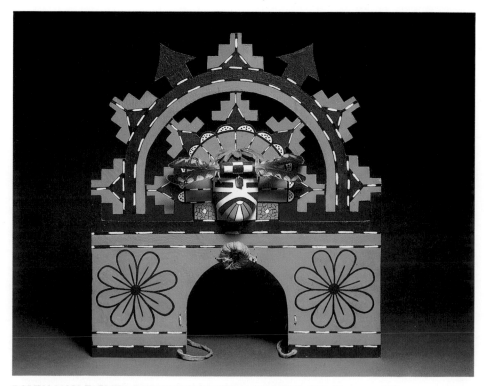

POLIK MANA TABLITA (BUTTERFLY KACHINA MAIDEN), 1981 (Cat. no. 310)

opposite SIO HEMIS TABLITA (ZUNI JEMEZ KACHINA) ca. 1970–75 (Cat. no. 308)

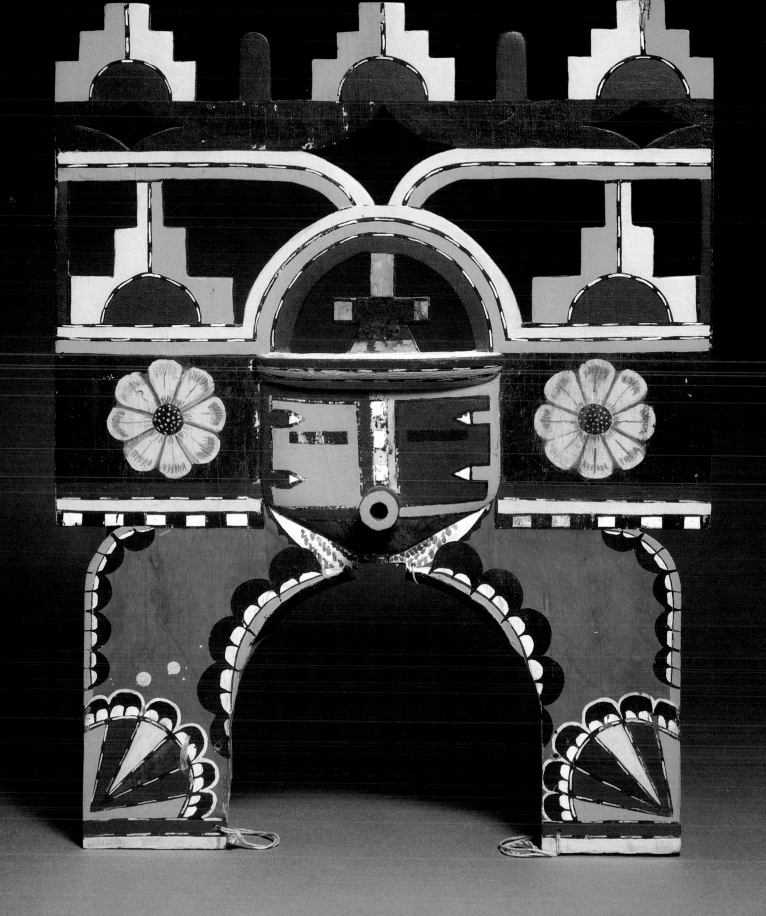

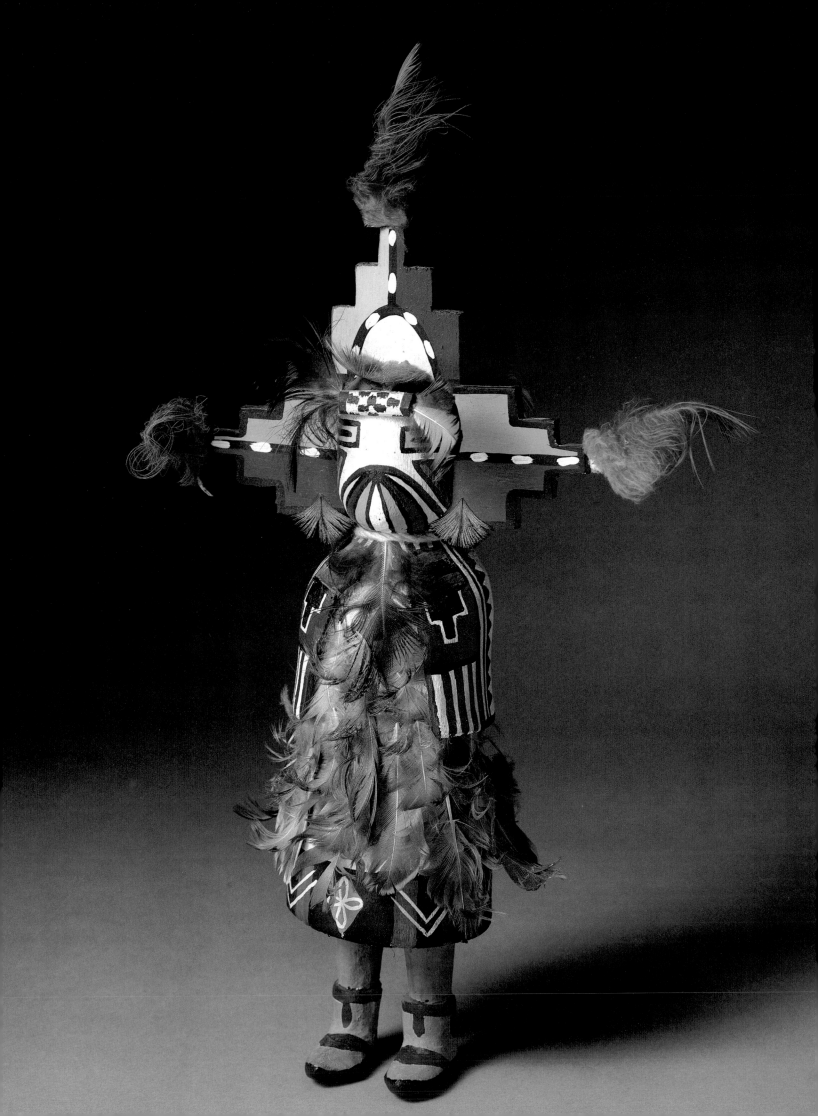

YOUNG GIRL'S CAPE, 1984 (CAT. NO. 330)

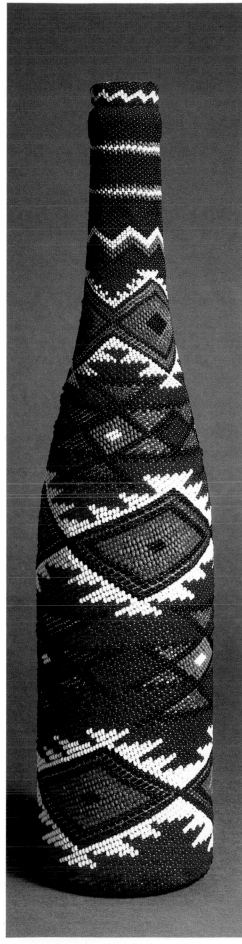

BEADED BOTTLE, 1977 (CAT. NO. 332)

opposite SHALAKO KACHINA, 1978–80 (CAT. NO. 315)

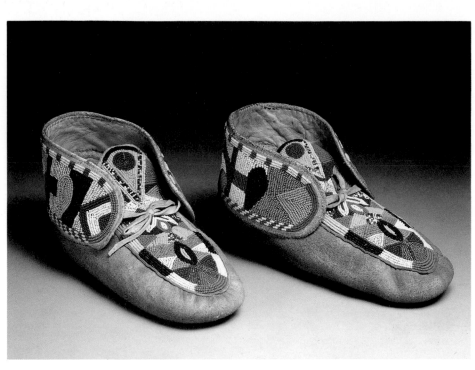

MOCCASINS, ca. 1965 (Cat. no. 341)

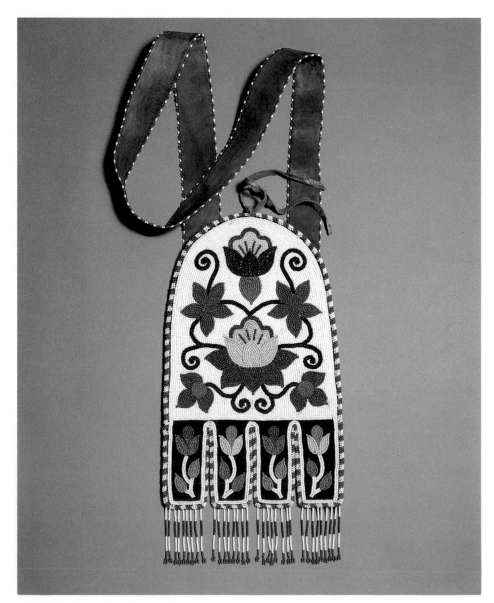

OCTAPUS BAG, ca. 1980 (Cat. no. 344)

ATHAPASKA

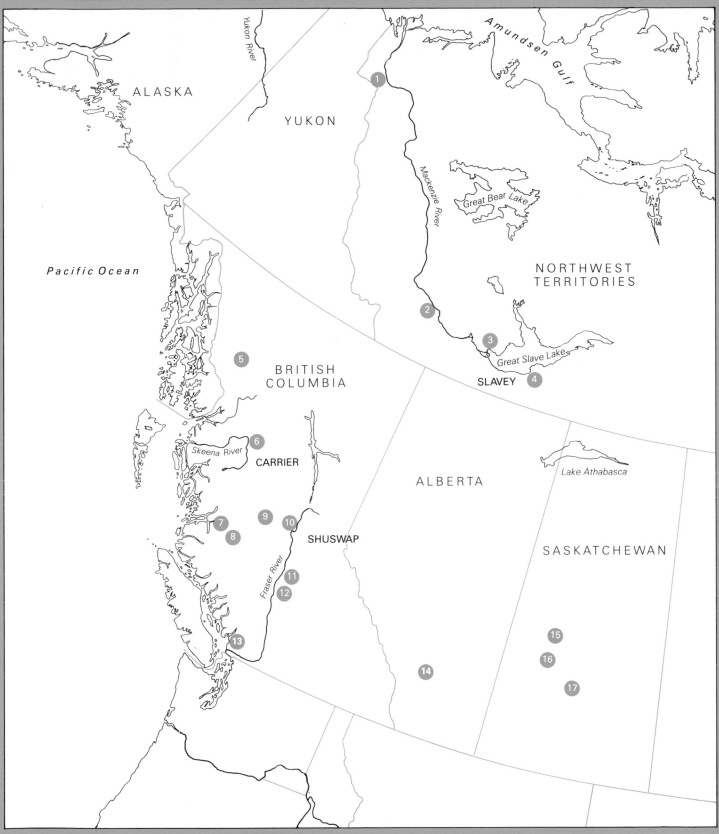

1 Fort McPherson
2 Fort Simpson
3 Fort Providence
4 Fort Resolution
5 Telegraph Creek
6 Moricetown
7 Bella Coola
8 Chilcotin Reserve; Anahim Lake
9 Fort Fraser
10 Prince George
11 Williams Lake
12 Shuswap Reserve; Alkali Lake
13 Vancouver
14 Calgary
15 Meadow Lake Reserve
 (Prairie Cree)
16 Red Pheasant Reserve
 (Plains Cree)
17 Saskatoon

338

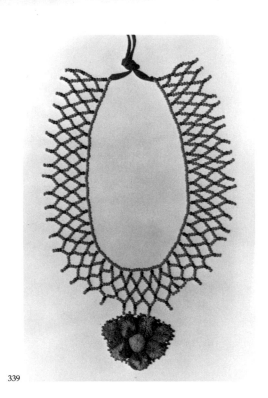
339

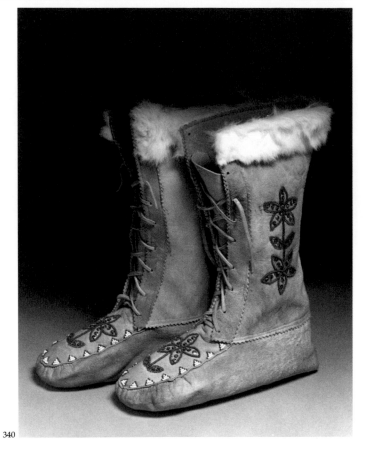
340

338, 339

Two TUFTED CARIBOU-HAIR "PICTURES,"
1980–81
Caribou hair, velvet backing
each 8⅞" h. x 7" w. (unframed)

TUFTED MOOSE-HAIR NECKLACE, 1980–81
Moose hair, beads
8" l.; tufted pendant 1½" h. x 2" w.

Makers unknown
Slavey
Fort Providence, Northwest Territory

Moose- and caribou-hair tufting was almost a lost art among the Slavey Indians by the 1950s; as late as 1977 a trader in Southern Canada considered himself lucky to get his hands on a "flower picture" of the type shown here (cat. no. 338). In recent years young women have been encouraged to learn; now the pictures have become plentiful, and the "daisy" flowerettes standard. The pictures have become the "fancies" of the North. Gauntlets, jackets, and moccasins are also decorated with moose- and caribou-hair tufting; a necklace such as the one seen here (cat. no. 339) was definitely a rarity until a few years ago. The best work today recalls old-style elaborated flower forms with attached petals that adorn

coats made at Fort Simpson and Fort Resolution. The Kutchin of Fort McPherson still make and use the traditional quilled "baby belts" that the Chipewyan, Slavey, and Koyukon once made in abundance.

The tufting process requires that the first winter hair along the backbone of the moose be cut, after which it is sorted and washed before dyeing. Dyes are both commercial and natural. The picture pattern is drawn freehand on velvet or other backing material with a stick dipped in a flour-water paste. Fifteen to twenty hairs are knotted together at one time, and the procedure is repeated to fill out the pattern. The tightness of the knotting makes the hairs stand up in a tuft, which is then trimmed down with scissors to give a smooth and rounded relief.

These three pieces were obtained from a Hudson's Bay Company factor who had recently come down from the North to operate a craft outlet for the company.

Purchased at Hudson's Bay Trading Co. Gift Shop, North Bay, Ontario, July 1981.

340

MUKLUKS, 1983
Smoked deerhide, rabbit fur, beads, sequins
13⅞" h. x 10½" l.

Dora Billy
Shuswap (Interior Salish)
Williams Lake, British Columbia

Difficult choices had to be made on every trip through Western Canada, which resulted in bypassing the Shuswap Reserve at Alkali Lake, as well as the Chilcotin Reserve at Anahim Lake, about sixty-five miles on the way to Bella Coola from Williams Lake. An Athapaskan consolation prize was this pair of Shuswap home-tanned mukluks which show the long-tongued crescent profile of Shuswap work, in contrast to the thicker, squared profile of central Cree mukluks (cat. no. 26), or the non-laced self-contained Northern Maritime type (cat. no. 2).

"They were just freshly brought in by Mrs. Billy... I'm not sure where she works," was the only information available about these mukluks.

Purchased at Marvin Williams Leather Shops, Williams Lake, British Columbia, August 1983.

342

343

345

341

MOCCASINS, ca. 1965
Smoked moosehide, beads, lining, thread
9⅝" h. x 11¼" l.
(*see colorplate, p. 248*)

Maker unknown
Carrier
Fort Fraser, British Columbia

The radically abstracted floral beading on these sumptuously decorated moccasins shows how greatly altered eastern flower motifs could become when they reached Athapaska. "It looks like they really could reinvent the wheel," was a Plains Indian comment on them. The decisive admixture of strong but varicolored triangles, ellipses, bars, chevrons, leaves, and blossoms creates a veritable mosaic in which natural observation and rainbow abstraction interweave in a fascinating way. They are of uncommon interest, for no other pair of like quality appeared in subsequent years despite the fact that beaded Carrier moccasins are still sold at Canadian Indian shops, obtained mostly from Moricetown, British Columbia.

Purchased at Horlick's Fine Furs, Prince George, British Columbia, November 1977.

342

BOX, ca. 1975
Birchbark, yarn, metal hanger, varnish
4⅛" h. x 12¾" w. x 12½" d.

Maker unknown
Carrier
British Columbia

This modern Carrier box should be compared with the old-style lidded Carrier sewing box made by Mrs. Agnes George (cat. no. 343). Both were made within three years of each other. Here the spruce lacings used by Mrs. George have been replaced by yarn thread; the birchbark has been varnished. Around the inner rim is a bent hanger frame, invisible from the outside. The difference is great, yet one hesitates to say "loss." Mrs. George's box is basic to the culture and is a superior manifestation. Yet this modern box is rather ingeniously present-day Indian in its resolve to make use of available materials.

Purchased at Horlick's Fine Furs, Prince George, British Columbia, August 1977.

343

SEWING BOX, 1972–78
Birchbark, cherry bark, spruce root
5⅛" h. x 10¼" w. x 8¾" d.

Agnes George
Carrier
Fort Fraser, British Columbia

This box was commissioned after a similar one, filled with sewing articles, was seen at a home in Hagwielgit, British Columbia, a Carrier village adjacent to Tsimshian territory which uses Northwest Coast crests and art styles. Inquiry led to elderly Mrs. Agnes George. This is a superior example of Athapaskan birchbark work with its characteristic spruce lacings in patterns, here used to create a stepped effect. The scraped designs (more visible when the box was new) depict flowers and mountain peaks, echoing the mountain range and park landscape of interior British Columbia at Fort Fraser, where Mrs. George, then in her nineties, resided.

Commissioned from maker, early winter 1977; received December 1978.

344

OCTOPUS BAG, ca. 1980
Smoked caribou hide, beads, canvas, felt
35¾" l. (including strap) x 8¼" w.
(see colorplate, p. 248)

Louise Q. Bea
Tribe unknown
Subarctic Canada

"Octopus" bags are so called because of the tabs along the bottom which recall tentacles. They were an invention of the Cree tribes of Eastern Canada, and the fashion for them crossed the continent during the course of the nineteenth century. Today they are rarely made. This fine recent example was made by one of the Canadian Athapaskan in the Northwest or Yukon Territories and is a mixed style that combines old and new elements. Old-style work was not fully beaded, as here; the flowers would have been placed against a cloth background. The tabs are done in an odd way, with white beaded frames on black felt. There is Saskatchewan Cree influence here, but the caribou-hide backing and straps are indicative of an origin in Subarctic Canada.

Purchased at Hudgins Indian Arts, Santa Fe, New Mexico, November 1984.
Private collection.

345

MOCCASINS, ca. 1970–75
Smoked moose or elk hide, felt, beads
8" h. x 11" l.

Maker unknown
Tribe unknown
Subarctic Canada

This pair of high-cuffed moccasins, typical of modern-day Athapaskan work from the Fort Providence, Northwest Territories region around Great Slave Lake, turned up in a shop in Iowa. The Mesquakie proprietor, Frank Pushetonequa, remembered only that they had been traded "down from up north someplace."

Sometimes the beading is more elaborated on moccasins of this general type, but these are nonetheless good standard examples of modern-day Athapaskan work, which has a Northern directness of execution. The white felt is characteristic. In the northern territories, such as the Yukon, Indian-tanned hides are generally used for fancy apparel, as they are easier to procure, just the reverse of what obtains farther south. Bird-quill belts, gauntlets, jackets and vests, and even "octopus" bags (cat. no. 344) are still made in this vast region of Northwestern Canada.

Purchased at Moccasin Tracks Trading Post, Toledo, Iowa, January 1980.

346

LIDDED CONTAINER, 1980–81
Birchbark, quills, spruce lining, smoked-hide ties
10⅛" h. x 9¾" diam.

M. Kotchua
Tribe unknown
Athapaska

These butterfly-flower designs sewn with bird quill in the "running" style, from the very northern region of birchbark work, are quite opposite to the solid-pattern quilling prevalent to the south. There is a tundra-like spareness of effect. Tightly wrapped lacing in two bands (one colored) across the rims of Athapaskan birchbark boxes, bowls, and even canoe models is characteristic; sometimes the effect is checkered, though not here.

"I've seen better, but it's the best one I've got," said the factor of the gift shop at North Bay, Ontario, who had only recently come down from years in the Canadian Territories and stocked Athapaskan crafts because of this association.

Purchased at Hudson's Bay Co. Gift Shop, North Bay, Ontario, July 1981.

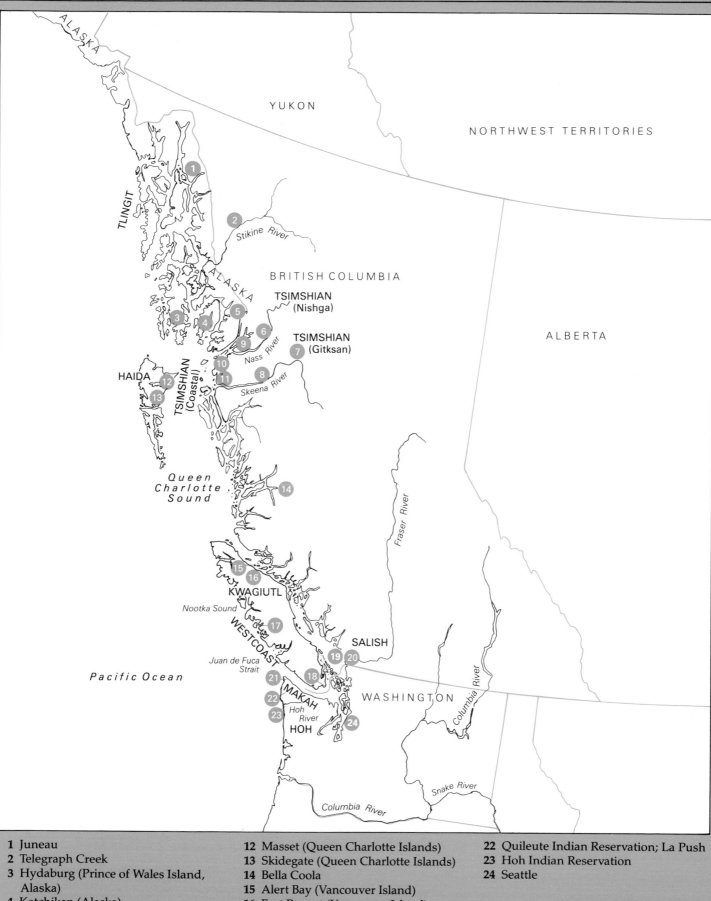

1 Juneau
2 Telegraph Creek
3 Hydaburg (Prince of Wales Island, Alaska)
4 Ketchikan (Alaska)
5 Hyder (Alaska)
6 New Aiyansh
7 Hazelton; Kispiox
8 Terrace
9 Kincolith
10 Port Simpson
11 Prince Rupert; Port Edward

12 Masset (Queen Charlotte Islands)
13 Skidegate (Queen Charlotte Islands)
14 Bella Coola
15 Alert Bay (Vancouver Island)
16 Fort Rupert (Vancouver Island)
17 Ahousat (Vancouver Island)
18 Victoria (Vancouver Island)
19 Vancouver
20 Surrey; Sardis
21 Makah Indian Reservation; Neah Bay; Wyaach Beach

22 Quileute Indian Reservation; La Push
23 Hoh Indian Reservation
24 Seattle

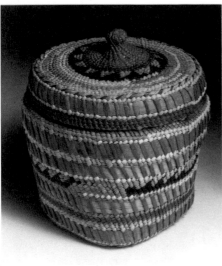

347

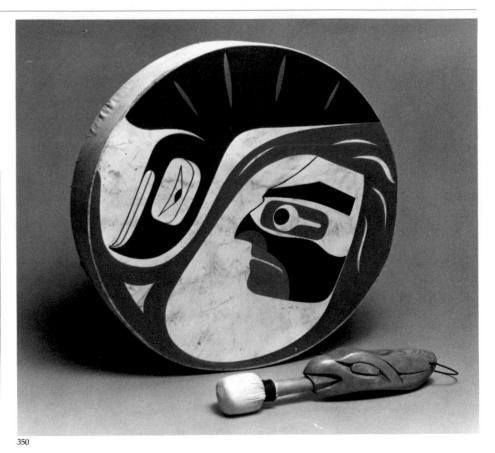

350

347

Lidded basket, 1983
Bear grass, cedar bark, Hawaiian grass
6⅜" h. (including knob·on lid) x 6" diam.

Leila Fisher
Quileute
Resident at Hoh Reservation, Washington

At the Quileute village of Lapush, Washington, I was advised to look up basket maker Leila Fisher at Hoh Reservation farther down the Olympic Peninsula. I found her midway through the weaving of this basket (fig. 11) and waited until she finished it. Born a Quileute, Mrs. Fisher married into the culturally similar Hoh people many years ago. Quileute basketry is similar to Makah work, but the standards are wider, more bark shows, and the result is bulkier in appearance. The whaling scenes are on a background of grass from Hawaii, sent to Mrs. Fisher by a nephew who lives there.

Purchased from the maker, September 1983.
Private collection.

348

Lidded basket, 1983–85
Bear grass, cedar bark, commercial dyes
3¾" h. x 5¼" diam.
(see colorplate, p. 273)

Mary Green
Makah
Makah Indian Reservation, Wyaach Beach, Washington

It becomes immediately clear when seeing the baskets of Mary Green that her work is the most even and consistent among her tribe. Mrs. Green began to make this refined lidded basket in 1983 especially for this project. In 1985 it was ready. "I nearly broke my neck on that one!" she exclaimed. "You have to hold the inset [standards] for the lid in your fingers and keep everything tight." The lid design is called a whirlwind, the whaler design is standard but is beautifully executed and the best the Makah make today.

Purchased from the maker, May 1985.

349

Large lidded basket, 1981
Bear grass, cedar bark, raffia, sea grass
11¾" h. (including knob) x 11" diam.
(see colorplate, p. 273)

Margaret Irving
Makah
Makah Indian Reservation, Neah Bay, Washington

"If it's *the* all-time basket you're after, you should have seen the one my sister [Margaret Irving] made, but I hear they've taken it to Seattle and sold it," said Isabel Ides, a venerable, soft-spoken Makah woman, as she worked on a basket lid in her seaside basket shop at Sooes Bay on the Pacific Ocean side of the Makah Reservation. "Too bad. It was one of the largest and best ever made around here." Two days later I walked into the Makah Museum at Neah Bay and there was *the* basket in the gift shop display – large, white, and incredibly handsome.

So large is this basket by Makah standards that it has retained its "bottom" of cardboard

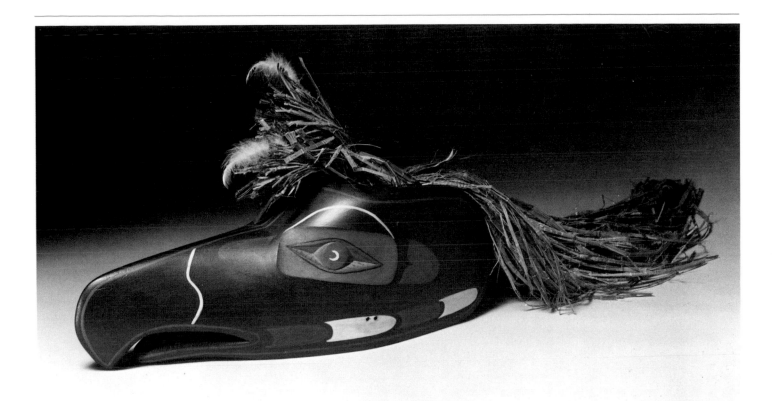

351

350

(not customary) set into the interior as backing for the bottom, the acid content of which will eventually cause conservation problems. The lip of the rim is thickened with a double row of diagonally twined bear grass. The knobbed lid, similarly reinforced, is as structurally tight as an old-style Nootka-Makah woven rain hat, which the form of the lid resembles. On the basket's walls are two eagles and two whaling scenes, recalling the whaling days of the Makah, the only Northwest Coast tribe that actively hunted whales. Both are standard Makah basket motifs. Not standard are the majestic proportions of this container and the large effect of the designs against the expanse of soft white bear-grass twilling. The bottom is of imported raffia woven around cedarbark spokes.

"It's one of our best, a piece of woven architecture," observed Grieg Arnold, the Makah director of the Makah Museum.

Purchased at the Makah Museum Gift Shop, Neah Bay, Washington, August 1983.

DRUM WITH CARVED BEATER, 1982
Deerskin, paint, wood, cloth
13" diam.; length of beater 14½"

Greg Colfax
Makah
Makah Indian Reservation, Neah Bay, Washington

This elaborately painted drum evolved from a sketch by this immensely talented young artist. After completing a preliminary sketch, which did not satisfy him, Colfax suddenly drew a circle isolating the most dynamic feature, which he then used as the design (fig. 26). The figures in the circle single out the point of concentration in which human and eagle eyes confront one another. "My idea for this came from two male eagles who fought each other senseless. A veterinary nurse who cared for wild birds took the two wretched looking bald eagles into

her house, where they perched on homemade stands in the living room. She invited the whole town! All of Neah Bay went through that room. The bird-man eye contact was relentless."

The abstract wavy lines separating the plummeting eagle from the staring human face (based on "wild man" ancestral Westcoast masks) are effectively metamorphosed from a whale-sea-wind feature of the preparatory sketch. The accompanying beater is carved in the shape of an eagle head, to add to the power of the ensemble.

Such hand drums are still used to accompany sacred songs at Makah dance events and until recently were usually played by four or five women seated in a row at the edge of the dance area. Now, according to one Makah, the men are taking a more active role "and the songs are getting better."

Purchased at the Makah Museum Gift Shop, Neah Bay, Washington, August 1982.

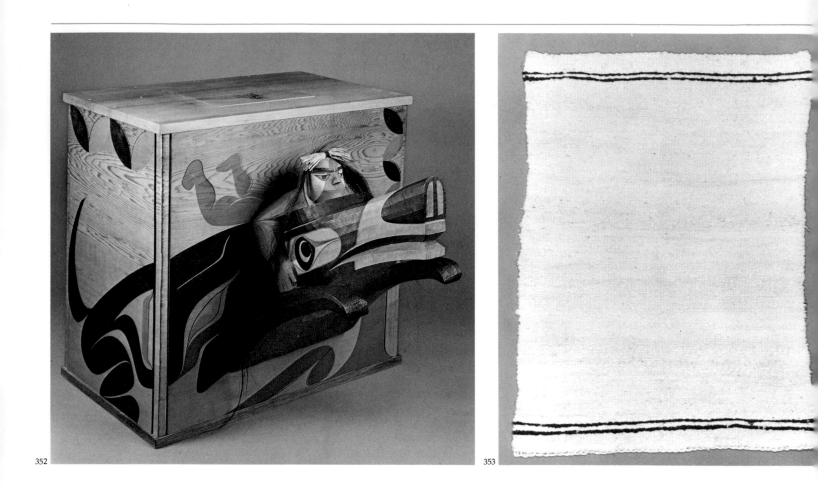

352

353

351

MASK, 1982
Wood, paint, cedar bark, feathers, down
7¾" h. x 19¾" l.

Ben Della
Makah
Makah Indian Reservation, Neah Bay,
Washington

This black raven mask is the type used in the winter Klukwalla ceremonies. It well exemplifies the sooty insouciance of the raven, both trickster and harbinger of cleverness. With its heavy curlicue forms, this mask points to the invigorating new ideas now infiltrating Makah art. This is Ben Della's second mask; in a few more years his carving style should become lighter, refined, and subtle.

Purchased at Washburn's Store, Neah Bay, Washington, August 1982.

352

KERFED BOX, 1982–85
Red cedar, paint, electronics, hair
26½" h. x 27⅞" w. x 16⅝" d.; projection at front 17⅜"
(See cover and color plate, p. 277)

Greg Colfax
Makah
Makah Indian Reservation, Neah Bay,
Washington

One of the glories of Northwest Coast art is the steam-bent (kerfed) box. The making of these boxes was given a modern day re-emphasis by the discovery over a decade ago of archaeological examples from the ancient Makah seaside town of Ozette, which had been covered by cliff subsidence.* When Grieg Arnold, director of the Makah Museum, was asked who was the best carver at Makah, he answered unhesitantly, Greg Colfax. In asking Colfax for such a box, I did not suggest any approach or subject. The idea was to bring together the past glory of the kerfed box and the possibility of its modern day furtherance through the talent of a superior artist. "I'm going to do it on the lost and found traditions," Colfax responded. "That's been bothering me a long time, and it's central to all of us and what we face as Indians today (fig. 27)."

The iconography of the box is described in the text (see ch. 4). With regard to its aesthetic aspects: the box has two-dimensional painting, carving in three dimensions (the projecting wolf with its rider), and even a fourth dimension, for it periodically plays a tape. "The box is a reason for people to speak about traditions lost and found. Different age groups will speak to this with drumming," Colfax explained. In the old days the lid would have been removable, so that the interior could be used for storage. Now a small lift-panel has been inserted at the top to house the tape deck.

During the three years the box was in work the initial concept underwent considerable evolution. The result promised to become ever richer and more powerful in simplification of means and refinement of theme, an artistic coalescence that has indeed been achieved.

*The Ozette Village archaeological finds are now displayed at the Makah Museum at Neah Bay.
Purchased from the maker, June 1985.

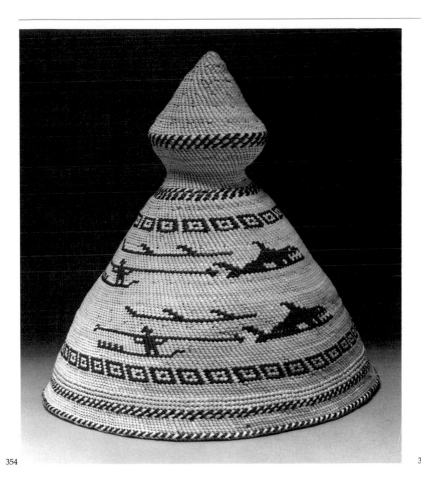

354

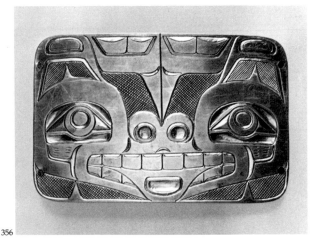

356

353

BLANKET, 1983
Home-carded wool
53" h. x 38⅛" w.

Georgina Malloway
Salish (Skowkale Band)
Sardis, British Columbia

Inquiry at Sardis, British Columbia, for a Salish weaver with "something special" brought me to the house of Georgina Malloway. What was special was that she was working on her first blanket on a loom newly constructed by her son (fig. 6). She had carded wool for the Sardis weaving cooperative for years and had watched her weaving friends at work, but this was her first attempt on her own. For this reason the blanket is of the simplest type, shaggy with two brown bands at top and bottom, conveying an archaic feeling. The blanket was almost complete when I arrived; however, this one had to be finished and taken off the loom and another blanket finished before both could be cut off.

In its simplicity Mrs. Malloway's blanket recalls the early Salish dog-wool blankets in contrast to the elaborate textiles made by the most accomplished contemporary weavers. Though attempts have been made to re-breed the Salish wool-producing dog, the result has not produced adequate wool, so sheep's wool is now used.

Purchased from the maker, September 1983.

354

HAT, 1981
Bear grass, cedar bark, dye
9" h. x 9⅛" diam. (at base)

Jessie Webster
Westcoast
Ahousat, Vancouver Island, British Columbia

Such knobbed hats are called *maquina* after the hat worn by Chief Maquina in the late-eighteenth-century sketch of the chief by Thomas de Suria, who accompanied the Malaspina expedition of 1791.* (Another similar hat was recorded by Captain James Cook's artist John Webber at Friendly Cove, Nootka Sound, in 1778.) The linear patterns of whales, canoes, whalers, and harpoons used here have long been a characteristic Westcoast (Nootkan) artistic convention (see cat. no. 347). Mrs. Webster, now in her seventies, is the most widely recognized Westcoast hat weaver working on Vancouver Island today.

*For an illustration of de Suria's sketch, together with the original Maquina hat (today in the Museo de America, Madrid), see Norman Feder, "The Malaspina Collection," *American Indian Art Magazine*, vol. 2, no. 3 (Summer 1977), p. 47, figs. 9 and 10.

Purchased at the Gift Shop, Vancouver Museums and Planetarium Association, British Columbia, May 1983.

355

MASK, 1979
Red cedar, cedar bark, paint, smoked buckskin
11⅛" h. x 16⅞" l. x 8" d.

Art Thompson
Westcoast (Nitnat)
Resident at Neah Bay, Washington

This mask represents the Thunderbird, one of the persona of the Klukwalla winter dances. Though the Thunderbird is widely believed in across much of North America, his most dramatic portrayals are among the Westcoast and Kwagiutl Indians. The carving of the mask was specially motivated. Art Thompson saw a photograph of an old "Nootka" mask in a museum catalogue* and felt inspired to make his own version of it for re-entry into the culture. He is not copying here, but paying a conscious act of homage to the ancients, linking past and present in the time-honored Indian way—emulation.

The two boards forming the sides of the mask are exquisitely formed and stitched together. The painting of Thunderbird's features has a planar style that complements the flatness of the boards.

*Wolfgang Haberland, *Donnervogel und Raubwal: Indianische Kunst der nordwest Küste Amerikas* (Hamburg: Museum für Völkerkunde, 1979), p. 74.

Purchased at the Makah Museum Gift Shop, Neah Bay, Washington, September 1983.

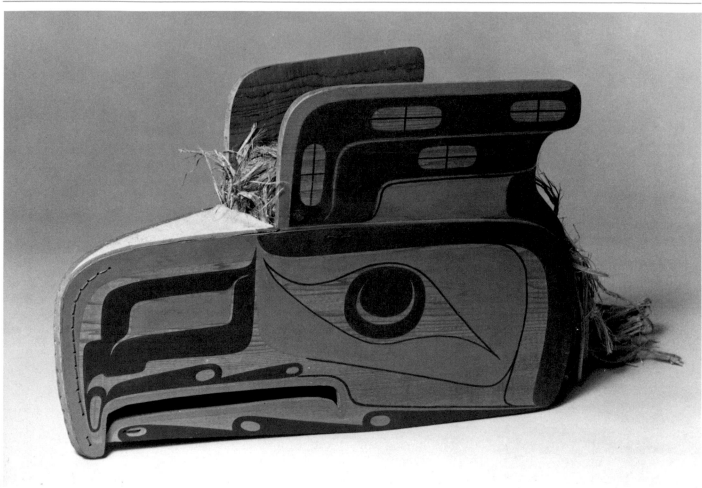

355

356

BELT BUCKLE, 1976
Silver on steel backing
2¾" h. x 4¹⁄₁₆" w.

Russell Smith
Kwagiutl
Alert Bay, Vancouver Island, British Columbia

Russell Smith is one of the most accomplished Kwagiutl jewelers working today. This is one of his early pieces, influenced by the Pan-Indian fashion for buckles, since this type of buckle was not worn on the Northwest Coast in olden times. The design, although somewhat heavy, is very traditional in concept. It represents a bear seen both frontally and from the side. Some years after the buckle was purchased Russell Smith noted: "I don't work like that today. I don't use heavy steel backings anymore, and my designs are more varied."

Purchased at the Gift Shop, Vancouver Museums and Planetarium Association, British Columbia, August 1977.
Collection Reverend Thomas W. Wiederholt, Kansas City, Missouri.

357

MASK AND RATTLE, 1982
Wood, paint, rope, cord, imitation fur
Mask 16½" l. x 8⅜" w. (at ears); rattle 11" l. (including handle) x 4" w. (including rope trim)

Bruce Alfred
Kwagiutl
Alert Bay, Vancouver Island, British Columbia

This mask and rattle, representing wolf and raven respectively, with their strongly carved, longitudinally aligned features and brightly contrasted surfaces completely covered in red, white, and black enamel, are typical pieces executed in what could be called Alert Bay Kwagiutl style.

Bruce Alfred, in his thirties, has worked at carving since 1978, with Douglas Cranmer, then Richard Hunt (cat. no. 361). He also makes tubular, painted Southern Kwagiutl rattles, kerfed boxes, and carved wood plaques.

Purchased at the Gift Shop, Vancouver Museums and Planetarium Association, British Columbia, May 1983.

358

MASK, 1983
Yellow cedar, paint, metal screws
13½" h. x 10½" w.; projection of horns approximately 15"
(see colorplate, p. 274)

George Hunt
Kwagiutl (Fort Rupert, British Columbia)
Resident at Victoria, British Columbia

This dramatic mask depicts Komoqua, King of the Sea and Lord of the Undersea World, where he lives with his subjects on a vast ledge beneath the waters. George Hunt has based his mask on an older one in the collection of the Provincial Museum at Victoria,* with which his family has long been associated.

*See Audrey Hawthorn, *Art of the Kwakiutl Indians and Other Northwest Coast Tribes* (Vancouver: University of British Columbia Press/Seattle: University of Washington Press, 1967), fig. 310.

Purchased at the Museum Gift Shop, Provincial Museum, Victoria, British Columbia, September 1983.

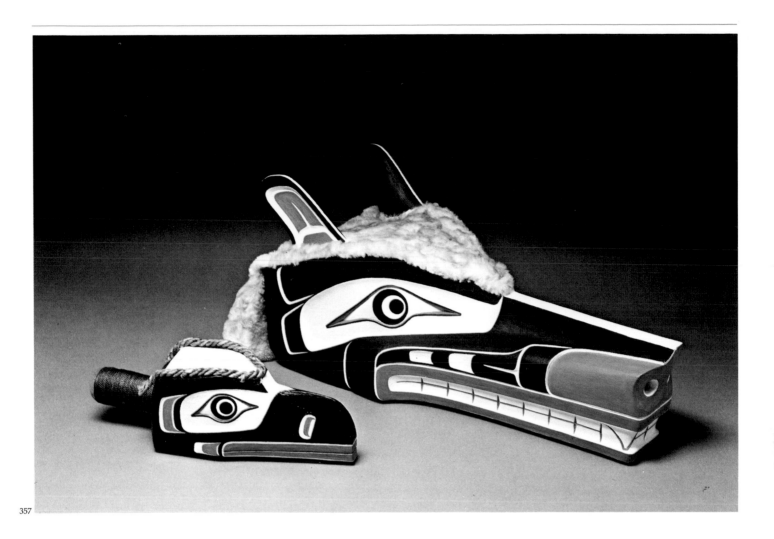

357

359

MASK, 1983
Yellow cedar, paint
8¹³⁄₁₆″ h. x 8⅝″ w.; projection of sunbeams 17″
(see colorplate, p. 274)

Henry Hunt
Kwagiutl (Fort Rupert, British Columbia)
Resident at Victoria, British Columbia

This dynamic circular mask with its projecting
fingers represents the sun. Such masks were a
feature of family history displays, since the sun
has little role in Kwagiutl myths. Sometimes
the Kwagiutl make transformation masks on
this theme, with an outer mask opening out-
ward by the pulling of strings to reveal an inner
image. The sun was a beneficent image asso-
ciated with wealth. It was not a crest from
which clan descent was figured.

Henry Hunt has served as master carver to
the Provincial Museum at Victoria, a position
first held by the famous Kwagiutl carver, the
late Mungo Martin.

Purchased at the Museum Gift Shop, Provincial
Museum, Victoria, British Columbia, September
1983.

360

MODEL CANOE, ca. 1978–80
Wood, paint
25⅜″ l.

Maker unknown
Kwagiutl
British Columbia

"There is no way to tell who made that canoe,"
said the anthropologist consulted at the
University of British Columbia Anthropology
Museum. "Our records show that we bought it
from a co-op in Ottawa, so it came back here
from the East." Such a "history" underlines the
frustrations of tracing origins and names in the
sphere of Indian trade once the object has left
its place of origin. Nonetheless, this canoe
model stands on its artistic merit alone. Its
adzed hull carries elegantly designed represen-
tations of the powerful Sisutl, the Kwagiutl
mythical double-headed serpent. A double
stacked thwart is holed for a mast, used to step
a broad sail—though whether the mast, or oars,
were originally provided with this model is not
known.

Magnificently sculpted large canoes
marked the high point in carving dugouts in
Indian North America. Their gradual dis-
appearance from Northwest Coast waters soon
after 1900 was a tragic loss to the native cul-
tures. Recently Norman Tait, the Nishga artist
and carver, made a full-size canoe and used it
on the waters of the Nass River (see ch. 4). Per-
haps the commanding lines and clipperlike
forms of these noble ships will be seen again at
native gatherings, recalling the days when
thirty-five-foot boats of this type carried visi-
tors and dignitaries from villages to potlatch
celebrations.

Purchased at the Museum of Anthropology Gift
Shop, University of British Columbia, Vancouver,
August 1982.

259

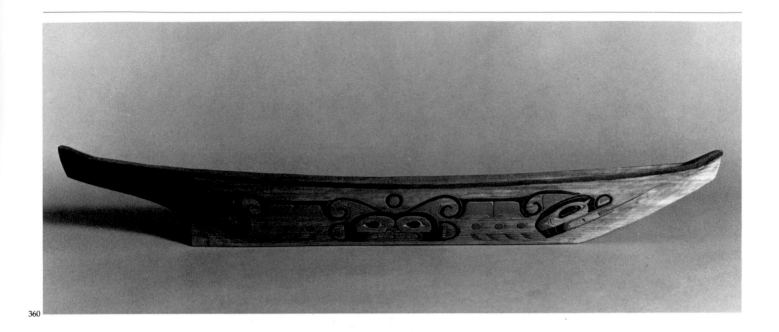

360

361

FRONTLET, 1982
Wood, paint, abalone shell
7⅜" diam. (irregular); projection 4¼"

Richard Hunt
Kwagiutl (Fort Rupert, Vancouver Island)
Resident at Victoria, British Columbia

Frontlets are worn on the forehead at high ceremonial occasions to assert crest privileges and, above all, to indicate the noble status of the wearer. This one was intended to be attached to a red felt trailer headdress (see cat. no. 377) hung with ermine tails and crowned with sea lion bristles. The abalone shell surround not only adds a traditional regal iridescence – like the sun bestowing its blessings – but focuses the onlooker's attention on the raven image in an extraordinary way: the raven seems to be emerging from the sun, blackened from flying too close to it in its beneficent effort to bring light to mankind. Since freshly gathered abalone shell is usually very pale, the deep color of these panels indicates that they were cut from an abalone gathered years ago. "You find them around sometimes in secondhand shops because people buy them up for ashtrays," a Haida woman of Southern Alaska explained.

The Kwagiutl type of frontlet descends from northern examples but employs projecting forms, exemplified here in the thrusting raven's beak. Richard Hunt is no less a master of the expressionistic forms and dramatic linear painted accents that greatly intensify the carved imagery than his forebears.

A member of an extremely distinguished Kwagiutl wood carving family, Richard Hunt was born at Alert Bay, Vancouver Island, but has spent most of his life in Victoria, British Columbia. Now in his thirties, he is the son and pupil of Henry Hunt (cat. no. 359), famous Kwagiutl artist and traditionalist. He has now succeeded his father as Master Carver in Residence at the Provincial Museum at Victoria, a position that has assumed dynastic importance in the maintenance of Kwagiutl artistic culture since 1952, when Mungo Martin, Henry Hunt's father-in-law, came to work on totem pole replication and restoration for the University of British Columbia.

Purchased at the Museum Gift Shop, Provincial Museum, Victoria, British Columbia, August 1982.

362

TUNIC, 1978–79
Felt, abalone shell buttons, plastic buttons
42" l. x 28"" w.
(see colorplate, p. 276)

Jessie Natkong
Haida
Hydaburg, Prince of Wales Island, Alaska

The wind was blowing gale force and sheets of rain were coming down outside the Hydaburg house where Mrs. Jessie Natkong was teaching an evening class in basketry. "Yes," she agreed. "I'll make you a tunic. Do you want a bear design on it like the one in that book?"*

The felt bear appliqué on the tunic is indeed based on the image "in that book."** It was, after all, a brown bear, the crest of Mrs. Natkong's adoptive father, Sukkwan Bob. The paired, leaping dog salmon in green felt below the bear are her own crest design and were added to indicate latter day ownership.

Tunics like this were worn by male dignitaries for crest display at old time "doings." They have long since gone out of fashion, but Mrs. Natkong, nearly ninety when she made this, was old enough to remember seeing them in the great days of elaborate Northern potlatch panoply.

*Referring to Robert Inverarity, Art of the Northwest Coast Indians (1950; reprint, Berkeley and Los Angeles: University of California Press, 1968).
**Ibid., fig. 4.
Commissioned from the maker, November 1978; received April 1979.

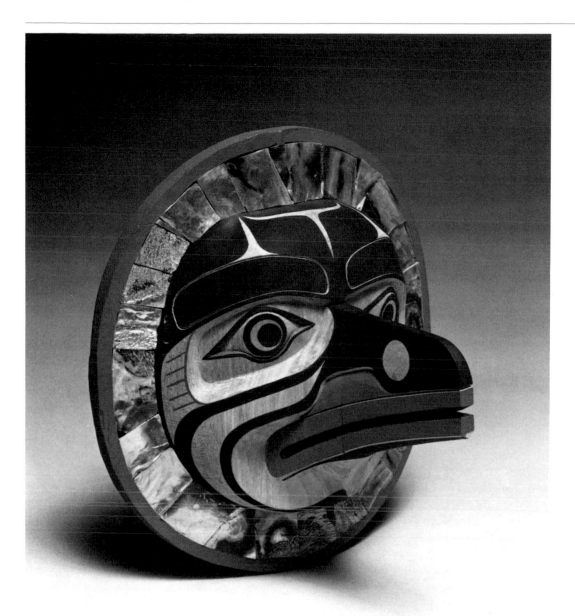

361

363

BUTTON BLANKET, 1982
Hudson's Bay blanket, plastic buttons, shell buttons, dentalium shell, two antique Chinese buttons, felt, cotton thread
60" l. x 51¾" w.
(see colorplate, p. 275)

Robert Davidson
Haida (Masset, Queen Charlotte Islands, British Columbia)
Resident at Surrey, British Columbia

Dorothy Grant
Northern Haida (Prince of Wales Island, Alaska)
Resident at Surrey, British Columbia

Robert Davidson and Dorothy Grant have recently collaborated on several traditional Northwest Coast ceremonial wearing blankets as designer and maker respectively. This blanket was the most striking of those seen. Here tradition is reaffirmed as its vocabulary expands: the cutout border appliqué, allowing the blue background to show, is a new feature, giving added richness to the overall concept, while the dramatic dogfish image, with its asymmetrically balanced fin, body, and tail foreshortened below the head, plays interestingly with old notions of Haida bilateral symmetry of design. There is strict balance here,

but of an occult variety, giving a sense of graphic immediacy heretofore absent in the old examples. The use of dentalium shell to express the dogfish teeth, employment of squared clasp buttons at the top, and inclusion of concealed felt wrist straps are new niceties of execution, showing the executant to be as knowing in artisanship as the artist is in design and concept. Great subtlety has been shown in the gradation of the buttons which echoes the intensity and diminution of the form lines. All told, this is a satisfyingly rich image to which nothing can be added, from which nothing can be subtracted.

Use of trade buttons for blanket designs became customary about 1850. Well into this century old Chinese buttons were especially favored. Two of these have been incorporated on the dogfish's forehead in conscious remembrance of the past (fig. 2), giving this innovative blanket additional symbolic value.

Purchased at the Gift Shop, Vancouver Museums and Planetarium Association, British Columbia, August 1982.

364

CYLINDRICAL LIDDED BASKET, 1978
Spruce root
3¹/₁₆" h. x 3⅛" diam.

Primrose Adams
Haida
Masset, Queen Charlotte Islands, British Columbia

"You've got to come over early before the doings begin and meet a basket maker who's only been working a short time but she's good," said Dolores Churchill, daughter of renowned Haida basket-making elder Selina Peratrovich (see cat. no. 365) and herself a skilled basket maker. "She's learned from mother and Florence Davidson and can do split work like you wanted" (see cat. no. 365). In split work the strips of already processed spruce root are pulled apart once more to make thinner strands, which produces a closer, fine-scaled weave. Only the most skilled weavers do this.

I found Primrose Adams at her sales table in the community house at Masset, which was being readied for the Charles Edenshaw Memorial Potlatch beginning that evening (see ch. 2). She sold me her twenty-third basket. Mrs. Adams has since gone on to become one of the few specialists making the finest Northwest Coast basketry.

Purchased from maker, November 1978.

364

365

SMALL CYLINDRICAL LIDDED BASKET, 1977
Spruce root, natural and commercial dyes
2⅞" h. x 3⅞" diam.

Selina Peratrovich (deceased)
Haida (Masset, Queen Charlotte Islands)
Resident at Ketchikan, Alaska

In her mid-nineties Selina Peratrovich was the dean of Haida Northwest Coast basket makers. She learned her craft from her mother-in-law. Her childhood was spent at Masset (Queen Charlotte Islands, British Columbia) and Howkan (Prince of Wales Island, Alaska); thus, she was known to both the Alaskan (Northern) and Canadian Haida groups and was often asked, as one of the leading dignitaries of the tribe, to speak at potlatches. An unforgettable impression was conveyed by the sight of Selina Peratrovich in an evening gown, addressing a potlatch gathering in eloquent Haida on native traditions from the perspective of great age while winter gales howled outside and rattled

the roof of the community house. She demonstrated basket twining far and wide and won many prizes, among them first prize at the Anchorage Historical and Fine Arts Museum (1973) and a blue ribbon at the Heard Museum (1974). Although the basket shown here is made from split spruce, she also worked in cedar bark. The red dye used here is from huckleberries (gathered with family and friends); the blue dye is commercial.

At the time of the *Sacred Circles* exhibition held at the Nelson Gallery of Art in Kansas City in 1977, Mrs. Peratrovich was asked through her daughter Dolores Churchill (also an accomplished basket maker) if she would make a basket in the difficult and refined split root technique. "No," was the response. "She is too old now to do that; do not ask her." Yet, late in the fall of 1977 this rare split-spruce root example of her work arrived in the mail. The running-guilloche motif was her hallmark in recent years, making her baskets easy to recognize.

Purchased from the maker, December 1977.
Private collection.

366

GOLD BRACELET, 1981
Gold
3⅜" l. x 1" w.
(see colorplate, p. 276)

Robert Davidson
Haida (Masset, Queen Charlotte Islands, British Columbia)
Resident at Surrey, British Columbia

Bracelets wrought from precious metals have been prestige items along the Northwest Coast since the 1880s. Even today a Haida family often has a treasure trove of them.

Robert Davidson's great-grandfather Charles Edenshaw is credited with perfecting the Northwest Coast bracelet as we know it today. Although most bracelets were made of coin silver (no longer the case), Edenshaw is

365

367

credited with an occasional gold bracelet. Robert Davidson, on the other hand, has made about "twenty-odd" gold bracelets to date. In this example, the hummingbird crest is skillfully interlocked by "sliding" the birds' long bills over one another to form the bracelet's central design feature. ("The hummingbird isn't really a crest," the artist explained, "it's a sort of good-luck thing for me.") The bodily parts seem to overwhelm the whole, a Northwest Coast convention carried by Davidson to new heights of innovation and synthesis.

Davidson's gold and silver work stands almost without peer in a medium already rich in contemporary productions. Because each of his bracelets is rethought afresh from conception to execution, he avoids the stereotyping natural in the use of Northwest Coast design elements, in which the vocabulary is highly standardized.

Purchased at the Gift Shop, Vancouver Museums and Planetarium Association, British Columbia, February 1981.

FRONTLET ON CAP, 1982
Wood, ivory, abalone shell, copper, commercial leather cap
7" h. x 4¼" w. (expandable)

Fred Davis
Haida
Masset, Queen Charlotte Islands, British Columbia

This striking frontlet depicts a dogfish with forehead arched above the face, sharp pointed ivory teeth in an aggressively opened mouth with tongue protruding, very much like that in Jim Hart's mask of the same subject (cat. no. 369). The confrontational aspect of the design is most striking when the frontlet is actually worn, when its effective heraldry becomes truly awe inspiring despite the small dimensions. At close range its exquisitely carved features win renewed admiration, as in the case of fine jewelry.

Fred Davis is a much respected young argillite carver with a large production already to his credit. This, however, is his first effort at wood carving. His lapidary training in argillite has served him well here in delicacy of formal restraint; in the polished finish of the abalone-shell elements in eyes, nostrils, and fin; and the remarkably smooth joining of the bone eye-slits to their abalone surrounds. All this finesse imparts an aspect of eerie monstrosity, sharklike and darting, despite the elegance in execution. This added tension between animalistic implacability and stylistic refinement often produces the most convincing Haida images, even more today than in the past.

The yellow leather cap is a different treatment from the old-style frontlet crown (cat. nos. 373 and 377).

Purchased at the Gift Shop, Vancouver Museums and Planetarium Association, British Columbia, May 1982.

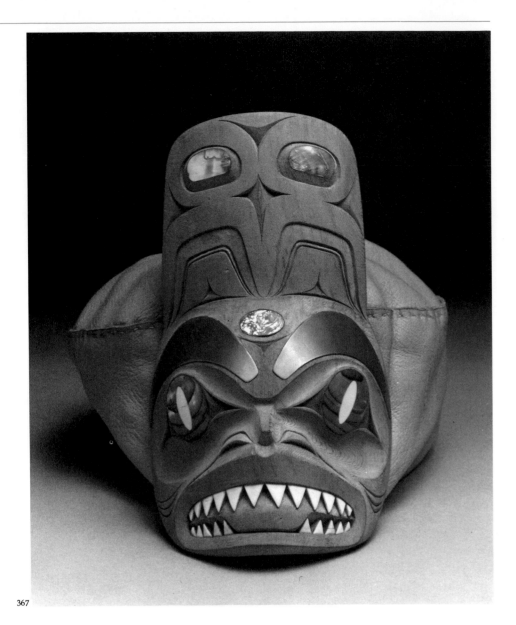

367

368

PAIR OF HOUSEPOST MODELS, 1976
Red cedar
each 13⅛" h. x 3½" w. (at base)

Robert Davidson
Haida (Masset, Queen Charlotte Islands, British Columbia)
Resident at Surrey, British Columbia

In July 1978, when visiting Masset, I heard the sound of adzes coming from a shed by the shore of the Masset Inlet. Investigation revealed two red cedar totemic houseposts with crest designs roughed in and some features already refined. Astride the huge posts were two small models, which the sculptor and his assistants were using as points of reference. I had stumbled onto one of the most extraordinary projects of Northwest Coast Indian artistic resurgence: an old-style plank house built by Robert Davidson with the support of a Parks Canada grant as a memorial to the legendary Charles Edenshaw, Davidson's great-grandfather and the best-known Haida carver from the turn of the century. The matched posts were an interior support system for the Longhouse.

In November the potlatch dedication was held for the nearly completed house, now with a carved and painted façade in place, which had been adapted (and greatly enlarged) from a chief's seat by Charles Edenshaw (in the Provincial Museum, Victoria, British Columbia), and only part of the roof still lacking. The new posts were temporarily raised on the stage of the Masset Community House amid feasting and speeches by Haida dignitaries. The next day the posts were raised permanently in the Edenshaw Memorial House with more speeches and a consecration procession around the exterior. In 1980 the house was totally destroyed, a victim of arson. The real loss was not only to the Haida, but also to the world at large, for the Edenshaw Memorial House was one of the most significant Indian art projects of our time, with regard to both tribal continuance and modern creativity. Of its grandeur only these precious, intricately composed small models remain.

The post at left refers to the eagle, one of the two major divisions to which all the Haida belong (the other being the raven). At the base is a human face, which serves to form the eagle's tail. The face is a "joint design" (a filler motif), according to the artist. A frog (a sub-crest of the Eagles*) is splayed on the eagle's chest, and above him is a legendary owlish half-human bird that whistles in the night but which is seldom seen, called Lia.**

The post at the right refers to the legend in which the killer whale kidnaps a man's wife. The wife is seen at the bottom of the post; above her is the killer whale whose dorsal fin projects like a spine above the nose of the husband. Above the husband are the pectoral fins of the whale, with eyelike joint designs, between the terminations of which sits the raven, at the top of the post. Since the killer whale is associated by the Haida with their raven division, both sides of the tribe's organization (phratries) are represented by the matching houseposts. "This is unusual," says Robert Davidson, "since in the old days in a Longhouse occupied by [an extended] family you'd show only your own animal, but this project was for all the Haida."

Now the famous rows of beach front houses with the old totem and mortuary poles have departed the Northwest Coast and contemporary economics makes impossible wholesale crest display in the old totem pole manner, hence the unified concept used by Davidson. This type of thinking also invests Eli Gosnell's conception of an all-Nishga pole (cat. no. 382).

*Charles Edenshaw was head chief of the Stastas Eagles from Kiusta, Queen Charlotte Islands.
**Davidson found him mentioned in John R. Swanton, *Contributions to the Ethnology of the Haida*, Memoirs of the American Museum of Natural History, vol. 5 (New York, 1909), p. 139 and pl. 16, figs. 2 and 3.

Collection Robert Davidson, Surrey, British Columbia.

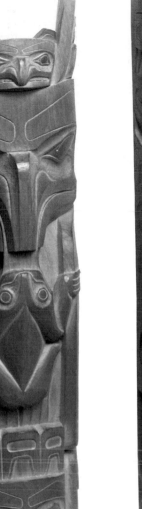
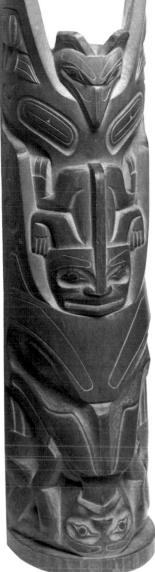

368

369

MASK, 1981
Red cedar, paint
12¼" h. x 9½" w.
(see colorplate, p. 280)

Jim Hart
Haida (Masset, Queen Charlotte Islands,
British Columbia)
Resident at Vancouver, British Columbia

This dogfish mask is the first mask carved by
Jim Hart, who has served as an assistant to the
Haida master sculptor Bill Reid. His first inde-
pendent work was a monumental carved relief
panel, also displaying a dogfish, which has
become a permanent feature of the continuing
exhibition of contemporary Northwest Coast
Indian art installed in the Provincial Museum
at Victoria. In this dogfish mask, through
swelling curves and a firm containment of
dynamic ascendant features—jaws, nose, eyes,
gills, and nostril crown—Hart has created a
masterwork in which tensions in form manifest
a wild state of mind, for "that," according to
the artist, "is what masks should do."

For sheer definition and strength of han-
dling, one cannot fault this carving, one of the
most powerful of recent Haida masks since
Robert Davidson's classic dogfish mask of 1974
(Provincial Museum, Victoria).* Here, as in
Davidson's mask, the sharklike creature re-
emerges from a spreading underwater cavern,
coming upward from the depths to shake the
very being of landbound men. Like Albrecht
Dürer, Robert Davidson in the prototype mask
felt the need to eliminate color completely and
concentrate on form. Like Matthias Grüne-
wald, Jim Hart has restored color—red and
black—in his more agitated, expansive variant.
Thus, the sense of confrontation is even more
immediate. The fine grain of the patterns in
Hart's mask are symmetrical, down to the
finest nuances in the widely opposed eye sock-
ets, so color accents do not interfere with the
smooth balance of the exposed wood surfaces.

Even the roof of the creature's mouth, behind
the jagged teeth, is carved in a paddlelike
extension; in an act of visual alchemy, the
dogfish seems able to swallow. The mask was
danced by the artist at a festival celebrating the
opening of an exhibition of Haida argillite work
(fig. 16).**

Although nearly a contemporary of Robert
Davidson, Jim Hart has only recently emerged
as a significant carver. His style is fast coales-
cing. In 1982, a totem pole by him (carved after
an old pole) was dedicated at the Museum of
Anthropology at the University of British
Columbia in Vancouver.

*Peter L. McNair, Alan L. Hoover, and Kevin Neary,
*The Legacy: Continuing Traditions of Canadian Northwest
Coast Art* (Victoria, B.C.: Provincial Museum, 1978),
fig. 66.
**Pipes That Won't Smoke, Coal That Won't Burn, exhibi-
tion catalogue (Calgary, Alta.: Glenbow Institute,
1981).

Purchased from the maker through the Gift Shop,
Vancouver Museums and Planetarium Association,
British Columbia, January 1982.

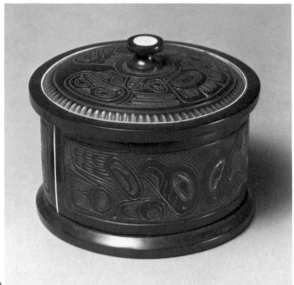

370

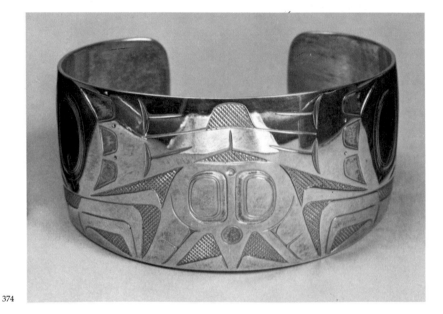

374

370

Round lidded argillite box (pyxis), 1978
Argillite, button ivory
2¼" h. x 2¾" diam.

Henry White
Haida
Masset, Queen Charlotte Islands, British
Columbia

At the potlatch on the occasion of the dedication of the Charles Edenshaw Memorial (see cat. no. 368) in November 1978, master argillite carver Henry White, a tall, angular man, took from his pocket a small cylindrical box, a specialty of this artist,* on which a carving had only just been started. He promised to finish it and send it on. This small pyxis is endowed with an all-around "eagleness": there is an eagle with wings outspread and tail fanned out around the inlaid knob, and four pairs of eagles are finely engraved in full profile upon the two curving side panels.

*For a similar piece, see *Pipes That Won't Smoke, Coal That Won't Burn*, exhibition catalogue (Calgary, Alta.: Glenbow Institute, 1981), p. 191, no. 153.
Purchased from the maker, November 1978; received spring 1979.

371

Argillite lidded box, 1977
Argillite
Box 4⅜" h. x 8" w. x 3⅛" d.; lid ⅜" h. x 8½" w. x 4" d.

Pat Dixon
Haida
Skidegate, Queen Charlotte Islands, British
Columbia

Haida argillite is found only at Slatechuck Mountain on Graham Island in the Queen Charlotte Islands and has been carved for trade or for sale since the 1820s. The Indians have sole rights to the quarry. Small argillite boxes, suggested by the larger "kerfed," or bent-wood, strong boxes traditional on the northern portion of the Northwest Coast, have been fashioned since the 1880s. In fairly recent years, argillite carving had become increasingly stereotyped in execution, routine and dry in its lack of inspiration; since the late sixties, however, it has become invigorated by a younger generation.

This work by Pat Dixon, a former protégé of the Skidegate argillite carver Pat McGuire, who died tragically early in 1978, carries on his teacher's high standards, carving argillite as a specialty with great skill and sense of design. The box is a stellar example of the dual revival of competence and imagination in contemporary argillite work. On its lid is depicted Wasco the sea monster, part bear and part sea mammal (note the fin on his back before the springy arch of his tail). On the ends of the box are the heads of a wolf and a bear in profile, the latter with larger front teeth. The front and back of the box have intricately carved reliefs after the scenes on old large wooden box fronts, though no single old example is evidently copied here. Remarkable in the craftsmanship of this box is the pervading element of control, which makes the form-creating lines smooth, clean, and clear, and never subordinate to masses of detail. That is why the planar surfaces read so well despite the complicated patterns and sub-patterns. Nowhere in the thread linking subordinate lines to form lines is overall proportion

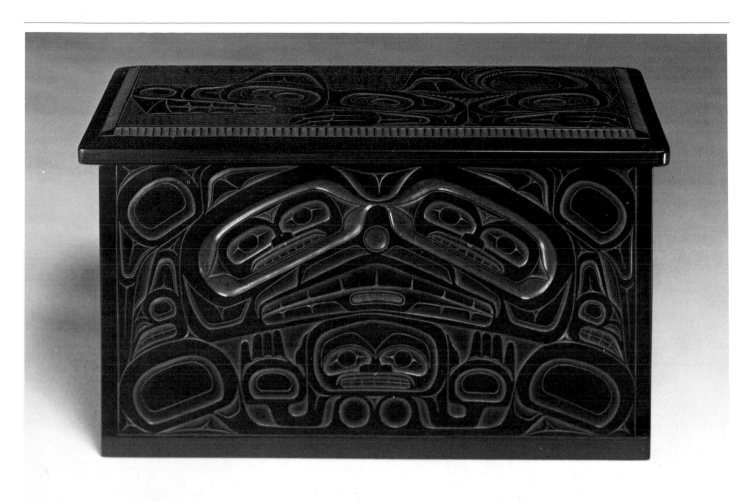

371

372

lost. The stippled effect on the lid suggests traditional adze carving on wood, but as it appears here the transfer is original with the artist.

Some of the Haida argillite carvers periodically leave the Queen Charlotte Islands to carve in southern British Columbia, particularly Vancouver, where there is a ready market for their work. In so doing they are following the precedent of earlier carvers. The often reproduced "bear mother" argillite carving in the Smithsonian Institution* was finished on shipboard in 1882 after having been begun in Victoria, British Columbia, and Robert Davidson, grandfather of the contemporary artist of the same name (see cat. nos. 363, 366, 368) used his argillite carvings in Vancouver to post a loan for house building materials in 1952.**

*See Frederick J. Dockstader, *Indian Art in America* (Greenwich, Conn.: New York Graphic Society, 1961), pl. 113.
**Margaret P. Blackman, *During My Time: Florence Edenshaw Davidson, A Haida Woman* (Seattle: University of Washington Press, 1982), p. 122.

Purchased at the Gift Shop, Vancouver Museums and Planetarium Association, British Columbia, August 1978.

RATTLE, 1983
Alder and birch wood, paint, human hair, silk thread, Indian-tanned ties, smoked hide, silk
Rattle 12″ h. x 3⅜″ w.; case 13″ l. x 3⅞″ diam.
(see colorplate, p. 279)

Victor Reece
Coastal Tsimshian (Hartley Bay)
Resident at Prince Rupert, British Columbia

This is the most beautifully carved rattle seen in five trips to the Northwest Coast between 1977 and 1983. During that period Coastal Tsimshian work has resurged, and the refined old-style jewelry-like carving is now seen again. In 1967 there were no new totem poles in Prince Rupert; in 1983 there were two. In addition, there was a bustling community of artists, aware and enterprising, and a whole positivism the community had lacked before. A group of younger artists, including Henry

Green, Dale Campbell, Dempsey Bob, actually Tlingit/Tahltan (cat. no. 383), and Victor Reece produce work that perhaps links most closely to the old style with its smooth surfaces and triangular facial forms (nose and mouth) so characteristic of the area. No work by Victor Reece was available in Prince Rupert, where he lives; this exquisite shaman's rattle, so particular in its delineation, and so different from Nishga and Gitksan work, was found in Vancouver.

The whiteness of the rattle emphasizes the representation of death. The case is part and parcel of the concept, like a casket with red silk lining for a rattle too delicate to breathe the outside air. It is personalized by the artist's name (short form) in cutout smoked hide applied to the inside lining. This rattle and its casket are, in fact, two of the most highly personal works in this collection.

Purchased at the Gift Shop, Vancouver Museums and Planetarium Association, British Columbia, September 1983.

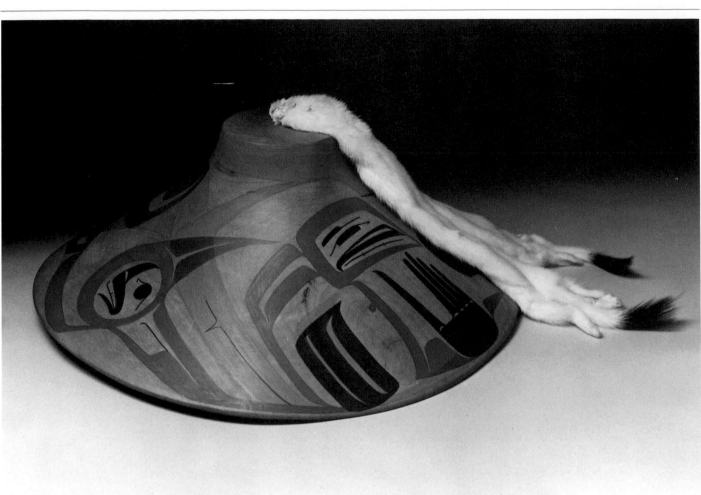

375

373

FRONTLET WITH HEADDRESS, 1981
Wood, paint, abalone shell, ermine
Frontlet 7½" h. x 5¼" w.; headdress 28" l. x 8"
diam. (irregular)
(see colorplate p. 278)

Gerry Dudoward
Coastal Tsimshian
Port Simpson, British Columbia

Gerry Dudoward is a member of a Tsimshian carving family whose work includes about eight of the reproduced poles that dot the central area of Prince Rupert, British Columbia.* Like theirs, Gerry Dudoward's reputation is localized to the coastal town in which he lives and works. Indeed, this delicately carved bear frontlet is so purely Coastal Tsimshian in style that it could have been made before the turn of the century. It is a purebred holdover, though no direct prototype seems to exist in either the collections of the Museum of Northern British Columbia in Prince Rupert, or the smaller museum at Port Simpson. Some such model may well exist, however.

*These poles are free copies of old ones and were set up as tourist/cultural attractions. The WPA in Alaska embarked on a similar program during the 1930s and forties, salvaging and copying old poles, which are seen today at Ketchikan, Klawock, Wrangell, and Hydaburg.
Purchased at the shop of the Museum of Northern British Columbia, Prince Rupert, September 1983.

374

SILVER BRACELET, 1981
Bar silver
3¼" l. x 1¼" w.

Earl Muldoe
Tsimshian (Gitksan, Kispaiox, British Columbia)
Resident at Hazelton, British Columbia

Earl Muldoe is one of the artists who has greatly matured on his own after an initial exposure to Northwest Coast art style at the 'Ksan School at Hazelton, British Columbia. The school was founded largely through the vision and foresight of Mrs. William (Polly) Sargent, wife of the local hotel proprietor and trader, who was the son of one of the first white settlers in this part of the province. Earl Muldoe's jewelry (he is also a master carver and printmaker) had taken advantage of soldering techniques (soldering edges, granulation) that he learned while attending a jewelry symposium for native artists and craftsmen held in 1974 in Vancouver. The increased technical vocabulary has been assimilated into his work completely, notably in the making of small gold and silver boxes of exquisite quality. The more his facility in working precious metals increases, the more "Indian" Muldoe's work becomes.

In the bracelet shown here, his most conservative aspect is seen. It is a traditional bracelet with his personal design, the flying frog, engraved in delicate, succinct bilateral relief across the outer face of the metal.

Purchased at the Gift Shop, Vancouver Museums and Planetarium Association, British Columbia, 1981.

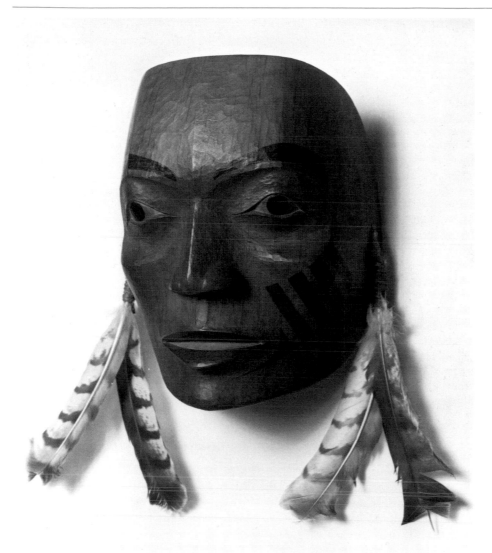

376

375

CLAN HAT, 1983
Red cedar, paint, ermine tails
7" h. x 6¼" diam. (at lower rim)

Vernon Stephens
Tsimshian (Gitksan)
Hazelton, British Columbia

Alone among the carvers of 'Ksan, Vernon Stephens believes that the stories and legends are not the property of individuals, as in the past, but are owned by all the people and free for artists to use. He has built an important narrative painting style around this belief in association with his carving. Both mediums come together harmoniously in this clan hat which would have been worn as a prestige symbol, with only the animal crest, to which one had established right, portrayed. Stephens is particularly noted for his carved storage boxes.

Purchased at the 'Ksan Association, Hazelton, British Columbia, August 1983.

376

MOURNING MASK, 1979–80
Wood, feather ties
8⅞" h. x 7¾" w.

Ken Mowatt
Tsimshian (Gitksan, Kispaiox, British Columbia)
Resident at Hazelton, British Columbia

Of the portrait type, this mask is worn on the forehead, since it has no eyeholes. The simplicity of the mask is deceptive. It is by one of the most sensitive of present-day Northwest Coast artists, whose work attains a serenity that is slightly astringent in its purity, and which at first glance is denied full appreciation due to its seeming simplicity. Actually, Ken Mowatt's work is an engagement of the highest standards, an effortless purity of form, line, and conception.

Purchased at the Gift Shop, Vancouver Museums and Planetarium Association, British Columbia, November 1981.

377

FRONTLET WITH HEADDRESS, 1982
Wood, abalone shell, paint, red blanket wool, ermine tails
Frontlet 6¼" diam.; headdress 26½" l. x 9¼" diam.
(see colorplate, p. 278)

Chuck Heit
Tsimshian (Gitksan)
Kispaiox, British Columbia

This wooden frontlet, with its waxed finish, roughly cut abalone shell plaques, and painted red and black accents is in sharp contrast to the Haida frontlet by Fred Davis (cat. no. 367). Here the moon is depicted in a very human guise; it looks even a bit sad, though projecting effectively to suffuse mankind with its abalone shell "beams." The red outer border harmonizes with the shoulder-length red blanket headdress. One wonders whether this piece was not meant to be used rather than sold, since the fashioning of a nearly complete ermine-tail headdress (by the artist's mother, herself a fine button-blanket maker) entailed a great deal of money and work. Only a stand of sea lion bristles projecting above the crown needs yet to be added, or was this the one touch of incompleteness that made a sale ethically possible?

Purchased at the Gift Shop, Vancouver Museums and Planetarium Association, British Columbia, August 1982.

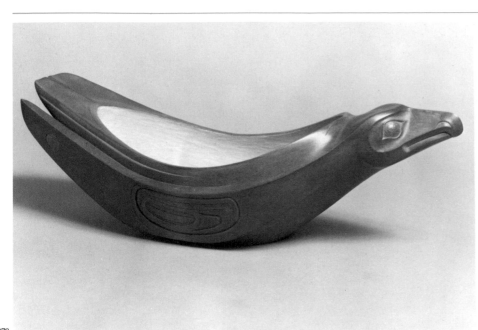

378

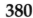

379

378

Bowl, 1980–81
Yellow cedar, stain
5" h. x 16" w. x 7" d.

Ken Mowatt
Tsimshian (Gitksan, Kispaiox, British
Columbia)
Resident at Hazelton, British Columbia

This graceful and magnificently poised eagle
feast dish is highly traditional in feeling and
concept, except that old examples would not be
sanded smooth and stained. The bowl's in-
terior, however, shows the old style textured
adze marks and is left unstained for contrast.
The flowing curves of this bowl repay study, as
they are the rhythms and designs of a great
carver. (For another example of Ken Mowatt's
carving, see cat. no. 376.)

Purchased at the Gift Shop, Vancouver Museums and
Planetarium Association, British Columbia, February
1981.

379

Speaker's staff (portion), 1977
Wood, copper, abalone shell
35½" l.

Chuck Heit
Tsimshian (Gitksan, Kispaiox, British
Columbia)
Resident at Hazelton, British Columbia

This "talking stick" was a gift to the author
from the Northwest Coast Gitksan group who
officiated with songs and entry dance at the
opening ceremonies of the *Sacred Circles* exhibi-
tion held at the Nelson Gallery of Art in Kansas
City in 1977. It bears a highly original design of
feather motifs carved around the shaft, repre-
senting a raven surmounted by a frog. Among
Northwest Coast peoples these staffs are held
by orators to attest their right to speak at
potlatches, to validate social prerogatives. In
previous times they were thrust forward to
declare war.

Chuck Heit studied with his uncle Chief
Walter Harris of Kispaiox, whose carving and
raising of his totem pole at Kispaiox in 1962
heralded the revival of Gitksan artistic culture.
Heit was nineteen years old when he carved
this stick; for another example of his carving,
see catalogue number 377.

Gift to the author, April 1977.
Collection Ralph T. Coe, Santa Fe, New Mexico.

380

Spoon, 1982
Alder wood
11" l.

Alver Tait
Tsimshian (Nishga, Kincolith, British
Columbia)
Resident at Vancouver, British Columbia

Alver Tait, who specializes in traditional
spoons, studied carving with his brother, the
distinguished artist and carver Norman Tait.
He worked on the totem pole raised at the Field
Museum in Chicago, which was carved by the
Taits to commemorate the opening of the
reinstalled Northwest Coast collection at that
institution (April 1982). Alver Tait has carved
doors and wood panels, and for the 1983 Royal
Visit he carved an alder wood eagle bowl
which was presented to Queen Elizabeth II by
the city of Vancouver.

This beautifully carved spoon, a type used
at traditional feasts, represents the raven who
stole the moon, held here in the raven's beak.
Every contour of the piece is proportioned
with exactitude down to the smallest detail.
Note also the exquisite control of swelling and
diminishing forms exhibited here by this in-
sufficiently known Nishga artist.

Purchased at the Gift Shop, Vancouver Museums and
Planetarium Association, British Columbia, March
1983.

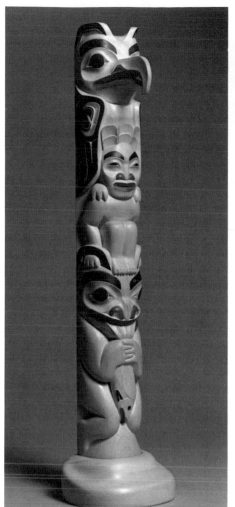

381

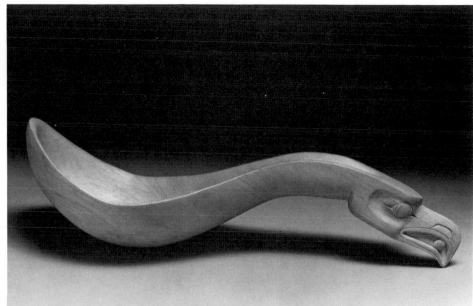

380

381

TOTEM POLE MODEL, 1983
Yellow cedar, paint
21½" h. x 5" w. (at base)

Kenny McNeil
Tahtlan/Nisha (Port Edward, British Columbia)
Resident at Prince Rupert, British Columbia

Kenny McNeil (fig. 4) is a nephew of the distinguished Tlingit/Tahltan artist Dempsey Bob (cat. no. 383) and is being trained by him. As a rule, less experienced carvers are given miniature totem poles and spoons to sculpt. But this pole is not routine. It owes to the teacher's style the undulating sense of form and the peculiarly smiling faces, both animal and human; but personal touches have been added to the family resemblances – in the man's hands projecting through the bear's ears, in the way the stylish eagle's feathers are pointed, like an old Prince Albert – which denote a rising talent, yet to be invested fully with Dempsey Bob's easy mastery of organically related forms.

Purchased from Dempsey Bob's booth at the National Native Indian Artists' Symposium, Hazelton, British Columbia, August 1983.
Private collection.

382

TOTEM POLE (details), 1977
Red cedar, paint
35' h.; 33½" w. x 25" d. (at base)

Eli Gosnell, George Gosnell, Joe Gosnell,
Sam McMillan
Nishga

Tsimshian (Nishga)
New Aiyansh, British Columbia

In 1969, when the Nishga people had been forced to abandon their old village and move across the Nass River to New Aiyansh, it might have appeared that final extinction of the old ways was at hand. A first step in tribal affirmation was taken by the women of the community. "I knew those women were up to something when they quietly offered to make some robes for the acolytes," Reverend McMillan, then Episcopal minister at New Aiyansh, said as he displayed the five magnificent button blankets the women had produced (fig. 40). "What they were really doing was reaffirming the old traditional clan system through the church service." They also made an altar cloth with appliqués of the four Nishga clan symbols.

Following suit, Eli Gosnell, a distinguished elder, undertook the carving of an all-Nishga totem pole. In 1977 this tall pole, a symbol of pride for all, was raised with appropriate ceremony beside the tribal building at New

Aiyansh (fig. 38). No totem pole had been raised in this part of the Nass valley for about seventy years.

The next order of business centered on a traditional clan pole, described as a "family pole." The carving of such a pole would demand funds beyond the resources of any New Aiyansh family, but a patron was found in Larry Hoback, the culturally sympathetic local school superintendent, and his wife, Jeanne, both non-Indians from Colorado. Eli Gosnell again started work in the old-style carving shed he had built beside his house for the carving of the all-Nishga pole. After he died in 1977, the pole was finished by his sons and son-in-law. Ever since, because there were no funds for its dedication potlatch, it lay on its wooden supports (fig. 3). The significance of this pole is that it is an old-fashioned clan pole, Indian generated. Poles of this type, once raised, may not be moved. However, in the Nishga view, this clan pole is not finished, for it lacks ceremonial consecration. Thus, there was the possibility that it might be lent to this project. And, indeed, the offer by the American Federation of Arts of a contribution toward the pole's potlatch upon its return to New

382

383

Aiyansh at the completion of its American tour has made its presence here possible.

From top to base, the images depicted on the pole are: an eagle, a killer whale, a man holding a salmon, a wolf, a grizzly bear, and a beaver, identified by prominent incisors and the stick held in the paws. Although these can be identified now, the story that connects them and which dictated their selection can only be told at the dedication ceremony, set for late 1988.

The New Aiyansh clan pole sets aside innovative considerations altogether. It could have been carved in the nineteenth century, during the heyday of the Nishga. Its images cling to the log with an elemental tenacity that contrasts with the more sophisticated style of most revival poles carved today, even those for Indian usage. Everything about the pole retains this old-time quality. Even the carving shed Eli Gosnell built in the early seventies, in which the pole was carved (fig. 39), shares it. Only in the deep interior valley of the Nass River does this elemental approach survive. Nishga art flourishes today in the hands of master carver Norman Tait and his brothers, inheritors of the tradition preserved untouched by Eli Gosnell, who only left his home territory for occasional visits.

Lent by Larry and Jeanne Hoback, New Aiyansh, British Columbia.

MASK, 1984
Red cedar, hair, sea lion bristle, paint, abalone shell, cowrie shell, Indian-tanned smoked-hide straps
14½" h. x 10½" w.
(see colorplate, p. 277)

Dempsey Bob
Tlingit/Tahltan (Telegraph Creek, British Columbia)
Resident at Prince Rupert, British Columbia

On the day the totem pole model by Kenny McNeil was purchased at the Native Indian Artists' Symposium (cat. no. 381), discussion began with Dempsey Bob about acquiring a piece from him, so that both master and pupil would be represented. This hawk mask is a result of the proposal put forth then.

Functional as it is, this mask is not a dance mask in the usual sense, but is meant to record complex history, which Dempsey Bob explains is "what I've been doing with these masks."

His multifaced masks are combinations of crests and stories. Here eagle and hawk are combined. The hawk is not directly related to his family, but his grandmother was an eagle. "Certain families wear certain masks at the winter ceremony dances to tell the stories that belong to the family history. In twenty years who is going to know? That's why I carved this mask (fig. 5)."

This mask recalls old Tlingit animal masks with their flat foreheads and high cornered ears; at the same time it is a highly original and expressive statement by the artist. The widely spaced forms and use of multiple images in an assertive manner contribute to the expressiveness of style, which also exaggerates the smile often seen on the old Tlingit masks. While the Tlingit part of Dempsey Bob's ancestry is of course stressed here, the Tahltan part is echoed in the careful selection of Indian-tanned smoked-hide wearing straps, sent to the artist by relatives in Telegraph Creek, British Columbia, where the Tahltan live.

Purchased from the maker, fall 1984.

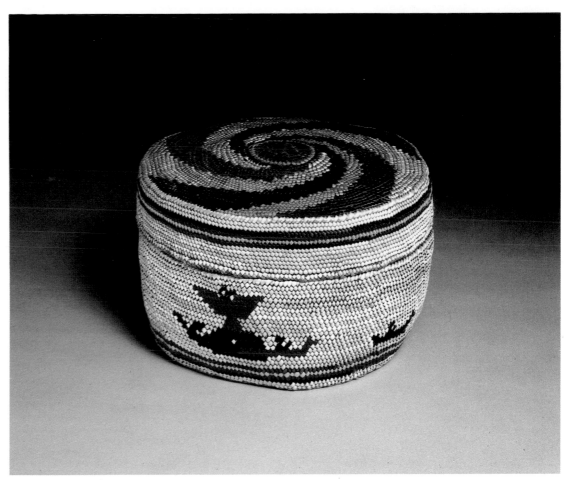

LIDDED BASKET, 1983–85 (Cat. no. 348)

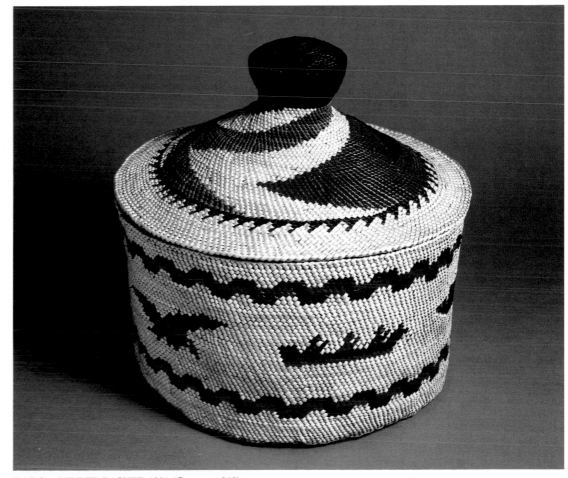

LARGE LIDDED BASKET, 1981 (Cat. no. 349)

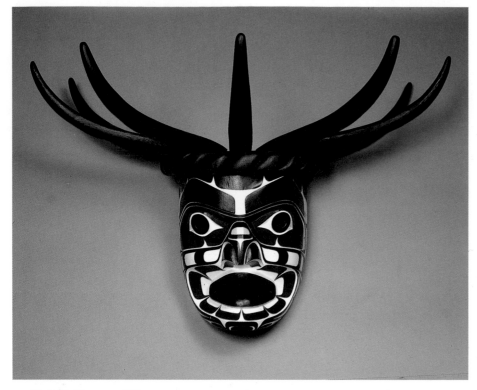

MASK, 1983 (Cat. no. 358)

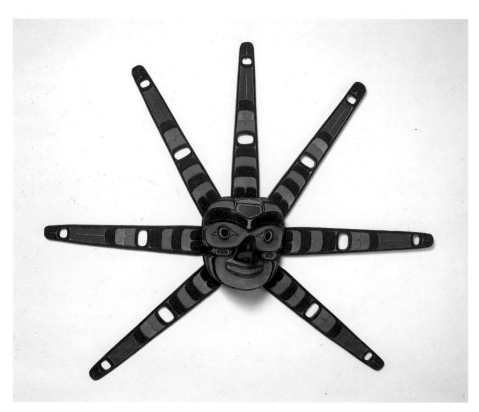

MASK, 1983 (Cat. no. 359)

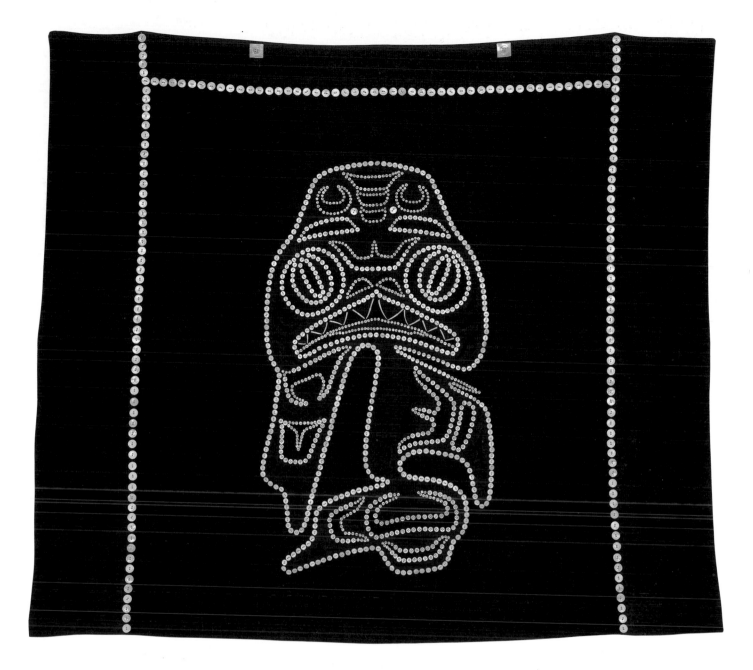

BUTTON BLANKET, 1982 (Cat. no. 363)

TUNIC, 1978–79 (Cat. no. 362)

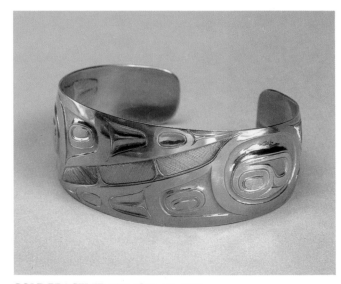

GOLD BRACELET, 1981 (Cat. no. 366)

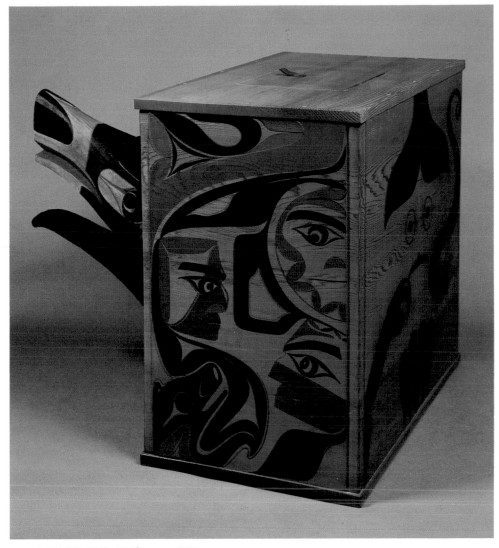

KERFED BOX, 1982–85 (Cat. no. 352)

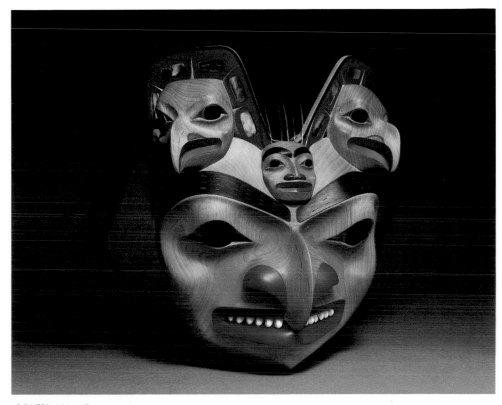

MASK, 1984 (Cat. no. 383)

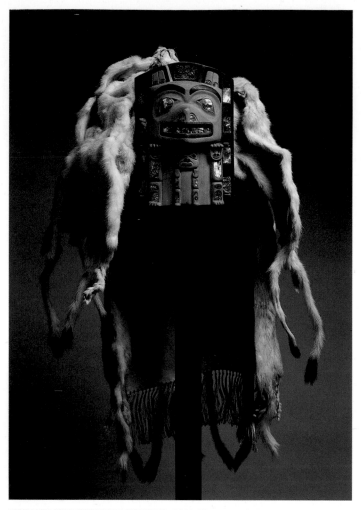

FRONTLET WITH HEADDRESS, 1981 (Cat. no. 373)

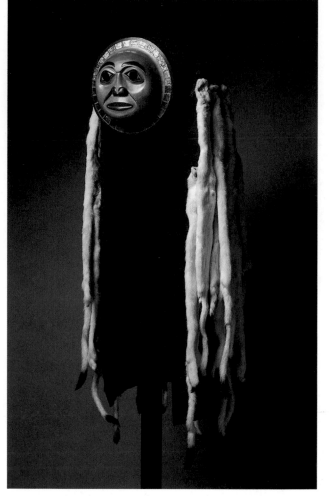

FRONTLET WITH HEADDRESS, 1982 (Cat. no. 377)

278

opposite RATTLE, 1983 (Cat. no. 372)

overleaf MASK, 1981 (Cat. no. 369)

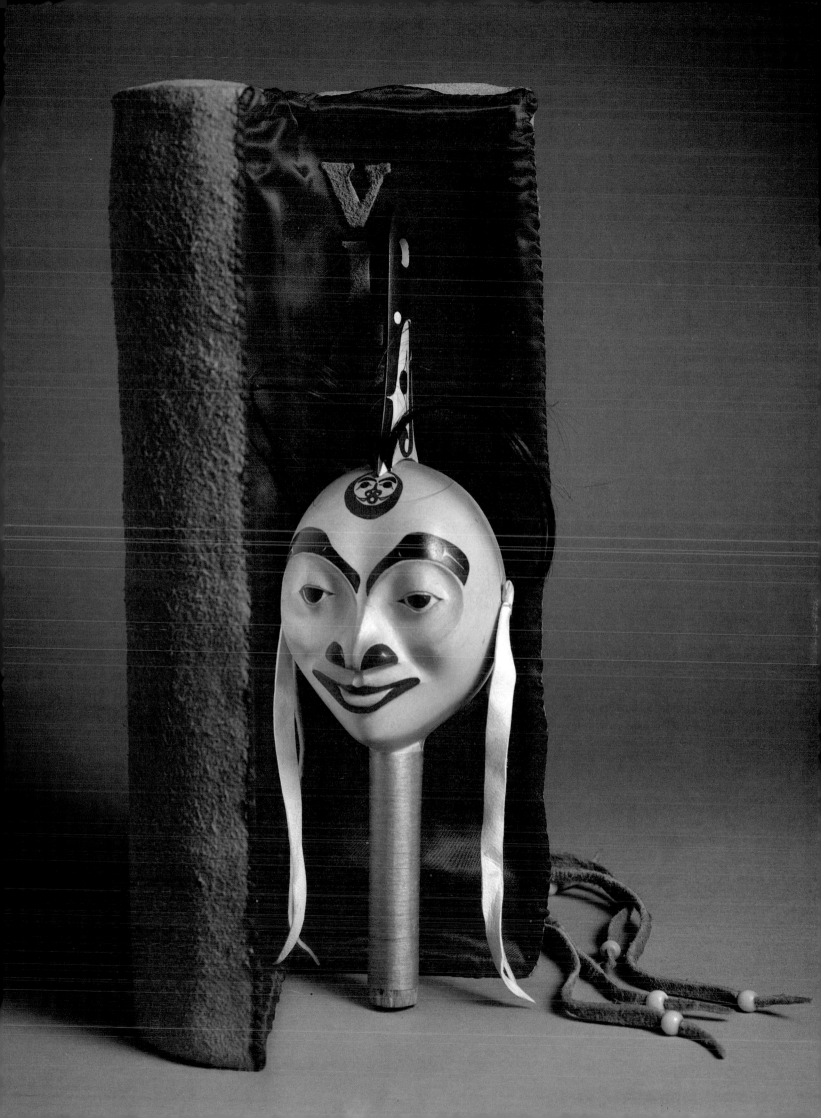

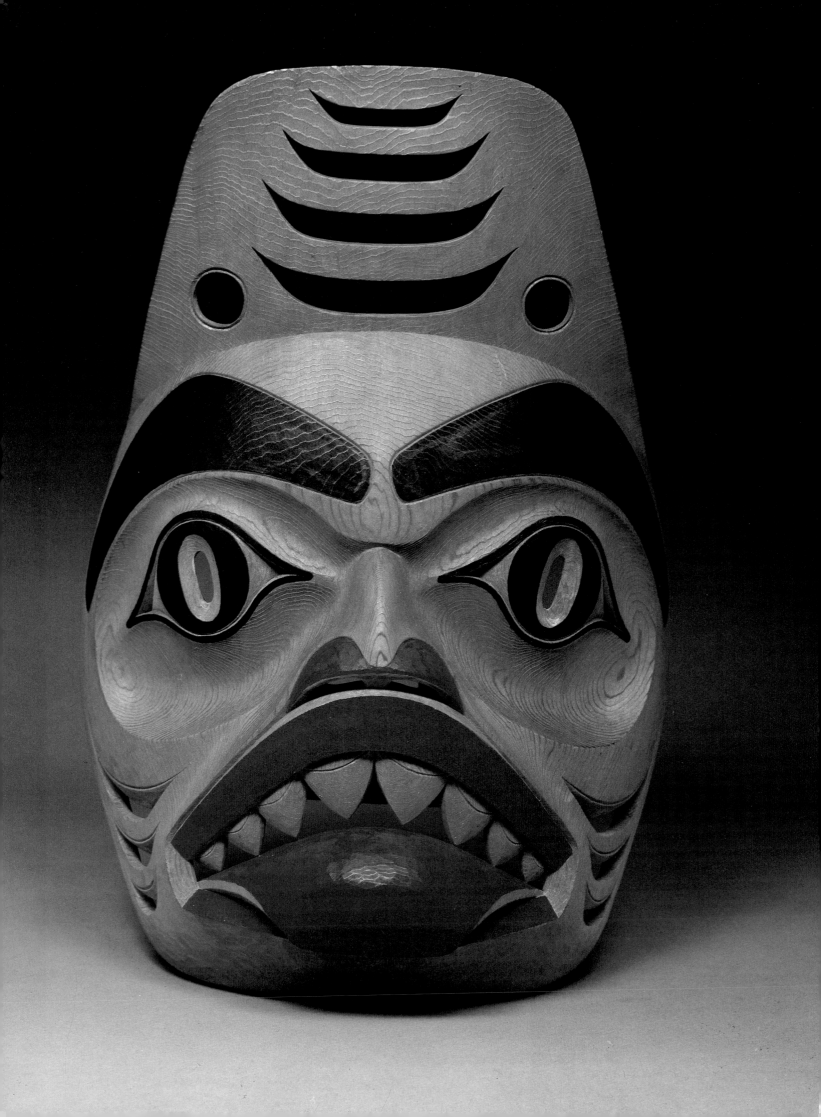

GLOSSARY

argillite A type of rock found at Slatechuck Mountain on the Queen Charlotte Islands, British Columbia, which only the Haida are allowed to mine. It is soft when worked and hardens through exposure to air.

babiche Rawhide lines used for webbing snowshoes, net bags, and toboggans.

band A sub-tribe or homogeneous settlement pattern within the larger tribal group.

bandolier bag A prestige bag with shoulder straps that evolved from the eighteenth/early-nineteenth-century shot pouch into a decorated, beaded item of apparel worn on special occasions, particularly among the Cree and Ojibwa.

banner stone A stone archaeological object having two symmetrical wings which is slipped onto a staff as a symbol of authority or on a spear to serve as a counterweight, dating from the late Archaic Horizon (ca. 1200 B.C.), found in Eastern United States and southern Ontario.

catlinite A slate usually (but not always) red named after the painter/explorer George Catlin. Mined chiefly at Pipestone, Minnesota, it is used in the making of pipes.

coiling A method of making pottery, especially in the Southwest, in which the walls of the vessel are built up by adding successive ropelike coils of clay. Pueblo potters thin, shape, and smooth the walls of the pot by scraping with a smooth implement.

concha Convex silver ornaments, usually round or oval, frequently set on a leather strap and worn as a belt.

coup To touch an enemy or animal with the hand or butt of a weapon or coup stick and return unharmed, considered to be more honorable than killing the victim.

cream tanning A post-World War II development on the Northern Plains involving heavy use of deer brain mordant, which gives hides a "creamy" texture. It is considered elegant and is reserved for finery. (There is also commercial cream tanning.) *See also* Indian tanning.

dung firing *See* firing.

firing The process of baking and hardening pottery. Ground, or dung, firing is the Indian home-style method, accomplished by placing dung chips around pots placed on the ground and protected with pottery fragments, sheet metal, or even license plates, and setting the mass on fire. *See also* kiln firing.

German silver A non-ferrous alloy of copper, nickel, and zinc, also known as nickel silver. A metal of European derivation, it has been widely used by Southern Plains Indians since the middle of the nineteenth century.

gifting Indian custom of giving gifts as an expression of friendship or honoring.

giveaway The ceremony of presenting gifts as a way of honoring the recipient or recipients.

ground firing *See* firing.

hair pipes Tubular lengths of bone (now more frequently plastic) used to ornament items of clothing.

heishi Various types of shell that are cut, drilled, ground, and polished into cylindrical beads.

housepost A post erected in the interior of a Northwest Coast house to support the roof, carved with images that indicate the importance, family ancestry, and social position of the owner.

Indian tanning The preparation of hides by soaking, scraping, and curing with mordant (lime or, preferably, brains) which gives the skins a soft effect (also called "home tanning" and "brain tanning"). Commercial (factory) tanning cannot achieve this since more of the hard upper epidermis is retained. A recently developed method of factory tanning uses brains and some handwork to give the effect of Indian tanning. *See also* cream tanning.

kachina One of the hundreds of supernatural beings that live in the San Francisco peaks, north of Flagstaff, Arizona, for part of the year and in Hopi villages for the remaining time, on ceremonial occasions impersonated by Hopi men attired in masks and costumes. Kachina dolls representing these spirits are carved by Hopi men and given to children as instructive images.

kerfed A method of turning corners in woodwork by incising and bending, at times by means of steam, thereby converting a single board into a box.

kiln firing Baking pottery in an electric or gas kiln, as opposed to traditional firing with dung. *See* firing.

kiva A structure, characteristic to the Southwest, often (but not always) subterranean, which serves as a gathering place for specialized groups or as a closed chamber for the celebration of restricted rituals.

lazy stitch A Plains technique of beading in which a thread is pulled through a number of beads before they are stitched down.

medicine bundle A gathering of various materials to which spiritual power is assigned.

micaceous Clay containing tiny flakes of mica, which give a sparkling appearance to the surface of an object.

naja	A crescent-shaped ornament appended to the bottom of Zuni and Navajo necklaces.
nickel silver	*See* German silver.
Pan-Indian	Pertains to the exchange of culture, ritual, and art forms as a result of the modern ease of intertribal contact.
parfleche	A storage bag, generally of rectangular shape, used to hold clothing, ceremonial gear, or, most frequently, meat (thus frequently referred to as "meat cases").
potlatch	An important Northwest Coast tribal ceremony celebrating such occasions as the raising of a totem pole, the dedication of a new house, validation of a crest, weddings, etc., during which there is a formal distribution of gifts accompanied by speechmaking, dancing, and lavish feasting.
powwow	A modern-day gathering for dancing, socializing, and trade, deriving in part from the Northern Plains Grass Dance, which in time began to take on secular connotations. Powwows can be small or large, tribal or intertribal, and are sometimes called "celebrations," which have in addition a strongly nationalistic as well as spiritual/historical reference.
prehistoric	In terms of American Indian archaeology, the period of Indian life that occurred before the written record. Although usually taken as before 1492, this varies according to locale. Also called pre-Columbian or pre-contact.
pueblo	One of the Indian villages in Arizona, New Mexico, and adjacent regions, which are built of stone or adobe in the form of communal houses, with kivas and plazas for gatherings, ceremonies, and dances. *See* kiva.
quillwork	A painstaking ancient sewing technique that uses dyed porcupine quills, moosehair, or, more rarely, birdquills, in which the quills are sorted, washed, dyed, then softened, usually in the mouth, then flattened, by mouth. The sewing is carried out primarily on the outside of the object, and a variety of stitching decorations has developed.
reservation	A tract of land to which Indians were removed or restricted by government treaties during the nineteenth century. Called reserves in Canada.
ribbonwork	Cutout designs of silk are applied to garments as decoration. Also called silk appliqué or ribbon appliqué.
roach	A construction usually of deer hair or porcupine fur tied to the top of the head to simulate the upright hair style of the Eastern Indians, used extensively from the Great Lakes through the Plateau. *See also* roach spreader.
roach spreader	A bone or metal plate inserted above the base of a roach to force the hair fringes upright. In use, it disappears from view.
scraping	A method of creating designs on birchbark in which boiling water is poured over the bark, after which the ground surrounding a design is scraped away. The remaining, scalded bark forming the design retains its red color.
shaman	The keeper of tribal lore and rituals, the evoker of visions, arbitrator of social customs, and at times, chief of the tribe. Also a medicine man, or doctor, who employs the trance as part of his system of diagnosis or perception.
silver	Coin silver is 90 percent pure; sterling silver is 92.5 percent pure. *See* German silver.
stroud	A coarse woolen trade cloth, often red in color, once widely used among the Prairie and Plains tribes. Its use today emphasizes Indian cultural legacy.
sweat lodge	A low, temporary beehive-shaped structure constructed of willow saplings and covered with branches, animal skins, or tarp in which steam is produced by splashing water on heated stones as part of ceremonial rituals. Sweating as a method of ritual purification was and still is widespread in Indian North America.
tinklers	Metal cones, used as fringe ornaments, noise makers, as well as clasps in Southwestern jewelry.
torn-tailored	Cloth ripped by hand rather than cut by scissors to form required shapes for sewing into clothing.
totem pole	A free-standing wooden pole set up before a house, carved and painted with a series of emblematic or crest symbols which may refer to family lineage, mythical or historical events, or honor a deceased tribal member. A form characteristic to Northwest Coast tribes.
trailer	A streamerlike appendage made of cloth or animal skin and at times highly decorated with beading, feathers, or brooches, suspended from a headdress or a belt.
turquoise	A semi-precious stone whose natural colors range from chalky blue to dark green and are interlaced with lines or blotches caused by the presence of other minerals. Treated turquoise has been subjected to a chemical hardener that darkens the color, although no dye is used. Imitation turquoise is a substance manufactured from various minerals or man-made materials and dyed.
warp/weft	Warp threads are the vertical threads attached to the top and bottom of a loom. The wefts are the horizontal threads that are woven over and under the warps.
yei	Highly stylized renderings of spirits deriving from Navajo sand paintings now found in Navajo weavings.

Index

Page numbers printed in italics refer to illustrations.

B. Tribes

Photo Credits

All photographs are by Bobby Hansson, except in the following cases:

William Barrett, Ridgefield, Conn.
fig. 32

Ben Blackwell, Oakland, Calif.
fig. 33

Courtesy *Charkoosta* (Pablo, Mont.)
fig. 28

Ralph T. Coe, Santa Fe, N. Mex.
fig. 3, 4, 6, 8, 9, 11–13, 17, 18, 21, 23, 27, 29, 30, 36, 37, 39

Robert Davidson, Surrey, B.C.
fig. 16

Chief Andrew Delisle, Caughnawaga, Que.
fig. 19

Don Goff, Jr., Ridgefield, Conn.
fig. 35

Sherman Holbert, Fort Mille Lacs Village, Onamia, Minn.
fig. 10

Herbert Lotz, Santa Fe, N. Mex.
fig. 22

Wes Lyle, Kansas City, Mo.
fig. 14

James O. Milmoe, Golden, Colo.
colorplate pp. 238–39, 240–41, black-and-white cat. nos. 290–292

Courtesy Museum of the American Indian, Heye Foundation, New York
fig. 2

Courtesy National Museum of Korea, Seoul
fig. 20

Courtesy Renwick Gallery, Washington, D.C.
fig. 7

Gregg Stock, Santa Fe, N. Mex.
figs. 24, 25

Courtesy Don Tenoso, Santa Fe, N. Mex.
fig. 41

Dale Tozer, Prince Rupert, B.C.
fig. 5

Reverend Thomas W. Wiederholt, Kansas City, Mo.
figs. 15, 38, 40